REMEX

REMEX

TOWARD AN ART HISTORY OF THE NAFTA ERA

AMY SARA CARROLL

UNIVERSITY OF TEXAS PRESS ◆ AUSTIN

This book is a part of the Latin American and Caribbean Arts and Culture publication initiative, funded by a grant from the Andrew W. Mellon Foundation.

Copyright © 2017 by the University of Texas Press
All rights reserved

First edition, 2017

Requests for permission to reproduce material from this work should be sent to:
 Permissions
 University of Texas Press
 P.O. Box 7819
 Austin, TX 78713-7819
 utpress.utexas.edu/rp-form

LIBRARY OF CONGRESS CATALOGING-IN-PUBLICATION DATA

Names: Carroll, Amy Sara, 1967– author.
Title: REMEX : toward an art history of the NAFTA era / Amy Sara Carroll.
Description: First edition. | Austin : University of Texas Press, 2018. | Includes bibliographical references and index.
Identifiers: LCCN 2017005974
 ISBN 978-1-4773-1064-9 (cloth : alk. paper)
 ISBN 978-1-4773-1137-0 (pbk. : alk. paper)
 ISBN 978-1-4773-1102-8 (library e-book)
 ISBN 978-1-4773-1103-5 (non-library e-book)
Subjects: LCSH: Arts, Mexican—20th century—Themes, motives. | Arts, Mexican—21st century—Themes, motives. | Arts and society—Mexican-American Border Region—History—20th century. | Arts and society—Mexican-American Border Region—History—21st century. | Arts—Political aspects—Mexican-American Border Region—History—20th century. | Arts—Political aspects—Mexican-American Border Region—History—21st century.
Classification: LCC NX514.A1 C38 2018 | DDC 700.972/0904—dc23
LC record available at https://lccn.loc.gov/2017005974

doi:10.7560/310649

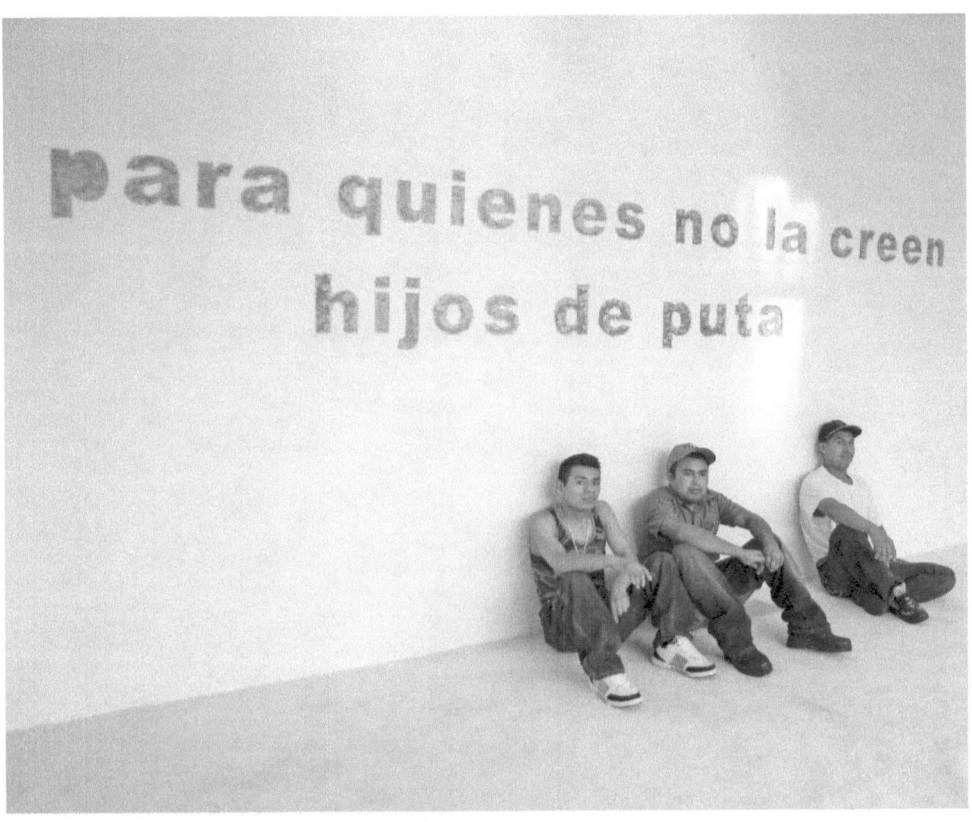

FIGURE 0.1. Teresa Margolles, *Operativo I*, 2008. Photographer Cecilia Jurado. © Teresa Margolles. Courtesy of artist and photographer.

From its beginnings, I intended this book to be for the "inoperative community" of artists, collectives, directors, curators, archivists, writers, and activists who have shared their work and ideas with me. But, à la Teresa Margolles's *Operativo I*, for some time I have also envisioned *REMEX: Toward an Art History of the NAFTA Era* to be for those who do not believe in the sacred and profane intimacies of art making, its criticism and histories, and the "art of economic government."

CONTENTS

PRELUDE
The Allegorical Performative 1

INTRODUCTION 10
Remix || re: Mex || REMEX
Toward an Art History of the NAFTA Era

CITY 41

NAFTA-ERA PERFORMANCE AND CONCEPTUALISM'S PREHISTORY 43

Mexico City, Readymade: The "PIAS Forms,"
Mexico's 1968, and Los Grupos 43

"Naco" as the Taco: No-Grupo, Maris Bustamante's *La patente del taco*, and Melquiades Herrera's Object Lifeworlds 52

POST-1994 GDPS AND LABOR WARS; INSTITUTIONAL CRITIQUE AND INCORPORATION 64

The Almost Ex Teresa Generation 64

Vicente Razo's Anthropological Materialism 74

Yoshua Okón's Art and Administration 83

Minerva Cuevas's *Logo*centrism 95

Francis Alÿs, Santiago Sierra, and the Age of Cuauhtémoc 108

Teresa Margolles, Remaindered 130

WOMAN 147

¿DESMODERNIDAD? LITERALISTS TO THE CORE! 155

Polvo de Gallina Negra's Maternal Prosthesis 155

REALLEGORIZING THE FEMALE FORM 163

 Lorena Wolffer's "El Derecho de Réplica" 163

 Katia Tirado's *Pub(l)ic Niches* 175

 Silvia Gruner's Fucked-Up Ethnographies 182

 Nao Bustamante's Inter-American Pageantry 193

BORDER 203

NAFTA-ERA PERFORMANCE AND CONCEPTUALISM'S PREHISTORY 205

 Art and Design: The Mexico-US Border after 1965 205

 The Border Art Workshop/Taller de Arte Fronterizo's
Open Door and Laboratory 221

**POST-1994 GDPS AND LABOR WARS;
INSTITUTIONAL CRITIQUE AND INCORPORATION** 235

 Guillermo Gómez-Peña's "North American Free Art Agreement" 235

 inSITE Specificity/Tijuana, Capital of the Twenty-First
Century 254

 From Undocumentation to the Undocumentary
(Alex Rivera, Sergio Arau and Yareli Arizmendi, Lourdes
Portillo, Ursula Biemann, Sergio De La Torre and Vicky Funari,
Chantal Akerman, Natalia Almada, _____) 286

POSTLUDE
REMEX || re: Mex || Remix
Untoward Art Histories of the Third Millennium 312

ACKNOWLEDGMENTS 323

NOTES 331

REFERENCES 347

INDEX 375

REMEX

PRELUDE

The Allegorical Performative

If you hold this book up to your ear, you might be able to hear, even feel, a bass line that runs through it. I call this bass line the *allegorical performative*, or, punning on the letter and spirit of both remix cultures and "mexicanidad" (Mexicanness), I know it as a *reMex*.

In 1998, I began researching performance art in Mexico City. My methodology included interviews, participant observation, and archival research. Blurring the line that divides life/work, it came to encompass collaboration and kinship. I was interested in gestures—often ephemeral—defined by their instigators as both politically and aesthetically innovative. In the decade that followed, I expanded my geographic focus to include the Mexican-US borderlands, in particular the Tijuana–San Diego corridor. I also expanded the formal range of my analysis to encompass video, installation, cabaret theater, net-art, architecture, cinema, and hybridizations of all of the above.

Indebted to conceptualisms, the breadth of this archive propelled me to reflect on my own bounded definitions of genre. As the Latin American art historian Mari Carmen Ramírez and others argue, conceptualism was never a singular entity. Although *Fountain* (1917)—a urinal that the French artist Marcel Duchamp signed "R. Mutt"—is heralded as a forerunner of conceptual practice, "conceptualism," the moniker, functions as an aggregator of a plethora of late-1960s practices that dematerialized art into ideas. Emphasizing process over product, focusing on "art after philosophy,"

conceptual artists have paradoxically rematerialized the artwork as the readymade to address the commodification of art and the mass-produced object. They have investigated and continue to address art institutions' complicities, limitations, contractual arrangements. They have turned to, inserted, and concretized language. Broadly speaking, practitioners of conceptualism under the influence of poststructuralist challenges to continental philosophy responded to post–World War II restructuring of base and superstructure. Yet because that restructuring was site-specific and time-sensitive, conceptual practices were also varied (*Global Conceptualism* 1999; Freire and Longoni 2009).

In the same time period in which the very concept of conceptualism took hold, a host of interdisciplinary formations that could loosely be grouped under the rubric of critical cultural studies—postcolonial, subaltern (Latin American and otherwise), gender and sexuality, and ethnic studies, including Latinx studies—also emerged, supplying us with powerful tools to read racial capitalisms and sex/gender systems, which convert human beings and regions into exchangeable objects.[1] Infrequently invoked in the same breath, these epistemological projects harbor affinities, especially in light of the aforementioned revisionary art histories' insistence on thinking of a spectrum of somatic practices that recognize art and life's inseparability (Taylor 2003).

Not to be confused with philosophical conceptualism, which posits that universalisms are produced regardless of the particulars of lived experience, conceptualisms, now modified to encompass neo-, post-, and de- conceptual practices, in the arts depend on what Ramírez (1999) playfully dubs the "contextura" (context + texture) of an artwork's re/production. As performance is paired with performativity, for the purposes of meeting *REMEX*'s archive on its own terms, when I refer to conceptualisms, I speak of artwork that engages "Conceptual *-isms*," including but not limited to, race, sex, class, able-, and trans/national -isms and homo- and xenophobias ontologically and epistemologically. Conceptual -isms in this formulation correspond to ideological formations that profile composite stereo- and archetypes, that establish and enforce continua of subjectivity-objectivity as hierarchies of personhood and value.

Contrary to prevailing debates regarding the social turn in art that either explicitly or implicitly oppose politics to aesthetics, this archive returns me to the democratizing etymological roots of the word "aesthetic"—that which is "perceptive by feeling." Aesthetics here is not confined to the white cube of the art museum or gallery, to the black box of the theater, or to the

material object of the book. Similarly, genre expands to encompass what the critic-playwright-novelist Sylvia Wynter calls the "genre/s of Man" (Wynter, cited in Weheliye 2014, 23).

Following the attentions to "the order of things" by the French poststructuralist Michel Foucault, Wynter (1994, 43) in the 1990s unbounded genre theory when she observed that young black men in the United States are regarded as the "Conceptual Other." Wynter's interventions form part of a body of work that from the 1960s onward rigorously interrogated knowledge production and distribution. This work paved the way for more recent treatments of "the art of economic government" (Foucault 208, 103), from the postcolonial scholar Rob Nixon's (2012) attentions to "the tragedy of the commons" as a genre of Cold War neoliberal doctrines to the literary critic Lauren Berlant's (2011, 4) elaborations on the present as a "temporal genre." Berlant offers that the "emerging event" reappears as "the situation, the episode, the interruption, the aside, the conversation, the travelogue, and the happening" (5). The back-and-forth relay that she mediates disambiguates x foreground and y background, thus permitting me to also contemplate the "contemporary" in both political and aesthetic terms.

Imagine the weave of the iconic visual puzzle of Rubin's vase that doubles as two profiles in conversation. Full apprehension of this illusion depends on the viewer's ability to register mutually constitutive pictorial fields. Some allude to this quasi-anamorphic drawing as an "allegory." From the Latin *allēgoria* or *allo* (Other) and *agoreuein* (speaking in the public sphere) and the Greek ἀλληγορία, allegory translates literally as "veiled speech." A technology that "commands a large percentage of the world's symbolic activity," allegory—the medium and the method—implicates word and image, sound and sight, touch, taste, and smell (Fletcher 2006, 77). It accounts for nested texts and environments ranging from the novel to the painting, from the nation-state to the world system.

The literary critic Angus Fletcher asserts that "we cannot understand the languages of politics and their rhetoric until we understand the allegorical method" (Fletcher 2006, 78). I'd add that we cannot comprehend the languages of post–World War II statecraft or multimediated cultural production without first examining that pair's garrulous dialogues. While German Romanticism bedrocks the French philosopher Jacques Rancière's arguments regarding the re/partition of the sensible, in *REMEX*, I argue that a critical mass of millennial Mexican and US artwork demonstrates that aesthetics and politics routinely circumvent the borders that we erect to police and separate them. The pair's intimacies, ebbing and flowing

intensities, form an infinite figure eight of drama and "social drama" whose varied rhythm is propelled by a rhetorical constant or "sovereign performative" (Butler 1997b, 71)—what I refer to as the allegorical performative.

Often cited in performance studies to illustrate a circuit of performance and performativity, the anthropologist Victor Turner's elaboration of the feedback loop of drama and social drama offers a model for understanding the Marxist literary critic Walter Benjamin's description of the relationship between the *Trauerspiel* (German tragic drama) and Central European history from the Thirty Years' War (1618–1648) to the 1919 consolidation of the Weimar Republic (Turner 1982; Benjamin 1998 [1928]).

The Origin of German Tragic Drama marked the beginning of Benjamin's lifelong preoccupation with *allēgoria*. In that monograph, Benjamin analyzes the codependency of allegory and symbol in nation and region narration. Benjamin's unfinished *Arcades Project* recalibrates his investigation of allegory to encompass the modern-colonial world system. Practicing an "anthropological materialism," Benjamin (1996) details the commodity's proliferation and mutation in the agora of the nineteenth-century Parisian arcades as the least common denominator of "capitalism as religion." Fashion, the poet Charles Baudelaire, the sex worker, mirrors, the arcades themselves, "letter" the city and the thinker's dialectical images of a world interior. In a series of essays addressing cultural production from Dadaism to futurism, surrealism, Soviet realism, and Nazi propaganda film, Benjamin further prioritizes the allegorical when he tracks realist, naturalist, and modern recalibrations of space and affect. Before the mid- to late twentieth century, Benjamin's corpus met with scholarly skepticism and resistance. Reappraisals of its significance coincided with poststructuralist and postmodern dramatic reevaluations of the power dynamics of symbol and allegory.

From the late 1970s onward in the West, a renewed privileging of allegory was predicated on reengagements with Benjamin's earlier resuscitations of allegory as medium and method. The literary critic Paul de Man (1979) muddied Romanticist hierarchies of value when he posited that all interpretations function as "allegories of reading." The art historians Craig Owens and Benjamin Buchloh re-synched Benjamin's attentions to allegory and periodization when they respectively identified postmodernism's "allegorical impulse" (Owens 1992) and associated a range of "allegorical procedures" (Buchloh 1982) with twentieth-century art making. At a respectful distance from those projects, the Marxist literary critic Fredric Jameson championed an even more spacious agenda for the allegorical. After

Benjamin, no one more systematically than Jameson has focused on tracking allegorical representations of the nation and the market forms (Hardt and Weeks 2000). A taut thread links two of Jameson's most widely read works, "Postmodernism, or, The Cultural Logic of Late Capitalism" (1984), the seed for his book-length study of the same name (1991), and "Third-World Literature in the Era of Multinational Capitalism" (1986). In an endnote to "Third-World Literature" (88), Jameson claims "national allegory" as an exemplary "mapping of the totality" as a "theory of the cognitive aesthetics of the Third World." He also locates "Third-World Literature" as a pendant to "Postmodernism." The admission dictates the terms of Jameson's rejoinder to the postcolonial studies scholar Aijaz Ahmad, who takes him to task for his formulation of "Third World Literature" (1992). In response, Jameson offers that he envisioned "Third World Literature" to be "an intervention into a 'first-World' literary and critical situation, in which it seemed important to [him] to stress the loss of certain literary functions and intellectual commitments in the contemporary American scene" (1987, 26). Jameson's "allegory of reading" and allegorical method, which emerges auto-ethnographically in this instance, is indebted to Benjamin's. Unlike Benjamin's "anthropological materialism," Jameson's modus operandi veers toward a more suspect us/them binary, however.

Tracking the allegorical fragment across work responding to the conditions of late capitalism, Jameson (1991, 5) weds the allegorical to the postmodern as an algorithm of both the market and forms of resistance to it, making clear that when he writes about postmodern culture, he refers to a "whole global, yet American" phenomenon. He muses on the dogged persistence of the nation form's "libidinal apparatuses" in the wake of social and decolonization movements, in effect turning away from the British novelist Wyndham Lewis's "fables of aggression" (the context of Jameson's [1979] original formulation of "national allegory") to a more ironically generic allegorical figuration of the Third World.

Just as you might tense a muscle in a social body scan, note the melancholic sensibility of Jameson's opposition. The interred perspective from which its Othering is staged betrays postmodernism as one "national allegory" among many. Rooted in the provincialism of post–World War II US socioeconomic hegemony, Jameson's account buries deep in its own political unconscious the synthesis it seeks to effect, a broader reading of the allegorical strategies of capitalism with those of nation narration boiled down to some First-/Third-Worldly critical difference. The distinction partially explains why not only Jameson's thesis on "national allegory" but

also his observations on postmodernism were received by feminist, ethnic studies, and postcolonial scholars other than Ahmad with equal parts skepticism and enthusiasm. Latinx Americanists, cognizant of Jameson's debts to phenomena like magical realism have debated the merits of importing theory (García Canclini 1990; Schwarz 1992; Richard in Ludmer 1994; Beverley, Oviedo, and Aronna 1995; Saldívar 1997; Brünner 1998). After September 11, 2001, these conversations returned to the United States. In the US humanities, the keyword "postmodern" was all but supplanted by the twinned keywords "neoliberal" and "global" in contexts beyond critical cultural studies. Simultaneously, mixed allegorical economies, restructured as the nation-state on the global market, continued to appear in discussions concerning the planetary imaginary, like optical illusions with pictorial planes as obfuscated as those of the Rubin's vase.

Chief among them, and running parallel to accounts of the nation's demise, was a set of social allegories that solidified, albeit at times by way of negation, the foundational fiction of market-state integration. If Jameson lamented the paucity of representations of First World collectivity, he did so against the backdrop of an explosion of plotlines of military alliances, trade blocs, and international accords in the second half of the twentieth century. From the United Nations, the United Arab Emirates, the World Bank, the International Monetary Fund, and the Washington Consensus to the rise and restructuring of countless transnational corporations and hybrid market-state structures, the most ubiquitous forms of transnational allegory were not composed by artists and novelists but by world leaders, public policy analysts, and corporate executives, who frequently returned our attention to the intimacies of culture and economy.

On this wavelength, the US neoconservative thinkers Francis Fukuyama and Samuel Huntington bemoaned "the end of history" and exhibited their own preoccupations with "the genres of Man" as they mapped out the thin veil of the present as a barbaric "clash of civilizations" (Fukuyama 1992; Huntington 1996). Alternately, the Uruguayan sociologist Gerardo Evia considered the "brutal symbolic" cartography of an advertisement for the company Syngenta: the fictive "Soy Republic," which annexes swaths of Bolivia, Paraguay, Brazil, Argentina, and Uruguay. Evia reads the advertisement as an allegory that "clearly reflects a conflict of powers that is at the center of recent discussions about globalization: the nation-state's loss of power at the hands of multinational corporations" (2004).[2] Evia's account, contrary to the literary critic Francine Masiello's disavowal of "neoliberal allegory" (2001) and the cultural critic Alessandro Fornazzari's observations

that allegory as a form fails as a transitional discourse because "its logic of abstraction [was] exceeded and rendered obsolete by the commodity form" (2013, 2–3) in the Southern Cone, clarifies that allegory continues to function as one, if not *the*, rhetorical operation par excellence for promoting the nation and the corporation as commodities on the world market.³

On the Mexico-US subcontinent, to be sure, the narrative force of allegory prevailed in the NAFTA era, overlaying and crisscrossing prior plotlines to topographically map the "New World Order" per US president George H. W. Bush's recycling of the phrase on September 11, 1990. Popularized by Woodrow Wilson and Winston Churchill, the "New World Order" on the order of Jameson's readings of "national allegory" represented both a vision of planetary unity and short-handed conspiracy theories of total control. In the Americas, the "New World Order" was regarded as synonymous with a palimpsest of New and Old Worlds. The observation perhaps explains the proliferation of complementary allegorical modes of reading in artwork, scholarship, and literature of the same period. *REMEX*, participating in this loop, is premised on the bold yet banal observation that NAFTA represented the most fantastical inter-American allegory of the turn of the millennium.

Signed by the leaders of Canada, the United States, and Mexico on December 17, 1992, the North American Free Trade Agreement (NAFTA) was billed as a trilateral bloc to eliminate continental trade barriers. NAFTA was promoted as the quintessential hard sell of the United States' and Canada's post-1960s restructuring and touted as Mexico's "green card to an international future" (Monsiváis 1991–1992, 59). Such triumphalist accounts were met with counternarratives of derision and dissent to such an extent that the temporality of the treaty, exceeding the date of its ratification, has come to epitomize the millenarian mind-set of an era. For example, late-twentieth-century Mexico's foremost essayist Carlos Monsiváis identified "two predetermined reactions to NAFTA: the apocalyptic and the utopic" (1992, 207). The binary logic anticipated NAFTA's graduated reconfiguration of North America, especially the treaty's implications for what the pioneering border studies scholar-poet Américo Paredes termed "greater Mexico."

With "greater Mexico," Paredes (1958) referenced a binational region spanning Northern Mexico and the US Southwest. In the years of my research for this book, from the late 1990s through the mid-2010s, an astonishing number of changes occurred in this subcontinental corridor, in effect binding Mexico's and the United States' political economies and

cultural imaginaries all the more tightly together. Because this paradigm shift represented a literal and metaphoric reconfiguration of North America, I came to attribute these changes to a synesthetic "NAFTA effect." Much later, I associated comparable sea changes in Mexican and US art making with phenomena and events (e.g., feminicide, California's Proposition 187, Operation Gatekeeper, the Mérida Initiative) tied to the overarching catalyst of NAFTA.

In the spirit of this archive, when I invoke Paredes's place-name, I imagine greater Mexico as thickening north and south. Simultaneously, I link that dramatic reterritorialization to the particularities of a period. To put a finer spin on the periodization that I propose, just as greater Mexico must be understood as expansive, so, too, the temporality of NAFTA must be regarded as exceeding its January 1, 1994, one-minute-after-midnight claim to fame—the stopped watch of the Zapatistas—that became the clarion call of a generation of alter-globalization activists.

Some of the most eloquent disavowals of neoliberal doctrine were sent electronically, postscripted from the Mexican-Guatemalan borderlands. Bearing witness to the catastrophe of socioeconomic restructuring in Chiapas, Mexico, and worldwide, those Zapatista communiqués clarify that NAFTAfication, whose seeds were sowed in the long 1960s, encompassed the transnational economic crises of the 1980s; the duration of NAFTA's negotiation beginning in the early 1990s; its protracted enactment from January 1, 1994, to January 1, 2008; and its post-2008 fallout effects, including extreme narco-violence and economic free fall worldwide. In *REMEX: Toward an Art History of the NAFTA Era*, I address this time period by focusing on a critical mass of artwork that "undocumented" the NAFTA effect.

Choppy. Citational. Incomplete. Forward- or backward-looking. Opaque. Procedural. Ironic. Layered. Baroque. Minimalist. The cultural production that has sustained my attention, on the one hand, follows what Owens, Buchloh, and Jameson, in defining postmodernism, associated with the allegorical. On the other hand, this archive's makers dissociated themselves from catchall revivals of allegory as medium and method. Resisting the universalisms if not the spirit underpinning Buchloh's, Owens's, and Jameson's theses, artists in Mexico City and in the Mexican-US borderlands turned to the details of the local and regional as a starting point for generating broader meanings and applications of allegory in the late twentieth and early twenty-first centuries. Their actions round out what I mean by the allegorical performative. If the linguist J. L. Austin (1962) defines performatives as utterances that "do things" rather than simply conveying

information, when I suture the allegorical to the performative, I refer to a rhetorical operation that exceeds both the linguistic of the literary and the visual of the artistic; that repeats and exposes the "alterity" within itself as a *"promising ambivalence"* (Butler 1997a, 91; emphasis in original).

While the turn of the millennium was noteworthy for its polarized discursive regimes that have spilled over into the twenty-first century, inflecting the United Kingdom's BREXIT vote and the 2016 US presidential election of Donald Trump, *REMEX*'s archive follows and furthers other rhythms that nuance the allegorical performative as a site-specific and time-sensitive reMex that cannot be treated as a linear and singular narrative.

Call and response: How do we develop, in the memorable language of the French sociologist Henri Lefebvre, a "rhythmanalysis" that is attuned to this archive's challenges to and repudiations of History with a capital *H* (2013)? Anyone who has ever taught someone else how to scan a poem knows that individual accents make a world of difference, harbor the potential to generate, in the words of the Zapatistas, "a world in which many worlds fit" (Marcos 2001). Where I stress syllables and where you do enables or disables either of our haiku's metered lines. Blanket definitions and theories function similarly. To site-read the allegorical performative's permutations in NAFTA-era greater Mexico, I first offer an abbreviated account of the cross-currents of the allegorical in Mexico and the United States, painting with broad brushstrokes the historical purchase of allegory in and for the subcontinent. I then summarize the form of *REMEX* to lay down its praxis-oriented dissonant tracks.

INTRODUCTION

Remix || re: Mex || REMEX

TOWARD AN ART HISTORY OF THE NAFTA ERA

The neologism "reMex" and its ungrammatical derivatives—"remex," "REMEX," "remexicanidad"—could send a mind in many directions. In late 2013, as debates raged in Mexico over the denationalization of its energy sector, I heard REMEX in all caps as if it culture-jammed one of Mexico's last state-owned corporations. In a Spanish that uses the words "petróleo" and "nafta" interchangeably, could I be forgiven the code-switching liberty of reading Mexico's petrolization as foreshadowing NAFTA?

After the infamous Arab oil embargoes of the 1960s and 1970s, Mexico struck it rich. Petróleos Mexicanos (PEMEX) discovered vast petroleum reserves that tripled the country's oil output. PEMEX mushroomed, constructing offshore drilling platforms and onshore processing refineries. Against the value of these petro-dollars, the Partido Revolucionario Institucional (PRI), Mexico's decades-long ruling party, responded to the global financial crises of the 1970s by doubling the publicly owned business sector of the economy, the parastate.[1] In 1982 at its zenith, Mexico's parastate comprised a vast, decentralized network of organizations and "fideicomisos" (funds), an imaginary geography that could be mapped onto the Mexican republic's literal states and regions. This empire stood in contrast to the sector's more humble origins as one tactic among many of Mexico's import-substitution industrialization (ISI) strategies.

Ironies abound in the annals of governance. In Mexico, one of the most persistent is still that a president associated with salvaging many of the

socialist ideals of the nation's 1917 revolution also created the infrastructure for the second Porfiriato.[2] In 1938, President Lázaro Cárdenas (1934–1940), acting on the precedent established by Article 27 of the 1917 Mexican Constitution, expropriated the holdings of foreign-owned oil companies and vast tracks of land along Mexico's northern border. Cárdenas's anti-imperialist gesture translated into a reclamation of the world's third-largest petroleum reserves from primarily US businesses. It also resulted in the re-creation of a no-man's-land of free trade zones (Fernández-Kelly 1983, 25).[3] His executive order spurred on the state's subsequent developmentalist phase of economic revolution from 1940 to 1970, commonly referred to as the "Mexican Miracle." His successors—Presidents Manuel Ávila Camacho, Miguel Alemán Valdés, Adolfo Ruiz Cortines, and Adolfo López Mateos—nationalized industries from railways to telecommunications, merging failing private businesses into the national corporate body. To maintain the ballooning parastate, they also borrowed overwhelmingly from US banks, skyrocketing the national debt from $3.2 to over $100 billion.

Boom, boom, boom, bust! In the early 1980s, as interest rates soared and oil prices plummeted, Mexico's economy teetered on the brink of collapse. In July 1982, Mexico achieved a dubious milestone, becoming the first Latin American nation to declare a moratorium on payments to service its foreign debt. The default rocked the world's financial system, signaling a larger crisis of confidence in ISI strategies. In August of that same year, President José López Portillo declared bankruptcy before nationalizing the country's banking system.

Post-1982, the dissolution of the Mexican parastate began. The pre-text of revolution unraveled for a trade policy loan (Babb 2001, 181). The Marxist cultural geographer David Harvey muses on the particularities of the Mexican Faustian pact: "In 1984 the World Bank, for the first time in its history, granted a loan to a country in return for structural neoliberal reforms" (2005, 100). Casting Mexico's lot in with domestic and foreign business interests, newly elected President Miguel de la Madrid (1982–1988) agreed to implement strict austerity measures, to lower national tariff barriers and protections in place for labor, and to privatize the bulk of the parastate's holdings.

One year after an earthquake measuring 8.1 on the Richter scale rocked Mexico City, claiming over ten thousand lives, Mexico opted to join an unnatural disaster of comparable magnitude—the General Agreement on Tariffs and Trade (GATT).[4] What followed was the nearly complete formalization of Mexico's open economy (Cypher and Delgado Wise 2010). The

hemispheric disaster capitalisms that ensued led many to invent novel names for the era's more viscerally felt realities. In Mexico, circumstances necessitated a wordsmith of the highest order. De la Madrid "dedazo"-ed or shoulder-tapped Carlos Salinas de Gortari, another US-educated technocrat, for the PRI presidential nomination. Notwithstanding accusations of election fraud, including a system shutdown on the vote count, in 1988 Salinas secured office with the promise of "social" versus "militant" neoliberalism (Charles Hale, quoted in Fox 1999, 99). Salinas's defeated opponent was none other than Cuauhtémoc Cárdenas, the only child of the 1930s reformist Lázaro Cárdenas.[5]

If the selection of Cárdenas functioned as a citation of the golden era of the post-revolution, the motif of that period's rebirth found its more ironic expression in the pomp and circumstance of Salinas's elided domestic and international policies. Countering the perception, even the conceit, of Mexico's perpetually deferred modernity, the Salinas administration (1988–1994) promoted a "new Mexico" of "democratic transition" that maintained the twofold narrative of cultural sovereignty and economic interdependence. Salinas spearheaded an array of fiscal and civic reforms that set the stage for the North American Free Trade Agreement. He dreamed as big as the New World Order, aspiring to lead the World Trade Organization (WTO) as late as 1995 when he fled the presidential office in disgrace.

By 1989—the year of the Berlin Wall's fall, Beijing's Tiananmen Square or June Fourth Incident, and the Washington Consensus—new laws permitted 100 percent foreign ownership in the largest sectors of the Mexican economy. By 1990, no permits were required for the majority of imports to Mexico. Within Mexico, socioeconomic disparities comparable only to those of the postindependence period—when the state seized and sold indigenous communal lands and vast church holdings—skyrocketed (Concheiro Bórquez 1996, 92). The remnants of the parastate became concentrated in the hands of an emerging class of conglomerate-owning elites known as "los grupos" (the groups). The political scientist Cristina Puga (2004) describes the sell-off of Mexico's public sector as not only a fulfillment of the nation's triangulated obligations to the World Bank, the International Monetary Fund (IMF), and the United States, but as the fait accompli of a qualitative shift in the relationship between the state and its increasingly consolidated business oligarchies. Central players in what's routinely referred to as the first phase of Mexico's neoliberal transition included the Grupo Monterrey, a bloc of northern industrial elites who recycled the positivist language of Mexico's nineteenth-century "científicos" (Hernández Romo 2004, 89).

In the 1930s, the Monterrey Group openly objected to Cárdenas's expropriation of the petroleum industry. By the 1980s and 1990s, the group's revivalist tendencies extended to the 1920s and 1930s representational economies of Mexican cultural nationalism. If the economists James M. Cypher and Raúl Delgado Wise (2010, 31; emphasis in original) characterize the Monterrey Group and los grupos more generally as "Mexico's *endogenous* version of neoliberalism," it is important to recall that these powerful players "reMexed" the hitherto seemingly antithetical discursive—visual, semantic, and somatic—regimes of the postrevolutionary nation-state and the one-world market to articulate and establish the site-specificity of a uniquely Mexican neoliberalism, which paradoxically was enmeshed with that of the United States.

In the late 1980s, los grupos, the new PRI with Salinas at its helm, and US business interests combined forces to launch a historically unprecedented marketing campaign in the US Congress (Cypher 1993). Designed to sell the "capital fiction" of continental free trade and, by extension, Mexico's collapsed nation and commodity forms, this initiative deployed Mexico's domestic neoliberal revolutionary rhetoric to promote a sutured Mexican-US economy (Beckman 2012). Before NAFTA, besides GATT, there was the Bilateral Commission on the Future of United States–Mexican Relations in 1986, the US-Mexico Bilateral Framework on Trade and Investment with Mexico in 1987, and the Omnibus Trade and Competitiveness Act of 1988.

In 1990, there also was a seemingly more innocuous blockbuster exhibition that translated Mexico's (art) history not only for US museumgoers but also for thousands of middle-class Mexicans who flocked to New York to view their own "'high' culture" (Franco 1999, 8).[6] From its title to its layout to its catalogue, *Mexico: Splendors of Thirty Centuries* (1990) presented a master narrative of "epic encounters" (McAlister 2001), "a will for form" revolving around the reconciliation of opposites.[7] Critics marveled, but also chafed, at the ribbons and bows attached to *Mexico: Splendors*. In New York, the title of the program of cultural events accompanying the show, "Mexico: A Work of Art," summed up for many the project's "audacious" and "unprecedented" vending of Mexico.

"Manhattan Will Be More Exotic This Fall!" proclaimed the advertising copy for "Mexico: A Work of Art." Coupled with *Self-portrait with Monkeys* (1938) by Frida Kahlo, the meme prompted the art historian Shifra Goldman (1994, 32) to describe the exhibit as selling "a sanitized image of Mexico—devoid of [the country's] terrible economic crises and social disintegration." The curator Brian Wallis (1994, 272) succinctly summarizes the marketing

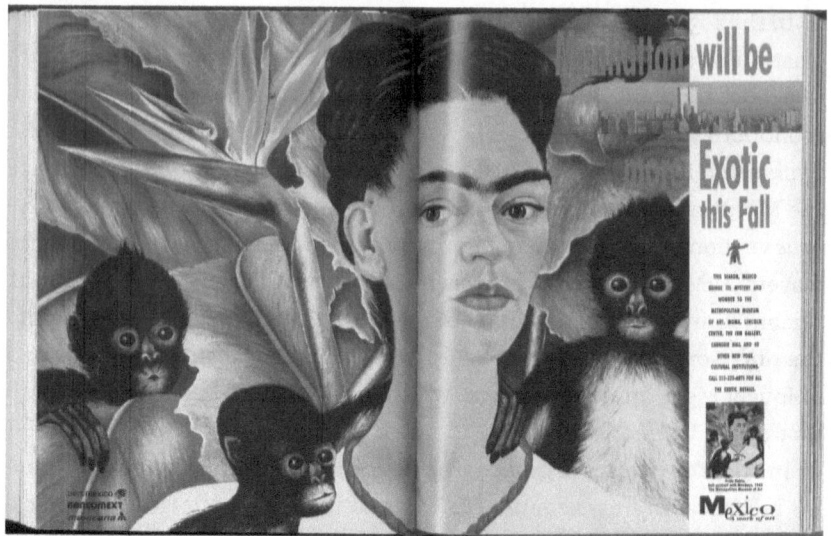

FIGURE 0.2. Advertisement for "Mexico: A Work of Art," *The New Yorker*, October 15, 1990.

campaign: "*Mexico: Splendors* [set] out, not only to map the art history of [Mexico], but also to compose a national allegory, to invent a fictive or at least enhanced past." Wallis's observation clarifies that the timeline of *Mexico: Splendors* omitted both muralism and artwork after 1950.

The exhibit also depended on a slippage between gender, genre, and goods, especially pronounced in the rhetoric of open markets. In Spanish, the word "género/s" functions as a homonym, referring to that threesome.

The show's monumental scale and form completed its contents, modifying and recommodifying the role assigned to cultural production—allegorical—in and for Mexico from the postrevolutionary period onward. Per the cultural critic Jean Franco's elaboration of Kahlo's en*gender*ment of Mexico™, and according to Latinx essayist-poet Rubén Martínez's caricature of the "Frida-Kahlo-ization of Los Angeles" (1991), the full import of *Mexico: Splendor*'s programmatic accessorization also exacted a substitution: the exchange of Kahlo for Diego Rivera.

SEEING LIKE A (MARKET-)STATE

Although many feminist, ethnic, and postcolonial studies scholars other than Aijaz Ahmad have taken Fredric Jameson to task for his First/Third

World binary, others have demonstrated the potentially productive insights afforded by the means, if not the ends, of Jameson's arguments. For instance, the literary critic Doris Sommer, repurposing Benjamin's readings of German tragic drama and Jameson's (1986) formulation of "national allegory," turns to the nineteenth-century Latin American novel "to notice *how* the rhetorical relationship between heterosexual passion and hegemonic state functions as a mutual allegory" (1991, 31). Sommer's formulation has been challenged but remains compelling in several nineteenth-century national contexts other than Mexico. By the early twentieth century, most would agree that it was not the novel but the linked mural and museum forms that mediated the Mexican postrevolutionary allegory of revolution and the hegemonic state function.

Although not always recognized as components of the Mexican parastate, Mexico's museum, salon, and university systems were made possible by Article Three of the republic's 1917 Constitution, which guaranteed Mexican citizens the right to a free education and established the office of the Secretaría de Educación Pública (SEP; Ministry of Public Education) in 1921. José Vasconcelos (1882–1959), the first Minister of Public Education, created and oversaw vast literacy campaigns. He also commissioned murals that reflected his channeled obsession with trademarking a uniquely Mexican aesthetic. Vasconcelos cultivated an origin myth of a post-Conquest, miscegenated Mexico as the cradle of a continental civilization—"la raza cósmica" (the cosmic race)—which at its core restages the legendary encounter between the Spaniard Hernán Cortés and his indigenous translator, lover, and cultural bridge, La Malinche (Doña Marina, Malintzin, Malinalli). The quintessential allegorical figuration of treacherous and maternal Woman, La Malinche makes clear the state's self-perpetuating aestheticization of economic, political, and religious transculturation.[8] Also referred to as "la chingada," she demonstrates how Mexico's first postrevolutionary "foundational fiction" operated not as an allegory of romance but as one of "enabling violation."

Facetiously writing of well-meaning bureaucrats of imperialism in the South Asian context, the postcolonial critic Gayatri Chakravorty Spivak notes, "What these functionaries gave was often what I call an enabling violation—a rape that produces a healthy child, whose existence cannot be advanced as a justification for the rape" (1999, 371). The dubious merits of Spivak's formulation permeate postrevolutionary Mexico's preoccupation with the racialized and sexualized figure of Woman.

A second "enabling violation" of postrevolutionary Mexico, partially

mitigating the conceit of its first, made room for a seemingly more fecund repro-narrative of the social. The Mexican anthropologist Roger Bartra (1996 [1987], 188) contends that the great myths of the Mexican Revolution were organized vis-à-vis the romance of the masses and the PRI as their socialist-leaning governing party. What began as a series of exercises in collaborative artistic production that produced "los tres grandes," Diego Rivera, José Clemente Orozco, and David Alfaro Siqueiros, was reproduced in and by Mexico's contradictory 1930s bid for socioeconomic autonomy.

In the 1930s, Cárdenas not only expropriated Mexico's petroleum reserves and borderlands, he also incorporated culture, prioritizing artistic expression in the state's everyday presentation of collectivity. As muralism became Muralism, a Conceptual -ism to rival any produced for imagining community, the PRI's avant-garde institutionalization of a hybridized aesthetics and politics was brought into sharp relief. "Seeing like a state" in post-1917 Mexico entailed more than urban planning, land management, or even the creation of failed public works projects, as detailed by the political scientist James C. Scott (1998). The Mexican postrevolutionary state maximized the arts and education as tools of biopolitical management. With the creation of the Instituto Nacional de Antropología e Historia (INAH; National Institute of Anthropology and History) in 1939 and the Instituto Nacional de Bellas Artes (INBA; the National Institute of Fine Arts) in 1946, Mexican cultural nationalism, centered in Mexico City, spliced its own Bhabhian "performative" and "pedagogical" temporalities into one another.[9] The INAH facilitated the trope of "el México profundo" (deep Mexico; Bonfil Batalla 1987) to complete the state's developmentalist chronoaesthetics. A transnational undertaking, the drive to catalogue and display indigeneity spawned such colossal monuments to what I term *anthropological nationalism* as the National Museum of Anthropology in Mexico City's Chapultepec Park (founded in 1963). "Indigenismo," at base a wider set of Latin American political ideologies that forward symbolic relationships between the nation-state and its indigenous populations, was key to the consolidation of postrevolutionary Mexico, casting indigeneity as nothing short of national patrimony. In contrast to the INAH, the INBA, the ostensible purveyor of real-time articulations of the nation, promoted a Mexican modernity that folded the PRI's modernizing agenda into modern art. Understood as functioning dialogically, the INAH and INBA were charged with the impossible task of reconciling the nation's anterior "primitivism" and its future modernization.

As the INAH and INBA articulated the museum as a genre, they

approached the horizon of the mythic. They set the watch, in conjunction with muralism, of the state's recursive allegorical impulse. National history becomes national allegory in the mural form's greatest amalgamations of social realism, populist anthropology, and Marxist-inflected architectural spaces before eclipsing all of the aforementioned.[10] Between "politicizing art" and "aestheticizing politics," muralism also flagged the allegorical as exceeding the boundaries of the Mexican republic (Benjamin 1968). An allegorical impulse dictated the terms of Mexico's international reception; it was inseparable from the United States' own bids on allegory as method.

A uniquely North American continental philosophy was hardwired into US nation narration from 1800 onward. Cultural studies scholars Toby Miller and George Yúdice (2002, 37) contend that because the 1848 Treaty of Guadalupe Hidalgo, which annexed the US Southwest, included provisions for affected populations' languages, it amounted to the US invention of "modern cultural policy in a Federal frame." The plotline of the United States' heroic individualism was scripted in both the northeast woods and the rugged Southwest (Turner 1894; Bolton 1933; Gutiérrez and Young 2010). Pre–Monroe Doctrine, the borderlands as a critical regionalism became the lowest common denominator of the United States' desire for hemispheric mastery, scripting the US myth of frontier masculinity (Slotkin 1992). By 1910, other fears and fantasies abounded to widen the lens of an "image environment" (Tejada 2009) that situated the Mexico-US border as North America's most spectacular "state-sponsored aesthetic project" (Brady 2002, 83). The Mexican Revolution became a source of consternation and entertainment for international observers. The border and cultural studies scholar Claire Fox notes that "images of the US-Mexico border of this era mark the emergence of an allegorical way of seeing the region" (1999, 69). More precisely, the postrevolutionary period remediated previous allegorical modes of partitioning the territory. A taxonomic and cartographic drive renegotiated the racialized and sexualized conjugal divide of the two nation-states. For an international Left, Mexico's socialist-inflected revolution, a clear counterpoint to the Russian Revolution, symbolized freedoms hitherto unimaginable. For Right and centrist observers, especially those located in the United States, the Mexican Revolution pitched its southern neighbor further toward contagion and promiscuity, toward a barbarism perennially reinvented as indigenous, poor, and anarchic.

By the midnight hour of Cárdenas's expropriations, external players had

reterritorialized the vast shadow repository of mexicanidad. Active participants in these elaborate symbolic transactions included the US writers and curators Katherine Anne Porter and Anita Brenner and the Mexican anthropologist Manuel Gamio. Porter, Brenner, and Gamio observed and contributed to postrevolutionary anthropological nationalism, organizing exhibitions of Mexican arts and crafts that stoked the flames of a craze for the folkloric. Their efforts were matched by the experimental documentary aesthetics of postrevolutionary Mexico's photographers, from the foreign nationals Tina Modotti and Edward Weston to Mexico's own Manuel Álvarez Bravo. Porter, Brenner, and Gamio's endeavors went hand in hand with the enterprising taste for all things Mexican cultivated by the Rockefellers and other hemispheric corporate citizens. The art historian Irene Herner juxtaposes *Mexico: Splendors* with an earlier speculative investment in Mexico as "a work of art." In 1930, Emily de Forest (the wife of Robert W. de Forest, the president of the Metropolitan Museum), Elizabeth Morrow (the wife of then US ambassador to Mexico), and Winthrop W. Aldrich (a banker and the brother of Abby Rockefeller, John D. Rockefeller Jr.'s wife) formed the Mexican Arts Association, Inc. to promote the arts in Mexico and the United States as a vehicle for mutual understanding.[11]

Nelson A. Rockefeller, in the capacity of president of New York's Museum of Modern Art and in cooperation with the Mexican government, staged *Twenty Centuries of Mexican Art* (May 15–September 30, 1940), which sampled muralism under the rubric of "modern art." Muralism—despite Rockefeller and Rivera's epic skirmish in Rockefeller Center, the very stuff of transnational allegory—fared better in this earlier promotion of a Mexican (art) history in the United States and was salvaged by US corporate altruism (Botey 2014a).[12] By the 1940s, muralism had also been salvaged by the US "cultural front" (Denning 1997) and the US government vis-à-vis New Deal subsidies of art. The Treasury Department's Section of Fine Arts and the Federal Art Project of the Work Projects Administration took a page from early Mexican postrevolutionary cultural nationalism, using muralism as a model of sustainable public art.

Before social protest and radical politics were neutralized in this decidedly regionalist endeavor, the mural form "screened" alter-narratives of collectivity unanticipated by theorists of the culture industries. The result was a cleaved continental anxiety/ecstasy of influence. According to the director of the Section of Fine Arts Edward Bruce, US artists and their backers were charged with learning from, but also curtailing, the "Mexican invasion on the border" (Bruce, quoted in Goldman 1994, 286)—a reference

to the Mexican muralists and not to the late-twentieth- and early-twenty-first-century's more familiar un/documented entrants whose "image" will preoccupy our attention in *REMEX*'s final section.

By the 1950s, the Central Intelligence Agency (CIA) preferred the freedom of abstract expressionism, itself indebted to Mexican muralism. Cold War cultural policy converted what the art historian Amelia Jones (1998) terms the "Pollockian performative" (after painter Jackson Pollock) into an abstraction of frontier masculinity. Muralism's reconfiguration morphed and reappeared in Mexico.

The Mexican Nobel Laureate in Literature, Octavio Paz, christened the disparate artists who sought to distance themselves from Mexican muralism "La Ruptura" (The Rupture). Before Paz's moniker stuck, the artists José Luis Cuevas, Pedro Coronel, Francisco Toledo, and Vicente Rojo collectively referred to themselves as the Joven Escuela de Pintura Mexicana (Young School of Mexican Painting). Varied in their aesthetics, they shared a disdain for the Mexican School of Painting and Sculpture's monopoly on state patronage.[13] Cuevas's efforts especially became the fodder for the first sustained vision of continental unification: Pan-Americanism in contradistinction to Latin Americanism or discrete nationalisms.[14]

In the late 1950s, Cuevas helped set the protoperformance and conceptual agenda of not only Mexican art but also Mexico's economy. Against the cult of muralism, Cuevas forged an enfant terrible aesthetics as cultish as Pollock's, staging such actions as the creation of an ephemeral mural in Mexico City's Zona Rosa. At a respectable distance, "the 'prophet' of antimuralism," Rufino Tamayo, the final entry in *Mexico: Splendors*'s teleology, also broke with his postrevolutionary indoctrination to synthesize pre-Hispanic art and figurative expressionism on trim canvases before he dreamed big as the Museo Tamayo (Goldman 1977, 16). The interventions of La Ruptura—from Cuevas to Tamayo—represent, according to the artist Manuel Felguérez (2012), less a desire to supersede Mexican art than an imperative to universalize it. The moment in Mexico was one of collective introspection under the sign of the modern. Paz's classic *Labyrinth of Solitude* (1981 [1950]) epitomizes a second strand of postrevolutionary Mexican cultural nationalism—the profiling or excavation of "national character," what I term *psychoanalytic nationalism*—a move away from the masses toward the insular citizen-subject. Sampling liberally from various authors (Samuel Ramos, Xavier Villaurrutia, Sigmund Freud, Alfred Adler), Paz generated a pantheon of conceptual personae, "The Pachuco and Other Extremes," to typecast Mexico, thereby establishing the formula

for Mexico's new man through a logic of elimination.[15] Paz's opening ambivalence regarding the displaced Mexican is matched by his unvarnished unease with the figure of Woman, split into a mother/whore dichotomy. Still unable to vote in the Mexican republic, literal women, like Mexican Americans in Los Angeles and working-class men on Mexico City's streets, were not accorded full personhood in Paz's impassioned soliloquy.

Paz both captured the shifting role of culture in Mexican civil society and foreshadowed the paradoxical emergence of mixed, hybrid economies across the Americas. The anti-allegorical impulse of La Ruptura after all occasioned an opening in the Mexican (art) market that was nothing if not allegorically inflected. In a deracinated rechanneling of the spirit of the revolution, President Luis Echeverría (1970–1976) assigned "las artes plásticas" a "misión patriótica" (patriotic mission) even as Mexican voices expressed renewed concerns about cultural penetration and Mexican youth challenged the state's modernization project (Frérot 1990, 84).[16] Mexican business responded enthusiastically to Echeverría's configuration of artwork as contributing to Mexico's capitalist development. In Mexico City and Monterrey, luxury hotels curated their own art collections and galleries. The Grupo Industrial Alfa amassed an art collection that necessitated its own exhibition space. Other Monterrey consolidated businesses sponsored juried art competitions. Banca Serfín and Banco Nacional de México began collecting and exhibiting art, producing monographs on artists' work.[17] Mexican art also enjoyed a renewed hypervisibility in the US market in the 1970s in no small measure because collectors preferred to import their "Latin flavor."

In a suite of essays as scattered yet as patterned as the night's constellations, Goldman traces the relationship between the visual arts and socioeconomic policy in and between Mexico and the United States from that decade onward. Focusing on Mexican petroleum, her chronology genders and racializes *Mexico: Splendors* as one exhibition in a series of "vendidas" (sell-outs), which we might read as calculated gambles on the allegorical. In early 1973, Armand Hammer, president of Occidental Petroleum and a trustee of the Los Angeles Contemporary Museum of Art, brought the *Treasures of Mexico* exhibit to Los Angeles. At the show's opening, Hammer rehearsed a time-honored script, "Art is an emissary [through which] ties between nations can be strengthened," before conceding that the new Mexican gas and oil discoveries would prove invaluable to the United States.

In 1977, Sotheby's opened its first auction of modern Mexican art to such resounding success that it offered Latin American art auctions every six

months thereafter (Goldman 1994, 323–324). One of its first sales included a self-portrait by Frida Kahlo, who at the time was known as little more than the tempestuous wife of Diego Rivera. The "Frida-Kahlo-ization" of the subcontinent had begun like some antidote or anecdote to muralism. Meanwhile, although the mural form in Mexico had been institutionalized by 1965, in the United States it underwent a dramatic rebirth as one of the Chicano movement's preferred genres. Offering a prototypical reMexing of the essentialisms of postrevolutionary cultural nationalism, Chicano cultural nationalism resuscitated and often hypermasculinized indigenismo with the imaginary geography of Aztlán, a mythic Aztec homeland in the Mexican-US borderlands, in part through the genre of the mural, whose iconography spanned decolonization movements and continents. In partial response to the durable good of muralism's "progressive politics," in 1978 the exhibit and forum *Mexico Today Symposium*, like *Mexico: Splendors*, wrote muralism out of its art history. The culturally war-torn 1980s picked up the pace of inter-American historical revisionism and acquisition. Investments in Latin American art corresponded to the United States' piqued interest in Mexican oil, its covert Central American wars, shifting continental (labor) demographics, and the inter-American drug wars, increasingly multimediated. They reflected safe hedges against a range of increasingly politicized genres from muralism to performance and video that rejected recycled narratives of "discovery."

How was it possible to be ultranationalist and globally minded on the 1980s Mexico-US subcontinent? In many regards, television and film from the World War II era onward had scripted the most in/visible answers to this question, supplying viewers with Good Neighborly inter-American national romances (Shohat and Stam 1994; Pérez Melgosa 2012). In Mexico, the Fundación Cultural Televisa, A.C. (Televisa Cultural Foundation)—one of several holdings of the Grupo Monterrey, under the leadership of San Antonio–born Emilio "El Tigre" Azcárraga Milmo—promoted melodrama before folding the genre back into an aggressive countercampaign of arts patronage. Televisa underwrote the costs of constructing Mexico City's Rufino Tamayo Museum of Contemporary Art, which opened in 1981 (Goldman 1994, 275).[18] As the first co-sponsorship between an individual artist, the Mexican state, and private industry, the museum represented an avant-garde arrangement that became a social melodrama, made possible by economic crisis.[19] Its newness mattered; it was nothing short of revolutionary.

Between 1982 and 1992, the Mexican government refused any private sponsorship of preexisting state-funded institutions but also deemed the

university and museum structures "the least 'productive'" components of the parastate (Debroise 2001, 51). Tamayo and Televisa modeled a third way, a marriage of convenience in a period of "institutional negligence" (53). That the romance soured did not dissuade PRI technocrats from following in the pair's footsteps. While the new PRI treated the old PRI as a dinosaur nearing extinction, it regarded the arts perversely as a sleeping lady in need of a kiss to wake her. The new PRI and los grupos collaboratively read the writing on the wall—that "culture," shorthanded as museums and muralism—was an ideological state apparatus. Recognizing the allegorical agency of the arts in postrevolutionary statecraft and international diplomacy, their position echoed the 1950s disenfranchised Mexican artists' dissatisfaction with the state's monopolistic arts sponsorship. It also stood in contradistinction to contemporaneous conservative denunciations of the arts in the United States.

The art historian Grant Kester contextualizes debates regarding the funding of the National Endowment for the Arts (NEA) in the 1980s and 1990s, which set the tenor of the culture wars in the United States, by returning to discussions leading up to the NEA's establishment. Kester (1998, 106) writes, "During the 1950s, art is seen as a cultural weapon in the Cold War. And during the 1960s it provided an additional justification for the expanding domain of state 'responsibilities' within the Great Society." Kester notes that by 1965 the arts were freighted with the weight not only of signifying "a new community responsibility" but also of having a use value for "channeling social unrest and reintegrating the disenfranchised" (ibid.).[20] The latter rhetoric, chillingly raced and classed, refers specifically to the management of US internal dissent (not only civil rights, gay and lesbian, and feminist but also antiwar and countercultural movements). It was mappable onto the United States' emerging inchoate, mixed allegorical economy—from the scripts of a "nation of immigrants" and "the great American melting pot" to that of the "gunfighter nation"—that birthed a multicultural-inflected neoliberal nation inseparable from the transnational reconfiguration of the sex/gender system of US racial capitalism in a South that extended beyond the borders of the actual nation-state.

The global economic recession from 1987 to the mid-1990s, the AIDS crisis, the digital revolution, the rise of the dot–com industry in the mid-1990s and the bursting of that bubble in 2000, Y2K catastrophe narratives, the first and second Gulf Wars—phenomena connected and disconnected from NAFTA—all contributed to the planetary sense that the United States represented *the* quintessential local articulation of the global. The Los

Angeles riots in 1991–1992, Anita Hill's testimony during Clarence Thomas's confirmation hearings for the US Supreme Court, the rise of the Moral Majority in the United States, challenges to *Roe vs. Wade*, Bill Clinton's impeachment proceedings and "Don't Ask, Don't Tell" policy on LGBTQ-identified military personnel (despite what the gender, sexuality, and ethnic studies scholar Jasbir Puar [2007] identifies as the United States' increasing "homonationalism"), 1980s/1990s immigration reforms, and the precipitous spike in Islamophobia after 9/11 (2001) intensified a cultural logic that shaped the United States before and after the McCarthy era. Museums, galleries, the publishing industry, universities, were reframed as contested sites of struggles in the decades preceding the new millennium. The bodies of women, people of color, the differentially abled, and LGBTQ-identified, per the terms of the feminist artist Barbara Kruger's aphorism "Your body is a battleground," persisted as equally intense zones of conflict. The litany of changes that I detail here, like Kester's temporally double-jointed contextualization of the NEA, suggests that Jameson's "Third-World Literature" and *Postmodernism* writings are best considered alongside a third, roughly contemporaneous essay by the author, "Periodizing the 60s" (1984). In the latter, Jameson makes the argument that "decolonization historically went hand in hand with neo-colonialism, and that the graceful, grudging or violent end of an old-fashioned imperialism certainly meant the end of one kind of domination but evidently also the invention and construction of a new kind—symbolically, something like the replacement of the British Empire by the International Monetary Fund" (184). The thinker's three essays make clear that a cultural logic of late capitalism, which he notes was implicitly elided with US imperialism, proved to be as operative a substitute for "old-fashioned imperialism" in the United States as it was abroad (1991, 5). Reactions to US exceptionalism were hardly uniform however.

In Mexico in the late 1980s, for instance, as federal allocations to the NEA were gouged in the United States, the PRI's rising technocrats slashed public services and denationalized industry, but revamped arts patronage by the state using the NEA as their model (Mayer 1996, 4). The Salinas de Gortari administration initialized the biggest changes to the arts and educational funding structures since 1921. The Consejo Nacional para la Cultura y las Artes (CONACULTA; National Council for Culture and the Arts, founded December 7, 1988) and the Fondo Nacional para la Cultura y las Artes (FONCA; National Fund for Culture and Arts, founded March 2, 1989) were designed to coordinate the diversification and expansion of state and private enterprise's collaborative funding of the arts. FONCA's stated

objective was the preservation of the arts, ranging from "living heritage" to the Mexican School of Painting and Sculpture to contemporary drama and music.[21] It was articulated in response to anxieties about both cultural and economic "penetration." In Mexico, across the political spectrum, the arts were held up as both a sword and a shield against NAFTAfication. Unlike a US electorate who projected the worst effects of NAFTA to be economic—recall the independent presidential candidate Ross Perot's conflation of NAFTA with a "giant sucking sound" of jobs heading south in the second 1992 US presidential debate—Mexican citizens, as if resigning themselves to the inevitability of economic penetration, took up the cultural as a weapon distinct from that fashioned by NEA architects.

CONACULTA and FONCA funneled money away from the INBA and INAH while also facilitating outside sponsorship of art exhibitions, museums, and archaeological sites. Los grupos took advantage of the generous tax incentives and loopholes written into this reorganization. Their actions also followed Goldman's contention that the qualitative difference between the 1970s and the late 1980s/early 1990s Latin American art boom boiled down to one of agency. Goldman (1994, 327; emphasis in the original), with less allowance for the persistence of Mexican cultural nationalism, observes that "a one-way cultural imperialism and its corollary, 'cultural dependence,' that flowed primarily from the United States" prevailed in the 1970s, but that by the 1990s, "the global alignment of power elites from nations of the First and Third Worlds . . . whose objective is the control of resources and cultural configurations *across national boundaries*" emerged, especially on the North American continent. By 1990, Televisa, which controlled nearly 100 percent of Mexican television, had become synonymous with the overarching privatization of culture that doubled as the latter's "Americanization" before it boomeranged back to galvanize Latinx viewership in the United States. Into this ambience, insert *Mexico: Splendors*, like some Trojan horse five years before the Tijuana artist Marcos Ramírez ERRE literalized the comparison bicephalously.

Goldman's "global alignment of power elites" enjoyed a decidedly Mexican base in the Friends of the Arts of Mexico, founded in 1988 by Azcárraga Milmo to "promot[e] the awareness and appreciation of Mexican art, cultural life, and history throughout the world" (*Mexico: Splendors of Thirty Centuries* 1990, ix). Fundación de Investigaciones Sociales, a subsidiary of several alcohol and media corporations that included Bacardi y Compañía, Casa Pedro Domecq, Compañía Vinícola Del Vergel, Grupo Cuervo, Grupo

Televisa, Tequila Sauza, and the Seagram Company, bankrolled Friends of the Arts of Mexico, which, in turn, teamed up with CONACULTA, the US Federal Council of the Arts, and the Rockefeller and Tinker Foundations to fund and promote *Mexico: Splendors* and *Mexico: A Work of Art*.

Mexico: Splendors demonstrates that we must dispense with the notion that culture played no part in NAFTA's brokerage or implementation. In practice, no "cultural exemptions" existed.[22] But the era, like those before and after it, suggests that we must read between the treaty's lines and its effects. Neither the US culture wars, which globally spread like a virus or Hollywood cinema, nor the Mexican *telenovela*-inflected "neoliberal style," can be separated from the particularities of the integration of the US and Mexican economies. The Los Angeles–based poet-musician–cultural critic Rubén Martínez observes of *Mexico: Splendors* and Salinas's overlapping arrivals in LA,

> That the art of diplomacy is no less aestheticized than the art of painting is evident in Salinas' performance for the Free Trade Agreement. The Harvard-educated economist's homely looks haven't prevented him from cultivating a complex image: blending old-style Mexican presidentialism (his sing-song speech delivery) with the persona of a worldly arts patron (if he had enough hair, you could imagine the ponytail). (1991, 17)

US viewers saw a version of this "film" more or less coevally. According to the political scientist Michael Rogin, it was called *Ronald Reagan, the Movie* (1988).

TOWARD AN ART HISTORY OF THE NAFTA ERA

The postcolonial critic Edward Said observes, "Beginning is not only a kind of action; it is also a frame of mind, a kind of work, an attitude, a consciousness" (1975, xv). If a book's beginning informs the arc of its argument, a word's beginning holds the power to rewrite the whole of its meaning. At the risk of trivializing Said's book-length attention to intention, I'd wager it's worth closely considering the hegemonic prefixes—"post-" and "neo-"—of the late twentieth century. Were appeals to the condition of the end of history and to new beginnings only reactive or reactionary? Decades after Monsiváis identified the polarizing logic of the NAFTA debates, the Mexican anthropologist Claudio Lomnitz (2012, 348) put forth that the "style"

of neoliberalism in 1980s/1990s Mexico engendered a broad revival of right- and left-leaning political language, from Salinismo to Zapatismo. Within this symbolic economy, "neomexicanismo," the other 1980s overriding Monterrey aesthetic, emerged as a counterfoil to the sign system of the new PRI and "democratic transition." Moreover, it accomplished this subversion because it drew to the foreground the period's performative and conceptual hierarchies of Mexican cartography and personhood.

The term "neomexicanismo" first circulated as an epithet. In some circles it persists as one. The Mexican art historian Teresa del Conde referred to the figurative painters of the 1980s associated with neomexicanismo first as *"los catastrofistas"* (the catastrophists), then as the school of "savage neoexpressionism" to emphasize their work's focus on Mexico's late-twentieth-century socioeconomic instability (Eckmann 2010, 3, 15). Only later would del Conde allude to the work's "Nuevo mexicanismos." Neomexicanismo has come to be associated with a neoexpressionist style of painting that cites, thus re-siting, national and popular symbols commonly linked to the idea of Mexico. Neomexicanist mainstays—such as the lush, jewel-toned canvases of the "norteños" Javier de la Garza (1954–) and Julio Galán (1959–2006)—exude "Otherworldly" baroque excess, bordering on the magically real, the auto-exotic, and, I'd add, the nationally abject.[23]

In the 1980s, the Monterrey Group aggressively began to collect neomexicanist canvases. Their acquisitions looked a lot like speculative investment—with all the accompanying highs and lows—insofar as they sought to drive up the work's value on the international market (Eckmann 2010, 51). The Monterrey Group's obsession with neomexicanismo explains dismissals of the work, but other assessments of neomexicanismo merit our attention.

For instance, the deceased French transplant to Mexico City, the art historian, curator, filmmaker, and experimental novelist Olivier Debroise (1990, 28) reflected at length on the relationship between neomexicanismo and "the irreversible 'Chicano-ization' of daily life" from the 1970s onward in Mexico. Debroise codes "Chicano-ization" as the cultural effect or "symptom" of an opening of the Mexican market, promoting a reading of neomexicanismo in the tradition of Paz, which implicitly depends on the denigration of politically decontextualized subjectivities. Debroise (ibid.) posits neomexicanismo as "pop-mexicano," suggesting that its existence arose "as if certain young Mexican painters felt culturally exiled in their own country, and turned their faces nostalgically toward past forms of expression, to a denaturalized folklore."

While he does not elaborate on the circumstances of those artists' sentiments, Osvaldo Sánchez, a Cuban transplant to Mexico City, art critic, and curator, opines freely on the neomexicanists' "sexile."²⁴ Sánchez (2001) maintains that neomexicanismo's "homosexual drive" denationalized emblematic representations of Mexican identity. Sánchez focuses first on the artists' fascination with the elided worklife of Kahlo, then examines the artists' fervent cataloguing of postrevolutionary cultural nationalism's invocations of indigeneity (in particular, the male indigenous body). His analysis is more compelling than the conclusions he reaches. The method that Sánchez attributes to neomexicanismo could be recoded as securing the opposite effect that he claims—a renationalization of iconic Mexican emblems—along the lines of Monsiváis's influential "reMex" of Susan Sontag's (1966) canonical essay "Notes on 'Camp,'" written in 1964.

In "El hastío es pavo real que se aburre de la luz en la tarde [NOTAS DEL CAMP EN MÉXICO]" (Ennui is a peacock that grows bored in the afternoon light [NOTES ON MEXICAN CAMP]), a much-cited essay originally published in 1966 but later included in the collection *Días de guardar* (1970), Monsiváis identifies a fissure in Mexican cultural nationalism. He notes that the supercilious zeal of institutionalized revolution, which he characterizes as the cultural weaponry of the "perfect dictatorship," increasingly met its match in another camp of the national-popular, the purview of the disenfranchised middle and working classes, from the early 1960s onward.

Unlike Sontag (1966, 107), who glosses camp as "disengaged, depoliticized—or at least apolitical," Monsiváis reclaims "national camp" as inherently political. Like some love child or "hijo de la Chingada" of Mexican psychoanalytic and anthropological cultural nationalisms, national camp represents a methodology of critique by which Mexicans reconfigure the levels of signification of material (i.e., the accessory—the feather boa, the knick-knack, or in the case of cultural nationalism, the silent film or images of the revolution) and conceptual objects (i.e., identificatory markers like gender or race, La Malinche, or *mestizaje*) (1970, 172).²⁵ The concept of "national camp" proves useful when considering the visceral, sometimes eviscerating, relationships of neomexicanist canvases to prior visualizations and performances of postrevolutionary cultural nationalism. It also proves useful when contemplating the reception and redeployment of the work.

Take, for example, de la Garza's *Enemigos I* (1989), whose title was airbrushed onto a full-page *Time Magazine* special advertising section for *Mexico: Splendors* without the artist's knowledge or permission. *Enemigos I*—which treats a "charro," or northern Mexican cowboy, watching his sleeping

lady surrounded by fruits—was renamed *Mexican Delights* and explained as "a classic example of the neomexicanismo style which was influenced by the country's Golden Age of Cinema in the thirties and the forties" (underlining in original advertisement, 1990).[26] Nowhere does the advertisement mention that the painting is not part of *Mexico: Splendors*. Instead, *Enemigos I*, legible as an allegory, became *Mexican Delights*, the crown jewel of a subsequent social allegory of the increasingly hyphenated market-state. Juxtaposed with a portrait of Salinas, also baldly advertising Mexico, the image's frame and picture plane expand to include the copy and images that surround it. They expand once again to form part of a larger history of Mexican culture, nested into advertisements for Cancún and Puerto Vallarta luxury hotels and beaches.

All the markers are here for us to read the cascading focal ranges of these page spreads as a process enacted on the doubly confiscated image per the performance studies scholar Jon McKenzie's (2001) observation that "performance" became a key term in the business as well as the art world from the 1950s onward.[27] All the markers are here for us to recognize the intimacies of neoliberal doctrine and allegory following the postcolonial literary critic Betty Joseph's (2012, 71) hypothesis that "the power of allegory to naturalize neoliberalism may have much to do with the structural similarity of the form to the axioms of neoliberal theory."[28]

Neomexicanismo collapses into the new PRI's and los grupos' business interests through a methodology deployed equally by de la Garza and by industry before and after the artist's remake of the film still. The elaborate rhetorical transactions that choreograph not only the painting's production but also its *re*production better explain why, for many, neomexicanismo came to allegorize something other than Mexico's global potential, registering instead a (gendered, raced, and classed) crisis in both painting and the nation's representation and reception inter/nationally. Debroise parses this crisis, paying close attention to its convergences with and divergences from those articulated by theory uninvested in the idea of Mexico. He reflects on 1980s/1990s Mexican artists' influences—*October*, Monsiváis, Sontag, Jameson, Chicano art—noting that, taken together, they enabled a "new artistic culture [that] used the national patrimonial heritage in a caustic 'remix,' in an attempt to revise the nation's iconography and modify its consciousness" (Debroise 2001a, 55).

Later, building on many of Debroise's characterizations, the curator-critic Cuauhtémoc Medina notes that as the 1990s unfolded, neomexicanismo repeatedly was opposed to a *Mexican* brand of neoconceptualism

epitomized in and by the figure of the Veracruz-born artist Gabriel Orozco. Championed by Benjamin Buchloh, who linked the postmodern to the allegorical, and others associated with the quarterly journal of art criticism and theory *October* (Bois 2009), Orozco's work set the tone for the emergence of a millennial and millenarian Mexican contemporary, which, like *Enemigos,* was never framed as art detached from circuits of exchange or place-based relationality, but refused to play the spectacle of trans/national abjection. To be clear, affect retains its bid on the allegorical but is muted in Orozco's performances of the ephemeral and the quotidian, and therefore accorded surplus value: Two hands clasp and unclasp a lump of clay in before and after photographs titled *My Hands Are My Heart* (1991). *An Empty Shoebox* in the 1993 Venice Biennale (before Mexico established its own pavilion there) overflows with the wishes, disappointments, dreams, and failures of all who linger in the exhibition space. In contrast to neomexicanismo's promotion of demonstrative excess, Orozco's minimal gestures were showcased as both less vulnerable to appropriation and as the cover art and recovery project of a generation of 1990s cosmopolitan cultural producers eclipsing Mexico proper.

Consider Orozco's *Pelota ponchada* (*Pinched* or *"Poncho-ed" Ball*, 1993), an image of a deflated soccer ball that now holds water against a rough backdrop of black asphalt. Its 2014 strategic placement on the cover of a catalogue for an exhibition whose curator, Alexandra Schwartz, claims was the first retrospective of 1990s US art, *Come as You Are: Art of the 1990s* (2014), speaks volumes about the era's and the continent's immaterial borders. If and when we de-border the United States to encompass its southern neighbor in a gesture on the (new world) order of Schwartz's, the aforementioned neoconceptualism/neomexicanismo opposition can be mapped onto the binaries of both NAFTA debates in Mexico and the United States and the US culture wars. The differences between Mexican and US tactics concerning an aesthetics of the everyday cannot be dismissed, but also deflate under pressure and render concave an encroaching subcontinental public sphere before refashioning it to hold new water.

Contemplate the following coincidence: the formal starting point of Latinx art historian Tomás Ybarra-Frausto's "Rasquachismo: A Chicano Sensibility" (Griswold del Castillo, McKenna, and Yarbro-Bejarano 1991) is also Sontag's essay. Ybarra-Frausto defines "rasquachismo" as a Chicano way of being and perceiving the world that, like Monsiváis's "national camp," depends on the political resignification of material and conceptual objects.[29] Ybarra-Frausto (like Monsiváis) politicizes rasquachismo when

he writes, "The Chicano Movement of the 1960s reinvigorated the stance and style of rasquachismo. The very word chicano, with its undertow of rough vitality, became a cipher repudiating the whiteness of experience" (Griswold del Castillo, McKenna, and Yarbro-Bejarano 1991, 159). The US-sited sensibility that Ybarra-Frausto details is as decidedly allegorical as "national camp" insofar as it mediates a consolidated object and the moving subject of self-determination, an imagined community (Anderson 1991) not congealed into a monolith.

There are no coincidences. Ybarra-Frausto's essay was included in the catalogue of the first exhibition of the Chicano Art Movement to appear in major art venues, *CARA*, or *Chicano Art: Resistance and Affirmation, 1965–1985* (1991). *CARA* opened at the Wight Art Gallery at the University of California, Los Angeles, on September 9, 1990. It lived up to its subtitle, meeting with resistance and affirmation. In that same year, Orozco squeezed life into *My Hands Are My Heart*; *Mexico: Splendors* peddled free trade; and neomexicanismo was featured in a series of seven collective and five individual exhibitions in New York City; San Antonio; Washington, DC; and Santa Monica that fell under the umbrella heading of the *Parallel Project* (1990). Organized by Patricia Ortiz Monasterio of Mexico City's Galería OMR in collaboration with the Galería Arte Mexicano (GAM) and Monterrey's Galería Arte Actual Mexicano (GAAM), the *Parallel Project*, true to its name, ran parallel to *Mexico: Splendors*, showcasing Mexican artwork post-1950. Viewing these art "events" side by side, like reading Monsiváis's and Ybarra-Frausto's "reMexes" of Sontag's notes together, provides us with a window of opportunity to connect the dots of a historical moment that could propel us forward but also send us back to the polyvocality of a greater Mexican allegorical performative—the master narratives it propelled and art workers' eurythmic, arrhythmic, and polyrhythmic analyses of the latter.

The noisy picture that emerges is neither a neomexicanismo nor a caustic remix. The question of how best to read a range of artwork can be formulated neither as "What is contemporary art?" (Smith 2009) nor "What was contemporary art?" (Meyer 2013). Those queries, like Jameson's formulation of postmodernism, are simply too generic. They sharply crop the "total speech situation" (Austin 1962) of an inter-American reMex. *Pace* Benjamin's observations that "[Karl] Marx lays bare the casual connection between economy and culture. For us, what matters is . . . the expression of the economy in its culture [N1a, 6]" (1999, 460) when faced with this "sovereign performative," a more specific question arises: How did greater

Mexican artists' bids on the social, the political, and the cultural as contested Conceptual -isms, notably those sited in Mexico City and the Mexican-US borderlands, come to be viewed as synonymous with the neoliberal-as-contemporary, with Mexico and the United States' cross-hatched transition? Trebling Turner's looping figure eight, this question clarifies why the form of *REMEX* also represents part of my method with this project.

Readers arriving at this book with the expectation of a linear narrative of NAFTA's history or of greater Mexican millennial artistic production may leave it unsatisfied. *REMEX* is divided into three sections, which are further divided into subsections. Functioning dialectically, this organization ensures that its parts build on and cross-reference one another and the project in full. While *REMEX*'s logic is accumulative, associative, and thus clearest when its sections are read together, each of its parts is capable of standing alone like a poem in a collection or a social actor in a collective.

REMEX's sections map onto three key allegorical figurations of the NAFTA era—"City," "Woman," and "Border." While I reference Mexico City, female artists of the time period, and the Mexican-US borderlands, in equal measure I refer to what Said (1975) describes as imaginary geography and what the earth artist Robert Smithson (1996) calls an artwork's "non-site" (as opposed to the literal site of its production) when I speak of the "City" with a capital *C* or the Border with a capital *B*. Explicitly gendered, the conceptual relay that maintains those territories also reproduces the allegorical figuration of racialized and sexualized Woman with a capital *W* as a surrogate for Mexico and Culture.

Attempting to route around the period's bipolar oscillations between the "neo-" and the "post-," in *REMEX* I additionally flag three prefixes that representationally correspond to the labor congealed in and by the artwork examined in each of the book's sections. Specifically, Mexico City cultural producers met the positivism of the new PRI and neoliberalism with a resounding "no-" or "non-" compliance to Culture in the service of the state. Female art workers contemporaneously situated both the neo- and post- as more clearly aligned with the "re-" cycled narratives. And border artists reworked the untranslatable "un-" of the "undocumented" as their preferred semiotic prosthesis.

"City," "Woman," and "Border" finally form a network of three "allegories of reading" that correspond to the rapid "genre-fication" of three objects of study: Mexico City contemporary art, greater Mexican feminist performance art, and Mexico-US border art. Focused on intermedial art that

31

trebles the neo/conceptual, the performative, and the "undocumentary," these sections attest to the inadequacy of describing *REMEX*'s archive as solely allegorical. Thick descriptions of "City," "Woman," and "Border" further illustrate all of the above distinctions that I am making.

CITY

While much of what passed for Mexican art in the 1980s fulfilled stereotypes and archetypes along the ideological lines of *Mexico: Splendors*, Salinas's revamped funding structure for the arts, as the success story of Gabriel Orozco suggests, also created openings for a more nebulously defined internationalization of Mexican art, surreptitiously setting the stage for battles to come over what truly constituted a Mexican "contemporary." By some accounts, the edgiest iterations of 1990s Mexico City art—its borderwork, so to speak—began as an appeal to the "alternative," but by 2002 was subsumed under the sign of the "contemporary" (Montero 2013) or, what Medina (2010) cleverly puns as the "contemp(t)orary." A 1990s critical mass of artists and collectives from Mexico City, or Mexico's Distrito Federal (DF), "corrupted" the aesthetic impulses of neomexicanismo and Orozco-trademarked neo/conceptualisms, to develop a range of hybrid practices that accented the neo/conceptual over the performative and the undocumentary, while nonetheless also drawing on the latter pair's propulsions. These artists recognized the centrality of the "lettered city" from the colonial period onward in Latin America (Rama 1996) and the privileging of the city as an allegorical figuration in varied accounts of the modern and the postmodern (Benjamin 1999; Sassen 1991). They also recognized the contradictory impacts of student, decolonization, and civil rights movements worldwide on art making on the city as a built environment, following the sociologists Luc Boltanski and Eve Chiapello's thesis concerning the effects of collaborative art making's conceptual and performative tactics on corporate practices and urban development.

Boltanski and Chiapello (2005, 105) define the projective city as "a mass of active connections apt to create forms—that is to say, bring objects and subjects into existence—by stabilizing certain connections and making them irreversible ... [as] a temporary *pocket of accumulation*, which creating value, provides a base for the requirements of extending the network by further connection." DF artists of the 1990s, resisting historical and presentist accounts of the centripetal motion of the city, respun the metropole's significance centrifugally to map the shape of its pockets. Haunted

by Mexico's unique '68, the fallout from "La Noche de Tlatelolco," the state's infamous massacre and disappearance of countless students and protesters a week before Mexico hosted the 1968 Olympics, unlike the generation of cultural producers immediately preceding them, these art workers recognized and incorporated into their curatorial and art practices the impact of these events (for instance, the ethos of youthful rebellion that chroniclers of Mexico's '68 valorized) on the relationship between statecraft and art making thereafter. Their points of reference were decidedly Mexican and international. The stories they collapsed in and through their practice, far from simple, increasingly were streamlined for export into a single, paradoxical narrative of DF-centrist experimentation, too. The allegory unfolded as follows: in the 1970s, DF-based cultural producers expressed disillusionment with the agenda of institutionalized revolution epitomized by the muralism movement and prior reactionary rejections of that experiment with a hybridized aesthetics and politics, including the emerging private gallery network. Reimagining political and public art, those artists worked in collectives called Los Grupos (not to be confused with "los grupos" of Mexican big business). Many of the groups produced work that loosely might be categorized as anti-allegorical (albeit not in the vein of La Ruptura).

The corpus of No-Grupo functions as a noteworthy exception to this generalization and thus as one interruption in the story of both post-1968 and post-1994 DF art. For No-Grupo's members (Maris Bustamante, Alfredo Núñez, Melquiades Herrera, and Rubén Valencia), the prefix "No-" assumed the stature of Smithson's elaboration of the "non-" in the "nonsite." Unlike Smithson, No-Grupo—and Herrera especially—like Benjamin, focused on the commodity as an "allegorical emblem," thereby opening up the map and territory.

Such an aperture was not without its ironies: it paralleled the "open market" propagated by discourses of free trade, one reason perhaps that the work accommodates its own incorporation into reMexed histories of and reactions to the period. In Boltanski and Chiapello's "spirit of new capitalism," artists and collectives of the 1990s and 2000s (i.e., Vicente Razo, Minerva Cuevas, Yoshua Okón, Francis Alÿs, Santiago Sierra, SEMEFO, and Teresa Margolles), following in Herrera's footsteps, registered the material and immaterial processes of the city's fragmentation in the 1980s after the 1982 devaluation of the peso and the 1985 earthquake by charting the Federal District's flows, blockages, and grids of relationality as staged encounters and confrontational distinctions between the real and the imaginary.

Their efforts signaled a new phase in artists' reinvestment in the commodity as a "critical fetish" (*The Red Specter 1.1* 2010). "City"'s archive generates rapid code-switches, subject-object illusions on the order of the consummate neoliberal assemblage of the market-city-state in this archive.

After 1994, DF artists reloaded the possibilities of Los Grupos' practices, splicing critiques of the postrevolutionary nation-state's foundational fictions, which opposed the provincialism of Mexico City as a federal district to that of Mexico's various states, into those of free market fundamentalism. They also exhibited a more flexibly accumulative relationship to art history than many of their 1970s predecessors, often recuperating the latter generation's histories to preliminarily draft their own. From performance art inspired by Mexico City's street vendors, to an artist's bathroom converted into a readymade museum of popular representations of Carlos Salinas, to installations that incorporate unclaimed human remains from Mexico City's central morgue, the work of "City" renders suspect master narratives of the market-state and the city, but refuses to jettison wholesale the romance of an allegorical method. In fact, this archive negated the negation of the foundational fiction of the federal district, the nation, and the market, displacing each's romance with the state onto the larger post-1968 countercultures' romances with irreverence and rebellion.

By the early aughts, the forms of this archive garnered global attention, frequently adhering to the tenets of "relational aesthetics" (Bourriaud 1998), "participatory art" (Bishop 2012), "conversation pieces" (Kester 2004), and "living as form" (Thompson 2012), but also mobilizing an aesthetics of "contradiction," "indecision," and "nihilism." The former terms, products of the same decade, were proposed to jumpstart conversations about artwork that focuses on the significance of the artist's or others' bodies in art making as a process. Existing on a broad bandwidth, such labels further generous readings of the social but also sometimes exist uneasily with the work of "City," which negatively redoubles on itself.

The situation, no less situationist, can be summarized in this light: much of "City's" work also appears to be animated by another drive, which fetishizes the product or object, be it a canvas, installation, or the city proper. The compromise of the work's equally antisocial tenor, following neomexicanismo's attempts to allegorize the late-1980s alienation of Mexico's consumer-citizenry and the accumulative logic of Orozco's deflated soccer ball, demonstrates how the allegorical performative regulates and

"radicates," per the art historian Nicolas Bourriaud's discussion of the artist as a "radicant," the language and the effects of both "democratic transition" and the tactics of experimental art making.

WOMAN

In the self-portrait by Frida Kahlo used to promote *Mexico: Splendors*, monkeys surround the artist. Interpreted by the Metropolitan Museum's audiotour to signify the "children she could not have," the primates, Franco (1999, 43) claims, are "twined around her neck and arms . . . [they] touch her breast as if proclaiming her part of unsubdued *tropicalismo*." Years later, they resemble other entities and people to me—outside investors, internal business interests, all vying for the attentions and the body of Mexico as Woman.

Mexico's myth of La Malinche is not an isolated phenomenon. Foundational fictions of Latin America, and the global South for that matter, time and again cast the European explorer as male and the indigenous populations with whom he came into contact as fantastically female or effeminate (Baddeley 1998). In these "social contracts," both parties morph into archetypes or allegorical figurations. Sexual violation, a reality of the Conquest, operated as the defining "pornotrope" of these repeat colonial encounters, extending beyond human beings to effeminize geography. In NAFTA-era Mexico, proponents and detractors of free trade overlaid this script with what the feminist economic geographers Katherine Gibson and Julie Graham, publishing under the moniker J. K. Gibson-Graham in 1996, identify as globalization's "rape script." If, as the literary critic Gordon Teskey (1996) notes, rape grounds allegory as a genre, Gibson-Graham (2006 [1996], 120) trace the ubiquity of late-twentieth-century references to penetration and domination by capitalism in texts like Jameson's *Postmodernism*. The consequences of understanding genre as capaciously as Sylvia Wynter, Lauren Berlant, and Rob Nixon do become even clearer, especially when thinking of specific shifts in North American racialized and sexualized capitalism.

Gibson-Graham's insights, read in conjunction with first encounter mythohistoriography, illustrate how and why, following Ahmad, we must periodize (per the terms of Jameson's treatment of the 1960s) both "Third-World Literature" and *Postmodernism* as profoundly gendered and raced texts (Ahmad 1992, 122). Gibson-Graham's and Ahmad's attentions to

feminine detail complicate Bartra's and other Latin Americanists' skepticism regarding the applicability of the keyword "postmodernism" to Latin America, too. Punning on the language of Jameson and other "conceptualists" of postmodernism, in *La jaula de la melancolía* (*The Cage of Melancholy*), Bartra (1996 [1987], 9) characterizes Mexico's late twentieth century as one of "desmodernidad." Bartra's wordplay is particularly clever because it mobilizes the word "desmadre," Mexican slang for "chaos." Embedded in desmadre is the "mother"-like symbolic Woman at the center of the state's and the continent's bids on perpetually deferred modernity by way of neoliberal transition.[30]

In "Woman," *REMEX*'s intermezzo, I disrupt this book's own binary logic, its "City"/"Border" juxtaposition, to argue that Lorena Orozco, Polvo de Gallina Negra, Lorena Wolffer, Katia Tirado, Silvia Gruner, and Nao Bustamante de- and re-allegorize the female form in the service of interrogating the NAFTA-era lay of the land. I examine these artists' and collectives' performances of Woman-Mexico's monumentality and their interrogations of other binary constructions of difference—male/female, North/South, top/bottom, nonracialized/racialized, haves/have-nots. A performance titled *If she is Mexico, who beat her up?* (1997) spotlights a woman who vogues a fashion runway. She is battered but dressed to the nines in the colors of the Mexican flag. Symbols of Mexico hang in the balance of monumental Woman's legs in a series of photographs titled *Los nichos púb(l)icos/The Pub(l)ic Niches* (1997). Another photographic series, *Don't fuck with the past, you might get pregnant* (1995), foregrounds a disembodied index finger probing several small pre-Hispanic stone fertility goddesses.

Although the artwork that I discuss in "Woman," dons, like clothing, various genres, it consistently draws attention to the effeminization of performance or body art by women artists. Like the art that I consider in "City," this archive makes a compelling case for the allegorical's durability as a constitutive continental performative—subject to reappropriation—immaterial yet as materially consequential as the utopian or queer in the performance studies scholars Jill Dolan's and José Muñoz's respective formulations of the "utopian performative" (2005) and "queer performative" (2009). "Woman"'s work enjoins us to read literally and thus ontologically allegory's etymology, to empathize with global spectacles of the ef/feminized nation as commodity. Simultaneously, this archive clocks the dwindling distance between Woman-Nation (Mexico) and Woman-Border as hyphenated pairings after 1994, reinventing how we apprehend

the transborder and the transnation—alibis appropriated for and by the free market—as allegorical affects of de- and neocolonial subject-object slippages.

BORDER

REMEX finally migrates north to the Mexico-US border's built environments that became particularly fertile staging grounds for the US culture wars leading up to and following NAFTA's and Operation Gatekeeper's inceptions. In "Border," I analyze the work of the Border Art Workshop/ Taller de Arte Fronterizo, Louis Hock, David Avalos, Elizabeth Sisco, Guillermo Gómez-Peña, Alex Rivera, Ursula Biemann, Lourdes Portillo, Sergio De La Torre and Vicky Funari, Yareli Arizmendi and Sergio Arau, Chantal Akerman, Natalia Almada, and inSITE (1992, 1994, 1997, 2000–2001, 2005). The cultural production of "Border" harbors formal connections with the archives of "City" and "Woman." It is also the product of its unique site of enunciation at the join and divide of the global North and South, a region usually spun centrifugally as both Mexico's and the United States' fabricated hinterlands. Reflecting the influence of post-1968 DF conceptualisms and performance and post-1960s (Chicanx and feminist) public art and politics, this body of artwork and activism bears the traces of corporate and state allegorical environments.

Like their DF counterparts, many of the artists, collectives, and curators whose efforts I examine in "Border" risked backward glances. Their Orpheus-like gazes fell on or around the convergence culture of 1965 that was impacted by the establishment of the NEA and the Border Industrialization Program (BIP); the passage of the US Voting Rights Act, the Immigration and Nationality Act, the Higher Education Act; and the birth of the Chicano movement. Structural transformation ushered in by these phenomena and events paved the way for centripetally oriented reconfigurations of the borderlands and art in the mid-1980s.

Although initially influenced by the Chicanx arts movement, in particular by Chicano (markedly masculinized) muralism, this work quickly assumed a more acerbic aesthetic, closer to that of the Los Angeles collective Asco (literally "disgust"—a rupture in the time-space continuum of triumphalist Chicano nationalism), a group whose work retrospectively has been compared to No-Grupo's, or the all-but-forgotten San Diego collective CACA. Post-1968, Asco's core members (Gronk, Harry Gamboa Jr., Willie Herrón III, Patssi Valdez) developed walking murals and "no-movies." The

"Asco performative" impacted early border cultural production in the San Diego–Tijuana corridor. Unlike Asco's actions, the latter work became focused on the new articulations of continental racialized and sexualized capitalism, developing a non/sited double consciousness, a method and repertoire of forms that I term *undocumentation*. Here the border fuels the work's commentary, but the allegorical figuration of the Border with a capital B (as a Smithsonian "non-site" or Saidean "imaginary geography"), increasingly in circulation in postcolonial, postmodern, and global celebrations of a borderless globe, also impacts the work's shapes and substance. At pains to illustrate the forces of borderization at play coevally with the New World Order, this archive cultivated a productively troubled relationship to the prefix "un-" of the "undocumented"—which awkwardly transitions to "in-" in the Spanish "indocumentadx." The work of "Border" focuses on extended metaphors that compared the borderlands first to postmodernism's laboratory and then to neoliberal globalization's maquila, or industrial park/factory.

In "Border," I analyze artwork that periodized the late 1980s, the early 1990s, and eventually the year 1994 as significant to the region's cultural imaginary. I identify two primary borderlands' responses to greater Mexico's NAFTAfication. On the one hand, art workers explicitly challenged restructuring precipitated by trade agreements like NAFTA. Their efforts mirrored the latter's rhetorical flourishes with direct calls for parallel structures of continental unity in works ranging from the "North American Free Art Agreement" to inSITE, the binational San Diego–Tijuana corridor installation festival, both of which amounted to counter- or alter-allegories of hemispheric collectivity. On the other hand, borderlands artists and collectives responded to the representational and lived effects of neoliberal globalization, to the statistic-driven logics of US Empire, and to the Mexican DF-centric mandate of institutionalized revolution with microgestures of counter- or alter-documentation that rewrote the allegorical terms of the linked neo/conceptual and performative impulses of these discursive regimes and all of the work that I examine in *REMEX*.

The distinction is especially pronounced in the realm of renovated documentary photography, video, and cinema as those iterations of the still and moving image intersected with a post–World War II range of genres from installation to performance art and various anti- and alter-globalization movements. Artists representing closed borders and, in particular, the increasingly displaced and militarized Mexico-US border for human beings juxtaposed the violence of allegory with allegorical vernacularisms in

works like a video triptych that establishes correspondences between families "crossed" by the Mexico-US border, residents of New Jersey overcome by an invasion of shipping containers, and new technologies on the Guatemala-Mexico border. They presented outsourced Fordism in Ciudad Juárez as evidence of US deindustrialization's elaboration of a new international division of labor. Or, they reverted to a slow cinema to illustrate the fast clip of Northern Mexico's escalating narco-violence.

This second set of undocumentary responses leads me to *REMEX*'s postlude, which I repurpose as an invitation. Namely, I argue undocumentation, a threshold limit of and for contestation, becomes another lens through which to understand the whole of this book's archive as working against post-1960s (art) history's contradictory desires for a coherent object of identity and difference and refutations of discursive master/saved dialectics. The allegorical performative, which informs not only one-world master narratives but "national camp" or "rasquache," assumes new shape as an operation that aesthetically harbors the potential to resist the truth claims of an elided imperial and empiricist optic of the transparent and objective. Enlisted in the service of state- and corporate-sponsored economies of representation, the allegorical performative in *REMEX*'s untoward and lowercased art history of the NAFTA era is co-opted and multiplied by art workers as the bass line for yet another "reorder of things" (Ferguson 2011).

The baseline of undocumentation: while redeployment cannot erase the complications of the artist's, spectator's, or critic's complicities in knowledge production and distribution, it can draw attention to the crossed wires, apertures, and blockages that complicate the feedback loop of politics and aesthetics. Expanding the purview of the commons beyond the market-state, the allegorical performative proliferates as the intellectual property of cultural producers who conceded neither the aesthetic nor the political to the nation-state, the free market, or the era's increasingly hyped hyphenations of that pair.

PREVIOUS PAGE:
FIGURE 1.1. Melanie Smith in collaboration with Rafael Ortega, *Spiral City*, 2002. © Melanie Smith. Courtesy of artist.

NAFTA-ERA PERFORMANCE AND CONCEPTUALISM'S PREHISTORY

MEXICO CITY, READYMADE: THE "PIAS FORMS," MEXICO'S 1968, AND LOS GRUPOS

So much depends on attribution, the "red wheelbarrow" of art history. The Mexican art historian, curator, and critic Itala Schmelz misremembers at least one crucial detail of the La Feria del Rebelde (Rebel's Fair) in Mexico City's artist-run space La Panadería (The Bakery). Schmelz marvels at the artist and mathematician Melquiades Herrera's (1949–2003) "celebrated performance in which he inserted a bottle of Presidente Brandy into his anus" (*Escultura Social*, 33). In fact, this action, calculated to coincide with the December 1, 1994, swearing in of the Mexican president Ernesto Zedillo, was performed by the self-described hermaphrodite, body artist, and legendary artist's model Melchor Zortibrandt, otherwise known as El Mago Melchor, at the behest of the artist, DJ, and curator Vicente Razo.[1]

Razo and El Mago Melchor reMexed the brandy's brand to ensure that it crudely functioned as the performance's allegorical punch line. But their attention to the intersection of nationalism, globalization, and commodification—and the latter's insertions into the quotidian, so to speak—in hindsight also marks an elision, the incorporation of a radical strain of performance into the eventuality of what would come to be regarded as a more generic global Mexican contemporary. Schmelz's misattribution consequently proves nearly as interesting as the event to which her December error alludes.

To understand the thrust behind El Mago Melchor's untitled performance, we first must remember the hybridized globalization and Conquest scripts prevalent in the mid-1990s. Then, we are in a position to play back an earlier period in Mexico City cultural production, indicative of a wider (art) historical paradigm shift.

Herrera's former collaborator—the pioneering Mexican feminist artist and theorist Maris Bustamante—suggests that the sea change that 1970s Mexico City collaborative art wrought on Mexican art represented the consolidation of what she calls "las Formas PIAS" (PIAS Forms). Bustamante clarifies that the acronym PIAS typographically literalizes the hybridization of the genres of performance, installation, and environments or ambient pieces (2008: 134). In 1993, Bustamante coined the phrase, which coyly plays on the word "pío," or "pious" in Spanish, ef/feminizing and pluralizing it to invoke a gendered multitude (pías). Equally noteworthy, "pías" (once again in possession of an accent) becomes a playful interpellation of the reader, corresponding to the familiar you (tú) declension of the verb "piar" (to chirp, tweet, chat, or disclose information)—actions frequently gendered in their connotations. Recalling the US performance artist Allan Kaprow's (1956) aggregation of "assemblages, environments, and happenings," Bustamante's acronym, often overlooked or dismissed, refers to artwork from the Mexican context whose "impure" forms question the production and distribution of art (2008, 134). Bustamante argues that the PIAS Forms represent "arte no-objetual" (nonobjective/nonobjectual art). The Peruvian art historian and Mexico City transplant Juan Acha (1979) described arte no-objetual as conceptually driven, usually urban-based artwork that blurs the boundaries of high and low culture, the folkloric and mass-mediated. In theory, arte no-objetual captures slippages between subject and object (the artwork, the mass-produced object, the handicraft, the citizen or those denied access to the latter category, the nation writ large) in an emergent aesthetic repertoire of the Americas. In practice, the PIAS Forms refine arte no-objetual to reflect the particularities of Mexico.

Bustamante dates the PIAS Forms to the advent of the literary and artistic movement Estridentismo (1921). Hypermasculinized, nation-centric, the Estridentistas routinely are opposed to the Contemporáneos, another postrevolutionary cohort who aligned themselves and Mexico with a cosmopolitan internationalism. Throwing her lot in with the nation form by way of the "strategic essentialism," indigenismo, Bustamante is quick to script rediscovery, noting that the PIAS have deeper roots in pre-Conquest cosmologies, which mark them as "distinct from European avant-garde models

of alternate art, despite the fact that they appear to be direct descendants of conceptualisms that trace a lineage to Futurism" (n.d., 1).[2]

Bustamante elaborates that from the early 1970s onward, Mexico City cultural producers and collectives rejected cultural nationalism's fictive monopoly on the categories of political and public art, renegotiating the intimacies of the political, the aesthetic, and the economic through practices that mixed genres and mediums. Importantly, this rejection did not involve an immediate turn to the market. Clearly, Bustamante's thesis hinges on productive contradictions. Her genealogy, conjuring the language of the "family tree" (1998), absorbs the theatricality of negation attached to various hemispheric speculations on "no-objetualismos" from at least the mid-1960s onward. To complicate matters, as I suggest in my attention to Bustamante's multifaceted plan on pías, the kinship the critic cognitively diagrams is charged with an explicitly feminist perspective that remains undervalued in twenty-first-century artistic, scholarly, and curatorial projects that pluralize global and Latin/x American conceptualisms. We needn't follow the rush to exceptionalize a vanishing History, though. Instead, like Olivier Debroise and his fellow curators Pilar García de Germanos, Cuauhtémoc Medina, and Álvaro Vásquez, who organized the multimediated compilation (exhibition, catalogue, and archive) *La era de la discrepancia: Arte y cultura visual en México 1968–1997* (*The Age of Discrepancies: Art and Visual Culture in Mexico 1968–1997*, 2007), we can rally around the flag of discrepancy.

Bustamante's propositions presage and part company with those of Debroise et al.'s ironically magisterial and thereby consolidating project. *The Age of Discrepancies* takes its title from a few lines uttered by the Universidad Nacional Autónoma de México (UNAM) rector Javier Barros Sierra in 1970, "They attack the University because we differ. Long live discrepancy, for it is the spirit of the University" (quoted in Debroise 2007, 16; catalogue translation). More explicitly than Bustamante's text, *The Age of Discrepancies*, an exhibit that opened one year before the UNAM's Museo Universitario Arte Contemporáneo (MUAC), both marks a qualitative shift in curatorial research and follows art making that maps onto the parallel tracks of a radical reordering of Mexican civil society linked to the UNAM student movement, the broader '68 movement, the Tlatelolco massacre, and the 1968 Summer Olympics.

Specifically, Mexico City was chosen as the site for the "Games of Peace" (October 12–27, 1968) in a vote of confidence that represented the first time that a developing country had been permitted to host the Olympics. In the

year preceding the games, Mexico's symbolic debut on the world stage, the (Gustavo) Díaz Ordaz administration spent the equivalent of 150 million dollars in preparation for the event. Coterminously, another wave of preparation gripped Mexico City.

In the summer of 1968, after Díaz Ordaz violated postrevolutionary Mexico's commitment to the university's autonomy, students from seventy universities and high schools formed the Consejo Nacional de Huelga (CNH; National Strike Council).

Barros Sierra led fifty thousand in a protest against the government that proceeded without incident, suggesting to the general public that despite representations of protesters as anarchist and communist agitators, the CNH's constituency was overwhelmingly peaceful. On September 9, Barros Sierra appealed to participants to return to the classroom. The CNH responded by placing an advertisement in the newspaper *El Día* that both reiterated their demands and requested that the general public join a September 13 Silent March. Their appeal was met with support from a larger left-leaning constituency in Mexico. Documents released after 2001 indicate that Díaz Ordaz, in consultation with the CIA, was determined to break the coalition's hold on the popular imagination before the Olympics began. He ordered the army to occupy the UNAM campus. On September 23, Barros Sierra resigned in protest after countless protesters were beaten and arrested. The police and army stormed the Instituto Politécnico Nacional campuses of Zacatenco and Santo Tomás, where students met the military's might with their own improbable twelve-hour show of force.

Approximately ten thousand people gathered in Tlatelolco Plaza (the Plaza of Three Cultures) in peaceful protest of these military operations on October 2, 1968. They chanted, "¡No queremos olimpiada, queremos revolución!" ("We don't want the Olympics, we want revolution!"). At approximately 6:15 p.m., soldiers, tanks, and trucks surrounded Tlatelolco. Shots were fired into the crowd from the nearby Chihuahua apartment building, the rooftop of the church of Santiago de Tlatelolco, the convent, and the Foreign Relations building. The snipers were members of the Presidential Guard, instructed to provoke the unsuspecting military forces on the ground. Their ploy was successful. The military responded by opening fire on the plaza. Chaos ensued, and the Olympia Battalion, a paramilitary branch of the Mexican government set up for Olympics security, corralled and arrested the leaders of the CNH. The operatives wore white gloves on their left hands, a secret sign for the military not to shoot.[3] Varying accounts suggest that dead, wounded, and missing protesters, bystanders,

and journalists were removed by military and garbage trucks. Participants taken by force were imprisoned or disappeared. Government-controlled media outlets reported that the CNH organizers provoked the attack and that there were a small numbers of casualties. Hearsay relayed another story. Like a stain, a tear in the mural of institutionalized revolution, Mexico's 1968 spread, amounting to what a memo to then FBI director J. Edgar Hoover characterized as "irreparable damage" for the country's ruling party. It etched into the Mexican national consciousness the dark side of the state's post-1950s bid for First World status.

From the early 1960s onward, Mexico City's denizens weathered the frenetic pace of infrastructural transformation. Newly erected freeways and overpasses carved up neighborhoods once teeming with walkers. Poorer areas of the city became difficult to access and exit. Drivers and passengers of cars, vans, and buses were caught in a traffic-jammed "teatro pánico," distinct from but akin to that developed by the Chilean artist, filmmaker, and theatrical director Alejandro Jodorowsky in the same decade in Mexico City. To ease congestion, a metro system, designed for the illiterate, was inaugurated in 1969. Its iconography remains suggestive of the variability of quotidian sign systems amid nationalized modernization. As green space where people could congregate was co-opted or eliminated, air quality plummeted. Socially dramatic disparities between haves and have-nots, inevitably coded in racial and ethnic terms, approached those that had preceded the 1910 revolution. Waves of impoverished migrants from the nation's provinces, including many women seeking freedoms hitherto unimaginable in Mexico's countryside, broke new ground on the shores of the capital's greater metropolitan area. Displaced, they constructed unincorporated shantytowns that exacerbated the valley's air and water pollution. Meanwhile, other transformations in the atmosphere reconditioned the terms of Mexican citizenship-subjectivity: kidnappings, robberies, and assaults skyrocketed to match the population's rapid growth. Mexico's Dirty War—the disappearance, torture, and death of countless political dissidents by government forces—raged through the presidential terms of the left-of-center administrations of Luis Echeverría and José López Portillo (1976–1982).

In a burgeoning Mexico City, the gap between postrevolutionary theory and practice became the elusive subject and interim object of representation. A critical mass of DF-based artists born roughly between the years 1945 and 1955 mined this gap conceptually, striving to forge community in the face of mounting local, national, and global socioeconomic inequalities.

Their work engaged specific impunities and locations to push back against the epistemic violence of imaginary geography, an aspect of the non-site detached from Robert Smithson's formulation of the latter. Tuned into this esprit de corps, Debroise et al.'s genealogy, like Bustamante's, devotes considerable attention to what the French artist-critic Dominique Liquois terms the "phenomenon" of Los Grupos.[4] "The Groups," or artistic collectives, are sometimes reduced to twelve in number: El Colectivo, Germinal, Fotógrafos Independientes, Suma, Marco, Mira, No-Grupo, Peyote y la Compañía, Proceso Pentágono, Taller de Arte e Ideología, Taller de Investigación Plástica, and Tepito Arte Acá. But increasingly they are understood in more expansive terms that accent the lot's elaboration of belonging as an urban art of the quotidian. Los Grupos' efforts, albeit distinct from collective to collective and even from member to member, challenged both the postrevolutionary foundational fiction of the inseparability of the political and the aesthetic and La Ruptura's heralded break from the Mexican School of Painting.[5]

Deceptively dubbed "post-public art," this generation's cultural production emerged out of its participants' previous experiences with or exposure to collective and multimediated cultural production after the 1968 student movement (Liquois 1985, v).[6] Students from UNAM's two art campuses were enlisted to produce and distribute graphic advertisements and calls for action, often under the supervision of the Taller de Gráfica Popular. Self-described "cells of cultural workers" or "no-artists," they experimented with established genres associated with Mexican cultural nationalism, including the linoleum block print and the mural, but also with mimeograph, photocopy, graffiti, ephemeral installation, and happening (2, 8). Their reconceptualizations of the work of art in the first stages of Mexico's neoliberalization cannot be extricated from their cooperative longing to expose the aesthetics of socioeconomic restructuring.

In this spirit, before the theorization of the "new spirit of capitalism," Los Grupos risked and dodged incorporation (Boltanski and Chiapello 2005). Their actions addressed local and global politics: "La noche de Tlatelolco," ISI and dependency theory, Central American conflicts, the Southern Cone's dictatorships, US civil rights movements and involvement in Vietnam. Refocusing on the class differential between cultural producers and a mass public, participants eschewed, even denounced, state-sponsored museums and funding structures. They learned from but also rejected alliances with the museum districts and independent galleries in the DF's historic center, Chapultepec Park, Coyoacán, and the Zona Rosa. And,

imitating the city's centrifugal growth, Los Grupos took their disenchantment with the deepening romance between the state and transnational capital, which had both edged out a vast majority of Mexico's citizenry and created deep pockets of opportunity for the enterprising 1 percent, to the streets and the airwaves.

Before 1990s artists "practiced the city" (Gallo 2004b, 91) centrifugally, Los Grupos activated the seemingly sprawling, aka "desmodern," megalopolis. Their proto-undocumentary gestures ranged from street performances to pamphleteering; roadblocks; and radio, television, and film hijacks. Reclaiming ubiquitous word-image assemblages, they unlettered the City as an allegorical figuration, mediating a return to the site-specificity of lowercased places. Their efforts, often process based, operated as time-sensitive interventions, although neither documentation nor the artwork as autonomous object was integral to the bulk of Los Grupos' intertwined aesthetics and politics. Liquois roughly divides the collectives into two waves that unanimously treated Mexico City—its parts and the whole—as their default readymades. Liquois stresses the first wave's earnest desire to re-create the revolution's primal scene of socially and politically engaged artwork. She posits that the second wave cultivated a more cynical relationship to social change and justice.

Whether or not we elect to subscribe to wave models, the combined humorous, irreverent, and righteous elements of the collectives' efforts make it difficult to periodize Los Grupos' actions in terms of a decisive rupture. For example, in 1973, what would become Tepito Arte Acá (Tepito Art Here)—Daniel Manrique, Alfonso Hernández, Armando Ramírez, and Carlos Plascencia—mounted the ironically titled exhibition *Conozca México, visite Tepito/Know Mexico, Visit Tepito*. The components of this faux tourist campaign, which resonates with the concept behind Elizabeth Sisco, Louis Hock, and David Avalos's 1980s bus poster projects in San Diego, California, proved less memorable than the show's location in Tepito, a "colonia," or neighborhood, that the US anthropologist Oscar Lewis (1961) introduced to English speakers with his culture of poverty thesis.

Tepito, one of the city's oldest working-class colonias, part of the 9.7 square kilometer area of downtown Mexico City declared a National Historic Site by UNESCO in 1980, is renowned for its "tianguis" (open-air markets) and high crime rates. The neighborhood laid the groundwork for an architectural history of mixed land use in the DF (Davis 2014, 159). Tepito Arte Acá, whose core constituency hailed from Tepito, characterized the group's MO as "born from the necessity of modifying our environment" (Manrique,

quoted in Goldman 1994, 130–131). Tepito Arte Acá confronted the city's leading art scene with the inequalities of a Mexico that was neither "romantic" nor "comfortable" (Liquois 1985, 16). Their praxis was bound to a social realism akin to, yet distinct from, that of muralism or the Taller de Gráfica Popular. While Tepito Arte Acá invoked the intersubjective, the group also championed the concept of the nation and city as osmotic subject-objects. Resisting the implicit entitlement narratives of a national or free enterprise allegorical, its members privileged the more modest, albeit no less rhetorically charged, perspectives of a vernacular urbanism.

Take, for example, *Plan for the Betterment of Tepito* that Tepito Arte Acá exhibited in Mexico City's Museum of Modern Art. The group aspired to interrupt the projected commercialization of Tepito, proposing with their architectural blueprint to sustain the neighborhood's cultural ecosystem, but also to develop new social and economic resources for inhabitants. Shifra Goldman (1994, 131) insists that the collective's "map is, in fact, a sociological and political document: a work of conceptual art." The same could be claimed for another group's ephemeral interventions.

Originally founded by Víctor Muñoz, Carlos Finck, and José Antonio Hernández, Proceso Pentágono later expanded to include Felipe Ehrenberg, Lourdes Grobet, Carlos Aguirre, Miguel Ehrenberg, and Rowena Morales. Proceso Pentágono outlined as their task nothing less than the subversion of the "ideology-implantations" of myth- and hero-creation (Goldman 1994, 131). In possession of an aesthetic that was politicized but also hermeneutically suspicious of the exceptional artist and nation forms, Proceso Pentágono located their production as an experiment in reconditioning the senses of the spectator. The collective sought to afford its publics new ways to think about and inhabit the city, the Mexican republic, and the world.

Such aspirations to "cognitive mapping" also guided the interventions of the Taller de Arte e Ideología (TAI)/Art and Ideology Workshop. TAI coalesced in 1975 as an outgrowth of the UNAM philosophy professor Alberto Híjar's seminar and workshop "Curso vivo de arte" (Living Art Course), a durational piece that corroborates the significance of shifts in the non-site of the university in this period, too. The interventions of TAI and Proceso Pentágono, along with those of two other groups—Suma and Tetraedro—were recommended by the Mexican artist-critic Helen Escobedo over artworks by individual Mexican artists for inclusion in the tenth Biennale de Paris in 1977. The coordinator of the Latin American contribution to the Biennale, the Uruguayan critic Ángel Kalenberg, had petitioned Escobedo to identify Mexico's emerging talents. Proceso Pentágono, often

ambivalent about participating in museum shows, fabricated an installation that replicated a police delegation's interrogation room. In *Proyecto Pentágono* (1977), the group explicitly linked US imperialism and dictatorial repression across the Americas to the state-sponsored museum form. TAI contributed to the show a wooden shipping crate, originally the property of Renault. After World War II, the French automobile corporation had relocated some of its plants to Mexican industrial hubs like Ciudad Sahagún, 95 kilometers north of Mexico City. TAI stenciled the words "IMPORT-EXPORT" and "Taller de Arte e Ideología ↑ TAI" on the side of the already ideologically loaded container. Thinking inside versus outside the box, TAI prepackaged the interior of a worker's makeshift shantytown home, "a microcosm of Third World misery" (Liquois 1985, 29)—a gesture that would return like the repressed almost two decades later at the Mexico-US border with the Tijuana artist Marcos Ramírez ERRE's *Century 21* (1994).

Holding themselves to the highest standards of institutional critique, members of Proceso Pentágono, Suma, and TAI deemed such discrete contributions unsatisfactory. They were determined to draw attention to the rift between their own representational politics and those of Kalenberg. According to the Mexican delegation, Kalenberg's conceptualization of the show failed to acknowledge the circumstances of the production of all of the biennial's Latin American entries. Accusing the curator of seeking to "respetabilizar" (a neologism that more or less translates to "respectfully stabilize") military dictatorships of the Americas, the conspiracy theorists released a countercatalogue for the exposition replete with essays by Gabriel García Márquez, Alejandro Witker, and Híjar.

In *Expediente Bienal X: La historia documentada de un complot frustrado* (The Biennale X Case: The documented history of foiled conspiracy; 1977), now considered a canonical text of the era, the bloc anticipated George Yúdice's arguments regarding the "expediency of culture" (2003). Claiming to chronicle Kalenberg's designs to silence or neutralize the dissent central to Los Grupos' modus operandi, the collective of collective's indictment solemnly begins, "To denounce [something or someone] is never easy . . ." Their treatise's subsequent righteousness would be difficult to stomach without its complementary and contagious sense of humor. Something comic or comic book–like informs the gravitas of *Expediente Bienal X*'s composition. It inoculates the catalogue's contents—at base a paper trail of correspondence between the groups and the biennial's organizers—against categorical dismissals.

Witness the volume's cover, which features a man with a gun, poised

above the question "Who manipulates art's distribution?" Here a notable conceptual tactic, also performative and undocumentary, of Los Grupos' alleged later work finds fulsome, urgent expression. Unbound from the overstated redaction of an allegorical PRI-revolutionary social or documentary realism, humor as the immaterial accessory of a once and future sentimental reeducation mediates the material realities of the colliding social allegorical storm fronts of the nation and global (art) market. Setting the bar high for twenty-first-century interrogations of the biennial form, for curatorial and artivist research projects alike, *Expediente Bienal X*'s (double) negativity lambasts the circuit of art making from artwork proper to curatorial reception as an ideological (state) apparatus, thereby expanding how we imagine the circuit proper.

"NACO" AS THE TACO: NO-GRUPO, MARIS BUSTAMANTE'S *LA PATENTE DEL TACO*, AND MELQUIADES HERRERA'S OBJECT LIFEWORLDS

Three artists stand beneath what appears to be a maze of scaffolding, as if inserting their own bodies into the force field of Latin American geometric abstraction, itself abstracted from the city form.[7] Rubén Valencia, the self-identified "ex-geometric artist," in coat and tie, arms crossed, would command the image's center of gravity if he were not eclipsed by the intensity of his two collaborators' body language. Foregrounded, Bustamante, utterly alluring in a veil and hat, stands, hands in her pockets. Receding into the background, Herrera clasps in his right hand a staple of the savvy Mexican market shopper: a plastic woven mesh bag. In the palm of his left hand over his heart, a sugar skull, typical fare for the Day of the Dead, becomes a playful recitation of the death of _____ (modernity/modernization, muralism, La Ruptura, Los Grupos, 1990s Mexico City alternative art . . . and, most importantly, Mexico) preceding Teresa Margolles's more aggressively nihilistic self-other portraits to the same effect.

In conversation, Bustamante (2014) contextualizes the image for me. The morning of September 16, 1982—less than a month after Mexico declared a moratorium on its payments to international creditors—the threesome strolled beneath bleachers that had been erected for crowds to hear López Portillo's Independence Day "Grito de Dolores": "¡Viva México!"[8] Sixteen days earlier, López Portillo had broken down sobbing in his final presidential address when he announced his administration's nationalization of the banking system.

FIGURE 1.2. Untitled photograph of No-Grupo, 1982. © Javier Hinojosa. Courtesy of photographer and Maris Bustamante.

Below the radar: in the annals of sky-scraping art histories yet to be composed of post-1968 greater Mexico, no group stands out quite like the sardonically named No-Grupo (literally "No Group," sometimes transcribed without the hyphen), 1977–1983. Increasingly contrasted with the contemporaneous interventions of Asco in Los Angeles, No-Grupo's efforts exemplify the distinction made between European Dadaists and Latin American "nadaístas" at the first Latin American colloquium addressing "arte no-objetual y arte urbano," held in Colombia in 1981 (Sierra Maya, Enrique, and del Valle 2011, 12).[9] There, Bustamante, Herrera, Valencia, and Alfredo Núñez, No-Grupo's core constituency, presented one of their signature "montajes de momentos plásticos" (exhibitions of visual or artistic moments), designed to showcase the individual members' work as much as the collective's "structure of feeling" (Williams 1977).

Los montajes choreographed No-Grupo's third way—to produce artwork across genres, legible within and outside of institutional strictures. Super-8 film, mail art, television, the paraliterary or hybrid text (published in newspapers, journals, and cultural supplements), images of staged scenes . . . "Penetrat[ion] of the system" (Bustamante, quoted in Chavoya and Gonzalez 2011, 314) was the only mastery of form advocated by No-Grupo's

members, jacks-of-all-trades. How to characterize the transition under way, exemplified by but hardly confined to the best practices of this group strategy?[10]

If the Marxist literary critic Georg Lukács (1962, 43) reads Walter Benjamin's monograph on the *Trauerspiel* as an allegory concerning the aesthetics of modernism, claiming that its baroque mask falls away to "[reveal] the modernist skull underneath," No-Grupo's work reminds me that multiple skulls signify "lo moderno" and that some skulls prove more tasty than others.[11] Creating performative interventions—although at that time they didn't call their work performance (Herrera 2000a)—No-Grupo's corpus, like *Expediente Bienal X*, avant-gardes the renegotiation of the PIAS Forms in both Mexico City and the San Diego–Tijuana corridor from the 1980s onward. Neither embracing nor rejecting national or corporate allegorical templates, No-Grupo's members refused to vindicate public art or the solitary artist-citizen-hero. Instead their efforts—per the title of the group's first retrospective—both went with the flow and simultaneously dealt a "jiggling blow to the artistic corset" (Un zangoloteo al corsé artístico) of post-postrevolutionary Mexico (*No-Grupo* 2011).

"Have a Coke and a smile": In *Esta coca-cola, recién descubierta . . . (This Coca-Cola, recently discovered . . .*, 1979), Herrera, working under the auspices of No-Grupo, implicitly citing (Latin American) artistic engagements with Coca-Cola's advertising schemes, attached a label to a bottle of Coke to market an existential dilemma of conspicuous consumption no less graphic than El Mago Melchor's: "This Coca-Cola, recently discovered by Pop-Art, after only ten years, has received a new lease on life, redeemed by art to be reintegrated into reality. Only a minor detail remains: to conserve it or to drink it, to view it as art or not—the decision is yours—." Herrera's provocation, one-fourth of a boxed lunch performance by No-Grupo, rejected and promoted institutional absorption. Invited to participate in the First Salon of Experimentation at Mexico's National Institute of Fine Arts, No-Grupo opted for an edgier intervention.

Reasoning that the fastest way to their publics' hearts would be through their stomachs at the hour of "comida," No-Grupo placed white lunch boxes on chairs outside the exhibition space. *This Coca-Cola, recently discovered . . .* was accompanied by additional artistic delicacies that promised to keep the performance's attendees on the edges of their seats: a small bag of candy attached to a print of the father of conceptual art Marcel Duchamp and a sheet of paper with lipstick kisses and the defiant proclamation, "Art is because you said so" (Bustamante, in Fusco 2000, 234–235). The collective's

treats, tricks of the trade, again favored the conceptual, talked the talk, walked the walk of Brazilian concrete and procedural poetries' renunciation of the *Coca-Cola*ization of Latin America and the wider decolonized Third World. If the Mexican cinematographer Rubén Gámez, in his film essay *La fórmula secreta* (*The Secret Formula*, 1965, 45 min.), sometimes referred to as *Coca-Cola en la sangre*, locates these concerns squarely in the DF's Zócalo, No-Grupo injected a goodly dose of humor into his cognitive mapping. Before 1990s performance artists like Coco Fusco, Guillermo Gómez-Peña, and Nao Bustamante interrogated quincentennial "rediscovery" scripts, No-Grupo's action exhibited a healthy skepticism toward rediscoveries of the obvious, including the limitations of the institution and its would-be critiques. Rather than decrying the complicity of Kalenberg in Latin American repression, No-Grupo offered an unsolicited contribution to the 1977 Paris Biennale: masks fashioned from photographs of themselves. As if to suggest that audiences could multiply the collective's presence in absence, these accessories, worn by volunteers, served as No-Grupo's multitudinous proxy.

Later, in 1978, No-Grupo "kidnapped and sacrificed" the Mexico City–based experimental painter and filmmaker Gunther Gerzso (with his consent) before creating "portable versions of his paintings." Then, in a comparable montage of plastic moments, *Atentado al hijo pródigo* (*Attack on the Prodigal Son*, 1979), they intervened in José Luis Cuevas's first solo retrospective, *The Return of the Prodigal Son*, at Mexico City's Museum of Modern Art. Also with Cuevas's participatory blessing, No-Grupo created knock-offs of the artist's paintings. Members of the collective wrote a postscript to his exhibition catalogue, critiquing the show's overarching Oedipal narrative—the artist returning to the Mexican state's system of patronage (*No-Grupo* 2011, 69). What remains most remarkable about these two actions: No-Grupo refused to enact the script of departure from and return to their object of critique. Their attack was directed at neither "prodigal sons" nor "los hijos de la Chingada," but at the paradoxically compulsory narrative of rupture and reintegration that permeates the libidinal apparatuses of national and market allegorical templates.

Cornering the market on an alter-collectivism, No-Grupo sold signed limited editions of Cuevas's "authentic sweat" with the marketing slogan: "Las reliquias duran toda la vida" (The [holy or auratic] relics last a lifetime; *No-Grupo*, 68). By the sweat of the low and the high brow, *Atentado al hijo pródigo* signaled a bridging of the sensibilities of La Ruptura and Los Grupos, a narrative stint in the signification of artistic production (the

redistribution of the artist as the optimal product). The action prototyped a way to do both and modeled a method further refined by Mexico City's millennial "new PIAS Formalists."

Sample Maris Bustamante's *La patente del taco* (*Taco Patent*, 1979), a performance imagineered in collaboration with No-Grupo that showcases food as a referent for continental relations. *La patente del taco*, which the performance studies scholar Roselyn Costantino (1996, 13) characterizes as "anticipating the consumer and imperial spirit of NAFTA," included various actions around Mexico City: One, Bustamante applied for and received the taco's patent, thereby becoming its official owner. Two, she created billboard images of the taco, which she mounted in high-traffic locations like metro entrances. Three, she granted reporters, including the popular Televisa talk show host Guillermo Ochoa, interviews about her newly acquired intellectual property.

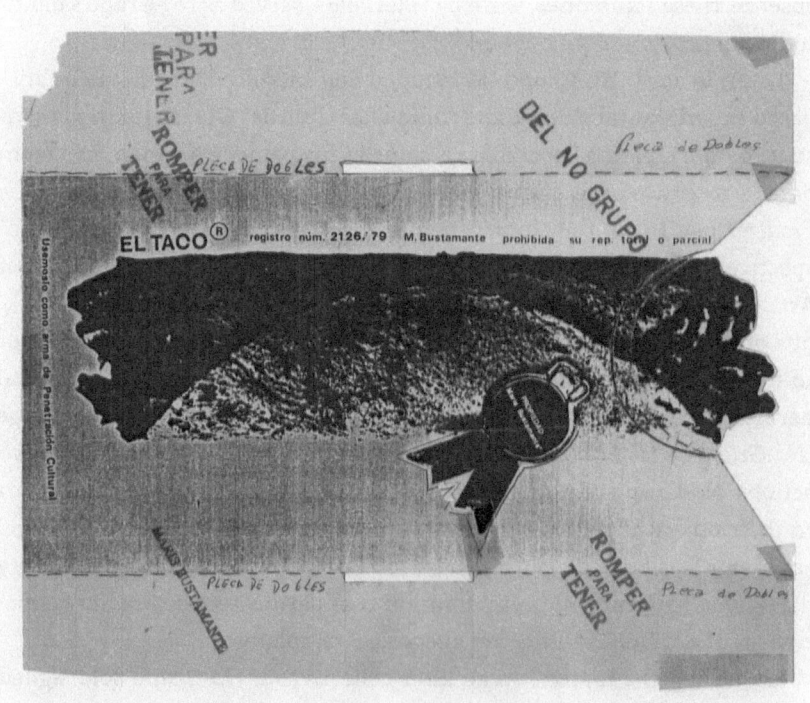

FIGURE 1.3. Maris Bustamante, *La patente del taco*, 1979. © Maris Bustamante. Courtesy of artist and Arkheia of Museo Universitario Arte Contemporáneo, Universidad Nacional Autónoma de México.

Callers jammed the commercial TV station's telephone lines during that interview. Sometimes anxiously, sometimes angrily, they queried, "Will we be permitted to eat tacos free of charge now?" Bustamante (2001a) recalls, "Even my dentist asked me if he still would be allowed to enjoy tacos." In response, the artist dared her interlocutors to "commit an erotic act: eat a taco." The action's explicit sexual overtones follow the pro-pornography and pro-incorporation orientation of No-Grupo, but also recall more specifically Bustamante's *Caliente! Caliente! (Mano a mano con Carlos Zerpa) (Hot! Hot! [Hand in hand with Carlos Zerpa]*, 1982), staged with No-Grupo and the openly gay Chilean artist Carlos Zerpa.

In *Caliente! Caliente!*, Bustamante donned the other Marx's (Groucho's) thick black glasses with a nose-penis attached before distributing copies of the disguise to onlookers. A sardonic double literalization of penis envy and national profiling, the prosthesis that Bustamante offered spectators, like the one she and her Polvo de Gallina Negra collaborator Mónica Mayer would fashion for Ochoa five years later—which we'll consider in the section "Woman"—operates as a tool in the service of a site-specific critique of aesthetic judgment. The year of soul-searching, we must recall, was 1982. Solidarity with Zerpa in this performance obliquely generated a hemispheric critique of US-backed and IMF-imposed austerity measures. Its *homo economicus* erotics, in the final instance, remained most clearly actualized in and by Bustamante's vying for the intellectual property rights of the taco, however.

Echoing No-Grupo's overarching mandate, but also NAFTA debates regarding "cultural exemptions," Bustamante (2001b) described the 65-meter-long taco she made for *La patente del taco* (1979) as "a weapon for Cultural Penetration." More than a decade before the artist embarked on her abstractly roomier series *Naftaperformances* (1994), *La patente del taco* relies on a humor familiar to denizens of the global South and to racial, ethnic, working-class, and queer subjects the world over. Terms multiply to describe the interobjectivity that this mind-set proffers, contrary to the art historian Clement Greenberg's (1961) kitsch panic: Borrowing. Recycling. Cannibalism. "Misplaced ideas" (Schwarz 1992). "First-, second-, third-degree kitsch" (Olalquiaga 1992, 1998). "Kitsch's first, second, and third tears" (Weiss 2011). And "disidentification" (Muñoz 1999). "Differential consciousness" (Sandoval 2000).

On some greater Mexican mystic writing pad, words and turns of phrase accumulate as quickly as the commodity fetishisms they are entrusted to describe. Nomenclature informs minor post-1968 histories of resistance to

teleological and triumphalist narratives of progress, mastery, and development. Although the critical art history collective Curare organized a conference and edited a special double issue of their journal around the pointed question, "Conceptualisms in Mexico?" (Herrera-Prats and Reyes Palma 2010), following the lead of many of that multipronged project's contributors, I'd argue that conceptually driven urban art practices emerged after Los Grupos' efforts in contradistinction to the post-1982 reorganization of state-sanctioned Conceptual -isms in Mexico.

Language to describe the centrality of popular culture and mass-produced objects appeared or was repurposed in roughly the same time period. Per the DF's Midas touch, consider the once and perhaps still derogatory or inappropriate, appropriated appellative "naco." Monsiváis, Mexico's hallowed protoconceptual poet, mockingly decries the naco as inheriting the middle class's hand-me-downs (1981). He highlights how naco once referred to an individual who zealously consumed certain types of mass-produced objects. A decade and a half later, Claudio Lomnitz (1996, 56) puts forward the sweeping thesis that tracing mutations in discourses concerning the naco offers a window onto "the changed relationship between nationality, cultural modernity and modernization" in Mexico. The objects that the naco accumulates might be referred to as "fayuca" (contraband goods; a colloquialism Valencia once deployed to describe No-Grupo's efforts as "fayuca conceptual"), whereas in other contexts they simply might be called "kitsch." "Cursi" is proof positive of transatlantic linguistic and affective trafficking. Formerly pertaining to handmade objects in Spain, "cursi" has so thoroughly come to occupy a space in the Mexican cultural imaginary—signaling the intimacies of the popular, the traditional, and the modern—that Monsiváis pledged allegiance, presumably with a hand over his heart, to "Mexico, Country of the Cursi" (1981, 171). What I seek to demystify with these entries in some naysayer's dictionary of "desmodernidad" is the robust range of an era's site-specific engagement with traditional/modern, underdeveloped/developed, subject/object, male/female, straight/gay, cold/hot, white/brown binaries, increasingly allegorized emblematically vis-à-vis the trembling or psychedelic commodity. No-Grupo's "arte para la re-pública" (*No-Grupo* 2011, 168) drew attention to a productive paradox—the return of a "national camp" along the lines of the Latin American cultural studies scholar John Beverley's (2011) call to rethink the role of collaboration with the state in the midst of neoliberal globalization.

If in the late 1960s the Argentinean critic-artist Oscar Masotta interjected, "After Pop, we dematerialize," a decade later, No-Grupo effectively

countered with "After happenings, we rematerialize." No-Grupo's collective and individual actions, contrary to the art historian Juan Vicente Aliaga's claim that arte no-objetual "[criticizes] the fetishization of the object," ventriloquized commodities (Aliaga, in Sierra Maya, Enrique, and del Valle 2011, 250), including the un-whole-y commodity of art. Herrera's solo efforts, especially, humorously enact an eternal return to the primal scene of the commodity's distribution and consumption as the new normal of Mexican citizenship-subjectivity. For instance, punning on the French founder of surrealism André Breton's frequently cited declaration that "Mexico is the most surrealist country in the world," Herrera authored a series of Polaroid instant photos, *Noticias del México surrealista* (*News from Surrealist Mexico*). The images, which place the accent on the "sur" of surrealism, include:

1. *A snapshot of a VW bug with the word "Revolucion" (sans accent) stenciled on its driver's door.* "Revolución" is clearly in reference to the thoroughfare that runs the length of the city north to south, but how difficult it is to resist the appropriation of the term as the return of some Mexican repressed!
2. *A snapshot of a sign for the Restaurant LALÉ, advertising POZOLE—a thick Mexican soup, heartier than postmodernism. The two O's of "pozole" are converted into blinking eyes either side of the nose of the word's Z.*
3. *A photograph foregrounding an image of a roasted chicken, pierced by an arrow, in turn, piercing the background of a heart—all painted on one of the ubiquitous metal doors that signal the day's close for a neighborhood business.* Talk about Barthesian punctum!
4. *A snapshot of a cobbler's advertisement, the letters of "EL EXORCISTA" (THE EXORCIST) in mirror-reverse below "Reparadora de Calzado" (Shoe Repair).*

Hypothetically, these photos' extended captions correspond to a series of short written essays that Herrera published under the nom de plume of his alter ego Hilario Becerril in small newspapers and a newsletter of the Mexican Communist Party (Henaro 2014, 108). Spooky-kooky, leveling out hierarchies between objects and human beings, Herrera's picture theory, homespun negative dialectics, and PIAS Forms in this instance and generally—set against the phantasmagoria of the first phase of Mexico's transition, the late 1980s—index Mexico City's informal economies. Gray versus black markets become the non/sites, in other words, shorthand the rapidly

fluctuating sites and non-sites, of Herrera's and the nation's performative collaboration. The ubiquitous pink tents of Mexico City's tianguis—what would become the puncta of the British-born artist Melanie Smith's vertiginous *Spiral City* aerial portraits of the DF (see figure 1.1), so called in direct reference to Smithson's iconic *Spiral Jetty* (1970), and the medium of the Mexican artist Eduardo Abaroa's *Obelisco roto portátil para mercados ambulantes* (*Portable Broken Obelisk for Ambulatory Markets*, 1992), a pink tarp installation formally indebted to the abstract expressionist Barnett Newman's *Broken Obelisk* (1963–1969)—for Herrera operate as the equivalent of Benjamin's Parisian arcades, stomping grounds for the artist's empathic identification with the commodity form.[12]

Benjamin (1999, 448) writes, "Empathy with the commodity is fundamentally empathy with exchange value itself. The flâneur is the virtuoso of this empathy. He takes the concept of marketability itself for a stroll [M17a, 2]." While Benjamin suggests that the flâneur's "last incarnation" is the sandwich man, Herrera's artwork prompts the question, Is the performance artist as a Cantinflas-inspired street vendor possibly in possession of a more advanced affective intelligence than that afforded to the sandwiched Man of Benjamin's modernist cartographies?[13] Critically mobilizing Abaroa's reMex of *Obelisco roto* (legible within the context of a series of Mexican remakes of conceptual art), the art historian Daniel Montero (2013), in *El cubo de Rubik, arte mexicano en los años 90* (a book whose cover is as delightfully pink as a tianguis tarp), links a shift in DF art making to Abaroa's mobile market.[14] Montero's analysis is compellingly forward-looking, but there's lost ground to be regained by turning around to recall Herrera's *dérives* when and if we contemplate DF prehistories of NAFTA-era neo/conceptualisms.

Lo-fi locative media, Herrera's "antiplanar maps" recognize the "Rubik trabajador," explicitly recommending three additional rotations of the Rubik's cube (Henaro 2014). Herrera's exercises—on and off the page—suggest that we needn't confine ourselves to cubes, be they white or Rubik's. Abaroa's attentions to ambulatory markets follow in the footsteps of Herrera's extrasensory perceptions of the economic forces acting on art.[15] Herrera, a graduate of the Escuela Nacional de Artes Plásticas en la Antigua Academia de San Carlos, collapsed the distance between the tianguis and gallery, between the mass-produced object and the art object, between the artist and the promoter or seller of Mexican art. Mimicking the cadences of "merolicos" (street vendors), mocking the city's artistic communities, and lip-syncing the free-market fundamentalism of Mexico's

technocrats, Herrera, a locative medium, sold his trench-coated, trenchant brand of conceptualism as a combined awareness of the mechanisms of the art market and the selling (out) of the nation.

In a series of short skits for TV UNAM entitled *Uno por 5, 3 por Diez* (*One for 5, 3 for Ten*, 1992, 10:24 min.; directed by Jorge Prior), Herrera hawked kaleidoscopes (modernism's iconic object) at traffic lights, relocating the street-corner vendor as an art worker, as disposable as the objects s/he vends. Within this enactment of exchange, the videographer, documenting the action, moves away from the smug realism of cinema verité, from the shakiness of the Mexican "superochero" (supereighter, so called for the super-8 film they used). He lodges the performer as a perennially reconstituted center within the kaleidoscope's shifting field of composition.

In *Uno por 5, 3 por Diez*, Herrera juxtaposes finance and postrevolutionary cultural nationalism's shared faith in modernization to interrogate his own artistic transactions. When asked, "What is performance?," Herrera enacts more than "sly civility" in his corporate mimicry: "Chrysler is performance."[16] The bottom line of an ad that was not translated from English into Spanish on Mexican television and radio, Herrera's repetition with a difference sheds light on a conceptual problem that located "performance" in as precarious a position as conceptualism/s in a DF imaginary.

FIGURE 1.4. *El señor de los peines* (Melquiades Herrera), n.d. © Javier Hinojosa. Courtesy of photographer.

Mexican artists were just as likely to disavow the English word "performance" as they were to renounce "happenings" as labels for their artistic production. Associating "performance," gendered in various Spanishes as masculine or feminine, with the discursive regimes of neoliberal doctrine, art workers of Herrera's generation refused easy labels for their actions, opting instead to hybridize genres and to regularly eschew categorization (Herrera 2000b). Naco as the taco (patent), to be fucked by socioeconomic restructuring and to live to tell the tale, reflects a same difference across Herrera's corpus and translates roughly into the contradiction of (1) being brown, Mexican, and in possession of a masculinity worth sparring for, and (2) being as open as the Mexican market. In *La crisis existencial del sorprendente hombre araña (The Existential Crisis of the Amazing Spiderman*, 2000), Herrera calls upon his publics to register his costumed hulking, brown-skinned body in the "contextura" of a sited negative dialectics, albeit without the added variant of interiorized homosexual panic laid bare by El Mago Melchor (Ramírez 1999). Not the phenotype of the prepackaged superhero, Herrera in *La crisis* bears more than a passing resemblance to Superbarrio (Super Neighborhood), who, dressed as a "luchador" (popular Mexican wrestler), successfully prevented more than fifteen hundred Mexico City evictions between June 1987 and May 1992.

The working-class spectator sport of "lucha libre" blurs the boundaries of drama and social drama in Mexico.[17] Superbarrio references the phenomenon, but also a particular crisis. Mexico's federal government under President de la Madrid issued no statement to the city's residents for a full day and a half after the 1985 earthquake. When the administration finally weighed in, it was to refuse external aid for the disaster's survivors. In disgust and disbelief, citizen brigades took cleanup and recovery into their own hands, modeling a commons in contradistinction to the shock doctrine of the "Chicago Boys."[18] A team of individuals under the Superbarrio moniker participated in this populism, legally representing families threatened with foreclosure and eviction. In 1989, those same social actors expanded their repertoire, touring California to lobby for immigrant rights in actions that included a collaboration with the Border Art Workshop/Taller de Arte Fronterizo (BAW/TAF), whose work we will consider in the "Border" section. A year later, Superbarrio offered tamal cooking demonstrations outside the US embassy after US soldiers invading Panama mistook tamales for packages of cocaine.[19] With the alleged backing of the "illegal aliens" Superman and Wonder Woman, Superbarrio ran for president of the United States in 1996, espousing the slogans "The American

Dream can't be free trade in the South and protectionism in the North" and "There can't be economic integration without political integration" (Camnitzer 2007, 257–258).

Like many DF artists after him, Herrera did not synthesize art and activism as explicitly as these co-embodiments of a greater Mexican barrio-logo/s. Nevertheless, he did strive to reclaim the ambivalent registers of an era. In *La crisis*, Herrera underscores the period's increasing tensions between conceptions of private property and public good/s. Using charts and diagrams to mock the artistries of governmental and corporate management, the artist considers hat styles, pointing out that the majority of his merchandise was manufactured in China. No longer simply a denizen of the commodity world, the commodity in Herrera's Tianguis Project—as networked as Mexico City—becomes a citizen of the world.

POST-1994 GDPS AND LABOR WARS; INSTITUTIONAL CRITIQUE AND INCORPORATION

THE ALMOST EX TERESA GENERATION

¿Qué es una casa-museo? . . . Se instala el triángulo: el mercado, la crítica de arte y el coleccionismo.
<div align="right">

CARLOS MONSIVÁIS, "LA HORA DE LAS ADQUISICIONES ESPIRITUALES: EL COLECCIONISMO EN MÉXICO (NOTAS DISPERSA QUE NO ASPIRAN A FORMAR UNA COLECCIÓN)" (1995, 247)

</div>

Herrera's first and only solo exhibition, *Divertimento, vacilón y suerte: Objetos encontrados (Colección Melquiades Herrera, 1979–1990) (Enjoyment, Fun, and Luck: Found Objects [Melquiades Herrera Collection, 1979–1990], 1999)*, functioned as a retrospective of the allegorical impulse and rechanneling of economic transition, driving the artist's assemblage of object lifeworlds. *Divertimento, vacilón y suerte* showcased Herrera's sustained humorous conflation of the commodity's seriality and the seriality of artistic practice after the "anti-aesthetic" of Mexico's *desmodernidad* (Foster 1983).

While the Museo de la Secretaría de Hacienda y Crédito Público, where the collection was first displayed, houses artwork contributed by artists in lieu of paying their taxes, between March 1 and June 20, 1999, Herrera tithed the inter/national-popular, diverting museumgoers' attention away from painting and sculpture to "the baroque canvas of our everyday lives" (Morales, quoted in Herrera 1999, n.p.). Amassed over an eleven-year

period, Herrera's collection refabricates the detritus of the domestic: diminutive mugs in the shape of boots, mass-cast ceramic drinking jugs sporting well-endowed female bosoms, plastic fruit sculptures, handheld mirrors in the image of a Hershey's chocolate bar. And, splayed in the middle of one image featured in the exposition's catalogue, Herrera, taking measure of his "artificial kingdom" (Olalquiaga 1998), makes a cameo appearance.

Nearly a decade and a half before the art historian Sol Henaro's exuberant *Melquiades Herrera* (2014), the artist reclines in a spoof of the classic female odalisque, dressed to the nines in a red coat, tie, and top hat. Empathy in the photo again casts Herrera as irrevocably interobjective. As panoramic as the murals of "los tres grandes" or the global market, Herrera's "performance" generates a chain of becoming-artist-commodity-city-nation . . . *Divertimento, vacilón y suerte* details a twofold "tale of the tribe."

First, the exhibition tells another story of "social hieroglyphics" that share an origin of mass production (allegedly placeless) and an origin of distribution (irrevocably site-specific). Second, it dwells in the living language of exchange value. From 1968 to 1988, Mexico operated as a de facto closed society. Few imports or mass-produced goods entered the country. Access to mass culture was also restricted.[20] Salinastroika—the popular name bestowed on the "sexenio," or six-year period, in which Salinas was in office as president—followed, a pun on the Soviet Union's perestroika under Mikhail Gorbachev. The wordplay had less to do with the formal dissolution of the Mexican republic and more to do with the flooding of Mexico's in/formal markets with products in the wake of the state's shift from an ISI model to that of an open economy. Like some excavation of a future anterior, Herrera's array of tchotchkes recalls the Brazilian cultural critic Roberto Schwarz's (1992, 143) argument that tropicalism's aesthetics of accumulation and displacement provide an "allegory of Brazil" that swallows Latin America. Herrera's arte/facts, like those upon which Schwarz lingers, speak to one another in a "total speech situation" that repackages and eclipses Mexico City. Not quite an allegory of Mexico, *Divertimento, vacilón y suerte*, now the property of the Escuela Nacional de Artes Plásticas (ENAP), betrays the fluorescent glow of an "affectionate treachery," the cryptic code of a phantasmagoria that would expand to include a core constituency of NAFTA-era cultural production. Marking not only the shifting triangulation of producers, products, and consumers, but also of the artist, the artwork, and the collector, *Divertimento, vacilón y suerte* thins the allegorical walls between those triangulations' representational regimes.

FIGURE 1.5. *Melquiades con corbata*, 1986. © Javier Hinojosa. Courtesy of photographer.

Literalizing cameos and doubling, the artist's body in the promotional material for the exhibit assumes the function of the tape-measure tie that he wears in one image of the same period. Specifically, Herrera models a cameo with his own countenance, a selfie before selfies were fashionable. The artist's accessories become the metric against which to gauge what

happened in the critical years between the disbanding of Los Grupos and the emergence of what the artist-critic Mónica Mayer (1996, 94), Bustamante's eventual Polvo de Gallina Negra collaborator, terms the "super-tianguis de los no objetualismos" (super-tianguis of nonobjectualisms).

Into the early 1990s, many of the artists who had participated in Los Grupos struggled to achieve some modicum of recognition within the shifting allegorical economy of "Mexico: A Work of Art." Official, often nationalized art channels did not fully register the PIAS Forms, let alone those forms' irreverent and uncompromising critiques of state- or market-sanctioned artwork. Los Grupos' diaspora—suddenly the constituency of no-grupos in the plural—incorporated the PIAS Forms' supposed formlessness into their solo work. They also archive-built (future) histories of the like-minded. Under the circumstances, some came to understand the pedagogical as performative, as the central centrifugal component of the Estridentista Manuel Maples Arce's (1921) inaugural broadside, which excoriates readers to "[attend] the performance of ourselves." Subverting the example of the postrevolutionary state, the 1970s generation met institutionalization and the language of art's "patriotic mission" with counter-institutionalization. They choreographed critique via their own privatizing bids on the museum form and its documentary aesthetics.

For example, *Pinto mi Raya* (translatable as "I paint my line/stripe," although the phrase also connotes "marking one's absolute limit"), founded by husband and wife artist-team Mónica Mayer and Víctor Lerma in 1989, drew the line as resolutely incorporative, reimagining borders as bridges. Mayer completed her undergraduate training at the ENAP before earning a master's degree in the sociology of art at Goddard College. From 1978 to 1980, she also participated in the Feminist Studio Workshop at the Woman's Building in Los Angeles, California. In the mid-1980s she returned to Mexico City, where she penned a weekly column on art events for the newspaper *El Universal* from 1988 to 2008. Lerma, originally from Tijuana, after studying architecture in the United States, relocated to the DF, where he completed an MFA in visual arts at the ENAP (*Pinto mi Raya* 2011). While *Pinto mi Raya*'s performances consistently treat/ed alternative art's documentation, their most significant work involved the Herculean collation of all the documentation of Mexican performance and conceptualism. The scope of the gesture qualifies and quantifies the conundrum of post-Tlatelolco collaborative art making in Mexico while also recentering it. Though very little art criticism was produced about this body of work before the 2000s, it captured the attention of a general public, receiving frequent coverage

in mass-media outlets from the 1970s onward (*Pinto mi Raya* 2000; Mayer, in Jones and Heathfield 2012).

Understood "in the American grain" of the hemispheric poet William Carlos Williams and in the transatlantic grain of the UK Art & Language group, in dialogue with Latin/x American conceptualisms, Lerma and Mayer breathed new life into this coverage as material yet ephemeral objects. Their home, full of newspaper and magazine clippings, once disinterred the Greek origins of the word "archive"—*arkheion*, "initially a house, a domicile, an address" (Derrida 1995, 2). Reassured by the establishment of art historical repositories like the Fundación Jumex Arte Contemporáneo in 2007 and the MUAC's Arkheia (whose name also invokes the expeditious Greek roots of "archive") in 2008, the pair post-2010 vends twenty years of the durational performance, digitized on ten CDs, while maintaining an active Internet presence (http://pintomiraya.com), paradoxically abdicating the responsibility of documentation. Not included in the project's 2.0 version is a second service industry *Pinto mi Raya* once conferred— that of the "egoteca," a neologism that derisively puns on the word "biblioteca" (library).

FIGURE 1.6. *Pinto mi Raya*, "Certificate of participation in performance," 1999. © Mónica Mayer and Víctor Lerma. Courtesy of artists and author.

Pinto mi Raya's egoteca complements Felipe Ehrenberg's *El arte de vivir del arte: Manual para la autoadministración de artistas plástic@s* (The art of living off one's art: A manual for visual artists' autoadministration; 2000). In an acerbic reference to the plethora of business and self-promotion catalogues paper-trailing Mexico's "democratic transition," and again echoing various traditions of conceptual art, Ehrenberg's portrayal of the artist's repeat performance breaks down the practicalities of self-promotion.[21]

In *El arte de vivir del arte*, Ehrenberg—a self-styled "neólogo," pioneering Mexican performance artist, ex officio of Proceso Pentágono, top executive of alternative art making—compares art making to medicine, suggesting that cultural producers should decide upon a specialty or elect to be general practitioners. He provides sample cover letters, résumés, and correspondence. He offers ways to handle researchers and excoriates artists to be punctual and organized. *El arte de vivir del arte* is a practical guide. It's also an institutional critique per the US conceptual artist Sol LeWitt's inventory of art as industry or the US "stealth Latina" conceptual artist Andrea Fraser's officious introductory remarks for inSITE97, one instantiation of the NAFTA-era binational installation festival. Grounded in an art historical past, blessing and rounding out the "radicant" (Bourriaud 2009), materialist poetics of an eventual 1990s generation of PIAS Forms "integrationists," the often-unremarked-upon DIY manual is suggestive of the contradictory impact of 1970s DF collectivisms on millennial greater Mexican art making. The magazine *Biombo Negro*, the distribution platform of a loosely defined collective dedicated to the publication of experimental fiction, was short-lived, succumbing by its own admission to the Mexican peso's 1995 devaluation. But in the late 1990s, Biombo Negro Editores received support from CONACULTA and FONCA to complete *El arte de vivir del arte*.

Politics imitate art and art imitates politics, or rather, the pair flows fluidly into one another. The 1990s new PIAS Forms begin to look and sound a lot like the so-called "radical freedoms" of the new PRI, Inc. Meanwhile, CONACULTA and FONCA were not opposed to folding performance and neo/conceptual practice into their renovated "official verse culture."[22] Compare Ehrenberg's text to PRI technocrat Rafael Tovar y de Teresa's *Modernización y política cultural* (1994), which details the Salinas administration's renovation of arts funding. Alternately, note that Bustamante marks the establishment of Ex Teresa Arte Alternativo (Ex Teresa Alternative Art, sometimes referred to as X-Teresa), a site dedicated to nonobjectual art, as the endpoint of this archive's chronology in "Conditions, Roads, and Genealogies of Mexican Conceptualisms, 1921–1993" (2008, 148). In

1993, the INBA and CONACULTA, at the urging of various artists, including Bustamante, Ehrenberg, Mayer, and Lerma, jump-started Ex Teresa.²³

If I were a gambling woman in search of Mexico's post-1968 beach beneath its paving stones, I might have placed my bets on the shoals of the deconsecrated former convent Santa Teresa la Antigua, the concreteness of its undulating floors. But, the XX generation casino-capitalized elsewhere. Ex Teresa is open seven days a week, and there is no cover charge to visit its exhibits. The museum's baroque exterior is uneven. Poorly lit, its crumbling neoclassical interior epitomizes the art historian Douglas Crimp's characterization of the "museum in ruins" (1993). Ex Teresa would be just another architectural quasi casualty of the 1985 earthquake if it were not the first state-funded museum dedicated to alternative art. Ex Teresa's third director, the curator-critic-artist Guillermo Santamarina, changed the museum's "last name" from Arte Alternativo to Arte Actual (Contemporary Art). Like Ex Teresa's form, Santamarina's gesture allegorizes the paradoxes of institutionalizing Mexico City's 1970s artistic revolutions.

Between religion and the state, the "better failure" of Ex Teresa consecrates the contradictions of the latter's redux: performance and neo/conceptual art in Mexico City's long 1990s were everywhere and nowhere, eventually rendering Mexico City their global equivalent and medium. Formally contagious but infrequently mapped onto the quotidian, these gestures' combined repertoire grounded, albeit unevenly, the discursive regimes of greater Mexican restructuring that rippled outward from the DF and Mexico's northern periphery.

After the peso's crash of 1994, Mexico's gross domestic product (GDP) was on the rise. Between 1995 and 2008, the republic's GDP climbed steadily. In the thick of this upturn, the two regions that geopolitically had orchestrated the nation-state's entrance onto the 1960s global stage glittered: Mexico City, some frenetic jewel set into a mountain ring, and the republic's border export-processing zones, a beaded necklace accessorizing the harsh line of Mexico and the United States' division, a de facto post-1965 reconfiguration of continental racialized and sexualized capitalism (Herzog 2006). Responsible for generating an estimated 21 percent of the GDP, with its combined metro area accounting for 34 percent of the national economy's growth, Mexico City, both the metropolis proper and the "critical regionalism" it represents, was nothing if not a "gross national product." A coterie of artists and arbiters of taste, recognizing the historical continuities of this contradiction, developed their practices accordingly, refusing to pledge allegiance to any single genre, medium, practice, or school of thought.

For cost reasons, the color section that appeared in the original printing of this book is rendered in black and white in this print-on-demand edition. The original color section may be viewed on the book's page on the Press's website.
https://utpress.utexas.edu/books/carroll-remex

PLATE 1. Vicente Razo, *Manoftheyear I*, 1995. © Vicente Razo. Courtesy of artist.

PLATE 2. Vicente Razo, *Museo Salinas* poster, 1995. © Vicente Razo. Courtesy of artist.

PLATE 3. Francis Alÿs, *Turista*, 1994, Mexico City. Photographer Enrique Huerta. © Francis Alÿs. Courtesy of artist.

PLATE 4. Francis Alÿs in collaboration with Rafael Ortega and Cuauhtémoc Medina, *When Faith Moves Mountains/Cuando la fe mueve montañas*, 2002, Lima, Peru. © Francis Alÿs. Courtesy of artist.

PLATE 5. Teresa Margolles, *Autorretratos en la morgue/Self-Portraits in the Morgue* (No. 5), March 1998, color photograph 100 × 125 cm, edition of 4 + 1 AP. © Teresa Margolles. Courtesy of artist and Galerie Peter Kilchmann, Zurich.

PLATE 6. Teresa Margolles, *Operativo I*, 2008, Y Gallery, Queens, New York. Photographer Cecilia Jurado. © Teresa Margolles. Courtesy of artist.

PLATE 7. Polvo de Gallina Negra (Maris Bustamante and Mónica Mayer), *Madre por un día, Nuestro Mundo*, 1987, television capture. © Maris Bustamante and Mónica Mayer. Courtesy of artists.

PLATE 8. Lorena Wolffer, *If she is Mexico, who beat her up?* Photographer Eugenio Castro. © Lorena Wolffer. Courtesy of artist and photographer.

PLATE 9. Lorena Wolffer, in collaboration with photographer Martin L. Vargas, model Mónica Berúmen, and graphic designer Mónica Martínez, "Este es mi palacio y es totalmente de hierro," from *Soy totalmente de hierro*, 2001, Mexico City (Plaza Santa Cruz-San Antonio Abad, Insurgentes and Avenida del Imán). © Lorena Wolffer. Courtesy of artist and photographer.

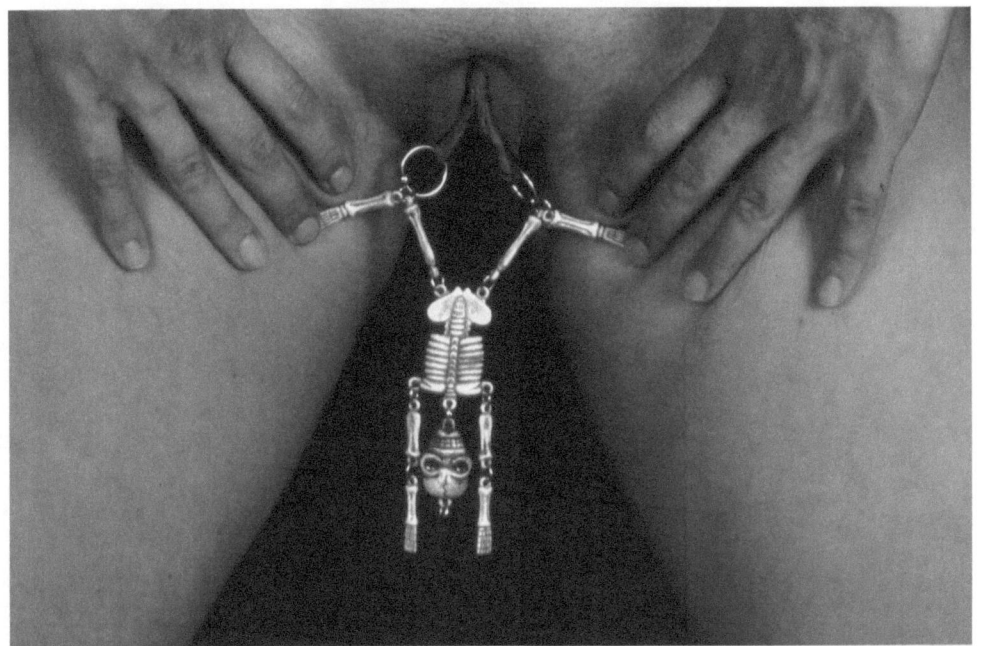

PLATE 10. Katia Tirado, from *Los nichos púb(l)icos*, 1997, color photographs, edition of sixty-four. © Katia Tirado. Courtesy of artist.

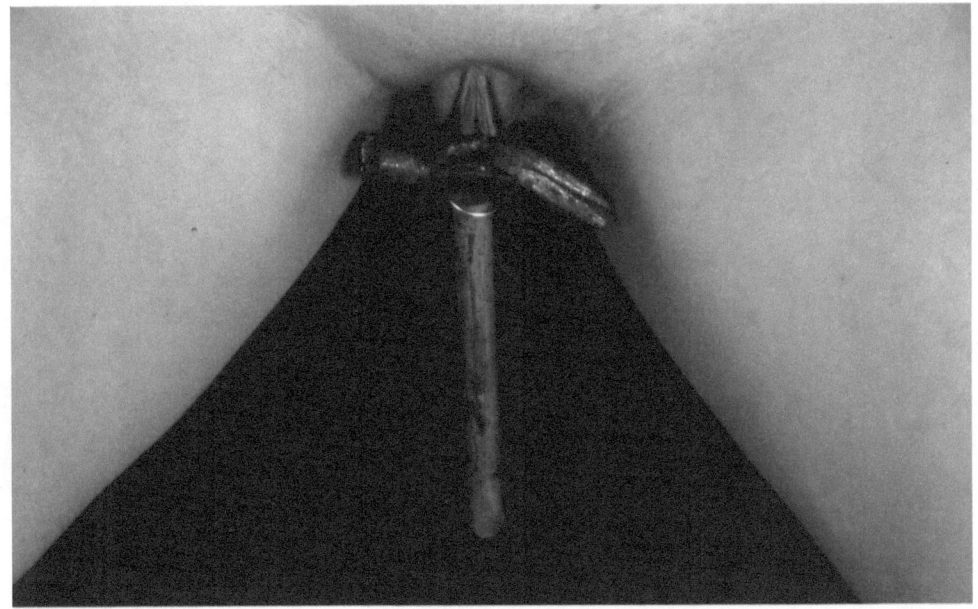

PLATE 11. Katia Tirado, from *Los nichos púb(l)icos*, 1997, color photographs, edition of sixty-four. © Katia Tirado. Courtesy of artist.

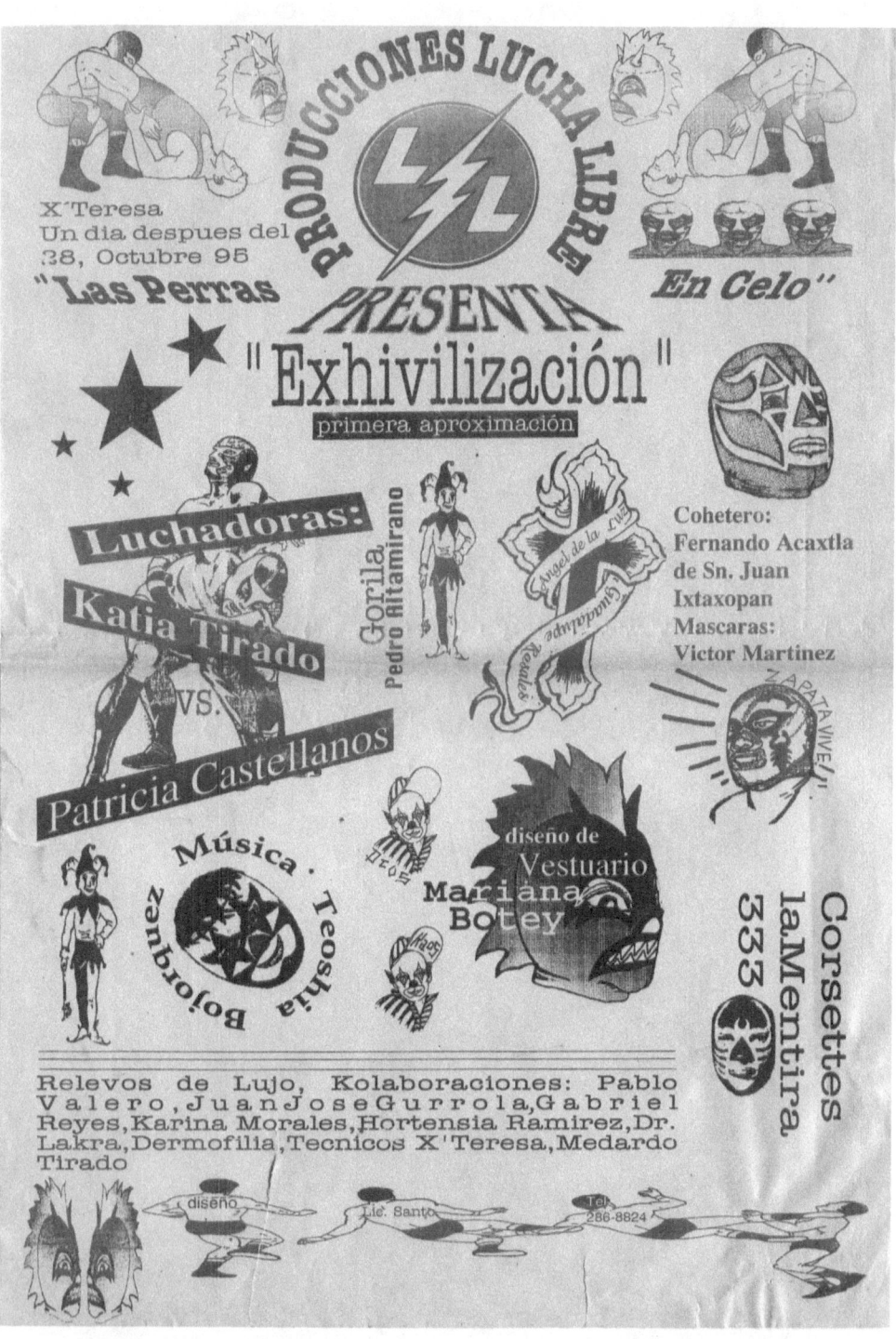

PLATE 12. Vicente Razo, *Exhivilización: Las perras en celo* poster, 1995. © Vicente Razo. Courtesy of artist.

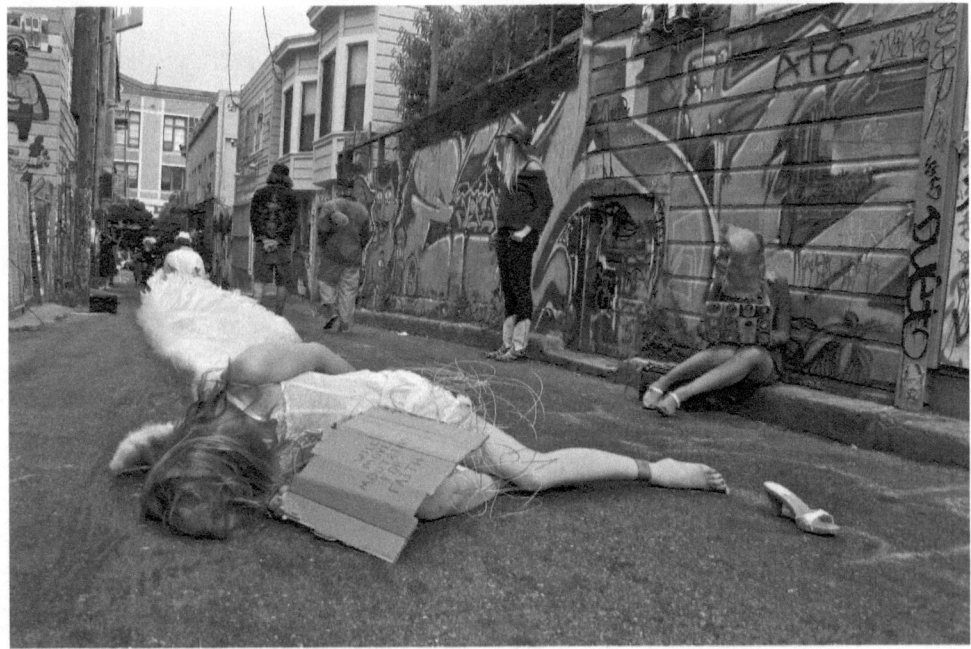

PLATE 13. Elizabeth Sisco, Louis Hock, and David Avalos, *Welcome to America's Finest Tourist Plantation*, 1988, San Diego, California. © Elizabeth Sisco, Louis Hock, and David Avalos. Courtesy of artists.

PLATE 14. La Pocha Nostra, street intervention during a Pocha Nostra International Summer Intensive in San Francisco, Clarion Alley, 2011. © La Pocha Nostra. Courtesy of Guillermo Gómez-Peña.

PLATE 15. Box 130 (file on disc in project box), Marcos Ramírez ERRE, *Toy an Horse*, 1997, photo of horse at night. Photographer unknown. © Marcos Ramírez ERRE. Courtesy of artist and inSITE Archives. MSS 707. Special Collections and Archives, University of California, San Diego Library.

PLATE 16. Box 173 (file on disc in project box), Krzysztof Wodiczko, *Tijuana Projection*, 2001, image of projection with skyline in background. Photographer unknown. © Krzysztof Wodiczko. Courtesy of artist and inSITE Archives. MSS 707. Special Collections and Archives, University of California, San Diego Library.

PLATE 17. Box 198 (file on disc in project box). Interventions/Javier Téllez, *One Flew Over the Void (Bala perdida)*, 2005, stuntman being shot out of the cannon, mid-air. Photographer unknown. © Javier Téllez. Courtesy of artist and inSITE Archives. MSS 707. Special Collections and Archives, University of California, San Diego Library.

PLATE 18. ERRE, *Prejudice Project*, 2006. Photographer Philipp Scholz Rittermann. © Marcos Ramírez ERRE and Philipp Scholz Rittermann. Courtesy of artist and photographer.

PLATE 19. Louis Hock, *Southern California: A Cinemural*, 1979, film still. © Louis Hock. Courtesy of artist.

PLATE 20. Lourdes Portillo, *Señorita Extraviada*, film capture, 2002.

PLATE 21. Vicky Funari and Sergio De La Torre, *Maquilapolis*, 2006, film still. Photographer Daniel Gorrell. © Vicky Funari and Sergio De La Torre. Courtesy of artists.

PLATE 22. Natalia Almada, *El Velador*, film capture, 2011.

PLATE 23. Ingrid Hernández, *La maquila-golondrina*, 2008. © Ingrid Hernández. Courtesy of artist.

PLATE 24. Astrid Hadad, *Copilli*, 1996. Photographer Maritza López. © Astrid Hadad. Courtesy of artist.

On and off the radar, on and off the payroll and pay scale, they accumulated an edgy portfolio of intermedial work, what I term the new PIAS Forms, to critique and ride the coattails of another Mexican miracle. Just as the forms that Bustamante's PIAS assumed were not without precedent, the era's new PIAS Forms resonated with work being produced across the Americas and globally. But they also proved site-specific. Cognizant of the inseparability of the economic, the political, and the aesthetic in this phase of Mexico's transition, this work's cultural producers reengaged the nation and the capital as ideas, performances, and dematerialized commodities on the global (art) market. In circulation, many of these practitioners became the goods. But before that inevitability, they cultivated an awareness of the inseparability of the subject-object into their art making, reclaiming the commodity's "metaphysical subtleties and theological niceties" (Marx 1977, 163) *pace* No-Grupo and Herrera's interobjectivity. Here the tension between the material and the immaterial found favor in an articulation of artwork whose producers were neither afraid nor unaware of their own potential incorporation.

Negotiating the relational, these communities and their corpora promise to complicate conversations about the use and exchange value of art practices that interpellate the viewer at the beginnings of the twenty-first century. At the very least, this critical mass, like Mexico City, resists containment in any monument to radical (aesthetic) dissent, not even one that modulates its intent with the orphaned prefix "Ex." Seeking alternatives, this expanding archive's artists nurtured myths of transnational autonomy and exchange; their political and aesthetic ambitions were rivaled only by those of big business and the state's global designs on one another.

Walk out of Ex Teresa. Cross the street to Mel's Café. Or, follow the latter's sensibility to numerous "alternative spaces," private galleries and museums, artist-run archives and performance venues: Yautepec. Proyectos Monclova. Petra. Gaga. Curare. Salón des Aztecas. La Quiñonera. La Galería *Pinto mi Raya*. Temístocles 44. Torre de los Vientos. Art Deposit. Galería OMR. Taller de los Viernes . . .[24] Microexercises in place making were inseparable from art making in Mexico City from the late 1980s onward. The intertwined practices guaranteed that many Mexicos would spiral out of the ground zero of Mexico City. During the especially heady period of 1990s rebellion, independent galleries and salons sprang up like dot-coms and were as short-lived. Those initiatives were framed as sidestepping state-financed institutions and modes of artistic distribution in the name of other economies of exchange. They were connected to the

subject matter of their constituencies' portfolios. I'd loosely translate these experiments in alter-legitimation as discrete attempts to gerrymander "free art zones" that would assign new exchange values to compositional concerns first elaborated by the post-1968 DF wave of PIAS Forms.

Such a translation has the virtue of not forgetting artists-critics' 1990s focused longing for assimilation into a singularized history of contemporary Mexican art, itself incorporated into master narratives of international art that accent the global South. Such a translation also has the virtue of implying that a relationship existed between 1990s experimental artistic practices and a coterminous experimental, experiential economics.

A modest harbinger of these shifts, Herrera's *Divertimento, vacilón y suerte*—rather than Ehrenberg's *El arte de vivir del arte* or Abaroa's *Obelisco roto*—prototyped an anthropological materialism to combat the increasingly consolidated state-market's conceptualisms, its construction of Mexico as a "hyperobject" in capital's "world interior" (Sloterdijk 2013). Contrary to Bustamante's plea for nonobjectual art, Herrera resisted pitting the fable of intersubjectivity against the logic of the commodity form and its consumption. The artist as object in *Divertimento, vacilón y suerte* is "the one and the many," performing an interobjectivity presaged by No-Grupo's playful autoerasure of collectivity and collectivism. Herrera's empathic efforts tap into "social creativities" driven by fetishistic enterprises (Graeber 2005). Hinting at a post-*October* 1968 negation of negation, his practices trouble the relationship between the PIAS Forms and arte no-objetual. Herrera's work demonstrates that the "No-" of "No-Grupo," like the "no-" of "no-objetual" marks not only the power of a negative dialectics but the power of the latter's negation. Non-objective, but not necessarily non-object-based, No-Grupo's arte no-objetual, sharpened to its finest point in Herrera's corpus, performs the era's vast sensorium of things, including human beings—subjected, subjugated to trans/national allegories of identity and difference. Juliana Restrepo T. speculates, supplementing Bustamante's allusions to pre-Conquest Mexico, that no-objectualism emerged out of Mexican "show business" per Monsiváis's attentions to Golden Age cinema (Restrepo T., in Sierra Maya, Enrique, and del Valle 2011, 26). Restrepo T. claims in veiled reference to No-Grupo that DF artists of the period didn't have to search far for their subject matter, but pieced together the naco or kitsch of the quotidian, "el deseo social" (the social desire), the reconstituted "deseo de revolución" (desire of revolution; 27).

Ostensibly favoring the walking mural -isms of an inter/national alternative and its local ground zero—Mexico City—to the Conceptual -isms

being showcased by the new PRI, this constituency aggressively set out to map from within the amplified force field of the period's object-worlds. They resisted, but also tapped into, the state's mobilization of culture in the name of economic restructuring. Not the stuff of an *Ex Teresa*, post-1994 DF art making aspired to both the extraterrestrial and the territorial, the viscerally real, an actor-network-theory of the city's "rituales de caos" (rituals of chaos; Monsiváis 1995). This archive—a cosmopolitan repertoire to rival the Contemporáneos'—set its watch against (national) allegorical re/commodification, fabricating other fables of artistic and political transcendence. In a perfect world, I thus imagine the closest approximation of a mobile museum of and to this work's affects to be *Fetiches críticos: residuos de la economía general/Critical Fetishes: Residues of General Economy* (2010), curated by Mariana Botey, Helena Chávez MacGregor, and Cuauhtémoc Medina.

Critical Fetishes opened at the Centro de Arte Dos de Mayo in Madrid, Spain. *The Red Specter* (2010) and *El Espectro Rojo* (2011),[25] written and designed by Botey, Chávez MacGregor, and Medina to accompany the exhibit, stakes the project's claims. Medina and Botey in that double publication especially blur the lines between curatorial and artistic practice in texts like "In Defense of the Fetish" (that underwent revision in its Spanish translation), which they juxtapose with work by Francis Alÿs, Miguel Calderón, Andrea Fraser, Alfredo Jaar, Margolles, the Raqs Media Collective, and Judi Werthein.

While all of the artwork included in *Critical Fetishes* and *The Red Specter* operates within the logic of what Botey and Medina term "artistic practice as *an immanent critique of the work of art as fetish*," the entry of one artist in particular—Vicente Razo—reminds me of the curators' participation in and unique debts to 1990s DF artwork (*The Red Specter* 2010, 15; emphasis in original). Razo, whom we might recall as La Feria del Rebelde's cocurator, is Botey's brother and Herrera's former student. But his contributions to *The Red Specter*, like his efforts that preceded *Critical Fetishes*, eclipse the luck of this dazzling (cognitive) kinship diagram.

Razo's *Public Address* capitalizes on smart technologies' inabilities to perceive a radicalized quotidian. Razo requested and received various household catalogues, promotional materials, and trial magazine subscriptions under unusual pseudonyms, including "Dan Graham's Cash," "Guy Debordis Crying," and "Karl Marx in Hell." Imagine *The Economist* (January 17–23, 2009), its headline "Renewing America" hovering above the visage of US president Barack Obama, addressed to "CAPITAL ISMISDEAD," or that

same address, gracing *Businessweek*'s dour pronouncements on oil and the economy (June 11, 2009). *Public Address*'s iterations, as if in response to Benjamin's aphorism "The experience of our generation: that capitalism will not die a natural death. [X11a, 3]" (1999, 667), functioned as limited editions, concluding when Razo's subscriptions terminated.

Of *Public Address*, Razo (2008) states, "These texts—inserted in the subject address of the publication—create industrially produced originals. In the context where the sentences appear they form a bizarre article, a nano science fiction." Excitable meets fearless speech on the heels of the Great Recession preceding the Arab Spring and Occupy movements. *Public Address*'s import extends beyond Mexico, or rather, amends how we might conceptualize mexicanidad, harkening back to Razo's earlier DF-sited work.

That mid-1990s social sculpture builds on the interobjectivity developed by Herrera and No-Grupo, offering a fuller articulation of the latter as anthropological materialism. In "On Interobjectivity," the historian of science Bruno Latour (1996, 233) considers how social life, at least in the human form, must depend on something *other* than the social world. He prods us to acknowledge that objects *do* something. But, he cautions, "If we want to give a role back to objects in this manufacturing of the social link, then we must of course also abandon anti-fetishist reflexes, just as we must abandon the other role given by the human sciences to objects—the objectivity of natural forces—as well" (236). Razo's corpus negotiates this both/and, specifically in relation to the overarching Conceptual –ism of "Mexico." It arrives at its unapologetic beginnings, red-spectering Botey and Medina's later arguments by mounting an aggressive countercampaign against the vending of the nation-state, inherently gendered as feminine. In the lexicon of this offensive, the "no-" or "non-" becomes a prefixation, both a shield and a weapon drawn against inequities—the era's contradictory flows and blockages of human beings, goods, and information.

VICENTE RAZO'S ANTHROPOLOGICAL MATERIALISM

> Che Guevara dominates the visual plane of a pyramid's base. Above the fallen Argentinean's forehead is a bloody crown of thorns, dried flowers, and a three-dimensional crucifix pointing upward to the sculpture's apex. Other ornamentation accents Che's flattened likeness—a tiny porcelain angel kneels on one of the revolutionary's shoulders. Guns and daggers outline his face. JESÚSCHE's background is baby blue. Seeds and tiny silver moons dot the pyramid's base and blossom into its vertices.

FIGURE 1.7. Vicente Razo, *JESÚSCHE*, 1995. © Vicente Razo. Courtesy of artist.

Tiny metal skulls and crossbones (charms, compact, but not as comforting as milagros) are scattered like shrapnel throughout Unkle Sam. *A figurine of Uncle Sam is wrapped in chains and holds a syringe, needle down, clenched in his teeth. Nails are propped against him like weapons stockpiled or a border fence. If you face this tío, immediately to the right at his feet, partially exposed blue-gray matter covers a skull like a toupee. To his left, a lone lucha libre counterarchtypes mexicanidad. Poised at the ready to rumble, the wrestler is not facing Uncle Sam, but you. An accomplice? A bodyguard? Some uneasy witness with his back to—or backed up against—Empire? The pyramid triangulates its viewers but offers no easy answers.*

Whitemen *(title originally in English) holds at its center a plastic action figure, replete with cowboy hat and lasso. Wild Bill Cody or Clinton? Above the figure's countenance, a silver death head hovers. Below its feet, a silver ring resonates. Throughout the pyramid, huayruro seeds mix with silver charms and corn kernels.* Whitemen's *ambience hums dark blue, but at its base, its crushed blacks fade into nihilism, viscous as petroleum.*

Is security increasingly private? Seguridad (Security) *includes a girly Queen of Hearts card, its pornography, juxtaposed with a dime store engagement*

FIGURE 1.8. Vicente Razo, *Plegaria espiritual macroeconómica*, 1995. © Vicente Razo. Courtesy of artist.

ring—all bling. And sandwiched between that pair? The color red foregrounds a sugar skull, a patch that advertises "Seguridad privada" (Private security), the gloved plastic hands of some Adam Smith Deus Ex Machina . . . silver moons and stars, like grains of sand, blur the lines, connecting this pyramid's base to its superstructure.

Plegaria espiritual macroeconómica *(Macroeconomic Prayer or Petition) consists of four pyramids, all illuminati. Foregrounded, one leads the other three in prayer and contains a pair of nazars as if to counter the global market's mal de ojo (evil eye). Behind that set of eyes, the tallest pyramid resembles a skyscraper whose center, a Buddha, paperweights a Mexican ten-peso note. An iridescent sandstorm rages around this "critical fetish." If you return to the first pyramid, your peripheral vision will catch sight of a second glittery Buddha to the sculpture's immediate right, on top of a US dollar bill. Buddha II's aura also rises like a storm. To the left, a nazar rests on a second ten-peso note, punctuating* Plegaria espiritual macroeconómica's *fourth pyramid.*

Pyramid Schemes

A series of pyramids, featured in the exhibition *In God We Trust: Pirámides* (1995), hover, forever levitating like Franz Kafka's seven dogs or my above

descriptions of some of their contents. Suspended dialectics, they eclipse Benjamin's snow globes. They are kitschier than the kitsch of religion, the state, or the market—a mean feat insofar as they reference the mean of each of those Conceptual -isms.²⁶ Their creator, Razo, cofounder of the DJ collective Sonido Apokalitzin and graduate of ENAP (BFA, 1999), New York University (MFA, 2002), and the Whitney Independent Studio Program (2002–2004), resists recycling pronouncements by Duchamp regarding the readymade when offering an explanation of their genesis.

Razo turns to distinctly Mexican luminaries, citing, for example, David Alfaro Siqueiros's postulate that plastic functions as a "medium enchanted by its epoch" (Razo 1999, 45). I imagine plastic's significance in Razo's pyramids by way of analogy: if the anthropologist Fernando Ortiz (1995) uses tobacco and sugar as allegorical figures and ethnographic subjects to counterpoint Cuban colonial economies, Razo uses plastic to oppose hemispheric neocolonialisms. Like Herrera, Razo is a patron of tianguis, where he collects objects, ideas, and intellectual property. The artist draws inspiration from popular craft and improvisation. Totemic, his appropriations both record and allegorize shifts in the idea of Mexico from the 1990s onward.

Sold in markets, resin pyramids usually harbor allusions to popular saints and mystical iconography not confined to the parameters of Christianity (i.e., lottery cards, coins, seashells, quartz, halos made out of grains of sand . . .). Rarely, however, are they understood as vehicles for channeling commentary on the political or socioeconomic. Pyramids protect, bless their owners' families, homes, and businesses. Razo's social sculptures augment the genre's function, reconstituting the form as a proto-"critical fetish."²⁷ Razo individualized his designs' interiors when he filled each with talismans of the new PRI, pop, and cultural references. He supplemented images of saints with those of folk heroes understood to be revolutionary (Emiliano Zapata, Pancho Villa). The results—microcosms of a global Mexican popular—infuse the archival and indexical with the auratic and the allegorical. While Herrera's performances and his collection of readymades treble the promise of the signifying properties of the mass-produced object for and in post-1980s Mexican artwork, Razo's sculptures tap into im/material commodities' abilities to generate vernacular iterations of collectivity in excess of the state or market.

Each recalls Herrera's archaeological excavations, but resituates those exercises more squarely in relation to Mexico's revenants, including its anthropological nationalism. Razo concludes his BFA thesis, "The Convergence of Urban Magic and Art: The Use of Plastic," which he wrote

under the direction of Herrera, with a veritable allegory of allegorical procedure:

> Strolling through the San Felipe de Jesús market with twenty pesos in my pocket, I saw a manual of pyramidal energy for only fifteen pesos. I bought the book, but when I was walking home, it struck me as strange that the text included photos of Emiliano Zapata and Francisco I. Madero... It turns out what I had found was a book whose cover referred to a manual of pyramidal energy and whose interior was *The History of the Mexican Revolution*. (1999, 71; my translation)

At first blush, Razo's account of a chance encounter suggests a honing of his teacher's methods or the reassertion of the truism "You can't judge a book by its cover." But the specificities of the distance between the manual's cover and its contents belie other realities. In "Mexican Art on Display" (Debroise, in Good and Waldron 2001), Debroise traces the figuration of Mexico in inter/national art expositions, noting Mexican art's vexed relationship with the state's fabulist pre-Hispanic past. Debroise homes in on the Mexican motif of the pyramidal ruin. A labor of the double negative, Razo's pyramids recalibrate that ruin's abiding presence as a national fetish. Like the curio cabinets, dioramas, or panoramas of the nineteenth and twentieth centuries, Razo's sculptures remind observers that the art historian Hal Foster's identification of "a new paradigm ... (that) has emerged in advanced art on the left: *the artist as ethnographer*" is old hat in Mexico (1996, 172; emphasis in original). What's new is a redeployment of that paradigm to critique its limitations, to reMex it as a performative. Razo recycles the constitutive remains of the national as his conceptual immaterial. He exposes the radioactive traces of postrevolutionary anthropological nationalism to the state's updated neoliberal marketing campaigns. While the visual anthropologist Tarek Elhaik (2016, 7) argues that Mexican artists and curators exhibited indifference "toward the Ethnographic Turn and its cross-cultural fixation of the Other," Razo's work suggests that 1990s artists demonstrated the latter's truncated vision by juxtaposing it to the ethnographic turn of the modern state decades earlier.

Global Mexico, "a work of art," takes the metaform of a pyramid crafted out of and through the violence of allegory—Orientalism's literal and imaginary de- and reterritorializations. Razo's appropriated form does not correspond to any known Mexican pyramid, however. Its citation is the

Egyptian ruin, triangulated by a US imaginary. Razo's holy relics demonstrate how the signifiers of "Mexico," the "United States," and "Egypt" sparked and still spark a chain reaction. Razo's pyramids navigate their publics' awareness of the supernatural elements of imagined community (be they of the nation, the market, culture, or assemblages of those "genres"). The exhibition's title—*In God We Trust*—which features the whole of the project and its projection, pointedly is in English, referencing US currency as the vulgar index of each pyramid's market value. The dollar bill, the most common denomination of US currency, was reissued in 1957: "In God We Trust" appears above the number "ONE" spelled out in capital letters. "ONE" is flanked on the right by the United States' Great Seal, on the left by that seal's obverse, a pyramid. Per philosopher Jean-Joseph Goux's (1990) formulation of money's "symbolic economies," each dollar harbors value to the extent that it formulates a précis of the United States of America. Replete with a protective charm, the "Eye of Providence," which Razo reworks in *Plegaria espiritual macroeconómica* (to highlight Masonic appropriations of the Egyptian Eye of Horus, the dollar's magic, an enchantment), invokes a string of proper names and mystified sovereignties. Two of Razo's compositions especially draw upon a law of equivalences—the conflation of rulers and deities. *Manoftheyear I* (1995) and *Manoftheyear II* (1995) crowd-source a breathless English and entomb renditions of Salinas (see plate 1). Both designs foreshadow Razo's *Public Address*, alluding to a January 1993 issue of *Time* magazine that granted Salinas "a kind of honorary Latin American man-of-the-year award" (MacArthur 2001, 78).

> *The base of* Manoftheyear I *supports Salinas's likeness. And, suspended more surely than a negative dialectics in the honey-hued resin above his image, multiple nails and screws point in the direction of the former president's visage. Not pinned in place, neither this hardware nor the image completes this sculpture's sentence of entombment, although each hints at a vernacular nationalism, discontent to revere the ex-ruler's body.*

> Manoftheyear II *encases Salinas like an insect in amber. A three-dimensional pink plastic caricature, a doll of the former president, is captured in two shades of blue resin. Bullets and seeds encircle the pyramid's base, generating a border as indeterminate as the one dividing kitsch and the neo/avant-garde.*

Hefty doorstops, these receptacles triangulate the market and two nation-states' colluding and competing economies. Navigating the sacralized

aspirations of Mexican anthropological nationalism, the denominational Orientalizing repertoire of US currency, and international assignments of value to rulers, *Manoftheyear I* and *II*, like countertalismans, become mementos of a North American Pangaeaic revival. Key entries in Razo's series, they illustrate the ways and means that the geometric structure of the pyramid—versus the sphere or the Rubik's cube or the planet as sphere—best approximates the hierarchical logic of neoliberal globalization. Transitional objects, *Manoftheyear I* and *II* also complement Razo's *Museo Salinas* (*Salinas Museum*, 1996).

There, the artist reconsidered how the domestic citation qua rematerialization of Salinas as both a corrupt object and a file corruption engenders alternative aesthetic and political assignments of value for the ruler's and the nation's bodies. Written up in *La Jornada* and *Art News* and spotlighted on Mexico's Televisa and the US's CBS News, *Museo Salinas* functions as an exercise in anti-anti-institution building, intelligible within the tradition of Herrera's alter-allegorical "collector's impulse" and 1990s DF place making.

Salinastroika II (The People's Sequela)

In 1993, Salinas masks first appeared on the street, soon to be followed by an onslaught of popular facsimiles of the president: dolls, stickers, T-shirts depicting Salinas as the Chupacabras (the term applies to a figure that purportedly sucks the blood of livestock in locations from Northern Mexico to Puerto Rico), Halloween and Day of the Dead figurines and knick-knacks, antipatriotic Judases to be burned on el Sábado de Gloria. . . . Razo began to collect these items and deposit them in his apartment's bathroom, which he then converted into a museum with the injunction, "Stop making readymades, start making museums" (see plate 2). Now that the *Museo Salinas* has been removed from the artist's bathroom and incorporated into the MUAC's permanent collection of post-1968 DF art, it's harder to contextualize the scope of the project's radicality, once as striking as the mismatch between the cover of a manual of pyramidal energy and the text of *The History of the Mexican Revolution*.

Circa 2000, like many, I made a pilgrimage to Razo's home. Taped above his bathroom's doorway, a handwritten note read "El Museo Salinas." And, inside, amid the artist's toiletries, Salinas's doppelgangers reigned freely, were afforded free rein, recombining in commodious conversation. Razo lined the upper half of the small blue room's walls with T-shirts, masks, dolls, posters, lollipops. Pop! LOL. Bookshelves overflowed with handicrafts: miniatures of the ex-president in clay, wood, and sundry mediums.

Museo Salinas remains in dialogue with global and Mexican iterations of and interventions in the museum form as a built environment. But Razo's institution, humbly grounded in the scatological, also resists such lofty aspirations, returning Duchamp's urinal to the bathroom per the observation of the Guatemalan architect Teddy Cruz and the Cuban performance artist Tania Bruguera (Cruz 2008).

Mythopoetic, the objects that Razo privileges in *Museo Salinas* are not presidential in the sense accorded collectibles in, for instance, the Richard Nixon or Ronald Reagan Presidential Libraries and Museums. *Museo Salinas* showcases quotidian depictions of a ruler's fallible body and actions, objects sold on street corners and in tianguis. The site, like the artist's pyramids, recharges the fetish, models the immanence of "defacement." The anthropologist Michael Taussig writes, "When the human body, a nation's flag, money, or a public statue is *defaced*, a strange surplus of negative energy is likely to be aroused from within the defaced thing itself. It is now in a state of *desecration*, the closest many of us are going to get to the sacred in this modern world" (1999, 1; emphasis in the original). The multiplication of Salinas as totem enacts a dethroning of the former president as a model ruler-hero-citizen-subject. It registers the counterhegemonic, a disavowal, intelligible by way of a contrast.

An image of a wooden toy with the lettering "Marcos vs. Salinas" below two boxers in each referent's likeness, squaring off, graces one page of *The Official Museo Salinas Guide* (Razo Botey 2002, 53). The eternal battle that the handicraft stages is folded into the museum's "educational outreach program." The emergence of Salinas as a fallen icon roughly coincided with the rise of Zapatismo's symbolic significance. The specificity of Salinas's representations collides with the revolution's black ski-masked anonymity to minstrel an alternate allegory of globalization. Razo invites us to compare the spectacle-effigy of Salinas, metonymic of Mexico's transition, with that of Subcomandante Marcos, metonymic of another "world in which many worlds fit" (Marcos 2001). Marcos, whose image was circulated outside of Mexico, stands in as an alternative to the continent's transition. But within Mexico, Salinas performs an equally monumental labor of signification, personifying the violence of the state's latest master narrative, its bid on the "contemporary." Salinas and Marcos—dialectically opposed—compose one sacrimonious medallion.

With *Museo Salinas*, with his resin pyramids, Razo mounts "a *mise-en-scène* of the allegory" of a *savage, primitive* nationalism that meets "a *savage primitive* capitalism" (*Critical Fetishes* 2010, 3, emphasis in original).

Commodity fetishism in these works is neither under critique or erasure, but is mined for its everyday allegorical value. If Herrera supplied his creative progeny with "a prototypical theory of allegory and montage based on the structure of the commodity fetish," Razo in his work excavates the attenuated auratic linkages between citizenship, cultural production, and consumption in post-1994 greater Mexico (Buchloh 1982). The artist renders equivalent two triangulations of the allegorical performative—that of the postrevolutionary national-political-aesthetic and that of the global-aesthetic-economic—demonstrating the pair to be two sides of a larger geometric structure. Walls kicked in, dimensionality understood as a general intellect, a fissure in the form of the obelisk makes explicit the dormant totipotency of anthropological materialism: dislocated from the artist's body, performance and performativity are relocated in the activated props of the social body's incarnate word.

The coin of the realm: Razo's pyramid schemes reincarnate the PIAS Forms as "arte no-no-objetual" in the service of rebellion. They follow Razo's explosive installation *Revolucionario institutional (Institutional Revolutionary*, 1994), in which the artist brewed Molotov cocktails in returnables advertising Ernesto Zedillo's presidential candidacy. If Herrera confronted his publics with the existential dilemma of Coca-Cola colonization and El Mago Melchor literalized the extended metaphor of economic restructuring for La Feria del Rebelde and in Razo's *Museo Salinas* for the short video *Presidencola (Presidential Cola*, 1996, 5:03 min.), Razo proposed other uses for carbonated beverages and their recyclables in the mid-1990s. By the early aughts, following the historic election of the Coca-Cola executive and Partido Acción Nacional (PAN) presidential candidate Vicente Fox (an event that broke the PRI's seventy-one-year hold on the Mexican presidency), artistic revolution veered toward bottled-for-export irreverence.

Behold the splendors of a hit series of art exhibitions focused on Mexico City cultural production, from *20 Million Mexicans Can't Be Wrong* (2002) to *Strange Currencies: Art and Action in Mexico City, 1990–2000* (2015). Behold the litany's transformation into a more effusive conglomeration of the critical fetish of global mexicanidad (following the insights of inSITE's bids on a greater Mexico), a "performance," furtively captured by *Critical Fetishes*. Before *Public Address*, for the South London Gallery show *20 Million Mexicans Can't Be Wrong*, curated by Medina, Razo resorted once again to tianguis-found objectivity—a book and its cover. Razo displayed the *Museo Salinas* alongside pages torn from a specialist's dictionary. A knock-off *Webster's* with an "Appendix of NAFTA Related Vocabulary" to rival our

mystic glossary of interobjectivity, the reference manual drives to abstraction its referent, the letter of NAFTA. Juxtaposed with black-and-white film stills from Smith's *Spiral City*, Razo's page proofs critically supplement our naysayer's dictionary of desmodernidad, provide us with the vocabulary to link the "NAFTArt" of socioeconomic restructuring to the sovereign allegorical figuration of Mexico City and its alternative symbolic economies. *20 Million Mexicans Can't Be Wrong* references the population of the largest city in the Western Hemisphere, establishing the exhibit more squarely as a Smithsonian "non-site." *NAFTA Spanish-English Dictionary*, like *Public Address*, moves mexicanidad beyond Mexico, but also links the latter's transition to the continent's and the globe's snow jobs.

Shake it up: languaging in this gesture demands an art history also cognizant of its own complicities in the construction of Mexico as object—an immanent and imminent domain of critique. If the neologism "NAFTArt," like "neomexicanismo," first emerged as an epithet, NAFTArt, in response to NAFTA, was remade in the relay between Mexico City and its outposts from Los Angeles to London. Montero dates handlers' (critics', curators', collectors') bestowal of the aura of the "contemporary" on DF alternative art making to 2002. NAFTA informs Montero's periodization, but the critic stops short of indicting his archive on this count. He also refrains from closely reading artwork. All artistry in Montero's analysis reverts back to the cognoscenti. In contrast, in real time, Razo, always the agile DJ, spun the reMex as neither an apocalyptic nor a utopian soundscape, but as the labor of the negative. *Expediente Bienal XXI? NAFTA Spanish-English Dictionary* suggests any history of late-twentieth-century DF cultural production must factor in an overarching feedback loop, the implications of "art incorporated" in Mexico (City)'s mis/translations.[28] Interpellated, we'll proceed along such compromised and reMexed lines.

YOSHUA OKÓN'S ART AND ADMINISTRATION

Word: Razo's injunction to his peers to start making museums and trouble followed shortly after he curated La Feria del Rebelde. Before the "Body" there was "The Bakery," an expansive work that reimagines a variety of Mexican and Factory Schools. In 2009, Yoshua Okón and several other 1990s DF-based luminaries opened SOMA, the first non-degree-granting art school and artist-run residency space in the Colonia San Pedro de los Pinos. The collective's stated aim was to offer a counterpoint to "the prevailing dynamics in schools, museums and galleries."[29] Okón, SOMA's cofounder,

promotes the project as a durational piece, as a natural extension of the place-making exercises that set the tenor of institutional critique for alternative art making in Mexico City in the 1990s. More specifically, he envisions SOMA as the extension of one project in particular.

In April 1994, Okón cofounded La Panadería, widely regarded as one of Mexico's most long-lasting and innovative NAFTA-era "laboratory-like environments" (Okón, in Dorfsman and Okón 2005, 10). For a few summers, Okón and his collaborator Miguel Calderón contemplated creating an independent artist-run space. After completing his BFA (1994) at Concordia University in Montreal, Canada, Okón returned to Mexico City, where he moved into a three-story building owned by his parents at the corner of Amsterdam and Ozuluama in the Colonia Condesa. The location proved ideal for leavening his and Calderón's waking dreams, not the least because the neighborhood did not experience full-on gentrification until the late 1990s.

The first floor of Okón's new home once housed an Eastern European, by some accounts kosher, bakery. It inspired La Panadería's (The Bakery's) innocuous name. Although Okón describes La Panadería as an eight-year "life project" (Dorfsman and Okón 2005, 7), the parameters of authorship—from the site's conception to its close—were more nebulous. Various individuals (Calderón; Artemio Narro, simply known as Artemio; and Abaroa, among many) lent their support to Okón's concept. Rebellious beginnings enabled what followed. La Feria del Rebelde, which included El Mago Melchor's inviolate performance, was organized by Razo and Schmelz expressly for La Panadería's inauguration. It preceded emerging art fairs—such as Zona MACO México Arte Contemporáneo—that would ground Mexico City as a hemispheric center of the global contemporary, but was contemporaneous with corporate fairs, vending the city and the nation.

Okón (2009) explains that he and his collaborators intended La Panadería to offer sanctuary outside of the state's narrowly defined categories of artistic exceptionality. Yet, because La Panadería's organizers took advantage of the PRI restructuring of arts patronage, La Panadería came to represent one of the first and most visible 1990s DF alternative art spaces with a hybridized financial platform. In this regard, La Panadería operated as a "social work" along the lines that the performance studies scholar Shannon Jackson (2011) proposes: that we should neither assume nor champion a divorce between institutional structures and creative practice. La Panadería's organizers encouraged a trafficking in ideas and artists that facilitated flows of influence too numerous to diagram.

Between 1994 and 2002, artists came and went. They transformed La Panadería into a scene for social networking, into a think-tank for an education without degrees. On the one hand, Okón's and La Panadería's embrace of a distinctly neoliberal both/and mind-set rendered suspect the site's art-beyond-art sensibilities, as well as the depth and breadth of its commitments to institutional critique. On the other hand, La Panaderia's loaves-and-fishes vision of unconditional hospitality—Okón's own admission that he worked from the premise that he would accept any proposal sent his way—situated the site as a historical hinge, as a portal through which a plethora of artists passed to arrive at their future anterior. La Panadería established place making as both a genre and its own best gentrification.

The explicit aesthetics and implicit economics showcased by La Panadería were mirrored, in turn, by its affiliated artists' practices. Nowhere is this productive symbiosis between an artist's portfolio and La Panadería's objectives more evident than in Okón's own career trajectory. Rounding out his North American profile, Okón completed an MFA at the University of California, Los Angeles, under the direction of the culturally inoculated artist Chris Burden. He then returned home to make his creative and critical fortunes in the conceptual and performative wager of La Panadería, as that site coincided with the artist's realization of performance-video-installation assemblages. Into the 2010s (as evidenced by Okón's cofounding of SOMA as La Panadería's sequel), a dialogue exists between the artist's skill sets: his visionary administrative talents and, for lack of a better phrase, his "bad-boy aesthetics."

Spectatorial "Mordidas"
Art histories of Mexico's long 1990s claim Okón's reputation as an enfant terrible was established with his debut collaboration with Calderón, *A propósito . . . (By the way/On Purpose/About . . .*, 1997). In that video installation, the pair juxtaposes 120 car radios with a video loop (52 seconds) of their stealing another. Calderón smashes a car's window before tersely intoning, "It won't come out." The car's alarm sounds. Okón's voice, rising, undertows the action, "Miguel, we've got to get out of here."

Generically, I'm inclined to read *A propósito . . .* as allegorizing art making as both a rip-off and a policed enterprise. Vaguely reminiscent of Juan José Gurrola, Arnaldo Cohen, and Gelsen Gas's short film *Robarte el arte* (*Stealing Art*, 1972, 35 min.), the project belatedly begs, borrows, or steals its title from a 1989 exposition in the former Convento del Desierto de los Leones. Under the pretext of staging a tribute to the German "social sculptor"

Joseph Beuys, Santamarina, in collaboration with Gabriel Orozco and Flavia González, mounted what's credited as the first Mexican exposition to situate performance as an expanded field of art making (Debroise 2007, 384). Apropos, Calderón does not acknowledge these precursors when he claims that *A propósito*... emerged out of his and Okón's frustrations with the city's high crime rates in the mid- to late 1990s. Still, the materiality of the towering collection of radios set against Calderón's narrative of "love and theft" (Lott 1995) set against the intermediality of *A propósito*... prompts me to wonder, What does it mean for two upper-middle-class young Mexican men to culturally slum, to engage in class transference in the name of further expanding the range of art in Mexico?

One answer to this question emerges in the moment that *A propósito*... appears most elliptical. Irony, another descriptor of *Expediente Bienal X*'s caustic humor, coalesces as the "Other" of an aesthetic after the postrevolutionary and the modern. Irony activates interpretations of *A propósito*... as an additional art historical "condensed allegory" (Fletcher 2012 [1964], 229). Angus Fletcher questions classical treatments of irony and allegory, the rhetorical categorization of irony as "anti-allegorical." He argues that the relationship between allegory and irony is neither oppositional nor that of a subcategory (irony) to a category (allegory). Fletcher reinterprets readings of irony as collapsing, like the floors of a building, the "multileveled segregations of allegory" (ibid.). Rather than emphasizing irony's destruction of allegory, he offers a protodeconstructionist reading of the pair's intimacies, underscoring that "irony still involves an otherness of meaning, however tenuous and shifty may be our means of decoding that other (*allos*)" (ibid.). He subsequently amends, "I think we might call ironies 'collapsed allegories,' or perhaps 'condensed allegories'" (ibid., 229–230). Per Fletcher's observations, Okón and Calderón's tactics of provocation and confrontation in *A propósito*... function to collapse a range of allegedly transgressive masculinities into one another. "A propósito," the phrase, contracted becomes "apropósito" (a brief theatrical piece), the word an alleged contract "between men." Drag on.

Okón manipulates the irony of his own and his publics' precarious access to and disenfranchisement from the pedagogical temporality of the global (art) history of the Mexican postrevolutionary state. Reconsider the distinction anecdotally by de-pairing Okón's and Calderón's practices and re-pairing Okón's and Razo's. If Okón and company planned La Feria del Rebelde to launch La Panadería, Razo cocurated the evening's program as a celebration of and call to Zapatista rebellion. Legend has it that Okón's

relatives ventured to attend the evening's presentations. Peering through La Panadería's windows, they were floored by the action of El Mago Melchor. On the second floor, Okón, Calderón, and others were staging their own evening extravaganza. An altercation erupted between Okón and Razo when the former asked the latter to tone down the first-floor actions. The pair's rift widened a divide already apparent between the art making of La Panadería's "stories" even as the sensibility of Razo and Okón found common ground in the fetishization of youthful rebellion against state-sanctioned Culture with a capital C (Botey 2016).

Okón's subsequent production reflects his concerted cultivation of a masculine aesthetics of irreverence—what regularly passes for the raw material of the avant-garde. Site-specific, it adheres to the configurations of what the Chilean writer Alberto Fuguet christened "McOndo." Fuguet writes:

> McOndo is no more and no less than a sensibility, a certain way of looking at life, or, better yet, of understanding Latin America (make that America, for it is clear that the United States is getting more Latin American everyday) . . . McOndo is a global, mixed, diverse, urban, 21st-century Latin America, bursting on TV and apparent in music, fashion, film, and journalism, hectic and unimaginable. Latin America is quite literary, yes, almost a fiction, but it's not a folktale. (2009, n.p.)

If pressed to locate McOndo on a map, I might venture that it sits at the crossroads of irony and allegory where Okón's efforts disencumber allegory of the pedagogical and unburden irony of the performative. Okón's (2012) new PIAS Forms, which he claims generically to be allegories, attend to inevitable fault-lines in the performance of Mexico that exceed the frames of art and literature, that extend beyond the state's spatiotemporal borders to encompass contact zones from the Conquest period to the second decade of the twenty-first century.

For instance, in the artist's single-authored *Chocorrol* (*Chocolate Bread*, 1997, 1:02 minutes), a video installation contemporaneous with *A propósito . . .*, Okón match-makes two dogs to stage a late-twentieth-century parody of the Latin American "national romance."[30] Exploring the pornotropic vicissitudes of cultural nationalism, Okón literalizes the mestizaje script in the service of a late-twentieth-century reMex that inverts the frame of reference, outing both the artist and his viewers as voyeurs. Okón rented from a breeder a female French poodle, intending to document his male pet Xoloitzcuintli's unrequited attentions. Xoloitzcuintlis, indigenous

to Mexico, were the favored pets of the Aztecs and consequently of Rivera, who incorporated them into muralism's iconography. The Mexican art critic Patricia Martín asserts that Okón once situated *Chocorrol* as a reflection on the European rejection of Mexican autochthony, as "a comment on difference, class, and social signifiers" (*Mexico City* 2002, 51). Unbeknownst to Okón, the female dog was in heat. The result, according to the poodle's enraged owner, was a "monstrosity" (ibid.).

Mockingly, Okón interprets such a reactionary epithet as evidencing the action's reproduction of a Latin American primal scene: the colonial encounter. At base, Xoloitzcuintlis are as rare as they are classed extensions of their masters. They index indigenista clichés as surely as toy poodles function as commonplace symbols of the nouveau riche.[31] *Chocorrol*'s allegorical affect suddenly exceeds immediate readings of the colonial encounter, forwarding another art history of the NAFTA era.

Ghosts! *Chocorrol*'s recorded coupling of the dogs suggests psychic hauntings in a nationally campy register: in a flash, we see a woman whose attentions are fixed on an unidentified object or incident in the room's corner. The dogs? The artist's process? Okón withholds evidence. Flatfootedly, he upends the viewer's field of vision to capture what is presumably his own foot in the camera's mouth. In a new millennium following the pop artist Andy Warhol's queer cinematic practices and the ubiquity of the technological means to produce and edit video, viewers might accept as a foregone conclusion that YouTube and reality television remake us all as chroniclers and witnesses. In this atmosphere, Okón's inclusion of two additional bodies beyond the dogs' in the video is destined to appear unremarkable. But, in 1997, the artist's loss of camera control contributed to what the curator-critic Betti-Sue Hertz characterizes as the improvisational quality of the artist's corpus. Hertz suggests, "Increasingly, his works have required yet another player, a third actor in the game of chance that breaks open social expectations. More and more, the viewer has become that third actor" (Hertz, in Arroyo 2010, 71).

I'd subscribe less to Hertz's narrative of artistic evolution, more to an account of the continuities across Okón's practices. Okón's portfolio—artistic and administrative—traffics in an auratic hybridization of the market-state, of the latter's critics and their mediums, including the PIAS Forms, imaginatively rebooted. Consistently, Okón creates video-installation-performance assemblages that privilege what the French philosopher Henri Bergson (1914) identifies as the "social value" of humor and, more specifically, the social value of irony as the great leveler and

reveler of socioeconomic difference. Affective triggers, Okón's efforts solicit his publics to consider frames of reference that exceed the bounds of the autonomous artwork from the video installation to the nation-state. *Chocorrol*'s haywire finale follows a formula evident across the artist's work; Okón draws his publics into the orbit of his work's arguments. We are framed and it's not a pretty picture. *Chocorrol*'s move toward entropy prods us to think beyond counterallegories of the colonial encounter, toward "a portrait of the artist as a young man" in a specific historical moment in Mexico City.

"Un rubio" (a blond, implying light-skinned), "un Judeo mexicano" (a Jewish Mexican—a label Okón's peers assign to him but that he emphatically rejects), and "un esquincle" (a colloquial term used to describe an adolescent often cast as a troublemaker), Okón (2012) remixes *Chocorrol* as an oblique self-portrait. But, because the work catches us looking, it also stages an alternative primal scene of interobjectivity: our own complicity in the making of the DF contemp(t)orary.

In *Chocorrol* and elsewhere, Okón manipulates his publics' discomforts with voyeurism and entitlement, extending those discomforts to the contradictory formulation of politically engaged, yet market-driven artwork. Most concretely, the artist collapses layers of socioeconomic division (La Panadería's upstairs and downstairs) into one another as if they represented the tiers of an overarching social allegory of identity and difference. Like the French Marxist philosopher Louis Althusser's interpellating call, Okón's work, more fully than Herrera's or Razo's, hails us all to acknowledge our roles in the (aestheticized) power structures-that-be. Exemplary of this interpellating effect, the artist's six-channel video installation, *Oríllese a la orilla (Con dinero baila el perro) (Pull Over to the Curb [For Money the Dog Dances]*, 1999–2000), whose very production depended on the informal economy of the "mordida," or "bribe" (literally "bite"), exacts spectatorial mordidas.

Ostensibly, *Oríllese a la orilla* meditates on the spectacle of the state, embodied in and by the figure of the male police officer. The series catalogues less the state's omniscient power and more its "diminished masculinity," its reliance on stand-ins who do the dirty biopolitical work because they lack class mobility, the spectator's privilege relative to this hierarchy, however. Okón has exhibited *Oríllese a la orilla* in inter/national venues like the DF's Centro de la Imagen (2000) and the Art and Public Gallery in Geneva, Switzerland (2001), initially on televisions turned sideways or upside down and later as a built environment of video booths, two layouts

that draw attention to the materiality of the television set. In the latter's floor plan, Okón resisted ordering the project sequentially. The spectator consequently interrupted and generated conversations across the project's partitioned segments. The experience mimicked Okón's own procedural commitment to dissensus: The artist cruised Mexico City, recruiting policemen to participate, at times challenging an officer to a fight, at other times literalizing the colloquialism of the project's parenthetical subtitle ("Con dinero baila el perro"), proposing that another dance for the camera for a set fee. Okón videotaped his subjects, on and off duty, recasting them as the city's underclass, recognizable linguistically via colloquialisms like "Oríllese a la orilla."

While timespace restricts what I can detail here, I'll offer a few choice summaries. In *Poli I* (4:14 min. loop), Okón never enters the camera's field of vision, but his presence as a stand-in for the viewer scripts the action. Numbered but unnamed, the dark-skinned police officer dismisses the artist as one of the "hijos de la sociedad" (children of the privileged). He elides Okón's socioeconomic position and the artist's light complexion and hair. The officer taunts Okón on camera, arguing that art belongs to the upper strata of Mexican society, which "we don't need anymore." He accuses Okón of recreational drug use and metrosexuality as he knocks him to the ground.

Poli II (1:26 min. loop): The camera aerially pans in on two squad cars. A radio dispatch exchange between the officers becomes the video's soundtrack. Viewers eavesdrop on the male *polis'*—the de facto polis—running commentary on two female pedestrians' bodies. In homoerotic conspiracy, the officers contemplate confronting and having sex with the women, dubbing their plan "Code 14."

In *Poli IV* (2:42 min. loop), another dark-skinned officer avatars authority, wielding his nightstick as if he were rehearsing for a kung fu action film. The policeman moves between demonstrating his prowess with this martial arts shtick, flexing his pectoral muscles, and grabbing his crotch. The net effect is overdetermined, tragicomic. *Poli IV*, like *Oríllese a la orilla*'s other discrete units, provokes uncomfortable laughter. Masturbation minus autoeroticism, the police officer's performance is incomplete without the equally masturbatory circuit of spectatorship. *Poli IV* operates as cultural soft porn representative of the hard-core classed and racialized divisions built into the police state.

Poli VI (5:39 min. loop): A shadowy staged-for-the-camera assault of a police officer (hired to play the part of "Poli VI") goes terribly wrong. "Prop or no prop, you need a permit for this," a second officer, newly arrived, quips.

Is this the performance's staged dissolution or simply a fortuitous mishap? Okón makes no effort to answer that question. Instead, as he is handcuffed and thrown in the back of a squad car, the artist testifies, "I'm getting arrested for doing my homework." Let the racialized and classed haggling begin. From *Oríllese a la orilla* onward, Okón implicates himself and his viewers in in/formal economies of representation. Race, gender, and nation as genres become as crossed as power lines throughout the work as Okón labors to lengthen the radius of his targeted inner circle of identification, tricking disinterested interest into something more visceral and immediate.

Consider *Bocanegra* (2007), exhibited in the Yerbabuena Center for the Arts, San Francisco; the Städtische Kunsthalle München in Munich, Germany; and elsewhere. Okón plumbs the limits of cross-cultural identification, creating a multichannel video installation that follows a ragtag band of DF Third Reich enthusiasts.[32] Okón gained his subjects' trust after attending their meetings for several weeks. World War II history buffs, weekend hobbyists, self-identified fetishists, devout fascists—the Aryan organization's members agreed to collaborate with Okón on the four orchestrated segments of *Bocanegra* (*A Walk in the Park*, *The Salute*, *The Movie*, and *The Gathering*) after the artist spent hours discussing with them the strengths and weaknesses of the Nazi triumphalist Leni Riefenstahl's propaganda filmmaking.

On camera, the project's participants appear to be aware of the style and tonal register of Okón's "undocumentary" aesthetic, its sharp divergences from Riefenstahl's. Okón's subjects camp it up, goose-stepping and philosophizing, clearly enjoying their anachronistic and displaced renditions of a 1930s/1940s Nazi performative. The artist's rumored Jewish ancestry lends the project a pathos that again collapses allegory and irony. But, named after the Mexico City street on which the group weekly gathers, itself named after the author of the Mexican national anthem (Francisco González

FIGURE 1.9. Yoshua Okón, *Bocanegra*, *The Salute*, film capture, 2007. © Yoshua Okón. Courtesy of artist.

Bocanegra), *Bocanegra*, which in Spanish colloquially means "foul-mouthed," the project's affect is layered.

In *A Walk in the Park,* Okón follows a march by the group through the Plaza Luis Cabrera located in the Colonia Roma Norte, a neighborhood refashioned into a gallery corridor by creative capitalists after the 1985 earthquake. The small band of eight men with their vintage uniforms and tattered, swastika-emblazoned banners literally and figuratively appear out of step with their surroundings. These are hardly the twenty- and thirty-something upwardly mobile artist and intellectual types, who render the neighborhood scenic. Middle-aged, pot-bellied, often dark-skinned, they role-play the identities, which the lived Conceptual -isms of race and class both enable and foreclose. Okón displays documentation of their march on five screens arranged as a pentagram into which we must step. Tragicomic, the men's ritual loops other rhetorical questions: What would possess individuals, in all likelihood the sometime objects of prejudice and derision, to identify with ideologies of blatant prejudice and repression? What are the limits of these subjects' dis/identification?

In *The Movie* (6:42 min. loop), one man declares his allegiance to the Nazi Party before a mirror cluttered with several images of Hitler and Nazi paraphernalia. He is dressed in uniform, right down to his swastika-imprinted underwear. Third Reich marching music plays as he pontificates with a microphone in broken German and Spanish, "Oh great Führer! . . . You have made our race sublime." Later, his face becomes *The Movie* and the project's truest mirror: it contorts, reflects momentary relief before it is shrouded in mourning, the pseudo lament, "Ah, I've ejaculated on it. No! Mein kepi!" There is an undeniable campiness to this scene that inflects my portrayal of it. Still, *The Movie*'s pathetic phallacy operates independently of any narrative embellishment. The mestizo man will never fit the stereotype of the white separatist, the object of his fantasy and emulation. He consequently reimagines his difference in a second coming of self-gratification cum justification.

In *The Gathering,* eight men swear their allegiance to the Führer, practice air raids, sing rousing hymns to the Republic, smoke cigars, drink beer, and pontificate on what it means "to be Aryan." In sum, they behave like most attending a consciousness-raising session or an artists'/intellectuals' dinner. One member of the group appeals to a revisionist history: "The Aztecs were pure, they simply did not mix. They didn't mix with the Olmecs or any other race. Let's put it this way: to be Aryan is to respect your race, as long as you don't make the mistake of mixing, you are Aryan."

In his unique formulation, Jews and Oaxacans are Aryan because they do not "intermarry." Purity and passing take on alternative meanings closer to those explored in *Chocorrol*. The hybrid installation *Bocanegra* assumes the new Mexican question is inseparable from its title's indeterminacy: What foul-mouthed anthem of national unity meets its maker here on a dead-end street?

The social actors of *The Gathering* speak in and through German National Socialism, in and through a postcolonial, not yet postrevolutionary, nationalism. The Marxist sociologist Susan Buck-Morss (1992, 41), in an equally mimetic flourish, channels Benjamin to conclude that fascism is the afterimage of mass culture and that "in its reflecting mirror we recognize ourselves." *Bocanegra*'s gathered parts, like those of *Oríllese a la orilla*, share features evident across Okón's oeuvre. Okón hybridizes performance, installation, video. He collapses the allegorical and the ironic into one another to create unsettling allegories of alternative place and art making that sardonically negate even the terms of their own production.

The Maquila School

Risas enlatadas (*Canned Laughter*, 2009)—a video installation by Okón that included such diverse elements as a single-channel video (9:56 min. loop), a photographic diptych (each 39 × 54.6 inches), three projections and five video monitors (total 14:25 min. loops), two racks for robes, and a table with 160 cans of "canned laughter"—made up Okón's contribution to *Proyecto Juárez*, which included the work of Carlos Amorales, Artemio, Santiago Sierra, and Teresa Margolles—all but one inSITE noninvitees. In 2007, *Proyecto Juárez*'s curator, Mariana David, rented a house in Ciudad Juárez, compiled a library on the region's history, and began to facilitate discussions between participating and local NGOs in a gesture vaguely reminiscent of inSITE. Okón made three trips to Juárez to develop his contribution to the project that vaguely recalls Razo's Molotov cocktails. Each visit confirmed for Okón the ideological distance between the border town and Mexico City. Juárez's export-processing zones captured Okón's imagination, becoming the set of *Risas enlatadas*.

Okón rented an abandoned factory, hired ex-maquila workers, interviewed them on how a plant is structured, and put them to work on his own project. The documentation of the process is as elusive as the manufacture of laughter. Okón filmed demos for the video installation. In one, a choir of forty-five workers in regulation hairnets and factory smocks stand on bleachers and laugh, led by their German supervisor. Their leader expounds,

"There are many kinds of laughter. This is a happy laugh, from one week's episode of the sitcom *Friends*. [*Laughter in unison*] . . . This is a witch's laugh from the region Schwartz Wald, an area of the Black Forest, where I am from. [*Laughter in unison*]." The faces of the workers are alternately impenetrable, noncompliant, bored, melancholic—none appear in the least bit amused.

A veritable parody of the work of the US-based artist Vanessa Beecroft or of Okón's DF contemporary and cocontributor on the project Sierra, of Yúdice's (2003, 287), reading of inSITE as an "artistic maquila," to which we will turn in "Border," the scene renders the immaterial material vis-à-vis the workers' pantheon of disaffected visages. Later, some of the participants "man" an assembly line, testing and affixing labels to the cans that contain a supposed variety of laughter. Is there anything really funny about this? The Maquila, a figuration, is extrapolated from literal maquilas that infamously became synonymous with the Mexico-US border and neoliberal globalization during the NAFTA era. As such, the set of *Risas enlatadas* is about as predictable as a Televisa laugh track, as the word "enlatada"'s other meaning of "cancelled" or "failed," or as Bergson's commentary on laughter.

The factory's name, after all, is Bergson. Distinguishing between tragedy and comedy, in *Laughter* (1914)—a text that Okón (2012) confirmed was the project's touchstone—Bergson writes, "The point of drama is to let us have a glimpse inside of ourselves, of what we would be if it wasn't for society, of our hidden nature or nature in hiding. Comedy, on the other hand, *serves* society by pointing out our antisocial tendencies and inviting us to laugh at them, thus encouraging us to correct them" (1914, 145; emphasis in the original). Like Bergson, Okón eschews psychological explanations of laughter. Unlike Bergson, Okón comes to no bounded functionalist conclusion on laughter's social use or exchange value. Refusing to supply us with "neat Marxist equations"—a claim that Okón pointedly makes to distinguish his work from Sierra's—the artist sidesteps analytic foreclosure (Okón 2012).

Risas enlatadas is and isn't about the maquilization of Juárez, the border, and Mexico. A serious theater of the absurd, Okón's mock maquila in the final analysis most closely resembles an absurd allegory of incorporation, of the function and faux production of laughter in culture industries, of Mexico as a system of signs on the (art) market. The motto "Make them laugh" cannot fill a can or bottle dissent in this scenario of remexicanidad. Before the "Body" there was "The Bakery," Okón's reply to the Factory and the Mexican

FIGURE 1.10. Yoshua Okón, *Risas enlatadas*, installation view, 2009. © Yoshua Okón. Courtesy of artist.

Schools, to inSITE, derisively understood as the fictive "Maquila School" of NAFTArt. To understand the scope of the artist's institutional critique we must read his skill sets broadly, comprehend his portfolio of new PIAS Forms as including the communities he and others imagined to market.

Risas enlatadas pokes fun at the travesties of the Mexican contemporary in both art and industry, at the earnestness of once alternative artists' networks (the very project, we might note, of La Panadería). As surely as the tricks of *la perruque* are absorbed into the theatricality of *Risas enlatadas*'s catalogue (de Certeau 1984), the artist's project tags a circuit in which he participated: turn-of-the-millennium Mexico City art was not made solely in situ or in some placeless "global." In the mid- to late 1990s, it was export-processed via inSITE and CONACULTA funding to the Mexican-US borderlands, remade piecemeal, and transported to other command centers on the great cultural chain of supply and demand (aka, being).

MINERVA CUEVAS'S *LOGOCENTRISM*

Benjamin's golden angel of history is not turned around; she's been beheaded and is lying on the ground. The original head of Mexico City's

iconic Angel of Independence statue, severed from her body, languishes on the floor of the Museum of Mexico City. A black flag shrouds the wall behind this allegory of national allegory in ruins. The title and caption—part image, part text—of this crime scene include a photograph of the statue intact, waving the Mexican flag. *El Ángel* (2012) takes its name from Antonio Rivas Mercado's iconic Monumento a la Independencia, popularly named El Ángel de la Independencia, on Mexico City's Paseo de la Reforma thoroughfare.

Reminiscent of the July Column in Paris, El Ángel is crowned by a gold-plated, twenty-two-foot-tall statue of Nike, the Greek goddess of victory. In 1902, President Porfirio Díaz ordered the construction of El Ángel to commemorate the centennial of Mexico's Independence from European rule in 1821. In 1910, the year that the Mexican Revolution began, *El Ángel* was inaugurated. Minerva Cuevas did not destroy *El Ángel* for her built environment of that same name; she borrowed the pieces of it, rubbled by a 1957 earthquake. As powerful as *El Ángel*'s 1958 restoration, Cuevas's installation does not remake the monument per its original signification. The angel does not witness catastrophe. She contributes to the "wreckage upon wreckage" (Benjamin 1968, 257). Per the whole of the artist's 2012 retrospective, the ruinous charm of being part of the problem proves as central to Cuevas's aesthetic as it is to Okón's. If Okón playfully indicts but also enacts incorporation, Cuevas generates critique from even deeper within the catacombs of the system. Represented by one of the city's toniest left-of-center galleries, Galería Kurimanzutto, Cuevas in the second decade of the twenty-first century is a mainstay of DF n(e)oconceptualism.

The art historian Alexis Salas convincingly argues that Galería Kurimanzutto's founders—the power couple José Kuri, a Columbia University–trained economist, and model Mónica Manzutto, whose first gallery job was at the Marian Goodman Gallery in New York City—leveraged a shift in the marketing of Mexican art on August 21, 1999, with their inaugural show, *Economía del Mercado* (*Market Economy*). For less than twenty-four hours, the then itinerant art space "performed the art exposition," displaying artistic curiosities to rival No-Grupo's delicacies (Salas 2016). Works by Gabriel Orozco, Cuevas, Abaroa, Abraham Cruzvillegas, Damián Ortega, Sofía Táboas, Gabriel Kuri (Kuri's older brother), Daniel Guzmán, and Rirkrit Tiravanija were laid out with and on fruits and vegetables in two stands of the Colonia Roma's Mercado de Medellín. One of fifteen produce markets in Mexico City designed by the state-affiliated high modernist

architect Pedro Ramírez Vázquez (Tlatelolco and PRONAF collaborator), the Mercado de Medellín phantom-sited Kurimanzutto's "friendly capitalism" (the title of the gallery's later show included in the 2002 Kwangju Biennial in South Korea, whose main irreverent work was the selling of photocopies of the Biennial's own catalogue) as uniquely representative of the global Mexican contemporary.

Salas, whose very name—the destiny of the signature—opens up additional rooms for other (art) histories of the NAFTA era, boldly reads Kurimanzutto as a key performance indicator of the Mexican (art) transition. But, in the middling 1990s, before Salas, Montero, and others advanced theses that posited gallerists, dealers, curators, and collectors as the true auteurs of DF art, Cuevas began her career as a culture jammer of the local, national, and planetary. By necessity, she culture-jammed and parodied the (art) history into which her interventions were being incorporated.

After completing her BA in visual arts at the ENAP in 1997, Cuevas cultivated a decidedly unfriendly relationship with capitalism.[33] Her work since then more indecisively has assumed two shapes that stem from her original engagements with discourses and tactics of the global social justice movement. On the one hand, Cuevas approaches the logo itself as a genre, converting its popular transmogrification into her artistic method, in interventions that, like Herrera's and Razo's, stress nationalisms' and corporate cultures' attentions to the commodity's performativity. On the other hand, Cuevas has corporatized her own best practices, creating an alter-allegory of DF contemporary art and growing later capitalism.

Logo No-go
Long before Cuauhtémoc Medina curated with Chávez MacGregor and Botey *Critical Fetishes*, he characterized in a catalogue essay for yet another 2002 show of Mexican artistic force—*Mexico City: An Exhibition about the Exchange Rates of Bodies and Values* (P.S. 1 Contemporary Art Center, New York; Kunst-Werke Berlin e.V., Berlin; and Museo de Arte Carrillo Gil, Mexico City)—Cuevas's installation *Piensa global-Actúa local (Think Global-Act Local)* as "try(ing) to transform the commodified condition of current aesthetic relations with the creation of *critical commodities* or counter-systems of commerce/propaganda" (*Mexico City* 2002, 45). More precisely, I'd amend that Cuevas's efforts reflect the artist's sustained engagement with one aspect of the commodity—its logo—the locus of its conceptual and performative aesthetics at the turn of the millennium.

Cuevas's products recall interventions in commercial design from Warhol's recycling of Campbell's soup cans to Chicana artist Ester Hernández's *Sun Mad* (1979). They also participate in a larger cultural moment when artists and activists combined forces to challenge the foregone conclusion of the free market. As artivism is to art and activism, the subvertisement is to subversion and the advertisement. The neologisms *artivism* and *subvertisement* materialized in the 1990s. Like 1960s artists who lent their skill sets to civil rights, antiwar, and student movements, 1990s cultural producers offered theirs (street theater and art, spoken word, graffiti, film and music) to alter-globalization actions for social justice. In this regard, Cuevas's appropriation of art making in the service of activism follows and resembles what I am reading as NAFTA-era DF artwork's appropriation of both Los Grupos' PIAS Forms and the more general hybrid production of a range of work now classified as "socially engaged practice," "relational aesthetics," or "living as form."

Cuevas et al. hijacked the impulse of an earlier moment of Mexican art. But Cuevas herself also jacked into a global zeitgeist, transforming the subvertisement into the genre and method of her artistic practice. Cuevas's acknowledged influences and contemporaries range from the US-based art collectives Critical Art Ensemble and ®™ark (later becoming the Yes Men) to the Spanish Las Agencias and their subsidiary the "anti-establishment lifestyle" Yomango (in a colloquial Spanish, "I steal"). Unlike those pre-Occupy collectivities, Cuevas single-authors interventions, sometimes accepting help from volunteers, but taking full credit and responsibility for her work's tactical designs.

For instance, *Piensa global-Actúa local*, a series of photographs that address the clothing of working-class "chilangxs," whose name follows the sloganeering of alter-globalization, focuses on the relationship between individuals' bodies and decorporatized logos. Men, women, children sport Nike, Tommy Hilfiger, Adidas branded T-shirts and shoes as if longing for those corporations' concepts over their commodities—"the brand as experience, as lifestyle" (Klein 2010, 21). The scenario might suggest Schwarz's (1992) pathos of Latin America's "misplaced ideas," but something else animates *Piensa global-Actúa local*. The languages of the aforementioned companies code-switch, mutate, and realign in the lurid "lure of the local" (Lippard 1998). Namely, we are just as likely to witness knockoffs of the brand name, another hollowing out of the corporation that Klein neglects to account for in her left-leaning "movement bible" *No Logo*. In Tepito, in La Merced, in the Zócalo, or lining the corridor of the street La Moneda

before you arrive at Ex Teresa, a resistance of the informal (economy) to the aura of the logo's exchange value (distinct from the auras that Herrera's and Razo's work irradiate) forges a "Hillfinger" out of a wannabe "Hilfiger," reverses the victory swoosh of the new corporate god/dess Nike, overpopulating tianguis with "commodities that proliferate along the margins" (Benjamin 1999, 42)—all mimicry in lieu of gimmick.

So, too, a series of photos, associated elsewhere with *Dodgem*, a 2002 installation by Cuevas in a DF amusement park, documents the logo's chameleonlike ability to blend into its environs. Dodgems (the British term for electric bumper cars) sport the decals of multinational corporations. Powered from the floor and turned off and on remotely, they bump up against one another, generating the alternate energy of an allegory of "the Oil Encounter" (Nixon 2011, 72). Texaco, Esso, Pemex—Cuevas's fixation on oil's corporate philanthropy—is contemporaneous with the artist's eco-artivist interest in Mexico's NAFTAfication, a *nafta*fication. Before the 2010 catastrophic B.P. oil spill, in *Causa y efecto* (*Cause and Effect*, 2007–2008, acrylic paint on walls, variable dimensions), Cuevas offered a civics lesson on the unnatural disaster of peak oil.

"Meme-hacking" PEMEX's logo, she clipped the plumed crown of the national corporation's iconic red eagle—here for all intents and purposes the eagle's "remex," or, ornithologically speaking, its flight feathers. The gesture, a memex, another portmanteau combining index and memory, reconfigures the agency of the latter against the repetition of the corporation's equally iconic drop of oil, always as red as blood. As if unleashing the terror of the new PRI's recitation of the allegorical performative, the error of Cuevas's revision in the visual plane of this mural hovers above a parental penguin and chick. The penguins, members of a bird species as flightless as the worker, are immobilized in an oil slick that flows the length of the composition. Their predicament interrupts PEMEX's nationalized color scheme, laying out a social reality in stark black-and-white terms.

Ergo, the sum total of the image-environment privileges the march of oil over the march of the penguins. It allegorizes the cause and the effect of an oil-financed modernizing agenda. Originally painted on rolling garage doors (featured in Herrera's Polaroids), following small businesses' utilization of that liminal space, the photographs of this local intervention introduce *Causa y efecto*, the installation. There, the artist presents "undocumentation" of blackened aquatic life, which she transforms into evidentiary found objects from the Gulf of Mexico's beaches. In glass cases, these specimens of birds, plant life, and coral reefs, partially or fully "painted" with

petro-residue, evidence the coastal consequences of offshore oil exploration and inter-American prejudicial legacies of tarring and feathering.

"Drill, baby, drill!" Languaging another story of unnatural disaster, these items become the alternate energy source of a critique of the socioeconomic, specifically detailing how the Mexican postrevolutionary state continues to default on the social contract it made with its citizens. *Causa y efecto* shares formal and thematic affinities with other actions by Cuevas, including *Melate* (2000).

Melate takes its name from one of the most popular draws of Mexico's Lotería Nacional para la Asistencia Pública (Lotenal) (National Lottery for Public Assistance). *Melate* plays on the Mexicanism "Me late" ("I like" or "I have a gut feeling"), underscoring the parastate's supposedly principled impetus.[34] The Mexican lottery dates back to 1770 when the Real Lotería General de la Nueva España, the first of its kind in Latin America, was established to raise funds for public initiatives like the construction of hospices for the poor. In 1960, all money raised through the lottery legislatively was designated the purview of the Secretary of Health, earmarked for public assistance programs. In the 1990s, the Mexican state plastered the red-hearted "Melate" with the amounts of jackpots to be won on public walls, on telephone calling cards, et cetera. Cuevas's *Melate* reworks the logos of that logo. The heart's and game's name on her reMex are bleeding. The subvertisement's statistics decry another story: "En México, 46,000,000.00 personas viven en la pobreza" (In Mexico, 46,000,000 people live in poverty).

Bingo! Propaganda for the national lottery becomes a commentary on the trans/nationalized social lottery otherwise known as class division. Cuevas again transferred this image-text to metal rolling garage doors, to concrete walls lining freeway underpasses and pedestrian walkways. She printed her "Melate" on posters to be wheat-pasted around the city. She mass-produced it on decals and stickers. *Melate*'s discordant melody reMexes a naturalized method: in Cuevas's multiverse, the new Mexican state hardly has cornered the market on the allegorical's remediations.

The artist's just-in-time merchandise piles up: Cuevas bottles water and labels it *égalité: Une Condition Naturelle* (*equality: A Natural Condition*, 2004) in lieu of "Evian: Eau Minérale Naturelle" (Evian: Natural Mineral Water). A "Donald McRonald" (2003, 2006) in a knockoff suit of the chain's mascot that substitutes the international symbol of biological hazard for the company's logo of golden arches confronts patrons of a McDonald's fast-food

chain with statistics about arteriosclerosis.³⁵ (Note that McDonald's here cannot be recuperated like McOndo. It does not flow in our veins like Coca-Cola, but perpetrates fatal blockages.) A pyramid of "Pure Murder" (in English) stacks "Del Montte" cans of stewed tomatoes against viewers on the exhibition floor.

A looming wall mural (500 × 600 cm), with a text in English, overshadows the *Del Montte* installation's (2003) low-hanging bulbous "harvest of Empire" and is juxtaposed with its subtitle, "100 yrs. suffice." "Dreaming on the pyramid," in another subvertisement, two skulls offer background for the copy "Del Montte [sic]/Criminal" in even clearer reference to Guatemala's former military dictator Efraín Ríos Montt, found guilty of the genocide of more than 1,700 indigenous Ixil Mayans in May 2013. Above and below this text are the words "Guatemala" and "Struggles for Land." Cuevas, like Razo but also importantly like Del Monte, minces no words to reperform histories of neocolonial collusion—in this instance, the United Fruit Company joining forces with transnational capital and the Guatemalan military to wage state-sanctioned terrorism.

Cuevas's most interesting interventions attend to the local, but also telescope up, implicating the city-state of Mexico and the globe. Her method accounts for the particularities of place while drawing from and contributing to the strengths of the "dark matter" of "art and politics in the age of enterprise culture" (Sholette 2011). I consequently first puzzled over the inclusion of *Drunker* (1995, 65 min.) in the artist's retrospective.

Drunker consists of a looping video that follows Cuevas alone, writing and drinking tequila. Below the video monitor sit reams of paper that the inebriated author produced: "I drink not to feel . . . I'm not drunk . . . I drink to talk . . . I'm not drunk . . . I drink to forget . . . I drink to remember . . ." What break-up does *Drunker* document? The art historian Jean Fisher argues that although the taped performance "seems like a purely personal act with little political resonance," Cuevas's (2011, 57) words suggest other narratives of trauma, "the anaesthetic effect of capitalist consumerism." Then, halting as if limning out the "para-" without the "-sitic" of her thesis, Fisher focuses on Cuevas's corpus outside of the specificities of millenarian Mexico. Months after I pondered whether or not *Drunker* belonged in Cuevas's retrospective, the politics of its location came into slow and dull focus for me, albeit as if I finally were awakening from a NAFTA(rt) versus Zapatista hangover. Before even the first anniversary of the treaty's implementation, Mexico's rendition of a "perform-or-else" neoliberalism veered

FIGURE 1.11. Minerva Cuevas, *égalité*, installation view, 2004. © Minerva Cuevas. Courtesy of artist and Kurimanzutto Gallery.

toward a metaphoric earthquake. On December 19, 1994, the Mexican state, still with Salinas at the helm, devalued the peso, committing what came to be known as "el error de diciembre" (the December mistake).

Triggered by the import intensity of export-led industrialization, a trade deficit financed for the most part by a flood of speculative investment into

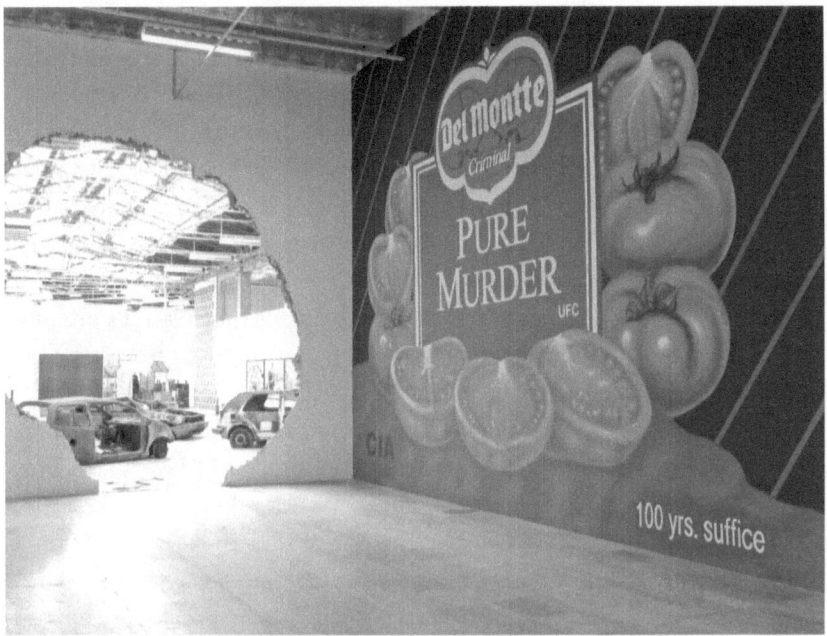

FIGURE 1.12. Minerva Cuevas, *Del Montte*, installation view, 2003. © Minerva Cuevas. Courtesy of artist and Kurimanzutto Gallery.

the Mexican stock market, and growing short-term debt (a sixth of which was slated to come due in 1995) in the hands of foreign investors, the crisis that ensued—what foreign economists derisively labeled the "Tequila Effect"—spurred the Clinton administration to urge the IMF to cobble together a rescue package of almost $50 billion dollars to stabilize the peso. Concomitantly it committed $20 billion of US discretionary funds toward the bailout with a puppeteer's strings attached: for the decade that followed, Washington had veto power over all of Mexico's economic decisions (Otero 1996, 7–9). Another frenetic round of the Mexican parastate's dismantling ensued, its redistribution this time disproportionately falling into the hands of foreign investors.

In *Drunker*, Cuevas grows "drunker" on the Tequila Effect that set the tone for the second half of Mexico's 1990s. *Drunker* makes clear it is not enough to read the artist's work as some generic response to neoliberal globalization. Still, *Drunker* is distinct from much of Cuevas's later work in two important regards. In the action, similar to El Mago Melchor's close encounter with a Brandy bottle, Cuevas allegorizes a problem but does not

intervene in it per se. *Drunker* represents one of a handful of actions in which Cuevas renders her own body central to the latter's documentation, as if bookmarking a crossroads in her corpus or, alternately, as if periodizing the collective happening of Mexico City's 1990s. Amid the flurry of 2010s curatorial initiatives and criticism now dedicated to the art histories of the DF's 1990s–2000s, the modest yet provocative title of Henaro's 2011 show at the MUAC, *Antes de la resaca . . . Una fracción de los noventa en la Colección del MUAC* (*Before the Hangover . . . a Fraction of the 1990s from the MUAC Collection*), stands out. Cuevas's *Drunker* anticipates that exhibit's premise: before the mourning after historical documentation, the gesture is made to forget to remember, to remember to forget.

Targeted, granted largely symbolic, direct action defines Cuevas's practice, especially her work falling under the umbrella of *Mejor Vida Corp.*® (*MVC*; *Better Life Corporation*, 1998–2012). MVC functions as a shell company whose activities include a parsing out of millennial DF art history. Cuevas, like her contemporaries, was awake to and aware of her work's growing market value. MVC systemizes the microgesture under the macrocover of incorporation. The project attests to Cuevas's extensive investment in the increasingly consolidated genre of the PIAS Forms in Mexico and transmedial practices beyond. It also documents the artist's faux fatalism regarding the inevitable incorporation of those forms into one-world master narratives.

In a tone both reactive and reactionary, Cuevas narrates *MVC*'s genesis, chronicling her own meted-out dissatisfaction with the art world, activism, and Mexico's unraveling social safety net. In 1997 when Cuevas hit upon the idea for her own in/corporation, the artist still wished to expose the economic underbelly of the art market by distributing art objects in public spaces like parks, shopping malls, and subways. Cuevas decided to wield what some regard as "post-political" cynicism in the service of a service industry of good.

In Cuevas's estimation, the alter-globalization movement rhetorically spoke to pressing issues within Mexico—the purchasing power of the multinational, the migration of work forces, the militarization-industrialization of the Mexican-US borderlands in the name of free trade—but proved contextually inefficacious. Alienated from and by many of the movement's post-Battle-of-Seattle tactics, Cuevas observed,

> In Mexico City, you have demonstrations every day, and you get used to them, sometimes they succeed on specific demands, but they don't have

a positive impact for the most part . . . at the end of the day, people only complain about the traffic jams. (2001)

Cuevas posed a Sphinx-like riddle to herself, absorbing what Luc Boltanski and Eve Chiapello (2005) characterize as late capitalism's absorption of post-1968 performance and conceptual practice: "What would the paradox of a corporation that lacked capitalist values look and act like?"

Renting an office on the fourteenth floor of the famously phallic Latin American Tower, which at the time was the tallest building in Mexico, Cuevas designed a website for her start-up that illustrates and enacts her corporate commitment to generosity (www.irational.org/mvc/). MVC's bilingual logo, not a rip-off per se but an appropriation of corporate giving's assumed altruisms, features the company's trademarked name *Mejor Vida Corp.*® above a drawing of a handshake and the sound bite "For a human interface" (in English).

On the site, you can order, free of charge, specific items, including pre-stamped envelopes, tear gas, magic seeds, lottery tickets, and perhaps my favorite in the endless cycle of applications and evaluations, letters of recommendation, and custom-made barcodes meant to replace preexisting ones on products; when used properly, they give the user a "built-in" discount. "Mejor vida" harbors fugitive references: the empty promises of (PRI) politicians, immigrant aspirations, "post-Fordist affect" (Berlant 2011), art—from the proletariat's to the culture industry's—the manufacture of waking dreams. Providing a platform with something for everyone, Cuevas never limited her corporation's efforts to the Internet. In actions intended to bridge the digital divide, Cuevas requested that the Mexico City Tamayo Museum waive its entrance fee while *MVC* products were on display there. When the museum retorted that this was impossible, Cuevas produced student IDs for visitors so they could enter free of charge. Or, on more than one occasion, the artist disrupted the crowded DF metro morning commute by distributing free tickets to people stuck in queues waiting to buy them. Cuevas also has swept and mopped metro stations' floors.

MVC's beautification campaigns especially shine when compared with contemporaneous actions like Francis Alÿs's *Barrenderos* (*Sweepers*, 2004). In the latter's documentation, Alÿs and Medina grease the palms of Mexico City police officers as readily as Okón, direct female street cleaners, rejoice in and reflect on their own foiled artistic plan, but never lend a helping hand to the workers.

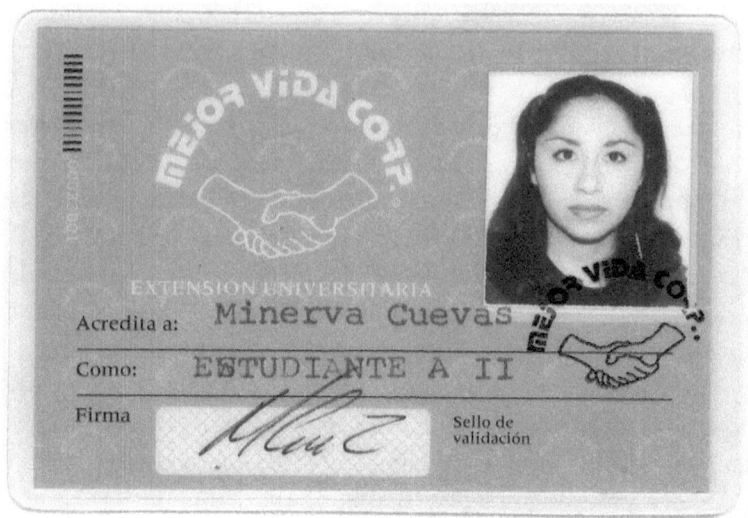

FIGURE 1.13. Minerva Cuevas, Student ID card, 2004. © Minerva Cuevas. Courtesy of artist and Kurimanzutto Gallery.

Medina: "Now let's see if they manage."

Alÿs: "It's more beautiful than I could have imagined."

A clean sweep: If the male artist and male critic's participation does not extend beyond the labor of observation and delegation of authority, Cuevas, under the sign of *MVC*, is in charge of only her own actions when she sweeps station platforms for *STC Cleaning Service* (1998). The effort she expends is reminiscent of Mierle Laderman Ukeles and other 1970s feminist artists' "sanitation aesthetics" (Jackson 2011, 75–103) although, to come clean, Cuevas resists such "gender-fication" of her work.

Of Cuevas's cave of a corporation and the work of Alÿs and Sierra to which we'll turn next, Medina (2000b, 149–150) writes, "There is an unmistakeable allegorical value in the thousand ways modernization, rationalization and development are resisted on the periphery through microscopic acts, even against the apparent interest of the perpetrators of those acts." *MVC* has been compared to a potlatch or a jubilee, but in practice, it doesn't adhere to either of those rituals' strictures. Per Medina's observation, *MVC* as a dematerialized art object, materializing "bare life" necessities, infiltrates the everyday. In so doing, it depends on the speculative wager that the seed of a good deed will spawn in some future tense an unpredictable, equally magnanimous gesture. Downsizing the French base

materialist Georges Bataille's ecstasy (1985), Cuevas's praxis veers closer to the French sociologist Marcel Mauss's configuration of the gift as a social contract (1967). Localized, Cuevas repurposes Herrera's "Chrysler is performance," replacing concerns over the distribution of the sensible with gestures of redistribution that assume the integration of market and gift-driven economies.

If *El arte de vivir del arte* filled the market niche of artistic self-promotion, *MVC* qualifies Ehrenberg's truisms on exchangeability. Some have characterized Cuevas as insisting on the absurdity of a corporation that presents expenditure without quantifiable profit. Such a reading misses the artist's offshore investments in artistic incorporation, the "oportunismo responsible" (responsible opportunism) undergirding the project (Medina, in Montero 2013, 141). Claiming no cultural exemptions, the artist, through and with *MVC*, creates a two-tiered allegorical response to the empty signifiers of the "neoliberal" and the "contemporary." While Medina pits the "microscopic act" against the commodity, in effect representing the pair as allegorical antimonies—the smallest common denominator of alter- versus neoliberal globalization—Cuevas syncopates allegory to *allègre*. She interrupts business-as-usual to reinstate a stateless state fiction with and against the premise of Gerardo Evia's reading of the allegories of globalization, proposing above all else that a better life merits incorporation. Projectively capacious, her marketing philosophy harmonizes in the multiple, sometimes contradictory, keys of progressive politics, the art world, state-market jingoism.

Listen on the lower frequencies. December 1, 2000, the day that President Fox, the candidate who rode on the coattails of both a fundamentalist promotion of the free market and a Zapatista re/appropriation of technology to target an overwhelmingly young, wired voting population, was sworn into office and his inaugural address was televised live throughout Mexico, Cuevas simultaneously broadcast an *MVC* pirate radio station. Cuevas's action depended on the prevailing rhetoric of (consumer) *choice*, saturating the airwaves during Fox's campaign (the rationalization: *at least he represents change*, regardless of whether he might be affiliated with the conservative party PAN, which, for instance, outlawed mini-skirts in parts of the country), on the lengthy blurred pedagogical and performative temporalities of the nation-state, and on the *logo*centrism operative across her corpus.

The parasitic possibility of co-optation in this gesture, like in all of *MVC*'s, looms threatening as a cumulonimbus cloud of information on the horizon

even as the artist para-siticly anticipates stormy weather. *MVC*'s feel-good "Other campaign" incorporates the brand name of Cuevas into that of Mexico then questions that incorporation. The "indecisive aesthetic" of *Drunker*, as it turns out, is no anomaly in Cuevas's corpus (Jameson 1992, 54). In its equal privileging of process *and* finished product, though, such enterprise begs the question, Does it—do *we*—get any better?

FRANCIS ALŸS, SANTIAGO SIERRA, AND THE AGE OF CUAUHTÉMOC

When I see photographs of *Placing Pillows* (1990), it's as if I hear those images emitting a sigh of relief in sync. The title of the action, one of Alÿs's first, blandly corresponds to the work's contents. In the same year that the Salón des Aztecas issued its call for *La toma del edificio Balmori* (*Taking Over the Balmori*, 1990), Alÿs placed pillows in the broken windows of buildings that had been damaged by the 1985 earthquake, abandoned, and then reclaimed by squatters.

The Balmori takeover remains a key event in the recent history of DF art, involving more than one hundred participants. The French-inspired building, located at the corner of Calle Orizaba and the Avenida Álvaro Obregón in the rapidly gentrifying Colonia Roma, was slated for demolition, allegedly wrecked beyond repair by the 1985 earthquake. Artists, operating within a post-1970s wider tradition of squatting locations, squared off against venture capitalism, filling the condemned site with ephemeral installations, poster art, paintings. The collective action, as durable in the imagination as José Luis Cuevas's ephemeral mural, warned DF denizens of the threat posed by socioeconomic restructuring to historic architecture and more generally to Mexico City. Ironically per Okón's formulation, the event countered gentrification with gentrification, however.

In contrast, Alÿs's *Placing Pillows* is as intimate as a second language learned by way of a pillow dictionary. Solo-authored like Cuevas's interventions, *Placing Pillows* smothers the radicality of *La toma del edificio Balmori* beneath its whimsically indeterminate tiered levels of meaning. It serves as an architectural model of the reconstruction versus the collapse of the segregated floors of allegory. *Placing Pillows*'s protagonists, also damaged apartment complexes, after all, comprised as many stories as La Panadería, La Feria del Rebelde, or 1990s Mexican art.

Like *La toma* or the corpus of Polish national, US-transplant architect-artist Krzysztof Wodiczko, which we will consider in "Border," *Placing*

Pillows animated architecture, but, in this instance, to suggest more pessimistically that the means to cushion the blow of disaster capitalism are never clear or freestanding. If *Placing Pillows*'s recipients could speak, they might not only sigh but also annotate my previous observations on the significance of Mexico City's 1985 earthquake to 1990s art making. The windows, as full as mouths, might mumble that the ghostly persistence of 1985 is comparable only to the years 1968 and 1994 in the city's collective unconscious. Protecting against the "shock doctrine" of transition that disaster accelerated, Alÿs's intervention temporarily absorbed precarity sans the promise of saving a neighborhood, a city, or a nation-state, or offering an (art) history. In this regard, comparable to Cuevas's work, Alÿs's action belabors a story of the artist's singular initiation into art making, Alÿs's debts and participation in the genre-fication of the PIAS Forms.

A paradox of practice: if Orozco left Mexico to realize the range of his neo/conceptual practice, Alÿs migrated to Mexico to realize his. Born Francis de Smedt in Antwerp, Belgium, Alÿs studied architectural history at the Institute of Architecture in Tournai, Belgium (1978–1983), and engineering at the Instituto di Architettura in Venice (1983–1986). Shortly thereafter, he was drafted into the Belgian army. Swapping civil for military service, he traveled to Mexico. After the DF's earthquake, Alÿs joined an NGO to help rebuild the city. In the process, he rebuilt the trajectory of his own lifework.

Alÿs met and socialized with key figures of the late-twentieth-century DF art scene—Gabriel Orozco, Smith, Medina, Cruzvillegas, and Thomas Glassford, among others. He abandoned his national obligations to set up shop in the city's devastated historic center. There, he began to work across genres (painting, video-documented action, slide projection, animation, short narrative). Now an internationally acclaimed and seasoned veteran of the Venice Biennale and a naturalized Mexican citizen, Alÿs has been accorded numerous solo exhibitions and retrospectives, in which he and many of his critics underscore the importance of allegorical modes of representation in his work. For instance, the art historian Mark Godfrey boldly argues, "Alÿs's practice is the most important renewal of the allegorical impulse identified in the early 1980s by Craig Owens" (Godfrey, Biesenbach, and Greenberg 2010, 18). There's no shortage of examples in Alÿs's efforts to support such an "allegory of reading."

In an area in the Zócalo near the railing of the Metropolitan Cathedral, where tradesmen ply their skill sets, Alÿs, in sunglasses, stands between day laborers whose placards read "Plomero en general gas" (Gas plumber)

and "Pintor y yesero" (House painter and plasterer). More than a foot taller than the compact man to his right, Alÿs subvertises his occupation, *Turista* (*Tourist*, 1994; see plate 3). In *El colector* (*The Collector*, 1991–1992), Alÿs pulls what appears to be a toy by its string through downtown DF streets. The magnetized unit collects all metal refuse that crosses the artist's path. In *Fairy Tales* (1992), Alÿs trails the blue thread of his sweater. As the artist meanders through the DF, the unraveling becomes the loss not of a unified narrative but of the latter's constitution.

Although much of this work, nearly as evacuated as Fletcher's "allegory without ideas" (2012 [1964], 398), reads like allegorical one-liners concerning the location of the artist in some generic allegorical figuration of the City (in other words, like Cuevas's subvertisements), I'd note, like the translator and cultural critic Irmgard Emmelhainz, who writes of 1990s/2000s Mexican art, that Alÿs's fixation on Mexico City reflects the extreme articulation of a trend, "The city's potential as epistemic space and thus as a rich carrier of sensible knowledge was exploited . . . Mexico DF became key in the imaginary of contemporary art, a metaphor or allegory of the shifting geopolitical borders" (Emmelhainz 2015, n.p.). By the late 1990s, Alÿs set out to flag his use of the city form as more than an allegory of "shifting geopolitical borders," however. His aggressive fable, per the terms of the era's overarching allegory, was one of Mexico (City) and eventually the whole of Latin America and the global South as beautiful "failures." It depended on connections the artist implicitly and explicitly made between Mexico post-1968 and post-1994, too.

While critics link Alÿs's person and his efforts to the European figurations of the Flâneur and the Situationist, the artist repeatedly disputes these characterizations, citing other precedents, admittedly as clichéd, for his work. First and foremost, after 1999, in collaboration with Medina, Alÿs re-sites the incomplete, constantly deferred project of modernity in Latin America and in Mexico as his inspiration.[36]

A paradox of practice, too: in 1997, in *Paradox of Praxis 1 (Sometimes Doing Something Leads to Nothing)*, Alÿs pushed a block of ice through the crowded downtown streets of the DF for nine hours until it had melted into nothing, or, into something else, five minutes of video documentation of the action. Alÿs describes the work as "a settling of accounts with Minimalist sculpture," but also as an allegory of the circumstances of Latin America (Alÿs, quoted in Ferguson 2007, 55).[37] Commentators have been least vocal on the action's video as artifact, but a few of the details of its representational economy linger if we keep the tape running: *Paradox of Praxis 1* opens with

the ringing of bells—those of the ubiquitous street vendors and garbage collectors). The camera of Alÿs's frequent collaborator Rafael Ortega (who also has collaborated with Smith) faces downward, focusing on the sidewalk. A trail of water like a snail's silvery path glistens, relineating our vision. We see Alÿs's red-Conversed feet and the stance of his body—his hunched back, his torso parallel to the frozen rectangular block and the line of the "paseo," itself as slow as a snail's.[38] Past storefront windows; passed by bicycles, dogs, and cars, pushing the ice for Alÿs begins as stoop labor before it becomes as light and quick as child's play paradoxically per Kaprow's plea for a "concrete art." Alÿs's kicking of an ice cube melts into a DF spectrum of noise: a car's horn, the vendor's call, pedestrians' conversations. At the video's close, three children crowd around what's left of the ice's fleeting monumentality—a puddle.

For *Viviendas por todos . . . (Housing for All . . .*, 1994), Alÿs built a makeshift shelter out of plastic campaign posters on August 21, 1994, the day of Mexico's presidential elections that resulted in the victory of "YupPRI" candidate Ernesto Zedillo Ponce de León.[39] He installed the dwelling over an air duct of the Zócalo's subway. The metro's hot air inflated the paraphernalia. Documentation of *Viviendas por todos . . .* includes Alÿs taking a Mexican "siesta" beneath the structure.[40] Or, in *Cuentos patrióticos (Patriotic Tales*, 1997), whose documentation includes black-and-white time-lapsed images and a brief video (25:35 min.), Alÿs leads twelve sheep around the Zócalo's flagpole. *Cuentos patrióticos* takes in the Metropolitan Cathedral (its pealing bells), the Palacio Nacional, the blue sky flocked with cirrus and cumulus clouds, the square teeming with life, before the camera pans Mexico's monumental flag and the shadow it casts on the ensuing spectacle. Non-Mexican viewers might plant the patriotic story of *Cuentos patrióticos* firmly in the flag at the center of the action. Such an interpretation, though not incorrect, is at least twofold incomplete.

In August 1968, the Mexican government, in an effort to counter the growing dissent preceding the Summer Olympics, ordered its civil servants to take part in a major rally supporting the PRI in the Zócalo. To register their discontent with this mandated action, the white-collar workers turned their backs on the platform where senior government officials were pontificating. Drowning out the platitudes of institutionalized revolution, the civil servants bleated like sheep, harmonizing a countertune to post-revolutionary cultural nationalism. In *Cuentos patrióticos*, Alÿs references this pre-Tlatelolco disturbance. He also domesticates it in a displacement of political meaning. As if in prescient response to the art historian Grant

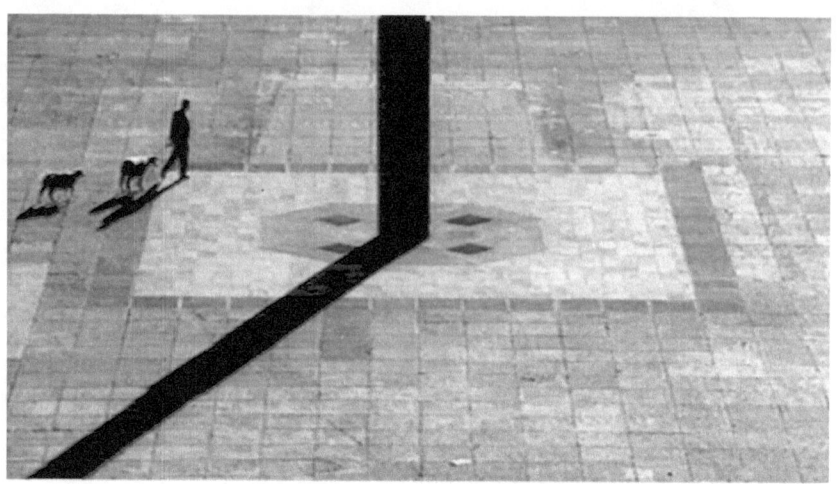

FIGURE 1.14. Francis Alÿs in collaboration with Rafael Ortega, *Cuentos patrióticos* (*Patriotic Tales*), still from video documentation of an action, 1997. © Francis Alÿs. Courtesy of artist.

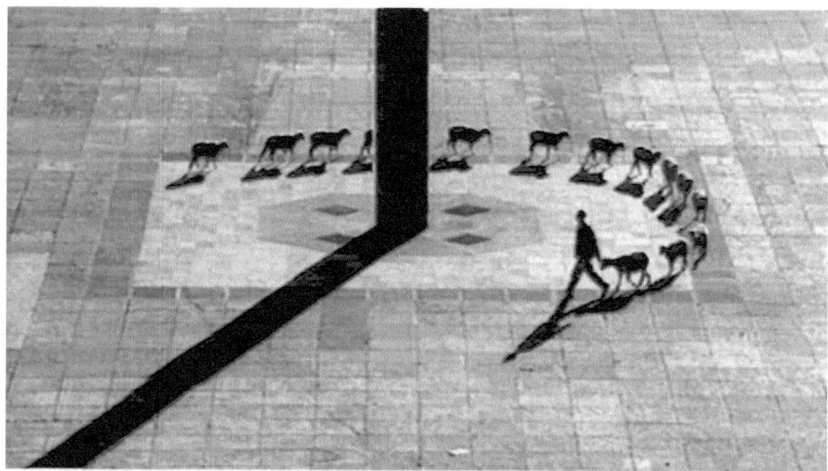

FIGURE 1.15. Francis Alÿs in collaboration with Rafael Ortega, *Cuentos patrióticos* (*Patriotic Tales*), still from video documentation of an action, 1997. © Francis Alÿs. Courtesy of artist.

Kester's (2009) desire to locate the artist's practices as responding to France's May 1968, as the Latin Americanist Samuel Steinberg argues, with *Cuentos patrióticos* Alÿs firmly establishes his 1968 to be Mexico's.

Steinberg (2016, 179) carefully reads the placement of this work's documentation in the Centro Cultural Universitario Tlateloco's Memorial del 68, noting that it "punctuates the museum's narration of the period from late July through August." While a closer look at the hybrid genres favored by *Cuentos patrióticos* (performance-video-installation) falls outside the purview of Steinberg's analysis, it's not inconsequential to our reading of Alÿs's practice. Performance art especially, the "black sheep" of 1990s Mexican conceptualisms, is led around the work's "bandera monumental" (monumental flag), too—the poignant legacy of Los Grupos, all but suppressed in the rushed disaggregation of the "Mexican" from the manufacture of a contemporary art that erases the nation form only to reinscribe it. Evidently Alÿs first intended *Cuentos patrióticos* to serve as a critique of Zapatismo's supporters gathering like sheep in the Zócalo. Mexican art on a global market, it seems, knew better than to follow the circumambulations of any stripe of revolution.

The structure of *Cuentos patrióticos* as a looping reperformance of allegory, the impulse of the action, plays out with a same difference across Alÿs's corpus: a simple gesture belies the incommensurability of the real and the imagined in "social allegories" writ large in and for Mexico. Although Steinberg makes a compelling case for *Cuentos patrióticos* as "repoliticizing re-presentation of Mexico, 1968 in its unbearable contingency" (2016, 176), the pairing of 1968 and 1994 across Alÿs's oeuvre compromises the perlocutionary, let alone the residual revolutionary, force of his argument. As Kester intuits, Alÿs's process and repeated focus discredit the political in this and other actions by the artist, although not for the reasons Kester expounds.

The formula is particularly pronounced in Alÿs's collaborations with Medina. A triumphalist defeatism constitutes the non/sites of the DF, Mexico, Latin America, the global South . . . like so many concentric circles radiating outward. In *Rehearsal I* (*Ensayo I*, 1999–2001, 29 min.), a man (Alÿs) in an unincorporated shantytown of Tijuana tries repeatedly to drive a Volkswagen bug, once the ubiquitous mode of transportation in Mexico, up a hill. He listens to a tape of a brass band rehearsing a "danzón." When the musicians play, he drives the car forward. When they pause, he stops the car. When they tune their instruments or talk, he lets the car roll backward or puts it in reverse. Medina frames the effort like this: "[*Rehearsal I*]

is an allegory of the struggle of Latin American societies to adjust to the social and economic expectations of their northern neighbors ... "(Medina, quoted in Godfrey, Biesenbach, and Greenberg 2010, 103).

Medina and Alÿs repurpose this commentary to explain their most widely touted allegory, *When Faith Moves Mountains* (*Cuando la fe mueve montañas*, 2002), included in the Third Biennial of Lima. On April 11, 2002, five hundred volunteers from the School of Architecture at the National School of Engineering in Lima, Peru, relocated a Ventanilla sand dune a few meters (see plate 4).[41] The documentation of what Medina and Alÿs term the "futile gesture" foregrounds a line of white shirts emblazoned with the name and date of the project, a sweaty brigade of shovelers combating the heat and the hint of an avant-garde. In "Lines of Entry," Buck-Morss repeatedly invokes "global realism" as a descriptor for the action (Buck-Morss, in Alÿs and Medina 2005, 137, 140, 141). It complements Medina's provocative project précis, also included in the earthwork's catalogue, while again locates *When Faith Moves Mountains* between a rock and a hard place, namely between the futility—and the "contingency"—of a post-1968 and post-1994 political and aesthetic watershed.

On the one hand, in a conversation included in the catalogue, Medina (Alÿs and Medina 2005, 104) cites "the classic rallying methods of Latin-American universities" (albeit referencing 1986 in this instance) when explaining the collaborators' strategy for recruiting volunteers for the action. On the other hand, in his short essay "Maximum Effort, Minimum Result," also included in the project's catalogue, Medina glosses *When Faith Moves Mountains* as "an application of the Latin-American principle of nondevelopment: an extension of the region's logic of failure" (178). The latter explanation echoes the "Other story" of Alÿs's no less subdued conceptual ambitions for the action. In an e-mail, the artist proposes, "Here we are attempting a kind of land art for the landless, and with the help of hundreds of people and shovels we build a social allegory" (24).

Alÿs's claim corroborates and complicates Kester's (2009, 416) argument that the artist's "desire to address the impact of modernization in Latin America obliges him to retain a conventional system of signification in which modernization is represented by various allegorical substitutes." Kester critiques *When Faith Moves Mountains*'s portrayal of collaboration as inevitable failure, but his reading of the action's perceived shortcomings again is overshadowed by his universalizing preoccupation with the 1990s intimacies of neoconceptual art and poststructuralist theory (407). Kester's indictment of Alÿs's project narrowly reframes the reconfiguration

of allegory in *When Faith Moves Mountains*, the location of collaboration in the project, itself elided with the language of under/development. The obvious is purloined as the letter of violence: The artists in the plural—Medina and Alÿs—are not up against the "relentless instrumentality of modernization" in some generic sense (417), but rather the structures of public policy, the strictures of allegory, veiling and unveiling "the art of economic government" in Latin America from the second half of the twentieth century onward (Foucault 2008, 131). Allegorical distanciation does not play out (solely) as a "poetic withdrawal" in *When Faith Moves Mountains* but as a literalization of a hegemonic trope—allegory—already in circulation in the daily naturalization of such unfair deals as open markets in exchange for the adjustment of debt. Alternately parsed, the import of *When Faith Moves Mountains* is indeed one of substitution. The medium is the message—the "sovereign performative" (Butler 1997a, 71), the engine of statecraft, meets corporate citizenship, post–World War II, in a specific hemispheric context.

We encounter a vulgar structuralism, the politics of a new PRI, in the gesture especially if we bring to bear on it the art historian George Kubler's 1960s reflections on "artistic geography." Kubler presented his theory at the first session dedicated to Latin American topics at the 1961 International Congress of the History of Art. Colonial Latin America in turn became central to Kubler's ideas in *The Shape of Time* (1962). The art historian Thomas Dacosta Kaufmann writes, "For Kubler, the Latin American colonies provided a classic example of what he calls 'extension.' Kubler says that in Latin America a 'gigantic outlay of effort at minimum standards of performance' determined the equipping of a continent, with lasting effects on the history of art" (2004, 226). Medina ironically repeats nearly verbatim Kubler's observation in his sound-bite characterization of *When Faith Moves Mountains* as entailing "maximum effort, minimum result" (Alÿs and Medina 2005).

The shape of time: settle into your seat, allow yourself to be hailed by *The Politics of Rehearsal*'s (2005, 30:05 min.) burlesque, recursive (art) history lesson. *The Politics of Rehearsal* offers quasi undocumentation of *Rehearsal II*, a striptease act performed for more than two hours in New York City's Slipper Room (167 Orchard Street), a Lower East Side burlesque club. In the Performa commission, a stripper (Bella Yao) dressed and undressed for art voyeurs, instructed to attend in formal wear. A soprano (Viktoria Kurbatskayer) and pianist (Alexander Rovang) rehearsed Franz Schubert's "Lied der Mignon" over and over. When Kurbatskayer and

Rovang stopped to review a musical passage, Yao dressed herself again. In an interview with the curator RoseLee Goldberg, Alÿs insists that he conceives of performance and its documentation as separate activities (Goldberg 2007, 204). The distinction choreographs Medina's leading role in the latter. In *The Politics of Rehearsal*, the critic joins the action as its fourth performer. Several sonic scores intersect over the footage of Yao, Kurbatskayer, and Rovang's performance. A newsreel of Harry Truman's first inaugural address (January 20, 1949, Washington, DC), sometimes called his "Four Points Speech," is spliced into the action. Truman outlines a program of aid intended to combat "poverty, a handicap" in the world's "underdeveloped areas." Adding to the cacophony, a disembodied voice, clearly recognizable as Medina's, places *Rehearsal II*'s and Truman's artistries on a par.

Medina instructs, "*The Politics of Rehearsal* is a metaphor of Latin America's ambiguous affair with modernity, forever arousing, and yet always delaying the moment it will happen." The voice of authority supersedes the movement of the nation's striptease, the figuration of Mexico as (violated) Woman in the contexts of development or free trade. Doing and undoing revelation, Medina's virtuoso performance sets the tenor of the politics of *The Politics of Rehearsal*, reasserting the aggressive presence of the (male) artist-critic assemblage. Medina, the project's truest centerfold, offers observations on 1980s–1990s Mexico and the distinction between work and labor. And, somewhere in the middle of this "ensayo" (where the Spanish word's double meaning as "rehearsal" and "essay" proves significant), Medina also directly addresses Alÿs, situating his own countertransferential analyses in relation to the artist's corpus. Medina teaches us how to read Alÿs, or more specifically, not only how to understand the ascent of the artist's "brand" on a global market, but how to interpret the precarious, yet indispensable role that a curatorial class has played in the production of NAFTA-era DF art. Medina, after all, "discovered" Alÿs in Mexico and simultaneously began to write about his work in the 1990s. Medina's discovery, in turn, influenced Alÿs's own looping rediscovery of "Latin America" and the pair's collaborative promotion of the region's failures.

The Loop (1997), Alÿs's contribution to inSITE97, illustrates this situation as a formal problem, now legible as the cleverly appropriated "failure" of Okón's *Risas enlatadas*. Alÿs resolves to go from Tijuana to San Diego without crossing the border. He followed a "perpendicular route away from the fence and circumnavigated the globe heading 67° South East, North East and South East again until [he] reached his departure point" (Godfrey, Biesenbach, and Greenberg 2010, 86). Critics generally read this piece as

juxtaposing the allegorical figurations of the nomadic artist of "one place after another" and the undocumented migrant. But *The Loop* is equally suggestive of what Alÿs avoids by way of the allegorical performative: a direct crossing into the idea or "incurable image" of Latin America (Elhaik 2016).

In other words, Alÿs and Medina's statements concerning Latin America prove productively tautological. The pair collaboratively have fashioned a narrative about, if not a series of, actions that function paratactically as allegories of the failure of allegories of Mexico, Latin America, and the periphery. Conveniently they edit out other possibilities (e.g., the collective energy and intellect of Razo's *Museo Salinas*). Of Mexico, Alÿs claims, "I think you could say that all the ingredients are present for Mexico to enter modernity, but there is this resistance . . ." (Alÿs, quoted in Elhaik 2016, 38). Could we not say the same of Alÿs and Medina's articulation of a DF contemporary? All the ingredients are present for the pair to articulate more fully the political stakes of their redeployment of an allegorical method, and thus to amplify the "promising ambivalence" of the latter as a tactic. But Alÿs, elevating himself to the level of an allegorical figuration or conceptual persona, dwells in the romanticism of his own status as an insider-outsider in Mexico City and Latin America. The result across the artist's corpus and much criticism of it, including Medina's, is an inverted encryption of the language and violence of neoliberal (national) allegory, the disturbingly parallel reconstruction of Mexico as a found object on the global market. To counter, we also must read allegorically.

In *The Seven Lives of Garbage* (1995), Alÿs tested the DF maxim that all garbage goes through "seven stages of sifting," like the Buddhist seven stages of purification, before it arrives at the municipal dump. Alÿs painted seven identical bronze sculptures seven different colors, then placed them in seven plastic bags in seven garbage piles in seven districts of Mexico City. Since then, he's wandered tianguis, waiting for the talismans to reappear, allegedly recovering two. I'm inclined to imagine that they materialized, repurposed, in other popular marketplaces.

Cuauhtémoc Buddha (2006–2009) appeared in a DF stall outside the Teatro de los Insurgentes where the third annual Simposio Internacional de Teoría de Arte Contemporáneo (SITAC; International Symposium on the Theory of Contemporary Art) was taking place. SITAC began in 2002 and is now an annual three-day event that includes lectures and artist talks. Artists Joaquín Segura and Renato Garza Cervera later claimed responsibility for the satiric sculptures, which substitute the visage of Medina for that of the Buddha.

FIGURE 1.16. Joaquín Segura and Renato Garza Cervera, *Cuauhtémoc Buddha*, 2006–2009. © Joaquín Segura and Renato Garza Cervera. Courtesy of artists.

Reminiscent of Razo's pyramids, the figurine outs a sovereign. In the late 1990s, Medina emerged as the leading voice of contemporary art history, criticism, and curatorial practice in the DF. Chief curator of the MUAC since 2013, Medina earned a BA in history from the UNAM in the early 1990s, then a PhD in the history and theory of art at the University of Essex a decade later, completing a dissertation on Fluxus International. Since 1992, he has served as a full-time researcher in the UNAM's Instituto de Investigaciones Estéticas. The first curator of Latin American Art Collections at Tate, London (2002–2008), Medina also was a key member of the critical curatorial initiative Curare (1991–2002).

As disenchanted with the museum and gallery circuits as the artists whose work they sought to engage, Curare, a tight-knit group of art historians, critics, and curators, founded a nonprofit private space in the Colonia Roma—a parallel structure to the 1990s artist-run alternative spaces—dedicated to researching modern and contemporary Mexican visual

culture. Curare organized exhibitions, courses, lectures, and public debates. Its members curated exhibits in Mexico and abroad and produced a triannual publication, which became a touchstone of Mexican art criticism through the 2000s, eventually spearheading *La era de la discrepancia*.

Debroise, another key Curare member, modeled ways to imagine art history and criticism as a "para-site" to art practice (Marcus 2000). The aspirations of a rising art class in Mexico City extended the project of Mexico's open market to the making and marking of "post-Mexican" culture. The relay here, per Cuevas's *Drunker*, involved the work of mourning the loss of a supposedly waning mexicanidad on the way to its contemporary global. Neither the modern nor the postmodern were at the center of this project, but they were already coded as anterior formations, annexed to a new "México profundo."

Debroise's ambitious reenactment of the Soviet avant-garde filmmaker Sergio Eisenstein's phantasmagorical masterpiece *¡Que viva México!* (*Long live Mexico!*, 1931–1932; 1979; 90 min.) represents one of the consummate performances of this epistemological negation of imaginary geography. For *Un banquete en Tetlapayac* (*A Banquet in Tetlapayac*, 2000, 100 min.), which first premiered at inSITE2000–2001, Debroise staged another intellectual dinner, inviting several artists and scholars to reflect on Eisenstein's unfinished treatment of the interlaced aesthetics and politics of the unfinished Mexican Revolution. The guest roster included Medina, Fraser, the art historian Serge Guibault, the conceptual artist Silvia Gruner, and the "cabaretera" (cabaret artist) Astrid Hadad, who all play historical figures featured in Eisenstein's "grito." As dependent on montage-as-method as Eisenstein's fragments, *Un banquete* includes a sequence that situates the film's participants in transit to the hacienda where Eisenstein shot segments of *¡Que viva México!* Medina, who later assumes the persona of Diego Rivera in the production, in the film explains Debroise's project as "the swan song of Mexicanism because *¡Que viva México!* is the myth of origin of the Mexican aesthetic, particularly in movies and photography."[42]

He continues, as if rehearsing for his later appearances in Alÿs's work, "So the fact that Olivier, who himself was a critic who had lots to do with the revivalism of the Mexican aesthetic, needed to do something that was not simply the understanding of history made me think that in a way . . . what he was doing was the mourning process of this whole possibility and the aesthetic of Mexico." Medina's insights foreshadow what I too facetiously term "The Age of Cuauhtémoc"—the critic's growing importance as a re/mediator of Mexican art. His observations also encapsulate a

generation's vested interests in the simple negation of a Mexican allegorical impulse. Into the 2000s, curators, critics, and historians strove to process the rapidly shifting terms of Mexico as non/site, vacillating between so-called post- and neo-articulations of the latter. The movement, at root performative, was most suggestive of a reMex. The "No" of the era formed the first letters of nostalgia, a complicated reconciliation with "the idea of Mexico" after the melancholic internalization of the object (as commodity).

Mexico's opening generated the historical conditions necessary for the globalization of a singularized 1990s Mexican neo/conceptualism and for the latter to shake any trace of the PIAS "folkloric" (the organic intellect of Razo's practice). For this moment of symbolic restructuring, Alberto López Cuenca claims Gabriel Orozco as "the metaphor that illustrates the implantation of neoconceptual strategies in Mexico" (quoted in Montero 2013, 237). But Medina secures Alÿs as the allegory of the implantation of a DF contemporary in an international imaginary. In this fairy tale, if the global South (standing in for Latin America, standing in for Mexico, standing in for Mexico City) fails, it succeeds by way of its Conceptual defeat -isms: One place. After. An Other.

Santiago Sierra's Remuneration

For every failure, there's an obstruction. Of airways. Of airwaves. Of traffic. In Mexico City's scenic 1990s, exchanging one allegory for another, many viewed the surest antidote to Alÿs's resigned romanticism to be a metered dose of the agent provocateur Santiago Sierra's "infra-realism." In the late 1990s, Medina tempered his enthusiasm for Alÿs's work with a counterinvestment in Sierra's efforts. More than any other critic in Mexico, Medina ensured that the signature of Sierra, like that of Alÿs, would emerge as a global free radical, dis/associated from Mexican particularisms. Although few in the second decade of the third millennium explicitly register the effects of Sierra's status as a foreign national (and a Spaniard no less) producing art in Mexico, in the 1990s, biography, once again bordering on hagiography, structured Medina's engagement with Sierra's chilangx interventions.

In 1996, Sierra moved from Madrid to Mexico City to escape "Spanish conservatism and gentrification" after completing his BA at Madrid's Universidad Complutense in 1989 and living for a short time in Hamburg, Germany. While living in Madrid, he had produced postminimalist sculptural forms, including "soft primary structures consisting of empty

containers" and "temporary installations made with heavy construction devices" (Medina 2000b). While these pieces implicitly dealt with the nature of work and the subject-object position of the art worker in particular, Sierra's attentions to the tropes of disposability and surplus labor found their fullest articulation in NAFTA-era Mexico.

Arriving in the DF a decade after Alÿs, Sierra witnessed the harsh specificities of the Federal District's widening rift between haves and have-nots in the aftermath of a disaster to rival the 1985 earthquake: Mexico's 1995 peso devaluation. Record unemployment left lower- and middle-class individuals and families destitute when, after "el error de diciembre," their already meager savings evaporated. Real wages remained well below pre-crisis levels through 1998 in Mexico. Violent crime in the capital escalated proportionately.

In 2001 and again in 2008, the economy was hit, and thus the nation was dealt additional body blows. The informal sector—from jobs to housing to medical care—ballooned, creating some monstrous new parastate to eclipse whatever had been or could be. The asymmetrical doubling of the sanctioned and unsanctioned, the documented and undocumented, the legal and illegal, the informal and formal sectors, in turn, masked and mirrored the contradictions of the Aztec Tiger's rising GDP. The times did not engender in Sierra a whimsical poetics, but they propelled formidable shifts in the artist's articulation of his aesthetic nonetheless.

Sierra's work expanded to include live actions. While Cuevas lamented the inefficacy of street protest because it generated traffic jams in the city versus sociopolitical change, Sierra intentionally staged street blockages and stoppages. The artist sealed off the entrances of a pedestrian bridge crossing two DF main viaducts with masking tape: *Puente peatonal obstruido con cinta de embalaje* (*Pedestrian Bridge Obstructed with Masking Tape*), Calzada de Tlalpan and Churubusco, México, DF, May 1996. Later, he covered a pedestrian street with cardboard boxes that both altered everyday traffic patterns and became instant homeless shelters: *15 hexaedros de 250 cm por lado cada uno* (*15 Hexaedra of 250 cm Each Side*), Calle de Gante, México, DF, November 1996. He obstructed traffic on Mexico City's main freeway, the Periférico, with a trailer truck, reproducing blockage as an art event: *Obstrucción de una vía con un trailer* (*The Obstruction of a Highway with a Trailer*), Anillo Periférico, México, DF, November 1998.

Proceeding by way of dissociation, Sierra's configurations of the darker side of development at first glance contrast sharply with Alÿs's performances of "unbearable lightness." Under closer scrutiny, the artists' efforts

prove complementary. From the outset, Sierra's work generated disquietude, distress, anger. Sierra's remuneration series of the late 1990s, for which he is best known, especially depends on the German Marxist playwright Bertolt Brecht's concept of an "alienation effect," the construction of scenes or situations that render the familiar uncanny. Doubling down on his formalization of obstruction, Sierra pressed human beings into the service of his artwork. Configuring day laborers as readymades in galleries and museums, the artist no longer simply inconvenienced or disempowered walkers and drivers.

The recipients of Sierra's attentions, broadly defined to include art publics, became front and center in these actions. Stage-blocking the bodies of the unemployed, the homeless, sex workers, drug users, the urban lumpen proletariat, Sierra explored the category of "meaningless work" and the terms of difficult, non/productive labor, first in Mexico, then elsewhere. Prototypes for Sierra's remuneration series include: (1) *Traslación de un automóvil* (*Transplantation of a Car*, July 1998), an action in which the artist paid ten men to dismantle an abandoned car, transport it to the Monterrey art gallery BF.15, and reassemble it there; (2) *Desmontaje y montaje de un lavamanos* (*Dismantling and Reinstalling a Sink*, November 1998), in which the artist filmed himself both dismantling his DF studio's sink and then calling a plumber to reinstall it. Sierra refined his method, describing these pieces as "economic metaphors." In August 1999, for *8 personas remuneradas para permanecer en el interior de cajas de cartón* (*8 People Paid to Remain inside Cardboard Boxes*), Sierra followed his title's directive, paying eight people to sit quietly inside huge cardboard boxes in a Guatemala City gallery. In October 1999, he "outsourced" his performance *465 Remunerated Persons* at the Museo Rufino Tamayo (Bishop 2009). Through a casting agency, Sierra hired 465 thirty- to forty-year-old "working-class type" mestizo males. Their temporary employment? To mingle in the museum's Sala 7 with the opening's patrons. Sierra's formulaic transactions proliferated, each piece's title precise in its detail of the work's minimalist execution.

One line, an aesthetic horizon———————————————

Economic metaphors, extended, became a singular allegory of growing later capitalism. Sierra, like Alÿs, practices allegorical distanciation, artworking the latter like a performative. Testing the ethical squeamishness of his publics, Sierra executed tattoo-based actions as the supposed endpoint of his quest "for an extreme labor situation where the lack of values

reveals work as a simple sale of time."⁴³ In *Línea de 30 cm tatuada en una persona remunerada* (*30 cm Line Tattooed on a Remunerated Person*, May 1998), Sierra paid an unemployed DF Mexican man the equivalent of a day's wages. In exchange, Sierra's "employee" permitted the artist to tattoo a 30-centimeter vertical line on the right side of his back. In *Línea de 250 cm tatuada sobre 6 personas remuneradas* (*250 cm Line Tattooed on 6 Remunerated People*, January 1999), Sierra paid thirty dollars apiece to six unemployed male adolescents in Havana, Cuba. The artist stipulated that each youth could have no previous tattoos, markings, or scars visible from the neck down. Lined up, he presented the group as his tabula rasa. Stock still, they faced the wall of a gallery as a continuous blue line was drawn across their backs. The aftereffects of the artist's job calls, like the "dirty business" to which those effects are attached, multiply ad infinitum.

Formally, *Línea de 30 cm tatuada en una persona remunerada* and *Línea de 250 cm tatuada sobre 6 personas remuneradas* treat the line as one of the elements of drawing, indispensable to the draftsman and artist. These two works generically reference the 1980–1990s art world and academia's obsession with tattoo and body art. Sierra's lines literalize the conceit of the "organic line and after" with which the art historian Ricardo Basbaum acknowledges the Brazilian artist Lygia Clark's contributions to developments in post–World War II art making. Basbaum imagines Clark's line as "intent on finding an escape from the linearity of dialectics" (Basbaum, in Alberro and Buchmann 2006, 87), as transcending the painting's two-dimensionality. Sierra asks the logical question: Where, if we escape the painting, are we going?

As Alÿs's work reminds viewers, lines compose territories as well as politicians' and corporations' promises. Lines demarcate, but also draw together, aesthetic, economic, and political imperatives and horizons. The "banality of evil" in Sierra's lines extends to their muted presentations. Gone is the lyricism of Alÿs's or even Herrera's *dérives*, the ironic humor of Okón's or Razo's hybrid forms. What remains ricochets as a baroque literalization of bureaucracy and institutionalization, which eclipses Cuevas's. Sierra's performances map the narrative tropes of free-market fundamentalism inherent in the New World Order's remuneration. They also disproportionately affect the working poor, the brown, and the economically grayscaled. An attention to "the art of economic government" informs all of Sierra's actions, recoded as transactions. The violence of this project is palpable. Despite its precision, it is also unchanneled. The artist reproduces what he reacts against. The actions' linearity and literalism—the logic of

FIGURE 1.17. Santiago Sierra, *Línea de 250 cm tatuada sobre 6 personas remuneradas*, 1999. © 2015 Artists Rights Society (ARS), New York/VEGAP, Madrid.

the empirical taken to its most extreme articulation of "bare life"—make Sierra's corpus, like Alÿs's, so drearily predictable. The reduxed logic is also what enables the work to effect blockages, impasses, and obstructions in the traffic of critical conversations.

Quite simply, Sierra's performances depend on negation, the "no-" of the era's atmospherics. They prod us to reperform classical moral conundrums regarding the responsibilities of the witness: Do spectators become accessories to the "crimes" of the artist's readymades—each piece becoming a social experiment encompassing whole salons, museums, and galleries? In 2000, Medina compared *Línea de 30 cm tatuada en una persona remunerada* and *Línea de 250 cm tatuada sobre 6 personas remuneradas* to public executions. He asked why these works' observers did not step in to stop the actions (Medina 2000b, 147). By the 2000s, after Sierra had represented Spain—not Mexico—in the Venice Biennale with a piece that barred all non-Spanish citizens from entering the pavilion, such questions resurfaced in a series of exchanges between Kester and Bishop in *Artforum International* and *October*, often heralded as defining the tenor of all discussions about art's "turn to the social" (Bishop 2004, 2006; Kester 2006).

Bishop's and Kester's treatments of the specificities of Sierra's work are as evacuated as the Spanish Pavilion that the artist created. (Yes, the Spaniards, who were allowed to enter the building, found that Sierra had put nothing in it. The nation, Sierra maintains, is as meaningless as its representations.) In *The One and the Many: Contemporary Collaborative Art in a Global Context* (2011), Kester claims that the stakes of his and Bishop's differences have everything to do with historical configurations of the autonomous art object and a broader set of assumptions about reception in art history that cast the viewer as a figure in need of enlightenment. Sierra's name circulates like a refrain, or worse, like an "autonomous object," becoming the "One" of *The One and the Many*. Kester returns not once, but several times, to Sierra's actions to enumerate their limitations. Strikingly, however, Kester's repetition compulsion disregards a series of best practices that he lays out for the art historian.

Kester (2011, 37) recommends that we base our engagements and evaluations of artwork on immersive interaction and a referential orientation to the location of a given work's production. Yet he effectively decontextualizes Sierra's gestures, reading them as he did Alÿs's as the product of a global-artist function. What would it mean to insist on siting NAFTA-era Mexico as the instigating force behind Sierra's practice? To do such an exercise justice, we would have to recall the political economy of the city and state, but also expand Kester's and Bishop's circumscribed definitions of the aesthetic per the terms of the post-1960s artwork that they discuss and that Sierra parodies. In Mexico, such an art history would necessitate that we, like the artists in question, return our gaze to Los Grupos. Bustamante impiously patterns just such a gesture when she banners the conclusion of her essay "Conditions, Roads, and Genealogies of Mexican Conceptualisms, 1921–1993" with three images of Sierra's *465 personas remuneradas*. Alÿs's *Turista* also visually annotates Bustamante's chronology, although Bustamante does not reference either artist in her text. The result—intentional or not—is an insinuation of the pair's actions into the PIAS Forms.

If Ex Teresa serves as the explicit final entry of Bustamante's chronology, the critic-artist's inclusion of Alÿs's and Sierra's images initiates an argument regarding the reconfigurations of various alternatives into a generic contemporary, serving as a preemptive rejoinder to chrysalis (art) histories of the NAFTA era. Sierra's work vaguely, albeit more fully than Alÿs's, encourages this process per his unease with art's professionalization and moneymaking schemes. Sierra dictates, "The money that serves to pay

for art is minted in the real world" (Sierra, quoted in *Santiago Sierra* 2006, 78). His target here is the art world, but also Mexico City's in particular.

A witness to DF and continental reconfigurations of racialized and sexualized capitalism and to the articulation of the city as a non/site for art, Sierra used not only DF pedestrian bridges and freeways but also the city's museums and galleries for his earliest sites of interruption. It is this "total speech situation" (Austin 1962) that we must defragment when reviewing the repetitive labor, blockage, and intrusion performances that Sierra oversees. Sierra's work aggressively, predatorily parodies the neo/conceptual gestures and negative dialectics—gendered—of his DF contemporaries. It also refuses to separate those neo/post/conceptual practices from site-specific and time-sensitive Conceptual -isms.

In *Modernity at Large* (1996), the anthropologist Arjun Appadurai addresses the proto-accelerationist logic of numbers in a British colonial imaginary. The exchangeability the Italian philosopher Giorgio Agamben (1998) details, per the Cameroonian philosopher Achille Mbembe's elaboration of "necropolitics," preceded his "bare life" limit case of the concentration camp (2005). New Worldly, it follows the German political theorist Carl Schmitt's elaboration. Agamben writes:

> Schmitt shows how the link between localization and ordering constitutive of the *nomos* of the earth always implies a zone that is excluded from law and that takes the shape of a "free and juridically empty space" in which the sovereign power no longer knows the limits fixed by the *nomos* as the territorial order. In the classical epoch of the *ius publicum Europaeum*, this zone corresponded to the New World... Schmitt himself assimilates this zone "beyond the line" to the state of exception... (1998, 36)

I'd note per Sierra's remunerative pedantry that in the NAFTA era, the avant-garde of the global import-processing zone, originating in the Mexican-US borderlands and spreading south like a stain, becomes the latest "free and juridically empty space," constitutionally mandated as the primal scene of the New World Border's "state of exception." Sierra literalizes the figures at hand.

Los penetrados (*The Penetrated*, 45 min.), a black-and-white silent film divided into eight sections, documents an action organized by Sierra in Terrassa, Spain, on October 12, 2008. Decades after the 1968 Olympics' torch relay re-created Columbus's "discovery" of the New World; years after the Spanish government bankrolled 1992 celebrations of that same

discovery script, protesters took to Mexico City streets chanting "500 years of what?," and artists raised objections to Columbus Day celebrations that coincided with Día de la Raza (Day of the Race) festivities in Spain, Sierra weighed in. New York City Team Gallery, Inc.'s press release for a 2010 solo exhibit of the work first summarizes the performance as featuring mirrored sets of blankets and black and white couples, ten imaginable combinations of men and/or women determined by a mathematical formula, having anal sex with one another. Its narrative then reverts to a blended language of literalism and interpretation when it describes *Los penetrados* as such: "Choosing to film on Día de la Raza, Sierra makes an allegorical connection between the conquest of the Americas by the Spanish and the penetration that occurs in the film."[44] If Alÿs and Medina together and apart generate elegies explicitly for the "modern" and the "alternative" and implicitly for the "contemporary," if Okón solicits and elicits neoliberal guilt in his viewers, Sierra offers crass historically spread sheets and stark analyses of economic penetration. The tactic, geo*graphically* remastered, continues in the artist's manipulation of text from the mid-2000s onward.

In Ariel typeface, all caps, 5.10 feet high by 13.12 feet wide, "NO" embarked on a voyage across the continents in July 2009. Documentation of *No, Global Tour* includes "NO" whizzing by Times Square on a tracker-trailer bed, becoming the defining line in an instant poem, cropped by its photographer. "Bank of/NO" is framed on the left by "Irving Berlin's WHITE/ CHRISTMAS" and on the right by "ONE WAY." And, peeking out from NO's gaping "O"—nothing more or less than the "sea" of New York (The Marriott in situ, neatly edited down to "Mar/New York"). Like some monumental reMex of No-Grupo's prefix, "NO" is propped against an indeterminate skyline. "NO" poses for glam shots with well-wishers whose faces have been pixelated. ("NO" receives no such courtesy.) The documentation of the word's free passage proliferates, is distilled into an armband. As if embracing both the charges of a vulgar Marxism and accusations of his complicity in and with the art market, Sierra blanketly but indiscriminately says "No" to totalizing narratives of globalization with another totalizing account.

The general turn to languaging that Owens identified in 1970s international (conceptual) art determines the form of this action and others by Sierra involving text. The impulse to consolidate an art history of the period also overdetermines the piece's reactive politics. Writing of Smithson's frequent recourse to language, Owens (1992, 43) claims that the artist views poetry as expressing "the desire for totalization." In contrast, Smithson seeks to fragment language, following Benjamin's reflections on

FIGURE 1.18 HERE. Santiago Sierra, *No, Global Tour*, 2009. © 2015 Artists Rights Society (ARS), New York/VEGAP, Madrid.

allegory. Owens (ibid.) elaborates, "For Smithson the appeal of the allegorical lay not only in this reciprocity of verbal and visual, but also in the fact that it offers an antidote to the totalizing impulses of art." In the wake of advertising's appropriation of the conceptual gesture per Cuevas's *logo*centrism and per Sierra's own previous didacticisms, the Spanish artist closes the circle that Smithson opens for us to stage block periodizations and interpretations imposed like tariffs on artistic conceptualisms in the so-called periphery.

First Owens renames Smithson's interventions "earthwords," then Sierra literalizes the critic's wordplay. Additionally, Sierra concretizes his debt to greater Mexico. *Sumisión (antes Palabra de Fuego)* (*Submission [formerly Word of Fire]*, October 2006–March 2007)—part of *Proyecto Juárez*, which included Okón's *Risas enlatadas* —is located in Anapra, an informal colonia at the foot of Cristo Negro Hill, a few meters from the US-Mexico border, on the west side of Ciudad Juárez. Anapra is an unsanctioned crossing point into the United States. For those who stay behind, Anapra's amenities include toxic lead levels, courtesy of ASARCO Foundry, or American Smelting and Refining Company, founded by Meyer Guggenheim. Anapra's population suffers a disproportionally higher number of cases of blood poisoning, anencephaly, and breathing disorders than other communities of greater Mexico. Residents also routinely wake up to find the bodies of Ciudad Juárez's murdered women in their backyards.

In response to these unnatural disasters, Sierra carved a single performative utterance into the heartland of the NAFTA corridor. Literally, the artist oversaw the chiseling of "SUMISION" (Helvetica type, all caps, no accent) into the ground in four-and-a-half-meter trenches, which then were lined with concrete. The letters, like incisions—à la Karl Marx's commentary on primitive accumulation in *Capital*, Vol. 1 (1992, 746), "And this history, the history of their expropriation, is written in the annals of mankind in letters of blood and fire"—were slated to be set on fire. The action's projected roster included a small flyover plane, an aerial crane commissioned to facilitate the filming of the event, and live-streaming documentation, but the performance's pyrotechnics were halted twice. First, the action was scheduled to coincide with the inauguration of President Felipe Calderón on December 1, 2006 (Baum 2010, 12), but federal officials intervened. Second, local authorities put a stop to *Sumisión* on the grounds that it would be hazardous to the environment.

In its stead, a concrete poem to rival any produced by Alÿs prevails. Described by the journalist Sergio González Rodríguez (2012, 38) as one of several "ultra-contemporary performances" in the region, *Sumisión* submits to the ironies of a reverse shot: the assembly line stiffening of language in

FIGURE 1.19. Santiago Sierra, *Sumisión (antes Palabra de Fuego)* [*Submission (formerly Word of Fire)*], 2006–2007. © 2015 Artists Rights Society (ARS), New York/VEGAP, Madrid.

a transnational face-off. *Sumisión*, a noun with sadomasochistic overtones, faces south. Like a false cognate, the imposing text becomes nothing more or less than itself—an art, submission.

What goes around comes around: as if to commemorate the close of his term in office, President Calderón produced his own "earthword" for Chihuahua-Texas. In February 2012, on the Mexican side of the Bridge of the Americas, Calderón enlisted Mexican soldiers to crush confiscated firearms with tanks and steamrollers. Then, in a second remarkably abject spectacle, he instructed the soldiers to weld the crushed weapons—at least six thousand assault rifles and pistols—into a massive concrete poem in English, visible from the US side of the border: "NO MORE WEAPONS."[45] "Dear friends of the United States," Calderón continued, again in English, in a public ceremony inaugurating his "artwork" on the Mexican side of the border, "Mexico needs your help in order to stop this terrible violence we are suffering. And the best way to do that is by stopping the flow of assault weapons into Mexico." The circle tightens like a noose: "Mexico," writ large, returns as the "dramaturgy of the real," as the non/site of unabashedly aestheticized governmentality (Foucault 2001, 160).

TERESA MARGOLLES, REMAINDERED

A little ways off from the fray, the solitary figure and corpus of Teresa Margolles redirect the post-1994 prefixation with the "no-" or "non-" into an Other aesthetic that suggests even more forcefully than Sierra's corpus that the neatest equations of allegorical incorporation carry incommensurable remainders. Against closure, my analysis of Margolles's artwork moves toward a larger reckoning with the "muerte sin fin" (endless death) of DF NAFTA-era art. It also torques my subsequent turn to female (performance) artists' contemporaneous transfigurations of Mexico-Woman.

First, a gallery walk-through: traversing P.S. 1 Contemporary Art Center's *Mexico City: An Exhibition about the Exchange Rates of Bodies and Values* (2002) in New York City, viewers encountered a roadblock distinct from Sierra's. To enter one gallery of the show, you had to sign a release form that included the ominous disclaimer, "P.S. 1 renounces all responsibility for any physical, mental, or emotional damages caused to the undersigned once he/she enters the installation." Those brave or curious enough to proceed stepped into a thick fog that converted them into participant-observers—you could not not inhale. True to its title, Margolles's traveling installation, *Vaporización (Vaporization)*, runs disinfected water taken from the washing of

corpses in the Servicio Médico Forense (SEMEFO; Medical Forensic Service), Mexico City's central morgue, through a fog machine. With the installation, Margolles, like Sierra, raises ethical, political, and aesthetic questions that resonate across her oeuvre, including: Does a remembrance and deployment of dead bodies in artwork give anonymous victims voice, or does it exact further violence, this time epistemic, against them?

Vaporización could easily be misread as the logical conclusion of Margolles's corpus if the work is decontextualized from the larger (art) history of NAFTA-era Mexico. Four years after *Vaporización*, a scant ten days after President Calderón was sworn into office, his administration announced Mexico's War on Drugs. Calderón's action reflected a partnership. His administration sought to dismantle the Mexican drug cartels; the George W.

FIGURE 1.20. Teresa Margolles, *Vaporización/Vaporization*, 2002. © Teresa Margolles. Courtesy of artist and Galerie Peter Kilchmann, Zurich.

Bush and later the Barack Obama administrations sought to interrupt the latter's smuggling routes. The political scientist Peter Andreas documents the US creation of a Mexican-US drug and human smuggling corridor in the late 1980s and the early NAFTA era. Andreas (2000) demonstrates that after President Richard Nixon's 1971 declaration of a "war on drugs" and the United States' paradigmatic shift from a strategy of rehabilitation to incarceration in the 1970s and 1980s, the George H. W. Bush and Clinton administrations in partnership with the Salinas administration (as a kind of trade-off for NAFTA) funneled drug movement into the greater Mexican corridor in an effort to break the Colombian cartels' cocaine routes through the Caribbean and southern Florida. The inadvertent consequence of this war of maneuvers was the fortification and diversification of the Mexican cartels. Since the mid-1990s, Mexico and the United States have repeatedly attempted to disrupt greater Mexico's narco-reterritorialization, but several factors, including northern demand for product and US gun trafficking (as Calderón notes), have rendered the project quixotic.

Born in the city of Culiacán, Sinaloa, often referred to as Mexico's "Narco Capital," Margolles faced these realities before many of her DF contemporaries were aware of this element of Mexico's 1990s transition. In the late 1980s, the artist left Sinaloa to study forensic science and philosophy at the UNAM (Margolles 2000). In 1990, Margolles and several musicians, actors, and artists came together to form an artistic collective. Their work ranged from impromptu heavy metal concerts to performance happenings in buildings still vacant or condemned after the 1985 earthquake. According to the art historian and philosopher José Luis Barrios, La Floresta, formerly a psychiatric hospital, was one of the collective's favorite haunts (Barrios, in David 2011, 74). Often criticized for its "male aesthetic" and infamous for its work with cadavers, SEMEFO considered "the life of the corpse," displaying tattoos cut from the dead and, later, skin-flecked gesso, which its members had pressed against literal unclaimed SEMEFO bodies (Margolles 2000). Although British and US artists like Damien Hirst and Andres Serrano worked with the corpses of animals, from sharks to human beings, roughly during the same time period, critics initially reduced SEMEFO's efforts to a redeployment of a Mexican fascination with the dead, citing the printmaker José Guadalupe Posada's skeletons in often ironically decontextualized and sweeping readings of national culture and postrevolutionary consciousness. Seemingly more sophisticated commentators

proposed connections between SEMEFO's performative memento mori and the Colombian sculptor Doris Salcedo's rememories, between SEMEFO's neobaroque tactics and the Viennese Actionists' sacrificial use of animals (among others, see Galindo 1994, Sánchez 1997, de Diego 1998, Zamudio Taylor 2000).

Reluctant to dismiss any of these interpretations, and years before Mexico City's Jumex Museum cancelled its 2016 retrospective of the Viennese Actionist member Hermann Nitsch's work, Margolles refined a list of alternative influences for her own and SEMEFO's efforts: Aristotle's cathartic shudder, Bataille's visions of excess, Beuys's scripts of post-traumatic stress disorder, the French dramatist Antonin Artaud's "theatre of cruelty," and, most importantly, the Mexican sociopolitical and economic milieu since the 1980s (2000).[46] Margolles's roster, coupled with her reflexive narrative of intentionality—"Mi ética es mi estética" (My ethics are my aesthetics; ibid.)—went a long way at the turn of the millennium to complicate readings of SEMEFO's output in the vein of the Cuban American artist-critic Coco Fusco's interpretations of the group's confrontational tactics.

Anecdotally presenting her initial exposure to SEMEFO via their first solo show, *Lavatio Corporis* (1994), a carousel of dead horses in Mexico City's Museo de Carrillo Gil, Fusco (2001, 62) argues that the exhibit demands "a reading in relation to Mexican national allegory" insofar as horses function as a "well-known icon of colonialism," an allusion established by SEMEFO's juxtaposition of the carousel and a reproduction of José Clemente Orozco's painting *Los teules* ("the epithet the Aztecs used to denigrate the Spanish conquistadors" [ibid.]). While Fusco defuses the allegorical in her argument to contrast SEMEFO's work with two other artistic responses to NAFTA, the specter of the "Other speaking," which she evokes, appeared in prior work by SEMEFO and ghosts Margolles's subsequent efforts.[47] It reroutes interpretations of SEMEFO's corpus as well as critics' periodizing impulses that would situate Margolles's and the collective's aesthetic as the "essence" of an alternative NAFTA-era Mexican art.

Medina claims that "the three phases through which SEMEFO and Margolles's work moved in the last ten years could be abstracted as a provisory schema for the stages of contemporary art in Mexico during the 1990s" (Medina, quoted in Gallo 2004b, 320). He then produces a timeline that, for all intents and purposes, commences where Bustamante's fades into black. A death without end, Medina's chronology does not lead to Gabriel Orozco's or Alÿs's whimsical Mexicanisms, but carefully embalms SEMEFO's

"swerve into conceptual art" (ibid.). Over a decade later, I'd wager that the ascendancy of Margolles's solo work, divested from SEMEFO's collective practice, most accurately schematizes the stages of Mexican "contemp(t)ory art," running parallel to larger social dramas.

Renewed interest in SEMEFO's gestures has followed in the wake of the circulation of Margolles's actions internationally in part because the artist's practice sharpens SEMEFO's death metal nihilism into a scathing critique of Mexico's savage democratic transition. To be sure, SEMEFO's work set the tone of Margolles's critique, but true to its commitment to formlessness, it consistently resisted a through line of argumentation.[48] In contrast, circa 2000, Margolles, moving away from SEMEFO's ethos of anarchy, began to experiment with solo production and to articulate a hyphenated aesthetics-ethics, complementary to but distinct from the collective's. *Autorretratos en la morgue* (*Self-Portraits in the Morgue*, 1998), one of the artist's first solo pieces, illustrates well Margolles's conversion of SEMEFO's totalizing negation (more diffuse than Sierra's) into a negative dialectics.

With this series of photographs, Margolles aggressively "en*genders*" her publics, offering an unsettling and prescient forensics of North American necropolitics. To be clear, engendering in these images does not appear as an explicit project or projection, but rather as the buried allegorical impulse of an increasingly more ubiquitous condition whose zones of enunciation included the streets, public forums, and the continental corridor of unsafe passage between Mexico and the United States. Margolles's work acquires meaning in all of these locations, remapping them as "states of exception." Keeping this in mind, in what follows, I examine select pieces by the artist to craft an amplified schema that registers Medina's stages of the Mexican contemporary as the stratification of a genre increasingly in possession of its own gendered dimensions.

Self-Other Portraiture, or, When Margolles ≠ SEMEFO

In the unreleased video of the private performance *Bañando al bebé* (*Bathing the Baby*, 1999, 7 min.), true to its title, Margolles bathes a dead infant. *Bañando al bebé* opens with a short shot, the camera's panning in on Margolles placing latex gloves on her hands to frame the ritual of the bath in terms of religious and medico-juridical imagery. Referencing the Madonna-and-child and Mary Magdalene bathing Christ's feet (reinforced by the presence of Margolles's hair in the video), the camera situates the artist as a middle-woman, concentrating on her torso in lieu of her face. The camera follows Margolles's presentation of a tin basin filled with water, the stark

tiles of the bathroom's claustrophobic echo (the doubling sounds of Margolles's gestures in contrast to the artist's speechlessness), and, then, the body of the child—already decomposing, a vision of rigor mortis.

Margolles bathes this corpse with a vengeance, scrubbing it with a brush one might use to clean a bathtub; she works to remove mold, to cut hair, and to grapple with pliers and a hammer to extract nails from the infant's hands. Lastly, she sets the basin aside and swaddles the cadaver in plastic wrap—a conclusion suggestive of clinical preservation and ritualized mummification. *Bañando al bebé* stands in sharp relief to, yet complements, Margolles's well-known installation *Entierro* (*Burial*, 1999), as if the latter had been interred within the former. In *Entierro*, Margolles took the infant of *Bañando al bebé* and, in a second private performance, buried him in a block of concrete. Margolles (2000) explained that because the biological mother could not afford to give the child a proper burial, and because both the mother and Margolles wished for the baby to be remembered, she sought to honor the infant by creating a memorial to him that held his corpse at its center.

While it doesn't take a leap of faith to recognize *Bañando al bebé* and *Entierro*'s connection, it initially might seem counterintuitive to juxtapose that connection with another; to approach *Bañando al bebé* as an expanding self-portrait vis-à-vis a comparison of it with a nearly contemporaneous independent project by Margolles, *Autorretratos en la morgue* (*Self-Portraits in the Morgue*, 2000; hereafter referenced as *Autorretratos*). In *Autorretratos*, Margolles revisits self-portraiture, authoring a series of images of herself with corpses from Mexico City's central morgue. The photos, vaguely reminiscent of portraits of families with their dead loved ones from Mexico's late nineteenth and early twentieth centuries, but also indebted to a host of post-1960s challenges to documentary realism, arrange the artist and her "sitters" in various stages of literal and metaphoric decomposition. For instance, in one, Margolles cradles/displays in her arms a badly beaten-to-death twelve-year-old girl (see plate 5). The artist as figure and a figuration here and throughout *Autorretratos* walks a tightrope—once again evoking the "sacred" Mother-Child dyad but also cross-referencing the clinical precision of the scientific via her white lab coat.

Autorretratos presents the body/self with disinterested interest. Yet, the push and pull of a relationship between Margolles's person as woman, symbolic Woman's currency, and the anonymous dead positions the feminine as that which locates these images as something closer to *self-other portraits*. Ironic literalizations of Agamben's "bare life" that further Mbembe's

(2003) formulation of "necropolitics," *Autorretratos* goads us to apprehend *Bañando al bebé* as also confronting and adding a temporal or periodizing dimension to a representational tradition, often regarded as universal, that posits femininity, narcissism, and death as equivalents (Bronfen 1992).

With an author function closer to that of the character of Antigone in a resistant strain of criticism and theory beholden to the shifting categorical imperatives of gender, Margolles in *Autorretratos* and *Bañando al bebé* relies on the gendered shock value of contrasting the quick and the dead. Placing herself as the female figure remediating rather than replacing "death," she stages "portraits of the artist as Woman" to suggest the kinships of life and death, of bio- and necropolitics, years before the Tamaulipas-based poet Sara Uribe (2012) reMexed the figure of Antigone to demand retribution for Mexico's dead and disappeared. By way of the contradiction inherent in the social contract, and contrast of, her body and those of the corpses with which she poses, the artist performs a double "surrogation" (Roach 1996, 36). Margolles as inter-subject expands and capitalizes upon Antigone's "limit zone" (*até*), reminding us simultaneously of Judith Butler's (2000, 82) pronouncement that "Antigone is the occasion for a new field of the human, achieved through political catachresis," and Jean Franco's (1989) and Diana Taylor's (1997) ruminations regarding the categorical impossibility of inhabiting Antigone's subject position as a Latin American woman.

Specifically, Butler (2000, 81) suggests that Antigone utilizes the contradictions that constitute "the melancholy of the public sphere" to throw that sphere into crisis. In *Antigone's Claim*, she interprets Antigone's location as "outside the symbolic or, indeed, outside the public sphere, but within its terms and as an unanticipated appropriation and perversion of its mandate" (ibid.). She goes on to insist that Antigone must be reappropriated from prior philosophical and theoretical appropriations of her figure (from Georg Hegel's to Martin Heidegger's, from Paul de Man's to Jacques Lacan's), even as she returns to Sophocles's drama to reproduce its heroine as a middling biopolitical agent, evoking gender as an allegorical operation with material and ethical consequences. Contrapuntally, catachresis here involves reclaiming the abject or debilitating, including the allegorical, that relegates Woman to the field of the symbolic as if she were interred in cement like the baby of *Entierro*.

Taylor, in *Disappearing Acts: Spectacles of Gender and Nationalism in Argentina's "Dirty War"* (1997), champions another point. Pondering the

limitations of a too-celebratory reading of Antigone's and the allegorical's mobility, Taylor offers an on-the-ground account of the effects of prescripted gender roles in Argentina's dictatorship years. Margolles's self-other portraiture brushes the circularity of both of these authors' arguments and, by extension, Antigone's inter- and extra-American legacies. Allegorizing the symbiotic relationship of sovereign power and bare life in an international circuit of the monetary, *Autorretratos* especially invites a reading that situates the photos as responses to local and global asymmetries. Margolles's presence in these de/compositions performs another kind of labor, clarifying the gendered agenda of the market-state and the artist's increasingly "bare life" minimalism. Arriving at structural inequalities via an amplification of the performatively allegorical effects of gendering as an operation, Margolles's growing corpus, read against this initial solo production, casts femininity like a shroud or shadow, greater than a male-female opposition. Here "gender," as Jasbir Puar (2007, 100) insists, cannot be understood as the "petrified sites of masculine and feminine," but as "the interplay of it all within and through racial, imperial, and economic matrices of power." With *Autorretratos*, Margolles enjoins us to intuit that the undead, often so disfigured that their features and their "color" are illegible, in their very status as the unclaimed occupy the lowest socioeconomic rungs (where the cross-pollination of racial and class typecasting in Mexico suffers a long history distinct from that of the United States). The artist displays these remains contrasted with her own gendered body; the resulting effect is that viewers perceive structural violence as hardwired into their own frames of reference.

Standing in as half of a Barthesian punctum, as the new narrative surrogate or middle-Woman, Margolles bears and lays bare witness, marking where the conceptual impossibility of Antigone—understood as the impossibility of agency in the face of world systems—becomes the allegorical hot-spot through and at which the viewer is dealt "acts of transfer" and transference. The Antigone effect in Margolles's self-other portraits follows Taylor's pessimistic reading of Antigone's nowhere-ness, even as it becomes the series' medium for hailing its publics as the raw materials of the larger social body. Gendering, understood as a particle in perpetual motion, reactivates the viewer as a participant-observer. Not solely about the female or feminine but more about familiarizing audiences with a practice-based theory of the intersubjective, gendering becoming engendering in *Autorretratos* outs Conceptual -isms, particulate matters of identity and

difference, that after 1994 increasingly appeared to be free-floating in Mexico as a built environment.

Vaporización's Release (of) Form
A recalibration of the feedback loop of politics and aesthetics after 2001 clarified the bleed—a hemorrhaging—of Margolles's corpus into the hemispheric War on Drugs and the charged ambiences of US Homeland Security. SEMEFO's absolute degree zero was ionized into critical intelligibility through *Vaporización* and subsequent actions by Margolles. Cannibalistic and cabalistic, *Vaporización*, for many, recalls respiration in New York City after September 11, 2001. Also likened to the realization of a Brazilian *Manifesto antropófago*, the installation forces its interlocutors to acknowledge that while all that is solid may melt into air, it does not disappear. As if taking up where Alÿs's *Paradox of Praxis 1 (Sometimes Doing Something Leads to Nothing)* leaves off, *Vaporización*'s "ether is bound up with particularization; it epitomizes the unsubsumable and as such challenges the prevailing principle of reality: that of exchangeability" (Adorno 1997 [1970], 83). *Vaporización*, all pervasive, forces its viewers to acknowledge that the aestheticization of globalization does not diminish social hierarchies that produce inexchangeability, but only socially redistributes "states of exception."

Just as Agamben refines his portrayal of the latter by revisiting Benjamin's *Origins of German Tragic Drama* (1998 [1928]) to suggest that Benjamin presents the allegorical as a kind of mist versus mystification, with *Vaporización* and subsequent works like *En el aire* (2003), which blew bubbles produced with morgue water into the air of museums and galleries, Margolles reorients the "particularization of the unsubsumable," presenting the materiality of immaterial labor as the corpse's dispersal, as the allegorical figuration of socioeconomic inequalities that choke the globe like smog or the dust following a skyscraper's demolition.[49] Margolles literalizes an ontological transformation in national allegory as form. She demonstrates the paraliterary dimensions of a performative that synthesizes to hyphenate the allegorical impulses of the market-state. Like the body, which is transubstantiated but does not vanish, allegory evaporates to smother us, conceptually supersaturating the gallery to transform it into the installation proper. In a state of water beyond Alÿs's formalist fallback on "the idea of Mexico," *Vaporización* and *En el aire* produce a literal scattering of humanity that eviscerates representation. As "PIAS Forms" that matter-of-factly enact de- and rematerialization, their analytical proposition is full-on audience interpellation.

Contrary to the whimsicality of Alÿs's walking cures, contrary to the barbarism of Sierra's top-bottom-dollar dogmatism, Margolles obliterates flesh in favor of distilled essence, a thick fog machine, performing the undocumentation of the undocumented. If the figure of Margolles proper functioned as a kind of osmotic membrane in *Autorretratos en la morgue* and *Bañando al bebé*, by the time we arrive at *Vaporización*, Margolles as mediator has vanished, to be replaced by her work's publics. Akin to Margolles's self-other portraits, *Vaporización* recasts its publics in the abject role of symbolic Woman. It deactivates boundaries between public and private, creating an alternate "state of exception," which postscripts engendering as allegorically algorithmic of inequality.

In an artist's talk associated with the Brooklyn Museum's show *Global Feminisms* (2007), Margolles devoted the lion's share of her presentation to a detailed and radical recontextualization of scientific descriptions of the water cycle. She observed that morgue water already enters the "great river of Mexico City," evaporates, and rains down on its inhabitants; that the world's citizens daily imbibe, inhale, ingest, exhale, and excrete one another. Nearly contemporaneous with her reflections, the Mexican government blasted its own lyric platitudes regarding ambience. In 2006, in cooperation with the Bush II administration, the Calderón administration fired its first shots in the continental Drug War. By 2008, the numbers of dead—collateral damage—across Mexico skyrocketed. In response to public outcry, Mexican officials offered a damning domestic narrative that re-gendered the hypermasculinities of the narco-aesthetic: "If you see dust *in the air*, it's because we're cleaning house" (quoted in González Rodríguez 2012, 51; my emphasis). Against this backdrop, the symbolic value of Margolles's work skyrocketed.

Actions like *Vaporización* that had been deemed distasteful or belabored assumed monumentally allegorical significance, retroactively reevaluated as prescient of the most pervasive and extreme labor situation. P.S. 1's supplementation of *Vaporización* in this atmosphere jacked up the work's meaning. In conjunction and in contrast, the museum's legally pragmatic addendum to the gesture—its requirement that spectators sign release forms—casually and causally reinscribed a critique of free-market maxims of choice that perpetuate hierarchy or insert "distinction" into Margolles's and Mexican art's very market value. Obliquely citing gendered imaginary geographies that *a priori*tize the very asymmetries that the artist seeks to demolish with the installation, P.S. 1's release form codifies a North/South divide in *Vaporización*'s production and reception, even as its repudiation of

form ironically presaged the expansion and contraction of Margolles's—like Sierra's or other 1990s DF art workers'—practice into language. The "No" or negativity here takes the shape of the body of Douloti at the close of Gayatri Chakravorty Spivak's essay "Woman in Difference"; it is splayed all over Mexico, the continent, and the globe (Spivak, in Parker et al. 1992, 113). Not only is the spectator all Woman, but "She" becomes both the "hijo" and the "puta" of an elided neoliberalism and neocoloniality.

Abstract as Expression: Conceptual –isms in Margolles's **Muerte sin fin**[50]
Operativo I (*Operative I*)'s "contextura" heightens perceptibility, "touching feeling." In June 2008, in the small but large-minded "Y Gallery," formerly of Jackson Heights (Queens, New York), Margolles, with the assistance of the gallery's director (Cecilia Jurado), spent four days carving into the gallery's wall, facing the street, a single phrase, "para quienes no la creen/hijos de puta" (for those who don't believe it/sons of bitches; gallery translation; see figure 0.1). On the storefront glass window, which buffered pedestrians and traffic from the impact of this epithet, Margolles transcribed Mexican and US journalists' accounts of the exponential spike in violent crime in Mexico since 2007 (see plate 6). Her use of con/text/ure resembles less the work of her DF peers, more the campaign of her contemporaries located in the Mexican-US borderlands. The unvarnished statistics translate from Spanish or English into damning evidence:

> Todavía faltan cuatro días para que concluya el mes de mayo y la cifra de homicidios dolosos es la más alta en décadas. Van 106 asesinatos en Sinaloa. [...] La mayoría de los casos han ocurrido en la capital del estado y a balazos.
> PERIÓDICO EL DEBATE (CULIACÁN, SINALOA—MÉXICO).
> 28 DE MAYO DEL 2008

> En 18 meses de gestión de Felipe Calderón Hinojosa se han cometido 4 mil 400 ejecuciones: 2 mil 794 de enero a diciembre de 2007 y mil 250 del primero de enero al 20 de mayo de este año.
> PERIÓDICO LA JORNADA (MÉXICO D.F.). 22 DE MAYO DEL 2008

> Drug traffickers have killed at least 170 local police officers as well, among them at least a score of municipal police commanders, since Mr. Calderón took office. Some were believed to have been corrupt officers who had

sold out to drug gangs and were killed by rival gangsters, investigators say. Others were killed for doing their jobs.
NEW YORK TIMES (NEW YORK, U.S.). MAY 26, 2008

Cada minuto entra a México un arma de manera ilegal. Son por lo menos, dos mil armas al día. 60% de las armas ilegales que circulan en territorio nacional provienen de Estados Unidos. en 12 mil puntos a lo largo de la frontera se compran y venden armas sin restricciones.
ONCE NOTICIAS, CANAL DE TELEVISION 11 TV (MÉXICO D.F.). 19 DE JULIO DEL 2007[51]

Both noun and adjective, an "operative," linguistically speaking, exerts power or force. It "does things" with words.[52] If an operative in popular parlance acts as an agent or (social) detective, in *Operativo I*, the operative commands or empowers us to act in the covert capacity of the rhetorician to maintain the momentum of the citational machine that Margolles "disappropriates" via found text.

The Mexican novelist-critic-poet Cristina Rivera Garza epigraphs Margolles before she conceptualizes the intimacies of what she terms "necroescrituras" (necrowritings) and "desapropiación" (disappropriation). Rivera Garza (2013, 33) posits necrowritings—always in the plural—as calling into question "the state or order of things and the state of our languages." In Rivera Garza's words, language exceeds the mechanics of writing, becoming not only the material of a conceptual practice but a performative intervention in the feedback loop of aesthetics and politics. In Margolles's languaging, such give and take is costly.

Viewers come up against a wall of narrative impossibility—a veritable obscenity tied to Mexico's expropriative pasts and presents, lurid and lurking beneath news reportage. The direct address of *Operativo I*'s interior challenge, reminiscent of Antigone's insatiable desire for accountability, grates up against the "neutrality" of journalists' documentation on *Operativo I*'s plate-glass window. The result disinters the manufactured divide buried in Jacques Rancière's formulations of the cut of the aesthetic. Closer to the situation articulated by the French philosopher Jean-Luc Nancy (1991, 32) in his formulation of "inoperative community," Margolles's found language hybridizes communication and contagion. A phrase twice removed, a drug gang's message tied to an executed lifeless body's ankle found on the corner of Gran Canal and Aguilas in Mexico City, "para

quienes . . ." was reprinted in the "police section" of the newspaper *Ovaciones* before it was chiseled onto the gallery's wall.

Una nota roja de una nota roja: the quote capitalizes on the genre of the Mexican pulp crime report (Piccato 2008). The two tracks of text (the window's versus the wall's words, facts checked by direct address) complicate, prove complicit with one another, signaling an incommensurability that spectacularizes a very different interstitial activation than that which we might first assume. A double-languaging, *Operativo I* offers us no trigger warnings, courting cognitive dissonance instead. As the second part of this installation, *Operativo II*, makes clear, things are never done with language alone. In *Operativo II*, the medium resurfaces as the message, *la nota roja*'s reconnaissance and reconfiguration, the allegorical's autodistanciation, a performative release of energy after the split of the atom of the already trans/national allegorical fragment.

In July 2008, Margolles covered "para quienes no la creen/hijos de puta" with two canvases, which, to the casual observer, might appear to be unremarkable exercises in abstract expressionism. They demonstrate the artist's debts to the Viennese Actionists, especially Nitsch's abstract splatter paintings involving blood and flesh. According to Margolles, her abstract compositions invoke the memory of bodies wrapped in sheets on the streets after the 1985 earthquake in Mexico City when there was not enough room to store the dead (Margolles, quoted in David 2011, 30). At the very least, their captions reveal the "Other" "speaking in the public sphere." *Operativo II* depends on the aesthetic strategies that Margolles (and SEMEFO) developed in collaboration with forensic teams at the morgue. In response to informants' calls, Margolles's ready-made *Operativo II* begins by pressing canvas against the wounds of crime victims in Mexico City before stretching that same canvas over painting frames. No longer confined to SEMEFO, the project tracks how the morgue—what Margolles has termed "a barometer of society"—overflows like the Factory and the Maquila (Schools), like the prison, like the hospital . . .

Art does not disavow its own frame here, but is reframed by and intertwined with a social real. *Operativo II*'s visual affect clarifies the stakes of *Operativo I*'s linguistic misfit. It also illuminates the purloined letter of my own prior reading of this work (Carroll 2010). The quotations from news coverage, like the body tag, are not simply text. They illustrate representation's material consequences. The word "operative" dominated the language of Mexico's War on Drugs. A binational response to narco-violence was coordinated, after all, via "operations."

In 2006, Calderón launched Operation Michoacán against the powerful cartel La Familia Michoacana. Operation Baja California followed in January 2007. The Joint Operation Nuevo León–Tamaulipas to target the Gulf Cartel and Los Zetas was announced on January 1, 2008. Operation Chihuahua went into effect on March 27, 2008, when federal and military forces were deployed to retake Ciudad Juárez. On May 13, 2008, Operation Sinaloa, directed against the Sinaloa Cartel, the Beltrán-Leyva Cartel, and Los Zetas in the state of Sinaloa, was initiated. On June 30, 2008, Calderón signed the Mérida Initiative, a US $1.6 billion security agreement between the United States and Mexico. Drug-related deaths for 2008 peaked at 6,500. Civic centers in Michoacán and in Northern Mexico morphed into zones of Uncivil War. Dead bodies were left on public display with warnings attached to their extremities. Decapitated heads punctuated thoroughfares. Shootouts interrupted morning and evening commutes, especially in Northern Mexican border towns. Despite the arrests of key cartel leaders and their personnel, despite the resignations of key police officers, the violence escalated. Public officials were attacked or assassinated. In 2009, the official death toll exceeded 8,000. Border towns emptied as people fled north and south to escape the violence. Journalists were coerced into printing graphic text and images of cartel activities, or were assassinated for doing so.

Like early documentation of Mexican performance and conceptual art, as work from "Border" corroborates, journalistic accounts afforded the most immediate and accessible coverage of and reaction to the prevailing atmospherics.[53] *Operativo I* and *II*, like a microstaging of Margolles's, Mexican art's, and Mexico's turn to language, reverse-shoot the juxtaposition of (artistic) production and (critical) consumption—performing what González Rodríguez (2012, 9) more generally describes as the "ultra-contemporary terrain of Ciudad Juárez (and Mexico) within a global machine." The Pollockian-turned-allegorical performative, itself the "ruin" of postrevolutionary Mexican muralism, is action-painted out of the white and Rubik's cubes, then reintroduced into the work's performance of value. With *Operativo I* and *II*, Margolles blurs the boundaries of so-called life and art as "Event" and "context," becoming "contextural," precede the collective "signature" (Derrida 1984)—"hijos de puta," a neoliberal reMex of postrevolutionary nomenclature ("hijos de la Chingada") for the nation as Concept.

Language commissioned to describe violence falls in between language performatively affixed as warning falls in between the alternate spoken word of the canvassed body falls in between any language that might be mobilized to describe the gaps in this vicious cycle. *Operativo I* and *II*

re-extend a critical advisory. Like some para-aesthetic versus paramilitary operation, *Operativo I* and *II* reMex the chasm between the written and the unspoken, the corporeal and the unincorporated. The unbridgeable divide reappears in Margolles's contributions to the Mexican Pavilion of the Venice Biennale 2009, curated by Medina, *¿De qué otra cosa podríamos hablar? (What Else Could We Talk About?)*. Only two years after the Mexican government invested in a permanent national pavilion at the Biennale in the hopes of transmitting another clear signal of Mexico's economic presence on the world stage, Margolles exposed something other than the state's aspirations for incorporation into the global market.

The floors and windows of the pavilion each day were mopped with water mixed with the blood of the victims of narco-violence in a repeat performance as eerily reminiscent of 1970s feminist artists' "sanitation aesthetics" as Cuevas's *STC Cleaning Service*. The flag, "done with fabric impregnated with blood collected from execution sites in Mexico" (*Teresa Margolles* 2009), was washed but never rinsed clean. Margolles displayed cards to cut cocaine that included images of victims of narco-violence and gold jewelry set with pieces of shattered windshields from Mexican zones of narco-violence, locked in safes in the pavilion. Finally, she commissioned various artists to once again "disappropriate" *Narcomensajes* (*Narco-messages*, 2009). Participants embroidered with gold thread onto previously blood-soaked fabric narco-messages collected from execution sites in Sinaloa. The messages included, "See, hear and silence," "Thus finish the rats," "Until all your children fall," and "So that they learn to respect," and "For the one who does not believe it/Sons of a bitch" (Para quien no se las creen/Hijos de puta). *Operativo I*'s phrase returns, grammatically incorrect or rewritten more resolutely as the aforementioned signature. Suggestive afresh of gendered genres, singular disbelief, an effeminized population . . . Not form for form's sake, the unraveling, vaporized, disintegrating corpse and its traces here and across Margolles's work allegorically offer up keywords like the ethical, the political, and the aesthetic as effigies "fashioned from flesh" (Roach 1996, 36).

If, as Benjamin posits, "the allegorization of the physis can only be carried through in all its vigour in respect of the corpse" (1998 [1928], 217), Margolles's increasingly transubstantiating human form—effeminized—and the languages it spawns key divides between words and bodies, between drama and social drama, at the heart of Benjamin's pronouncement. Detailing the convergence of the figural and the poetic via a divergent "bare life" minimalism that schisms the textual and what it re/presents, Margolles's

contributions to the Mexican Pavilion at the Venice Biennale, like *Operativo I* and *II*, incite us to recognize and take up our predetermined mantles of intersubjectivity and interobjectivity, to imagine gender's performative range of motion as that which punctuates Mexico's ongoing domestic violence. Across Margolles's work, the corpse does a double duty, is both minimal as the literal and neobaroque as the allegorical. Like the deadpan prose of the fourth book of Roberto Bolaño's *2666* (2004), the artist's corpus re/presents a "visceral realism" of "las artes plásticas" (art as plastic explosives) that exceeds the literalmindedness of Sierra's gestures, veering closer to the viewpoints of "Border"'s undocumentaries.

Navigating between this Scylla and Charybdis is the operative challenge posed to the spectator of Margolles's "muerte sin fin," but also and perhaps more importantly to the would-be (art) historian, critic, or public policy maker of Mexico (City) as non/object and non/site. The end's means and ends are rewritten in and as their looping, demolitional beginnings. The PIAS Forms ghost 1990s DF artwork. The DF alternative, like Mexico's neoliberal transition, did and did not represent a rupture with previous (art-making) traditions. Certain strands of Mexican neo/conceptualisms and performance were remade and negated at the turn of the millennium. A decade before Margolles pulverized a Ciudad Juárez house formerly occupied by a woman who was brutally murdered, created a minimal sculpture out of its dust for Mexico City's MUAC, and then built a community center at the house's prior location in a three-part action titled *La promesa* (*The Promise*, 2012), she backed a cement truck up to the open door of La Panadería. On August 14, 2002, Margolles filled the gallery with cement mixed with SEMEFO water used to wash the dead. Schmelz lyrically recalls *Fin* (*End*), "When the cement set we could see the vapor rising . . . on that rainy night human souls and invisible humors floated in the humid environment" (Schmelz, quoted in Dorfsman and Okón 2005, 272).

The (masculine) aggressivity of the action in contradistinction to that driving *Entierro* is characteristic of work of the 1990s and 2000s that wrested art—the subject and object—away from the market-state only to return it wholesale. The aggressively creative license of Schmelz's reading, like her enabling misattribution of El Mago Melchor's body art to Herrera, is characteristic of the era, too. Performative, but not always in possession of clearly articulated political objectives, much of this period's corpus—from Cuevas's MVC and Okón's *Risas enlatadas* to Alÿs's *Cuentos patrióticos* and Sierra's de-lineations—mimed and mined collective representation, dis/appropriated and was appropriated. What would it mean to look to and

for artwork that re-sited the tactics of post-1968 art making—in Mexico to the PIAS Forms—by more precisely defining its aesthetic and political rights-based claims? What would it mean to examine the gendered dimensions of the period by homing in on the efforts of artists who pulled back the curtain covering the fog-qua-femicide machine of so-called democratic transition? In "Woman," we'll rotate those questions in *REMEX*'s picture plane to concentrate on select female art workers' de- and reallegorizations of NAFTA-era Mexico-Woman.

WOMAN

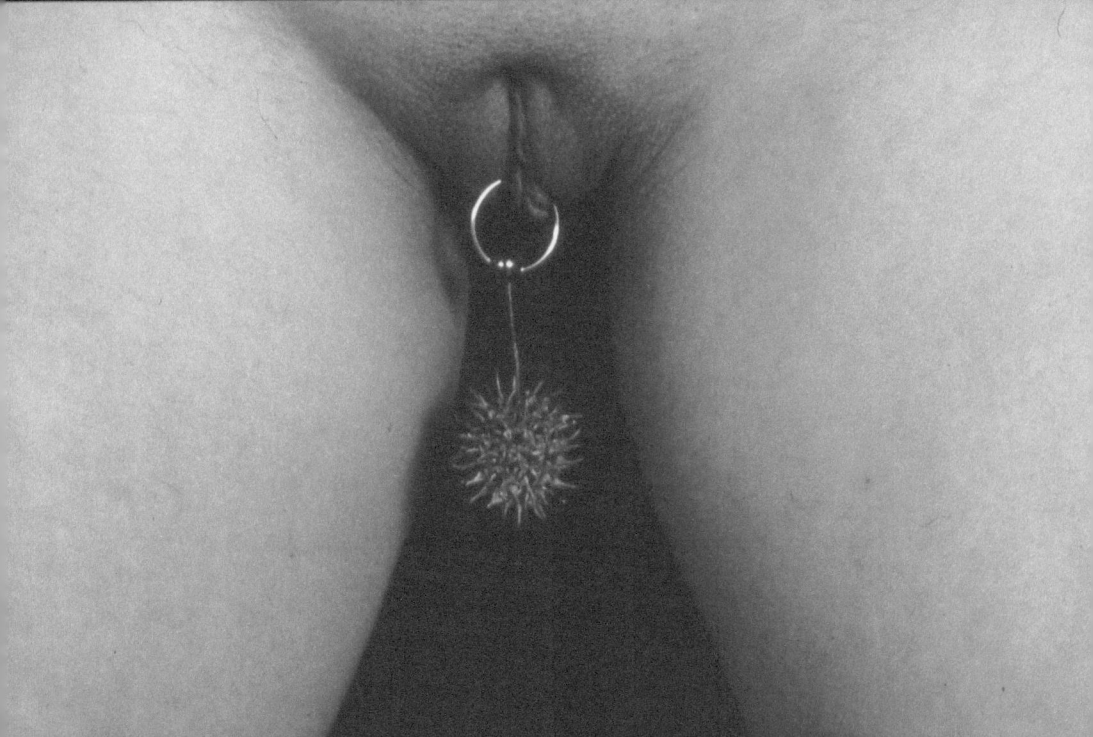

PREVIOUS PAGE:
FIGURE 2.1. Katia Tirado, *Los nichos púb(l)icos*, 1997. Courtesy of artist.

Las marcas de lo masculino y de lo femenino son conjugaciones interactivas . . .
—NELLY RICHARD, *MASCULINO/FEMENINO*

In January 2000, as various celebrations of the new millennium unfolded in Mexico City, the performance and multimedia artist Lorena Orozco presented *Comunicación en re menor (Communication in D Minor)*. In the performance, Orozco sat in a chair in a circle chalked into the center of the square of the Plaza of Santo Domingo. She faced a man playing a flute. Orozco calmly rose from her seat, produced a power saw, and began to take apart the platform on which the man performed. In an interview, Orozco (2000) explained that she did not intend for her action to rehearse the cacophonous note of gender. Instead, she imagined it as addressing "certain questions about power and what it means to be human." Orozco's commentary did little to unsettle my gendered reading of the performance. As feminist theory and practice instructs, an account of gender permits us to entertain the very questions that Orozco poses. Moreover, such an account permits us to do so performatively.

Materialized in the extreme opposition of two figures in *Comunicación en re menor*, gender, a phantasmatic affect, becomes a sonorous *re*-citation of the interactive conjugations of the masculine and feminine. Indeed, even the piece's title invites such free versification. In *Comunicación en re menor*,

"re-" and "menor" double not only as musical notation but also respectively as the prefix signifying the repetition inherent in gender's performativity and as minor or secondary citizenship. Offering an extreme portrait of a reMex, the pair alludes to the broader significations that gender has taken on since the colonial period. The weight Orozco's title imposes on the performance's somatic movement mandates that we approach the work allegorically. It doesn't take a leap of faith to imagine the figure of Orozco in *Comunicación en re menor* as refusing to play the feminine audience to the masculine "social drama."

Stepping outside the hermeneutic circle that locks her in as an allegorical figuration, Orozco cuts to the chase, the base upon which the primal scene of mastery unfolds. Donning a pair of pink gloves, Orozco troubles "género/s"—"gender," "genre," and "mercantile goods." No longer beholden to the neo/colonizer or the caudillo (masculine strong man, a straw man after all), the artist presents a minor version of a repeat encounter, the short-circuiting of the communication inherent in the consolidation of gendering as a transnationally naturalized performative. Yet, because the violence of *Comunicación en re menor* is no longer enacted *against* the female form but *by* her, the performance catalyzes a homeopathic, or alternately homosocial, destabilization of cascading binaries. Armed with more than a power saw, Orozco unveils gender as a trembling formation, as the midriff of a participle, which we already encountered in the work of Teresa Margolles. Orozco stages and blocks allegorical interruption. Both utilizing and representing an allegorical procedure, the artist suggests that the "house" that binaries (male/female, light/dark, top/bottom, North/South, US/Mexico, high/low . . .) build remains susceptible to deconstructive reconstruction, but needn't be razed as Margolles's "House of Culture."

Orozco's performance, ostensibly shying away from specific commentary on Mexico, reveals a set of tactics that localize the thesis of the literary critic Barbara Johnson's "Women and Allegory" (1994). Johnson extols: "Allegory is speech that is other than open, public, direct. It is hidden, deviant, indirect—but also, I want to emphasize, public. It folds the public onto itself. It names the conflictuality of the public sphere and the necessity of negotiating those conflicts rhetorically" (ibid., 61). According to Johnson, the open secret of allegory is gendered when the female figure in the painting *Theory* comes to symbolize and/or stand in for allegory proper. The location of difference as Woman mutates into the symbol of allegorical procedure in neo/liberal constructions of communicative reason. Johnson

highlights the slippage between allegorical procedure and the symbol it generates (Theory = Woman, first visualized in theory by *Theory*, the painting), designating Woman as the driving force of *allēgoria* in the spirit of the literary critic Gordon Teskey's excavation of the codependency of allegory and violence, sited around the rape of Woman.

Teskey, Johnson's contemporary, imagines Woman's symbolic significance as coded in spatiotemporal terms. Turning to the figure of Francesca da Rimini in the fifth canto of Dante's *Inferno*, he notes, however, that air pockets are written into the allegorical tradition, where women rebuke Woman's violation and pragmatically countertheorize. Teskey (1996, 25) expounds, "We are shown a woman in the process of being made, or almost made, into a sign. But it is the incompleteness of this transformation, meeting with resistance from its subject, Francesca, that the poet is setting before us." Francesca interrupts *allēgoria*, spotlighting the contradictions and possibilities of resistance embedded within fluid allegorical ecosystems. She holds allegory to its own promise of "permanent parabasis" (Spivak 1999, 156n64). Envisioned as a middling, meddling agent, Francesca represents one ego on a kinship diagram of "traitorous women."[1]

Orozco's character in *Comunicación en re menor* offers another ego perspective. Acquiring site-specific allegorical import, Orozco takes up in this piece "the project of displacing the male-centered national allegory, exposing the dubious stereotyping that was always inherent in the epics of nationhood that constitute the Latin American canon" (Franco, quoted in Yúdice, Franco, and Flores 1992, 75). Orozco's *Comunicación en re menor* emerges specifically out of millennial Mexico, itself emerging out of a preceding historical culture of predicament, which Franco generically identifies.

In *Plotting Women: Gender and Representation in Mexico* (1989), Franco reads two novels, one by Elena Garro, the other by Rosario Castellanos, as ensnared in a sticky web whose "problem is rooted in [the writers'] attempt to appropriate the then hegemonic genre—the novel as national allegory" (ibid., 146). Orozco plots additional coordinates of interpretation and resistance. Literalizing the allegorization of the female figure, the relation between "monuments and maidens" (Warner 1985), or, in the greater Mexican context, between mothers and traitors, Orozco presents herself as a monument in motion, reintroducing a Benjaminian dialectic into Doris Sommer's (1991) formulations of "national allegory" in Latin America. Orozco's character aggressively reclaims the public square, once synonymous

with the Latin American public sphere and the citizen, aggressively gendered male.

Three blocks north of the Zócalo and the Metropolitan Cathedral, the Plaza of Santo Domingo houses the Church of Santo Domingo, including all that remains of the first monastery established in New Spain. The current rendition of the church there, completed in 1736, is "Mexican Baroque," with a front façade covered in the blood-colored volcanic stone known as "tezontle." It opens onto the plaza, which is flanked by a Tuscan colonnade where scribes since the colonial period have composed letters and official petitions for their il/literate clients.

The communication Orozco writes must be understood against this backdrop of a post/colonial historic, histrionic. It also corresponds to an explosion of NAFTA-era body art that trafficked in the period's most ubiquitous transitional object, the allegorical figuration of Woman. Sometimes regarded as "minor," this archive has had to compete with artwork falling squarely under the rubric of the DF contemporary. It also has had to reckon with externally imposed designations of what constitutes Mexican performance.[2] In "Woman," I focus on performance art by women who locate their own production in the visual arts. My intervention begins with an origin myth, that of the first feminist collective, Polvo de Gallina Negra (PGN; Black Hen Powder; Mónica Mayer and Maris Bustamante), and their now canonical action, *Madre por un día* (*Mother for a Day*, 1987).

Like Orozco's *Comunicación en re menor*, *Madre por un día* re-sites allegory's etymology—*allo* (Other) and *agoreuein* (speaking in the public sphere)—but updates it televisually. *Madre por un día* set the stage for other work that more explicitly responds to the commodification, racialization, and sexualization of Mexico from the mid-1990s onward. In what follows, I consider how that work's creators use a *methodology* of "reception as a mode of performative, not merely passive, practice" (Chow 1991, 121) to embody the figure of Woman specifically at the center of the allegorical performative. This method might lead some to believe that the work in "Woman" overlaps with or takes up where neomexicanismos leave off. To be clear, this archive situates the latter as part of a more general reMex under way. The critical difference between neomexicanist canvases and "Woman's" work boils down to one of agency: The archive of "Woman" adds nuance to the feedback loop of art and politics. Opening the circuit, it depends on a deallegorization and a reallegorization of Woman. The double movement follows the cultural studies scholar Stuart Hall's mandate that we decode and recode cultural scripts. It acknowledges the critical theorists

Gilles Deleuze and Félix Guattari's sonorous elaborations on de- and reterritorialization and "conceptual personae" (1994). And, it echoes the Mexican feminist Marta Lamas's (2011) characterization of her own contributions to feminisms' "transmissions and retransmissions."

Following Lamas's detailing of feminist praxis in Mexico, in particular, because this double movement is exacted in the name of aesthetic and political representation for women and other minority subjects, it finally makes visible the links between performance and performativity, between conceptualisms and Conceptual -isms, in greater Mexican art workers' analyses of the NAFTA era. Imagine if the sleeping figure in Javier de la Garza's *Enemigos I*, renamed *Mexican Delights* by advertisers and the new PRI, were to wake up and put her own body into motion, outing herself as the framed fetish. Between "marcos" (frames) and "marcas" (trademarks or signs), the artists whose efforts I consider in "Woman" trouble the prefix "neo-" of "neomexicanismo" and neoliberal doctrine by foregrounding an accretional gendering of Mexico, which began with the colonial encounter, evolved in the age of the "national romance," was transfigured in the longue durée of the postrevolutionary period, and was reinvented from the late 1980s onward. Unlike Margolles, these art workers make clear that the effects of accretional gendering, while extending beyond literal women, disproportionately impact female citizen-subjects. They also offer possibilities for the latter process's interruption when they compile and connect two inventories or catalogues.

With the first inventory, the artists enumerate prior critical, sometimes read as synonymous, configurations of the genre of monumental Woman as the consummate fetish in *both* the psychoanalytic *and* Marxian senses of the term, congealed symbol of the nation in the institutionalization of postrevolutionary Mexican (national) allegory, and inter-American transitional object. Across these formulae, the emphasis is placed on how Woman, a racialized, classed, and sexualized spectrum of effects, functions as currency, is tokenized as Culture and Nation.

The same artists interrupt the coordination of Woman by way of a second inventory of affect—shame, self-love, jealousy, ambivalence, melancholia. "Ugly feelings" (Ngai 2007) morph into "allegories of emotion" (Terada 2001) to rival "structures of feeling" (Williams 1977). But, per the Other speaking in the public sphere of allegory, affect and effect finally can be recognized as interchangeable with these parallel tracks. If the postcolonial literary critic Rey Chow (1991, 121) writes, "Westernization, which is not necessarily present in a visible, thematic form, nonetheless haunts

modern Chinese writings in the form of *emotional effects*, which include those of misery, frustration, despair, as well as emancipation," the work of "Woman" *re*acts against the flows and stoppages of internal and external trade, which, haunting the era's greater Mexican political *and* aesthetic unconscious, naturalize the marketplace as the wildest West and the final frontier.

¿DESMODERNIDAD?
LITERALISTS TO THE CORE!

POLVO DE GALLINA NEGRA'S MATERNAL PROSTHESIS

At the center of 1980s Mexico-as-miracle-disaster narratives are a set of mothers and their lost generation. On Friday, August 28, 1987, Mónica Mayer of *Pinto mi Raya* and Maris Bustamante of No-Grupo appeared on the well-known Televisa talk show *Nuestro Mundo* (*Our World*; cited as *Nuestro Mundo* 1987) and granted its primetime host Guillermo Ochoa the honor of being "mother for a day" (Bustamante 2012; *Pinto mi Raya* 2011). Their appearance formed part of the series *Madre por un día*, itself part of *¡MADRES!* (*MOTHERS!*, 1987).

Bustamante and Mayer consider *¡MADRES!*, which took place over several months, to be their "most ambitious work" (Mayer 2004, 39). To begin, the women decided they needed to be pregnant so that they could fully comprehend motherhood as a construct. "Naturally," Mayer narrates tongue-in-cheek, "we needed the help of our husbands, who, as artists, perfectly understood our intentions" (ibid.). Then, Mayer and Bustamante fashioned a mail-art project, which made public their conceptualization of maternity as life/work. Mayer and Bustamante sent a series of letters to the Mexico City artistic community and the press. In these, they speculated on such topics as the contrast between their relationships with their own mothers and utopian scenarios of motherhood in the year 5000. In a second mail-art project, the pair solicited correspondence from the general public, asking that participants share what they had not been able to say

to their mothers. Creating a compilation of the responses they received, the women assembled a Mother's Day montage, an alternative Mother's Day monument. Finally, the pair presented a series of performances concerning motherhood in DF museums and galleries.

These performances followed PGN's earlier 1985 performance-lectures on feminist art, which they presented in several metropoles across Mexico when both participants were pregnant. Bustamante humorously recalls that she arrived at one of those events with a supply of "brujitas" (literally, "little witches"), or firecrackers. When audience members ducked or sauntered to the auditorium's exits, Bustamante threw the firecrackers, exclaiming, "No one leaves a feminist art conference." To her surprise, those departing returned to their seats to listen to the pair (Bustamante 2009). Such take-no-prisoners tactics, predating Vicente Razo's Molotov cocktails, like PGN's epistolary campaigns, blurred the line between the artists and their publics. They were legible within the contexts of post-1968 feminist art worldwide and 1970s Latin American performance, conceptual art, and mail art. They also were inspired by and contributed to conversations in Mexico regarding feminisms, which intensified after the UN's first World Conference on Women took place in Mexico City in 1975.

Mayer's experiences—participating in the Movimiento Feminista Mexicano (Mexican Feminist Movement) and the Coalición de Mujeres Feministas (Coalition of Feminist Women) and working in Los Angeles with her master's thesis advisor, the US feminist artist Suzanne Lacy, in the Feminist Studio Workshop at the Woman's Building in Los Angeles (open from 1973 to 1991)—by her own account also prepared her to collaborate with Bustamante. PGN's efforts, equal parts resistance against "cultural penetration" and "lubrication" of the art system, in turn presaged Mayer's convening of the Taller de Arte y Activismo Feminista (TAAF; Feminist Art and Activism Workshop). Mayer's practices effortlessly transverse her own and her collaborators' un/documentary, performative, and conceptual proclivities.

As early as 1978, Mayer presented an interactive intervention titled *El tendedero* (*The Clothesline*) in which she invited women to complete the phrase "As a woman, what I most detest about the city is . . ." (Mayer 2016; catalogue translation). Contributors handwrote their responses on pink slips of paper that were hung with clothespins on clotheslines in Mexico City's Museo de Arte Moderno (MAM). For US viewers, the action simultaneously might invoke domestic labor, an airing of "dirty laundry," and the termination of employment; in Mexico, the clotheslines crossed the

wires of women's "testimonio" with rooftop laundry, a ubiquitous symbol of domestic labor. Mayer (2016, 195) explains that with the intervention, she focused on quotidian street harassment of Mexican women. A year later, Lacy included a second version of the project in her multifaceted intervention *Making It Safe*, commissioned by the Santa Monica community organizing group Communitas. *Making It Safe*'s methods, designed to raise awareness and consciousness regarding various forms of violence from rape to incest and harassment against women, included pamphleteering, dialogue sessions, speak-outs, and an art show in the municipality's commercial district. The project formed one of the case studies of the master's thesis "Feminist Art: An Affective Political Tool" that Mayer submitted in 1980 to Goddard College. The final component of that same thesis, like Mayer's work as a whole, according to Andrea Giunta, was "ahead of its time" (Giunta, in Mayer 2016, 94; catalogue translation). "Traducciones: Un diálogo internacional de mujeres artistas" (Translations: An International Dialogue of Women Artists") brought artists from the Woman's Building to Mexico City to take part in a workshop with Mexican female artists from the DF, Cuernavaca, and Oaxaca. A year later, Mayer presented documentation of these greater Mexican exchanges at the Woman's Building, which included audiovisual materials and a book addressing pre-Hispanic goddesses, Mexican feminism, and the sociopolitical roles of women in Mexico. Almost three decades later, Mayer restrung her clotheslines in the exposition *Sin centenario ni bicentenario: Revoluciones alternas* (*With Neither a Centennial nor a Bicentennial: Alternate Revolutions*, 2009) at the Universidad Iberoamericana and in the artist's solo show *Si tiene dudas . . . pregunte: Una exposición retrocolectiva de Mónica Mayer*, 2016) at the MUAC. The latter's title, proposed by the Argentinean art historian María Laura Rosa, is a telling subversion: it reflects Mayer's long-standing commitment to collaboration and collective practice (Mayer 2016, 33–34).

Rather than focusing on the singular work of Mayer, the "retrocollective" charts her participation in PGN; *Pinto mi Raya*; the Woman's Building; and another feminist Mexican collective, Tlacuilas y Retrateras, which also was founded in 1983.[3] The sum of Mayer's and Bustamante's individual and collaborative experiences, including their mail-art, set the stage for PGN's televised male-art, perhaps the pair's best-known work. In the televised broadcast of *Madre por un día* (*Nuestro Mundo* 1987), the artists named "ten important men in [their] community to be 'Mother for a Day.'" Because Ochoa had showcased Bustamante's *La patente del taco*, he can now be counted among *Madre por un día*'s lucky few. Mayer and Bustamante

presented Ochoa with an apron that gave him the appearance of being in the third trimester of a pregnancy (see plate 7). Before donning the prosthesis, the television host quizzed the performance artists about their line of work. Bustamante, who initially did most of the talking in that exchange, responded to Ochoa's inquiries about the status of *La patente* before redirecting the conversation back to the feminist agenda of the pair's collaborations. Drawing Mayer into the conversation, Bustamante tacked between an introduction of Polvo de Gallina Negra, the women's art collective, and a contextualization of *Madre por un día*.

Nuestro Mundo boasted over 200 million viewers that day in Mexico and across the Americas. Many of those spectators chose to participate in the performance's "mother camp" (Newton 1972). For instance, some viewers called in to complain about Mayer, Bustamante, and Ochoa's "lack of respect" for motherhood's sanctity (Bustamante 2001a). Such contributions, albeit negative, highlighted the aura of motherhood as an institution. Nonplussed, Mayer and Bustamante were careful to contextualize this perspective as the problem.[4] The distinction—a simple sound bite—that they hoped to implant like a subliminal message in viewers' minds, cleaved along the following lines: The mother, per Octavio Paz's contribution to *Mexico: Splendors* and his entry for Woman in *The Labyrinth of Solitude*, figured as a fragmented subject in the Mexican cultural imaginary, as violated Woman, or La Chingada; as Malinche, the Eve of the nation; and as the Virgin of Guadalupe. But Mayer and Bustamante recognized a slippage between those "spectacles" that equally depended on the national allegorical as its lubricant.

With *Madre por un día*, the pair strove to update representations of maternity because those "currently in circulation had been painted by men" (Bustamante, in *Nuestro Mundo* 1987). Noting the iconicity afforded to motherhood in narrations of the nation, they sought to rediscover the obvious—the pendulous figure of Woman—metonymic of gender as radical difference (the make-or-break of weak and strong, South and North, bottom and top, have-not and have oppositions). With *Madre por un día*, Bustamante and Mayer created a countertransferential primal scene, which first unveiled allegorical procedure as a favored technology of the state. Neither lamenting the limited options afforded to women nor critiquing the naturalized linkage between pregnancy and male ownership of women's bodies, the pair then cultivated a pregnant middle ground, which might be parsed as following what Carlos Monsiváis later termed the "utopia indocumentada" (undocumented utopia) in everyday elaborations of gender,

sexuality, and nation (although, to be clear, Monsiváis only refers to feminism in the latter formulation as a kind of after thought [1991–1992: 60]). Concomitantly, they tested their hypothesis that television functioned as *the* museum of modern art in Mexico from the 1980s onward (Bustamante, in *Nuestro Mundo* 1987).

In *Hybrid Cultures*, Néstor García Canclini (1991, 70) considers Paz's involvement in Televisa's promotion of a 1982 Pablo Picasso exhibit at the Tamayo Museum in Mexico City, detailing how the media conglomerate, which had cofinanced the museum, decontextualized and commercialized Picasso's oeuvre, using Paz (arguably another media conglomerate) as its mouthpiece in "one of those seductive games of contradiction and complicity between art for the elites and art for the masses." With *Madre por un día*, Bustamante and Mayer redrew the lines in the sand between the cultured, the popular, and the massified when they shifted the terms of cultural engulfment and assimilation—coded formally as mass mediated and thematically as externally imposed—to that of potential and anticipation. Without moving mountains, the pair appealed to audiences whom García Canclini and others dismissed as "Televisa-fied." According to the collaborators, public art's relationship to the culture industries didn't have to be scripted as one of anxiety. Televised citizenship didn't necessarily mean that the viewer (or the nation) had been "violated" or engulfed. Rather, performative and conceptual gestures could in vitro fertilize mass media. Feminist performance art could plant the seeds of a radical politics in the public sphere. Post-reality TV and culture jamming, the strategy may sound plausible but short-sighted. In late 1980s Mexico, approximately one decade before, it was tantamount to treason to go on the airwaves and question the terms of "repro-narrativity" (Warner 1993). *Madre por un día* reverberates as a double act of insemination. Ochoa, impregnated by Mayer and Bustamante, feebly attempted to reassert his "macho" presence on air. Ultimately, he took on the feminine, a reversal of Bustamante's prior performance *Caliente! Caliente!* in which she had worn and distributed to her audience prosthetic "nose-penises." Reimagining the fetish of the pregnant woman's stomach—a stand-in for Woman in the Mexican cultural imaginary, Mayer and Bustamante shared the love of maternal agency to highlight how questions of national re/production depend on discourses of masculine transfer and transference. Knocking Ochoa up, the artists poked fun at the fictive qualities of motherhood's reification, feminisms' furtive longings for epistemological origins, and artists' and intellectuals' ongoing divisions between high and low cultures.

The effects of *Madre por un día* proliferate. PGN's televisual performance expanded the potential pool of applicants for national motherhood.[5] The presence of Bustamante and Mayer on *Nuestro Mundo* constituted a cultural hijack, a forced, momentary recognition of feminist cultural production more generally in Mexico. While some might assert that visual artists like Nahui Ollin or Frida Kahlo, or even Concepción Jurado, represented Mexican protofeminist performance artists, most art historians respect Bustamante and Mayer's claim that they cofounded the first Mexican feminist performance art collective in 1983.

The pair formed Polvo de Gallina Negra in response to Los Grupos' and the greater Mexican art scene's lack of engagement with feminist praxis and female artists' participation in performance post-1968. Seasoned veterans of artistic collaboration, these mother hens originally envisioned a larger collective, but the other women with whom they discussed the idea declined to participate because each feared it would hurt her chances of being recognized as a "legitimate artist" (Mayer 2000 and Bustamante 2001a). Undeterred, Mayer and Bustamante chose a name for themselves that anticipated the resistance to and criticism of PGN's right-to-choose. They widened their search for potential allies and collaborators as if prescient of the future embrace of their efforts.

Polvo de Gallina Negra is a black powder sold in Mexican herbal markets to thwart the actions of the evil eye. Mayer (2004, 38) writes, "We knew that in this world it is difficult to be an artist and riskier yet to be a female artist, so we decided to protect ourselves with a name that would act as a talisman." She continues, recounting PGN's objectives:

> (1) to analyze the image of Woman in art and the media of communication, (2) to study and promote the participation of women in art, and (3) to create images from the departure point of the experience of women in the patriarchal system, based in a feminist perspective and with the goal of transforming the visual world and thereby altering reality. (Mayer 2004, 38)

While PGN created other performance and conceptual work, the pair most spectacularly realized their objectives through their appearance on *Nuestro Mundo*. *Madre por un día* caught the signal of another telecommunicative frequency, of an Other representational economy wherein the female form could be reallegorized as a "critical fetish." "Reading the romances" of citizenship-subjectivity, the artistic process, and the relationship between

post-1970s Mexican conceptualisms, performance art, and popular and consumer cultures (Radway 1991), PGN anticipated theses regarding the alternative's conversion to a Mexican contemporary. Turning the tables on transnational kinship diagrams, Mayer and Bustamante established themselves as indispensable accessories of Mexico's performance, as mothers of Mexican performance and feminist art.

Their mutation in the meme heralded PGN's progeny: the particularly high number of women in 1990s–2000s greater Mexican performance or body art. "Woman" belongs to Mayer, Bustamante, and their "daughters," although perhaps not quite in the manner that Mayer envisioned. Chronicling the rise of alternative art in Mexico with the actions of Los Grupos in her memoir and art history *Rosa chillante: Mujeres y performance en México* (2004), the artist traces the changing roles and ambitions of women in Mexico City's art world, while also acknowledging evolving conceptions of the political in female cultural producers' work from the 1970s to the early twenty-first century. Arriving at the turn of the millennium, Mayer muses, "I've noticed that if 'the personal was political' for us, female artists of the nineties follow the maxim, 'the political is personal'" (ibid., 76). In my treatment of subsequent work in "Woman," I implicitly address Mayer's inversion in order to link it to a multifaceted awareness of the allegorical performative in greater Mexican cultural production. In particular, I keep an ear to the ground to note that between Woman and Nation; between Woman, Nation, and Border; between women and what might be understood as "standpoint epistemologies" of 1970s First World feminisms; first-borns reinvent origin but not always in terms that privilege linear teleology.

If efforts like PGN's also allegorize the very terms of originary penchants in [Walter] Benjamin's altered "sense of the 'originary,'" which "does not so much summon up the primordial as the *yet to be* in works, their utopic trace" (Adorno 1997 [1970], 172; emphasis in original), the work that followed Mayer and Bustamante's actions refuses to reproduce origin myths, providing instead ontological modes of reading for Woman. Hallowed, haunted middles, like PGN's strap-on stomach—the accoutrement of maternal-national "drag [that] allegorizes gender"—the actions I consider in this section complicate PGN's objectives (Butler 1997a, 145).

In the efforts of "Woman," racialized and sexualized Woman at times becomes an accessory to be put on and taken off in the service of literalizing "symbolic equivalences [as] spatialization" (Schneider 1997, 117) and interruption. At other times, she is regrounded in the experiences of literal

women. In either case, the prefix "re-" is key to Woman's transfiguration. If the artists whose work I treated in "City" repurposed the "No-" of "No-Grupo" or "no-objetual" and the "non-" of "non-site," the artists whose efforts I examine in "Woman" wield the minor "re-" of communication to alter the significance of Mexico and Culture as Woman. Imagine a black thread of the obvious, disintegrating into the powder of a black hen feminine, dispersed as the particulate matter of Margolles's *Vaporización* in the countermobilization of Mexico as monumental, intracontinental Woman. "Woman" functions as *REMEX*'s permanent parabasis and prosthesis, an additional syllable attached to a word to alter its form and contents. In the break, "Woman" becomes a commitment to reading between the lines and across binaries, including but not limited to "City" and "Border," Mexico and the United States, politics and aesthetics, and symbol and allegory.

REALLEGORIZING THE FEMALE FORM

LORENA WOLFFER'S "EL DERECHO DE RÉPLICA"

If Mayer and Bustamante, deallegorizing the female form, attempted to outfit Ochoa with a maternal phallus, the Mexico City–based artist, curator, critic, activist, and second director of Ex Teresa Lorena Wolffer approaches the "problem" of Woman from a different angle that nevertheless advances a rights-based claim to aesthetic and political representation. For over two decades, Lorena Wolffer also has waged war against prevailing constructions of Mexico and women, against the beloved and reviled archetype of Mexican Woman. The sum total of Wolffer's work gathers evidence of literal and epistemic violence, inventing new meanings for the juridical concept "el derecho de réplica."

"The right to retort" first appears as the right to revise the terms of structural violence written on female bodies in the artist's 1990s performance art before assuming its more familiar connotations in Wolffer's post-2007 privileging of language. In the mid-1990s, Wolffer, one of the few openly feminist artists in Mexico, appropriated the figure of Woman from discourses of the state and the fashion industry. Alluding to "allegories of empire" (Sharpe 1993) in Mexican and US narrations of nation in the NAFTA era, the artist generated a series of performances focused on "transform[ing] the female body into a metaphorical blueprint of the Mexican national territory, a site through which Mexico's current social, political, and economic crisis can symbolically be expressed" (Wolffer 1998). In *Báñate* (1992–1993), following Ana Mendieta's *Sweating Blood* but preceding

the Guatemalan performance artist Regina José Galindo's *¿Quién puede borrar las huellas?*, Wolffer bathed herself in blood in a ritual intended to foment collective healing. In *Mexican Territory* (1997), Wolffer lay naked for six hours on a surgical table while thirty liters of cow's blood dripped onto her and a voice endlessly recited, "Danger, you are approaching Mexican territory." Or, collapsing the word "alien"'s bivalent meanings into one another in order to create a mythological Mexican-extraterrestrial woman, in *Alienation* (1998), Wolffer played the part of a "Mexican-alien wrestler seductress," intent upon devouring the United States.

What these works have in common is a double movement of de- and reallegorization that plays itself out across the artist's subsequent early work, including *If she is Mexico, who beat her up?* (*Si ella es México, ¿quién la golpeó?* 1997–1999), *Soy totalmente de hierro* (*I Am Completely of Iron*, 2001), and *Mientras dormíamos (el caso Juárez)* (*While We Were Sleeping [the Juárez Case]*, 2002). Wolffer's 1990s and early 2000s body art systematically unveils the Othering dimensions of developmentalist rhetoric that casts Mexico as a "second sex" and second-class citizen of the continent's NAFTAfication. Wolffer's use of her own body in this oeuvre does not amount to an airing of the personal or private. Instead, it allegorizes a specific experience of neoliberal globalization, the repeat violation of the Mexican body politic, internally multimediated by the republic's technocracy.

Visualize a split screen. On the right-hand side, Francis Alÿs's *Politics of Rehearsal* unfolds languorously as a scene of thwarted seduction. On the left-hand side, a second striptease, *If she is Mexico, who beat her up?*, moves like stopgap animation, revealing the terms of subcontinental violation. Formulated as a question, *If she is Mexico, who beat her up?* goads its publics to assume the role of "social detective" per Fredric Jameson's (1998, 315) suggestion that "detective stories allegorize the social totality" where "society as a whole is the mystery to be resolved." Demystifying the violent process of allegorization that facilitates the conflation of Woman and Nation, Wolffer converts the fashion runway into a political gangplank (see plate 8).

The feminist scholars Caren Kaplan, Norma Alarcón, and Minoo Moallem (1999, 6) maintain that "nation-building in modernity is always predicated upon Woman as trope [. . . even as] the woman/feminine signifier continues to serve as an alibi or figure of resistance in the fraternal struggles for control of the nation-state and the national project." In the contemporary era, nation building and free trade time-share Woman. Moreover, as sex work and art work collapse into one another in post/modernist

formulations of art as prostitution and resignifications of the latter (Bryan-Wilson 2012), Woman as trope acquires layers like sweaters that prove difficult to unravel, let alone shed.

In lieu of incorporation, in league with historicization, always accessorize! In red heels and a green Mexican "verde limón" dress, Wolffer takes in all the aforementioned as her narrative accessory. Wolffer veils her face and vision with a green scarf. She dons an army green jacket. She ties around her waist a red and white polka-dotted scarf. She showcases an EZLN (Ejército Zapatista de Liberación Nacional) T-shirt. Acquiring a "chola" attitude, Wolffer vogues sunglasses and a baseball cap's greater Mexican iconography (the flag and the Virgin of Guadalupe) before upturning the symbolism to beg viewers' attentions like coins to be had.

Meanwhile, slides of Wolffer and a transgendered artist are alternately projected onto the wall behind the runway. The juxtaposition establishes that both are in nation drag. A recording of the 1996 US Senate hearings on the drug decertification of Mexico plays in lieu of Harry Truman's inaugural address. In the video documentation of the action by K. D. Davis, the camera abruptly zooms in on cuts and bruises on Wolffer's body. What remains? The question: *If she is Mexico, who beat her up?*

The literary critic Debra Castillo localizes time-honored formulae:

> [There is] an implicit underlying connection between the raped woman and the nation, between the children born of violence and the Mexican male-force. It reflects as well an aggressively denied fear of future violence against the motherland, a penetration by, say, the United States, that Mexican men would be powerless to prevent. (1998, 19)

In *If she is Mexico, who beat her up?*, Wolffer recognizes the abuse and shame grounding this "allegory" before repurposing it. Abuse graphs, renders graphic the performance's tonal shift. Reading the bruises on her arms and legs, Wolffer strikes another pose, scooping up her clothes and scooting off stage, head down and self-reproachful.

If Karl Marx declared shame "a revolutionary sentiment" (Sartre, quoting Marx, in Fanon 1963, 14), but also noted that "a nation and a woman are not forgiven the unguarded hour in which the first adventurer that came along could violate them" (Marx 1977, 304), Wolffer embodies the transnationalization of Woman as a violent process of *allēgoria*. She affects a critique of the market-state assemblage. Locating *If she is Mexico, who beat her up?* as a NAFTA-era coproduction, she proxies the effeminization of Mexico. Wolffer

reiterates the neocolonial stakes of maintaining the foundational fiction of raced, gendered, and sexualized violences, where figurations of colonized populations and the nation-state as a sexualized and racialized feminine coevally exist in a global political unconscious as the operating systems of the New World Order's territorial epistemologies.

Balanced between a Mexican male gaze sexualizing "la raza cósmica," the ghost of the colonial encounter as a national primal scene, and a US qua global male gaze that counterracializes the enactments of similarly scripted imperial violence, Wolffer's performance foregrounds a "between men" component of competing nationalisms (Sedgwick 1985). It demonstrates the shortsightedness of dating globalization to the late 1990s. Woman as the object of exchange forges kinship ties between nation-states. Wolffer generates a de Manian blurring of the symbolic and allegorical, particularly apparent in what one does not see in the artwork's documentation: "At various moments during the action, audience members are invited . . . to have a Polaroid taken with 'Miss Mexico' on the runway for only one dollar" (Wolffer 1998).

If the performance studies scholar Rebecca Schneider (1997, 5) argues that much feminist performance art seeks "to make apparent the link between ways of seeing the (female) body and ways of structuring desire according to the logic of commodity capitalism," Wolffer's performance enacts Schneider's pronouncement, even as it locates it in ubiquitous conversations about free trade. Flexibly accumulating symbolic registers, Wolffer generates a feminist theory of transnationalism that deterritorializes dominant "territorial epistemologies" that map the female body "in the porno-tropic tradition of colonialism" (McClintock 1995, 354). Wolffer both critiques the conceit of "national allegory" and teaches us to revalence it in the tradition of allegorical imagery as "appropriated imagery; [where] the allegorist does not invent images but confiscates them" (Owens 1992, 204). She casts each viewer as capable of detecting friction among practices of signification, which not only typecast but spawn violence against women in the name of Woman.

In turn, if in *If she is Mexico, who beat her up?* Wolffer focuses our attention on the hyphenation of Woman and Nation, with *Soy totalmente de hierro*, she clarifies that the pair function as an assemblage, Women-Nation-Commodity. In July and August of 2000, Wolffer staged a "countercampaign" against one of Mexico's largest department stores, El Palacio de Hierro. In collaboration with the photographer Martin L. Vargas, the model Mónica Berúmen, and the graphic designer Mónica Martínez,

Wolffer designed and placed five billboards in ten locations throughout Mexico City.

All responded to El Palacio de Hierro's "Soy Totalmente Palacio" billboards that privilege thinly chiseled white Woman. Ironically entitled *Soy totalmente de hierro*, Wolffer's pieces demanded of their publics the ability to cross-reference multiple (Mexican) femininities.[6] In Wolffer's designs, Berúmen stands alone. Next to or superimposed on Berúmen's body, text asserts everywoman's rights. Two designs acknowledge the situated-ness or location of Wolffer's would-be model of citizen-subjectivity: "Lo curioso es que creas que puedes controlar mi imagen" (The curious thing is that you believe you can control my image) features a shot of the project's model posing against the backdrop of stacked television screens, in reference not only to televisual advertising but to the pioneering video artist Nam June Paik's installations of TV sets. "Ninguna campaña es capaz de silenciar mi voz"—a tag which, I'd note, carries the weight of a double entendre in Spanish, translating as both "'No advertisement' *and* 'No political campaign' has the capacity to silence my voice"—highlights Berúmen angrily assessing a surreal series of burning billboards. The pair function as the *ars poetica* of *Soy totalmente de hierro*, contextualizing the project's "social realism" and repositioning Berúmen.

Whereas El Palacio's ads leave their female figures floating in space against various floral wallpapers, in Wolffer's designs, Berúmen is sited. El Palacio's ads locate Technicolor in the models' accessories (i.e., in their purchasing power). Wolffer's designs place Berúmen in living color. Dark-skinned, Berúmen in red stands out against a black-and-white cityscape. "Este es mi palacio y es totalmente de hierro" (This is my palace and it's totally made of iron) most explicitly spoofs on El Palacio's campaign, depicting Berúmen's fierce reclamation of her own body and surroundings (see plate 9). The billboard's manifesto of belonging refutes laments that women lack agency, that monumental Woman's status in the Mexican national imaginary circumscribes all female bodies.

"¿Quién te enseña cómo ser mujer?" (Who teaches you how to be a woman?) directly addresses viewers. The performative design, which boldly advertises the project's pedagogical ambitions, places Berúmen in front of the "Escuela Revolución," questioning not only the technologies of mediascapes but also those of "ideological state apparatuses" like the educational system (Althusser 1971). Finally, "El problema es que pienses que mi cuerpo te pertenece" (The problem is you think that my body belongs to you) features Berúmen on public transportation, sandwiched between

a male gaze and a man brushing her body, two points on a continuum that routinely reduce women to circulating objects. Stuck in literal traffic, but also party to a "traffic in women," lowercased woman flaunts attitude in lieu of self-absorption.

Consistently claiming her primary occupational identification to be that of a performance artist (Wolffer 2001a), Wolffer chose to exclude her own body from *Soy totalmente de hierro*. Instead, conceptually, the project is indebted to culture jamming, early feminist mixed media and theory, and public art. For instance, *Soy totalmente de hierro* recalls the word-image compositions of the US artists Barbara Kruger and Jenny Holzer, acknowledged influences on Wolffer (2001b). It also interrupts Mexico's myth-making penchants, the raw material of the state's postrevolutionary Conceptual -isms. Wolffer addresses the well-rehearsed opposition of a masculinized tradition of public urban art (muralism), while also following David Alfaro Siqueiros's observations that the mural and billboard forms are interconnected. Finally, Wolffer cites a contrasting school of performative self-portraiture evident in work ranging from that of Kahlo to that of the neomexicanist Nahum Zenhil. Like Mayer and Bustamante, Wolffer hoped to broaden her artwork's publics and, with the project, to blur the lines between the popular, the cultured, and the massified. Appropriating tropes of the fashion industry to remap the synapses between Woman, Nation, and Commodity, Wolffer's *Soy totalmente de hierro* espouses a dashing connection of the dots—commodity fetishism and trans/nationalism background the racialized female form, "practicing" the city as an *allo-modern* monument of and to resistance.

If Daniel Montero marks 2002 as corresponding to the year when what had been deemed alternative DF art was redeemed internationally as contemporary Mexican art, Wolffer also cites 2002 as significant for her work, albeit for distinct reasons. By 2002, the everyday effects of the free market's promulgation of "states of exception" were written brutally across Mexico. Unconsciously subscribing to the gender biases that modulate neoliberal doctrine's triumphalist narratives of exceptionality, alter-globalization proponents countered with their own exceptional narrative of the "case of Juárez." *Mientras dormíamos (el caso Juárez)* precipitated a shift in the artist's practice. Alluding to the inadvertent reinscription of a cultural logic that promulgates "disposable women and other myths of global capitalism" (Wright 2006), the title of *Mientras dormíamos (el caso Juárez)* (2002) retains for the artist the right to replicate sensationalist coverage—televisual to juridico-political—of Ciudad Juárez femicide (murder of women).

It has been estimated that one thousand or more women have been raped and murdered and countless others disappeared in Ciudad Juárez, the border twin of El Paso, Texas, from 1993 onward. The number of unsolved murders earned Juárez the nickname of "the city of the dead girls" in the mid-1990s before the border town became the 2010 "murder capital of the world." A puzzling array of conspiracy theories has arisen in response to this crisis: Authorities and laypeople initially claimed the body count to be the work of a group of serial killers. Some have suggested that six Mexican men so wealthy that they are beyond arm's reach of the law are playing a gruesome game with each other. At one point, officials hypothesized that an Egyptian national committed seven of the murders, and then paid a gang and subsequently bus drivers from his jail cell to up the numbers. In the late 1990s, Francisco Barrio, then governor of the state of Chihuahua, blamed the victims, insinuating that they led double lives as sex workers. Others have speculated that the women were caught in the crossfire of the inter-American drug wars, that the police themselves are the offenders, or that the victims were selected through pictures taken of them on payday at the maquiladoras. Countering and supplementing these theories, a cottage industry of films, academic essays, novels, and journalistic articles has followed the case of Juárez (e.g., Fregoso and Bejarano 2010; Gaspar de Alba and Guzmán 2010).

Mientras dormíamos (el caso Juárez) refers to this "total speech situation," but also more specifically to *Mientras dormías*, an early morning segment of 1990s Juárez news that broadcast graphic footage of murdered and mutilated women. Mexico-US border chronicler Charles Bowden borrowed that television segment's title for an essay—often credited with bringing to US readers' attention the femicide in Juárez—that he wrote and published in *Harper's Magazine* (1996). When Wolffer recycles the phrase, she pluralizes its direct address to emphasize collective response, or lack thereof, to "the Juárez case." *Mientras dormíamos (el caso Juárez)*—like Margolles's, Santiago Sierra's, and Yoshua Okón's efforts—implicates its publics and its author on more than one level. In the performance, Wolffer inscribes the circumstances of the missing and murdered women of Juárez onto her own torso in a gesture that follows Mayer and Polvo de Gallina Negra's bookkeeping, Cristina Rivera Garza's theory and practice of "disappropriation," and Mexico City–based journalist Sergio González Rodríguez's epilogue to his book-length "national essay" in *The Femicide Machine*, "Instructions for Taking Textual Photographs" (2012, 99).

Arriving onstage in the clothing of a maquila worker (a simple cover-up

shirt that a female employee would be required to wear on the shop floor, a hairnet, and underwear), Wolffer puts on latex gloves and demonstrates to the audience a black Sharpie pen. A disembodied voice recounts the details of the women's deaths and disappearances in Juárez, the marks of violence on the victims' bodies (missing nipples, bruises, burns, cuts . . .). Wolffer annotates each crime note as if it were a textual photo to be catalogued on her own body.

Schneider (1997, 117; emphasis in original) argues, "[Karen] Finley's literalization of symbolic equivalences is also a spatialization. That is, Finley *maps* the 'hit' of engenderment, the violence of patriarchal gender

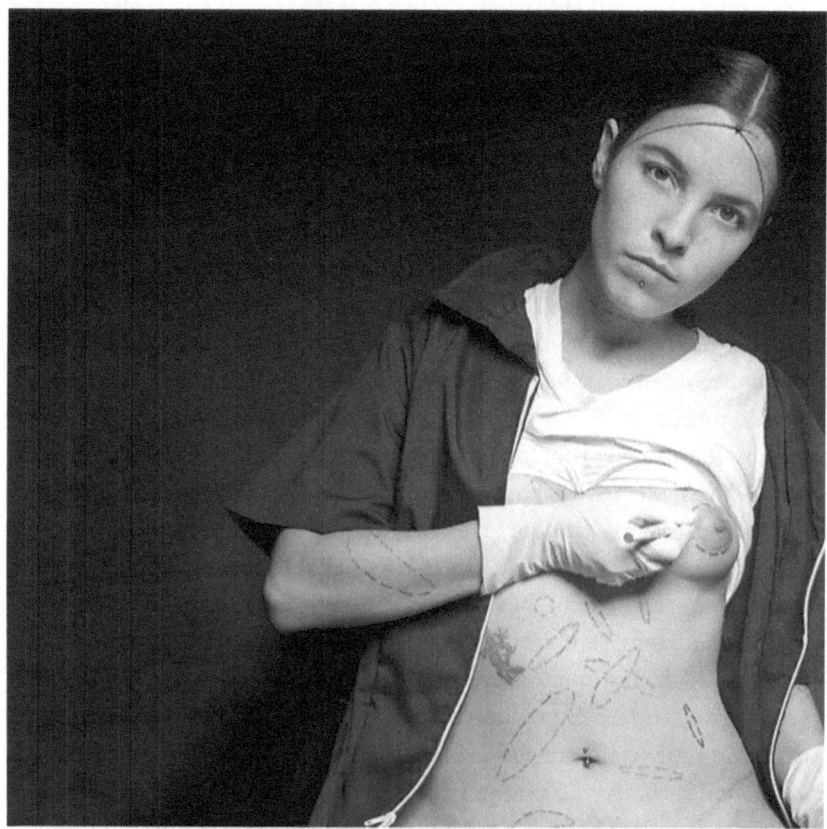

FIGURE 2.2. Lorena Wolffer, *Mientras dormíamos (el caso Juárez)*, 2002, Museo Universitario del Chopo, Mexico City. © Lorena Wolffer and photographer Martin L. Vargas. Courtesy of artist and photographer.

symbolics, upon her bodily parts." In Wolffer's portrayal of the "Juárez case," we witness the symbolic hit of racialized and classed engenderment, the roping off of the expansive crime scene of continental literal and epistemic violence. *Mientras dormíamos (el caso Juárez)* and *If she is Mexico, who beat her up?* allude to the ongoing centrality of Woman in historical mappings of Mexico as an assemblage of aesthetic, economic, and political phenomena, while locating that centrality as inextricably linked to the republic's northern boundary. The performances riff on turn-of-the-millennium symbolic "social dramas," implicit correspondences in the greater Mexican imaginary between Nation and Woman that increasingly substituted Border for Nation (Turner 1982).

Wolffer's paired performances recognize the allegorical slippage between Woman-as-Nation and Woman-as-Border—the symbolic collapse of Mexico into its borderlands. "Damaged goods," "a gaping wound," "a hemorrhaging populace," understood as the racialized feminine and effeminate, the Nation-becoming-Border in these performances shorthands the performativity of continental allegorical habits. With *Mientras dormíamos (el caso Juárez)*, *Soy totalmente de Hierro*, and *If she is Mexico, who beat her up?*, Wolffer maps a spectrum of female objectification by way of de- and reallegorization. At times, Wolffer utilizes a surrogate to perform everyday woman. At other times, she repurposes her own body to mark the coordinates of literal and epistemic violence against women. In all these actions, the artist claims the allegorical performative's ideological indeterminacy, locating her methodology as ontological.

By 2007, however, the artist's modus operandi would move more decisively in the direction of "social practice," a terminology that—full disclosure—causes Wolffer some consternation (Wolffer 2015d). While *Mientras dormíamos (el caso Juárez)* presaged the growing importance of found text and public documents in Wolffer's work and the artist's prior embodiments of Mexico, Wolffer (2015b) poignantly details her own dissatisfaction with the action as a spur to revision, "By focusing on Juárez, I could think violence was *over there*. This was a strategy of denial for me. But violence was never far away." Consciously distancing herself from the disinterested and thus dissociative enactment of damaging metaphor, Wolffer (2015d) strove for "a denormalization of violence, a recognition of its existence in my own history and in that of my neighbor, my mother, or my friend." A definitive shift in Wolffer's engagement with the concept of "el derecho de réplica" roughly coincided with President Calderón's declared War on Drugs, with

the consolidation of a Mexican global contemporary's nod toward a generic political, and with the 2007 passage of the Ley General de Acceso de las Mujeres a una Vida Libre de Violencia.

Designed to guarantee women far-ranging protection against physical and psychological abuse, the latter legislation established a protocol for aiding victims of abuse at preexisting twenty-four-hour emergency shelters. *Soy totalmente de hierro* gained Wolffer unexpected entrée into one of those shelters, the Refugio de Fundación Diarq IAP. No copy remains of the questionnaire that Wolffer distributed there, but the artist recalls how women's nuanced responses to it prompted her to drop any pretext of objectivity in her artivism (Wolffer 2015c). As public policy makers and theorists parsed the semantic differences between "femicide" and "feminicide," as art historians and critics jostled over the best terminology to describe politically and socially minded artwork, Wolffer pondered, How do we reconcile the good intentions of legislation with the everyday lived experiences of women in Mexico? Where do we draw or paint the line on art's abilities to raise consciousness and propel social change?

Such questions, which dominated conversations in the wake of a controversy related to Wolffer's first solo show in Mexico City's Museo de Arte Moderno in summer 2015, honor and echo dilemmas articulated by Elena Poniatowska and others who attempted to write histories and chronicles of the Tlatelolco massacre. Such questions more generally have centered gender and sexuality studies, area and ethnic studies, and an even more capacious array of interdisciplinary experiments in knowledge production since the long 1960s. For example, Gayatri Chakravorty Spivak (1988) famously posed the question, "Can the subaltern speak?" before modeling for readers a deconstructionist and feminist praxis in her essay of that same name. While this is neither the time nor place to parse the details of Spivak's method and argument, it's worth recalling that the postcolonial theorist opens "Can the Subaltern Speak?" with an attention to the "screen-allegories" of some of the most well-regarded theoretical texts penned after France's 1968.

Targeting the work of Michel Foucault, and Gilles Deleuze and Félix Guattari, Spivak argues that we must measure the silences that haunt contemporary political theory's troubling of the "genres of Man." She emphasizes process over product, seeking neither to colonize nor capitalize on the dialectic of identity and difference (a point worth recalling when returning to the lines Alÿs and Cuauhtémoc Medina draw in the sand, too). "Can the Subaltern Speak?"'s contributions to conversations concerning political

and aesthetic representation touch circles of debates in both Latin American cultural studies and documentary studies, notably those regarding the genre of testimonio. While some critics have claimed a privileged position for testimonio as a political tool (Beverley and Zimmerman 1990; Arias 2001; Beverley 2004; Stoll 2008), others, reading literally, have questioned the genre's ability to bear the weight of witness. The opposing positions roughly could be mapped onto long-standing "dissensus" regarding the legitimacy of photography and documentary film's claims on objectivity and transparency. As noted in "City," DF artists in the NAFTA era doggedly insisted on the insufficiency and inefficiency of a generic "return to the real." In "Border," we also will encounter a range of challenges to conventional documentary aesthetics. The shift toward text in Wolffer's practice refashions the implicit and explicit undocumentary drives of both sections' archives, clarifying that undocumentation applies to borders beyond the geographic.

In 2008, the same year that the Ley General de Acceso de las Mujeres a una Vida Libre de Violencia para el Distrito Federal went into effect, Wolffer began to envision narrative explicitly as reparation. *14 de febrero* (*February 14th*) maintains elements of Wolffer's 1990s body art, while also signaling the artist's own turn to testimony. On Valentine's Day 2008, Wolffer, dressed as an adult escort, distributed chocolates at streetlights on Avenida Revolución, a DF artery. The festive candies were laced with the sobering words of Mari, one of Wolffer's interlocutors, "He lit her on fire . . .," "I had to buy brooms . . ."

Language does not function in *14 de febrero* as a repurposed medium, as an "earthword" qua concretization of concession per Santiago Sierra's *Sumisión*. Rather, the gravity of Mari's fragmented life story, more explicitly even than Margolles's found text, "does things with words," charging Wolffer's efforts with the letter and spirit of "el derecho de réplica." Or, in *Encuesta de violencia a mujeres* (*EVM*; *Survey about Violence against Women*, 2008), Wolffer canvassed some two thousand women in the DF Zócalo and in ten metro stations. Respondents who were survivors of violence received a red "≠" button. Project participants fortunate enough not to have weathered physical or emotional abuse firsthand received a green "=" button. To Wolffer's surprise, after one presentation of this project, resonant with Mayer's and other early feminist artists' documentary aesthetics, the secretary of the UNAM's Psychology Department asked if Wolffer would permit her to number-crunch *Encuesta*'s "data." The results—unlike limited government surveys conducted at hospitals, which suggest that married women are more likely to be victims of domestic violence than their

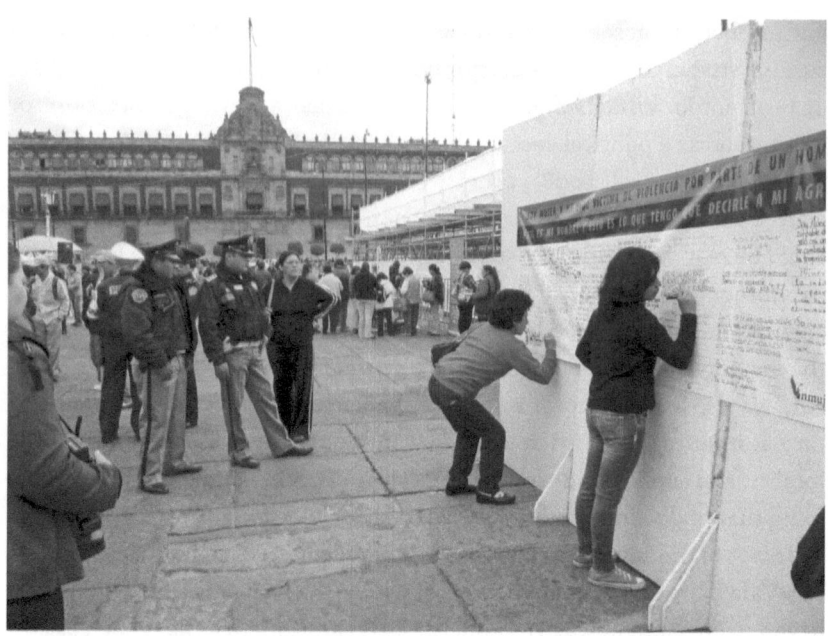

FIGURE 2.3. *Muros de réplica*, 2008, Zócalo, Día Internacional de la No Violencia contra las Mujeres, Inmujeres DF, Mexico City. © Lorena Wolffer. Courtesy of artist.

unmarried counterparts—paint a portrait of an open season on all Mexican women (Wolffer 2015a).

Wolffer's data collection, quasi-undocumentation, prompted the artist to imagine forums for dialogue and witness in the tradition of Los Grupos' community-building PIAS Forms and Mayer's interactive clotheslines. In 2008, Wolffer erected *Muros de réplica* (*Walls of Reply*) in the Zócalo. Within four hours, the project's walls were overflowing narrative repositories. In 2009, in *Actúa testimonial* (*Perform or Offer a Testimonial*), women's responses to their aggressors' verbal abuses became sound art, audio files hanging in the air. From 2010 to 2011, Wolffer organized *Evidencias* (*Evidence*, 2010–2011)—everyday objects and their donors' written explanations of those objects' reuse or repurposing against them. In *Estados de excepción* (*States of Exception*, 2014), for which Wolffer won the 2014 Artraker Award for Social Impact, the artist served four-course meals in public spaces in Mexico in the hopes of generating conflict-free temporary autonomous zones for conversation among female participants. With *Estados de excepción*, the artist, even more meticulously than Sierra or Margolles, particularizes Giorgio Agamben's (2005) use of the phrase, referencing Article 29 of the Mexican

Constitution that suspends the populace's rights in war or conflict, invoked in the state's War on Drugs.

To be sure, Wolffer never ceded her "right to replicate" popular constructions of Mexican Woman in works like *Mapa de recuperación* (*Map of Recovery*, 2009) and *Antimemorias: Enmiendas públicas* (*Antimemories: Public Corrections*, 2011) that involve the artist's body in collective healing rituals similar to *Báñate*'s. Wolffer's mobilization of ritual to mediate the disconnection between legislation and lived experience is striking. Yet in these later actions, Wolffer remains resolute in her refusal to speak for others. Gathered testimony grounds the actions, even as any explanation of its significance across the pieces falls short. "El derecho de réplica," Wolffer's post-2007 corpus suggests, names our individual right to retort, but also marks our shared responsibility to bear witness. In these projects, Wolffer complicates the meaning and practice of mobilizing the literal, revising the terms of her prior embodiment of the allegorical.

KATIA TIRADO'S *PUB(L)IC NICHES*

If Polvo de Gallina Negra created a strap-on maternal prosthetic and Wolffer breathed life into Woman-Mexico before she turned to community-based practice, Katia Tirado multiplies Mexico-Woman by sixty-four in her series of self-portraits *Los nichos púb(l)icos* (*The Pub(l)ic Niches*, 1997).[7] Tirado's photographs of her own shaved genitalia, pierced with widely recognized symbols of mexicanidad, rehearse in-between-ness and transition. They displace the market niche of Woman in narratives of the nation. They obliquely reference the pre-Hispanic, specifically the Pyramid of the Niches in Tajín, Mexico (named a World Heritage site in 1992).

In *Los nichos púb(l)icos*, Tirado's legs frame "emblems of Mexican ideological patriarchy," relegating them to the status of "souvenirs." Tirado (2000) describes her artistic philosophy as a homegrown "voodoo terrorism." A product of the niches that the public sphere generates, *Los nichos púb(l)icos* taps into our knowledge of the postrevolutionary Mexican state's mobilization of monumental Woman.

While some of the emblems that the artist features, like the Mexican flag, are self-explanatory, others signal tensions in the production and maintenance of cultural nationalism, including conflicts between the traditional and the modern and the masculine and the feminine. Tirado's object choices function as both maternal and lesbian phalluses. They cleave along the fault lines of the overtly national, the natural, and the technological. For instance,

FIGURE 2.4. Katia Tirado, from *Los nichos púb(l)icos*, 1997, color photographs, edition of sixty-four. © Katia Tirado. Courtesy of artist.

FIGURE 2.5. Katia Tirado, from *Los nichos púb(l)icos*, 1997, color photographs, edition of sixty-four. © Katia Tirado. Courtesy of artist.

to rehearse mexicanidad, Tirado demo-ed a papier-mâché skeleton for the Day of the Dead and a papier-mâché Judas for el Sábado de Gloria (see plates 10 and 11). To consider the natural, she opted to poke fun at stereotypes concerning the female body. Fish and seedpods contrast with hammers and springs. The juxtapositions resonate with discourses concerning the modern and the contemporary, with gendered, sexualized, classed, and raced constructions of Mexico. Together, the "recuerdos" ("souvenirs," but also "memories") stage critiques of "Woman-is-to-nature-as-man-is-to-culture," but also complicate the analogy by registering that culture itself is feminized in oppositions of base and superstructure.

Functioning autonomously, these images, like the individual practices I consider in REMEX, accumulate meaning when they are read together as a collection of minor symptoms or "critical fetishes." Such an expansive interpretation of "relational aesthetics" extends to the artist's attention to scale.

Tirado repeated many of her choices in varying sizes to document what she regards as a "particularly bipolar Mexican tendency" to miniaturize and monumentalize the world (ibid.). Tirado notes that Mexican culture idealizes the figures of the Woman and the Indigenous, but simultaneously treats literal women and indigenous communities as "diminutives." Per this contradiction, one of the most remarkable things about these images is their cropping. Tirado exposes a female body but blows it up to monumental proportions. The literary critic Marina Warner clarifies that monumental Woman never "refer[s] to particular women, does not describe women as a group, and often does not even presume to evoke their natures" (1985, 12). In Tirado's Los nichos púb(l)icos, Woman corresponds to the Pazian "wound." Tirado contrasts the wound's ability to bear and bare the weight of the now miniaturized national stand-in. The artist's images document the slippage between symbol and allegorical figuration. Like Wolffer's early performances, they generate a feedback loop of de- and reallegorization.

Chow maintains that modernity and nation narration come together in the space of "feminine detail." She writes, "The problem of women . . . can now be rethought as the kind of detail that a culture either dismisses point-blank or subsumes under the largest and most irresponsible terms. Under this double process of erasure, we need to learn to read the tracks of the detail in a different way" (Chow 1991, 119). Clarifying the gender of detail orientation, Tirado's project even more pointedly teaches us how to read the fine print of allegories of empire and nation. Tirado's close-ups track a tension between objects, positioning the female body as that which

potentially constitutes objectification and a more critical interobjectivity in a trans/national imaginary.

Less self- or self-other portraits than object-reorientation lessons, Tirado's images suggest that the political and the cultural hang in the balance between Woman's legs. Well-hung, Tirado's photos explode the maxim that having the phallus amounts to re/producing it. *Los nichos púb(l)icos*'s presentation of the accumulation of miniatures in the alcove or niche of Woman follows García Canclini's (1991, 127) observation that "the tension between monumentalism and miniaturization, between the archaic and the recent, gives verisimilitude to the museum as a staged synthesis of Mexican nationality." Recalling artists' peep shows, ranging from the French painter Gustave Courbet's *The Origin of the World* (1866) to Marcel Duchamp's *Etant donnés* (1946–1966) and the US performance artist Annie Sprinkle's *Post-Porn Modernist* series (1989–1995), Tirado's *Los nichos púb(l)icos* nonetheless dispenses with the necessity of the sanctioned museum space of display. If Vicente Razo advised his contemporaries to stop making readymades and start making museums, Tirado makes both, seeks no architecture outside her self. In this instance, the female body artist becomes the nation's belated, yet greatest sex museum. Tirado spreads her legs wide to address the concept of Mexico in the broadest sense imaginable. But, unlike Razo, she resists disclosing her work's age to be that of NAFTA. In contrast, the exhibition of *Los nichos púb(l)icos*, embedded within a performance in triplicate, contextualizes Tirado's own private periodizing kink.

Ex-civilization's "Wounded Attachments"

Tirado featured *Los nichos púb(l)icos* in an action regarding, but not limited to, female same-sex dynamics. The intervention's homoerotic elements unsettled many of Tirado's publics who read the work literally. Years later, I feel more confident proposing an allegorical interpretation of the experimental theatrical production to supplement prior literal readings of it. Tirado staged *Exhivilización: Las perras en celo* (*Exivilization: Bitches in Heat*, 1995–1997) three times in three places. Presented in Ex Teresa and the Museo Carrillo Gil, *Exhivilización: Las perras en celo* enjoyed its third run in Mexico City's popular central market La Merced, known for its goods ranging from kitchen essentials (cutlery, pots and pans) to human merchandise (sex workers).

The piece's title, like that of *Los nichos púb(l)icos*, requires careful explication, not the least because it depends on another neologism, sometimes doubly translated as "Exhibition/Ex-civilization." That translation, which

produces an asymmetry, does not capture the range of meaning behind the original. "Exhibition/Ex-civilization" buries references to Sigmund Freud's *Civilization and Its Discontents* (1962 [1930]). It indexes the barbarism of free-market fundamentalism. The second half of *Exhivilización: Las perras en celo* layers pun on pun, capitalizing on the proximity of "celo" (heat) and "celos" (jealousy) in Spanish while mixing metaphors. *Exhivilización*, unlike *If she is Mexico, who beat her up?* with its "between men" premise, stages a rivalry between women. When viewing this piece, then, we first must ask: To what end does the work's attention to difference serve? Are both *shes* in this piece Mexico? Or, who or what do these women represent?

While many viewers of NAFTA-era DF art relish the legend of Superbarrio's appearance after Mexico City's 1985 earthquake, appreciate the Mexican artist Lourdes Gourbet's photographic immortalization of the cult of the Mexican film star El Santo and Mexican wrestling more generally, or delight in the Mexican artist Carlos Amorales's mixed-media engagements with the spectacle of the latter (and, I'd add, cite Amorales's infamous 2009 SITAC striptease contribution to discussions of feminist art), few recall Tirado's bold venture into the niche (art) market of lucha

FIGURE 2.6. Katia Tirado, *Exhivilización: Las perras en celo*, 1995, La Merced, Mexico City. © Katia Tirado. Courtesy of artist.

libre. *Exhivilización: Las perras en celo* was promoted as a lucha libre match with a poster designed by Razo of Museo Salinas (see plate 12). It featured two luchadoras (wrestlers), Tirado and the artist Patricia Castellanos. Mariana Botey, the eventual coauthor and curator of *Critical Fetishes* and *The Red Specter*, fashioned the work's unusual costumes. The women's genitalia were connected via a large tube. A series of plastic ropes bound their arms and legs together, making it impossible for either to move without the other in tow. Each participant wore a wrestler's mask, replete with synthetic manes, vests that exposed her breasts, and jaguar-patterned shoulder and kneepads. Tied to each woman's thighs were pistol-shaped lighters, commonly used in Mexican kitchens. The ludicrousness of "the game" was apparent from the outset. At the wrestling ring's four corners were penis-shaped posts (1.6 meters in height), designating the cardinal points north, south, east, and west. If one of the pair managed to reach a post, she would activate it with her lighter and it would "ejaculate" (Prieto Stambaugh, in Taylor and Costantino 2003, 253). While ostensibly the luchadoras competed to "remap the nation," this pair paused to caress one another, to create what the Mexican performance studies scholar Antonio Prieto Stambaugh (ibid., 254) terms, "a sadomasochistic spectacle of phallocentric pain and homoerotic pleasure." Around this center, Tirado projected *Los nichos púb(l)icos*. The photographic series thus accessorized the performance and vice-versa. The images become phalluses representing phalluses in contradistinction to Prieto Stambaugh's fixation on the performance's posts and post-'s, however.

The easy reading of this spectacle remains that *Exhivilización: Las perras en celo* addresses the exclusion of female subjects from the fictional status of monumental Woman. Left to struggle on their hands and knees, the "real women" in the center of the performance only exist beneath the neon representation of Woman as open wound-secret. But the shared exhibitionist streak of *Exhivilización: Las perras en celo* and *Los nichos púb(l)icos* and allegory's recourse to the symbolic in the collapsed public sphere complicate this interpretation. The poet-critic Susan Stewart (1984, 71) argues, "We find the miniature at the origin of private, individual history, but we find the gigantic at the origin of public and natural history." She goes on to propose a reckoning with that dichotomy. In *Los nichos púb(l)icos*, Tirado synthesizes Stewart's perlocutionary opposition, highlighting, *pace* Chow and the French feminist Luce Irigaray (1981), the goods exposed between Woman's legs. In *Exhivilización*, Tirado remobilizes those images to generate a supposed break between the temporalities and temporal lobes of the modern

and the contemporary. The result is a jolt to the continent's brainwaves that disrupts its unconscious. In Tirado's *Los nichos púb(l)icos*, the miniature becomes part of a public and natural/ized history. Reified Woman amounts to the monumental offshoot of a private/public divide, of the Other ghosting the self's portrait. In contrast, the real-worldliness of *Exhivilización: Las perras en celo* slowly accrues the structural violence of meaning.

As discourse in the mid-1990s increasingly cast all Mexican citizens as feminine or effeminate, Mexico, itself ef/feminized, became a lucha libre for capital investment. The contrast between the projected images, the symbols of mexicanidad between Woman's legs, and the women fighting it out in a "marketplace of ideas" suggests the divide between two allegories of the nation-state—one registered in a lofty frame, the other reduced to "bitches in heat." The contrast highlights the contradictory elements of the Mexican revolutionary project and its articulation by way of a suddenly pronounced periodization, as compulsory as heterosexuality: the state's social revolution from 1921 to the early 1940s versus the state's neoliberal revolution from the mid-1950s to the 1990s. *Exhivilización* multimediates the divide between the languages of promised yet deferred modernity and those of contemporaneity, in the imaginary spaces bridging the languages and realities attached to each. Moreover, the performance does so by way of social melodrama.

As Prieto Stambaugh chronicles, after one of these phalluses was lit, a man wearing a gorilla mask carried a woman of short stature, someone who previously would have been referred to as a "dwarf" or "midget," into the ring. She was "dressed as a cross between Miss Mexico and a quinceañera" (Prieto, in Taylor and Costantino 2003, 254). She sang songs popularized by Mexican film. The presence of these additional players makes clear the remarkable range of Tirado's influences, from Tod Brownings's film *Freaks* to Alejandro Jodorowsky's *Santa Sangre*, Mexico City urban underground punk and tattoo scenes,[8] and the environmental theater of Juan José Gurrola and director Julio Castillo, the artist's former teachers. What's left to unmask? Promoting first the precarious location of lowercased woman, Tirado displays the wares of Woman as cultural capital. She renders the public and the national, curiously diminutive as dangling fetishized objects, caught in between, in transition. In *Los nichos púb(l)icos* and *Exhivilización*, Tirado de- and reallegorizes the female figure like some rapid code-switch between the multiple connotations of the projects' titles. The projects operate in conversation with the work of Wolffer, but also with artwork by the sex-positive DF performance artist Rocío Boliver and the

now defunct DF performance collective EDEMA (Eduardo Flores and Ema Villanueva). *Los nichos púb(l)icos* and *Exhivilización* re-perform the opposition staged between the solitary male citizen-subject and the subversively narcissistic woman in the shadow of monumental Woman, but the carnivalesque performance does not stop there.

Denaturalizing the naturalization of Woman-wound-Border (racialized) as a symptom and monument in the psychoanalytic and anthropological double helix of Mexican nationalism, Tirado reclaims the use value of a metanarcissism. She insists on repositioning Woman as both intersubjective and interobjective, as a vital connector in the allegorical synapses of the nation-state. Finally, following the Italian Marxist Antonio Gramsci's mandate that "the starting-point of critical elaboration is the consciousness of what one really is . . . as a product of the historical process to date, which has deposited in you an infinity of traces, without leaving an inventory" (Gramsci, quoted in Said 1978, 25), Tirado, true to her own name, honors the "discarded." Upping the ante on taking inventory, she reactivates state-sanctioned fetishes and the stereotypical "feminine" emotion of jealousy in the service of transnational critique.

SILVIA GRUNER'S FUCKED-UP ETHNOGRAPHIES

If everything hangs in the balance for Tirado, no one can bear to wear the weight of Silvia Gruner's accessories. *Collar de Antigua* (*Antigua Necklace*, 1995), a 6-meter-long string of red, white, and blue beads created from washing soap found in Antigua, Guatemala, spans the steps of a Mayan ruin, hangs from the elaborate façade of a crumbling colonial church, as if to connect disparate baroque sign systems. Gruner describes the work as a "waiting piece," as something she created after "sitting Shiva" (in the wake of her father's passing), as a prelude to *El nacimiento de Venus* (*The Birth of Venus*, 1995). It is part trade fetish in the transatlantic Arab, pre-Hispanic, Judeo-Christian, and African imaginary; part abacus; part rosary. As the literary critic Emily Apter (Apter and Pietz 1993, 3) reminds us, "Fetishism as a discourse weds its own negative history as a synonym for sorcery and witchcraft (*feitiçaria*) to an outlaw strategy of dereification." We might expand upon Apter's point to note that the strategy loops to encompass re-reification.

An image of *Collar de Antigua* on a billboard crowns the corner façade of the iconic Art Deco mixed-use building Ermita (1930–1931) in the Colonia Condesa near Chapultepec Park, itself a crowning jewel of the architect

Juan Segura's experimental pluralization of the modern. In the 1970s and 1980s, that vertex, where Avenida Revolución and Avenida Jalisco feed into one another, advertised "Mexico Calza Canada" (a popular shoe brand). *Collar spectacular para el edificio Ermita (Spectacular Necklace for the Ermita Building*, 1997) assigns new meaning to "Mexico wears Canada," in the NAFTA era. The multimedia artist Silvia Gruner, like Tirado, reMexes postrevolutionary anthropological and psychoanalytic nationalisms, but also mass and consumer culture, as if to suggest, like PGN, that each represents limbs on and of the same monstrous effeminized social body. Like Tirado, Gruner revalences "feminine details." More sharply than Tirado, Gruner homes in on the gendered significance of Mexico's museum-ification.

If we already witnessed artists' post-1968 institutional critique in "City," Gruner scrutinizes anthropological nationalism's investments in the indigenous and the feminine. Linking anthropological nationalism to cartographic constructions of the republic, Gruner targets indigenismo as a racialized, sexualized, classed, and gendered ideological state apparatus, interrupting its operation with a de- and reallegorization of Woman. In turn, the artist generates counterinventories of mexicanidad that straddle nation-states and millennia. Gruner (1996), who received her BFA from Bezalel Academy of Art and Design (Jerusalem, Israel) in 1982, and her MFA from the Massachusetts College of Art (Boston) in 1985, claims that from the beginning of her career, she sought to rescript anthropology, archaeology, and architecture as mediums for interpreting and representing Mexican culture in global and local contexts. If, as Claudio Lomnitz (1996) and others have observed, in Mexican cultural production the literary, the aesthetic, and the social scientific have enjoyed a symbiotic relationship, Gruner's oeuvre draws upon this threesome's "interior circuit," referencing ethnographic and archaeological narratives to highlight their constitutive ambivalences.

Camera-roll, in her video installation *Inventario* (*Inventory*, 1994), Gruner (1996) sought to maximize the potential of "the anthropological language of the camera" in her representation of the household objects in a man and woman's separate rural homes. Gruner (ibid.) describes the piece as an examination of the "cultural remnants of the country through which I reconstruct stories." But her presentation of the work breaks with the realist or documentary pretexts of the social sciences. Underscoring her gendered re-vision of anthropological nationalism by culling the household objects she examines into the categories of "male" and "female," Gruner instead mines the museum per the African American conceptual artist Fred

Wilson. In *Natura-Cultura* (*Nature-Culture*, 1996), a series of 156 color photographs, Gruner ties red ribbons around each object she includes in her inventory—from handicraft to shoe to broom—before depositing them in the piece's frames or "niches." Gruner summarizes *Natura-Cultura*'s significance in terms that recall Tirado's description of *Los nichos púb(l)icos*:

> [This is] an installation of objects found by way of an archaeology of cultural residue . . . This work is located in the place where the categories (of "nature" and "culture") are erased, ridiculed, and rendered mythic. The value of the objects is reinstalled and reflected in relation to their physical presence and their artistic-magical order. (2000)

In *Fetiches domésticos* (*Domestic Fetishes*, 1992), Gruner reconstructs and groups together various found objects from rural households to suggest a relationship between the domestic, coded as indigenous (that of the home), and the national (that of a fragmented Mexican corporeality, specifically an effeminized body politic). A "comal" used to make tortillas becomes a stage for a set of tchotchkes that are both folkloric and mass-mediated. Hanging clay pots on closer examination are inscribed with the Old Testament names "Salomé, Judith, Sansón y Absalóm." The project loosely follows others by Gruner that teach us to expect Indians in a range of unexpected places in the pan-Mexican imaginary. (We might note the traces of Jews in unexpected places, too, or more precisely, Gruner's encryption of the crypto-Jew in the greater Mexican unconscious.) The impulse behind *Fetiches domésticos* is distinct from that attached to the younger Mexican artist Tania Candiani's border-based transformations of household objects like colanders and brooms into helmets and spears in *Protección familiar* (*Family Protection*, 2004). But, it shares affinities with Candiani's homegrown "weapons of the weak" insofar as both artists' efforts radically repurpose the "gross domestic product" to map, but also ward off, literal and epistemic violence perpetuated in the name of racialized and sexualized Woman. More precisely than Candiani's project, in name alone, Gruner's anticipates Botey and Medina's formulation of "critical fetishes." Indeed, all of Gruner's 1990s work offers a layered feminist critique of anthropological qua indigenista constructions of women and the indigenous poor in Mexican culture and of the racialized ef/feminization of Mexico in neo- and postcolonial transnational narratives. These counterinventories only partly explain Gruner's subsequent references to a pre-Hispanic past, though. Gruner clearly is concerned with the generic reification of mexicanidad in the 1980s–1990s moment, epitomized

in and by the formulation of neomexicanismo, but also in the expectations of an emerging DF alternative for the most part oblivious to the experiences of actual women. (In this regard, Gruner's efforts, like Wolffer's early body art, address the symbolic.) Gruner's inventories purposefully don't match up; she will not play the violated or glorified nation (recall that Olivier Debroise conscripted Gruner for *Un banquete en Tetlapayac*, specifically to play the part of Kahlo).

In the video installation and time-lapsed photographic series *Don't fuck with the past, you might get pregnant* (1995), tellingly titled only in English, Gruner creates another maternal prosthesis qua phallus. With her index finger, she "fucks" several small pre-Hispanic stone fertility goddesses. Gruner's references to a postrevolutionary anthropological nationalism are not lost on Medina—although, he does not refer to them as such—in his "La prohibición como incitación" (Prohibition as incitement; 1998). Instead, Medina inserts midway through his essay "a real-life parable": the story of Mexican president Ernesto Zedillo Ponce de León's May 1997 reception of US president Bill Clinton in Mexico City's National Museum of Anthropology. Medina cites a section of a local newspaper's coverage of Zedillo's cultural diplomacy, "The atmosphere was pregnant with all the weight of the past" (Medina, in Gruner 2000, 14). What merits no mention in Medina's otherwise clever social allegory: the wait of the present effeminizes the Mexican nation-state, a prohibition that resurfaces as a provocation as irreverent as any forwarded by Yoshua Okón and Miguel Calderón. *Don't fuck with the past, you might get pregnant* catalogues "fucked-up" versions of Mexico's History with a capital *H*, instantiated in and by the hybrid formation of an anthropological-psychoanalytic nationalism, actively forged in a dialogue between Mexico and the United States from the 1920s onward.

The conjunctive allegorical figurations of Woman and Native stand in for Mexico's ongoing continental subjugation, mirroring Trinh T. Minh-Ha's assemblage of *Woman, Native, Other* (1989). But, years later, the project's title and contents also reverberate as a warning to the would-be (art) historian of the alternative-becoming-contemporary who'd force *Don't fuck with the past, you might get pregnant* into too narrow a slot of interpretation.

In another time-lapsed series of photographs, Gruner reMexes the conceit of *Don't fuck with the past, you might get pregnant* to critique the commodification of Mexico and Mexican art in the wake of NAFTA's passage. In *How to Look at Mexican Art* (1995), whose title in English not only speaks but shouts as loudly as the meaning of the words that compose it, Gruner's fingers do the work of "fucking" what stands in for Mexico—a "molcajete"

FIGURE 2.7. Silvia Gruner, *Don't fuck with the past, you might get pregnant*, 1995. © Silvia Gruner. Courtesy of artist.

(stone mortar and pestle used to grind corn). Gruner's molcajete is so overused, a hole is worn through its base. Gruner's disembodied finger tests that hole, the expectations externally imposed upon, but also internalized by, Mexican artists.

How to Look at Mexican Art proves genuinely instructive if we recall the increasingly exceptionalized narrative of a DF contemporary set against the literal and imaginary geographies of the "Mexican exception" of the NAFTA-era continent. The image/video/installation once again reflects Gruner's fascination with Mexican household objects. It also links that fascination explicitly to Gruner's concern with trans/nation narration. In *How to Look at Mexican Art*, Gruner, like her contemporaries, addresses Mexico's exoticization that doubles as the republic's effeminization and economic emasculation (rethink US postrevolutionary-era fervor for the Mexican folkloric, rethink neomexicanismos). Six degrees, in turn, separate *How to Look at Mexican Art* from the artist's video performance *In Situ* (1996).

FIGURE 2.8. Silvia Gruner, *Don't fuck with the past, you might get pregnant*, detail, 1995. © Silvia Gruner. Courtesy of artist.

Like Tirado's *Los nichos púb(l)icos* and *Exhivilización: Las perras en celo*, *In Situ* juxtaposes the monumental and the miniature. "In *her* original place," in position, site-specific, Gruner as artist-giantess holds between her teeth another pre-Hispanic fertility goddess, modeling and licking its backside. Gruner's reference to Freud's vagina dentata is obvious here; her reference to Mexico, more oblique. What Gruner mouths remains up for dispute. Gruner cites constructions of a mythic past, which fetishize Woman by reducing her to a pre-Hispanic stone idol and constructions of the nation-state repackaged to sell a period and a place. That said, the artist never narrates transnational consumption in singular or linear terms, but overlays the territories mapped by *allēgoria* with a dizzying array of borders and circuits that braid cartography and kinship into one another.

"The Jewish Question"

If Gruner's 1990s work repeatedly stages an archaeological dig in the post-revolutionary Mexican political and aesthetic unconscious, it concomitantly underscores the subjective quality of her own interventions in that project as a Jewish Mexican woman. Frequently, Gruner has incorporated

into her practice the details of her mother and her grandmother's exile to flesh out her own self-diagnosed "borderliness" (Gruner, in *inSITE2000–01* 2002, 184). Like Wolffer's work, Gruner's hybrid pieces dwell in a "disjuncture and difference" (Appadurai 1996) that collapses the Nation into the Border (although with Gruner, we see time and again various borders through her invocations of Guatemala, the United States, and faith-based statelessness). If *In Situ* inserts a parodic feminist orality into Gruner's aesthetics, *El nacimiento de Venus* reshapes Gruner's oral fixation. In contrast to Okón, who does not identify as "Jewish," Gruner imbues her artwork with an awareness of her family's diasporic consciousness.

While the title of the intervention suggests a remake of a classical depiction of feminine beauty and its maintenance (the toilette of Venus), Gruner (2000) explains that her ultimate inspiration for this multimediated piece was her discovery of a soap-making machine in Mexico City that featured a Nazi swastika. The machine prompted Gruner's artistic reflections on her family's passage from Europe to Mexico: In 1945, Gruner's grandmother (Sidonia Karman) and her mother (Ana María Gruner) were rescued from the Ravensbrück concentration camp by the Swedish Red Cross. A year later, Karman and Gruner senior sought asylum in the Americas. *The Birth of Venus* includes videotapes of Karman narrating in English her experiences with the Nazis and of Gruner senior offering childhood memories in Spanish of the consequences of her family's displacement. In direct reference to the Nazi manufacture of soap from human fat (and in clear contradistinction to SEMEFO's and Margolles's use of the latter), Gruner produced with the recovered soap machine thousands of pink pre-Hispanic goddesses: a hybrid primitive—anthropological and psychoanalytic—commodity fetish. She then scattered these talis*women* throughout *The Birth of Venus*, putting some in boxes, using others to line walls. In some of these boxes four of the soaps appear. Two are stamped with the numbers that were tattooed on the arms of the artist's mother and grandmother. The other pair carries numbers that the artist assigned to herself and her sister, postmemory survivors of the Holocaust. Finally, in several articulations of the exhibit, including one in San Diego, California, Gruner packed the equivalent of her own weight into a self-portrait as plainspoken in its title as any of Sierra's—*Mi peso en jabón* (*My Weight in Soap*, 1995). Gruner also stenciled a self-reflective fragment onto one wall of the exhibit that refers to her grandmother, her mother, and herself: "The three of us, like the soap-machine, have not turned out to be historically 'biodegradable'" (Gruner, cited in Pincus 1998).

The postcolonial literary critic Anne McClintock forever has altered how I will see soap. McClintock (1995, 214) examines soap advertising as "allegor[ies] of imperial progress as spectacle." She reads the advertisements as presenting soap as a fetish "that is both art and commodity" (215), "as a technology of social purification, inextricably entwined with the semiotics of imperial racism and class denigration" (212). If soap for McClintock represents a both/and, for Gruner, it illuminates the missing link in considerations of the nonnegotiability of certain subjects' challenges to the imaginary geographies of empire and nation. Indexing Gruner's identity, *The Birth of Venus* complicates ongoing narratives of belonging and difference, appearance and disappearance, documentation and undocumentation.

The performance studies scholar Ann Pelligrini writes, "The Jewish woman cannot appear in [Sander] Gilman's analysis [of Freud] except in drag: as a Jewish man *or* as a 'whitened,' presumptively Gentile, woman. *All Jews are womanly, but no women are Jews*" (1996, 28; emphasis in original). Gruner corroborates Pelligrini's thesis while also amending it, *All Mexicans are womanly, but no women are Mexicans . . . all Mexicans are womanly, but no women are Jewish Mexicans*, especially from the early 1980s through 2008. Like *Don't fuck with the past, you might get pregnant, The Birth of Venus*, one of four representations of the goddess referred to by the Israeli art historian Gannit Ankori (2001) as a "Jewish Venus," de- and reallegorizes Woman, de- and reterritorializes Nation as collapsed categories of identification in Mexico and beyond. If the dissolution of the *Collar de Antigua* initially seems like a welcome prospect, no amount of bubbles in the air, pace Margolles's *En el aire*, would be sufficient recompense for *The Birth of Venus*'s disappearance. *The Birth of Venus* incorporates the personal into the racialized and nationalized commodity fetish, re-siting identity as the sum total of its durable contradictions. The work "births" future motility into Gruner's corpus, reconfiguring the artist's interests in (Nation-)Woman as a steady-state attention to a recitation of the psychoanalytic, too.

Gruner's inSITE2000–01 PIA, a performance-video-installation titled *Narrow Slot/Sueño paradójico (Hendija estrecha/Paradoxical Dream)* probes the relationship between the artist's and Mexico's histories and the particular role of art in each's "scripture." If for inSITE94, Gruner created a memorable string of pre-Hispanic goddesses (Tlazolteotl, the woman in childbirth) to "[construct] a false, symbolic museum of anthropology . . . in one of the most conflict-ridden and least accessible stretches of the [Mexico-US] border" (see Debroise's essay in *inSITE94* 1995, 31), with *Narrow Slot*, she generates an archive of film footage and tape recordings that

mine the artist's "internal borders" (Gruner, quoted in *inSITE2000–01* 2002, 186). Gruner hired one psychoanalyst from Tijuana and a second from San Diego to drive her car back and forth across the Mexico-US border. She lay in the backseat. While each analyst took turns at the wheel of analysis, Gruner discussed her border-line tendencies. The recorded banality of the artist's "Tijuana–San Diego sessions," in contrast to the collective Nortec's iconic "Tijuana sessions," in oblique reference to the limited number of slots for artists in inSITE or other expositions, also attests to the narrow slots of identity and difference. Unable to achieve "normalcy"—a consolidated citizenship-subjectivity—Gruner presents an inventory of her fragmented personhood. The US-Mexico border—another "narrow slot" or shared 21 miles in the region—is crucial to these conversations, remediating the whole of Gruner's prior and future corpus as border studies.

As it did in many DF artists' efforts around the turn of the millennium, the organizing principle of Gruner's work moved away from a local recursive articulation of mexicanidad toward an elaboration of the global in borderized terms, a reterritorialization of Mexico as a sensibility or non/site versus a superfluous sited citation (Gruner 2012). Borders choreograph Gruner's video installation *Un chant d'amour* (*A Song of Love*, 2004, 10:22 min.) that takes its conceit and title from Jean Genet's only extant film (1950, 26 min.). Genet's project must be read against his sustained and multifaceted engagement with literal and symbolic borders, ranging from sexual prohibition (as incitement) to the Palestinian struggle for self-rule. Gruner's *Un chant d'amour*, roughly contemporaneous with the pop star David Bowie's tribute to Genet's film, features two male prisoners who communicate with smoke signals through a "glory hole" as a guard watches and masturbates. In the artist's adaptation of Genet's love song, Gruner herself (parenthetically present in absence) becomes the voyeur-guard between men. In conversation, she describes her research for the project in often run-down porn theaters. She shares details of the work's reception, claiming that while each installation of *Un chant d'amour* was unique, she consistently sought to create temporary autonomous zones of intimacy (free trade zones, so to speak) with and for the project. Gruner delights in the fact that couples flocked to the Sala de Arte Público Siqueiros in Mexico City to make out when it was exhibited there. Finally, the artist locates *Un chant d'amour* in her work's trajectory, clarifying that it forms part of her turn away from the explicitly "mexicano" (Gruner 2012).

But how far did Gruner turn? Or, perhaps better put, how far did she fall from Mexican art's family tree? By her own account, she increasingly

defied expectations imposed upon her to produce the commodity of contemporary Mexico, its NAFTAfication after the mid-1990s. Gruner marks her two-channel video installation *Away from You* (2000) with its title—as showy in English as *How to Look at Mexican Art*'s—as shifting the paradigm of her production. Presented in 2003 at Mexico City's Laboratorio Arte Alameda three scant years after the space's opening, *Away from You* is routinely reduced to yet another lover's monologue. The didacticism of this interpretation dishonors the piece's translucent qualities, the motion of light in water it activates. Literally, *Away from You* tracks a woman who swims back and forth. Looping, the female form is central to *Away from You* but hardly archetypal. While she does not cross the neat lines laid out for her by the pool's lap lanes, her mind seemingly wanders, as if Gruner were layering her claim on the transnational. Put differently, this swimmer cannot get any distance from us—her publics—from the expectations we bring to her, and by extension Gruner's, life/work. Disallowed the conventional screen of allegory, she underscores the real's mediated relay. Pushing off and back from interpretations of *Away from You* that expose an excessively emotive interior circuit, Gruner goes cerebral in her description of the project's conceptualization, "None of my previous works is as specifically architectural as this piece. Using the video as a starting point, I'd note that I had the opportunity to design a swimming pool in a hotel in Playa del Carmen (Quintana Roo), and that experience, the pool itself, informed my filming of the legend *Away from You*" (Gruner, quoted in Ceballos 2003).

Gruner's cool legend of expanded architecture and cinema exacts a critical dis/association, a saline-laced dissociation that renders the broken romance, to which this piece alludes, universal salience. Gruner resorts to the reinvention of the glossy poolside scene, repurposing a region long associated with Mexico's "Splendors" (recall the extradiegetic advertising surrounding the special advertising section used to promote that exhibition), to re-site the work's local appeal. Plato's cave (allegory) is built from below, literally from the ground up, but also is dappled global in this new "PIAS Form" (video-installation-performance). Which is to say, the work casts the dilemma of Mexico City NAFTArt in an altogether different light: a pool of talent—greater Mexican artists—is consigned to the repeat performance of Mexico (City) as object. As a critical mass, these artists sink or swim, at their own risk, on the global market. Gruner's legend *Away from You* uncannily remediates *How to Look at Mexican Art*. Like *Un chant d'amour*, the work reverberates as more or less of a challenge to long-standing

labyrinth-of-solitude mandates to profile national character. The invective, a performative, of both *Away from You* and *Un chant d'amour* glides into an elided difference: to read against the grain of the works' compartmentalized interpretations.

Against psychoanalytic nationalism, of erect walls and a hole, *Away from You* resonates with installations of fragmented swimming pools produced by the DF-based minimalist Sofía Tabóas from 1999 onward, with the Scottish artist Anya Gallaccio's untitled 1994 contribution to inSITE, and with Natalia Almada's short film *All Water Has a Perfect Memory* (1999). *Away from You* dissolves into the murkier depths of *Un chant d'amour*, resurfacing to mark each's renovated bid on the allegorical as the overarching architecture of the period's master narrative. Conjuring "the long hiss" of US immigration control's homoerotics (Brady 2008), *Un chant d'amour*, like *Narrow Slot*, remains fixed, fixated on the psychic proximity of the Border to Woman, this time redacted to encompass "Other extremes." Or, like Gruner's earlier action *500 of Impotence or Possibility* (1995, 10 min.), it dredges the channels of collective memory. In the latter 8mm film, an industrial crane ceaselessly dips a 500-kilogram necklace of beads, fashioned out of volcanic rock and strung on steel wire, in and out of San Diego Bay. The sound of the crane's movement is mediated by the lap of two waves, the ocean and traffic on the freeway, running parallel to one another and the project. Woman, like the anniversary of the colonial encounter, is only suggested here like a rumor, a murmur, or a waking dream. She resides in the un/canny of the continent's political and aesthetic unconscious like so many parallel dark continents.

If Woman historically served as a Mexican monument, after 1994, the force field of her sacred and profane union with the Nation was mapped more generically as feminine or effeminate in relation to Mexico's industrialized and militarized northern border, in relation to Culture with a capital *C* as the state's diplomatic emissary. Prior collapses of Woman into Border were aggravated by and aggregated into wider conversations regarding neoliberal globalization. Gruner rethreads the beads of Woman-Nation-Border time and again to create alternate "collares" of dis/identification. As unforgiving as Margolles, she sounds off, chiseling a title—*Un chant d'amour*—into the walls of exhibition spaces.

The pink noise of the phrase's execution challenges sound bites of socioeconomic restructuring, the structural violence of the latter's in/civilities. Again, like Margolles, Gruner stages "inoperative community," coupling shadows on the theater walls of transition. Both artists promote

more than compartmentalized representations of consumer qua sexual choice, however. Disaster porn for the twenty-first century with all its fettered relativity, *Un chant d'amour*, like Gruner's work more generally, like Margolles's, reminds me that the palpable longing buried in be*longing* can be outlawed and outsourced by the processes of borderization, but it also always makes home unhomely, another step on the road to historical recovery or undocumentation. Nation-continent-planet: Gruner's corpus reMexes the feminine as traitorous arbiter and accessory of the allegorical performative.

NAO BUSTAMANTE'S INTER-AMERICAN PAGEANTRY

In 1992, a woman stepped onto a floodlit stage, conspicuously outfitted as a "post-modern Aztec Priestess/Dominatrix" (Muñoz 2006a, 196) in a feather headdress, leather gloves, a scanty bikini and harness. Inviting white men to step up and atone for their sins of Conquest, she personified a period that the United States is still passing through, the culture wars. Explicitly citing the quincentennial celebrations of the discovery and conquest of the Americas, the artist parodied the era's quintessential expression of neoliberal guilt (versus re/producing it). She strapped on a burrito as a dildo, another critical prosthesis. Her supplicants bent down to take a bite out of their crimes against the Americas. Who wouldn't want tasty absolution in this parody of truth and reconciliation? Nao Bustamante's efforts hum in the NAFTA-era's key of re menor, too.

Bustamante's work spans multiple mediums—performance art, installation, video, public intervention—and the Mexico-US border. Born in California, Bustamante attended the San Francisco Art Institute, "cutting her (artistic) teeth" in the Bay area art scene between 1984 and 2001 (http://www.naobustamante.com/about.html). Perhaps best known for her renegade appearances on *The Joan Rivers Show* (1992), where she played Rosa, a "stunt exhibitionist," and on Bravo's reality television series *Work of Art: The Next Great Artist* (2010), Bustamante nonetheless never needed to be re/discovered.

Indig/urrito, one of Bustamante's early works, humorously gives its viewers timespace to remediate affectively reparative readings of gender, sexuality, and race. José Muñoz considers the ritualistic elements of *Indig/urrito* or, more specifically, the (nervous) laughter and discomfort it routinely invokes in explicitly psychoanalytic terms. He notes that biting down on and ingesting the mythic phallus—the joke of *Indig/urrito*—centers on

the wish "for the other to absolve us of our negative emotions" (Muñoz 2006b, 196), but also sometimes disturbs male viewers with its simulation of fellatio. He adds that the "butt of [this] joke is not only white men in general, but . . . one white man in particular: Freud" (ibid.). And, almost like an aftertaste, he muses that Bustamante's queer phallus (like Butler's lesbian one) is racialized as Mexican.

Indig/urrito—a neologism already split as the subject or the North American continent—splices the words "indigenous" and "burrito" into one another. A mouthful: what more can be said about the *pun*ishing phallus of Bustamante's gesture? For starters, after the other Bustamante's—Maris's—*La patente del taco* (and her penis-nose), after Superbarrio's tamal cooking lessons, it would behoove us to be patently clear that food materializes, matters in inter-American relations. The "burrito" (literally the "little donkey" in Spanish, read as "little ass" in this delectable scenario) is regarded as resolutely Northern Mexican (Ciudad Juárez), Southern Californian (Los Angeles, San Diego) cuisine.

In other words, from its impious impetus, the burrito was of and from "greater Mexico." But, when (Nao) Bustamante holsters the burrito instead of the dildo or the gun, when she gerrymanders half of her performance's title as "-urrito," she takes a bite out of another neat reference to uneven, homosocial power relations—the long-standing affective apparatus of the border "between men" that lubricates both the fictions and frictions of Northern Mexico and the US Southwest. Moreover, when she replaces the *B* of "Burrito" with the castrated specter of the "indig——-," she seasons her performance's racialized recipe with a historically site-specific (sex) panic. Only half a claim to territory, as close to indignation (indig/nation) as indigeneity, Bustamante's fusion cuisine neither pledges allegiance to the abiding US gastronomical allegory of the melting pot nor caters to the "Ho" of Westward expansion. Piling it on, Bustamante as "iron chef" rejects the national profiling inherent in postrevolutionary Mexican psychoanalytic nationalism, the DF-centrism of José Vasconcelos's borderism, "La cultura acaba donde empieza la carne asada" (culture ends where grilled meat begins).

Bustamante offers another aesthetics of incorporation, of illicit union. Get it up. Documentation of the performance demonstrates the fulsome power and pleasure of transnationally campy abjection—an Otherworldly w/holiness like a sacrament, taken kneeling, that some of *Indig/urrito*'s enlisted clearly savored as part of their participant observation. The joke, after all, is on all of us, the children of Freud on a continent worlds away

from the Continent, the progeny of the activated prop of Woman. Bustamante, as "gurugay" as Liliana Felipe in *Los hijos de Freud* (a Mexico City 2001 cabaret classic by the indomitable Jesusa Rodríguez and Carmen Boullosa), reconfigures herself as a vessel and agent of New Age-y (New World B/order) attrition. The Mexican flavor of *Indig/urrito* vitally factors into its reparative queerness, its promise of a critical accounting of an identity with difference. In Muñoz's interpretative universe, however, the advantages outweigh the disadvantages of downplaying the "Mexicanness" of the performance and of Bustamante's work more generally.

Muñoz elegantly makes the case against "vulgar Mexicanist" readings of Bustamante's corpus on more than one occasion. In "The Vulnerability Artist: Nao Bustamante and the Sad Beauty of Reparation" (2006b), his dismissals of such exercises in racialized interpretation are not as absolute, however. Like Grant Kester's regarding Sierra, they are dislocated from the scene and "scenarios of rediscovery" that *Indig/urrito* supplants. The contradictions in Muñoz's readings deliciously invite "disidentification" with the conclusions he later reaches regarding Bustamante's potential purchase on a continental remexicanidad. The postcolonial theorists Ella Shohat and Robert Stam instruct:

> The "Columbus story" is crucial to Eurocentrism, not only because Columbus was a seminal figure within the history of colonialism, but also because idealized versions of his story have served to initiate generation after generation into the colonial paradigm. For many children in North America and elsewhere, the tale of Columbus is totemic; it introduces them not only to the concepts of "discovery" and the "New World," but also to the idea of history itself. (1994, 62)

In the early 1990s US culture wars, we must recall, conscientious objectors challenged the "sanctioned ignorance" of celebrations of Columbus's "discovery" of the Americas. They also recognized the relationship between the debates surrounding that "discovery" and conversations about Westward expansion, free trade, and the New World Order. The stakes were nothing less than the proliferation of histories, the "unthinking" of Eurocentrism.

On the frontlines of this battle, a critical mass of artists reperformed the colonial encounter to draw attention to mainstream allegorical appropriations of the Columbus story and reactions to calls for critical reflexivity regarding its rehearsal. Because Bustamante's *Indig/urrito* indexes these 1492/1992 "Columbus debates," any pat dismissal of the work's

"mexicanidad" needs to be taken with a grain of salt (that recognizes the artist's far-reaching impact; e.g., consider the unappetizing citation of her work in the discrediting of her brother Cruz Bustamante's 2003 California recall election). *Indig/urrito*'s reference to the legacies of the Conquest situates the performance as decidedly greater Mexican.[9] Decidedly layered, the performance participates in the larger conversation that elided the Conquest and the continent's neoliberal transition, too. Bustamante plays on the "wages of whiteness" and maleness, on stereotypical dismissals of multiculturalism that portray the latter as demanding unfair contrition. But she also serves up all of the above as a joke, not on Freud, but on the historical psychoanalysis of a continent. Bustamante outs the obvious, the stakes of the 1492/1992 "looking glass" in and with *Indig/urrito*. Territory and the female form collapse into one another, become the background against which history reveals itself once again to be tragic-comic. The resulting standpoint hauntology carries over into Bustamante's *America the Beautiful* (1994–2002).

Teetering on a towering ladder, climbing up and over it, the artist personifies the struggle to consolidate the historically ef/feminized allegorical figuration of "America." *America the Beautiful*, which Bustamante has presented in various locations, formed part of her contribution to the landmark binational collaboration between five US-based Latinx artists and five Mexico City–based artists, *Terreno Peligroso* (*Danger Zone*, 1995), which included Wolffer and Guillermo Gómez Peña and took place at UCLA and in Mexico City's Ex Teresa. *Terreno Peligroso*'s title alone conjures the artists' shared cartographic ambitions. In conjunction with, but also in departure from, the feminist and queer performance studies scholar Laura Gutiérrez's reading of the performance as a critique of Marilyn-Monroesque blonde ideals (2010, 143), in accord but also disaccord with Muñoz's more general interpretations of Bustamante's work as feeling the down of brownness (2006), could we entertain the possibility that *America the Beautiful* more fully grounds *Terreno Peligroso*'s continental ambitions than any of the other contributions to the project?

Formally speaking, *America the Beautiful* draws upon various traditions of performance art, especially those implicitly gendered female, even as it locates the Latina body in between—in transition and transit—on top of a ladder-turned-pedestal. A political burlesque show that predates *Politics of Rehearsal II* and *If she is Mexico, who beat her up?*, *America the Beautiful* returns me to Jones's (1998, 215) reflections on the virtues of "subversive narcissism," in this instance, part and parcel of my investment in apprehending

FIGURE 2.9. Nao Bustamante, *America the Beautiful*, 1995, Ex Teresa, Mexico City. © Nao Bustamante. Courtesy of artist.

literalization as an *allo*-tactic of de- and reallegorization. Using her body and the well-worn trope of the damaging effects of idealized female beauty on female subjects' images of self, Bustamante composes for and in the show a contretemps diametrically opposed to the naturalized tempo of the era's sovereign and somber allegorical performative. She literalizes both neo/colonial discourses that equate Woman with the territory of America and readings of the female form that dictate the terms of the latter's appearance. The conflation suggests that the imaginary space of America, like Woman, or in conjunction with her figuration, is a "failed" performance, a series of repudiations, which leave the monumental hanging as yet another underachievement.

Like Wolffer in *If she is Mexico, who beat her up?*, Bustamante scripts peripeteia as a cascading affect. *America the Beautiful*'s narrative employs a precarious soundtrack that contributes to its mood shifts. The performance opens with another striptease, as languid as the Cheshire cat's grin. An old record player sits beside a short ladder on the stage. Undressing, Bustamante enters (stage left) as the lights dim. Beneath a spotlight, searching through scratched and chipped LPs, she spins tunes that in the main digress

into a record's skip or static. Planned obsolescence? Bustamante is "becoming" as a "vulnerability artist." Courting disaster, she teeters on the brink of discovery, scales instability. Perched on top of a short ladder, the artist garlands herself with a paper toilet seat cover. She opens a small compact. Curling her eyelashes, applying lipstick beyond the bounds of propriety, patting excessive amounts of gold powder onto her cheeks, she generates a cloud like a mystique around her. The particulate matter in the air faintly resembles that generated by Margolles's *Vaporización*, but appears at first glance "lighter." *Maybe she's born with it. Maybe it's Maybelline.* Chuck Berry's hit single "Maybelline" segues into a recorded sermon then into the Four Aces's "Love Is a Many-Splendored Thing." Bustamante dons a blond wig, whose volume she teases up with ample amounts of hairspray.

As an opening act, this sequence clearly messages its audience that "Bustamante is in drag." Like Wolffer who catwalks the runway of Woman and Nation, Bustamante suffers fashion indignities. Bustamante dwells not only in the incommensurability of the female form and territory but on the better failings of the individual female body. Incommensurability—staged as the "slip" and "Miss America" of allegory—marks Bustamante as a drag (artist). Incommensurability, staged as "the exhaustion of difference," subvertises melancholy, exposing the cacophonous bars of the latter's melody. Bustamante's drag genders territory, rendering both "thoroughly and radically *incredible*" (Butler 1990, 141). Put differently, while demonstrating remarkable fidelity to Butler's observations on drag, Bustamante's process extends those observations to geography before falling off the ladder of all of the above. Butler writes:

> [Drag] allegorizes *heterosexual melancholy*, the melancholy by which a masculine gender is formed from the refusal to grieve the masculine as a possibility of love; a feminine gender is formed (taken on, assumed) through the incorporative fantasy by which the feminine is excluded as a possible object of love, an exclusion never grieved, but "preserved" through the heightening of feminine identification itself. In this sense, the "truest" lesbian melancholic is the strictly straight woman, and the "truest" gay male melancholic is the strictly straight man. (1993, 23; 1997a, 146–147; emphasis in original)

Drag endows Bustamante's performance with yet another border ontology as its standpoint epistemology. Drag infuses Bustamante's performance with the free radical range of performativity, the stuff of *Mother Camp*'s and

Gender Trouble's wet dreams. Taping her breasts, stomach, and buttocks into place (like a true self-packaged commodity), striving to arrive at some smaller version of borderline Woman, Bustamante remains attentive to the larger-than-life shadow that she casts on the wall behind her. After scaling a second, steeper and more rickety, ladder, which an anonymous assistant provided for her, the artist pauses to smoke a cigarette, to take a break at the ladder's apex, to survey the topography of her audience below.

A bird's-eye view: Do we, the performance's spectators, measure up to Bustamante's impeccable standards? The diva's time-out, which furthers the performance studies scholar Richard Schechner's (1985) arguments about "dark play," permits her to take full advantage of the spotlight upon her. Turning her back to the lowly, she stages a play within a play. All the better to catch a king or queen! As readily as Gruner makes a screed, a screen from scratch in *Away from You*, Bustamante's fingers, doubling as rabbit's ears, rescript the writing on the wall behind her. One dumb (Playboy) bunny attacks another in this scenario of discovery. Per the maxim that "Americans" see a man in the moon while Mexicans see a rabbit, Bustamante obliquely references mexicanidad, too.

The O of the spotlight becomes the beam traversed by her shadow play. This play within a play of Bustamante's resembles a quickening Kara Walker silhouette, dovetailing nicely with two other peripatetic moments or acts in the overarching performance. In the first, when Bustamante finally climbs down the other side of the ladder, she signals to her audience that she expects applause. In the version that I witnessed at the 2002 Hemi Encuentro in Lima, Peru—in the world of difference that the Hemispheric Institute of Performance and Politics makes for Latin/x American performance studies—viewers, in deference to her sense of entitlement, gave her protracted recognition. Holding a bouquet of roses, which further overdetermined the exchange between the artist and her publics, Bustamante glowed, beaming and bowing. When the applause died down, Bustamante and her spectators' honeymoon soured, however. The tone of the performance shifted. Abruptly, Bustamante whipped objects on the stage with her roses. She bit the roses off their stems, chewed their petals up, and spit them out, spewing them at us. If we had tittered as Bustamante teetered on her ladders, our nervous laughter was shushed by the diva's temper tantrum—indulgent as the "treat of a weepie" (Doyle 2013, 86). Bustamante's stormy weather culminated in her regurgitation of the flowers off-stage.

Curtain-call, kitten-style: When Bustamante returned center stage, the second and final act of *America the Beautiful* began—bitter, sweet as the

Jamaican candy "Bustamante backbone." Lining up bottles on a table, each containing a distinct volume of water, Bustamante blew us one last torch song, "America the Beautiful." Recall that Gutiérrez reads Bustamante in *America the Beautiful* as Marilyn Monroe–esque. Ending with her hand over her heart as if to pledge allegiance to the flag (or JFK), Bustamante lip-synched, "I love you," before exiting the stage. The lack of transition between these two parts of *America the Beautiful* has contributed to such streamlined and disjointed readings of the performance.

Against such borderization, I want to underscore that *America the Beautiful* promotes a borderlands anti/thesis. Woman caught in the narrative undertow of socioeconomic restructuring—from 1492 to 1992, from 1982 to 2008—functions as the paradigmatic transitional object of the Americas. Offering a series of microgestures, Bustamante in *America the Beautiful* de-allegorizes to re-allegorize the macroaggression inherent in historically gendered, becoming sexualized and racialized, allegories of the continent. *America the Beautiful* sits squarely in the critical genealogy of "Woman." The performance mitigates *REMEX*'s South-to-North jet stream.

By 2011, "Mexico," as some prefix for a "Work of Art," was all but forgotten, was everywhere for everyone. From the early 1990s onward, however, the work of securing Mexico's prominence in global (art) history was done on the back and bridge of Woman. Francine Masiello (2001, 43) writes of Southern Cone alternative cultural production, "Gender is often the material limit against which the system is tested and produces, in this dark season of postpolitics, new terms of identification, new forms of recognition, as well as new expressions of doubt." If, as the literary critic Stephen Greenblatt (1981, vii) generalizes from another timespace, "allegory arises in periods of loss, periods in which a once powerful theological, political or familial authority is threatened with effacement," the artists in "Woman" approach cartography as an ideologically fraught form of transnational composition and re/citation. They engage in forms of "plotting" related to, but distinct from, those that Franco (1989, xii) attributes to prior women writers who examined the "discursive positionings" of Woman in Mexican society.

Lorena Orozco, Polvo de Gallina Negra, Lorena Wolffer, Katia Tirado, Silvia Gruner, and Nao Bustamante's PIAS Forms suggest that the cartographic habits of the transnation extend beyond "practicing its cities" and "performing its borders." Their efforts, on the one hand, demonstrate that to address how Mexico is imagined one must take into account Other lays of the land—how geography is gerrymandered into the likenesses of its

literal and symbolic inhabitants. "Woman"'s work underscores the performativities of both nation and commodity narration, each's allegorical habits and "structures of feeling." Taking inventory of a greater Mexican reliance upon the accessory of Woman, the producers of this archive recognize a link between Mexico City and Mexico's geographic and symbolic borders that police the parameters of (cultural) citizenship.

Culture as a handmaiden of the state morphs into the latter's monumentality in a global imaginary, both of, but not simply in, the kingdom of representation. Following this archive's lead, I position "Woman" as a ligature, as a "vanishing mediator" (to supersede the archetype of the curator) in REMEX. As I signaled through my reading of Bustamante's America the Beautiful, the cultural production of "Woman" indexes how the sign of Woman in the context of hypermasculinized neoliberal globalization becomes synonymous with the vulnerable Nation. Drawing upon historical representations of colonial encounter as territorializing allegories of rape distinct from those catalogued by postcolonial critic Jenny Sharpe, this archive surveys late-twentieth-century representations of economic development as generating startlingly parallel allegories of (enabling) violation. Site-specifically, the work in equal measure suggests radical realignments of Woman-Nation and Border in the NAFTA era.

Writing of Ania Loomba's study of Mizo renditions of Hamlet, the postcolonial critic Ranjanna Khanna (2003, 261) ponders "our" inability to "unlearn" or "simply replay" the plays of the canon. Woman's work locates the female form as a rhetorical meme capable of coordinating racialized and sexualized Mexico at home and abroad. The archive performs greater Mexico's elongation and amplification in terms that acknowledge that for some, the nation-state and its relational remembering is decidedly more foreign than for others. Rehearsing to catalogue the ploy of figuration that constitutes Woman as fetish, as a transitional and transferential object, the efforts of this section rattle Mexico's "cage of melancholy" (Bartra 1996 [1987]). Better put, the work relocates the latter cage as a heightened "melancholy of the public sphere" (Butler 2000, 81), reMexed from the late 1980s onward.

Woman's work follows McClintock's (1995, 218) observation that "all fetishes . . . visibly express a crisis in value but cannot resolve it." Haunted by prior and present thumbnail sketches of monumental Woman, this work's producers literalize the female form itself as a PIAS Form to resituate and read beyond it. As such, their plays of and for trans/figuration

become modes of interpretation that remediate the allegorical performative. Not about "reading like a woman" but tantamount to reading *for* and rerouting Woman, these artists' interventions map a third space of parabasis. Fashioned out of the flotsam and jetsam of the transnation's lingering literality, these women's efforts speak to the gendering of place and space before doubling back to and down on the literal female form. In the wake of deconstruction, these art workers, armed with the accessory "re-," lay bare the homonymic elision of género/s—gender, genre (allegory), and commerce in citations of the "post-" and "neo-." Central to their collective performance "en re menor": one line—the Mexico-US border—in the NAFTA era constitutes national, racial, and sexual identity as difference in absolutist terms that contradict the period's social allegories of integrated markets.

PREVIOUS PAGE:
FIGURE 3.1. Gustavo Artigas, *The Rules of the Game*, photo of field/court/ backboard outside, 2000–2001. © Gustavo Artigas. Courtesy of artist and inSITE Archives, BOX 150, MSS 707, Special Collections and Archives, University of California, San Diego Library.

NAFTA-ERA PERFORMANCE AND CONCEPTUALISM'S PREHISTORY

ART AND DESIGN: THE MEXICO-US BORDER AFTER 1965

In January 1988, the same month and year that San Diego, California, prepared to host its first Super Bowl (XXII) and a year and a half before the city's convention center opened, an artivist collaboration by Elizabeth Sisco, Louis Hock, and David Avalos made the rounds of the city. *Welcome to America's Finest Tourist Plantation*, part of the San Diego Bus Poster Project, was featured on the rear exterior of one hundred San Diego city buses.

The 21 × 72-inch poster utilizes both word and image (see plate 13). A set of hands, handcuffed by a Border Patrol agent, is framed to the left diagonally by a dishwasher's hands, scraping food off a plate; to the right by a single hand, reaching toward the placard "Maid Service please." On the one hand, only the disembodied hands in these images are "colored"—brown. On the other hand, in red, subvertising business as usual, the found language of the piece's title contributes to its appropriation of San Diego's self-promotion as "America's Finest City."

"Welcome to America's Finest Tourist Plantation" is interspliced with language already in circulation, resulting in a transversal logic. Sans image, the poem, potent as any written by "City" artists from No-Grupo to Teresa Margolles, reads:

SAN DIEGO TRANSIT
Welcome to America's Finest
Tourist
Plantation

CALIFORNIA

CORNER SWINGS
← WIDE →
WHEN THE BUS TURNS

In "Collaborative Public Art and Multimedia Installation" (Chavoya, in Chabram-Dernersesian 2006), the Latinx studies scholar C. Ondine Chavoya details *Welcome to America's Finest Tourist Plantation*'s significance as a durational performance, focusing on media outlets' sensationalist reception of the work and the artists' later incorporation of that reception into their 1992 museum-based installation *Welcome to the Finest*. Chavoya echoes the artists' stated intention that the poster for *Welcome to America's Finest Tourist Plantation* was "by design not the 'product' in and of itself, but rather a catalyst for public dialogue" (ibid., 139).

The distinction clarifies that the limited edition poster from its inception was imagined as a "conversation piece" rather than as an autonomous art object (Kester 2004). Chavoya explains that *Welcome to America's Finest Tourist Plantation* must be apprehended against other border artwork whose context "is the United States' master-narrative: its self-definition as a nation of immigrants" (Chavoya, in Chabram-Dernersesian 2006, 137). Chavoya's synopsis is as bounded and porous as any gesture of periodization or the built environment of the Mexican-US borderlands, which, after the mid-1980s, became a site of border art and the non-site of the Border with a capital *B*. In contrast, I wonder, What would happen if we read the project through the lens of the region's lengthier cross-border inhospitality industries and frontier complexes?

Falling forward entails feeling backward. In 1989, Installation Gallery commissioned a downtown San Diego art billboard by Sisco, Hock, Avalos, and Deborah Small. The artists created an "espectáculo" (spectacle) that featured Martin Luther King Jr. posing a multiple-choice question:

Welcome to America's Finest
a) city
b) tourist plantation
c) Convention Center

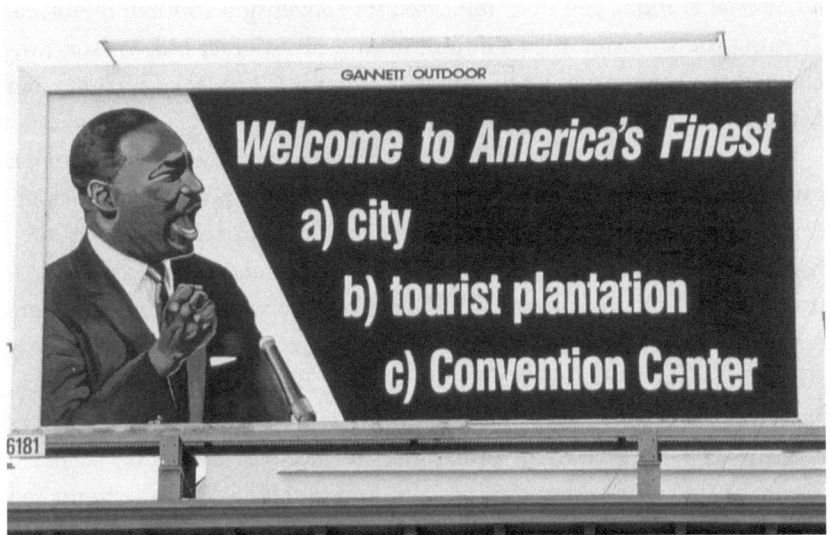

FIGURE 3.2. Elizabeth Sisco, Louis Hock, and David Avalos, *Welcome to America's Finest*, 1993. © Elizabeth Sisco, Louis Hock, and David Avalos. Courtesy of artists.

The format of this pop (art) quiz prods us to look beyond narratives of US exceptionalism. It advocates a mode of interpretative scansion that connects the dots of places and spaces to the historical genres and legal fictions of personhood. Making those connections entails linking 1980s regional land-use debates to conversations about political economy that acknowledge shifting continental labor pools beyond the San Diego–Tijuana corridor. After King, the most obvious public figure referenced by Sisco, Hock, and Avalos's intervention is San Diego's longest-serving mayor (1971–1983) and California's eventual governor (1991–1999) Republican Pete Wilson. In July 1971, at the height of the Vietnam War's unpopularity and following the game-changing media spectacles of the 1968 Republican and Democratic national conventions, the Republican National Committee (RNC), with the blessing of President Richard Nixon, selected heavily militarized San Diego, dubbed "the birthplace of California" and the "Gibraltar of the Pacific," to host its 1972 convention.[1]

City leaders viewed the opportunity in the same light that the Díaz Ordaz administration had regarded Mexico's hosting of the 1968 Olympic Games, in short, as a developer's dream. After a March 1972 ITT Corporation donation of $400,000 to San Diego, earmarked for the convention, blew up into

a national scandal, the RNC relocated its convention to Miami, Florida. Turning the situation into a different kind of visibility bid, Wilson proclaimed the convention week "America's Finest City Week," birthing San Diego's advertising meme, "America's Finest City."

From the late 1970s onward, Wilson tirelessly promoted the rebrand, initiating a redevelopment campaign of the city's downtown and waterfront, whose centerpiece was the San Diego Convention Center.[2] In 1983, fiscally conservative San Diego voters approved funds for the bayside facility near the Gaslamp Quarter. The San Diego Convention Center's doors opened in November 1989. A simple balancing of the books subsequently goes a long way in explaining denunciations and defenses of Sisco, Hock, and Avalos's intervention: The joke on the city that *Welcome to America's Finest* played—similar to the titular irony of Tepito Arte Acá's 1973 *Conozca México, visite Tepito*—hinged on viewers' knowledge of Wilson's extenuated response to the RNC. San Diego hotel-motel taxes not only footed the bill for the convention center but also paid for a goodly portion of *Welcome to America's Finest*. Like Lorena Wolffer, who recalls the connections that Siqueiros draws between the billboard and mural forms, Avalos, Sisco, and Hock mark the proximity of art, politics, and business in 1980s San Diego.[3] Then the trio adds meaning like value to that recognition.

The figure of King in *Welcome to America's Finest* ups the ante of the original poster's seemingly straightforward reference to a "tourist plantation." Hardly the language of Wilson, option "b" of the poster's choices conjures the specters of other sets of hands in the art and design of 1980s Southern California and the US and global South. The invisible hands of a cross-border market dictate the presentation and overarching argument of *Welcome to America's Finest Tourist Plantation* and *Welcome to America's Finest*. Their nimble fingers re-string "a," "b," and "c" as beads on the same collar of continental signification. King's visage functions allegorically, accentuating an elision of the political economy of San Diego–Tijuana and that of earlier transatlantic capitalisms.

While cultural geographers and political scientists attribute neoliberalism, repeatedly misunderstood in the singular, to Milton Friedman and the Chicago School of Economics, dating the reinvention of the term to post-9/11 (1973) Chile, such avant-garde experimentation in the "art of economic government" cannot be confined to the singularity of the Southern Cone. While American studies scholars focus on a US transition from racial liberalism to liberal and neoliberal multiculturalism after the civil rights movement in the United States, such shifts in racialization overlook the

collapse of the twentieth-century remix of color lines and international dividing lines, notably at the Mexico-US border.

In the wake of President Lázaro Cárdenas's 1935 decree to end gambling in Baja California, his 1938 expropriation of foreign oil holdings and vast tracks of land along Mexico's northern border, the Great Depression, and the United States' massive repatriation of Mexicans and Mexican Americans residing within its boundaries, the Mexican government under Manuel Ávila Camacho (1940–1946) engineered (with Franklin Delano Roosevelt's administration) the Bracero Program to demonstrate Mexico's commitment to the Allies' war efforts. Like others before me, I want to stress the effects of languaging here, the Conceptual -isms underpinning policy. In name alone the Bracero Program established the shot of a synecdoche.

Bracero—literally "strong armed"—reduced Mexican citizen-workers to their arms (note: not to their "right to bear arms," but to *their arms*). The Bracero Program was designed to remedy a combined short- and windfall: a shortage of labor in the United States—predominantly in California and Texas—and a surplus of labor in Mexico.[4] From its inception, the Bracero Program benefited both participating nation-states. When World War II ended, the temporal reach of the Bracero Program's arm was extended until 1964. Its long-lasting effects were both literal and symbolic, as the program prototyped an integrated binational economy. It exemplified what Michel Foucault (2008, 117) dubs the dawning US "anarcho-liberalism," eventually elided with "Empire's workshop" after the two world wars (Grandin 2006).

Negative, indeed catastrophic, associations of neoliberal globalization with corporate personhood, the privatization of the commons and public resources, and speculative foreign investment reflect adaptations of neoliberal doctrine whose "laboratory" was the 1970s Southern Cone. Advising General Augusto Pinochet immediately after the bloody overthrow of Chile's democratic socialist president Salvador Allende on the Americas' first 9/11, Friedman transplanted the phrase and technique of "shock treatment," using it as an extended metaphor to index the coincidence of the coup and the country's post-traumatic stress disorder immediately thereafter— hyperaccelerated economic and public policy shifts (Klein 2007). Friedman's preferred methodology, which cast the state as the ultimate guarantor of the market's freedoms, depended on an aesthetics of appropriation, inseparable from the Bretton Woods Agreement and the establishment of the International Monetary Fund (IMF). Chile, Brazil, Uruguay, Argentina . . . in domino-like, quick succession, fell to the overarching social allegory of

the one-world free market. When I turn my attention to the Bracero Program, I register that while neoliberalism's 1973 origin myth remains compelling, if we're going to think globally, there's clear evidence to suggest that the post-1938 Mexico-US border represents an equally viable timespace for contemplating the advent of neoliberal restructuring.

Following social scientists, historians, and cultural critics who productively have disagreed on neoliberal globalization's impetuses, dating the doctrine behind it variously to pre– and post–World War II German ordoliberalism and the economist Fredrick Hayek's related defense of classical liberalism and post–World War II British and US anarcho-liberalisms, including John Maynard Keynes's macroeconomics, Roosevelt's New Deal, and President Lyndon Baines Johnson's "Great Society," I'd posit that the Bracero Program milestones Mexico and the United States' collaborative commitment to the eventuality of a North American neoliberal transition predicated on a continental re-division of extralegal alienation and racialized *and* gendered labor and resource extraction.

In the United States, to be sure, the Bracero Program solidified prevalent "racial scripts" that associated the generic Mexican with unskilled, menial, repetitive labor (Molina 2014). It also masculinized those scripts; braceros were first and foremost *male*. In Mexico, the Bracero Program augmented a remarkably complementary script, sending the postrevolutionary landed but still poor and unskilled (read: indigenous) campesino north in the name of national progress and *his* education. The program partially staved off the nation-state's "Indigenous Question"—what to do with a vast multiracial population, still denied full access to Mexico's abiding allegorical performative of intergalactic "mestizaje." It also tapped into and recharged the vestiges of the US frontier myth, splicing that genre and the master narrative of a nation of immigrants irrevocably into one another. The inadvertent effect was that if Mexico's and the United States' aesthetic and political fates were not already interlaced, the Bracero Program sealed the deal economically. Planting the seeds for a revised greater Mexican "migrant imaginary" (Schmidt Camacho 2008), the program systematized racialized, gendered, and sexualized hierarchies of cheap, expendable labor on the continent, legislating a Jaime Crow to match the "new Jim Crow" of the late twentieth century.[5] The Bracero Program coordinated un/sanctioned flows of Mexican labor north. The increasing consolidation and codification of the duties of the US Border Patrol—again rhetorically spun with clear reference to prior allegorical articulations of US frontier masculinity—coincided with the United States' repeated legislative extension of the Bracero Program from

1942 until 1964.⁶ Still, the US Border Patrol and the Bracero Program represented neither the whole of a subcontinental agenda for modernization nor the whole of the United States' or Mexico's respective agendas for the management and documentation of their internal "Third World" populations.

In the 1960s, with the Programa Nacional Fronterizo (PRONAF; National Border Program), Mexico set out to improve its northern image, still coded as barbaric, empty, seditious, illicit, and Americanized, in a DF-centric imaginary. PRONAF began as a 1950s public relations campaign with an appeal by the Mexican government to journalists on behalf of the historically maligned borderlands. Before PRONAF, the prevailing image of the border was one of anarchy—illicit pleasure, transience, lawlessness, smugglers' and informal economies—matched only by the United States' representation of the free spirit and barbarism of the Wild West. The PRI longed for more positive representations of its northern frontier just as it wanted more balanced representations of Mexico in general. By 1961, on the eve of bracero repatriation, PRONAF graduated into a more ambitious (PR)I border urban development and beautification agenda with a budget of nearly 411 million pesos (32 million dollars), reinventing the 1876 Porfiriato conversion of the region into a free trade zone.

Antonio J. Bermúdez, the former head of PEMEX, former mayor and forever native son of Ciudad Juárez, became PRONAF's director general and lead spokesperson, coordinating its construction of international crossings, malls, and museums in nine border cities. Waxing as lyrical as Walter Benjamin regarding the Parisian arcades or Melquiades Herrera regarding the DF tianguis, Bermúdez outed himself as one of the masterminds behind PRONAF's reified binational mystique when he declared the project's intent to be nothing less than the fabrication of a vast national shop window, "la ventana de México," on the border (Fernández-Kelly 1983, 24).

With PRONAF, Mexico City party-liners posed and foreclosed the question, What does the (Mexican) border dweller want? They intended to harness consumer desire, that of the American-dreaming Mexican citizen as likely to shop in Texas as in Tamaulipas; the repatriated, but nevertheless still nationally exiled, bracero; and the US weekend tourist or businessman. The art historian George F. Flaherty marks the PRONAF moment—often codified as inadequate and ineffectual—as congruent with the PRI's turn to the "affectual infrastructure" of consumer-citizenship (forthcoming, 7). He terms Bermúdez's, and by extension the PRI's and Mexican northern business's, agenda as "proto-neoliberal" (11) in its desire to bring the border region into the folds of the national market. We might concur with

Flaherty's assessment without sacrificing a more expansive reading of the many scenes of the paradigm-shifting drama under way.

The Bracero Program and PRONAF represent fragments of an integrationist continental philosophy predating NAFTA. Within and through this emerging political economy, the sturdy metaphors—albeit mixed—of shop windows and laboratories generated new configurations of cowboy-Indian, nativist-native romances. As Flaherty illustrates, the magisterial jet-set lines of PRONAF's border crossings signaled the PRI's deliberate departure from the populist aesthetics of 1930s Mexican cultural nationalism and its calculated return to continental cooperation.[7]

The stated intentions with these checkpoints, or "Puertas de México" (Gateways to Mexico), as well as with PRONAF's shopping and museum complexes, were multifarious: high visual impact, unimpeded flows, and the cultivation of cosmopolitan "hybrid cultures" (García Canclini 1990). PRONAF's architecture streamlined rupture and continuity; materialized one syncretization of the wild North/Southwest legends of unfettered (entrepreneurial) freedom long before the cultural logic of late capitalism generically composed the region's binational allegory. PRONAF's lead planners included Mario Pani, the überdesigner of Mexico City's satellite-ization and chief architect of the mass housing project Nonoalco-Tlatelolco, and Pedro Ramírez Vázquez, the mastermind of the prefabricated school-house and Mexico City popular markets, codesigner with Rafael Mijares and Jorge Campuzano of the National Museum of Anthropology. Such projects read in conjunction with PRONAF formalized the PRI's high modernizing ambitions for the redevelopment of Mexico socioeconomically. They resolutely moved the party's agenda away from its prior preoccupations with social revolution and toward investments in financialization and industrialization—in sum, toward a distinct 1950s social revolution, inextricably bound to the United States' "War on Poverty" and civil rights initiatives. The purloined letter of the law: while the stakes of PRONAF were economic, they were always, already aesthetic, too.

Location, location, location! Eclipsing (Pete) Wilson's dream of waterfront development for San Diego, PRONAF was at heart a *beautification* project "to hook" guileless shoppers of products from tchotchkes to locations. Billed as an extension of PRONAF, the Border Industrialization Program (BIP) consequently merits our consideration as a hybridized economic-aesthetic intervention. Legitimized as a system of industrial border-crossing whereby raw materials could be imported into Mexico duty-free, assembled or manufactured with inexpensive Mexican labor, and exported

back to the United States with duty paid only on the Mexican value added, the BIP even more clearly than PRONAF precipitated a formulaic linkage between Northern Mexico's and the US Southwest's economies. It also choreographed a narrative shift in a critical regionalism's emplotment.

BIP planners looked to Operation Bootstrap (Operación Manos a la Obra) for inspiration, a program whose name resonates with military and border fortification campaigns but also, read literally in Spanish, lends another set of hands to Sisco, Hock, and Avalos's *Welcome to America's Finest Tourist Plantation*. Originally proposed by the US-based Arthur D. Little consulting firm, Operation Bootstrap is credited with industrializing Puerto Rico's agricultural economy. Richard Bolin, manager of A. D. Little's PR contract from 1956 to 1961, shortly thereafter was enlisted by the Mexican government to research and develop the BIP. Bolin's tasks ranged from promoting Northern Mexico to US industrialists to coordinating US funding for Sunbelt growth.[8] The revenue stream that Bolin generated, attendant with the circuit of exchange that BIP inaugurated, spurred the Mexican state to continue to rethink its position on foreign direct investment (FDI). The revisions exacted on the 1917 Mexican Constitution in the name of the BIP paved the way for further constitutional edits through the 1980s and 1990s. Globally, those revisions secured Mexico's reputation as a leader of offshore processing and free trade zones. Regionally, they fostered a conducive climate for the unparalleled post-1994 *maquila*ization of Mexico's northern border.

The neologism "maquiladora," or "maquila," denotes where "the miller's fee is paid." The first maquila appeared in Mexicali, to be followed by plants in Tijuana, Ciudad Juárez, and other Mexican towns along the Mexico-US border (Héctor Manuel Lucero, in Dear and Leclerc 2003, 109). Maquilas' prominence and connection to urbanization underscores the heuristic fallacy of taking at face value *REMEX*'s "City"/"Border" opposition. These plants were overwhelmingly foreign-owned, predominantly by US companies (122). As the days of the Bracero Program drew down, the number of undocumented Mexican male entrants to the United States rose precipitously. Originally intended to remedy this situation, the BIP created distinctly gendered employment opportunities in the Mexican-US borderlands.

If the Bracero Program displaced countless young men, in the 1970s, first families, then single young women, traveled north in search of employment. Think pink to rewrite what's normally understood as pink collarization. While the years immediately following the Mexican Revolution

were marked by a sharp rise in female migration to Mexico City, the years immediately following the first phase of Mexico's neoliberal transition saw a sharp spike in female migration to Northern Mexican border towns. Maquila operators' employment remains piecemeal, as fragmented as the products they assemble. The temporal window of each woman's productivity is curtailed. Factory managers, predominantly male and foreign nationals, oversee more than line production. Pregnancy tests routinely run into efficiency screens into beauty pageants (Fernández-Kelly 1983; Salzinger 2003; Wright 2006). The cultural geographer Larry Herzog registers that in 1970, there were 160 maquiladoras in Mexico, employing 20,000 workers. By the late 1980s, only a (Carlos) slim *l* separated the verb "maquillar" ("to beautify" or "to put on makeup") and its corporate cousin "maquilar" (to maquila-ize or construct as a factory/free trade zone) in Mexico's northern export-processing zones.

By 1995, 2,400 maquilas with an estimated 325,000,000 workers helped dictate the terms of a new greater Mexico, what Avalos ironically recognizes as corresponding to the Chicano meme "un pueblo, sin fronteras" (Avalos, in *La Frontera* 1993, 63). Male manual laborers, doubly displaced by industrial gerrymandering, followed the scattered borders and circuits first mapped out by the Bracero Program, becoming the "impossible subject" of the historian Mae Ngai's (2004) US history of immigration. Each modeled a revised composite archetype for the social allegory of a nation-of-immigrants. Welcome to the Finest: Ngai argues that the juridical figure of the "illegal alien" was invented in the United States vis-à-vis a shell game. Within this representational economy, the Immigration and Naturalization Act of 1965, or Hart-Celler Act, which repealed the system of national origin quotas, created a biometrics that established a quota of 20,000 foreign national entrants per year, per country, thereby ending "a hierarchy of racial desirability" (ibid., 227). In reality, the act replaced one set of hierarchies with another.

Paraphrasing David Reimers, "after 1965 the third world came to America," Ngai (2004, 228–229) registers that this new system was not without its ironies: 1965 US immigration reform and civil rights were cut "from the same cloth of democratic reform," which "constructed alienage as a lack, as citizenship's opposite." Moreover, as the ethnic studies scholar Roderick Ferguson (2012, 162) observes, the "drama of affirmation," which the act represented, favored professional or elite technical labor, predominantly from Asia. For the first time, a cap was set on inter-American migration,

in effect manufacturing the late-twentieth-century immigrant crisis at the Mexico-US border.⁹

The cut—political, economic, aesthetic—that Ngai references depended on the particular repeat performance of the Mexico-US border as "una herida abierta" (an open wound; Anzaldúa 1987, 25) and a DuBoisian color line. It recalibrated the sliding scales of continental personhood. To continue to mix metaphors for the sake of syncing a legal fiction's form and contents: Ngai's cloth was spread wide. It extended transnationally. It accommodated many cuts because it was woven out of various critical contradictions—the frontier myth repurposed for a man-on-the-moon Star Wars trade and arms race and post–civil rights neo/liberal multiculturalisms. It was fashioned to expedite the movement of goods, including disposable workers, and the blockage of human beings outside of the parameters of legitimized citizenship.

In "Border Art Since 1965" (Berelowitz, in Dear and Leclerc 2003), the art historian Jo-Anne Berelowitz focuses on art making that reacts to the exceptionalism of this borderization. Cutting sign, so to speak, she divides border art's production into three periods: "identity politics (1968–1980)," "multiculturalism (1984–1992)," and "globalization (1992–Present)" (144–145). She observes a relationship between the Chicano movement, other struggles for civil rights and racial justice in the United States, and the emergence of border art in the San Diego–Tijuana corridor. Over a decade later, the art historian Ila Nicole Sheren (2015, 2) forwards a compatible periodization when she writes of a "border problematic." Sheren suggests that nearly identical microperiods mark the negotiation of the border as site and as Robert Smithson–inflected non-site.

Connecting the map and the territory to a timeline and history, Sheren's deft intervention makes room for the recognition of commonalities between the cultural production of "City" and "Border," although Sheren does not go there. Like Berelowitz, she constructs a genealogy that is circumscribed because she rarely crosses the Mexico-US border in her analysis. Furthermore, by focusing on the cut versus the join, Sheren downplays the feedback loop that maintains the meta-intervention of the artwork that she seeks to read as a cohesive archive. Per the remixed 1972 slogan of the United Farm Workers (UFW), "Sí, se puede," *we can do better*.

A convergence culture: The Chicano movement's birth roughly overlapped with the US Voting Rights Act and the Immigration and Nationality Act of 1965, the US Civil Rights Act of 1964, the "War on Poverty" package (the

Social Security Act of 1965, which created Medicare and Medicaid; the Food Stamp Act of 1964; the Economic Opportunity Act of 1964, which created Vista and Job Corps; and the Elementary and Secondary Education Act), the Higher Education Act, and the National Endowment for the Arts (NEA) by US presidential decree—all key legislation of the Kennedy-Johnson era. The birth of the Chicano movement, at roughly the midway point of the United States' involvement in Vietnam, also overlapped with the advent of the BIP. Scholars do not routinely link the BIP and the attendant shifts in Mexican labor demographics to shifts in the United States' management of its immigrant and minority populations. Much less do they connect the rise of a US interest in the arts and education to the legacies of Mexican art and design or to the research and development of the continent's integrated market. But I cannot shake the synergy of Mexican and US agendas here.

The diagonal lines that frame *Welcome to the Finest Tourist Plantation*, the image-word-context of the piece's would-be poem, meet at the convergence of the aforementioned list's politics and aesthetics. The vast disposable reserve labor pools associated with free trade zones along the Mexico-US border made possible a same difference—the aggregation of one form of segregated labor in the US South and across the United States and another underwritten by US un/sanctified immigration. Undocumented labor and free trade zones facilitated the supposed desegregation and deindustrialization of the United States, the import-minded reorientation of the US economy, and the export-minded reorientation of the Mexican economy. Continental labor politics in turn were inseparable from demands for self-determination in the United States, including those voiced by the Black and Chicano nationalist movements. The participation of César Chávez's National Farm Workers Association, later the UFW, in the Delano, California, grape strike in the mid-1960s bedrocks one, if not the most pervasive, of the abiding origin myths of Chicano nationalism. In that bid for equality, the arts, and more specifically video, played a key role in aligning the planets of the workers' rights-based claims and higher law doctrine principles of the movement (Marez 2016).

The Latinx studies scholars Ramón Saldívar (1990), José David Saldívar (1991), José Limón (1992), Alicia Gaspar de Alba (1998), Chon Noriega (2000), and Guisela Latorre (2008) turn our attention to narrative, poetry, film, television, muralism and curatorial politics to amplify conversations about the representational scope of Chicanx nationalisms' interventions in hegemonic US fictions. Helping us to think the forms and platforms of Chicanismxs, these authors' analyses make clear that while it's tempting

to daydream that, indecisively loyal to the postrevolutionary Mexican aesthetics and politics, Chicano muralism threw a brick through the shop window of Mexican modernization, re-animating the epic genre's quest for the pre-Hispanic and regional, we would be daydreaming if we subscribed wholesale to this alternative fable of exceptionalism. Splicing US and Mexican allegorical impulses into one another, Chicano muralism in its early years reimagined the configurations of art and collectivity sans the fetters of state or market, albeit often at the expense of women, LGBTQ-identified individuals, and the undocumented.

This is the unsettling perspective from which Noriega shoulders some of the burden of honoring the cognitive dissonance in movement aesthetics. Accenting beginnings over origins in his treatment of the work of the collective Asco, Noriega notes that in March 1968, high school students, including Asco members Gronk, Harry Gamboa Jr., Willie Herrón III, Patssi Valdez, participated in walkouts or "blowouts." The "no-grupo"'s later walking murals and "No-Movies" encapsulate the Asco performative. Each mutated genre challenges the contemporaneous aesthetics of not only Chicanx, but also Southern California conceptual and performance art more generally (Noriega, in Gamboa 1998; Chavoya and Gonzalez 2011).

Before Asco's "disgust" affected binational border cultural production, Avalos, Berelowitz, Eva Cockcroft, and Guillermo Gómez-Peña, among others, signal that Chicano Park stands out in a chronology of 1960s–1970s Chicanx art and activism in Southern California (Cockcroft 1984; Gómez-Peña 2001; Berelowitz, in Dear and Leclerc 2003; Avalos 2014a). In the early 1960s, the state of California displaced thousands in the southeast corner of Logan Heights, known as Barrio Logan, with the construction of Interstate 5 and the San Diego–Coronado Bridge. While Logan Heights, a combined industrial and residential area first associated with canneries and then with "yonkes" (junkyards), had been home to San Diego's largest African American community, after the Mexican Revolution its demographics shifted. Completed in 1969, the freeway and bridge projects—like Mexico City's and Los Angeles's freeway construction—divided Logan Heights, creating for its residents a de facto concrete ceiling. Demonstrating a resilient general intellect, residents lobbied to build a park beneath the pylons, like they lobbied for additional jobs and education and lobbied against police brutality and racism. The San Diego city council initially approved the request. Unbeknownst to the predominantly Mexican American residents, the state subsequently rezoned the "undercommons" for a highway patrol station and parking lot. The affected community only learned of the

change of plans when the state broke ground for the station. In response, on April 22, 1970, Barrio Logan residents formed human chains to block the bulldozers. Protesters occupied the disputed territory for twelve days, participating in such "floricanto"-inflected acts of civil disobedience as raising the Chicano flag from a telephone pole and planting flowers. Because the bridge and the ground below it belonged to California, municipal and state agencies entered into retracted negotiations that led to the city's purchase of the land.

Soon after, Salvador "Queso" Torres, a local artist involved in the site's occupation, founded the Chicano Park Monumental Public Mural Program. Muralists drew up plans for the area before also lobbying for a clinic and cultural center. In 1971, the San Diego Parks and Recreation Department granted the movement an additional site in Balboa Park for the Centro Cultural de la Raza. The distance between what had been the 1915–1916 home of the Panama-California Exposition and Barrio Logan introduced a literal and metaphoric rift into the community. Chicano Park's first mural was painted in 1973. Guillermo "Yermo" Aranda, a member of the Centro's founders, Los Toltecas en Aztlán, organized and oversaw its production. The Bay Bridge pylons quickly were covered with murals that attest to the cross-pollination of Chicano and Mexican nationalisms. Chicano Park, later designated a US historical landmark, and the Centro Cultural de la Raza, singular achievements for San Diego, must be understood as inseparable from public conversations regarding socioeconomic disparities that linked regional and continental restructuring and the arts to one another from the 1960s onward.

Just as it would be a mistake to reduce the cultural arm of Chicano nationalism to muralism, it would be an analytic misstep to read Chicano Park, the Chicano Free Clinic, and the Centro, the entities and the organizing that enabled their creation, as emerging out of a single, unified aesthetic and political project. As Cockcroft recognizes, some Logan Heights residents refused to accept the Centro's Balboa Park location. Mario Torrero, Queso, Tomás "Coyote" Castañeda, and Victor "Cozmos" Ochoa established a separate center and gallery, the Congreso de Artistas Chicanos en Aztlán (CACA) in Logan Heights (1984). CACA, an acronym whose meaning—shit—rivals Asco's strategic vulgarity, recalls Dadaism, Arte Povera, and more specifically the Italian artist Piero Manzoni's fixations on "la merde"; it also proves suggestive of the substantive differences at play in regional struggles for aesthetic and political sovereignty. Against essentialist configurations of greater Mexico, CACA's members humorously engaged the scatological sensibilities of bygone avant-gardes, the "ugly feelings" (Ngai

2007) attendant with reclamations of symbols like the Indian swastika. Contrary to suggestions that Gómez-Peña introduced a No-Grupo and Asco-driven punk and punster repertoire into the Tijuana–San Diego corridor, the pre-Gómez-Peña presence of CACA, a collective in possession of an irreverence to rival No-Grupo's or Yoshua Okón's, necessitates that we accord Bajalta California (as Baja California, Mexico, and California are sometimes called) more complicated artivist genealogies.

To that end, I'd note that shifts on the Mexican side of the border in equal measure set the stage for the San Diego–Tijuana corridor to emerge as a hotspot of the 1980s greater Mexican culture wars. Founded in 1889, Tijuana, "Tia Juana" or TJ, like her older "sister" Ciudad Juárez, cultivated an inter/national reputation for being sexually and politically permissive (Gutiérrez 1996), especially during the crucial years when the borderlands were zoned and de-zoned as "free." The copy sans original "sin city" attracted revolutionaries from Ricardo Flores Magón to Rita Hayworth as well as business and servicemen. Avenida Revolución, home to the legendary Hotel Caesar, remains the stuff of hypersexualized and racialized fantasy. But, by 1985, Tijuana—like Juárez—had diversified its purchase on the continental imaginary. Synonymous with its export processing zones, the metropole increasingly stood in for another gendered, racialized, and sexualized industry that would overtake tourism as Mexico's second largest revenue stream after petroleum by the turn of the millennium (Louie 2001, 69). Unlike Juárez, Tijuana simultaneously was connecting its cultural and technological infrastructure to its northern neighbor's.

A concentration of wealth in the region lent credence to the maxim that money makes money, fueling deep-pocketed investments in Mexico's "Gold Coast" and the United States' Pacific Rim. Some of the most aggressive 1970s and 1980s Mexican capitalist (aesthetic) ventures were engineered at the farthest northwest tip of the republic. In 1982, as the Mexican economy crashed, the Centro Cultural Tijuana (CECUT), with its iconic spherical amphitheater—designed by Pedro Ramírez Vázquez and Manuel Rosen Morrison to resemble San Diego's planetarium, itself a symbol of Southern California's aerospace industry—helped open Mexico for further "space exploration." President Miguel de la Madrid designated the Programa Cultural de las Fronteras (PCF; Cultural Program of the Borders) to be PRONAF's progeny, declaring PCF's purpose to be that of intervening in Mexico's "cultural desert."[10] Fully initiated in 1983, PCF was expanded under Salinas, courtesy of his administration's revolution in the arts, CONACULTA/FONCA. Such artistic expenditures were matched by

investments in academic think tanks on both sides of the border. In 1976, the San Diego Regional Bicentennial Committee, along with Roy Harvey Pearce, Dean of Graduate Studies at the University of California, San Diego (UCSD); César Grana, director of the Center for Iberian and Latin American Studies (CILAS) at UCSD; and Wilson, organized three binational dialogues about border resources and culture, FRONTERAS 1976.[11] In 1979, the political scientist Wayne A. Cornelius founded UCSD's Center for US-Mexican Studies. In the early 1980s, Jorge A. Bustamante became the director of Tijuana's Center for Border Studies of Northern Mexico (Avalos, in *La Frontera* 1993, 62). Public-private ventures, these initiatives in turn impacted the forms and contents of an aesthetic—what I call "undocumentation"— prevalent across the best work of Berelowitz's and Sheren's microperiods.

An undocumentary drive infuses Mexico-US border art workers' responses to the era's market-state master narratives that remapped land, population, and resource extraction and management. Unlike DF artists' often inchoate, sometimes politically indeterminate, responses to technocratic restructuring of cultural funding outlets and of the role of culture in international diplomacy, border artists developed a wide, if not long, view on institutional critique at "la esquina de México" (the corner of Mexico).

Where one of the poorest cities in Mexico meets one of the richest in the United States, a political and aesthetic feedback loop ignited a continental war of images that proved particularly fierce in the two decades preceding Operation Gatekeeper's implementation. The political scientist Joseph Nevins notes:

> At the beginning of the 1990s, it was estimated (on the basis of Border Patrol apprehensions) that close to the majority of unsanctioned crossings of the almost 2,000-mile-long US-Mexico divide took place in the narrow stretch in and around San Diego. Given this, many of the emblematic images associated with the war on "illegals" that first emerged in the 1970s—one that intensified greatly in the 1990s—came from San Diego. (2002, 3)

This representational economy reflected the increasingly coordinated cross-border management of people, goods, services, and information: undocumented entrants sought menial, temporary labor in the integrated economies of Northern Mexico and Southern California. They filled the ranks of crossers in what came to be known as San Ysidro's "banzai runs." The personhood of each risked being reduced to the "sign of the times,"

highway signage depicting a silhouetted family, like deer, darting across Southern California's interstates.

The literary and cultural studies scholar Elizabeth Abel prefaces *Signs of the Times: The Visual Politics of Jim Crow* (2010, xvii) with two haunting questions: "What modalities of racism still fracture the social landscape after the dismantling of Jim Crow? Where would the racial signs of our times be situated, and what language would they use?" As several Bajalta California artists suggest, an iconic traffic warning represents one stand-in for the consolidation of North American racial as well as gendered capitalism.

Against the aesthetic cut of this advisory, could we squint to witness the totality of rebordering under way from the mid-twentieth century onward? Could we cognitively map glitches in the full performative matrix that would come to be coded as one of Mexican contemporary art's gateways to the global North? With their bus poster designs, Sisco, Hock, and Avalos proposed an alternate iconography that foregrounds the conceptual and performative intricacies of the new divisions of labor, not as an abrupt and absolute shift, but as ghostly and contingent re-elaborations of inequality. A set of handcuffed hands framed by a dishwasher's hands and another hand reaching for the placard "Maid Service please" belie a regional-becoming-planetary bait and switch.[12] *Welcome to America's Finest Tourist Plantation* was inspired by civic advertising and by the post-1960s integration of distinct US and Mexican labor pools that was itself predicated on earlier binational frontier mentalities. Avalos clarifies that the artists' allusion to San Diego as plantation was mirrored in contemporaneous conversations taking place in San Diego's Committee on Chicano Rights (CCR). There, he and other activists were connecting the dots of rapid reconfigurations of racial capitalism in the San Diego–Tijuana corridor and the prior racial capitalism of the US South and transatlantic. Two aspects of the organizing he references are worth remembering: it was multiracial, and, before *Welcome to America's Finest Tourist Plantation*'s presentation, it bedrocked the artivist sensibility of the Border Art Workshop/El Taller de Arte Fronterizo (BAW/TAF), the Tijuana–San Diego collective that put the genre of border art on the map for inter/national audiences.[13]

THE BORDER ART WORKSHOP/TALLER DE ARTE FRONTERIZO'S OPEN DOOR AND LABORATORY

A quarter of a mile east of the Tijuana International Airport, on the Mexico–United States border, a door once opened only from the Mexican side of the

border. On the door's frame, 134 keys hung, each of them an invitation to the undocumented "to cross the border with dignity" (BAW/TAF 1988, 46). The artist Richard Lou, who installed the door there on May 28, 1988, also distributed copies of the door's keys in several of Tijuana's unincorporated colonias. *Border Door* is gone, allegedly removed by the US Border Patrol.[14] And, the Mexico-US border has been fortified across its almost 2,000-mile stretch in the decades following Lou's action. Still, the artist's poetic gesture persists, another portal on the order of Mexico City's La Panadería, through which we might time-travel to revisit what's been framed as border art's populist beginnings.

Berelowitz, Sheren, and others credit Avalos with founding BAW/TAF in June 1984. Earlier that year, Avalos, then the artist-in-residence, administrative assistant, and gallery curator at the Centro Cultural de la Raza, had organized a groundbreaking show, *Border Realities*, at the Galería de la Raza in San Francisco (February 23–March 23, 1984). *Border Realities*, as its title suggests, brought together artwork that addressed Mexico-US border conditions. Avalos insisted on featuring not only the work of Chicanxs but work by individuals with varied identities, identifications, and connections to the region. He also opted to display several hybrid genres of artwork, including performance, film, and installation.[15] Although many of the artists whose work Avalos chose for *Border Realities* would become the first cohort of the BAW/TAF, the artist-curator insists that he cofounded BAW/TAF with Víctor Ochoa, Jude Eberhard, Michael Schnorr, Sara-Jo Berman, Philip Brookman, Isaac Artenstein, and Guillermo Gómez-Peña. Avalos's humility remains as hauntingly citational as Lou's door.

BAW/TAF, pronounced like some slant rhyme of Bauhaus, offered more than a simple threshold to cross. It laid the foundations of the "house" of border art, beginning in 1984 when its members announced the border region to be their "intellectual laboratory." BAW/TAF's claim doubled the lien that the market-state had placed on the borderlands as a site of (social) scientific experimentation. It recalls Friedman's reference to his Chilean laboratory (and his curious valorization of the immigrant in the theoretical), Néstor García Canclini's characterization of Tijuana as the "laboratory of postmodernism," and Charles Bowden's (1998) characterization of Juárez as "the laboratory of our future." It invokes DF art workers' conversion of Mexico City into a readymade. It acted as a centripetal force in the region, contributing to the generation of a new aesthetic center and figuration, the Border with a capital *B*. Indeed, fully coalescing in the late 1980s,

the laboratory analogy would dominate right- and left-leaning binational conversations about the Mexican-US borderlands.

Before the metaphor veered toward cliché in global characterizations of free trade, BAW/TAF members gathered weekly to "discuss human rights violations by the border patrol, media depictions of Mexico and Mexicans and US policy toward the South" and to develop strategies and tactics to "intervene directly in the social landscape of the border" (Berelowitz, in Dear and Leclerc 2003, 37–38). BAW/TAF's transmedial gestures reflected a collective righteousness, members' artistic and activist shared sense that by straddling the Mexico-US border they stood on the right side of history. While Gómez-Peña (in Fusco 1995, 147) notes that there were precursors to BAW/TAF's actions—such as the 1969 Toltecas in Aztlán who, "without ever explicitly stating it, used the border as a laboratory"—he maintains that in the mid-1980s, "the US-Mexican border region did not have a developed cultural infrastructure, so we had to create one." Closer to a lowercased truth: the cultural infrastructure that existed in the region was tightly bound to the research and development of industry. Its logic was fine-tuned to operate in tandem with the latter's obfuscated aesthetic. BAW/TAF's efforts and very existence risked the wager of interrupting and repeating with a difference the commonsense of the period's technology transfer/ence.

Attentive to the performative effects of post-1965 borderlands language and stereotype, members still credit the Centro Cultural de la Raza as enabling their practice. They also highlight the distinctions between their actions and those of earlier Chicanx-identified cultural producers. For instance, the artist-theorist D. Emily Hicks, who obtained her PhD from UCSD's Literature Department, underscores the contradictory influence of the Mexico City "neólogo" and former member of Proceso Pentágono Felipe Ehrenberg on BAW/TAF's strategy and tactics. Ehrenberg participated in the BAW/TAF's 1986 *Café Urgente: A Social Dialogue on Contemporary Border Consciousness*, a hybrid performance art piece and scholarly symposium prescient of Curare's curatorial interventions and inSITE's exploration weekends. Hicks (quoted in Sheren 2015, 94) credits Ehrenberg with "revitalizing" BAW/TAF, with shoring up the group's confidence to "go against the muralists of the old [Chicano] school and the traditional way of doing political art." She also notes that Ehrenberg extended an ominous warning that BAW/TAF would be wise to refrain from offering too strident a critique of Mexico's ruling party (Hicks 2014).

Border realities in the San Diego–Tijuana corridor generated messy ecstasies of influence. BAW/TAF members repeatedly cited their inspirations as ranging from Mexico City's Los Grupos to collaborative art making emerging out of 1960s–1970s US-based civil rights movements, Fluxus International, and 1980s and 1990s AIDS organizing (Gran Fury and ACT UP). Early on, Gómez-Peña forwarded an ironically more linear, triumphalist periodization of BAW/TAF's formation:

> We must remember that 1984 was a key year for the Chicano cultural movement. Institutions like La Galería de la Raza (San Francisco), SPARC (Los Angeles), and El Centro Cultural de la Raza (San Diego) began a process of redefinition of their relationship with the larger society, which led to the shedding of separatism and the creation of multicultural alliances with other Latinos as well as Blacks, Asians, feminists, and gays. BAW/TAF was an offspring of this original impulse. (1991a, 37)

In this register, BAW/TAF aspired to nothing more or less than the interruption of the border as a state-market sponsored aesthetic project. BAW/TAF members subscribed to the belief that "political actors do not merely respond to public pressure to 'do something' about drugs and illegal immigrants. Instead, they skillfully use images, symbols, and language to communicate what the problem is, where it comes from, and what the state is or should be doing about it," years before Peter Andreas (2000, 8) made such a pronouncement fashionable for political scientists and public policymakers. Berelowitz also oversimplifies the case when she writes that BAW/TAF redirected phrases that the popular press from the 1980s onward assigned to "immigrant laborers without papers":

> Prior to their interventions the media had referred to this group of people as "illegal aliens," thereby producing a category of human being coterminous with subjection, domination, and exploitation and defined by a quintessential "otherness." Subsequent to BAW/TAF's efforts, the term "undocumented worker" and "undocumented immigrant," with their vastly different associations, became widespread. (Berelowitz, in Dear and Leclerc, 2003, 160–161)

With a usage perhaps not as prevalent as Berelowitz's optimism of the intellect projects onto BAW/TAF's interventions, the semantic difference that the term "undocumented" engenders in her pronouncement

nevertheless has furthered how I think about the collective's contributions to the consolidation of border art and border studies. The labor of fastening the prefix "un-" (versus "no-," "non-," or "re-") to a body of artwork does not represent a simple pessimism of the intellect that negates the status quo. Instead, the un- of undocumentation indexes a mode of erasure operative in the act of documentation proper. It illuminates what was and is hidden in plain sight.

Yet, unlike the prefixes "no-," "non-," or "re-," "un" is not an unencumbered border crosser. "Un-" becomes "in-," in "indocumentación" when it code-switches into Spanish. A range of artwork produced after 1984 reimagined the sometimes overlapping, sometimes distinct Mexican and US neoliberal logics of transparency, which included, but were not bounded by, the statistic, the percentile, the spreadsheet, the documentary, or the exposé. This work responded to the fastidious politics of allegories of unification with a will to erase, strike-through, and palimpsest the latter. A binational drama–social drama figure eight seemingly sprang to life after 1984.

Discussions regarding BAW/TAF's work and current events in the region not only augmented the group's actions but rounded them out in the manner that Chavoya suggests debates about *Welcome to America's Finest* were indispensable to its realization. Thus, in response to a campaign dubbed *Light Up the Border*, spearheaded by Muriel Watson, a town councilwoman and the widow of a Border Patrol agent, and Roger Hedgecock, a San Diego County radio celebrity, former member of the San Diego Board of Supervisors, and mayor of the city who left office after a felony conviction, BAW/TAF, in collaboration with other regional art and activist collectives, proved the best offense to be a good defense. Watson and Hedgecock petitioned drivers to shine their headlights on a stretch of the border where supposedly undocumented workers under cover of darkness entered San Diego each night. BAW/TAF members and others held up mirrors, bouncing the headlights' glare back at the right-wing artivists.

The simplicity of the gesture speaks truth to power: much of BAW/TAF's practice partook of and contributed to a baroque sign system that linked art's political unconscious to politics' aesthetic one. Their minimalist corporal and conceptual gestures, unbound from the white cube, the book object, and the black box, became searchlights in the long night of socioeconomic restructuring. The flexed muscle of *Light Up the Border*'s reflexivity demonstrates how the best group think of the place and period did not blur the boundaries of the artistic and the political but drew attention to the pair's inseparability.

Which came first, the chicken (pollo) or the egg (continental restructuring)? Like *Welcome to America's Finest,* the action begs the more obvious question, Where does such a performance begin and end? Pete Wilson argued that the originating gesture of the "performance" was not BAW/TAF's, but Watson and Hedgecock's. Wilson's art history, in sync with BAW/TAF's, attests to the strength of border cultural production in the region in the late 1980s and early 1990s. The singular achievement of BAW/TAF's actions, before Sisco, Hock, and Avalos's bus poster ever made its rounds, was to shine a light on the various border-related actions of the period. BAW/TAF repeatedly held up a mirror to the present to betray its intertwined politics, aesthetics, and economics.

Illuminating naturalized and overly simplified social allegories of the period, BAW/TAF interventions unveiled the integrated market-state as neoliberal doctrine's reigning regional imperial fiction. In turn, the collective manufactured alternative modes of seeing late-twentieth-century greater Mexico. The impulse to edit or redirect prevailing conversation drove BAW/TAF's strategy and tactics, designed to display and displace the affective logic of Mexico-US border public policy. Against the bookkeeping of governmentality (the statistic, the percentile, the spreadsheet) and against the "discourses of sobriety" of journalism, traditional—even left-leaning triumphalist—documentary cinema, and nongovernmental organizing (Nichols 1991, 3–4), BAW/TAF's actions troubled who and what constituted the undocumented, expanding the circumference of the term beyond its stock attachments to the nouns "worker" and "entrant."

To this end, their self-published *Border Art Workshop (BAW/TAF) 1984–1989: A Documentation of 5 Years of Interdisciplinary Art Projects Dealing with US-Mexico Border Issues (a binational perspective)* = *Taller de Arte Fronterizo (BAW/TAF) 1984–1989: Documentación de 5 años de proyectos de arte interdisciplinario sobre asuntos de la frontera de Estados Unidos con México (una perspectiva binacional)* (1988), a multilingual compilation of documentation of the group's actions, recoded as reactions to current events, and responses to those actions (images, newspaper clippings, poems, drawings, and manifestos) reads as a postautonomous art action and early example of undocumentation.

Funded by Artists Space in New York City, the California Arts Council, La Jolla Museum of Contemporary Art, and the Centro Cultural de la Raza, the volume reflects the members' drive for self-determination, their desire to situate the stakes of their production, sometimes in reaction to, sometimes in conjunction with, critics' and curators' assessments of their projects.

Before iconic images of Lou's *Border Door* were given second lives online, two photographs of *Border Door* (later attributed to Jim Elliott) and a radio text about the installation written by Lou and Gómez-Peña were included in the volume (46–47). Directly preceding the images, members catalogued and rubber-stamped "VERSION OFICIAL," a journalist's commentary on a well-known San Ysidro–Tijuana zone of undocumented crossing. In a flourish of montage worthy of BAW/TAF, Edward L. Fike characterizes the border at this location as "one square mile of hell," quoting Edward H. Harte, publisher of the *Corpus Christi Caller-Times*, to paint a surreal portrait of the region. Inclusion of this commentary in *The Border Art Workshop (BAW/TAF) 1984–1989* performed an obvious function worth repeating: BAW/TAF's tactics were crafted relationally in contradistinction to sensationalist and nativist public performances that cast the border as the ultimate guarantor of the autonomous "art" object of the nation-state on the open market. If *Pinto mi Raya* compiled media coverage of Mexico City's PIAS Forms to archive a history of alternative art, BAW/TAF wrenched the documentary aesthetics of journalism out of its usual frames of reference, more explicitly refining the terms of an undocumentary practice—their own—in opposition to the truth affects of proto–Fox News coverage.

The "artificial hells" here—to reanimate the phrase near and dear to Claire Bishop (2009)—were not those of some neo- or post–avant-garde, raised to the power of two or three, but those of Conceptual -isms, rendered commonsensical in the Debordian "society of the spectacle" to which said neo/post/avant-garde reacted. Hence the rhetorical question, captioning the juxtaposition of the Mexican calendar pinup and the profile of the Robocop, "On which side of the border is the avant-garde?" (ibid., 86). Like Los Grupos in the DF, who reconfigured the work of art in response to postrevolutionary cultural nationalisms and the internationalism of Mexico's modernizing agendas and popular culture, BAW/TAF reacted to what they perceived to be US, Mexican, and Chicano nationalism's competing, but also colluding, desires for mastery. In this representational gamble that contributed to the border's rezoning as a non-site, each articulation of collectivity was crafted and naturalized as a social allegory in garrulous conversation. Put differently, BAW/TAF caught and rode the wave of a continental "run for the border."

On October 12, 1986, Columbus Day/Día de la Raza (a convergence later marked by Santiago Sierra), at Border Field Park/Las Playas de Tijuana—where Tijuana, San Diego, and the Pacific Ocean meet—BAW/TAF lined up six mirrors on both sides of the border fence. Six Mexican and six US artists

stood in front of those mirrors, twelve actors in total. First Lady Pat Nixon had stood her ground in the same location, inaugurating Border Field State Park on August 18, 1971 (a little over a year after the Chicano Park stand off), with the words, "I hope there won't be a fence here too long." She participated in a tree-planting ceremony, then cajoled the Secret Service to cut a section of the barbed-wire fence open so she could cross "illegally" and shake hands with the Mexican nationals witnessing her participation in the park's dedication.

Nevins (2002) recounts Nixon's actions in the final chapter of *Operation Gatekeeper and Beyond: The War on "Illegals" and the Remaking of the US-Mexico Boundary*, observing with the advantage of 20/20 hindsight that the most remarkable thing about the former First Lady's performance was its reception. Media coverage neither condemned nor condoned Nixon's flagrant disrespect of an international border (ibid., 189–191). Only later would international division in that same location be fortified, and thereby reconfigured as the late-twentieth-century's new normal. Less than a month after *End of the Line*, on November 6, 1986, the US Congress enacted the Immigration Reform and Control Act (IRCA) that was then signed into law by President Ronald Reagan. Otherwise known as the Simpson-Mazzoli Act, the IRCA legislated a pathway to US citizenship for the undocumented that had lived in the United States since or before 1982, sanctioned employers who knowingly hired undocumented workers, and beefed up border enforcement. The legislation bellwethered a linked series of 1990s attempted reforms in US immigration policy and border fortification, which the political scientist Christina Gerken (2013) argues hinged on a call for a new immigrant quota based on the comparison of nineteenth- and twentieth-century immigrant bodies' potential for incorporation into the social body. Dissecting the cut that Ngai fingers, Gerken contends that late-twentieth-century rhetoric linked the racial and sexual nonassimilation of "undesirable aliens" (e.g., Mexicans) to the overburdened welfare state and the assault on US culture and family. Simultaneously, the US in/formal service sector and agribusiness fell back on this same labor pool.

The quintessential pushback against reconfigured racial capitalism in the United States increasingly was multimediated, too. In mediascapes, the fence at Border Field Park/Las Playas, stretching taut into the Pacific after 1986, became a key site for the visualization of unsecure borders. BAW/TAF anticipated the significance of the strategic location in the United States' image bank of deterrence. For *End of the Line*, participants, outfitted

as social sculptures, offstage blocked the border game. On the Mexican side of the border, the cast of characters included:

"El Taxi" (The Taxi Driver)
"La Criada" (The Housekeeper)
"La Fácil" (The Easy)
"El Vato" (The Homeboy)
"El Nopal" (The Cactus)
"El Indio" (The Indian or Indigenous)

On the US side, a corresponding menagerie of "conceptual personae" scripted the action:

"El Surfer" (The Surfer)
"La Turista" (The Tourist)
"La Punk" (The Punk Rocker)
"El Marine" (The Marine)
"La Migra" (The Border Patrol Agent)
"El Obispo" (The Bishop)

Each performer embodied a trans/nationally campy, cursi, "rasquache"... stereotype. Meanwhile, another artist, deus ex machina, did not hold up a mirror to the social real, but shattered all expectations of the latter when he broke *End of the Line*'s literal mirrors. Nonplussed, his collaborators surrounded a freeway-shaped table balanced on the Mexico-US dividing line. Turning the table, they interacted with one another, drawing onlookers into the action. Three items on the table—dice, a heart with a cross, and an arm—signaled the performers' earnest bids on allegorical figuration. Vaguely reminiscent of the Last Supper of Christian iconography, of Asco's *First Supper (After a Major Riot)* on Whittier Boulevard, the action defies easy classification.

In the foreshortened background of the Pacific Ocean, other participants set three ships on fire (the *Niña*, the *Pinta*, and the *Santa María*). The year 1492, a neo/colonial prefixation that configured Nao Bustamante's *Indig/urrito*, informed this action's didactic recitation, its return to an even earlier foundational fiction of cultural contact: "We welcome you, but first we must fingerprint you, interrogate you, probe you, scope you... We exempt you, we absolve you, we exonerate you, but only if you qualify for our

benevolence..." (BAW/TAF 1988, 17). In *End of the Line* and at the end of every line they relineated, BAW/TAF's aesthetic depended on undocumentation. The collective deployed a logic that reMexed mediums and metaphors, genres and goods.

Which came first—the performance or the line drawings? *End of the Line*'s "social actors" double as the icons on "lotería" (lottery) cards in *The Border Art Workshop (BAW/TAF) 1984–1989*. "El Mundo" reverses the market-state's machinations. If the Uruguayan constructivist artist Joaquín Torres-García, a proponent of geometric abstraction, created a series of inverted South American maps in the 1940s, BAW/TAF incorporated the conceit of these South-up designs into their projection of alter-globalization. "El Coyote" holds a woman in his viselike jaws. "La Migra" is weighed down by the albatross of his own binoculars. "El Pe$o" features the Mexican eagle and serpent in a bubble as if to insinuate that the "Mexican miracle" was slated to burst time and again. "La Turista," all-camera, models a happy-go-lucky female un/documentarian. And "La Sirena," abject as some thinly veiled La Llorona, false-cognates the siren on top of a patrol car, driven by an INS skeleton. Stereotypes abound in BAW/TAF's role-play and across *The Border Art Workshop (BAW/TAF) 1984–1989*. They were the point after all. A return to the fine line between archetype and stereotype—what I dignify as allegorical figuration across REMEX— informs the strengths and limitations of BAW/TAF's interventions.

From its outset, BAW/TAF sought to dismantle preconceived, widely circulated truisms about the region. In addition, the collective was the product of larger-than-life characters' negotiations of identity and difference. Publication of *The Border Art Workshop (BAW/TAF) 1984–1989* solidified the group's visibility, preceding its work's inclusion in the 2000 Venice Biennial and the collective's late-1980s restructuring. But the sheer density and diversity of the anthology speaks not only to the density of regional land use but also to the loosely united practices of the group's constituents.

From BAW/TAF's inception, membership in the group was fluid and contentious. In 1987, Artenstein, Eberhard, Brookman, and Berman left BAW/TAF and were replaced by Hicks, Robert Sánchez, Berta Jottar, and Rocio Weiss. By 1990, only one of the original members remained, although Ochoa (a co-instigator of CACA) and Michael Schorr (the first Anglo-identified muralist of Chicano Park) were ensconced in BAW/TAF's ranks. Some of this turnover was predictable with a large working group, but some of the fluctuation in BAW/TAF's membership reflected participants'

conflicts over the preferred direction of, and relationship between, art and activism in the borderlands.

In 1988, for instance, several women artists, educators, and critics who had been associated with the BAW/TAF cofounded Las Comadres ("comadre"'s meanings include friend, godmother, and sister). Las Comadres proposed to engage the border from an explicitly feminist perspective, claiming as one of their impetuses the male-dominated atmosphere of BAW/TAF.[16] Flying below the radar as surely as No-Grupo, Polvo de Gallina Negra, or CACA, Las Comadres' "re menor" herstories, juxtaposed with the legend of BAW/TAF's, illuminate fissures in border (art) histories: binational masculinist politics becoming aesthetics reproduced once again in critical regionalisms on both sides of the border.

Consider the bad blood between Avalos and Gómez-Peña, which became especially pronounced after Gómez-Peña garnered a MacArthur "Genius" Fellowship. In what Berelowitz (1997, 82) characterizes as a thinly veiled allegorical poem, "me 'n u," included in *La Frontera*'s catalogue, Avalos blasts Gómez-Peña,

> Always impersonating somebody's Other,
> he'd climbed to the top
> of his pyramid scheme,
> claiming it a vantage from which he alone
> had the privilege to observe
> where everyone else was coming from.
>
> Defining the center
> with his own marginal authenticity,
> he'd become known as a border metaphor
> trapped inside a sham man's body.
> (*La Frontera* 1993, 69)

While Avalos's poem re-sites the masculinist politics tagged by Las Comadres, it also points to another tension that dogged BAW/TAF as a collective. Born, raised, and educated in Southern California, Avalos linked his art to regional activisms, while Gómez-Peña claimed a set of Mexico City and Los Angeles influences. A portrait of extremes? Rather than reading Avalos as the "practice" to Gómez-Peña's "theory," I'd note that the pair's distance and proximity epitomize BAW/TAF's overriding praxis by way of dissensus.

Exacerbating the collective's internal differences, the 1980s–1990s art world was "discovering" and classifying the "genres" of border art, feminist art and art by people of color despite or perhaps because of national debates regarding taste and funding. As surely as the right-wing questioned multiculturalism in museum and university complexes, Gómez-Peña charged *La Frontera*'s organizers with recycling the language of BAW/TAF to receive attention and funding for the exhibit.

In "Death on the Border: A Eulogy to Border Art," Gómez-Peña (1991b) mourned what he perceived to be the end of the line—the dwindling efficacy of BAW/TAF. Arguing that border art was a casualty of the US culture wars, Gómez-Peña sounded a lament:

> In 1989 everyone went border . . . The La Jolla Museum of Contemporary Art (now the San Diego Museum of Contemporary Art) alone raised more than half a million dollars for a four-year border project to essentially bring big names from out of town. Instead of turning the margins into the center, it was bringing the center to the margins . . . Who has really benefitted from all the border hoopla? . . . One year before the much-touted 500th anniversary of Columbus' "discovery of America," border art has become a casualty of a dominant culture that continues to ransack ideas, images, spiritual strength and exotic lifestyles from without and its own Third World within. (ibid., 8–9)

Gómez-Peña's prognosis left the era's cultural front on edge, even as it ironically solidified the artist's position as border art's iconic representative.[17] In contrast, Avalos's argument—that there might still be room to maneuver within a wider field of the social and by extension the aesthetic, perhaps closer to Gómez-Peña's sustained position in the final analysis—received less attention. What if—?

What if we returned to the sum of Avalos's contributions to *La Frontera*—an exhibition that formed part of Dos Ciudades/Two Cities, a series of Tijuana and San Diego art events and publications that was devoted to border art—to linger with the long view of Avalos's argument? Avalos embeds "me 'n u" in the essay "A Wag Dogging a Tale," itself embedded in *La Frontera*'s catalogue like some messianic shard. In "A Wag," he links reconfigurations of form in Bajalta California artwork to reconfigurations of form in the region's political economy. He also recognizes the significance of Bajalta California artwork in and to the post-1980s US culture wars (and vice-versa).

Avalos anticipates the argument that the integrationist or assimilationist logic of grant opportunities influenced the shape of a pocket: greater Mexican border art. In turn, the critic-artist-curator tests his hypotheses in two additional contributions to the show.

In Sisco, Hock, Avalos, Small, and Scott Kessler's untitled installation featured in *La Frontera, Welcome to America's Finest Tourist Plantation*'s poster returns like the repressed. An advertising meme—redacted into the rhetorical question, "America's Finest?"—subvertises a bus bench above seven silhouetted bottles and torsos, some of which contain a trowel, a set of hands, a baseball bat, and a question mark. While Chavoya and others suggest that the "PIAS Form" created a pedagogical environment in which viewers could contemplate the "Great Art Debate" attached to the original project, the bus bench as ideologeme adds another layer of meaning to the project's prior (art) history lesson. Because city buses (and their boycotts) figured prominently in US civil rights struggles, because car cultures of Southern California classed bus riders, the presence of the bus bench in this restaging of the project more explicitly links questions concerning public transport to national debates concerning political and aesthetic representation. To review the media coverage of the previous poster projects, viewers literally had to "wait for the bus"; sit-in the archive.

Relatedly, Sisco, Hock, and Avalos indexed the stakes of redistributing the sensible in Southern California with *Art Rebate/Arte reembolso* (1993), the public artwork that they created expressly for *La Frontera*. Sisco, Hock, and Avalos signed and distributed $10 bills to 450 undocumented workers in the San Diego–Tijuana region, in effect laundering grant money they'd received for the project's realization as if it were the found art of the action. The artists self-consciously imagined the gesture as dissolving borders that separate debates regarding aesthetic judgment, public funding of the arts, and US immigration policy from one another. *Art Rebate*'s form and contents again foreground economic restructuring in the borderlands, connecting the latter's circumstances to 1980s/1990s cultural skirmishes, including ones regarding the very definition of citizenship. *Art Rebate* highlights how recipients of the project paid taxes and social security. Per the era's polarization, however, like *Welcome to America's Finest*, *Art Rebate* generated less dialogue about the hypocrisy of lawmakers and more fiscally and culturally conservative backlash against collaborative and socially engaged art.

Commissioned for the very show that Gómez-Peña lambasted, *Art Rebate* prompted its most vocal detractors to follow the money, to audit

FIGURE 3.3. Elizabeth Sisco, Louis Hock, and David Avalos, *Art Rebate/Arte reembolso*, 1993. © Elizabeth Sisco, Louis Hock, and David Avalos. Courtesy of artists.

the museum's and Centro's funding streams. When all was said and done, because the NEA had supported *Dos Ciudades*, rebate became debate became a lightning rod for more heated exchanges over what constituted art worthy of patronage. Meanwhile, a different kind of backlash, connected to Avalos's critique of Gómez-Peña's "wounded attachments" to typecasting, was mounting against the self-styled "Mexterminator." The riff, a rift, a "rifa" . . . was complete. Mexico-US border art after 1992 did not die, but it split at the root to multiply of and beyond the region.

POST-1994 GDPS AND LABOR WARS; INSTITUTIONAL CRITIQUE AND INCORPORATION

GUILLERMO GÓMEZ-PEÑA'S "NORTH AMERICAN FREE ART AGREEMENT"

Years before Gómez-Peña became Avalos's "wag dogging a tale"—an icon of both border and performance art—his recycling of stereo- and archetypes reflected both the artist's increasing synthesis of his Mexican and US influences and his restless search for genres outside the enclosures of Mexico City and borderlands' radical art practices and commonsensical understandings of place and personhood. In the United States, when performance studies scholars imagine the centrality of performance art to the culture wars, a few names come to mind: Holly Hughes, Karen Finley, Tim Miller, Gómez-Peña . . . While the work of Hughes, Finley, and Miller, three of the NEA Four, is tagged as evidencing the performance and performativity of gender and sexuality, thereby suturing the late-twentieth-century interdisciplinary formations of performance and gender and sexuality studies (Hughes and Román 1998), the corpus of Gómez-Peña does another kind of double duty, is mobilized to illustrate the performance and performativity of the border and to stand in as one of the requisite references of both performance and border studies, two interdisciplinary formations that also came into their own in the 1980s–1990s. Additionally, as the communications studies scholar Eduardo Barrera Herrera (1995, 16) observes, assignments of value to Gómez-Peña's work have promoted tautologies that legitimate

appropriations of Mexico-US border culture and monumentalize the Border with a capital *B*, in critical theory addressing the postmodern and postcolonial.[18] How did Gómez-Peña achieve this level of iconicity? In the face of the artist's, border studies', border art's, performance studies', postcolonial studies', and postmodernism's interconnected yet unique "installations" in a global imaginary, how do we account for Gómez-Peña's contributions to our understandings of the border, greater Mexico, and Latin America as subjects and objects in the historical moment of continental transition in which his work first garnered recognition? How do we pinpoint his inter-American conceptualizations of performance as a genre?

Perhaps we could and must begin by recognizing a strategy that Gómez-Peña has maintained across his solo and collaborative work. Even more aggressively than BAW/TAF, Gómez-Peña literalizes, appropriates, exaggerates, and inverts naturalized or normalized constructions of individual and collective identity and difference. While the artist often describes his practice as a reverse or "inverse anthropology," he also has emphasized that his own work and border art more generally depend on a slippage between allegory and symbol.

In an interview with Sheren, Gómez-Peña insists, "border artists understood that if a symbolic action, an allegorical action in a highly charged political territory such as the border could be picked up by the media and become emblematic, it would affect the way both countries understood the border" (Gómez-Peña, quoted in Sheren 2015, 98). Sheren puzzles over the artist's conflation of symbol and allegory, ultimately reinscribing a rhetorical border into her analysis when she writes, "I would argue that most examples (in border art) of the symbolic gesture fall within the realm of symbolism rather than allegory" (ibid.). In contrast, we might note that the relay between allegory and symbol enables Gómez-Peña's protracted intervention in the aesthetics and politics of the era. It marks the artist's relocation of a DF attention to the city/City as non/site to the Mexico-US border and Gómez-Peña's participation in a specific neoliberal transition: the enshrinement of the Border as an allegorical figuration. In what follows, I focus on how Gómez-Peña synthesizes the visual, verbal, and corporeal languages of Mexican psychoanalytic and anthropological postrevolutionary cultural nationalisms and US cultural nationalisms (including postmodernism) of the post–civil rights era. Building on that analysis, I consider how Gómez-Peña nested this synthesis into his broader engagement with socioeconomic transition, specifically NAFTA as a master narrative.

To be clear from the outset, my reading of Gómez-Peña's oeuvre is

targeted and focuses on the artist's 1990s solo and collaborative production. Because Gómez-Peña's work is prodigious and is as frequently scrutinized as Francis Alÿs's or Santiago Sierra's, my goal is (1) to treat it as a historical hinge in thinking the consolidation of border art as NAFTArt, and (2) to create a "photo-performance" *pace* the artist's own early twenty-first-century art historical reperformances (González and Gómez-Peña 2009).

A Chilango Becoming Chicanx

The Mexican anthology of Gómez-Peña's multilingual writings, *El mexterminator: Antropología inversa de un performancero postmexicano* (The mexterminator: A post-Mexican performance artist's inverse anthropology, 2002), was a long time coming. Although numerous compilations of the artist's work have been published in the United States, *El mexterminator* functioned something like José Luis Cuevas's DF show *The Return of the Prodigal Son*. Gómez-Peña is legendary in Mexico for what he accomplished after leaving the DF. Representing the global monumentalization of Mexican performance art, Gómez-Peña's aesthetic paradoxically diverged sharply from the aesthetics of the communities who have come to recognize his work as significant, however. The distance between Gómez-Peña's practice and that of other DF cultural producers of his generation speaks to the artist's dual aesthetic citizenship, his consummate status as a border-crosser, or what he once termed his position as a chilango-becoming-Chicanx subject (2000, 12).

That distance—evidenced in the nod of the anthology's title to California's eventual Republican governor (2003–2011) Arnold "The Terminator" Schwarzenegger, another film to rival "Ronald Reagan: The Movie"—also marks Gómez-Peña's successful incorporation by other means into the genre-fication of Mexican performance art. While Gómez-Peña's work cleaves closest to the ostracized archive of "Woman," ostensibly offering the missing hybridization of performance coming out of the visual arts and cabaret theater, his artistic strategies at a remove from those of the DF contemporary and the cabaretera scenes also speak to the artist's refusal to renounce counterintuitive allegiances to the allegorical figurations of the solitary (male) genius, the restless lone postrevolutionary hero, and the urbane man of letters.

Gómez-Peña's hyperbolically gendered body and performance art intervenes in binational constructions of mexicanidad that depend on the mediation of the Border as a figuration of various literal and imaginary geographies and kinships. His work succeeds with sizeable recourse to

languaging, the spoken and written word (a distinction anticipated by the varied efforts of Los Grupos and their members—e.g., Melquiades Herrera, Maris Bustamante, Roberto Bolaño—after those collectives' dissolutions). But, the artist's aesthetic also hinges on the materiality of the image, its accessorization.

Gómez-Peña was born (1955) and raised in Mexico City. He received his undergraduate degree in linguistics and literature from the UNAM. A student of the city's literary workshops led by Juan José Arreola, Salvador Elizondo, Hernán Lavín Cerda, and Alicia Reyes, Gómez-Peña describes his early work, like that of his immediate predecessors, as resisting the sensibilities of "the colonized literary circles" (1991a, 28). He claims his "true literary activities" as being "on the streets of Mexico City, [my] playground and laboratory" (ibid.). Often rehearsing his allegiances to the capital, he maps out his DF forbearers: merolicos (street salesmen), "carpas" (theater tents), Los Grupos, and the shifting socioeconomic configurations of the museum in Mexico, notably its privatization (1984). He writes, "Mexico is an extremely theatrical country, and Mexico City is its most effervescent example" (36). He notes, "From Aztec to post-punk, all styles, eras, and cultural expressions are intertwined in this megapastiche called 'el DF' (Mexico City); and those of us who grew up in such a context developed a vernacular postmodern sensibility, with intercultural fusion at its core" (26). Such expressions squarely situate Gómez-Peña's corpus within the orbit of post-1968 artistic reclamations of the city. They flag his substantial conceptual contributions to BAW/TAF's invocations of the border region as a laboratory. And, they resonate with solitary models of practicing the city that predate all of those collectives' actions.

I reference the opposing masculinist poetics of Mexico's immediate postrevolutionary era (a point half taken up by Maris Bustamante, we might recall, when she traces a genealogy of the PIAS Forms back to the Estridentistas), including their impact on Octavio Paz's later international reification of the Latin American national essay as a genre.[19] Paz—after Samuel Ramos, but also after the Contemporáneos—was fascinated with urban scapes, with the stylized bodies of men on greater Mexico's city streets. Ramos and Paz charted a continuum of working-class Mexican—from Mexico City to Los Angeles—masculinities. Via pseudoethnographic and psychological profiling of the "everyday practices" of chilangos and "angelenos" (natives of Los Angeles), understood as decidedly theatrical, Ramos and Paz identified the racialized and classed Mexican male as overcompensating for his feeling of inferiority in displays of sexualized verbal

prowess. The earnestness of both men's efforts to portray a unified Mexican trans/national, implicitly male identity has provoked admiration and derision. Late-twentieth-century historical revisionists have written of the performative, pointedly homo/erotic dimensions of Paz's and Ramos's "object choices" (e.g., Irwin 2003; Limón 1998). Showing versus telling, Gómez-Peña's work offers another revisionist account that pays homage to Paz's and Ramos's arguments as the baseline of the artist's own hybridization of anthropological and psychoanalytic Mexican cultural nationalisms. Across his performance, installation, photo, and hybrid jam sessions, Gómez-Peña takes up the thread of Paz and Ramos's shared interests in typecasting, in wordplay, and in a greater Mexican masculine homosocial continuum, materializing the theses of that dynamic duo.

Gómez-Peña's engagement with the work, his extended excavation of a domestic and continental homonational unconscious, rhetorically is neither mimetic nor appropriative, however. Instead, Gómez-Peña's best actions reverse or invert the negative classed and racialized valences traditionally placed on the anti-heroes of Paz's and Ramos's "national romances." Gómez-Peña's overarching method levels out hierarchies, de- and reallegorizing Paz's and Ramos's conceptual personae, and assumes the stature of nation drag per the terms of "Woman"'s work, per BAW/TAF's recourse to arche- and stereotypes.

Hence, in *El Museo de la Identidad Congelada* (*The Museum of Congealed Identity*, 1996) in Mexico City's Ex Teresa, Gómez-Peña becomes "the subject of display," his body modeling the in/authenticity of accessorized personhood (González 2008). In an image documenting the performance, the artist wears a cowboy hat decorated with feathers and a headdress. A snake wraps around the artist's neck. A tiger-striped vest covers his bare chest. A tattoo of vaguely pre-Columbian design falls just below Gómez-Peña's averted gaze. In one leather-studded and gloved hand, he holds a knife suspended, at the ready to cut out his own tongue. En vivo, he chanted in various languages, moving rapidly between Spanish and English, reciting poems like prayers or spells. Or, in *Performero* (*[Mere] Performer*, 1995), one year after Alÿs's *Turista*, Gómez-Peña, in equally "multi-culti tribal gear," sits behind a placard, handwritten, riddled with misspellings, again in Ex Teresa. The figure's seemingly earnest petition brings to mind the era's revamped indigenismos, the aspersions cast by Mexican cultural elites of the period on Zapatismo and this same demographics' unabashed bids on restructured arts funding, the cloaked rhetoric of cultural exceptionalism attached to the NAFTA debates in the DF and beyond, and the ex-centricity

FIGURE 3.4. Guillermo Gómez-Peña, from *El Museo de la Identidad Congelada*, 1996, Museo de la Ciudad de México. © Guillermo Gómez-Peña. Courtesy of artist.

of performance for Mexico City's alternative-becoming-contemporary. It also conjures the integration of neo/liberal multiculturalisms into US institutions of cultural capital. Gómez-Peña's placard inaugurates a North American campaign: "PERFORMERO/me corrieron del Museo de Antropologia/No econtré chamba en Joligud/Nadie me cre qe soi Zapatista/El Jeronimo de la 18" (PERFORMERO/They threw me out of the Museum of Anthropology/I didn't find a job in Hollywood/No one believes that I'm a Zapatista/The Jeronimo of the 18; Gómez-Peña 1996, 107; translation in documentation and errors intentional in original Spanglish).

We might marvel at the ironic irreverence—along the lines of what we witnessed in Vicente Razo's *Museo Salinas* or Yoshua Okón's *Risas enlatadas*—of this figure's campy escape from one museum into another as we might marvel at the ironic irreverence of converting Ex Teresa into a Museum of Congealed Identity. But, more to the immediate point, a dynamic interplay of word and image undocuments stable signifiers in these performances, demonstrating Gómez-Peña's rehearsal of the quid pro quo slippage of symbol and allegory in a greater Mexican quotidian.

Chief among Paz's pantheon of allegorical figurations, "The Pachuco,"

the first accorded a proper name by the thinker, is repurposed repeatedly in Gómez-Peña's actions. Like Paz decades earlier, Gómez-Peña exited the DF (1978), but never fully left the capital, to complete his most influential work. In 1980, pre-BAW/TAF, in Los Angeles during his tenure studying post-studio art at the California Institute of the Arts, Gómez-Peña and his then wife and artistic collaborator Sara-Jo Berman founded Polyesis Genética, a performance troupe that drew on Latinx and urban art to create interdisciplinary and multigenre work about Mexico-US borders (Gómez-Peña 1991a, 32). Gómez-Peña cultivated an interest in and deep connection with Los Angeles–based Chicanx art, gravitating especially toward Asco's anti-aesthetic.

The best reading of Gómez-Peña's preoccupation with "the Chicano" takes the artist at his own word, "I am a Mexican in the process of Chicanization" (2000, 12). But other elements of Gómez-Peña's recourse to arche- or stereotype reproduce the "problem" of a party-line poststructuralist emphasis on repetition with a difference. Cultural historians increasingly cite pachucxs as Chicanxs' Los Angeles forebears. On the one hand, almost unreflectively, Gómez-Peña inverts and exaggerates Paz's caricature of the displaced Mexican when he relocates the Chicano (male)—elevated to an allegorical figuration—as his "reluctantly postmodern" condition qua figuration of possibility for remapping the Mexico-US subcontinent. On the other hand, Gómez-Peña's fascination with all things "Chicano" follows the Chicanx's more general alleged reversal of fortune in the Mexican cultural imaginary. I refer to Olivier Debroise's observations on 1980s Mexican artists' ambivalent fascination with Chicanx art and culture (Debroise, in Good and Waldron 2001, 55) and the critic's description of the "Chicanoization" of Mexican culture from the 1970s onward (Debroise 1990, 28). The latter process was rivaled only by indigenismos in the late twentieth century, although the Conceptual -isms underpinning each must be understood as connected. The Chicano in Debroise's and his DF contemporaries' formulations simultaneously becomes a suspect and a new "revolutionary" archetype (anonymous as the ski-masked Zapatista, as everyone and no one in migratory Mexico). The Chicano is worthy of emulation, but he also doubles as a Wynterian genre for "cultural slumming" (in no small measure because the archetype is also implicitly classed, raced, and gendered as the disenfranchised). The formula is pre-scripted, cleaves close to Paz's and Ramos's.[20] If Paz in 1950 couches his appropriative discussion of the "pachuco" in explicitly performative terms, "The *pachuco* carries fashion to

its ultimate consequences and turns it into something aesthetic" (1981 [1950], 15), Gómez-Peña takes up the contradictions of that assertion as a fashion opportunity and opportunism—donning types from the old-school Chicano nationalist, "gangbanger," drug user, and others—across his allegorically inflected performances.

Gómez-Peña collapses the pachuco into the Chicano (like the "geography" of Woman). He then theatricalizes the elision, converting the Chicano into the subject position from which to double down on the links between Mexican and US nationalisms. The chain of signification's change of perspective is maximized with minimal effort pace *When Faith Moves Mountains*. It is anachronistic, pre-Chicanx for all practical purposes, yet "post-Chicano" (pre-*Phantom Sightings: Art after the Chicano Movement* [2008]) insofar as the artist aspires to incorporate the heroic poetics of Chicano nationalism into an extended narrative of remexicanidad whose ground zero remains Mexico proper. The gesture distinguishes Gómez-Peña's "anxiety of influence" from the anxieties of influence the national essayists provoke in the hybrid writing of figures like the Tejana feminist Gloria Anzaldúa. The gesture separates Gómez-Peña's mobilization of types from Asco's and BAW/TAF's typecasting.

The "problem" (to re-cite that language)—which prompted José David Saldívar (1997, 95) to question parenthetically whether Gómez-Peña's playfulness occurs "at the expense of critical multicultural work," understood as US-based—could be resolved neither by Gómez-Peña's (2000, 12) glib retorts to his critics, "(Will I ever become a 'real' Chicano? Will I ever 'arrive'? Will 'they'—the border guards of identity—ever let me?)," nor by his second relocation to the literal Mexico-US border. If Gómez-Peña claims Mexico City as Mexico's most memorable work of performance art, he qualifies Tijuana as its most ambitious installation (Gómez-Peña, in Fusco 1995, 155). Just as the artist fetishizes types, he converts metropoles, regions, and nations into *Smithson*ian non-sites per the terms of 1990s Mexico City artists' pedestaling and redistribution of the DF as the global megalopolis par excellence. Moving to Tijuana–San Diego, Gómez-Peña exacted a similar conversion process on the border, turning his home into "Border Inc.," developing a series of bilingual projects, including a radio show and the experimental magazine *The Broken Line/La línea quebrada* with Marco Vinicio González (ibid.), and eventually marrying his second wife, Emily Hicks, at *End of the Line*'s Border State Park/Playas de Tijuana.[21]

The force of Gómez-Peña's conversion, like the force of his inversion tactics—the fodder of his conceptual bent—in turn both helped catapult

BAW/TAF's work into an international spotlight and contributed to the artist's falling out with the collective. Put differently, from the late 1980s to the early 1990s, the years that Gómez-Peña spent in San Diego–Tijuana, he concretized and then consolidated his overarching method. The half decade or so also represented a time in which the artist figured centrally in the enclosure of the commons of border art. Transnationally profiling the allegorical dimensions of the latter's brand of performance and conceptualism (artwork that guaranteed a border/Border asymmetry), Gómez-Peña refined his citation of the Mexico-US dividing line as a vehicle for thinking continentally and globally. He developed his authorial voice through and against the emerging backdrop of a version of performance unique unto the United States, through and against the robust performance of cross-border commerce.

Numbers fail to tell the whole story, but they do corroborate the fallacy of a "City"/"Border" opposition. About 84 percent of US-Mexico border populations are urban, with San Diego and Tijuana representing the largest border conurbation. If between 1970 and 1988 the combined GDP of Mexico's northern states remained the same or even decreased slightly, while the combined GDP of the United States' Sunbelt rose from 1988 onward, the transborder un/documented GDP shot up dramatically first in anticipation and then as a consequence of NAFTA's passage, the "immigrant panic" that Gerken details, and the coordination of the US and Mexican War on Drugs. (For instance, the GDP of Tijuana increased even as San Diego, already the United States' wealthiest border city, benefited from the region's socioeconomic restructuring.) In response, Gómez-Peña amplified the range of his typecasting, developing his own metrics for managing and assessing the art of free trade.

Two performances that became eventual video/installation collaborations with the former BAW/TAF member and director Isaac Artenstein stand out from this half decade, *Son of Border Crisis: Seven Video Poems* (1990, 16 min.) and *Border Brujo* (1990, 52 min.). At first glance virtually indistinguishable, as Claire Fox (1999, 127) notes, *Son of Border Crisis* functions something like the "alter ego" of *Border Brujo*. In title alone, *Son of Border Crisis* pays homage to Paz, but throughout the performance and its video documentation, Gómez-Peña also distances himself from the literary giant's increasingly party line cultural nationalism. Reclaiming, like Margolles, the prerogative to sign off with the moniker "hijos de puta," the artist, with tricked-up gestures and wordplay that ford the transnational divide between Mexico and the United States, reinvigorated psychoanalytic

nationalism. Erecting "temples of confession" in No-Grupo–inspired "montajes de momentos plásticos," Gómez-Peña renovated, became his own best "medium" of ethnography. Drawing upon vernacular Spanishes, Englishes, and other literal and imagined languages and geographies, he "versioned" working-class urban greater Mexican masculine subjectivities, also including those of gringo tourists and nativist radio personalities (e.g., Hedgecock). If Sigmund Freud suggests revelations of the unconscious happen in our slips of the tongue, Gómez-Peña's hyperbolic punning situated the Mexican-US borderlands as some "temporary autonomous zone" of a global uncanny (Bey 1985).

The border—its literality, its function continentally—dictated the terms of the artist's rapid-I-movement, his staging of counter/transfer/ence. Singing, screaming, howling à la Allen Ginsberg through a bullhorn, Gómez-Peña compares "art without ideas" to "tacos without salsa." He ruminates on the "Mexican mind." The artist assumes racialized, sexualized, classed, trans/nationalized characters and caricatures like costumes. The "Border Brujo," a figure of fifteen personae that Gómez-Peña claims to have been possessed by from 1988 to 1990, demonstrates the extent of the artist's commitment to the "shaman" *pace* Joseph Beuys—the performance artist—as archetype, too, although the sheer density of the visual and performative planes in *Son of Border Crisis* and *Border Brujo* and the details of each's layered ontological text-images set Gómez-Peña's practice apart from Beuys's work.[22]

Perched in front of an overflowing altar, wearing a Border Patrol agent's jacket that is covered with buttons (images of Frida Kahlo, the number 187 struck through in clear reference to California's Proposition 187), beads, and shells, Gómez-Peña breaks into tongues. He takes swigs from a Clairol shampoo bottle. The organizing trope or operation, one of allegorical figuration, drags the post- after Paz, after Mexico, after conceptual practice either side of the border and the avant-garde out into the open. The artist's "rupture" and continuity with the national allegorist's value system becomes the expanded cinema of a talking versus walking mural. Carlos Monsiváis's formulation of "national camp" at long last blatantly rubs elbows with Tomás Ybarra-Frausto's elaboration of "rasquachismo" in the built environments of these proto-undocumentaries, regenerating the allegorical performative in gestures that fold commodity aesthetics back into the discursive vectors, image environments, and performative matrices of the new millennium's tales of the tribe.

Actually using Gómez-Peña's work to define rasquachismo, Ybarra-Frausto, like other cultural workers of the period, practices what he

theorizes, "The rasquache inclination piles pattern on pattern, filling all available space with bold display. Ornamentation and elaboration prevail, joined to a delight for texture and sensuous surface" (Ybarra-Frausto, in Griswold del Castillo, McKenna, and Yarbro-Bejarano 1991, 156). In the case of Gómez-Peña, patterns and textures, like identity-backed securities, are flash traded, repackaged, and represented as so many baroque folds in the fabric of a binational market-state's spectacular phantasmagoria. The artist's cadences follow movement poetics, Chicano and Black nationalist but also Beat and Nuyorican poetries, a 1980s–1990s critical mass of US performance and political rhetoric, all steeped in the genre of the monologue. Gómez-Peña's language play honors the legacies of a bifurcated postrevolutionary poetics, not fully acknowledged by Bustamante when she periodizes the PIAS Forms.

To complicate matters, Gómez-Peña's languaging cannot be separated from the pictures he snaps and develops like X-rays. The artist's wordplay functions within his overarching allegorical system like wave is to particle in Albert Einstein's theory of relativity, like "dialectical image" is to film in Sergei Eisenstein's theory of montage. The corporeal density of Gómez-Peña's actions literalizes the complexity of a moment tied to transcontinental shifts in self and collective representation. Gómez-Peña's efforts elucidate that while socially dramatic proclamations heralded the end of the subject, the nation-state, history, and objectivity, paradoxically, the final decades of the twentieth century also approximated the gilded age of incorporation. Poststructuralism (remixed), postmodernism, multiculturalism became the best brands of neoliberal transition in the United States (Duggan 2003) before being exported elsewhere. *Son of Border Crisis* and *Border Brujo* reflect critical contradictions, debates, and rebates projected onto US and hemispheric art and politics after the long 1960s worldwide.

Gómez-Peña's 1990s performances especially are grounded in US (queer) exceptionalism, the particularities of the public sphere's cultivation of a unique homonationalism. The second congealment of Gómez-Peña's authorial voice must be understood as riding the wave of glossy Gap-Benetton color bloc institutionalization. But, before that folding in, Gómez-Peña's interventions set a bar for performance's sustained engagement with the dramatic monologue. The artist himself asks and tells: after the case of the NEA Four, performance in the United States became synonymous with the monologue and an effusive queerness. Hughes and the performance studies scholar David Román underscore the importance of spotlighted

subjectivities with the title of their edited anthology of queer performance, *O Solo Homo* (1998). "The talented tenth" whose work they showcase evolved out of a collective politics that pluralized and fragmented the United States' "national allegories" in the 1990s. Performance, tied to Judith Butler's groundbreaking *Gender Trouble* (1990), the AIDS crisis, and the rise of a "Queer Nation," became the keyword for imagining identity as subject to trans/mutation (although I'd note that Butler focuses on the commonsensical script even as that aspect of her text is often relegated to the parenthetical). With his characteristic incisive flair, Gómez-Peña charts the above sea change, summarily forcing intersectionality by way of a racialized and sexualized greater Mexico, into the conversation.

Explaining his own practice and that of a generation's, Gómez-Peña (2000, 126) acerbically hits the high note of a pedagogical temporality: "[W]hite liberal audiences loved to be scolded by 'angry artists of color.'" Monologic performance, autobiographical but not strictly testimonial or documentary, was, after all, lo-fi, easily produced on a shoestring budget. It complemented, but was distinct from, what passed as performance art in Mexico from 1992 to 2000 before Mexico's early-twenty-first-century post-porn movement and the artist's prodigal return to the DF. Presenting a self's story to stage a confrontation with their audience members, performance artists mobilized a "subversive narcissism" (Jones 1998, 215) to insist on inserting the nation's Others into transnational scripts of "imagined community" (Anderson 1983), an altogether distinct enactment of penetration.

Gómez-Peña's body language, his code-switching, his attentions to stereo- or archetype, his commitment to the pose, sited his practice and person as perfect "specimens" of multimediated performance and border art, of performance studies and border studies (after the initial interdisciplinary bids of ethnic studies were staked on US university campuses). But, disconnected from the literal Mexico-US border, the Border as non-site also immaterialized the effects of the artist's efforts. In this crucial decade, the Border becomes Gómez-Peña's consummate symbol qua allegorical figuration, itself a synecdoche for the esprit de corps. In works like *Border Brujo* (1990a), the artist combines the US (queer) monologue with the Latin American national essay to reflect on sovereign personhoods, offering his publics ample visual and verbal clues to process the labor congealed in the work as performative.

The gamble behind this incorporation from the outset was calculated. The artist risks reproducing the very stereotypes and archetypes that he seeks to throw into relief. An "I" for an "I": while the transcribed quality of

Gómez-Peña's actions muddies the waters of selfhood, it also supplements readings of the artist's personae as misogynist and homophobic. Of Gómez-Peña's practice, the Latin Americanist Jill Kuhnheim (1998, 26) argues that "despite an appearance of heterogeneity, Gómez-Peña ultimately reinforces his authority as artist and as emblem of a particularly masculine bicultural identity." Defending himself against such critiques, the artist retorts:

> There's a disturbing tendency in America [the United States] to take things literally. Since our work is highly symbolic and metaphorical, it appears to be very much out of context in the current culture. We're living in a time in which confessional narrative is the primary means of communication, and we don't engage in confessional narratives of authenticity. Neither do we engage in psychological or social realism. The work is really not about "us." (Gómez-Peña 2000, 170)

Gómez-Peña's rebuttal depends on our apprehension of the prominence afforded the allegorical action in the artist's corpus, but it also trades one literalism for another to deploy the un- of some Freudian *uncanny* as slippage.

In this vein, possibly seeking to introduce greater distance between his own and others' "extremes," the artist, along with Roberto Sifuentes and Nola Mariano, founded La Pocha Nostra in 1993.[23] In 1995, the collective relocated to San Francisco. In 2001, it was incorporated as a nonprofit. With La Pocha Nostra, Gómez-Peña's aesthetic, of the No-Grupo variety, was redefined vis-à-vis an allegiance to the alternative and collaborative that was reminiscent of the scenic commitments of Mexico City's 1990s art making. The performance troupe became a vehicle through which Gómez-Peña ensured the drag and "pedagogical temporality" of the ephemeral diorama, its reconfiguration as a tableaux vivant mural or as a photo performance in the cultural imaginary of performance studies as an inter/discipline. Thus, we find not only "one place after another" (Kwon 2002) but one persona after another in La Pocha Nostra's "archive and repertoire" (Taylor 2003): In early 1994, on Rodeo Beach in front of San Francisco's Golden Gate Bridge, Gómez-Peña and Sifuentes, recycling the language of anti-immigration and Proposition 187 proponents, proclaimed themselves to be "public enemies of California" and staged their own "crucifictions." Two years after the "burning cross" of the LA riots, the pair hung on 16-foot-high crosses for hours before nearly three hundred spectators cut them down from their stations (Gómez-Peña 1996, 102). Post-9/11

(2001), in numbered interactive rituals that make up the series *Mapa Corpos*, Gómez-Peña et al. acupunctured a woman's body to map the US War on Terror. (Recall how the ritualized healing of the effeminized social body, first pioneered by artists from Beuys to Marina Abramovic and reperformed by Wolffer and others of "Woman," functions as an abjectified trope of performance art.) Post-2008, in photo performances and performance jam sessions worldwide, La Pocha Nostra staged another War on Terror. Gómez-Peña and his frequent collaborator, the Native (Pooyukitchum/Luiseño) and Mexican American performance and multimedia installation artist James Luna, accessorized heroic frontier masculinity. Gómez-Peña, outfitted as a postcontemporary "Lone Ranger," sits hunched over at the bar of some western cantina (presumably the cash bar of an art opening) with Luna, the never tonto Tonto. Or, hit(wo)men of La Pocha Nostra reMex Alÿs and Cuauhtémoc Medina's Lima Biennial action *When Faith Moves Mountains*. Medina and Alÿs's allegorical one-liner becomes a conceptual petition of the homeless (artist): the handwritten cardboard placard "Will Move Mountains for Faith," vaguely reminiscent of both Alÿs's pre-occupation as "Turista" and Gómez-Peña's detailing of his 1996 escapade from the National Museum of Anthropology, but updated for the twenty-first century, sits propped in the foreground against a scantily clad fallen angel (of history). (See plate 14.)

The complexity of these "dialectical images," from *Cruci-fiction* to *Will Move Mountains for Faith*, belies Gómez-Peña Inc.'s methodological rigor. But the performance troupe's allegorical accumulation, enabled via formulaic inversions, suggests the disingenuousness of La Pocha Nostra's jab at Alÿs (and Medina) and their ironic self-recognition as a conceptual "Mafia," too. The patterns and textures of Gómez-Peña's countless reversals of types pile up, timespace specific but also generic, presenting a formidable challenge for art historians of the vanishing present: How do we mark rupture across this artist's "fugitive landscape" of production? How do we balance an attention to the work's continuities with a recognition of the specificities of individual performances' challenges to aestheticized politics and economics, to politicized and monetized art making?

Undiscovering the New World Border

Two Undiscovered Amerindians Visit the West (1992) signals a crucial refinement of Gómez-Peña's ambitions. Pre-Pocha, the collaboration of Gómez-Peña and Coco Fusco marks a dramatic departure from and reframing of Gómez-Peña's (if not Fusco's) practice. *Two Undiscovered* follows the

formula that Gómez-Peña lays out for the "allegorical action," but also sites the political stakes of the latter in conversation with the overarching social allegory of the period, recasting the triumphalist narrative of globalization as a repeat performance of borderization.

The "un-" of "undiscovered" in the work's title explicitly challenges neocolonialist claims of mastery and origin. The premise of the project: Fusco and Gómez-Peña, recently discovered "primitives" from an island in the Gulf of Mexico, are on tour in the colonial "freak show" tradition of displaying live human beings or their remains. The pair enacted *Two Undiscovered* in several locations, including Washington DC's Smithsonian Institution National Museum of Natural History, the Field Museum of Chicago, London's Covent Garden, and Madrid's Plaza de Colón, modifying the carnivalesque "scenario of discovery" slightly in each (Taylor 2003).

Consistently, Gómez-Peña was bare-chested; wore a headdress and sunglasses; recited poems in un/documented languages; and flashed his male genitalia, which otherwise were tucked between his legs, for five dollars. Fusco wore face paint and a wig, Converse high-tops, and a grass skirt. She ate bananas, watched TV, and danced for spectators for twenty-five cents.

Two Undiscovered resonates with, but also stands in contrast to, former BAW/TAF members Lou and Sánchez's lesser-known intervention *Los Anthropolocos* (1992), whose title cleverly substitutes "locos" (craziness) for the "logos" of anthropology. In that durational piece, set in an unspecified future, Drs. Ritchie A. Lou and Bobby J. Sánchez study the archaeological traces (e.g., an excavated Barry Manilow LP) of the white or "Colorless Empire." Like Lou and Sánchez, Gómez-Peña and Fusco in the same year redirected ethnography's attentions toward the global North. More pointedly than Lou and Sánchez, however, Gómez-Peña and Fusco flaunted and vended their in/authenticity to "fieldwork" their publics per prior actions by Gómez-Peña. The result was that, like Sisco, Hock, and Avalos with *Welcome to America's Finest*, Gómez-Peña and Fusco generated a firestorm among the literal-minded in and out of the art world.

Two Undiscovered's allusions to Roger Bartra's "cage of melancholy," Max Weber's "gilded cage," Fredric Jameson's "prison-house of language," whether intentional or not, are noteworthy, but we cannot account for the monumental loneliness represented by and in the totalizing apparatus of this work solely by way of continued citation. The most compelling contextualization of *Two Undiscovered* is Fusco's.

Despite Fusco's admission that she and Gómez-Peña "took a symbolic vow of silence with the cage performance," she broke that vow with both

Couple in a Cage (Fusco and Heredia 1993, 30 min.) and the essay "The Other History of Intercultural Performance," which she refers to as the "conceptual underpinning" of the latter video (Fusco 1995, 39). In her essay, Fusco details *Two Undiscovered*'s reception to delineate its conceit. *Couple in a Cage*, more clearly legible through the lens of the genre of undocumentary than Gómez-Peña's prior video documentation of his performances, illustrates well how Fusco and Gómez-Peña sought to suture, and thereby short-circuit, the general collecting and curatorial impulses of art and anthropology per each formation's distinct crisis of representation. Deploying both pastiche and parody, *Couple in a Cage* could be misinterpreted as forwarding a postmodern relativism. Affectively oscillating between humor and pathos, the film's urgent political message, however, does not afford us the luxury of an indecisive aesthetics.

Fusco's "undocumentation" demonstrates how the artists advanced a larger cultural agenda of prefixation, the un- of not only BAW/TAF, but that of Ella Shohat and Robert Stam's *Unthinking Eurocentrism*. Destabilizing the museum and gallery, Fusco and Gómez-Peña folded both built environments into their work's cage of figuration.

Per the "allegorical actions" of Gómez-Peña and BAW/TAF, the consummate repeat performance "undiscovered" with and through the action was not authored by the artists or their audiences. Rather, a style of governmentality that irrevocably cross-contaminates the aesthetic, the political, and the economic becomes the "art" rediscovered by Fusco and Gómez-Peña in the action. *Two Undiscovered* drew attention to the loop of drama and social drama, approaching it as an open circuit. The performance interrupted the propagation of a very particular master narrative that encompassed and extended beyond the 1990s Mexico-US border. I refer once again to the overlaid allegories of colonial encounter and the open market. The unthinking world beat celebration of Columbus's discovery of the Americas, which catalyzed Nao Bustamante's *Indig/urrito*, also sparked *Two Undiscovered*. Fusco writes, "When we began to work on this performance as part of a counter-quincentenary project, the Bush administration had drawn clear parallels between the 'discovery' of the New World and his 'New World Order'"(1995, 38).

The quincentennial festivities—in the thick of the largest run ever of the US bull market from December 1987 to March 2000 and the emergence of Mexico's globally competitive 1 percent (witness Carlos Slim's ascendancy on the Forbes tally of the world's richest)—hinged on a layering of ends that Gómez-Peña and Fusco, like many of their contemporaries, strove to

disambiguate. The refrain of 1492 shorthanded as a primal scene, itself shorthanded the complexity of cultural contact, mobilizing but also flattening it as a paradigm shift in planetary consciousness akin to the revelation that the world is round. For peoples of the re/discovered New World, this provincial remix of Western thought paralleled another end of history lost on the "Last Man" Francis Fukuyama—racial genocide, unprecedented sexual violence and environmental degradation, and cultural annihilation.

In 1992, as I cite-read in this book's "Prelude," an opening of the world market, the failure of communism, and the Washington Consensus were applauded as the inevitable consummation of a momentous shift in global consciousness comparable to that experienced in the Columbus era. This shift was accelerated per the maxim that cyberspace erased race and Other markers of in/difference, per the nascent birth of database aesthetics. For peoples of this New World (Order), such presentism replicated the suspended temporality of "civilizing missions." *Two Undiscovered* remains iconic because it succeeded in capturing the spectacle of transition as one of historical transfer and counter/transference following the overlaid rape scripts of globalization and settler colonialisms. *Two Undiscovered* modeled sly resistance, functioning like a meme of the metaprojects of postcolonial and ethnic studies. The accumulative logic of the intervention matched the palimpsestic with the palimpsestic. The challenge to participant observers after Fusco and Gómez-Peña's (art) historical Event involves defragmenting the work's "contextura"—the where, when, and how of the emergence of an alternative imaginary geography—"a great trans- and intercontinental border zone" where worlding and bordering became interchangeable. The latter process (versus end product) makes clear that the symbolic action of *Two Undiscovered*, like the work of Katia Tirado or Silvia Gruner, must be excavated for its allegorical layers and cannot be extracted from the timespace of its production.

Some preliminary version of *Two Undiscovered*'s challenge to the era's glitchy master/saved dialectic informed Gómez-Peña's contributions to BAW/TAF, but also hastened the artist's break with that "Grupo" in 1989. Readings that confine Gómez-Peña's individual and collaborative efforts to the geographies of the US-Mexican borderlands willfully ignore the artist's repeated articulations of a "transcontinental consciousness" (Gómez-Peña 1991b, 9), "a border gnosis" (Mignolo 2000) understood as representative of migration, postmodernism, and hybridity. But, if an allegorical way of seeing the US-Mexico border becomes most apparent in the instances of its mutation—like some black cat in *The Matrix* (1999) of the Wachowski

siblings—the NAFTA era presented an opportunity to catch a baroque sovereign's doubling, a premise on which Gómez-Peña, neoliberal as the aforementioned film's Neo, bet his career. Gómez-Peña neither was nor will be solely of the literal Mexico-US border. His dog in the fight was as non/sited as Alÿs's and Sierra's. The work of Gómez-Peña functions as a game-changing entry in an Other (art) history of the NAFTA era because, more than any other artist of the period, he repeatedly materialized the terms by which the Mexico-US border came to allegorize and thus accessorize not only a greater Mexican but also a general postmodern-becoming-neoliberal consciousness.

Sheren (2015), pluralizing a phrase by Fox (1994), notes that 1990s border art by all appearances morphed the Mexico-US dividing line into a "portable border." An alternate way of reading the code-switch—Gómez-Peña's own repeated recourse to inversion—is that cultural producers responded to a process already set in motion. Government and industry's reconfigurations of the region constituted "allegorical actions" to rival any that were composed by art workers in response. Like the counter-*Light Up the Border* campaign, Gómez-Peña's solo and collaborative works did not set the terms of this conversation, but participated in it. Gómez-Peña's actions, like BAW/TAF's, take a measure of power, the beat frequency of (social) drama. His corpus before and after *Two Undiscovered* depends on his development of a synthesized method of embodied literalization, inversion, and exaggeration that is only viable because the system it references internalizes a larger political-aesthetic feedback loop.

After 1992, after *Two Undiscovered*, Gómez-Peña's performance even more noticeably waxed conceptual. The Border (with a capital *B*) supplied the artist with the bass line of his practice. The trajectory of Gómez-Peña's attentions to the literal social and economic conditions of the border as a region waned. The shift reflected his subsequent focus on relationships between greater Mexico and the world, but also dictated the terms of his turn to a widening dioramic qua marketplace consciousness.

Self-appointed cultural diplomat, the artist in NAFTA drag indexed a synthaesthesia of transnational narratives, the epistemic violence of a hybridized allegorical performative. The appeal to community in Gómez-Peña's corpus through the late 1990s—from his coproduced Orwellian meets Orson Wellesesque *1984/War of the Worlds* sci-fi occupation *NAFTAZTEC: Pirate Cyber-T.V. for A.D. 2000* (1994), replete with "A Brief History of Performance Art" (1996, 114), to the artist's twenty-first-century nostalgic "reperformances"—reverberated, played into a "temporal geography"

(Brady 2002), the conspicuous consumption of the Border becoming a stand-in for a One World master narrative, the retrospective "Ex-plendors: 3,000 Years of White Art" (Gómez-Peña 1996, 43).

In clear reference to the blockbuster exhibition *Mexico: Splendors of Thirty Centuries*, "Ex-plendors" marks the same difference the artist's work sought to foreground. By the early aughts, Gómez-Peña and his collaborators actively expanded the scope of audience participation in their diorama-inspired presentations. La Pocha Nostra no longer simply solicited the fantasies and reactions of their viewers, but invited and incited spectators to enter and alter the configurations of artworks under way. Gómez-Peña et al. transformed observers into participants, the raw materials of Beuysian "social sculpture," ephemeral living museums and mural forms. Simultaneously, wielding the indeterminacies of categories like the hybrid, the migrant, and the nomad in the racial and sexual interstices of "new ethnicities" (Hall, quoted in Morley and Chen 1996) as readily as the pachuco, the macho, and the "pelado," Gómez-Peña and company updated the artist's virtual museum of congealed identities, generating counterinventories of allegorical figurations, geographies, and philosophies for the turn of the millennium.

Note the language of market diversification, the foundational fiction of global unity, like Mexican postrevolutionary anthropological and psychoanalytic nationalisms, like US multicultural nationalism/s, once again gets turned on its head but is never fully disavowed per the terms of the narrow bandwidth of the DF contemporary (even if Gómez-Peña emphasizes his work's distance from that of the latter chosen few). Armed with the burden of being an icon of performance and border art, of performance and border studies, Gómez-Peña mobilized the violence of allegory to interrogate an emerging continental cultural logic of late capitalism unremarked upon by Jameson. Pressing subjectivity's nose to the glass, Gómez-Peña's solo and collaborative gestures advanced a retrograde theory of the Border that both centralized and disavowed it as the symbol qua allegorical figuration of neoliberal globalization. Refusing to jettison the unifying ambitions of the latter as conceptualism, Gómez-Peña rewrote the tenor of this foundational fiction over and over again in a crucial period of his practice's development from 1992 to 2000. In particular, scanning the utopian ambitions and the manifesto-like quality of NAFTA as Derridean "signature, context, event," Gómez-Peña advocated that we "force open the matrix of reality to admit unsuspected possibilities [. . . to redefine] our continental topography [. . . as] the New World Border" (1993a, 59).

In the artist's elaboration of performance, worlding becomes bordering (and vice-versa) insofar as he exposes the internal contradictions of NAFTA as the most prominent inter-American "social allegory" of the turn of the millennium. A shift in the purview of appropriation marked Gómez-Peña's call for "nonaligned artists to create a structure parallel to NAFTA, a Free Art Agreement for the ongoing exchange of ideas and noncommercial artwork . . . experimental projects [that] must take into consideration the various processes of diaspora, hybridization, and 'borderization' that our psyches, communities and countries are presently undergoing" (1993a, 60). Invoking not only NAFTA, but also the Non-Aligned Movement (NAM) of the 1960s (a confederation of states that refuted the binary cultural logics of the Cold War and the Hot Peace), Gómez-Peña centralizes the US-Mexico border as his primary referent for a borderlands consciousness against borderization. But here's the rub: like some "involuntarily postmodern" reinvention of Mexican or Chicanx cultural nationalisms' Freudian slips, Gómez-Peña's other NAFTA still depends on the dominant model that it appropriates, upturns, and dresses down.

The second path of border art after 1992 involved artists' and curators' creation of alter-narratives of continental and global unification. Gómez-Peña's corpus exemplified this trend. After his break with BAW/TAF, after his denunciation of border art's co-optation, the artist proposed a parallel structure to free trade. He embodied one, too. In between, other multi-verses rebuilt on the fiction of continental unification emerged in the Mexican-US borderlands, including inSITE, the binational public art "triennial" that presented site-specific interventions for the San Diego–Tijuana corridor in 1992, 1994, 1997, 2000–2001, 2005, and in its 2010 archive, tellingly located in the University of California, San Diego Library's Special Collections, Tijuana's CECUT, and Mexico City's Arkheia of MUAC.

INSITE SPECIFICITY/TIJUANA, CAPITAL OF THE TWENTY-FIRST CENTURY

Could Gómez-Peña have dreamed up a better marketing scheme for a "free trade art agreement" than inSITE? Few journalists, fewer scholars in the humanities—whether they pledge an allegiance to a discipline like (art) history or an interdisciplinary formation like performance or border studies—acknowledge that NAFTA's complete implementation spanned fifteen years. InSITE, a repeat act of transfer and transference to rival any of Gómez-Peña's gestures (the artist's fierce repudiation of the festival

notwithstanding), emerged out of and in conversation with NAFTA's narrative bids on continentalism. InSITE's longevity maps onto the period of NAFTA's negotiation, its implementation from 1994 to 2008, and its immediate aftereffects. As another parallel structure to the agreement, it consequently merits our attention. As a covert gateway for DF alternative-becoming-contemporary art's entrance onto the global art market, as a clearinghouse of a generic configuration of border art, and as a backdrop against which the consolidation of a Tijuana twenty-first-century aesthetic occurred, it also invites our scrutiny.

In what follows, I examine the thread and the threat of a dialogue between the rhetoric of regional economic integration and the concept of inSITE. More specifically, like the Mexican curator Lucía Sanromán and the Italian-born, US-based anthropologist-artist Fiamma Montezemolo, I mine inSITE's archive by offering an abbreviated chronology of the project.[24] In 2014, Sanromán restaged several of inSITE's entries in Cuernavaca, Mexico, to outline chronologically its artistic and curatorial trends against contemporaneous sociopolitical events. *InSite: Cuatro ensayos de lo público, sobre otro escenario (InSite: Four Rehearsals/Essays of the Public, in Another Scenario)* brought together eighteen entries from four of the five iterations of inSITE in Cuernavaca's La Tallera (Sanromán 2014a). In the same year, Montezemolo completed a video essay, *Echo* (2014, 38 min.), that examines the afterlives of nine Tijuana-based inSITE contributions. Sanromán's and Montezemolo's combined attentions to the intimacies of the archive and the (social) body inspire my own reflections on inSITE specificity and Tijuana's millennial rebranding. Faithful to periodization, like Sanromán, I address inSITE's sweeping claims on and for border art by tracking the articulated concepts behind each of the festival's iterations. Demonstrating additional fidelity to the cognitive dissonance—an incognito dissidence—of the trace, like Montezemolo, I approach discrete contributions to those iterations as if they were messages in bottles cast into the sea of the festival at large. The result, following *REMEX*'s algorithm, is wholly my own: a focus on the propensity of inSITE contributors to allegorize the triennial as a complementary or counterallegory to NAFTA. In addition, I listen for other histories that inSITE—at times opportunistically—quantified and qualified, notably those of Tijuana's ascendancy as (a) border art capital.

Enabling Beginnings
Improbably, the controversy surrounding *Welcome to America's Finest Tourist Plantation* freed up the seed funds for inSITE's first iteration (Avalos

2014a). Sisco, Hock, and Avalos's public art piece, part of their bus poster project for Installation Gallery, nearly cost the alternative arts venue one of its funding streams. When the city of San Diego threatened to pull a grant it had allotted to the gallery, the site's affiliates scrambled to come up with an alternate proposal to retain the funds (Avalos 2014b). In less than four months, Mark Quint, then owner of Quint Gallery in La Jolla, California, and Ernest Silva, an artist and professor of Visual Arts at the University of California, San Diego (UCSD), proposed and executed inSITE as a pilot project.

Envisioning inSITE as a resource-sharing, community-based initiative distinct from the quasi-umbrella funding structure and border arts mainstreaming of *Dos Ciudades*, Quint and Silva organized a one-up festival to restore the "lure of the local" to border art. At the cusp of the biennial era, two years after *Mexico: Splendors*, one year after *CARA*, and one year before *La Frontera*, the project side-streamed the Columbus Debates, Gómez-Peña's "Ex-plendors," and the curator Mary Jane Jacob's 1992–1993 *Culture in Action* in Chicago. If Bajalta California was marked as a potentially exhausted corridor of political art in the wake of BAW/TAF's efforts, it's crucial to remember that the 1992 articulation of the festival, focused on installation, laid the groundwork for inSITE itself to become the region's longest-running "installation." With a scant budget of $3,000, Quint and Silva placed the work of forty-three artists in twenty-two local galleries, museums, and independent artist-run spaces, primarily on the US side of the border, in effect prototyping what would become a gathering of platforms for the subsequent institutionalization of border art regionally and internationally.

1994

Despite San Diego's politically conservative leanings, independent arts spaces like Installation Gallery, founded in 1980 and dissolved in 1992; Sushi Performance and Visual Art Gallery, also founded in 1980 and shuttered in 2011; and UCSD's Visual Arts or VisArts Department lived up to and bolstered the city's reputation as artistically progressive. Although universities on both sides of the border participated in the festival over the years, the trace of UCSD's presence in particular runs like a red or black thread through the festival's iterations insofar as VisArts faculty, students, graduates, and affiliates regularly participated in the project, the department's conceptual and performance foci profoundly impacted those iterations' organization, and one of inSITE's three sets of archives is housed in UCSD

Library's Special Collections. That said, by inSITE's second articulation, which focused on "site specificity," Silva had fallen out of the picture.

In 1994, Quint teamed up with Michael Krichman, an arts enthusiast and attorney who worked for the San Diego law firm Latham and Watkins. Krichman brought to inSITE his legal and administrative skills set. As noted by the journalist Miriam Raftery, he also joined inSITE with a distinctly global vision of borders. Raftery quotes and paraphrases Krichman:

> After the Berlin Wall came down, a friend suggested starting up a new business. "We went off to Poland looking for contemporary art from Eastern Europe," he recalls, "but what really interested us was the artists themselves." Krichman and his colleague established a residency program, bringing Eastern European artists to San Diego to live and work. "InSITE is a natural evolution from that," he explains. (Raftery 1997, 92)

Corroborating Sheren's and Berelowitz's respective periodizations of 1990s border art as exceeding the Mexican-US borderlands, Krichman's leap from the collapsed Second World to the North American division of First and Third Worlds reverses the course of Gómez-Peña's extrapolation of US-Mexico border art to the globe. Intriguingly, however, Krichman's evolutionary narrative also navigates the narrow strait that, on the one hand, defined Mexico-US border art's institutionalization, and, on the other hand, hardwired allegorically inflected responses to the latter into all of inSITE's future iterations.

From 1994 onward, a tension remediated border art, mediated its generic elevation, and modulated the former and the latter's effects on specific contributions to inSITE. Because participants in this "total speech situation" allegorized the festival most frequently in terms that targeted its land use, their contributions nonetheless returned border art to greater Mexico. InSITE entries repeatedly reproduced the boilerplate genres of Southern California and Mexico-US border noir, fragmenting the festival's own consolidated allegory of regional unity by tagging its overarching ambitions to be in dialogue and disagreement with master narratives of a generic contemporary. If inSITE enshrined the Border as a non-site of negotiation, it depended on artists' targeted engagements with Bajalta California. By 1994, the seventy-six invited artists, in consultation with inSITE organizers and thirty-eight nonprofit institutions in San Diego and Tijuana, chose the times, places, and terms of the interventions they staged.

In the same year that Silvia Gruner lined the border wall with figurines

in the shape of the Aztec goddess Tlazolteotl, the Scottish installation artist Anya Gallaccio gold-plated hairline fissures in and fixtures of the decaying pool and fountain of the iconic Tijuana casino and resort near the Agua Caliente racetrack. "Satan's playground," as the resort in its heyday was known, is credited with inspiring the landscape of Las Vegas (Vanderwood 2010). Gallaccio's untitled entry, preceding Gruner's *Away From You* fixation on the swimming pool, draws attention to the wreckage of Tijuana's golden age as the rune and ruin of Mexico's tourist and service economy and Southern California's poolside dreams. Not as ominous as the gold-threaded texts of Margolles's 2009 borderwork, Gallaccio's project nonetheless effeminizes conversations regarding land use. Her reparative reading of the cracks navigated the festival's surface and depth, was carried on the current of an indictment: if inSITE consolidated border art in the Tijuana–San Diego corridor, it also was apprehended as draining and gilding the lily of a regional pool of talent.

Even more unequivocally positioned as institutional critique than Gallaccio's intervention, *Century 21* (1994) raises its "tierra y libertad" claims like a tattered neomexicanist flag. With *Century 21*, Marcos Ramírez, the former lawyer turned construction worker turned artist colloquially known as "ERRE," juxtaposed the disposable income of Mexico's arts-minded elite and the disposability of the Mexican working poor.[25] In the shadow of CECUT's iconic Bola, ERRE modeled a makeshift dwelling of corrugated metal, wood scraps, and refuse after the structures of Tijuana's unincorporated colonias. Unlike those structures, *Century 21* was rubber-stamped by both the municipality of Tijuana and inSITE organizers. ERRE posted on the edifice's exterior permits functional in name alone. He explained that while the documents legitimated *Century 21*, they were procured in exchange for mordidas. Like Okón's *Oríllese a la orilla (Con dinero baila el perro)*, *Century 21* exposed corruption, mismanagement, and deregulation. An emerging Tijuana luminary, ERRE with *Century 21* also exposed the distance and proximity of Tijuanese artists to official Mexican and US cultural outlets.

Rebellious beginnings: Para-sitic, parasitic, the installation siphoned electricity for its television that ran 24/7 off of CECUT. Effectively exteriorizing the interior of TAI's 1977 shipping crate, *Century 21* remade "a microcosm of third world misery" on the doorstep of state-sanctioned culture's gated community. ERRE's project, like Gallaccio's, targets the late-twentieth-century accelerated reterritorialization of Northern Mexico and the US Sunbelt, but more explicitly than hers, *Century 21* constructs to

deconstruct inSITE's untimely claims, risky as real estate investment in the region. The installation's title and signage, after all, were salvaged from the Century 21 Real Estate Company.

Like Minerva Cuevas's *logo*centrisms, *Century 21* subvertises the divide between investments in the arts and disinvestments in social safety nets. A study in contrasts: the squat—a waning echo of Gómez-Peña's transnational camp—anticipates Occupy encampments, becomes the cover art of a generation before and after Latin American conceptualisms, social engagement, and relational aesthetics expanded and contracted our aesthetic lexicons. Hypermasculinized in its aesthetic, *Century 21* finally demonstrates subtle affinities with the stockpiled weaponry of the Los Angeles–based performance artist Chris Burden, teacher of Okón.

Burden, who authored the iconic *Shoot*, escalated the region's arts race, amassing five thousand war toys. Dividing his bounty into two camps, the artist staged a face-off to rival San Diego and Tijuana's. While *A Tale of Two Cities* borrows its name from a Charles Dickens novel, Burden's inSITE94

FIGURE 3.5. Marcos Ramírez ERRE, *Century 21*, 1994. © Marcos Ramírez ERRE. Courtesy of artist.

installation viscerally references the heavy Mexican military presence in Tijuana in the postrevolutionary period, early narcotics turf wars in TJ in the 1980s and 1990s, the central role of the military and prison industrial complexes from at least the World War II era onward in San Diego's boom and bust cycles, and the escalating US militarization of the Mexico-US border. Burden's intervention, like ERRE's, assumes the burden of reality-checking inSITE's ambitions. Both projects remind us that from its impetus inSITE leveraged dramatic political, economic, and aesthetic disparities between cities (e.g., San Diego and Tijuana, San Diego and Los Angeles, Tijuana and Mexico City, and Los Angeles and New York City). Responses to inSITE projects from 1994 onward were scripted along comparably aggravated and aggrieved allegorical credit lines.

Accounts of the festival's instantiations repeatedly focus on the shadow that the border, sometimes simplistically configured as a stand-in for US capital, cast over any single artist's contribution to the project. "Welcome to America's Finest" meets "Welcome to the New Berlin Wall" as if to lend credence to Foucault's juxtaposition of the births of German and US neoliberalisms or to rewrite Krichman's citation of the Fall of the Berlin Wall. The art critic Michael Duncan describes neither inSITE nor individual entries within it when he reviews the physical manifestation of the international boundary line as a scare-quotable "installation." Instead, as if channeling BAW/TAF, Duncan writes,

> [The] show [was] dominated by the physical presence of the barricades along the US-Mexico border. At the beach, a 10-foot barrier now extends about 30 yards into the ocean; fresh graffiti on the Mexican side reads, "Welcome to the New Berlin Wall." With such a daunting "installation" already in place, the artists who attempted to fashion works that responded politically to the border must be given points for chutzpah. (1995, 52)

The art critic Klaus Steinmetz achieves a similar effect when he waxes lyrical, "A few meters further on, the most eloquent installation, that of the Government of the North which decided to extend the fence and cut off the sea" (1995, 87). Duncan's and Steinmetz's observations illuminate and obfuscate a larger point. In the relatively short time span in which the pair's attentions were focused on the border fence, not only the IRCA under Reagan but Operation Gatekeeper under Bill Clinton—a policy by the linguist Noam Chomsky's account, inseparable from NAFTA—were

restructuring the region's varied (aesthetic) ecosystems, including those of the sensible.

Operation Gatekeeper targeted the westernmost stretch of the US border from the Pacific Ocean to the Port of San Ysidro. Before Gatekeeper and the IRCA, there was no state-sanctioned "installation" jutting into the Pacific, only BAW/TAF's and others' performances of the latter's future anterior. The best entries across inSITE's fifteen-plus years, like early border art, microperiodize these socially dramatic shifts in regional infrastructure. They register that while repartitioning affected both Tijuana and San Diego, it did not precipitate the same effects in each metropole because socioeconomically the twins were fraternal, not identical.

An expanded timeline of the aesthetic force field of inSITE, mindful of this asymmetry, would include an entry on the 1994 assassination of the PRI's handpicked presidential candidate Luis Donaldo Colosio. Colosio's assassination at one of his Tijuana campaign rallies is often compared to Robert Kennedy's in Los Angeles. Some suggest a domino effect, that the politician's death made possible the historic presidential election six years later of PANista Vicente Fox. Others misdate Colosio's demise to the advent of Mexico's protracted imprecation in the hemispheric drug wars when they attribute his assassination to the Salinas de Gortari family and Tijuana's drug-trafficking cartels. Whether or not these accounts are accurate, they fall back on the stalwart fiction of Mexico's centralized corruption and peripheral dissent. They also emerged coevally with depictions of Tijuana as the rising "creative capital" of twenty-first-century Mexico. Tijuana's purported lawlessness was wielded as an inSITE asset. It lent the project the aura of the "alternative." Festival organizers cashed in on San Diego's reputation as a ground zero of border art and US militarization, too. Tapping into connections and contrasts between the two cities, inSITE coordinators reimagined the biennial not only as a gatekeeper of globally marketable site-specific art, but also as *the* avant-garde and cultural frontier of NAFTAfication. Ehrenberg (1994), a seasoned DF veteran of Los Grupos and the growing cult of CONACULTA, succinctly summarized this fabrication, "InSITE 94 is the only exhibit in the world dedicated to the border genre, it is also the first binational event after NAFTA was signed." The connection, which Ehrenberg exposes like cracks in Gallaccio's swimming pool, signals inSITE's foundational "culture of expediency," the mirror or inverse image of George Yúdice's (2003) "expediency of culture."

Before the Mexican state financed its own national pavilion at the Venice Biennale, cultural administrators treated InSITE as if it were Mexico's

continental hedge fund. Because inSITE94 represented the first year that the Mexican government substantially contributed to the project, Southern California art veterans again cried foul, reiterating that border art as a genre had been co-opted, discounted, or sold out. Pouring salt into their wounds, Krichman mused to a local reporter, "A great deal of the conceptual reason [for inSITE] was to get the culture that San Diego lacks" (Krichman, quoted in Deeley 1994, n.p.). Perpetuating the perception that inSITE organizers discounted the aesthetic legitimacy of previous border cultural production, Krichman's observation fueled arguments that the festival was depoliticizing the work of a prior generation or repoliticizing it as a centrist celebration of the region's NAFTAfication. Krichman's statement regarding the desired effects of inSITE also implicitly privileged San Diego, albeit as a lack.

All but the third of these criticisms would dog inSITE across its iterations. To compare and contrast the damage done by Krichman's free (trade) association, if late-1990s artists and curators in Mexico City seemingly sought to tidy up a Los Grupos "folkloric" or non-objectual appeal to refashion art as a sharp blade and strong shield against cultural penetration, inSITE organizers, straddling the border, disavowed 1980s regional art's prior eschewal of the object, even as they armed themselves with border art's alleged political aspirations. Meanwhile, the aforementioned DF intelligentsia trained their sights on the Tijuana–San Diego corridor, approaching it as a backdoor, keyed as Lou's, to the international art market.

1997

InSITE97 served as a tipping point for inSITE proper. By 1997, inSITE was "established," much closer to being both binational in practice and international in visibility, with both US- and Mexico-based directors, Krichman and Carmen Cuenca and twenty-seven participating nonprofit institutions in San Diego and Tijuana. The festival, focused on "public space," was composed of an exhibition and community-based engagement projects on both sides of the border. InSITE97 observers and critics described it as "grown up" and "professionalized" (Hollander 1998, 47) in part because for the first time the project included curators from outside the region (Debroise, Jessica Bradley, Ivo Mesquita, and Sally Yard).

The California Arts Council, the City of San Diego Commission for Arts and Culture, the NEA, CONACULTA, FONCA, the Instituto Nacional de Bellas Artes, the Mexican Government Tourism Office, the James Irvine Foundation, the Lucille and Ronald Neeley Foundation, the Warhol Foundation, the Rockefeller Foundation, the JUMEX Foundation, the

US-Mexico Fund for Culture, Grupo Calimax: while inSITE claimed an impressive roster of Mexican and US financial backers, CONACULTA and FONCA, which supplied half of the overhead necessary for the year's realization, left the festival vulnerable to charges that an inordinate number of DF-based artists and curators were included in its lineup.

CONACULTA funds, in particular, came with the stipulation that half of the project's participants had to be Mexican artists liberally defined. The caveat set the stage for totalizing interpretations of inSITE *pace* Yúdice's instrumentalist comparison of the triennial to an "artistic maquiladora" (2003, 287). Yúdice goes through the mechanized motions when he writes:

> [inSITE] can be conceived of as an artistic maquiladora whose executives (the directors of the art event) contract with managers (the curators) to map out the agenda for flexible workers-for-hire (artists) who in turn produce or extract (cultural) capital by processing a range of materials: the region (especially the border and the neighboring urban ecologies), the publics and communities who invest their col*labor*ation in the success of a "project," social issues transformed into "art," and local cultures and international artistic trends that constitute the two poles of the new international division of cultural labor. (287–288)

To be clear, contrasting maquila routinized labor to the production of inSITE art risks diminishing the struggles, exploitations, and hardships of primarily young working women in border industrial parks. It also risks diminishing the privileges, access, cultural value, and capital attached to inSITE commissions. Yet, decontextualized from its original formulation, Yúdice's "allegory of reading" in a limited way could prove useful for addressing the subterranean significance of inSITE to and for an aesthetic network whose millennial fabrication became the paving stones over the beach of post-1968 art in Mexico City. Moreover, his analogy demonstrates a remarkable fidelity to an allegorical impulse driving aggressive fables of globalization and a range of artwork included in the triennial's iterations throughout the duration of NAFTA's implementation.

InSITE offered a cadre of DF artists and curators international exposure. Those cultural producers' efforts measured up to festival contributions from more highly visible global art workers. Via an association with the Mexico-US border, the work also was "politically accredited," acquiring some gilded modicum of political or social significance by way of association with previous border art making. Put differently, Gómez-Peña set a

trend—go to the border to legitimate your practice—which inSITE systemized. In this formulation, the DF's evaporated PIAS Forms were replaced by the domesticated radicality of a new border art that never crossed the borderline per the terms of Alÿs's *The Loop*. Or, as Okón satirizes with *Risas enlatadas*, inSITE became an export-processing zone for select DF artists and thinkers. From 1997 onward, we witness the rise of the coproduced DF/inSITE "Maquila School," one artificial effect of the quota system tied to the paired CONACULTA/FONCA funding streams. Similar to Monterrey business interests' (los grupos) desired, but never achieved, inflation of neomexicanismo's value on the global market, this school scrambled the symbolic economy of Bajalta California.

Consider the reMex typographically. When characterizing inSITE as an "artistic maquiladora," Yúdice italicizes the labor congealed in col*labora*tion. Yúdice's wordplay, inseparable from his analogy, resurrects the question of a new regional and continental division of labor. It also complicates prior readings of the terms of that division. While early border art focused on undocumented labor and the figure of the Migrant, by the turn of the millennium, the rapid expansion of export-processing zones on the Mexican side of the Mexico-US border remapped the focus and terms of representation in Northern Mexico and Southern California. Namely, the Laboratory as an allegorical figuration rapidly met its match in the Factory (School), another conceptual coordinate on a global cognitive map of the sex/gender system of racial capitalism. In other words, italicization in Yúdice's argument marks a peak regional emplotment.[26]

In this atmosphere, risky comparisons between inSITE and NAFTA were demoted to junk bond status per Ehrenberg's 1997 own turn to the etymological. Reviewing inSITE97 in the Mexican journal *Artes de México*, Ehrenberg (1997, 2) first parses the connotations that the neologism "inSITE" carries in English before musing that the Spanish verb "incitar" (to incite) permits us to imagine additional import for the triennial. Cuenca and Krichman, as well as Debroise, Bradley, Mesquita, and Yard, encouraged reclamations of the festival's edginess along such lines. They folded mounting charges of complicity against inSITE back into the project's very organization. Or, in a more cynical reading per the "new spirit of capitalism" (*Always incorporate!*), the pair enjoined inSITE97 and the festival's subsequent curatorial teams to opportunistically interrogate inSITE's overarching presuppositions. Of inSITE97's "mutual opportunism," they explained: "It was decided early on that the terms 'installation' and 'site-specific,' which had figured in the programs of inSITE92 and inSITE94, would be set aside

in favor of an investigation of public space—as a *subject* to be explored, not merely as a *site* for locating works" (*inSITE97* 1998, 8; emphasis in original).

The distinction spurred the self-described "critical realist" and UCSD Visual Arts MFA alum, Alan Sekula to pair photographs of 1996 San Diego RNC Convention attendees—twenty-four years after Wilson's rebranding of the city—with images of San Diego's homeless (often military veterans) in *Dead Letter Office*. Sekula, lauded for his photo and film essays, which conceptually renovated documentary aesthetics and critiques of political economy, minced no words concerning NAFTA(rt)'s standing reserve army: "A reservoir of cheap labor is contained and channeled by the hydraulic action of an apartheid machine. The machine is increasingly indifferent to democracy on either side of the line, but not indifferent to culture, to the pouring of oil upon troubled waters" (Sekula, in *inSITE97* 1998, 102).

In an equally excoriating critique of inSITE's collusion with the hyphenated market-state, Andrea Fraser, of *Museum Highlights* and Olivier Debroise's *Un banquete en Tetlapayac*, delivered *Inaugural Speech* at the festival's 1997 opening. Fraser's performance emphasized the festival's overt capitulations to the rhetoric of free trade. Directly preceding the artist's action, the US Attorney for Southern California read a letter from President Clinton. The undersecretary of Foreign Relations for Mexico read a letter from President Zedillo. Each leader commended inSITE97's organizers and participants for setting the bar so high on binational collaboration ("Con los mensajes" 1997; *inSITE97* 1998, 68–70). Like a ghost underwriter, Fraser parodied these endorsements to stress the inseparability of art, industry, and governance's greater Mexican "inferiority complex":

> For us, this event is a unique opportunity to step up to the world stage. We want people to realize that there is a lot going on down here...
> We are not provincial.
> We're the gateway to the Pacific and Latin America. We're the information hub of NAFTA...
> We should also be a major center for art...
> Our binational strength can help us to get there...
> As more and more of our Latin American friends are joining our museum boards and country clubs, and purchasing estates in our neighborhoods, we are discovering that we have more in common than art, golf, and horsemanship. There are also political and economic interests that we share. (*inSITE97* 1998, 69; underlining in original)

While Fraser's and Sekula's contributions to inSITE97 indict the festival, ERRE's 1997 contribution, ideologically closer to Gallaccio's 1994 intervention, looked the region's gift horse in the mouth. Re-siting, inciting the time-honored comparison of avant-garde art and the Trojan horse, *Toy an Horse* epitomizes inSITE's productive contradictions.

ERRE represented cultural penetration as bidirectional when he deposited *Toy an Horse*, a monumental wood-and-metal false replica of the Trojan horse of Greek mythology, in the midst of the waiting lines of cars on the Mexican side of the San Ysidro Port of Entry, the world's busiest sanctioned border crossing point (see plate 15). Fifty meters from the international border, the mutated creature's two heads gazed in opposite directions. En media res, the artwork as double entendre echoed inSITE's middle-of-the-road politics. It toyed with the idea of the border/Border as non/site. The would-be cultural invader in the decoy, like the would-be ghost in the artistic maquila, straddles two force fields that conjoin one continental allegorical performative. The feedback loop of art, territory, and industry in the Tijuana–San Diego corridor governed both the indeterminacy of ERRE's intervention and the point at which it still comes into sharpest focus: organizers' efforts to maintain a distance between inSITE and previous performative, conceptual, and undocumentary interventions, which addressed such hot-button topics as immigration and border industrialization, depended on festival contributors' citations of those prior actions and the inequities to which they first responded.

2000–2001

By inSITE2000–01, the festival's tempo was set by one of the horse's two heads, pulling into the lead. If Benjamin claimed Paris to be the capital of the nineteenth century, Tijuana increasingly was vying to capitalize on the twenty-first. Despite Tijuana and San Diego's economic inequities, the valences on the cities' cultural asymmetries were reversed by TJ's millennials.

The musicologist Alejandro L. Madrid (2008, 4) argues that Tijuana's border art boom emerged in tandem with, even out of the city's Nor-tec ("Nor" for "North," "tec" for "technology") electronic music scene.[27] Madrid dates Nor-tec's birth in Tijuana to 1999, when locals sampled the traditional sounds of Northern Mexico ("norteño" and "banda sinaloense," or Sinaloan brass band sounds), remixing them with European and US electronic dance music. If we needed another soundtrack for *REMEX*, we wouldn't have to strain our ears to catch Nor-tec's bass lines. Madrid contends, "The idea

of Nor-tec as an articulation of local tradition from the north of Mexico through modern technology was quickly embraced by local video and installation artists and by graphic and fashion designers; this transformed it from a musical experiment into an aesthetic of hybridity" (ibid.).

Years after inSITE's 2005 swan song, a generation of tijuanense art workers credit the festival with altering the tone and tenor of Tijuana's political and aesthetic unconscious. They suggest that inSITE exposed Tijuana residents to the perils and pleasures of public, ephemeral art (Donovan 2006; Zúñiga 2010; Pimienta 2014; Sanromán 2014a). What inSITE certainly furthered, along with border development and two decades of border art after BAW/TAF's initial conceptualization of the latter, was residents' embrace of the "incurable image" (Elhaik 2016) of the region as a harmonized, yet discordant, system.

The "tijuanense" aesthetic "rose from the cellars of the CECUT in the '90s" (Ochoa Palacio, quoted in *Strange New World* 2006, 243), but also from Tijuana's streets and unregulated construction and commerce zones. As figure eights loop, this aesthetic subsequently impacted the forms and substance of contributions to the festival. By the third millennium, a used car salesman had rewritten Tijuana as a verb. "Tijuanear," subsequently wielded to generate civic pride, translates awkwardly into English as "to Tijuana." Colloquially, its meaning encompasses (1) making do à la rasquachismo, (2) enduring overuse and abuse, and (3) the liminality of perpetual border-crossing. While the risks of appropriation cannot be underestimated here, it's worth remarking that "tijuanear" shares a kinship with other entries in the naysayer's dictionary of desmodernidad, which we began to collate in "City." The curator Rachel Teagle hits a celebratory note, bordering on the unreflective, "To live in Tijuana is to remix, reuse, reinvent, and reconceive stagnant cultural imperatives and artistic practices" (*Strange New World* 2006, 105). Although CECUT and clubs along the Avenida Revolución served as artistic centers, three other built environments came to be synonymous with the capitalist realism of the city's third millennium: the aforementioned Maquila; the Yonke, or junkyard, placeholding the residue of Mexican production and US consumption (note the valence here is diametrically opposed to that of the yonke in San Diego land-use struggles during the occupation of Chicano Park, its significance as a false cognate may be worth mentioning, too); and the Border (where the literal border's variability encompasses walls, a fence jutting into the Pacific, and checkpoints, in other words, is no longer reducible to "the fence and the river").[28]

A fourth allegorical figuration, disquieting as Culture for and of free trade, rounded out the threesome. Magnanimous as the Statue of Liberty, *Tijuana III Millennium*, locally known as "La Mona" or the Doll, points a pinky to the sky per the hand gesture that locates TJ on the map of Mexico. La Mona remains as monumentally vulnerable as Nao Bustamante in *America the Beautiful*. In 1989, the same year that the Goddess of Democracy materialized in Tiananmen Square, the TJ artist Armando Muñoz erected La Mona, a 56-foot-tall, 18-ton sculpture in La Colonia Aeropuerto, to commemorate Tijuana's 1989 centennial. La Mona doubled as Muñoz's home, tripled as the symbol of the so-called "La Tercera Nación"'s (The Third Nation's) unconditional hospitality. Maquila, Yonke, Border, Woman: the sum of these conceptual coordinates, like the sum of BAW/TAF or Gómez-Peña's stereo- and archetypes, reconfigures totality as a record of the extreme divide between those in possession of the global and those locally dispossessed of the avant-garde means to righteously renounce des/modernity. From the late 1990s onward, a critical mass of Tijuana's cultural producers, like and sometimes in conversation with their DF counterparts, proposed alternative plotlines for globalization delinked from neoliberal transition. Subscribing to a transborder vision that connected the metropoles of Mexico City, Tijuana, San Diego, and Los Angeles, these art workers proposed a unique reMex that trebled the prevailing allegorical performative, grounding both their collective practice and the cultural logic of a unified hemisphere. Transnational kitsch, camp, cursi, naco, infrarealist . . . the rainbow spectrum of a pulsating border culture was concentrated in Baja California, *below* California.

Fussible of the Nortec Collective crone-bounces the mind-set's infectious lyrics in English: "Tijuana makes me happy." Featured in the film of the same name, but also on the album *Tijuana Sessions, Vol. 3* (2005), the song's urgently light tone truncates the city's more troubled history: "Some call it the happiest place on earth. Others say it is a dangerous place. It has been the city of sin. But, you know, I don't care . . . Tijuana makes me happy . . . Bang, bang."

The artivists Fran Ilich and Luis Humberto Rosales took seriously the atmospherics, dehyphenated as the fragments of "Nor-tec." They modeled *Borderhack!*, which included net art, border cinema, ISDN (Integrated Services for Digital Network) connections, conferences, and workshops, after a 1998 German/Polish border festival, Kein Mensch ist illegal (No One Is Illegal). Kein Mensch ist illegal ran parallel to documenta X.[29] A rough model for inSITE, a forerunner of the twenty-first-century's international

exhibition circuit, documenta, has been held every five years in Kassel, Germany, since 1955. Unlike the Venice Biennale, which morphed into a venue to showcase national cultures and global commerce, documenta was conceived of as an antidote to Nazi cultural censorship. Like the Venice Biennale, in the late twentieth century, it began to function as something like an isotope to neoliberal governance. Both the place and timing of Kein Mensch ist illegal's metamorphosis into an immigrant rights movement consequently proves as significant as Ilich and Rosales's transplantation of the latter to the Mexico-US border.

While Kein Mensch ist illegal encampments were staked in Europe where East meets West, Ilich and Rosales rotated the axes of the project to squat where North meets South. Spearheaded by Laboratorios Cinemátik, a collective interested in cyberculture and Nor-tec, the Tijuana iteration of Kein Mensch ist illegal, in contrast to more literal translations of the German ("No one is illegal"), was renamed *Borderhack!* and reverse-imagineered. The participants' goal was not to dissolve the border, but to reflect on its repeat performance along the lines of BAW/TAF's previous interventions. Mindful of proximity—the regional fabrication of motherboards and circuit panels, labor predominantly performed by women—*Borderhack!*'s organizers also hyperlinked performance and conceptual practice to the emerging hybrid genres of net.art and net art, thereby eschewing Luddite renouncements of the high-tech.

InSITE2000–01, as a state- and corporate-funded event, unfolded against this backdrop, as the backdrop, of these "undocumenta" practices. No longer plausibly "alternative," inSITE2000–01 enthusiasts, like art workers pedestaling 1990s DF art in the same period, both mourned the festival's institutionalization and hastened to assign it (versus any single commissioned artwork within its iterations) the honorary title of "contemporary." Krichman, Cuenca, and the year's curators, Mesquita, Yard, Susan Buck-Morss, and Osvaldo Sánchez, aggressively promoted their own version of "institutional critique" in response:

> The curators proposed to break with the tradition of inSITE as a large-scale display of temporary works, and to think about focusing away from any traditional notion of exhibition at all. Rather, what the curators had in mind was the installation of a cultural practice in the region . . . Many works would unfold as events, performance, or spectacle—visible at particular moments and thereafter only as documentation. (*inSITE2000–01* 2002, 14–15)

The resonances with the formal impulses of earlier border art (BAW/TAF's or Sisco, Hock, and Avalos's actions), but also with contemporaneous Tijuana artivist practice, are unmistakable but go unacknowledged or are "politically sanitized" in this summary of rupture that imagines a discrete before and after to inSITE's History with a capital *H*. The operative elision, a sleight of hand, again most closely resembles the erasure of the correspondences between the formal tactics of the PIAS Forms and those of alternative 1990s/2000s Mexico City art, remade in the transmission and translation across generations.

The most compelling entries of inSITE2000–01—the temporal plateau of the festival in its entirety—remained preoccupied with representing this level of contradiction, the form of inSITE and its relationship to the non/site of the border/Border. This work's critiques anticipated and forwarded the prevailing projection of the festival, that of cognitive dissidence in dissonance, onto a future anterior. Like 1990s DF art making, inSITE's parts and whole crossed a line, moved toward a renunciation of any clear party line. If inSITE94 and inSITE97 had been enthusiastically or more reluctantly promoted as parallel structures to free trade, by inSITE2000–01, organizers—as if digesting the insights of the festival's former contributors—sublimated the comparison of art and industry in the year's favored theme, "processes of cultural practice." Along such borderlines, Gruner's *Narrow Slot/Sueño paradójico* (*Hendija estrecha/Paradoxical Dream*) merits our renewed attention as a reflection on border art confined to the narrow slot of the festival. Or, both elaborations of the DF-based artist Gustavo Artigas's *The Rules of the Game* (2000) assume the now familiar shape of inSITE allegories.

Outsourcing performance as readily as Razo, Sierra, or Okón, Artigas invited two US Boys Club basketball teams to play against each other in the indoor gymnasium of Tijuana's Escuela Preparatoria Federal Lázaro Cárdenas. In the same place at the same time, he pitted two Mexican high school soccer teams against each other. Because the participants were minors, Artigas and inSITE required that the adolescents' parents sign permission slips, in effect drawing the adults into the arena (see figure 3.6). Two sets of referees oversaw the separate matches, while one general referee followed both. Two groups of cheerleaders rallied the crowd, a mixture of out-of-town cultural capitalists and transborder curious locals. Bilingual announcers offered blow-by-blow descriptions of the individual matches.

Spectators found themselves wondering less which soccer or basketball team would win and more whether either tournament could weather the

FIGURE 3.6. Box 220, Folder 10, Gustavo Artigas, *The Rules of the Game*, 2000. Letter to parents of participants from inSITE. Creator: inSITE 2000, copyright passed along to UC San Diego Library (permission granted by library). Courtesy of inSITE Archives. MSS 707. Special Collections and Archives, University of California, San Diego Library.

other's presence. Like some collision of storm fronts, the athletic palimpsest replicated the era's discordant hyphenation of global market and state fictions. Cuauhtémoc Medina commented on the unusual competition's composition, "In his game of basketball/soccer, Artigas created a symbol of harmonic confusion that is suggestive of a political possibility for generating national fusion without conflict and without assimilation, fusion that is not based on integrationism or blending but on a regime of differences" (*inSITE2000–01* 2002, 59).

No doubt "the harmonic confusion"—echoing NAFTA's citation of tariff nomenclature, namely, the "harmonized system"—extended beyond the national to encompass both border and (Mexican) global contemporaries, sometimes harmonious but often at odds. Less remarked upon, Artigas's installation of the same year and name directly engaged and played on reviewers' continued insistence that the border fence represents the area's most memorable installation (see figure 3.1). It also recalled pre-Gatekeeper pickup games of soccer at the join of Las Playas de Tijuana and Border Field Park. A backboard attached to the fence became both an unexpected sounding board—something to bounce a ball and ideas off of—and an unbounded court for a spontaneous game of handball or tennis. Growing the division of states vertically *and* horizontally, it repurposed the rules of the border game as recreational equipment.

In contrast to the aforementioned documentation of Artigas's double match, the documentation of this half of *The Rules of the Game* downsizes the former's courtly chaos, furthering Medina's speculations on fusion sans integration. Blue sky flecked with cumulonimbus and the physical border snaking into the horizon re-lineate the solitude of NAFTA as master narrative. Gone is Lou's "Border Door," although its loneliness against the backdrop of fantastic westward expansion prevails. In its stead, another adaptation of the frontier stands, further testimony to art's muddied elaborations of political economy.

Backed up against the border wall, art repurposes blockage to erect unexpected and surreptitious crossings. To reiterate, circa 2001, the year that Daniel Montero accords to a Mexican contemporary, a prized DF aesthetic was smuggled onto a global market vis-à-vis inSITE at the Mexico-US border. Or, alternately, that mirage was bounced off the backboard of international division. Artigas's open and closed courts, summing up the entrenched stereotypes of both the art of economic government and inSITE, modify Gómez-Peña's modus operandi: transport outside players into a locale, then witness their capacity to acclimate to their new environment.

Such a managerial logic governed inSITE's continued inclusion of significant figures from the art world in its 2000–01 iteration. It also impacted García Canclini's commentary during the last public conference associated with inSITE2000–01's four "Exploration Weekends." Specifically, García Canclini singled out Mark Dion's *Blind/Hide* (2001) as an inSITE "failure," comparing it to the success of Krzysztof Wodiczko's *Tijuana Projection* (2001). Rather than assign value to either project, I prefer to read each as indicative of inSITE's hand in the reborderization of the region; to more generously imagine *Tijuana Projection* as forming part of the suture of border art as a genre to the relocation of an undocumentary aesthetic in cinema from the mid-1990s onward; and to approach *Blind/Hide* as anticipating the configuration of the inSITE archive as the festival's final instantiation without end.

Tijuana Projection (2001), drew upon and revised a genre pioneered by Wodiczko in which the Polish artist highlights synergies between buildings and bodies. Wodiczko, who notes the prevalence of the allegorical in art created under the Eastern European communist era, previously had avoided the "son" of cinema's "son et lumière" tradition in his projections, which he claims function as phenomenological and allegorically driven investigations into "clothing architecture." In this corpus, *Border Projections* (Parts I and II), included in *Dos Ciudades* (the exhibition to which Gómez-Peña attributed the death of border art) and executed on two consecutive nights in 1988, are worth recalling to calibrate the difference that sound made for *Tijuana Projection*.

For *Border Projection* (Part I), Wodiczko projected a chained set of hands, holding up a still-lifed fruit basket, onto the Spanish revivalist façade of the San Diego Museum of Man's steeple, and another set of hands, grasping a knife and fork, on either side of the institution's entrance, as if the latter were an open mouth poised to consume all visitors who crossed the museum's threshold. Constructed to commemorate the Panama Canal's completion, the museum in Balboa Park (the location of Barrio Logan's hard-won Centro Cultural de la Raza), as Wodiczko implies, masks and unmasks the region's neo/colonialist aspirations. For *Border Projection* (Part II), the artist projected onto the 60-foot-diameter façade of La Bola ("The Ball" of Artigas's border games?), CECUT's huge spherical-shaped Omnimax theater, the image of a man with his hands clasped behind his head. Wodiczko's choice of La Bola was as calculated as his selection of the San Diego Museum of Man.

If films usually are projected onto the screen of La Bola's interior, Wodiczko forced his spectators to stand outside of the sanctioned space of

performance, to complete his inversion of the architecture's function. In this regard, the project dovetails with and arguably literalizes the cinematic genre of the undocumentary to which we will soon turn. It also offers us a novel (literal!) way to read Gayatri Chakravorty Spivak's commentary on "screen-allegories." Question marks punctuated the intervention's reference to contemporaneous immigration debates. Wodiczko's three sets of hands called and responded to the trio represented in *Welcome to America's Finest Tourist Plantation* of the same year. And, over a decade later, with *Tijuana Projection*, Wodiczko returned to the scene of *Border Projection* (Part II), updating not only the formal terms of his intervention but also his commentary on Bajalta California's international division of labor. Opting to site *Tijuana Projection* solely on the Mexican side of the border, Wodiczko projected the faces and live, recorded testimonies of six women, employed by Tijuana's industrial parks, onto the sphere's façade.

His choice of mediums, so to speak, as García Canclini's enthusiastic endorsement of *Tijuana Projection* and Yúdice's contemporaneous focus on the figuration of the Maquila suggest (Yúdice also participated in the final "Exploration Weekend" conference), was calculated to the extent that it corresponded to the dramatic shifts in regional employment opportunities I previously registered. As undocumented migration routes were pushed east, working conditions just south of the Mexico-US border captured the political imagination of local and alter-globalization activists and cultural workers. In Wodiczko's project, female participants did not represent silenced, suffering, or even defiant, monumental Monas, beaten-up Mexicos, or beautiful Americas, however. Equipped with wearable technologies designed by the artist (that recall the pragmatism of his previous vehicles for the homeless), Wodiczko's collaborators had been prepped for more than a year for their participation in the project. Two organizations, Grupo Factor X (founded by one member of Las Comadres) and Yeuani, coordinated with inSITE organizers and the artist to coach the women psychologically before *Tijuana Projection*'s two consecutive nights (Krichman and Cuenca, in *inSITE2000–01*, 2002, 75). Many of these women would go on to participate in Fusco and the border-hacktivist (literally a participant in *Borderhack!*) and UCSD professor Ricardo Dominguez's production of *Dolores from 10 to 10* (2002), an online simulation with a live Internet feed from Helsinki's Museum of Contemporary Art, and in the filmmakers Sergio De La Torre and Vicki Funari's "undocumentary" *Maquilapolis*, in effect becoming regulars on the Bajalta California art circuit.

But, before De La Torre and Funari placed cameras in these "promotoras'" (female maquila employees and labor activists) hands, the women detailed the abuses they'd survived at the hands of maquila management, local police, and family members. They also chronicled their friendships and organizing efforts. The ensuing spectacle reinvigorated CECUT as a cultural site of performance and projection, blurring the lines of the suspended disbelief of both aesthetic and political representation.

The mirage of La Bola, transformed into women's talking heads, deeply impacted many of the actions' observers, myself included. Contrasting sharply with the speechless, disembodied hands of *Border Projections'* "(Museum of) Man," the immediacy of the women's voices and countenances reworked Wodiczko's attentions to the allegorical, but demonstrated how those attentions served to screen contradictions in the artist's project, too. Indeed, *Tijuana Projection*'s commissioned translator from

FIGURE 3.7. Box 173 (file on disc in project box), Krzysztof Wodiczko, *Tijuana Projection*, 2001. Image of projection from booth. Photographer unknown. Courtesy of artist and inSITE Archives. MSS 707. Special Collections and Archives, University of California, San Diego Library.

Mexico City, on hand to interpret for non-Spanish speakers, broke down in tears during one of the project's live transmissions. Of that incident, Wodiczko (2015, 40) comments, "The emotionally disturbing narrative of the projection became emotionally disturbed itself." *Tijuana Projection*'s renovation of the city's iconic landmark of cultural progress tied to post-1982 economic development was further heightened by serendipity. The second and last night of these outdoor events, it rained. The result was more uncanny than Gómez-Peña's transnational drag: On the women's globe-like countenances, audience members witnessed coincidence, how the atmosphere conditions, the blurry tracks of ideology and just weather colluding to perform tears (see plate 16).

Per questions routinely posed to artwork with activist aspirations, the soundtrack of the project crystallized spectators' resistance to *Tijuana Projection*'s organizing conceit. The night La Bola "cried," an argument for the infelicity of enlisting working Mexican women to participate in an artist's project acquired additional ammunition. In response to García Canclini's privileging of *Tijuana Projection* over other works commissioned for that year's festival, audience members at the final "Exploration Weekend" conference pushed back, wondering what protections were in place for the women following their disclosures. Such practical inquiries, all but brushed aside by García Canclini, echoed critiques of Sierra's actions (e.g., the allegation that Sierra overlooks the quotidian lack of protections for the precariat), despite ostensible differences between the artists' work. Wodiczko (2000, n.p.), more diplomatically than his Spanish counterpart, defended *Tijuana Projection* and his top-down corpus of projections (which depend on architecture's monumentality), with the claim that he had intended with the genre, and *Tijuana Projection* in particular, to bring "into public space controlled by class and gender hierarchies the privatized suffering of women." Wodiczko elaborated in his project statement included in the year's exhibition catalogue,

> For the women this was a great step forward psychologically and ethically. This performative speech-act, making the passage from testimony to transformative public action, became an important bridge to developing a capacity to intervene in real life. The response evoked in the public, whose members in a sense became co-actors in the event, furthered the dynamic in turn. As a result, this artwork may bring the city of Tijuana closer to fully acknowledging the people who are her inhabitants and what their lives are like. (*inSITE2000–01* 2002, 77)

Such triumphalist assessments, for some, only further demonstrated the artist's regional disconnection and paternalism. Although Wodiczko sited *Tijuana Projection* as a reclamation of the "agora" by the "allo" or "Other speaking," many "Exploration Weekend" audience members reread *Tijuana Projection* as out of place and out of touch, as being less about the documentation of inviolate lifework conditions and more of an allegory of inSITE's Mexican and US metaprojections onto Tijuana. The tension followed what Spivak describes as enforcing borders between aesthetic and political representation.

In "Can the Subaltern Speak?," Spivak (1988, 291), limning out the limitations of Michel Foucault's poststructuralist histories, notes: "The clinic, the asylum, the prison, the university—all seem to be screen-allegories that foreclose a reading of the broader narratives of imperialism." To this list, we might add the cultural center and the art festival. While the aggregate of *Border Projections* I and II and *Tijuana Projection* clarify that Wodiczko was not unversed in the region's shifting international division of labor, *Tijuana Projection* also reinforces the point that a huge gulf separated the triennial "industry" and the machinations of outsourcing. Following Dion's *Blind/Hide*, which served as the foil to *Tijuana Projection* in García Canclini's defense of Wodiczko's actions, artists and critics' fixations on inSITE allegories threatened to derail prior border art's stringent critiques of the region's NAFTAfication, too.

"All's Quiet on the Western Front": although García Canclini singled out *Blind/Hide* as one of inSITE2000–01's "failures," the installation's composure continues to ruffle the feathers of the festival as a "screen-allegory." Binoculars, a short-range telescope, a library of bird-watching manuals, maps of avian migratory routes, a desk and chairs, clothes, knapsacks, water, hats, photos of birds one might see, paper, colored pencils, and watercolors: for inSITE2000–01, Dion constructed a functional shelter for bird-watchers, which he placed in the Tijuana Slough National Wildlife Refuge, an area that abuts both the Mexico-US border and a US Air Force base. Like *Tijuana Projection*, *Blind/Hide* (2000–2001) bore the traces of its author's previous projects, which operate as meticulous facsimiles of laboratory and surveillance units. *Blind/Hide* also spoke to the artist's childhood experiences in San Diego, the home of his grandfather, who served in the US military (Dion 2011).

Dion, an avid environmentalist, regularly draws attention to art and science's mutually constitutive taxonomic impulses in installations that allegorize the pair's representational complicities (ibid.). In the spirit of

FIGURE 3.8. Box 156 (file on disc in project box), Mark Dion, *Blind/Hide*, 2000–2001. Building without people—1 image. Photographer unknown. Courtesy of artist and inSITE Archives. MSS 707. Special Collections and Archives, University of California, San Diego Library.

Fusco's Other history or Fred Wilson's "mining the museum," Dion's mode of institutional critique broadens the circumference of how we might imagine undocumentation, underscoring the ironies (and allegories *pace* Okón) of attempts to document the latter with technical precision.[30]

Blind/Hide opens onto a nested set of allegories concerning transnational surveillance. Which is to say, to interpret this installation as simply being about observing birds is to be taken in by the comforts of the blindnesses it brandished. When visiting *Blind/Hide*, you might have had the luck to spot a Great Blue Heron or a Painted Bunting, 2 of the 370 documented species of birds that make their home in the Tijuana River Estuary. But you would have been just as likely to catch a glimpse of a fighter jet overhead. *Blind/Hide*'s proximity to the border situated it as an ideal location from which to contemplate the migratory paths of "pollos" (literally, "chickens"—birds of another feather—slang for "undocumented entrants"). Post-9/11, *Blind/Hide* accrues additional meaning insofar as it resembles the makeshift, mobile checkpoints of the Border Patrol within the United States' 100-Mile Zone. In the mind's eye, forever perched near the corrugated steel fence (made of landing strips used by the United States in the first Gulf War) that makes up the border wall, *Blind/Hide* probes the Bajalta

California intimacies of the aerospace and defense, art, public policy, and in/hospitality industries. *Blind/Hide* calls upon us to bear witness to ways of seeing that exceed the optic—the labor of the negative congealed, yet constantly shape-shifting, in the Mexico-US border's maintenance.[31] Notably, sound figures into the piece in the guise of aural juxtapositions—birdcalls and jet engines—resulting in an undocumentary elaboration of what Gilles Deleuze and Félix Guattari (1987, 350) term the "deterritorialization of the refrain."

In sum, Dion's installation weakly resembles BAW/TAF and other border artists' previous interventions. It more forcefully presages post-9/11 media and artistic engagements with new technologies of border surveillance (e.g., unmanned aerial vehicles or drones, mistaken for birds) that redacted the "laboratory model" of the region. Even *Blind/Hide*'s cleft title, which materializes the conceit of the screen, invokes the paradoxes of "watching" versus "seeing" that which is perceptible by feeling. *Blind/Hide* seemingly invites us to return to Paul de Man's twofold observation that all criticism depends on the cleaving of blindness and insight and that any interpretation always takes on the status of allegory (1979). The installation becomes "a watcher's blind," functioning not only as a birding unit, but also as a literalization of Theodor Adorno's conceptualization of the monad, his statement that "all art has a quality of blind making" (1997, 192). Re-siting inSITE's "indecisive aesthetic," like ERRE's *Toy an Horse*, *Blind/Hide* finally threads inSITE's built-in allegorical ambitions through the needle of the mounting tensions between institutionalization and institutional critique and free trade and borderization in the region. In other words, in this outpost to and of NAFTArt, the structural limits of cultural diplomacy meet the diminishing political returns of the greater Mexican "Maquila School" to signal the festival's final reverberating lines of flight.

2005

Despite or because of Tijuana's post-9/11 (2001) factory flight and escalating narco-violence, inSITE_05 represented the triennial's most elaborate iteration. Like inSITE2000–01, which had expanded its programming beyond commissioned art to encompass a film and video series curated by the Mexican sociologist Norma Iglesias Prieto and the Latinx art critic Rita Gonzalez, the festival's finale, inSITE_05, diversified its forms of expression to include four programs, "Interventions," "Scenarios," "Conversations," and the CECUT/San Diego Museum of Art collaborative exhibition *Farsites/Sitios distantes* (2005).

On the one hand, inSITE_05 repeated the collaboration's long-standing formula of matching art workers to locations. "Interventions," curated by Sánchez, Tania Ragasol, and Donna Conwell, included twenty-two artists whose processes were documented in the catalogue *inSITE_05 [Situational] Public* (2006). Documentation of "Scenarios" (*Tijuana Calling*, online projects, curated by the new media artist Mark Tribe; the archive project entitled the *Mobile_Transborder Archive*; and the visual and sound event *Ellipsis*) were also included in *inSITE_05 [Situational] Public*. On the other hand, inSITE_05, maximizing its investments in inwardly directed institutional critique, branched out to orchestrate "Conversations," which transpired in San Diego and Tijuana between November 2003 and November 2005 (see *Dynamic Equilibrium: In Pursuit of Public Terrain* [2007]), and an exhibition of the work of fifty-two artists focused on "urban rupture."

A tension between incorporation and the "radicant" kernel of early border art especially returned like the festival's repressed in "Scenarios," a curatorial metagesture that acknowledged the explosion of "Nor-tec," maquila high-tech manufacturing, and electronic and digital artwork in the region. "Scenarios" provided an ephemeral platform for works that, embracing the Mexico-US border's portability, nonetheless remained grounded in a politics of place. For example, Fusco and Dominguez contributed the online game *Turista Fronterizo*. Consisting of a modified Monopoly game board that restored to the latter its Marxist impetus, *Turista Fronterizo* also digitized and updated BAW/TAF's lotería cards to feature new border stereo/archetypes like the Tijuana "Junior" (or wealthy son of the Mexican businessman) and the San Diego "Gringa Activista." The Mexican artist Ángel Nevarez and the Peruvian-American self-identified "dot .commie" and "dot.comic" Alex Rivera produced *LowDrone*, an unmanned aerial vehicle that played corridos or border ballads for Border Patrol agents. And the new media artist Anne-Marie Schleiner and the Mexican architect Luis Hernández contributed *Corridos* (2005), an open-source video game that mapped fictive border tunnels. Detained in the Denver International Airport, Hernández was denied entry into the United States and later banned from the country when Homeland Security mistook *Corridos* for a national security threat.

The Argentinean artist Judi Werthein's contribution to inSITE_05 was the only other commissioned artwork to generate comparable border disturbance. Matching Alÿs's loop with an equally intricate circuit of production and consumption, Werthein designed *Brinco* (*Jump*), a pair of sneakers, which she manufactured in China; distributed for free in Tijuana's Casa

FIGURE 3.9. Anne-Marie Schleiner and Luis Hernández, *Corridos*, open-source screen shot, 2005.

del Migrante, the Casa de la Madre Asunta, and the Casa YMCA de Menores Migrantes-Tijuana (YMCA House of Immigrant Minors in Tijuana); and sold for $215 a pair in a San Diego Boutique (donating all proceeds from the sales to a shelter in Tijuana). The olive green, red, and white sneakers included a compass; a map of Tijuana/San Ysidro; an image of the Mexican patron saint of migrants, Father Toribio Romo; and a flashlight. The Associated Press and the BBC World Service picked up *Brinco*'s story. Werthein jumped into the international spotlight when she was accused of the US federal felony of "aiding and abetting illegal entrants," by right-wing media outlets. Coverage of the project looped stock images of undocumented entrants jumping the border fence and wall as if once again to literalize the region's overarching feedback loop. The artist's inbox was inundated with e-mail hate messages. InSITE organizers handily sampled these in *inSITE_05 [Situational] Public* as if to get their border game back on. Schleiner and Hernández's and Werthein's projects twice restored to inSITE_05 the early interventionist aura of post-1968 and border cultural production (albeit at a high personal cost to the former artists), but the works also reinforced inSITE's constitutional paradoxes.

The festival's breadth that final year, tangibly apparent in the confusion

of its three publications, further evidenced its heavy hand in the institutionalization of border art as a genre and anticipated the collapse of the festival's self-referentiality into its own best archive. An alternate reading of Werthein's accessorization more generously groups the project with Torolab's and bulbo's counterbids in "ERRE-menor" to reground border cultural production, sited or non-sited by inSITE, in a tijuanense aesthetic. Founded by the Tijuana architect-artist Raúl Cárdenas in 1995, Torolab splices the laboratory and maquila models into one another in gestures which, like some of the DF "contemp(t)ory," suggest we needn't oppose the subversive and the institutional. Like Los Grupos or BAW/TAF, Torolab carried out a series of para-sitic studies (falling back on architectural history, urban ethnography, fashion, and Latin American art and literature for inspiration). Its research included the monitoring of air quality and avant-gardening. Eventually identifying the T-shirt as one of their preferred mediums, the collective founded the ToroVestimienta line, which also produced *Transborder Trousers* for the would-be border-crosser. Torolab's foray into fashion culminated in *La región de los pantalones transfronterizos* (*The Region of the Transborder Trousers*, 2004–2005). Outfitting five people with GPS-integrated clothing, Torolab tracked their movements to generate lived maps of Bajalta California. Bulbo, an artivist collective, film production company, marketing firm, record label, and online art gallery (ultimately more diversified in its production and holdings than Cuevas's *MVC*), in the same time period conducted their own investigations into popular fashion design. Bulbo launched *La tienda de ropa* (*The Clothes Store*, 2005) independently and later in loose affiliation with inSITE. As detailed as Dion's outpost, but as temporary as a tianguis stall or a maquila start-up, *La tienda*, sited in a booth in a Tijuana shopping mall, afforded inSITE fashionistas the opportunity to custom-order silkscreened T-shirts. (Imagine yours truly five months pregnant with a design of androgynous figures scaling her baby bump in imaginary homage to Polvo de Gallina Negra's radicalization of motherhood.)

Such ventures foreshadowed the collective's social art work *Tijuaneados anónimos: Una lágrima, una sonrisa* (*Tijuaneados Anonymous: A Teardrop, a Smile*, 2009), a weekly drop-in group therapy session intended to aid participants in dealing with post-2008 global economic free fall and regional violence. As the eponymous documentary *Tijuaneados anónimos: Una lágrima, una sonrisa* (2010, 82 min.) details, renting a retail space across from CECUT, bulbo store-fronted a collective catharsis modeled after the twelve-step program of Alcoholics Anonymous. Like the collapsed stories

of the late-1990s DF alternative, the gesture reMexed documentary aesthetics' bids on the transparent and the fictive. Serious and facetious as the verb tijuanear, which bulbo frequently cites when explaining the project, it editorialized the region's de-partition of the sensible in markedly affective terms that followed the aforementioned new lines of flight of several of inSITE_05's closing entries.

Notably, the Venezuelan, Mexico City–based artist Javier Téllez's *One Flew Over the Void* (*Bala perdida*), offered a parting inSITE allegory on August 27, 2005. *One Flew* seemingly charted the trajectory of both the DF contemporary's and Tijuana-based border art's incorporation into millennial art histories in a language that alluded to the mental health of the region. Positing the international dividing line as the void over which the lost bullet flies, Téllez doubly outsourced the project's actions.

In a portion of the project frequently overlooked, but significant for its nod to Ken Kesey's 1962 novel *One Flew Over the Cuckoo's Nest* and its dubious ableist politics, Téllez enlisted the participation of patients at a Tijuana mental health facility. The patients marched in a band amid the crowds gathered to witness a spectacular border crossing that had been cleared in advance with US Customs and Immigration.[32] If the walk in the park of Okón's *Bocanegra* flagged the latter project's pathos, the psycho-geography mapped by *One Flew* was all but lost in that second outsourced element of the artist's action. Téllez hired the professional stuntman and US citizen David "The Cannonball" Smith to cross the border in a manner befitting his nickname.[33] While Téllez elaborates in his original project proposal that *One Flew* was "based on the everyday tactics of bird migrations, the spatial trajectory of the human canon (*sic*) ball would underscore the shared airspace of the zone" (inSITE archive), I'd counter that, like Teresa Margolles's *Fin*, the piece mapped both avian flight patterns and remapped inSITE as the death without end of a genre.

To date, the project supplies us with alternative ways to read Dion's *Blind/Hide*, bulbo's *La tienda*, and numerous other inSITE contributions as alluding to the migratory paths of border cultural production. All told, Téllez's *One Flew* shot not only Smith out of a cannon, but border art out of a canon, further underscoring how the flow of the region's artistic energies was reversed and dispersed by the turn of the twenty-first century (see plate 17). Traversing Las Playas de Tijuana and Border Field Park, the event drew hundreds of onlookers, from art tourists to local vendors and celebrities such as Alejandro González Iñárritu and Gael García Bernal (at the time on location to film *Babel*). *One Flew* answered projection with a human

projectile, suggesting that while inSITE may have overshot its objective to create a regional art program, its "gimmick" needn't dissuade us from remembering the festival piecemeal. The requisite allegorical mode of reading remains as applicable to the whole of *REMEX* as it is to inSITE, the institution.

"Archive Fever"

InSITE's buried, layered, and incomplete documentation becomes its greatest instantiation. If *Blind/Hide* resembled *La tienda* resembled Teddy Cruz's "infoSite" units for inSITE_05 resembled ERRE's *Century 21*, these isomorphic projects were reMexed in ways presumably unanticipated by their producers in and for inSITE's final iterations.

In May 2009, inSITE opened its first archive as an installation at the CECUT in Tijuana. In March 2010, an identical archive became available for researchers in the University of California, San Diego Library's Special Collections. In May 2010, the inSITE archive opened once again in the MUAC in Mexico City. Time capsules to counter the deleterious effects of the slow release capsule of NAFTA, these archives extend inSITE's purchase on a period. Despite inSITE's limitations, often delimited by its critics, the project as a macro-repeat performance, as a disparate set of micro-gestures, like Gómez-Peña's corpus, denaturalized the naturalized (art) history of a social drama, the most fantastical inter-American allegory of the turn of the millennium, NAFTA proper. In the face of the enduring radicality of this gesture, the task of the critic becomes the task of the translator, resurfaces as another set of isomers best expressed as questions: How can and should we undocument what these resources hide, their blindnesses? How do we honor the enabling beginnings of inSITE specificity, its varied insights into a "style of neoliberalism," time-stamped and site-specific? How do we produce a larger accounting of the intimacies of the economic, the aesthetic, and the political in this project without succumbing to the collector's or curator's impulse to propagate master narratives (the definitive brief history, the cultural logic of x, y, z . . .), without reproducing singularized keywords or phrases (postmodernism, neoliberalism, the allegorical performative . . .)?

While inSITE's configuration as a parallel structure to NAFTA may be self-evident, schematized readings to this effect fail to account for critiques of the pair as mirror images that are prevalent across inSITE's many festivals. InSITE established a cross-border platform for art from and beyond the region. It also coincided with and furthered international recognition

of Tijuana as a cultural center strategically situated in the twenty-first-century free trade corridor. Like DF art circa 2002, Tijuana art, heralded as part of the "discovered" alternative, survived because of and despite incorporation into larger narratives of Mexican art forwarded in the name of a national global contemporary. Select Tijuana art workers negotiated this revised "City"/"Border" position, aware of their own complicities in such dichotomous thinking. After 1999, over sixteen shows were devoted to the fictive consolidation of a tijuanense aesthetic. *Strange New World: Art and Design from Tijuana* (2006), which opened at the Museum of Contemporary Art San Diego (MCASD) one year after inSITE shuttered its "maquila," included a billboard project by ERRE in collaboration with the MacArthur Fellowship–winning cultural critic Mike Davis.

Man up! ERRE's intervention, which presages the increasing significance of text in the artist's practice, attests to (border) art workers' continuing commitment to undocumentation as a militant research method. In 2005, the Minutemen made their presence felt in the San Diego–Tijuana corridor and across the US Southwest. *Prejudice Project* (2006) features a lone man—Davis—his back and graying head turned away from the camera (see plate 18). He gazes out, at, over what would appear to be the border that doubles as the horizon line in the design's visual plane. *Prejudice Project*, like *Borderhack!*, remaps westward expansion on a South-North axis. Its caption simultaneously echoes frontier tropes of masculinity and US fears of penetration to rival any generated by Mexico. ERRE's billboard challenges viewers to rethink the period's "genres of Man": "Don't be a man for just a minute. Be a man your whole life."

Like Wolffer, like Sisco, Hock, and Avalos, the artist did not imagine his installation's interlocutors to be solely for the art cognoscenti. A scale model of the design was included in the MCASD show. A full-size billboard was installed on Interstate 5, the main thoroughfare between San Diego and Tijuana. Southbound, but on the left-hand side of the freeway across the northbound lanes, the billboard's last frontiersman, like the viewer, faces the international border and Tijuana. Less than a mile away, another billboard, paid for by the Minutemen, railing against "illegal aliens," appeared soon after, on the other side of the freeway, on a street leading to Las Americas Premium Outlets, a mall that attracts shoppers from both sides of the border (Ramírez 2015). ERRE and others read the Minutemen recruitment campaign as a direct response to *Prejudice Project*. Could motorists tell the difference between art and its instigation in this uncanny performance of counter/transfer/ence? What did "Davis," the protagonist of

ERRE's project, see on the signage's screen(-allegory)? What did he project onto the receding horizons of the billboard's and territory's doubled borderlines?

The feminist legal scholar Katie Oliviero (2011, 680) notes of the Minutemen, "like border checkpoints, [they] are as much a performative threatening of force as its substantive exercise." "Framers framed," watchers watched, conduits of recycled nationalism, the "artivists," as pop-historically minded as the Zapatistas, followed the precedent of organizers of the *Light Up the Border* campaign and the binary logic of the NAFTA debates and US culture wars when they reasserted the primacy of the Mexico-US border as a repeat performance. After 9/11 (2001), in the midst of Immigration and Customs Enforcement (ICE) raids and deportations of undocumented workers from the United States, Davis, as a metatextual figure, points us toward and away from the gravitational pull of this aesthetic-political force field, writing a degree zero to rival Sierra's. "Under the perfect sun," Davis stands his ground, becoming another son of border crisis.

FROM UNDOCUMENTATION TO THE UNDOCUMENTARY (ALEX RIVERA, SERGIO ARAU AND YARELI ARIZMENDI, LOURDES PORTILLO, URSULA BIEMANN, SERGIO DE LA TORRE AND VICKY FUNARI, CHANTAL AKERMAN, NATALIA ALMADA, _____)

Sometimes a screen is only a screen. If we saw a consolidation of the archive of border art through and with inSITE that also resulted in global attention to the site-specificity of Tijuana as one fictive capital of the twenty-first century, in a range of film and video practices we catch sight of a range of renewed attentions to the greater Mexican conditions of (artistic) labor and production. Claire Fox (1999, 59) characterizes 1980s border documentaries as unable "to escape the restrictive binary logic of mainstream NAFTA debates." She addresses how labor and management used the video because of its low overhead cost and portability to create didactic documentaries about borderlands labor and environmental politics. Without resorting to an equally binary logic to trouble Fox's characterizations, I want to underscore that another articulation of the border documentary, which traversed the byways of border undocumentation more generally, arose in the same time period. Its production only intensified in the ten additional years of NAFTA's implementation.

Revising undocumentation as method, this archive makes clear that

earlier critical mass of border art challenged not only NAFTAfication but also modes of documentation spanning the arts and "the art of economic government." The expanded cinema I reference blurs the lines between documentary and fiction filmmaking *pace* the cinema studies scholar Michael Chanan's (2007) claim that the pair become indistinguishable in post-1950s new cinema of Latin/x America.[34] More generally, it recalls cinema's earliest roots in documentary fictions and self-reflexivity concerning labor politics, epitomized in and by the father of cinema Louis Lumière's short *La sortie des usines Lumière* (*Employees Leaving the Lumière Factory*, 1895). Following Hal Foster's (1996) remarks on the "return of the real," this work reflects art's millennial privileging of renovations in documentary aesthetics, exemplified in and by documenta 11's focus on new documentary strategies in the visual arts (its curator Okwui Enwezor's question, "How can one document bare life?"). Often absent from discussions of the latter but clearly evident across the sweep of inSITE entries, the Mexico-US border served as a backdrop, if not a focus of, a specific variation of this trend in no small measure because UCSD united several of its practitioners.

Consider the efforts of Sekula or the interventions of the feminist artist-critic Martha Rosler, including the very title of her oft-cited 1981 essay "In, Around, and Afterthoughts (on Documentary Photography)" that performs this body of work's privileging of the parenthetical and nonlinear.[35] Or, more immediately to the point of undocumentation's connections to NAFTAfication, consider the work of the photographer and UCSD Visual Arts graduate and professor Fred Lonidier.

Lonidier from the 1970s onward focused on border labor relations, producing "conceptual photography" and artivist gestures like *N.A.F.T.A. (Not a Fair Trade for All)*. Collaborating with the San Diego Support Committee for Maquila Workers after he was banned from exhibiting in the CECUT, Lonidier equipped a trailer truck with his artwork and writing, taking *N.A.F.T.A.* to Tijuana's streets, touring the parking lots of Baja California's industrial parks. Lonidier's accelerated commitment to the destabilization of political and aesthetic projection in his drive-ins and drive-bys decelerates the moving image, morphing the 1990s accent on performance in border cultural production into the 2000s accent on "textual photographs" (González Rodríguez 2012). The "blind/hides" of binaries supersede dialectics, spiral into the free association of dialects, which in turn are folded into a legacy of performative photography that Fox herself and the art historian–poet Roberto Tejada date to the Mexican Revolution's border skirmishes.

Add Hock. Take in the meandering pace, the poetic attention to detail and the everyday that informs *Southern California: A Cinemural* (1979, 70 min.). Sit with the understated but durationally linked projects *The Mexican Tapes: A Chronicle of Life Outside the Law* (1986, 221 min.) and *American Tapes: Tales of Immigration* (2013, 228:02 min.). Hock, trained as a poet (BA, University of Arizona, 1970) and an artist-filmmaker (MFA, School of the Art Institute of Chicago, 1973), coproduced with Sisco and Avalos the San Diego Bus Poster Project. He also single-authored installations that address greater Mexico, labor, immigration, and natural resources. *International Waters/Aguas internacionales* for inSITE97 consists of a "two-headed" water fountain that spans the border. *Pirámide del Sol: A Monument to Invisible Labor* (2002), a great pyramid of plastic produce baskets, installed in Mexico City's La Panadería, rivals Cuevas's *Del Montte*. More immediately significant, Hock helped prototype what I am referring to as the undocumentary genre.

In *Southern California*, Hock ran a single thread of 16mm film through three side-by-side projectors, staggering each by twenty seconds. The subtitled result was a kaleidoscopic poem as compelling as Herrera's *Uno por 5, 3 por Diez*. The project's shifting images and text remediate and meditate on the last frontier economy of Southern California. One sequence re-sites claims to "a better life," nearly two decades before Cuevas's *Mejor Vida Corp*. The tone of *Southern California* is both reflective and interpellative (see plate 19). Rolling like a slot machine, its hypnotic admissions, presaging post-1992 double visions of the New World, suggest that few viewers can escape projecting their desires onto geography, that the gesture is as characteristic of casino capitalism as it is of "screen- allegories." Hock, as literal as Wodiczko, projected *Southern California* onto storefront windows and walls, creating makeshift screens that transformed the film into a mural, before circulating it in museum and gallery spaces.[36]

FIGURE 3.10. Louis Hock, *Southern California: A Cinemural*, screen capture, 1979. © Louis Hock. Courtesy of artist.

In *The Mexican Tapes* and *American Tapes*, Hock wears his heart on his sleeve but hardly subscribes to black-and-white political or aesthetic dichotomies. Hock has no distance from the subjects featured in these films because he is an insider-outsider in the community he chronicles. The filmmaker follows the lives of undocumented workers in the Analos Apartment Complex in Solana Beach, where he also resided with his then girlfriend Sisco. The workers are Hock's friends. They also turn the camera back on the filmmaker.

Hock occupies a privileged position as an artist and US citizen in this dynamic, but he also refuses to wield that privilege to claim the fiction of journalistic or social scientific neutrality. Hock's gaze, most prevalent in *The Mexican Tapes*, is neither ethnographic nor voyeuristic. Instead, in the four-part series, his position, like the stories the project filters, accumulates meaning. The quartet, which aired on PBS, BBC, and Televisa, eschews the gentility of plot, but is determined by a quotidian that is reshaped by Hock and Sisco's presence in it. Intimacies nurtured over thirty-plus years subsequently inform *American Tapes* (2014), which premiered at the Museum of Contemporary Art San Diego. Children who role-played Border Patrol agents and "illegal aliens" in the courtyard of Analos—an everyday "border game" far more frequently staged than BAW/TAF's or Dominguez and Fusco's—in Hock's "sequel" to *The Mexican Tapes* are US citizens, business owners, lawyers, and accountants. The paired projects compose one longitudinal study as compelling as any historian's or sociologist's but cannot be characterized as affording their viewers the luxury of bullet-point takeaway arguments. Instead, the pace, if not the message, of each series is inefficient in the tradition of "slow cinema." Against the lightning strike of the advertisement or newsflash, against the unified master narrative of the ascendant free market, Hock's intervention drags, requires the delayed reaction of three decades to offer a translucent argument for comprehensive US immigration reform.

Confronting preconceptions of the border in predominantly US-based scholarship and public policy that locate it simply as the division between the United States and Mexico, *The Mexican Tapes*, *American Tapes*, and *Southern California* critique the documentary's clichéd investments in propagandistic fact-finding or self-righteous political action as surely as they critique public policy and academic treatises that elaborate crisp theses held at arm's length from the lived realities of economic and political displacement. Intent upon offering alternative perspectives on Manifest Destiny regional and national Conceptual -isms, this archive's aesthetics,

FIGURE 3.11. Louis Hock, *The Mexican Tapes: A Chronicle of Life Outside the Law*, screen capture, 1986. © Louis Hock. Courtesy of artist.

varied as its contents and political nuances, are comprehensible vis-à-vis a range of post-1960s labels affixed to documentary practices that crisscross the borders of cinema, performance, and conceptual art making that reframe the art historian T. J. Demos's (2013) observations on the "migrant image."

From the humorous shorts *Why Cybraceros?* (1997) and *A Day Without a Mexican* (1997); to the linked meditative projects *Señorita Extraviada* (2002) and *Maquilapolis* (2006) that address femicide, environmental degradation, and factory flight; to the distinct but formally empathic *De l'autre côté* (2002) and *El Velador* (2011)—the best practices of this work learn from conceptual, poststructuralist, and critical cultural studies' challenges to linear and universal narratives in the service of recovering and remaking US-Mexico border art's site-specificity. Following undocumentation, the stakes of affixing the prefix "un-" to the word "documentary" cannot be reduced to purely formalist readings of the work's effects. Hock's attentions to undocumented workers in *The Mexican Tapes* model the terms of this work's presentation, reiterating the most literal-minded explanation of what the "un-" of undocumentary accomplishes.

Tracking figuration, this body of social practice—part of the medium's and the region's larger performative matrices—refuses to succumb to cost-benefit analyses but also resists the formal distanciation or nihilism of experimentation for the sake of experimentation alone. Instead, an associative logic empowers these films' reanimation of the prefix "un-" in a manner that once again can be nuanced transversally with a nod to the poetic. The poet-translator Rosa Alcalá stages an opposition of the "Documentary: The lyric of unrehearsed chemicals / acts out the tensions of progress" to "Undocumentary: The man who joined / old world industries of textile / . . . is not a video / to behold" (2010, 13) in a collection whose cover significantly is borrowed from Sekula's *School Is a Factory* (1978–1980).

Alcalá's defiant insistence that "the subaltern cannot speak" through the moving image or pages of the documentarian belies the stakes of my reading this work as undocumentaries. While Davis, Jim Miller, and Kelly Mayhew (2003) claim, like some sharp counterpoint to Fox's observations on border documentary, that no sustainable challenges to Southern California's restructuring have been mounted, an aggregate set of undocumentaries, sidestreaming and following what we have considered thus far in "Border," demonstrates that an archive of sustainable and sustained contestations of shifting labor dynamics on the full length of the Mexico-US border emerged in the NAFTA era. In what follows, I project "trailers" onto the screen of ERRE's *Prejudice Project* to illustrate what I mean and to elaborate further on the work's relationship to the larger method of undocumentation.

Alex Rivera

In one scene of his acclaimed senior project at Hampshire College *Papapapá* (1995, 26:45 min.), LowDrone creator and experimental filmmaker Alex Rivera plays "The Border Bunch" to culture-jam televisual and border games. The sitcom *The Brady Bunch* frames a discussion of 1990s immigration reform inseparable from continental socioeconomic restructuring. Against "il/legality," art muddies the objectivity of legislative taxonomies of personhood. More specifically, the tenets of documentation, the requirement of demonstrating birthplace, an individual's year of entrance into and years of residence in the US, are met with the armature of undocumentation (intuition, affect, humor, the subject-object relay of personhood, montage, juxtaposition, utopian plagiarism).

The media scholars and filmmakers Alexandra Juhasz and Jesse Lerner label documentary films that resist the genre's foundational fiction of transparency "fake documentary" (2006).[37] *Papapapá*, like a host of late-1990s and

early-2000s undocumentaries, links free trade to the shifting configurations of North American racial capitalism, per the terms of the recalibration already identified by Sisco, Hock, and Avalos. Ontology here merges the social body of a continent with bodies ranging from the inter-American migrant to the US consumer-citizen. Frequently adhering to the fake documentary's refusal to differentiate fact from fiction, the short video, web design, and films of Rivera, which have been featured at the Museum of Modern Art, at the Guggenheim Museum, at Lincoln Center, and on public television, anticipate and probe the fictional interior and exterior landscapes that falsely partition greater Mexico's NAFTAfication.

In *The Borders Trilogy* (2002, 8:56 min.), produced for PBS's *Point of View* (*POV*), Rivera reenacts the period's mapping of the "New World Border." Aesthetically discrete, as if the three screens of Hock's *Southern California: A Cinemural* had been teased apart, the project's triptych functions like three poems in a series. "Love on the Line" begins with an intertitle that locates the piece thematically, "In the 1990s, a US law was enacted that punished some *legal* immigrants for visiting their countries of origin." It then re-sites the post–Operation Gatekeeper fence between Border Field State Park and the Playas de Tijuana. "Love on the Line" includes brief interview clips of families divided by the wall.

"Container City," *The Borders Trilogy*'s "middle passage," is contained by this intertitle: "In the late twentieth century, as the United States closed its borders to increased immigration, it opened its borders to 'Free Trade.'" From there it predicts the "container invasion," informing viewers that shipping containers, what Sekula and Noël Burch in their film *The Forgotten Space* (2012) treat as a central agent for the spread of global capitalism and what the cultural critic and philosopher Alberto Toscano cites as the very figuration of circulation, have accumulated in a New Jersey subdivision. Rivera's tone mocks both apocalyptic and celebratory spins on the open market. Transnationally campy in a vein related to yet distinct from Gómez-Peña's performances, "Container City" sports tongue-in-cheek commentary, such as, "The abandoned containers are slowly taking over." The short's subtitles repeat the observation that the United States is "a consuming region," in effect overwriting "migrant melancholia" with the alienation of the US citizen. Especially foreboding if we recall the Great Recession and mortgage subprime crisis a scant five years after the film's distribution, this segment of the trilogy nonetheless offers the project the small consolation of comic relief.

In contrast, the third section of Rivera's sequence secures *The Borders*

Trilogy's claims on undocumentation. Although it could be argued that *The Borders Trilogy* reads as a meta-exercise that trebles focal and affective ranges, in "A Visible Border," Rivera most overtly toys with focalization to treat flows and blockage on the Mexico-Guatemala border. Jim Hurley, a market analyst for the Aberdeen Group, supplies the segment's voiceover, explaining American Science and Engineering Inc.'s late-1990s development of new surveillance technologies. Rivera presents a close-up of an X-ray image that becomes a banana truck with "human contraband." If Benjamin claims that a photograph's caption secures its meaning, "A Visible Border"'s subtitles clarify that the undocumented entrants "captured" in and by these X-rays were in transit to the United States, but never made it into Mexico. The clarification opposes Rivera's aesthetic to that of the Border-as-Panopticon.

Rivera's linked website *Cybracero* (1997), which includes his short *Why Cybraceros?* (1997, 4:51 min.) and his feature-length science fiction film *Sleep Dealer* (2008, 90 min.), also visualizes and slyly mimics surveillance technologies deployed at international borders. These projects, like Cuevas's *MVC*, are indebted to the artivist tactics of meme hacking and culture jamming. They expand how we might imagine post-Chicanx or Latinx art, demonstrating connections between the undocumentary and the "mockumentary," more fully than his immediately recognizable un/documentary, *The Sixth Section* (2003, 26 min.).[38]

A portmanteau that the *Oxford English Dictionary* dates to 1965, the mockumentary frequently promotes a political or social agenda, presenting fictive events in a spoof of more traditional documentary. In *Cybracero*'s

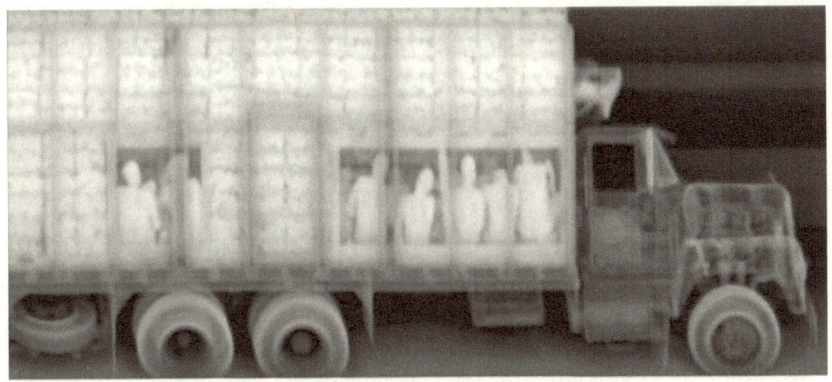

FIGURE 3.12. Alex Rivera, *The Borders Trilogy*, screen capture, 2002. © Alex Rivera.

press release, Rivera resorts to and reabsorbs history to bolster his faux corporation's claims and reinforce the linkages that Sisco, Hock, and Avalos facetiously tagged between a US post-antebellum racial capitalism and its reMex. Parodying an early promotional film, *Why Braceros?* (1959), which was "presented as a public service" by the Council of California Growers, in *Why Cybraceros?*, Rivera subvertises,

> These robotic workers are specially designed by the US Department of Labor to be optimized for farm tasks. Using a series of simple commands, a Mexican worker can, from Mexico, watch their live Internet feed, decide what fruit is ripe, what branch needs pruning, and what bush needs watering . . . in American lingo, cybracero means a worker who poses no threat of becoming a citizen.

The project, premised on a slippage between the neologic and the neoliberal, not only resonates with Okón's irreverent video assemblages that we considered in "City" but also operates in solidarity with the Mexican filmmaker Sergio Arau and the Mexican actress and former "Comadre" Yareli Arizmendi's *A Day Without a Mexican* (1998, 28:16 min.), a short film that, like Rivera's, morphed into a feature-length fiction film of the same name (2004, 98 min.) and is indebted to the new racial capitalist thesis of Sisco, Hock, and Avalos's bus poster project.

In fact, if Arizmendi appears in *La Mera Frontera* (1997, 90 min.), Hock's undocumentary reenactment of a 1918 Arizona–Sonora border skirmish, Arizmendi and Arau pay homage to Hock, who makes a cameo appearance in *A Day Without a Mexican* as "Lewis Hawk," a would-be grower, who laments, "Only Mexicans know how to fix Japanese cars." Arizmendi and Arau are not afraid to quote or poach from other influences, too. Despite the pair's disclaimer that their film was inspired by "A Day Without Art," there are so many overlaps between *A Day Without a Mexican* and the dramaturg Douglas Turner Ward's award-winning *Day of Absence* (1966), it's tempting to imagine that production as the absent center of Arizmendi and Arau's film.

While the film's menagerie of stereo- and archetypes recalls BAW/TAF, Gómez-Peña, and Fusco's recourse to reverse ethnography, the overriding narrative of *A Day Without a Mexican* follows Ward's mobilization of stereo- and archetypes. Recognizing typecasting for the allegorical procedure that it is, Arau and Arizmendi, more capaciously than Gómez-Peña and Fusco, map a NAFTA-era US political unconscious. Mimicking Ward's pedagogical aspirations, they burden their video to the breaking point with statistics

FIGURE 3.13. Sergio Arau and Yareli Arizmendi, *A Day Without a Mexican*, screen capture, 1997. © Sergio Arau and Yareli Arizmendi.

and facts that debunk conceptual personae (most notably, the Mexican, a stand-in for all immigrants from Latin America). The resulting tragicomic drama, as if extending the metaphor already articulated by Sisco, Hock, and Avalos, suggests that the absorption and disappearance of Latinx workers—documented or undocumented—is inseparable from other "scenes of subjection" in the United States.

What goes around, comes around: like Sisco, Hock, and Avalos's bus posters, *A Day Without a Mexican* in its later feature-length incarnation also provided a concrete form for grassroots political action against the proposed but never actualized Border Protection, Anti-terrorism, and Illegal Immigration Control Act (H.R. 4437), or "Sensenbrenner Bill." Passed by the House of Representatives on December 16, 2005, H.R. 4437 would have made residing in the United States as an undocumented entrant a felony. It also would have imposed stiffer penalties on those who knowingly employed non–US citizens and required that the United States beef up its fortification of 700 miles of the nearly 2,000-mile Mexico-US border. Organized to coincide with May Day celebrations, "A Day Without an Immigrant"/"El Gran Paro Americano" demonstrations boasted over 1 million participants. Supporters embodied *A Day Without a Mexican*'s politics of charting and performing erasure, boycotting the everyday—schools,

work, shopping—to emphasize the US economy's dependence on undocumented labor from the late 1960s onward. In the wake of those protests, H.R. 4437 died in the Senate when it was not brought to the floor before the 109th Congress's close.

While it runs counter to undocumentation's drive toward derealization to suggest that the intimacies of representation and the social real can be neatly mapped onto *x* and *y* axes of cause and effect, the symbolic remobilization of Arau and Arizmendi's cinematic thesis suggests that neither the relativism of the postmodern nor the alleged relativity of the multicultural fully accounts for a circuit of politics and aesthetics that the work makes visible in the face of quotidian erasures in the past and present. The stakes of undocumentation are not only located in the discursive but also extend to human rights–based struggles that eclipse the post-1965 bounds of the museum, the theater, and the university complexes.

Lourdes Portillo
Unlike the binary politics of the documentaries that Fox examines, those of the undocumentary explicitly consider the limitations of representation. In this regard, there are similarities between the undocumentary form and what the cinema scholar Bill Nichols terms the "performative documentary." In *Blurred Boundaries* (1994), Nichols revises his previous categorizations of documentary to accommodate work of the 1980s and 1990s, which he characterizes as "performative" and "dialectical." Nichols writes of this work:

> Though sharing the preference for the local, the concrete, and the evocative, performative documentary also generally insists on the dialectical relationship between precisely this kind of richly and fully evoked specificity and overarching conceptual categories such as exile, racism, sexism, or homophobia... performative documentary addresses the fundamental question of social subjectivity, of those linkages between self and other that are affective as fully as they are conceptual. (ibid., 104)

To ground his classification, Nichols offers several examples, including the Latinx filmmaker Lourdes Portillo's collaboratively directed requiems *Las madres: The Mothers of the Plaza de Mayo* (1986, 64 min.) and *La ofrenda/ Days of the Dead* (1988, 50 min.). Building on Nichols's terminology, the cinema scholar Sylvie Thouard argues that Portillo's campy *The Devil Never Sleeps/El diablo nunca duerme* (1994, 82 min.), a film that Portillo notes

Mexican audiences read as a national allegory, "calls to mind feminist performance art, while refusing to offer narrative resolution" (Thouard, quoted in Portillo 2001, 119). Portillo's *Señorita Extraviada* (*Missing Young Woman*, 2002, 74 min.) harbors formal affinities with *The Devil Never Sleeps* and the filmmaker's prior work that treats collective trauma, but it also diverges from that corpus, marking an aesthetic and political break in both the filmmaker's work and border undocumentation.

Specifically, if thus far I have considered undocumentaries that focus on the NAFTA era's new racial capitalism, by the turn of the millennium, several women filmmakers also had committed themselves to recognizing the latter for the sex/gender system that it is. Unlike the work of "Woman," which, with the notable exceptions of Mayer's pioneering documentary efforts and Wolffer's community-based actions, addresses the symbolic redeployment of Woman as Mexico, Border, and Culture, select cultural producers from greater Mexico and beyond trained their sights on the working conditions of literal women in the Mexican-US borderlands.

In the case of Portillo, *Señorita Extraviada* fits this pattern. *Señorita Extraviada* grapples with the feminization of the Mexican border's workforce and Ciudad Juárez feminicide as layered "formal problems" of public policy and neoliberal transition. Portillo's project joins a host of others, including Wolffer's *Mientras dormíamos*; González-Rodríguez's *The Femicide Machine*; and the Swiss filmmaker, curator, and theorist Ursula Biemann's video essay *Performing the Border* (1999, 42 min.), that draw attention to the crisis in Juárez. Because actual outtakes from *Performing the Border* appear in *Señorita Extraviada*, it's especially tempting to read those two films dialogically. *Performing the Border*, which Biemann characterizes as a "video essay," offers an idiosyncratic theorization of the root causes of feminicide (Driver 2013, 319) that follows the tactics of the "performative documentary," outlined by Nichols, as well as the lion's share of well-intentioned activism, journalism, art, cinema, and scholarship testifying to the post-1993 links between violence against women, economic restructuring on the continent, and the impunity of state and corporate agents. If the film, following its title, "performs the border," the filmmaker in the film's voiceover acts out a belabored theory of alienation:

> There is a connection between repetitive sexual violence and the form of production of a high-tech culture, between the technologies of identification, reduplication, simulation, and the psychological disposition of a serial killer . . . The Industrial Revolution has produced famous serial

killers. Our era of the second Industrial Revolution . . . has outsourced production to the US-Mexico border, exporting at the same time this urban pathology. (1999)

In contrast, Portillo withholds from viewers the satisfaction of theoretical analysis or investigative closure in *Señorita Extraviada*, formally *"measuring silences, if necessary—into the object of [her] investigation"* (Spivak 1988, 296; emphasis in original). In fact and fiction, she crafts *Señorita Extraviada* (2002) in contradistinction to what the media scholar Abigail Solomon Godeau terms a "double act of subjugation," first by the social, and then by the documentary, filmmaker. Portillo places at the center of her film Spivak's haunting question, "Can the Subaltern Speak?," reMexing it to fit the circumstances of the borderlands' racialized and sexualized new division of labor. In turn, the filmmaker prioritizes the testimonies of victims' families over her own ruminations on the "femicide machine." While the inclusion of the eyewitness is considered to be de rigueur for the documentary, in the case of *Señorita Extraviada*, the accounts' inclusion has the effect of pushing the would-be video essay into a polyvocal register.

In *Señorita Extraviada*, Portillo splices TV coverage of the women's deaths, photographs of the missing and the deceased, and footage of Juárez into one another. In some sequences, the city's monumental flag, like its DF counterpart (each part of a program initiated by President Zedillo in 1999), flaps in the wind. In others, women, entering and leaving maquilas, remake cinema's aforementioned originary fascination with the worker leaving the factory. Or, shoe shop windows contrast with lost shoes in the sand or the shoes on the feet of slain women in Anapra (the site of Sierra's *Sumisión*). By far, however, families' attempts to make sense of the nonsensical, to recapitulate the events that surrounded the events of their loved ones' disappearances, remain the most unsettling sequences in the film.

Alluding to the "screen-allegories" previously imposed as explanations of violence against women in Juárez, Portillo juxtaposes the presumptions of these accounts against the more "modest" narrative habits of the victims' families, which re-spool the film's undocumentary logic. If Northrop Frye argues for an "allegorical continuum," Portillo (2002) explains, "The facts of the cases seem to be whimsically constructed. I find myself mistrusting everything I am told and everything I read. The only reliable sources of information are from the victims and their families," as if to suggest the stark divide between the discursive regimes of the "femicide machine" and social actors' coping mechanisms. With nothing left to go

FIGURE 3.14. Lourdes Portillo, *Señorita Extraviada*, screen capture, 2002. © Lourdes Portillo. Courtesy of artist.

on, Paula Flores reads the behavior of her daughter María Sagrario González's pet parakeets in the days surrounding González's disappearance. Flores's testimony poignantly underscores another allegorically mediated quotidian:

> I knew something was wrong. Her boyfriend Andrés had given her two parakeets. When I put them in the sun . . . one of them was dead . . . the one called Clint. The parakeet called Luis only let her hold him. I started to take him out and he didn't bite me. I asked him about Sagrario. "Luis, do you know where Sagrario is?" And, he nodded. The parakeet seemed to understand. He shook his head as if he were saying, "Yes." The parakeet left on Tuesday . . . and on Wednesday they found my daughter's body. We found out on Thursday. I felt that the parakeets knew. (ibid., 2002; subtitled translations from film)

The alternate language of the parakeets, according to Flores (or better put, Flores's explanation, which constitutes the search for the trace of the Other

in the seemingly supernatural "natural world") haunts *Señorita Extraviada*, reappearing as the film's signature visual referent in its credits, where sequences of the caged birds background the names of those involved in the work's production (see plate 20). Although *Señorita Extraviada* critiques Occidental allegory's repeat performances of the Border, it also salvages allegorical scansion as a viable operation in situ. Portillo's takeaway argument does not amount to a wholesale dismissal of *allēgoria*, but an elegiac call to consciousness: If the devil never sleeps, then the shared labor of undocumentation in the NAFTA era borderlands requires another form of and for accountability, an *Antígona González*–like recounting of both the dead and the devil in the details that amassed while "we" were sleeping.

Sergio De La Torre and Vicky Funari

Woke, Fiamma Montezemolo echoes Adorno's observations (1984) on the genre of the essay when she describes *Echo*, her short video that investigates the traces of nine inSITE commissions in Tijuana. More specifically, Montezemolo, like the cinema scholar Timothy Corrigan, links the tactics of the video essay to Adorno's discussion of the essay as "methodically unmethodical" (Corrigan 2011, 23). While "docudrama," a term usually reserved for cinematic genres in which historical events are re-created via documentary and dramatic techniques, could be applied to the Mexican filmmaker Sergio De La Torre and the US filmmaker Vicky Funari's *Maquilapolis* (2006, 60 min.), I'm more inclined to read the project, after Biemann's or more convincingly after Portillo's, as radically revising the hybrid genre of the film essay.

Maquilapolis treats two battles—for severance pay and for environmental clean-up—but, is not reducible to those fights in the twilight of Tijuana's factory flight. Like *Señorita Extraviada*, which indexes conspiracy theories, discarded humanity, shoe shop windows, *Maquilapolis* patterns disposability in an effort to articulate the terrifying performative range of constative ideologies. On the one hand, *Señorita Extraviada* and *Maquilapolis* offer two models of undocumentation, which privilege dialects as themselves dialectical images.[39] On the other hand, Funari and De La Torre go a step further than Portillo, patterning a collectively authored video essay vis-à-vis their incorporation of video diaries into the film.

Maquilapolis's video diaries situate it in a tradition of border art that underscores the Austinian social contract among cultural producers, their "informants," and audiences to bear witness to social injustice. *Maquilapolis* does not depend on "an implicit binary opposition of order and disorder

FIGURE 3.15. Vicky Funari and Sergio De La Torre, *Maquilapolis*, screen capture, 2006. © Vicky Funari and Sergio De La Torre.

[to] uncritically organize . . . representation" (Soto 2007, 420). Rather, the film addresses how the impulse to catalogue the life stories of women of the global South becomes another aesthetic operation that must be denaturalized. The film's form and content critique a documentary drive that is contingent upon the projective fantasy of transparency, "truth," and the trope of the global North saving the global South.[40] The video diaries threaded through *Maquilapolis* enable it, like *Señorita Extraviada*, to showcase allegorical vernacularisms. Anchoring *Maquilapolis*, they offer multidimensional portraits of Tijuana, its inhabitants, and the undocumentary process.

Maquilapolis, a neologism, references Tijuana as the "city of factories." Like Wodiczko's *Tijuana Projection*, *Maquilapolis* locates the maquila as the symbolic and literal site of the global North's consumption of Mexico; involves a collaboration with Grupo Factor X, a Tijuana-based nonprofit founded for and by women for self-empowerment; and privileges the testimonio as a speech act. In fact, many of *Tijuana Projection*'s participants were featured in *Maquilapolis*—a situation that more clearly contextualizes Factor X as a clearing ground for women's organizing efforts and self-actualization. Unlike Wodiczko's *Tijuana Projection*, *Maquilapolis*—whose

soundtrack is none other than that of Bostich and Fussible of the Nor-tec Collective—does not monumentalize the women who participate in its production.

Funari describes *Tijuana Projection* as if it were a splinter in the eye of *Maquilapolis*:

> The things Wodiczko did wrong came back to haunt us in a negative hermeneutics of suspicion. Wodiczko's project was the first time for many of these women to talk about their experiences, and Wodiczko didn't do any follow-up... It took an incredible amount of work to convince them that Sergio and I had a different process. *Tijuana Projection* was a ghost in the room. (2007)

In an effort to differentiate their project from Wodiczko's, Funari and De La Torre shied away from comparisons of maquila labor and artivist co/production. Eschewing an added layer of consumption—the artist's or activist's "expedient" interests in the Mexican female worker—Funari and De La Torre imagined *Maquilapolis*'s intervention as both form and content based:

> We wanted to engage in a collaborative process that would break with the traditional documentary practice of dropping into a location, shooting, and leaving with the "goods," which would only repeat the pattern of the maquiladora itself. We embrace subjectivity as a value and a goal... this is more than just a film—it brings together filmmakers, factory workers, and artists. (De La Torre 2007)

Revisiting Yúdice's model of "cultural col*labor*ation" quite literally by following in the footsteps of Wodiczko, Funari and De La Torre set up video workshops, putting cameras in the hands of already politicized promotoras. The women, in turn, produced the diaries that make up a fourth of the film and feed into *Maquilapolis*'s reluctant foray into periodization. Functioning like video essays within a film essay, they infuse the project with the sentiment of the "good fight," and set up a frame for the project to reenvision the auteur function (see plate 21).

Often contrasting sharply with the film's more experimental elements—its time-accelerated sequences and performances of the interchangeable commodification of maquila workers and the products they build—the "viscerally real" diaries insert a spectrum of affect into a project that otherwise assumes a more traditionally "sober" documentary "structure of

feeling." Specifically, while almost all of the diaries treat the difficult work/life situations of their creators, they likewise present camaraderie among the promotoras and Funari and De La Torre. They provide comic relief and attest to the psychic dimensionality of their creators, undocumenting racial and gender profiling. Lastly, the diaries, by resituating the women as the film's coproducers, rethink prior citations of the Laboratory, the Maquila, and collaboration in the region.

Chantal Akerman

Of the Jewish Belgian filmmaker Chantal Akerman's *De l'autre côté* (*From the Other Side*, 2002, 99 min.), the French philosopher Jacques Rancière writes, "The film's political impact consists precisely in the way it turns an economic and geopolitical issue into an aesthetic matter, the way in which it produces a confrontation between two sides, and a series of conflicting narratives around the raw materiality of the fence" (2010, 150). Rancière's characterization of Akerman's film is reminiscent of firsthand accounts and reviews of the various instantiations of inSITE that comment on the border overshadowing any single artist's contribution to the event. Rancière assumes a priori that Akerman's film, and not the border fence, dictates the terms of what he calls "the cut of the aesthetic." Yet, what if "the raw material of the fence" were not as "raw" as Rancière and others before him have imagined? What if the fence itself were bound to an aesthetic that Akerman and other artists seek to undocument?

If *Señorita Extraviada* and *Maquilapolis* give voice to inhabitants in the borderlands region, the final examples of undocumentary to which I now turn expand the genre's focus to encompass more fully landscape and ambience. Undocumentary practice on both sides of the border works against aestheticized, sensationalist coverage of homeland insecurities. Speaking subjects dictate Akerman's stylistic choices in *De l'autre côté*, but the filmmaker privileges long-winded silence, too. Akerman's early high-definition, multilingual film (whose title is in French, but whose dialogue code-switches across a Spanish-English-French spectrum of languages) by sympathetic accounts is difficult. *De l'autre côté*, like various undocumentaries I've referenced, attempts translucent periodization by bearing witness to the fallout effects of the years 1994 to 2001 in one region of the Mexican-US borderlands.

Formally, *De l'autre côté* cleaves close to the filmmaker's earlier work that focuses on interiors and architectural design and is slow moving with minimal dialogue. Indebted to French New Wave filmmakers, including

Jean-Luc Godard, Akerman is attuned to questions regarding exodus and genocide in the film, too, perhaps because her mother was a Holocaust survivor. The filmmaker went to the US-Mexico border post-9/11 (2001) to address human rights violations in the region. *De l'autre côté* begins in Agua Prieta, Sonora (Mexico), with border dwellers' firsthand accounts of lost relatives who attempted to enter the United States. Akerman's focus then shifts to neighboring Douglas, Arizona, and Los Angeles. The filmmaker interviews a local restaurant owner; a married couple on their ranch, who reflect on their border fears after 9/11 (2001); a Mexican consul; and a sheriff. From the start of the film, then, it appears that 9/11 will define Akerman's periodization. The temporality of the film is more astutely delimited than this, however.

Although all of the above segments of *De l'autre côté* powerfully tug on viewers' sympathies and antipathies, Akerman's consideration of the reconfiguration of post–Operation Gatekeeper border wall-fence ecologies refines the project's challenges to imperial optics from the televisual to the thermal-imaging enhanced. Akerman's film undocuments the effects of a US "prevention through deterrence philosophy," which converts the desert into a policing mechanism. Akerman's sustained attention to place and her relentless scrutiny of landscape in the style of her previous "images within images" (see Sultan 2008) are "arresting." They literally arrest *De l'autre côté*'s development.

FIGURE 3.16. Chantal Akerman, *De l'autre côté*, screen capture, 2002. © Chantal Akerman.

De l'autre côté slows down to translate the Agua Prieta–Douglas join of the border's alleged "emptiness" into a cacophonous roar. Or, more accurately, the film's double portraiture of inhabitants and landscape, which locates the film as marking two event horizons: 1994 and 2001, sharpens the divide between the border as "discursive vector" and "just weather." *De l'autre côté* forms part of a repertoire of cultural production that personifies the Sonoran Desert to denaturalize its politicization after Operation Gatekeeper.

In art and literature that range from the Mexican photographer Julian Cardona's images of "brassieres hanging off bushes near Sásabe on the line at a place where guides are known to rape women coming north" (Bowden and Cardona 2008, 223) to the Mexican American writer Luis Alberto Urrea's *The Devil's Highway: A True Story* (2004), the desert is "outed" as an active agent in US border enforcement and informal literal and symbolic economies of trafficking. It is revealed as complicit in reconfiguring the terms of "disposability" in the Mexican-US borderlands. By tapping into this repertoire, Akerman returns the undocumentary to a more general archive of undocumentation.

Akerman presents an Other history of immigration before closing her film in Los Angeles, itself legible as a connected ecosystem in US immigration policy's "environmental built theater" of North American neoliberal transition (Schechner 1994). Driving at night, Akerman offers a story of a missing female day laborer, presenting the undocumented again as the trace of the economic ghosting the continent. While her poetic account veers toward the allegorical, it also elaborates undocumentation as a double movement of the inscription and erasure of the undocumented worker. Turning the wheel, Ackerman accents the resonances between Adorno's use of the prefix un- in his elaboration of the "methodically *un*methodical" essay and cinematographers' millennial mobilization of the un- in their articulations of the undocumentary form. The argument—an indictment of market-state integration—in *De l'autre côté*, across the films I have touched upon, and indeed across all of the artwork of *REMEX*, materializes in the loop and in the relay to *and* from the other side.

Natalia Almada

Natalia Almada, a 2008 Guggenheim, 2010 USA Artist, and 2012 MacArthur Fellow, began her career with the short film *All Water Has a Perfect Memory* (2001, 19 min.), which treats not only the tragic death of her older sister, Ana Lynn, but also the filmmaker's greater Mexican citizenship. Almada's

FIGURE 3.17. Natalia Almada, *Al Otro Lado*, screen capture, 2005. © Natalia Almada.

work since *All Water* has continued to "undocument" ghosts in her own and the Mexican-US subcontinent's imaginaries. *Al Otro Lado* (*To the Other Side*, 2005, 66 min.) and *El Velador* (*The Night Watchman*, 2011, 72 min.), for instance, become echo chambers, teeming with revenants.

In the former, Almada, like Akerman, portrays the hazards of crossing into the United States from Mexico after 1994. She contrasts those hazards with the relative ease of movement of narcotics and "narcocorridos" between the nation-states. If Andreas associates the 1990s with not only a spike in drug smuggling across the US-Mexico border but also a sharp escalation in US and Mexican efforts to curb this traffic (2000, 51), in *Al Otro Lado*, Almada captures this history as the sound of music. Almada follows an aspiring "corrido" composer, Magdiel Rubio Burgos, to ground her treatment of the growth of a transborder music industry. Rubio Burgos's ballads, along with other narcocorridos, become the undocumentary's soundtrack, and could become our own after Nor-tec in a regional resounding of the era's reMex. Rubio Burgos's ballads structure the film's narrative as significantly as the film's visual footage.

Within the first few minutes of *Al Otro Lado*, the Latinx singer Jenni Rivera weighs in on the corrido's significance. Rivera, who after the film's release died in a 2012 plane crash, notes that her career was built on her

appeal to a generation of "kids speaking in English, but singing in Spanish." She also explicitly states that she set out to re-gender a genre. Rivera details the stylized personae of several singers who left their mark on her banda production. Chief among them, Chalino Sánchez rose from Sinaloan roots as humble as Rubio Burgos's or Margolles's. Linking Rivera's story to others', Almada ties the narco-political economy to rural Mexico's NAFTA-era economic devastation. While much has been written on the devastating impact of NAFTA on Mexican rural agricultural communities, less consideration has been paid to the treaty's repercussions on Mexican maritime communities after transnational squabbles over safe tuna fishing garnered early NAFTA-era attention. But, the agreement's regulations and deregulation profoundly affected Mexican Pacific fishing villages, too, prompting many of those communities' denizens (like their rural farming counterparts) to migrate to Mexico City, Mexico's northern border, and the United States. Almada's film charts this history. Like Andreas, she focuses on a late-twentieth-century uptick in human and drug smuggling in greater Mexico's remotest regions. Unlike Andreas, but like Hock, Almada refuses to provide us with a bulleted account of cause and effect. Instead, Almada homes in on affective dead-ends and dead-time; the downward spiral of white, brown, and pink noise after economic displacement.

Consider Rubio Burgos's compositional process: the filmmaker scatters the lines and notes of a corrido that Rubio Burgos crafts throughout the film. In so doing, Almada also converts *Al Otro Lado* into a meditation on cinematic production. Meanwhile, like Hock, Rivera, Portillo, and Akerman, Almada refuses her publics the satisfaction of easy closure—epistemological or otherwise. We do not know the fate of Rubio Burgos after he swaps a corrido for a guided border crossing. The film ends with a beginning, the young man embarking on his undocumented rite of passage. Upbeat, he crosses the literal Mexico-US border. Carrying an empty Coca-Cola bottle filled with water, he subvertises the film's credits in a gesture that Herrera would have applauded, "Always at big events, drink Coca-Cola." The camera tracks, like a reverse long shot, a maddeningly inconclusive establishing sequence: the composer, like Portillo's missing young women, is swallowed up by a desert. We are left with the cold comfort of sign-cutting aestheticized and politicized geography and with the weight of inter-American dreaming, the "impossible subject" of a second life in the United States.

Finally, waiting structures *El Velador*. To understand the interminable

FIGURE 3.18. Natalia Almada, *El Velador*, screen capture, 2011. © Natalia Almada.

FIGURE 3.19. Natalia Almada, *El Velador*, screen capture, 2011. © Natalia Almada.

pace of the film, we must recall what it interrupts. *El Velador* treats Sinaloa's narco-culture. A literal and metaphoric wind—and rain—blows through the undocumentary as surely as the literal and metaphoric winds that swept Mexico and the United States after 1994 and 9/11 (2001) run through Akerman's *De l'autre côté*. *El Velador* features the night watchman Martín of the graveyard Jardines de Humaya in Culiacán, Sinaloa, Mexico, the

burial ground for Sinaloa's narco-elite that made a cameo appearance in *Al Otro Lado*.

Almada's camera follows Martín from dawn until dusk. During that twenty-four-hour period, Martín follows Mexico's news on a flickering television screen. He waters the dust outside of the opulent mausoleums he's charged with watching (see plate 22). Unlike Rubio Burgos of *Al Otro Lado* or Southern California's disembodied narrator, *El Velador's* protagonist harbors no dreams of a better life, however. While Martín is relegated to a ramshackled, badly wired one-room shed, some of the tombs he guards are air-conditioned, equipped with expensive sound systems that continuously loop the dead's favorite narcocorridos.

Like Akerman with *De l'autre côté*, Almada slows down the passage of time to contrast it with the temporality of Mexico's accelerated crisis. Against what Curtis Marez terms the "automatic-weapon aesthetic" (2004, 13) of feature films concerning drug control and war, against sensationalist news coverage of Mexico's narco-violence, Almada's cinematic long shots meditate on and thus remediate the crisis of more than 100,000 dead from narco-related violence since 2006. Through the crackle of Martín's television, the families' showy wakes for and burials of their loved ones, and the cacophony of the mausoleums, the film transversally documents Mexico's Uncivil War. Children, women, and dogs clean, survey, and walk amid Jardines de Humaya's tombs. If Portillo peppers *Señorita Extraviada* with portraits of Juárez's disappeared and murdered young women, Almada highlights banner photographs of young men in their twenties. The images convert the mausoleums into shrines of and to hypervirility. They unearth linkages between turn-of-the-twentieth-century revolutionary masculinities and turn-of-the-twenty-first-century narco-masculinities in the palimpsestic logic of the corrido's turn from the former to the latter, in a hyperaccelerated overcompensation of and for the era's gendering effects.

The soundtrack of *El Velador* is not solely the corrido. Rather, the film's ambient audio expands, sediments many layers: The clatter of construction. Men with calloused hands daily build this city of the dead's subdivisions. Weather. Or not. Almada is clear that "foleys"—the insertion of sound in the film's postproduction process—supply *El Velador* with its tempo/rality and mood (Almada, in Meckler 2014). But, notably absent from the filmmaker's moving image environment is the web and its cybernetic loops. Digital divides become the unspoken rules, the most banal afterimages of *El Velador's* sluggish pace.

Against the multi-mediated vilification and the romanticization of Northern Mexico, a region that per Margolles's oeuvre from the late 1990s onward generically was elided with all things narco, *El Velador* scans and sounds a mind-numbing built environment of en*gender*ed precarity. Nothing and everything happens in *El Velador*. Surveillance footage: as Martín watches and bides his time, we watch and bind our time, too. The image here is beholden neither to irreconcilable opposition nor split-second synthesis, but, like *Vaporización*'s, is continuous and interpellative. It dissolves into *El Velador*'s atmospherics, the dissensual logic of undocumentation. A roundabout rather than a two-way street of politics-becoming-economics-becoming-aesthetics, another allegory of violence against the "slow violence" of allegory, *El Velador* follows the feedback loop of drama and social drama in the Mexican-US corridor in the death without end of NAFTAfication. Like Hock, Rivera, Arau and Arizmendi, Portillo, De La Torre and Funari, and Akerman, Almada presents us with an alternate point of view on neoliberal transition as an antidote to Conceptual -isms. Extended metaphors are eclipsed by mixed, or better put "reMexed," metaphors as Allegory with a capital *A* recedes into the allegorical.

Panning up from Akerman's *De l'autre côté*, Rancière (2010, 151) forces the film, its reframing of our perceptions, out of its very frame of reference—the Mexico–US border—when he writes: "Film, video art, photography and installation art rework the frame of our perceptions and the dynamism of our affects. As such, they may open up new passages for political subjectivation, but they cannot avoid the aesthetic cut that separates consequences from intentions and prevents their (*sic*) from being any direct passage to an 'other side' of words and images." Rancière's pronouncement is premised on provincially European divisions between public and private, the aesthetic and the political.

Bienvenidxs a Tijuana. Welcome to America's Finest: the work of "Border," like that of "Woman" and "City," enjoins us to reconsider Rancière and others' investments in Borders, implicitly coded as Old Worldly, to revisit heighted millennial recitations of the allegorical performative through the lens of the undocumentarian. From Sisco, Hock, and Avalos's *Welcome to America's Finest Tourist Plantation* to BAW/TAF's and others' counteroffensive against *Light Up the Border*, to ERRE's *Prejudice Project* and Almada's *El Velador*, the artists and collectives of "Border" recontextualize public policy and multimediated responses to it and intersplice political and aesthetic representation. In these methodically unmethodical gestures, the market-state's foundational fictions are as historically

vulnerable to dis/appropriation as the social allegories that came before them and the post-1968 artwork from which they borrow. There is no partition of the sensible, no left and right hemispheres—political and aesthetic—of the unconscious. Instead a loop feeds into and feeds off of the neo/conceptual and somatic tactics of art and politics, situating that pair—an assemblage—as the most impious PIAS Form of the third millennium.

POSTLUDE

REMEX || re: Mex || Remix

UNTOWARD ART HISTORIES OF THE THIRD MILLENNIUM

In October 2008, in CECUT's show *Proyecto Cívico Project*, curated by Lucia Sanromán and then curator of Mexico City's Museo de Carrillo Gil Ruth Estévez, I ran across an image that, like Paula Flores's narrative of interspecies communication in *Señorita Extraviada*, will not quit my mind. The Tijuana-based photographer Ingrid Hernández's *La maquila-golondrina* (2008, cut) presents a portrait of disposability that once again stresses the relationship between racialized and sexualized labor and location at a temporally inflected focal range, the special effects of the years 2000–2001 on Tijuana's border industrial complex (see plate 23). In the image, foreground and background seamlessly blend into an interior landscape which, textured as braille or *allēgoria*, cannot maintain the appearance of distinctions between public and private, exterior and interior. Light streams through holes onto an abandoned factory's floor. The architecture's apertures, the cracks and holes in its form, which ironically make the photo possible, qualify the ways in which the building embodies ruin. Perforations punctuate its performative. Against developmentalist pornotropes, the photo, like Teresa Margolles's *Operativo II*, veers dangerously close to fetishizing structural violence.

La maquila-golondrina's title, a deceptively poetic phrase in Spanish, literally translates into the "factory-swallow," as in swallow, the bird that migrates. A vernacularism that migrated into socioeconomic and political analyses of Latin American "factory-flight" (Klein 2000, 223), "la maquila-

golondrina" responds to the highly stylized and formally minded language of public discourse, becoming another "bird" to catch sight of from Mark Dion's *Blind/Hide*.

Hernández's image, like some molted flight feather or *remex* that flutters to the decimated shop floor, prompts me to think about what it means to write toward the ambivalent, shimmering horizon of an art history that registers, but never arrives at, the sanctuary of a master narrative. *REMEX* is premised on the bold yet banal observation that NAFTA, a rhetorical palimpsest, represented and still resonates as the most fantastical inter-American allegory of millennial and millenarian globalization. Unmoored from the official date of its advent, NAFTA's complete implementation corresponded to a socioeconomic reconfiguration of the Mexico-US subcontinent that profoundly impacted the aesthetic and political unconscious of the region. In *REMEX*, I have considered artistic responses to this reconfiguration, coded as the "contemporary," a leap beyond the "post/modern." This work is inseparable from the "art of economic government" to which it responded. Across this book's three sections, which map onto three greater Mexican allegorical figurations and prefixations of the Mexico-US corridor—"City" (no-/non-), "Woman" (re-), and "Border" (un-), I have focused on artwork that trebles what I term the allegorical performative by way of neo/conceptual, somatic or performative, and undocumentary tactics.

Over the course of researching and writing *REMEX*, I witnessed much of this work's integration into the non/sites of its production, especially circa 2001, when this archive tonally shifted. Contrary to Terry Smith's (2009, 245) formulation of the contemporary as "being perpetually out of time, or at least not subject to historical unfolding," contrary to Richard Meyer's (2013) formulation that contemporary art is a past tense, the conceptually minded performance, video, installation, cabaret theater, net art, and architecture that populate *REMEX*'s pages demand untoward art histories—irreverent and disappropriative—that locate the work in relation to proliferating pasts, presents, and futures. Addressing aesthetic and political representation, this archive clocks for me the critical difference and distance between "toward" and "untoward." In *REMEX*, I recycle the prefix "un-" against the flourish of conclusion to heed the imperative of undocumentation forwarded especially by post-1984 border art. I position this book less as a linear and capital-lettered Art History, more as a conceptual provocation to match provocations forwarded by its archive.

Put differently, if I defer arrival at the savagery of a unified narrative's civilizing mission, I do so to pry open places and spaces in the seamless,

prepositional directive "toward," to ward off enclosure, closure as *REMEX*'s fait accompli. Affectively, I am in good company: a range of early-twenty-first-century writing, curatorial initiatives, and archive building that focuses on (Latin American and global) conceptualisms and sited art making, from *Global Conceptualism: Points of Origin, 1950s–1980s* (1999) and *Conceitualismos do Sul/Sur* (Freire and Longoni 2009) to *Phantom Sightings: Art after the Chicano Movement* (2008) and *Resisting Categories: Latin American and/or Latino?* (2012), like the artwork that has sustained my attentions, multiplies, spirals, decenters, and recenters how we understand genre. The impact of the artworks and artivisms informing these projects is ontologically significant. It's also ultimately as ideologically indeterminate or "promisingly ambivalent" as "rasquache," "national camp," or the allegorical performative.

In a pink-washed Mexico City whose elite refuse to cede centripetal privilege, preferring to transform the city's image and fiscal budget in a transition from DF (District Federal) to MCXD (Ciudad de México), a consolidation of a 1990s/2000s DF neo/conceptual practice continues by way of privatizing exercises in place making. Consider the billionaire Carlos Slim's serpentine, hour-glass-figured Museo Soumaya, which plays the femme to the butch, or the jauntily crowned, sharp-angled fortress of Museo Jumex, the "progeny" of Eugenio López Alonso, heir to the juice company Jumex. Set against the backdrop of the Colonia Polanco's outdoor shopping mall Plaza Loreto, each museum marks the rematerialization of the Mexican capital as arte non/objectual, as the gendered non/site of a contemporary that exceeds either of these institution's walls (Santiago Sierra's fulsome aesthetic treatise, after all, reMexed in the artist's 2016 collaboration with Yoshua Okón, "Excusado," a tiled toilet that cites Edward Weston's 1925 photograph of that same name, but also unmistakably resembles Museo Soumaya, becoming the institution's retrospective architectural model). Named in honor of Slim's late wife, Soumaya Dolmit, the Museo Soumaya houses art and archaeological artifacts from various centuries and continents, a sweep that for many visitors can be overwhelming. The JUMEX is committed to artwork that overwhelms visitors for other reasons.

No excuses! If we think of the relationship between form and content with and in these two museums, we stand poised to arrive at new ways to understand how and why the male/female divide enacted through architectural designs merits mention. If Culture in the early 1990s was defined as modern and modernizing, yet feminine and vulnerable (returning to the

Frida effect) in exhibitions like *Mexico: Splendors*, through the NAFTA era in Mexico City, it was refashioned by artists and the state as a shield to guard against penetration and as a sharp blade to mount the best offensive defense.

A bumper sticker with the culture-jamming observation "El género es violencia," distributed in the 2010s by Lorena Wolffer, rings doubly true, "Gender/genre is violence." Its key phrase also flirts with "género"'s pluralization ("los géneros"), "Goods are violence." The triple entendre of género/género/géneros influenced greater Mexican female and feminist artists of the NAFTA era, who claimed performance, the "black sheep" of DF neo/conceptualisms, as their preferred genre of intermediation. While no one circled a flag pole in the production of this work, the DF alternative-becoming-contemporary especially demonstrated an ambivalence, on par with its unease with Zapatismo, toward this archive.

A longer version of this book as redress would address the intimacies of body art and cabaret theater that I flagged in one of "Woman"'s endnotes. Adding another fold to the drape of *REMEX*'s ultrabaroque fabric, in this hypothetical expanded edition of *REMEX*, I would examine Astrid Hadad's (2001) elaborate accessorization of the collapse of violated Mexico-Woman as allegory in and through the mirrored doubling of 1492/1992. Hadad's espectáculos (spectacular shows) complement the efforts of Polvo de Gallina Negra, Wolffer, Katia Tirado, Silvia Gruner, and Nao Bustamante. (In fact, some of the cabaret artist's early costumes were designed by Maris Bustamante [Hadad 2001].) Hadad's figure graced neomexicanist canvases before her visage was featured on billboards in Los Angeles, promoting *Mexico: Splendors*, too. In Southern California, it was as if Hadad's socially melodramatic expression were the manifest destiny of Frida Kahlo's in New York, or as if the two women, as conjugations of Woman, reinvigorated the connection between the mural and billboard forms. Hadad's performance of Mexico, her song, dance, and haute couture, influenced Olivier Debroise's decision to include the cabaretera on the exclusive guest list of his remake of Sergei Eisenstein's *¡Que Viva México!*

In *Un banquete en Tetlapayac*, Hadad, like Nao Bustamante in *America the Beautiful*, scales a ladder before performing at its apex. Unlike Bustamante, who surveys the spectatorial continent from her newfound heights, Hadad sings a marketing jingle that reminds Mexican citizen-consumers to buy national products. In 2012, Mexico City's Museo de Chopo bought into Hadad's powerful extended metaphor of Woman-Nation when it exhibited several of the artist's lavish costumes. Spoofing on José Vasconcelos's

motto for UNAM: "Por mi raza hablará el espíritu" (For through my race the spirit will speak), the runway show was titled *Por mi espíritu hablarán mis trajes* (For/Through my spirit my clothes will speak). In the exhibition's trim catalogue, Hadad explains *Copilli*, an outfit of her own design, in "Alegoría de la república mexicana" (Allegory of the Mexican Republic). She links the multibreasted iconography of her skirt to the Aztec prince Copilli and the Egyptian goddess Isis. Hadad's statement reads as an allusion to her own Lebanese-Mexican indigenous background. It also becomes a template for thinking of each of the performer's garments as being for and against a historically constructed social body that she metonymically dons to revolutionize as farce. Hadad's nationally allegorical hand-me-downs, inseparable from her musical numbers, reMex afresh the bass line of the allegorical performative in NAFTA-era greater Mexico (see plate 24).

Transnationally campy, Hadad as built environment de- and reschools me in a contradiction laid out by the performance studies scholar Laura G. Gutiérrez. Gutiérrez (2010, 7) writes, "It could be argued that sexual permissiveness in cultural representation and in public discourse has found a sort of ally in neoliberalism in the context of Mexico." The alliance here speaks more generally to the ongoing incorporation of the cultural production, which I treat in *REMEX*, into art histories of the 1990s and 2000s, a phenomenon that for some remains unsettling.

As surely as performance art and cabaret performance in Mexico and the United States cross-pollinated one another at the turn of the millennium, select border art was appropriated, streamlined into aggressive fables of postmodernism and postcolonialism, and surreptitiously reconfigured as Border art with a capital *B*. In 2014, ERRE, refusing to cede this archive's radical beginnings, cut shields out of crude oil barrels, then decorated them with the subvertised logos of transnational corporations that stand to benefit from Mexico's denationalization of its petroleum reserves. "Hell" and "Mexxon" are reminiscent of Minerva Cuevas's merchandise and wordplay. Of the riot gear, ERRE says (in Diaz 2014), "I'm from a generation that was forged or cemented in this idea that this [Lázaro Cárdenas's 1930s expropriation of Mexico's oil] had been a patriotic decision—a recuperation of our dignity and the elimination of every damn trace of colonialism." His commentary, which rallies the national, stands in opposition to Teddy Cruz's investment in re-creating the ambience of Tijuana's "informal, nomadic communities" in homes that privilege "techniques of the body" over the zoning laws of San Diego (Mauss 1973) and reflect "undocumented utopias" of exchange.

Cruz's corpus, which rose to prominence after 9/11 (2001), like Hadad's but in an altogether different register, trebles a range of Conceptual-isms that oppose North/South, male/female, domestic/foreign, public/private, white/Other, sanctioned/unsanctioned, high/low. The San Diego–based architect approaches each binary as an unnatural disaster in need of synthesis. For Cruz (2008), the border is not a line, but it does function to define a textured ecosystem that demands "new readings of globalization" predicated upon a "radicalization of the local." Cruz insists on an extrapolation: "a political equator," "a necklace of geographies of conflict," more overblown than Silvia Gruner's "collar," which features the conjoined "beads" of Tijuana–San Diego as 60 linear miles (ending 30 miles into TJ). The makeshift communities of Tijuana usually dismissed as pockets of abject poverty are of particular interest to Cruz. The point of departure and return for ERRE's *Century 21*, these unincorporated territories, in the words of Cruz, represent "nonconforming densities, the blurring of property lines, alternate modes of ownership and neighborhood involvement" that acknowledge transborder dynamics outside the purview of sanctioned commerce: a flow of waste going South (garage doors, cars, houses ... transported to Tijuana as garbage), a flow of people going North with no sign of welcome (ibid.). Although Cruz explicitly proposes an approach beyond aesthetics (often calling for the return of Marcel Duchamp's urinal to the bathroom), he also implicitly links aesthetics, politics, and economics in his repeat performance of an experimental architecture, which, like Krzysztof Wodiczko's, subscribes to the conceit that architects not only design buildings but blueprint agency for those dwellings' inhabitants. Just as the architects Robert Venturi, Denise Scott Brown, and Steven Izenour in *Learning from Las Vegas* (1977 [1972]) sought to question the object of architecture in relation to lifestyles and demographic shifts, Cruz recontextualizes their "White Majority" argument, in effect reminding his publics that if we learn from Las Vegas, Las Vegas learned from Tijuana. Cruz (2008) defines the stakes of his lifework: "Density continues to be thought of as amounts of units per acre (how it's defined in organized architecture and academia), but density needs to be thought of as amounts of exchanges per acre."

The distinction breaks with the logic of US westward expansion, reMexed in the NAFTA era, and staunch Mexican defenses and offenses against cultural penetration, but it also follows the formula of DF cultural producers' subscription to a both/and: an embrace of Mexico's "glasnost" and a refutation of the state's airtight subscription to allegories of neoliberal globalization after 1982. While many, including the cultural critic Aron

Vinegar (2008), locate *Learning* as a foundational text for the convergence of architectural and postmodern theory, the divide between *Learning*'s thesis and its status as a late-twentieth-century referent is striking. The problem is especially pronounced in Fredric Jameson's extended engagement with *Learning* in *Postmodernism*. Indexing the volume's "aesthetic populism," Jameson (1991, 89–190) elaborates on postmodernism's fascination with the "'degraded' landscape of schlock and kitsch." By his argument's close, however, when he circles back to architectural theory and practice with his vertiginous reading of the Bonaventura Hotel and his characterization of postmodern hyperspace's transcendence of the "capacities of the individual human body to locate itself, to organize its immediate surroundings perceptually, and cognitively to map its position in a mappable external world" (223), it is notable how little he seems to have learned from *Learning*. The dilemma that Jameson maps as a periodization, one of profound disorientation in late capitalism, comparable to the disorientation invoked by the modern cityscape, flies in the face of *Learning*'s thesis and actually performs an alternate argument closer to the one he lays out in "Periodizing the 60s." In the main, Venturi, Brown, and Izenour caution against an impulse to caricature diffusion as unmappable. Instead, they contend,

> The Las Vegas Strip is not a chaotic sprawl but a set of activities whose pattern, as with other cities, depends on the technology of movement and communication and the economic value of the land. We term it sprawl, because it is a new pattern we have not yet understood. The aim here is for us as designers to derive an understanding of this new pattern. (1977 [1972], 76)

The "non-integrating gap" between their insistence and *Learning*'s reception and redeployment provides me with a "contextura" from and in which to diagram other kinships replete with their own relational aesthetics. Smuggling border quotidians as cultural capital South to North, Cruz repurposes yet again spatial reconfigurations, mixed-use dwellings (a home upstairs, a business downstairs) in his San Ysidro "Living Rooms on the Border" project *Casa Familiar*. While Cruz (2008) views the US-Mexico border as emblematic, he also extends an imaginary line from the US-Mexico border around the world, cruising a dystopian political equator "that roughly corresponds with the revised geography of the post-9/11 world according to Thomas P. M. Barnett's scheme for *The Pentagon's New Map*."

Cruz (2008) notes that Barnett, a US military strategist, divides the globe into a "Functioning Core," or parts of the world where "globalization is thick with network connectivity, financial transactions, liberal media flows, and collective security," and a "Non-Integrating Gap," "regions plagued by politically repressive regimes, widespread poverty and disease, routine mass murder, and . . . chronic conflicts that incubate the next generation of global terrorists." Neither an inversion nor a conversion narrative, Cruz's cartography, after Barnett's, signals possible reentries for architecture into the fray of geopolitics and economics, a conglomerate which, building on the Argentinean cultural studies scholar Beatriz Sarlo's (2000, 24) observations on Walter Benjamin, functions as "the ruins of an edifice yet to be constructed."

To learn once again from Tijuana in this formulation is to bypass the alleged disorientation of late capitalism to cross into "critical regionalisms" forged by integrated market-states. Undocumentation takes *place* as its starting point on this spacetime continuum. Cruz's manifest densities reorient *REMEX* as surely as the Zapatista postscript suggests that the kernel of an argument is often encapsulated in its afterthoughts and non sequiturs. His pragmatic adaptation of the language of borderization reminds me that if the better "failures" of the twentieth-century avant-gardes teach us anything, it is not how to read art as equaling life, but how to perceive the aesthetic operations of the reminted market-state. The aesthetic I reference corresponds to what is naturalized or normalized in the quotidian relay of subject-object formation. Late-twentieth- and early twenty-first-century cultural production that champions modalities of institutional critique reasserts the aesthetic's original meaning—that which is "perceptive by feeling."

Just as nineteenth- and twentieth-century anthropologies lowercased Culture to propagate cultures, this corpus reenacts the powerful thesis that the Aesthetic requires a comparable democratization. It insists that the aesthetic must be read beyond the confines of the white cube, the black box, or the book object. It demonstrates the disambiguation of *x* foreground and *y* background. "Allegory," from the Latin *allēgoria—allo* (Other) + *agoreuein* (speaking in the public sphere)—from the Greek ἀλληγορία, roughly translates as "veiled speech." A technology that "commands a large percentage of the world's symbolic activity" (Fletcher 2006, 77), allegory—as medium and method—implicates word and image, sound and sight, touch, taste, and smell. It accounts for nested texts and environments ranging from the novel to the painting, from the city to the nation. Resisting the

melancholic poetics of the lone citizen-subject ensconced in his McMansion or (Macondo/McOndo) treatise on the nation-state and/or world system, Cruz, as surely as the undocumentarians of "Border"'s close, foregrounds the performativity of everyday allegorical practices that hum in the background of artworks' and public policy's production and reception.

As the twenty-first century continentally drifts further away from the start date of NAFTA, as it consolidates in Pangaea-like fashion the spirit and letter of the treaty, the question becomes, What strategies and tactics akin to Cruz's permit us to sing off-chart and off-key the question, "In what tense does one write *the time after* NAFTA?" (Nielsen, quoted in Emmelhainz, Hutton, and Kedzior 2014, 128). The beat plays on. To write untoward art histories of the third millennium, we must listen for collective responses to remixed Conceptual -isms post-9/11 in the midst or the wake of the Arab Spring, Occupy, Ayotzinapa, Black Lives Matter, the Tea Party, and the rise of the Alt-Right ... While NAFTA haunts the "aesthetic unconscious," the "temporal geographies," of proponents and detractors of market integration, it also marks overarching shifts in the narrativization of collectivity and ideologies of form (Jameson 1981; White 1987). In October 2013, before state players posted the Trans-Pacific Partnership's (TPP) terms, heated discussions concerning the impact of the TPP and coverage of those conversations repeatedly referenced the work-in-progress as "NAFTA on steroids." In early November 2013, WikiLeaks released to the public sections of the draft of TPP, in effect demonstrating the agreement's formal and thematic affinities with its cited forebear. Almost coterminously, revaluations and commemorations of NAFTA began to flood cyberspace and the airwaves. Coverage of the anniversary of the treaty's implementation had its academic analogs—conferences, panels, retreats—all devoted to remembering, cataloging, and documenting NAFTA's before and after tempos and temporalities. By February 2014, US and Mexican presidents Barack Obama and Enrique Peña Nieto and Canadian prime minister Stephen Harper were meeting "to reboot" the agreement. In the summer of 2016, United Kingdom citizens, reacting against the fictions of the market-state, voted to leave the European Union in what's commonly called the BREXIT referendum. Their decision sent stock exchanges into temporary free fall. The US presidential race in parallel real time illustrated the staying power of NAFTA as event and extended metaphor. The Democratic, Republican, and Independent candidates Bernie Sanders, Hillary Clinton, Donald Trump, and Jill Stein all ran on platforms coupling NAFTA

and TPP and denouncing free trade and globalization. Coverage of the Democratic and Republican Conventions was dominated by discussions of the deleterious effects of NAFTA on middle America and the US Rust Belt.

REMEX it: The story or through line of this collective conversation recycles the bipolar currents of the pre-passage reception of NAFTA (e.g., Muñoz Ríos 2013; Lowrey 2014; "NAFTA at 20" 2014; Sergie 2014). On the one hand, politically right- and centrist-leaning supporters of open markets and austerity measures vigorously continue to endorse the "social allegories" of planetary economic solidarity. On the other hand, politically right-, centrist-, and left-leaning opponents or conspiracy theorists of one-world-market narratives decry the precarity that those forms have leavened, citing the effects of structural adjustment on labor (unions), agriculture, human rights, and the environment. Meanwhile, the international biennial circuit flexes its muscle, the art market becomes a favored site of speculative investment, and the Getty Museum's multipronged *Pacific Standard Time* uncannily ghosts TPP like the rise of a select Mexico City contemporary and inSITE-doubled NAFTA.

REMEX it: The bicephalous Trojan horse stands tall. Carlos Monsiváis's description of the NAFTA debates still applies to cultural clashes of national, often isolationist and neoliberal, often transnational, "tropics." While there are valid reasons why art historians often advocate for a thirty-year rule in art history and criticism, there are equally valid reasons why interdisciplinary critical cultural studies scholars frequently focus on what Jasbir Puar (2007) characterizes as the archive rushing toward us. *REMEX* never drew breath outside of the representationally volatile ambience that Monsiváis described. Instead, I wrote this book from within the culture wars that impacted my archive. From this "blind/hide," I paid close attention to artists' redeployment of the allegorical performative in the service of undocumentation. Turning to a body of artwork that at first glance, like Las Vegas, could be mistaken for sprawl, I resisted the desire to perpetuate black-and white interpretations of the consequences of the continent's market integration, to mourn contemporary art practices as lost or unrealized radical gestures. I analyzed cultural producers' responses to the aesthetics and politics of key events in the period that punctuated the negotiation, complete implementation, and immediate aftermath of NAFTA, an era that itself depended on periodizations of prior decades, most notably the long 1960s. Throughout, I read figuratively but also, I would insist, literally. In the end, my hope is that this methodology will elucidate some

of the era's arresting shades of gray and contribute to future art histories of the late twentieth and early twenty-first centuries. If Edward Said (1975) recommends that beginnings should enable what follows from them, mark up, cut up, scratch, remix *REMEX* as your varied, very own.

ACKNOWLEDGMENTS

Friends and colleagues have urged me to acknowledge my position as a "native ethnographer" in this project. My contrarian self remains unsure that such an admission is necessary or wholly accurate, but my alter ego obliges for the record.

A trinational product of continental exchange, I was a child of the 1970s/1980s Mexican-US borderlands and the heir of others' binds to the US-Canadian borderlands. I am a beneficiary of 1960s/1970s US social movements and decolonization movements worldwide. My consciousness was raised in the discursive milieu of 1980s/1990s multiculturalism, identity politics, and the supposed first wave of the US culture wars. I collaboratively bear witness to neoliberal transition in multiple genres across many environments. This work is hard. In the face of it, people fall apart every day, and there isn't any way to calculate what could have been lost if someone had not been saved. I've been led to water. I've been ferried across oceans. I've been painted into and coaxed out of corners. I've been offered a leg up to keep walking, to reMex every extended metaphor (myself included). And, for all of those second, third, fourth, fifth . . . chances, I gratefully acknowledge a multitude.

My parents, Patrick and Donna, and my grandparents, especially Ace and Jerry, loved and supported me from day one. They were also responsible for my earliest experiences of a bordered and borderless continent. My siblings, Jenny, Patrick, and Katie, and their families have stood by me

through thick and thin. Extended kin, including the Purdy and Zacaltelco-Rincón families and Dulce Morales, have offered me safety nets at key moments in this book's creation.

I'm fortunate to claim more than one institutional birthplace. I trace *REMEX*'s impetus to my South Texas public school education, then follow it through my undergraduate training at Princeton University in anthropology and creative writing and my graduate training in anthropology at the University of Chicago, creative writing at Cornell University, and literature at Duke University. My graduate school advisors and dissertation committee members, Jean Comaroff, Terence Turner, Archie Ammons, Ken McClane, Fredric Jameson, Antonio Viego, Irene Silverblatt, Alberto Moreiras, and Janice Radway, remain tree-tall models of critical creative excellence for me. Students, colleagues, and friends at Princeton, Chicago, Cornell, Duke, and more recently at Northwestern University; the University of Michigan; the University of California, San Diego; and SOMA in Mexico City have worked tirelessly to school and unschool, to skill and deskill me.

With what fondness I recall conversations in and beyond the classroom walls and studios with Michael Jiménez, Toshiko Takaezu, Lauren Berlant, Terry Turner, Tim Murray, Hortense Spillers, Satya Mohanty, Eve Sedgwick, Wahneema Lubiano, Ken Surin, Ranji Khanna, Robyn Wiegman, Priscilla Wald, Anne Allison, Michael Hardt, Grant Farred, Joe Donahue, Rob Sikorski, and Natalie Hartmann. And, my peers at the aforementioned institutions remain peerless. They also are fearless supporters of my life and work. I am a better person because my path crossed those of Christopher José Meade, John Lim, Winnie Hu, Frank Romagosa, Elliott Young, Leslie Gates, Hilary Abell, Rachel Stein, Kari Robinson, Angela Shaw, Kyoko Uchida, Wendy Walters, Dylan Willoughby, Jodie Medd, Desirée Martín, Jini Kim Watson, Rachel Price, Lili Hsieh, Julie Chun Kim, Evie Shockley, Tabea Linhard, Guillermo Rosas, Michael Ennis, Javier Krauel, and Virgina Tuma.

Upward of seventy artists in Mexico City and in the Mexican-US borderlands, many of whom I now count as friends, opened their hearts and studios to me, engaged my ideas, and talked me through my arguments' missteps. I am especially fortunate to have met Lorena Wolffer, Yoshua Okón, Vicente Razo, Ema Villanueva, Eduardo Flores, Melquiades Herrera, Mónica Mayer, Victor Lerma, Katia Tirado, Maris Bustamante, Sergio De La Torre, Vicky Funari, Alex Rivera, Astrid Hadad, Carla Herrera-Prats, Nate Harrison, Eduardo Abaroa, Louis Hock, and David Avalos.

I appreciate everything that Phil Deloria, Sid Smith, Greg Dowd, Mike

Schoenfeldt, June Howard, and David Porter, in their capacity as departmental chairs and directors, did to try to make space for me at Michigan. I am blessed to have had the opportunity to work alongside Hannah Rosen, Magda Zaborowska, Stephen Berrey, Ruby Tapia, Josh Miller, Gillian White, Adela Pinch, Cathy Sanok, Terri Tinkle, Meg Sweeney, Lucy Hartley, Sara Blair, Jonathan Freedman, Scotti Parrish, Amy Stillman, John Cheney-Lippold, Colin Gunckel, Larry La Fountain-Stokes, Silvia Pedraza, Dan Ramírez, Anthony Mora, Lori Brooks, Scott Lyons, Scott Kurashige, Paul Anderson, Naomi Andre, Yeidy Rivero, Tung-Hu Hui, Victor Mendoza, Anne Gere, Anne Curzan, Petra Kuppers, Sarita See, Lucy Hartley, Alisse Portnoy, Kristen Hass, Bruce Conforth, Tiya Miles, Julie Ellison, Richard Meisler, Holly Hughes, Khaled Mattawa, A. Van Jordan, Andrea Zemgulys, Yopie Prins, Gustavo Verdesio, Abby Stewart, Cody Walker, and Alan Wald. Susan Najita, Sandra Gunning, María Cotera, Evelyn Alsultany, Nadine Naber, Alex Stern, Lisa Nakamura, and Linda Gregerson merit special mention as steadfast Ann Arbor friends and confidantes. The fierce love of Susan and Sandra especially reminds me of the adage that we only learn the identities of our truest friends when we are pushed to our absolute limits.

I will always cherish the conversations, many in the context of the University of Michigan's Rackham Graduate School interdisciplinary workshop the Border Collective, that I shared with Bonnie Applebeet, Orquídea Morales, Elizabeth Barrios, Peggy Lee, Meryem Kamil, Maryam Aziz, Kris Klein Hernández, Martín Vega, Brian Whitener, Mary Renda, Mika Kennedy, Paul Farber, Kristy Rawson, Vivian Truong, Sony Coráñez Bolton, Rolando Palacio, Jallicia Jolly, Iván Chaar-López, and Francheska Alers-Rojas. At Michigan, Tammy Zill, Marlene Moore, Tabby Roth, Mary Freiman, and Judy Gray are or were pros at fielding pragmatic questions related to teaching, research, and writing (TZ, R.I.P.). They also know how and when a quick hug can restore some modicum of dignity to a coworker's step. The Wellman-Pérez, Pauer, Bowles-Pous, and Harris families are exemplary Buhr Park neighbors; and Laura Emiko Burns's empathic powers and math skills will not be forgotten.

At UCSD, where I was a visiting scholar in the Visual Artist Department from January to December 2010 and a frequent informal visitor for over a decade, I am grateful to have shared ideas and company with Natalia Molina, Roshy Kheshti, Grant Kester, Roberto Tejada, Patrick Anderson, Elana Zilberg, Jordan Crandall, Brett Stalbaum, Michael Davidson, Lesley Stern, Anya Gallaccio, Lisa Cartwright, Curtis Marez, Shelley Streeby, Cristina Rivera Garza, Anna Joy Springer, Long Bui, Steve Willard, Sara

Solaimani, Omar Pimienta, Jenny Donovan, Felipe Zúñiga, Elizabeth Chaney, Tatiana Sizonenko, Rubén Ortiz-Torres, and Teddy Cruz. San Diego without Bruna Mori, Ryan and Jacinto Wardwell, and Paula Poole also would be unimaginable.

In the professions at large, I marvel at the intelligence and generosity of Kristin Pesola, Lucía Rincón Zacalteco, Claudia Algara, Mónica Russel y Rodríguez, Micol Siegel, Lessie Jo Frazier, Stephany Slaughter, Hortensia Moreno, Helena Chávez MacGregor, Alexis Salas, Sarah Luna, Rita Raley, Beth Frost, Claudia Rankine, Beth Ann Fennelly, Ann Fischer-Wirth, Fred Moten, Laura Harris, David Lloyd, Maca Gómez-Barris, Zach Blas, Ana Paulina Lee, Josie Saldaña-Portillo, Lucía Sanromán, Mimi Sheller, Hana Iverson, Sarah Dowling, Kara Keeling, Richard Morrison, Sergio Delgado, Cuauhtémoc Medina, Antonio Stambaugh Prieto, Angie Cruz, Susan Zieger, Christina Svendsen, and Ilka Kressner.

REMEX began as my dissertation. At Duke, the Graduate School (Aleane Webb Research Award, international research award, and summer dissertation fellowship), Center for Latin American and Caribbean Studies (FLAS fellowships, Tinker grant, travel grants, and Latino/a Studies research grant), Center for International Studies (Ford research grant), Women's Studies Department (graduate dissertation fellowship, travel award, and Ernestine Friedl Award), and North American Studies Center (FLAS fellowship, research and travel grants) financially supported my research in Mexico City in the summer of 1999 and from January 2000 to July 2001 and my dissertation writing. At the University of Michigan, the Departments of American Culture and English Language and Literature, the Center for World Performance Studies, the Center of Latin American and Caribbean Studies, the College of LSA, and the Institute for Research on Women and Gender funded additional research and writing that enabled me to transition this project from a dissertation into a book. In fall 2008, Michigan's Comparative Literature Department also awarded me a Global Ethnic Literatures fellowship.

REMEX benefited from my participation in the School of Criticism and Theory Seminar "Ritual, Play, and Performance," led by Richard Schechner, at Cornell University in summer 2004; and the NEH seminar "Walter Benjamin's Later Writings: *The Arcades Project*, Commodity Culture, Historiography" organized by Alexander Gelley at the University of California, Irvine, in summer 2011. I am grateful to Northwestern University, and in particular to its English Department, for awarding me a 2005–2006 Mellon Postdoctoral Fellowship in Latino Studies. Although I regret that

circumstances necessitated that I decline a summer 2006 Rockefeller Humanities Fellowship ("Cultural Dimensions of the Mexican Transition: Migration, Culture, Gender, and Violence") at the Centro Regional de Investigaciones Multidisciplinarias—UNAM in Cuernavaca, Mexico, I appreciate the faith that Lourdes Arizpe and members of that fellowship's selection committee placed in my work.

Staff at Ex Teresa: Arte Actual's Centro de Documentación and at the UNAM Museo de Arte Contemporáneo's Centro de Documentación Arkheia were indispensable allies at numerous stages in this book's production. Staff in UCSD Library's Special Collections and Archives, notably Heather Smedberg, helped me navigate the inSITE archive. Every summer since 2010, the contemporary art space SOMA in Mexico City has welcomed me as an artist-writer in residence. It is impossible to quantify or qualify the impact of SOMA's hospitality on *REMEX*.

Early iterations of this book's arguments, sometimes more detailed in their readings of artworks, appeared with these titles in the following venues: "Incumbent upon Recombinant Hope: EDT's *Strike a Site, Strike a Pose*" (*The Drama Review*, 2003); "A Critical Regionalism: The Allegorical Performative in *Madre por un día* and the Rodríguez/Felipe Wedding" (*e-misférica*, 2005); "'Accidental Allegories' Meet 'The Performative Documentary': *Boystown, Señorita Extraviada*, and the Border-Brothel→Maquiladora Paradigm" (*SIGNS: Journal of Women and Culture in Society*, 2006); "La lateralización de la historia, *Maquilapolis* y el efecto de los años 2000 y 2001," (*Representación y fronteras: El performance en los límites del género*, UNAM/PUEG/UNIFEM, 2009); "*Muerte sin fin*: Teresa Margolles's Gendered States of Exception" (*The Drama Review*, 2010); "From *Papapapá* to *Sleep Dealer*: Alex Rivera's Undocumentary Poetics" (*Social Identities: Journal for the Study of Race, Nation and Culture*, 2013); "Of Ecopoetics and Dislocative Media"; ([({})] *The Desert Survival Series/La serie de sobrevivencia del desierto*, Office of Net Assessment/The University of Michigan Digital Environments Cluster Publishing Series, 2014); and "*El derecho de réplica*: Performance—Lorena Wolffer—Performatividad" (*Lorena Wolffer/Expuestas: Registros públicos*, Cuaderno, Museo de Arte Moderno, 2015). I am grateful to editors and organizers affiliated with those venues for their commitment to my work.

REMEX in equal measure benefited from the feedback that I received on papers I presented at numerous Modern Language Association conventions, American Studies Association's conferences, Latin American Studies Association's Congresses, and Hemispheric Institute of Performance and

Politics' Encuentros; the Association for Theatre in Higher Education conference in Montreal, Canada; the Congreso de la Asociación Internacional de Literatura y Cultura Femenina Hispánica at Grand Valley State University; the Louisville Conference on Literature and Culture since 1900; the National Feminist Graduate Student conference in Austin, Texas; the American Comparative Literature Association conference in Puebla, Mexico; and the American Anthropological Association's meeting in San Francisco, California. Audiences at and members of Spelman College's English Department; UCSD's Ethnic Studies, Visual Arts, and Literature Departments; American University's English Department; Emory University's Spanish Department; the University of Arizona's Sex, Race, and Globalization Project; the University of Pittsburgh's English Department; the Tepoztlán Institute for the Transnational History of the Americas; the Newberry Library's Seminar in Borderlands and Latino Studies; SOMA; and the Centro Nacional de las Artes in Mexico City offered invaluable commentary and constructive criticism on drafts of this book's arguments.

I also am indebted to individuals who engaged with the whole or parts of *REMEX*. Laura Gutiérrez extended feedback and friendship at key points in this book's and my own development. Diana Taylor, Petra Kuppers, and Sarita See, and several of my University of Michigan colleagues read and participated in a manuscript workshop for an earlier draft of this project. Mariana Botey pushed me in friendship and solidarity to recognize subterranean links across this book. Her confidence in and utterly brilliant comments on drafts of *REMEX* crucially informed my revisions of it. I never imagined that Claire Fox's work could become more of an inspiration to me than it was at this project's outset. Then I met Claire and realized the obvious: it is one thing to cherish a person's writing, another thing to experience that person's intellectual generosity off the page. Rachel Price, Julie Chun Kim, Lili Hsieh, Genevieve Abravanel, Jini Kim Watson, Evelyn Alsultany, Anthony Mora, Lori Brooks, Scotti Parrish, Lorena Wolffer, Yoshua Okón, Susan Najita, Sandra Gunning, Sara Blair, Cathy Sanok, Adela Pinch, David Avalos, Alexis Salas, Brian Whitener, Desirée Martín, and Mary Renda offered inspiration and encouragement, including helpful commentary on drafts of this book's arguments.

Samantha Force and Danielle Taubman excelled as UROP research assistants. I am fortunate to have had the opportunity to work with several English, American Culture, and Rackham "Diversity Allies" summer research assistants: Joanna Lin Want, Hannah Noel, Orquídea Morales, Bonnie Applebeet, and Peggy Lee. *REMEX* is better for these brilliant and

diligent women's attention to detail and aerial perspectives on what is prosaically possible.

I tested the patience and goodwill of the University of Texas Press in a protracted low point in my work-life juggling act. The press's smart, competent, and compassionate staff made it possible for me to let *REMEX* go. I am grateful to Theresa May, who first noticed and acquired the book for the press; Kerry Webb, who, inheriting the project from Theresa, approached it with comparable enthusiasm and respect; Nancy Warrington, who meticulously copyedited the manuscript; Molly Frisinger, Victoria Davis, and Robert Kimzey, who managed the ebbs and flows of the book's production; and Angelica López-Torres, who shepherded me through myriad details in the manuscript's preparation.

If relationships are wrecked over tenure-track jobs and books, I am the luckiest of lucky to still be able to call Ricardo Dominguez and Césaire (aka Zé) Carroll-Domínguez "home." With super-heroic fortitude, a grace as haunting as Graciela's, and an unshakeable faith in the value of my work, Ricardo and Zé have weathered the ups and downs of my writing process and my institutional indigestibility. Although I cannot evade gravity's pull, Ricardo maintains that apples fall up. His buoyant optimism of the will balances out my pessimism of the intellect. Ricardo has engaged with this book's ideas profoundly, consistently, unconditionally. He also makes an eye-opening cup of coffee. Meanwhile our son and love supreme, Zé, reminds us that he is one of the original X-men; that every time he seizes he catches a glimpse of other dimensions and universes. Who am I to disagree? While I cannot accompany Zé on his intergalactic journeys, I do listen and sometimes pretend to be the Watcher on the dark side of his moon. Shock therapy was devised to mimic a convulsion in the hopes of resetting the brain. If epilepsy in the nineteenth century functioned as an allegory of chaos in the marketplace, by the twentieth century the image of sudden surges of electrical activity in the brain served other representational ends. Folded into the master narrative of economic restructuring by the Chicago Boys, shock therapy became a prominent leitmotif of neoliberal doctrine. Per usual, a chasm divides and connects the literal and the imaginary. For the record: I finished this book during a protracted period of medical crisis. Many thanks to the doctors and nurses of Mott Children's Hospital and the Children's Hospital of Boston who helped us to care for Zé so that I could also complete *REMEX*. In particular, I appreciate Dr. Nancy McNamara, who exceeds our highest expectations for doctor-patient communication.

Finally, I've never wanted or been able to establish borders between the critical and the creative in my writing. My participation in two performance projects, *El automóvil gris/The Grey Automobile* and the *Transborder Immigrant Tool* (TBT), especially impacted *REMEX*'s form and contents. In 2002–2003, I translated, codesigned subtitles, and created a motion-based poem for the Mexican director and playwright Claudio Valdés Kuri's stage production *El automóvil gris*, which features a 1919 Mexican silent film of that same name, Benshi-style narrators, and a piano player. Appropriating *El automóvil gris*'s documentary-fiction hybrid form, Valdés Kuri's play overwrites that classic work's presentation of a turbulent turn-of-the-twentieth-century Mexico City with a representation of an equally turbulent turn-of-the-twenty-first-century Mexico City. Immersed in this project, I practiced before I theorized the allegorical performative. Specifically, my involvement in *El automóvil gris* reminded me that while the production's aesthetic might appear to be indebted to a generic postmodern, its sensibility is also decidedly sited, in effect challenging universalist constructions of the latter. In 2008, I joined the Electronic Disturbance Theater 2.0/b.a.n.g. lab (Ricardo Dominguez, Brett Stalbaum, Micha Cárdenas, Elle Mehrmand) to coproduce the *Transborder Immigrant Tool*. Housed on a GPS-enabled platform, TBT represents a last-mile safety device designed to guide the disoriented and thirsty, regardless of nationality, to water caches and safety sites on the US side of the border. I composed two series of poems for TBT, the first about desert survival, the second more explicit in its experimentation with poetic conceptualisms. Deepening my understanding of the charged discursive environments from which border art first emerged, my participation in TBT helped me name and further comprehend the political and the aesthetic stakes of undocumentation in the artwork that I examine across *REMEX*.

NOTES

PRELUDE: THE ALLEGORICAL PERFORMATIVE

1. For more on racial capitalism, see Robinson (1983), Melamed (2011), and Leong (2013). I use the term "Latinx" here and throughout *REMEX* to sidestep male/female binaries inherent in the Spanish language. I also utilize "x" in lieu of "a/o" word endings in terms like "Chicanx" or "chilangx" (Mexico City resident) that otherwise would linguistically reproduce those same binaries. If the binary is relevant to the argument that I am making, however, I use the "o" or "a" ending.

2. Here and across *REMEX*, unless otherwise indicated, all translations from Spanish into English are my own.

3. Masiello (2001, 17) argues that in the Southern Cone, the project of writers in the postdictatorship years was not to represent "an allegory of neoliberalism," yet the allegorical informs their work constantly (65–66, 68, 71, 77–78, 94, 98, 100, 134, 138, 180, 206–207). The tension here, a critical contradiction, belies a circuit of representation, an Other story of the allegorical performative.

INTRODUCTION: REMIX || RE: MEX || REMEX

1. In 1990, the Peruvian writer Mario Vargas Llosa, hardly a paragon of leftist politics, declared in an oft-cited telecast live debate with Octavio Paz that Mexico's PRI represented Latin America's "dictadura perfecta" (perfect dictatorship).

2. The reign of Porfirio Díaz from 1876 to 1911 is commonly referred to as the Porfiriato. Díaz (1830–1915) held power in Mexico in the years prior to and corresponding with the beginning of Mexico's revolution from 1910 to 1917, sometimes dated from 1910 to 1920.

3. The sociologist Dag MacLeod contends that the parastate was the defining feature of postrevolutionary Mexico. He argues that paradoxically the parastate

also set the Mexican neoliberal transition apart from all others. Between the years 1983 and 2000, Mexico's sustained privatization focused on the parastate's dismantling, and the sheer length of this project accounts for Mexico's distinction for MacLeod (2004). The literature on Mexican oil is extensive; for example, see Meyer (1968) and Brown (1993).

4. Negotiated during the UN Conference on Trade and Employment, GATT was signed into agreement in 1947 and lasted until 1993. It was modified in 1994 but remains in effect under the World Trade Organization (WTO) that replaced GATT in 1995.

5. In response to the situation, on May 5, 1989, Cuauhtémoc Cárdenas and others broke with the PRI to cofound the Partido de la Revolución Democrática (PRD; Party of the Democratic Revolution).

6. The question of middle-class Mexican interest in this show is worth considering despite the art historian Irene Herner's (1990) observation that "it is fundamental to remember that the exhibit was constructed from the point of view of the foreigner and is for foreigners."

7. Octavio Paz, who wrote the catalogue's introduction, was awarded the 1990 Nobel Prize in Literature on the very day that he inaugurated *Mexico: Splendors*, in effect locating him as one of the show's many splendors on display.

8. A variety of theorists, writers, and historians note that Mexican national identity simultaneously gets scripted around the figures of La Malinche and the Virgin of Guadalupe (Franco 1989, Cypess 1991, Steele 1992, Castillo 1998). In a move to bypass the Catholic Church, the postrevolutionary state was focused on La Malinche.

9. The postcolonial theorist Homi Bhabha (1994, 145) writes, "In the production of the nation as narration there is a split between the continuist, accumulative temporality of the pedagogical, and the repetitious, recursive strategy of the performative." In the allegorical method, the pair is conjoined, however.

10. See Mariana Botey (2014b), who tracks indigenismos through readings of muralism and other depositories of nationalized Mexican visual culture.

11. Abby Aldrich Rockefeller founded the Museum of Modern Art in New York City in 1929, one year before her brother became the first president of the Mexican Arts Association, Inc. For more on the extensive involvement of the Rockefellers in Latin American art and US hemispheric foreign policy, see Claire Fox's *Making Art Panamerican: Cultural Policy and the Cold War* (2013), especially chapter 1, "Art Enters the Union: The Transition from World War II to the Cold War."

12. I reference Rockefeller's decision to whitewash Rivera's mural in Rockefeller Center in 1933. The showdown between the pair, or, more pointedly, the anti-imperialist "showmanship" of Rivera in that showdown, secured Rivera's place in a pantheon of revolutionary Latin American artists (Herner 1986).

13. Paz would concur with these cultural producers eventually, but at this point in time, he still subscribed to the more populist rhetoric of the postrevolutionary. Cuevas remains a controversial figure for his larger-than-life personality and for his graphic treatment of death, sex, and politics.

14. Fox convincingly argues that Cuevas was coauthored by José Gómez Sicre under the auspices of the Pan American Union (2013).

15. For more on Paz's debts and Freudian drive in Mexico, see Limón (1992, 1998), Balderston and Guy (1997), Irwin (2003), and Gallo (2010), among others.

16. Though beyond the purview of my narrative, the financialization of craft as cultural patrimony also blurred the lines previously demarcated between the INAH and INBA, resulting in the 1970s creation of the Fondo Nacional para el Fomento de las Artesanías (FONART; National Fund for the Development of the Folk Arts), intended to provide grants and loans to artisans and to organize the sales of handicrafts in FONART-branded storefronts (Coffey 2010).

17. For more on this period, see Eder (2014).

18. For more on Azcárraga Milmo, see Claudia Fernández and Andrew Paxman's sensationalist biography of the mogul, *El Tigre: Emilio Azcárraga y su imperio Televisa* (2000).

19. For more on the rift between Tamayo and Televisa, see Debroise (2001, 52), among others.

20. Kester quotes New York congressman Hugh Carey, speaking in support of the NEA in the mid-1960s, to reinforce his argument about race. Carey claimed: "An outpouring of creativity (stimulated by the NEA) [would] . . . do far more than even the Civil Rights Act to bring them [the ghettos] into the mainstream of American culture" (quoted in Kester 1998, 106). For an indispensable compilation of early key texts from the culture wars, see Bolton (1992). An updated volume would include *National Endowment for the Arts v. Finley*, 524 U.S. 569 (1998), 97–371.

21. CONACULTA's most recognizable and immediate antecedent was the Subministry of Culture of SEP, but in the process of forming the council, Salinas de Gortari also annexed various institutions and entities that addressed national culture (including the subministry).

22. In chapter 1 of *The Fence and the River: Culture and Politics at the US-Mexico Border* (1999), Fox also considers the paradox of the language of "cultural exemption" in NAFTA as a treaty and the realities of the "significant, even hyperbolic" role culture played in NAFTA's negotiation.

23. What passes for "neomexicanismo" remains an open question, the inspiration for a 2011 retrospective inaugurated in Mexico City's Museum of Modern Art. *¿Neomexicanismos? Ficciones identitarias en el México de los ochenta* ("Neomexicanisms? Identitarian Fictions in 1980s Mexico," 2011) overlapped with *Neo-Mexicanism, a New Figuration: Mexican Art of the 1980s*, a US-based exhibition. This second show, curated by Teresa Eckmann, opened in the Instituto Cultural de México in San Antonio, Texas, in 2010. Note that the question of whether to hyphenate or not is as crucial as the question of thinking the movement in the singular or plural here.

24. I borrow this term from scholars of the LGBTQ Caribbean, including Manolo Guzmán (1997), Lawrence La Fountain-Stokes (2009), and Yolanda Martínez-San Miguel (2011). Inevitably, I reMex sexile's meaning here.

25. Monsiváis's interpretation predates 1980s and 1990s connections being made

between camp and kitsch in queer and other minority subcultures (even as it predates attempts to map or diagram intersections between queer and postcolonial/global ethnic studies).

26. *Enemigos I* reproduces a closely cropped still from Gabriel Figueroa's film *Enemigos* (1933).

27. I'd add that the page is subject to further reappropriation. Witness its incorporation into the catalogue *The Age of Discrepancies: Art and Visual Culture in Mexico 1968–1997* (Debroise 2007, 320). Witness, too, its function in my argument.

28. Joseph arrives at this argument also by reading an advertisement, a 2007 marketing campaign by the *Times of India* that contrasts the global aspirations of the new India with the state's previous longings for modernization, now coded as "traditional."

29. I am aware of the Latinx cultural studies scholar Ramón García's critique of the apolitics of Ybarra-Frausto's thesis (García, in Chabram-Dernersesian 2006), but I disagree with the conclusions he draws.

30. The Mexican artist Rubén Ortiz Torres punningly Anglicizes this neologism when he titles one of his retrospectives *Desmotherismo* (1998).

CITY

1. El Mago Melchor served as an artist's model for José Clemente Orozco and David Alfaro Siqueiros, among others.

2. Indisputably, there is a level of auto-exoticization characteristic of indigenismos, a variation on what I termed Mexican anthropological nationalism in Bustamante's provocative genealogy.

3. The glove in Mexico's 1968 morphed into a political accessory for both the Right and the Left. In the 1968 Olympic Games' award ceremony for the men's 200-meter race, African American athletes Tommie Smith and John Carlos accepted their gold and bronze medals on behalf of the United States with unforgettable Black Power salutes. In a transnational imaginary, Smith's and Carlos's black-gloved fists, synechdochical of the US civil rights movement, meet the white-gloved fists of Mexican state-sponsored terrorism in signifying free fall.

4. This transpires despite Debroise and Medina's admission that they were "exasperated by the vague way the Grupos . . . were being invoked (when they were even remembered) as the sole antecedents for neo-conceptual practices in Mexico" (Debroise 2007, 26).

5. For example, post-2000 historical revisionists, themselves "savage detectives," add the novelist Roberto Bolaño's Infrarrealistas to Los Grupos' numbers (Debroise 2007, 214–215).

6. I am indebted to Mariana Botey for flagging an obvious discrepancy here. Many in Los Grupos were not college age when the Tlatelolco massacre occurred. Thus, a blanket argument that links these collectives to the 1968 student movement is implausible unless we take into account what the cultural critic Marianne Hirsch (1997) terms the "postmemories" of the children of Holocaust survivors.

7. Art historians roughly date the height of geometric abstraction to the years

1948 through 1988 and associate the movement or trend with South American artistic luminaries like the Uruguayan Joaquín Torres-García and the Brazilians Lygia Clark and Hélio Oiticica.

8. September 16 is the national holiday that marks Mexico's postcolonial status following its break from the Spanish and French. A reenactment of "El Grito de Dolores" initiates the holiday's celebrations each year.

9. In 1983, one of Asco's No-Movie stills, "Chicano Cinema," was featured as "part of a conference and exhibition on the US-Mexico border at the Center for Third World Economic and Social Studies in Mexico City" (Noriega 2000, 198). It's tempting to imagine No-Grupo's members chancing upon their contemporaries' complementary prefixation with "No-." In 2011, Bustamante published an essay in the catalogue for Asco's first retrospective in the Los Angeles Museum of Contemporary Art in which she tracks "synchronies between Asco and No-Grupo." *Memorias del primer coloquio latinoamericano sobre arte no-objetual y arte urbano* (Memories of the First Latin American Colloquium about No-Objectual and Urban Art) appeared in print thirty years after the colloquium took place in Medellín, Colombia. Juliana Restrepo T., the acting director of Medellín's Museum of Modern Art, describes the compilation as "the fulfillment of a debt owed to history" (Sierra Maya, Enrique, and del Valle 2011, 10). No-Grupo, Ehrenberg, and Lourdes Grobet represented Mexico at the event.

10. No-Grupo rejected the label of "collective," declaring: "We are not a forced and fraudulent collectivism which frees responsibility in confortable [sic] anonymity. The No-Grupo is a workshop of critique, of attitudes, and positions" (Jauregui 2011, n.p.).

11. Lukács interprets Benjamin's argument allegorically to note its temporal layers, claiming that Benjamin's ongoing attentions to the allegorical represent his attempts to address new regimes of symbolic practice on a par with the emergence of high capitalism.

12. No son of (Robert) Smithson, but nevertheless indebted to his theory and practice, Smith relocated to Mexico City in 1989. In 2011, she represented Mexico in the Venice Biennale. Before that, with Francis Alÿs, she ran Mel's Café. In collaboration with Rafael Ortega, she also created the film component of *Spiral City/Ciudad Espiral* (2002), aerial images of Mexico City in clear homage to both the DF and Smithson's *Spiral Jetty*.

13. Mario Fortino Alfonso Moreno Reyes (1911–1993), known as Cantinflas, was a comic film actor, producer, and screenwriter, who often portrayed poor and working-class Mexicans. In his faux Nobel Prize acceptance speech, Herrera refers to his own "cantinflesca" tradition (Herrera, quoted in Henaro 2008–2009, 129).

14. Daniel Guzmán and Luis Felipe Ortega's "remakes" (1995) of performances by the US artists Bruce Nauman, Vito Acconci, and Paul McCarthy were motivated less by a desire to recapture an elusive artwork or to generate a parody of it, and more by the artists' need to insert "Otherworldly" actions into a closed (symbolic) economy.

15. Consider Abaroa's (1999) unpublished undergraduate thesis on Los Grupos, "Bitácora artística."

16. This marketing slogan enjoyed considerable purchase in Mexican performance communities. As Dulce de Alvarado (2000b, 59) notes, Luis Carlos Gómez went so far as to assume the name of D. J. Chrysler in his performances in both the art and music worlds.

17. Monsiváis argued that lucha libre was more capable of standing in for mexicanidad than any other late-twentieth-century cultural practice.

18. For accounts of the earthquake's effects on civil society, see Poniatowska (1988) and Monsiváis (2005).

19. Note that these lessons, like Bustamante's taco patent, recognize a relationship between food and Empire.

20. In separate conversations, the artists Pilar Villela (2001b), *Pinto mi Raya* (2011), Yoshua Okón (2011), and Rubén Ortiz Torres (2010) expanded on this narrative, describing the limited access to both mass culture and art materials that they experienced while living in Mexico City between 1968 and the late 1980s. Lorena Wolffer emphasized that the Mexican government imposed restrictions on public gatherings in this period, such as concerts in the Zócalo (2015b).

21. Intent upon selling the book, Ehrenberg recognizes the power of self-marketing, too. When I contacted him to request an interview, he agreed with the stipulation that this manual would be my required reading prior to our conversation (2001). Ehrenberg, who began his career in Los Grupos (Grupo Suma), was exiled from Mexico post-Tlatelolco. He sought asylum in England, where he joined Fluxus. For a comprehensive evaluation of Ehrenberg's contributions to Mexican art, see *Felipe Ehrenberg: Manchuria visión periférica (Manchuria Peripheral Vision)* (Llanos and Hellion 2007).

22. Montero (2013), drawing heavily on Mayer, contends that a collapsed CONACULTA/FONCA was Mexico's leading benefactor of arte no-objetual until the early 2000s.

23. Eloy Tarisico is often credited with spearheading the effort to establish Ex Teresa. He served as the museum's first director.

24. Mayer catalogues this phenomenon in *Escandalario: Los artistas y la distribución del arte* (2006).

25. *The Red Specter* and *El Espectro Rojo* take their names from a figure in Karl Marx's *Eighteenth Brumaire of Louis Bonaparte* (1852). *The Red Specter* and *El Espectro Rojo* appeared one year and six months apart in English and Spanish. The English version is labeled "Year 1" (Madrid, May 2010); the Spanish, "Año 2" (Ciudad de México, Diciembre 2011). They contain similar materials, but in part due to copyright restrictions, they do not have identical contents (Medina 2015b).

26. The postcolonial theorist David Lloyd (1999, 90) argues that there is a "conjunction of nationalist and religious artifacts as domestic objects" that are interpreted in twentieth-century cultural production through the lens of kitsch. The anthropologist Michael Taussig (1997, 94) claims that "kitsch [becomes] an appropriate aesthetic for the magic of the state."

27. I once asked Razo how many pyramids he had made in total. His reply was illuminating, "I have no idea . . . I think it was a period when art production was way less professional (and I miss that)" (Razo 2013).

28. I borrow "art incorporated" from Stallabrass (2004, 108–109), who sparingly references the case of Mexico. Because Razo's *NAFTA Spanish-English Dictionary* precedes the Mexican "reader" Hugo García Manríquez's (2015) systematic yet mercurial Spanish-English grayscaling of NAFTA, *A-H Anti-Humboldt: A Reading of the North American Free Trade Agreement*, by over a decade, it suggests other genealogies of conceptual poetry in Mexico than those espoused in the 2010s. It also precedes Razo's self-identified conceptual poetry actions, his various "Jornadas de Poesía Administrativa." Razo invited me to participate in the third instantiation of those convocations. I used the gathering to officiate Mayer, Lerma, Razo, and Yoshua Okón's signing of image release forms for this book. Imagine that gesture as conceptual writing, too.

29. See somamexico.org/seccion/acerca-de-soma-about-soma/, accessed February 12, 2012. Since its impetus, I have spent at least a week each year participating as a scholar/artist-in-residence in SOMA's Summer School, coordinated by the Mexican artist-critic Carla Herrera-Prats.

30. This title also alludes to "Chac Mool," a short story by Carlos Fuentes that treats the Mesoamerican sculptural form of that same name.

31. I take responsibility for this reading of the piece despite Okón's insistence that my preoccupation with class overlooks everyday reactions to the Xoloitzcuintli's appearance. Okón emphasizes that the "average Mexican" is overwhelmed by the breed's "ugliness." He links this reaction to his own constant preoccupation with questions of taste and aesthetic judgment (2012). I remain unconvinced that my account and Okón's "ugly feelings" are mutually exclusive.

32. This piece also rehearses a Latin American fascination with National Socialism and the figure of the Nazi.

33. Cuevas describes herself on her 1990s c.v. as an "artist, activist, and subway user." I fancy Herrera's 1980s calling card, a facsimile of a metro ticket emblazoned with his name, as one of her tickets to this biosketch.

34. This title also carries the echo of neomexicanismo's unrealized autodenomination ("mevalismo") as if to tide the latter's damn.

35. *Donald McRonald* joins works by greater Mexican artists Ximena Cuevas, Miguel Calderón, and Nao Bustamante that touch upon the marketing strategies of the Golden Arches in the Americas and tap into alter-globalization's robust critiques of "the McDonaldization of society" (Ritzer 1993). The action flips the script of narratives of the decimation of national patrimony, similar to Maris Bustamante's *La patente del taco*.

36. Alÿs claims, "[T]he flâneur is a very nineteenth-century European figure. It goes with a kind of romanticism which does not have much space in a city like Mexico City" (Ferguson 2007, 65). We, of course, could counter this declaration with a recollection of the literary games of the Contemporáneos and the Estridentistas.

37. While Alÿs has sold some of his pieces for as much as $600,000 dollars (albeit to himself), he and Ortega make their videos of actions freely available on francisalys.com.

38. Alÿs pointedly describes his actions as "paseos," the Spanish word for walks

or strolls, rather than as Situationist *"dérives."* *Paradox of Praxis 1* is often paired with *Ambulantes* (*Pushing and Pulling*), a series of images, predominantly of street vendors, that Alÿs took between 1992 and 2002 in Mexico.

39. The date is significant because it is illegal in Mexico for campaign posters to be visible on Election Day.

40. In 2006, Alÿs again responded to the Mexican presidential elections with artwork. In *Untitled (Bandera)* (2006), Alÿs walks, carrying a Mexican flag on a pole over his shoulder. Knotted in the middle, the flag drags on the ground, attracting several dogs that follow the artist in another modern procession.

41. The black sheep, at last! An epigraph included in the catalogue for *When Faith Moves Mountains* clarifies that the project takes its name from the Central American writer Augusto Monterroso's "La fe y las montañas" (Faith and Mountains), included in *La oveja negra y demás fábulas* (1969).

42. Medina also plays Rivera in the US filmmaker-critic Jesse Lerner's *Magnavoz* (2006), based on the Estridentista poet Xavier Icazal's 1926 essay "Magnavox." *Magnavoz* includes Gurrola, reading Icazal's text. And Mayer wrote and directed another interpretation of Debroise's film, *One More Dinner . . . or a Banquet in TelapaMUCA* (2011), which features Medina, among others. Mayer created the film to accompany an exhibition she curated in the MUAC that mined Debroise's papers and ephemera, *Una visita al archivo Olivier Debroise: Entre la ficción y el documento* (2011). Mayer's linked projects to my mind lay the groundwork for the amplification of "undocumentation" in the "Border" section of this book.

43. Sierra, quoted in gallery literature, 2000.

44. See teamgal.com/exhibitions/179/los_penetrados, accessed April 15, 2016.

45. Calderón's performance also recalls the DF-based artist Pedro Reyes's action *Palas por pistolas* (*Shovels for Pistols*, 2008). In Culiacán, Reyes collected and melted down 1,527 weapons. With the resulting metal, he produced 1,527 shovels, which he distributed for free in schools.

46. According to Debroise, the Mexican artist Alejandro Montoya, who worked with animal and human corpses in the 1980s, influenced Margolles's and SEMEFO's corpora. Debroise (2007, 346) notes that Margolles was Montoya's assistant on several of his early installations.

47. See the facetiously titled artwork *Homenaje a los 400 españoles caídos en la Conquista* (*Homage to the 400 Spaniards Fallen during the Conquest*, 1992), which included a skinned horse's head.

48. See, for instance, David (2011).

49. Giorgio Agamben (2005, 55) contends that Benjamin's "description of the baroque sovereign in the *Trauerspielbuch* can be read as a response to Schmitt's theory of sovereignty," where Benjamin's re-vision of Schmitt's concept of sovereign power hinges on the question of "sovereign indecision," insofar as "the baroque sovereign is constitutively incapable of deciding." For Agamben, such a move signals the ways in which, for Benjamin, "the state of exception is no longer the miracle, as in [Schmitt's] *Political Theology*, but the catastrophe" (56) whereby the baroque becomes restoration's antithesis and "a theory of the state of exception is devised" (Benjamin, quoted in ibid.). While Agamben's agenda is

not the aesthetic per se, the sympathies his argument harbors for the aesthetic enable him to locate Benjamin's "baroque sovereign" as tied up with the performative force of the speech act in the public sphere of the letter of the Law itself aestheticized.

50. Margolles's 2004 show *Muerte sin fin* borrows its title from a collection of poetry by the Contemporáneo José Gorostiza, *Muerte sin fin* (1996). I repurpose that title once again.

51. The following translations from Spanish to English were provided on a gallery handout:

> There are four days to complete the month of May and the number of intentional homicides is the highest in decades. There have been 106 killings in Sinaloa. [. . .] Most cases, involving fatal gun shots, have occurred in the state capital.
>
> EL DEBATE NEWSPAPER (CULIACÁN, SINALOA, MEXICO), MAY 28, 2008

> Within eighteen months of management under Felipe Calderón Hinojosa, there have been 4,400 execution-style killings committed: 2,794 from January to December 2007, 1,250 from the first of January to May 20th of this year.
>
> LA JORNADA (MEXICO CITY), MAY 22, 2008

> Every minute, a gun enters Mexico illegally. That is, at least two thousand weapons a day. Sixty percent of the illegal weapons circulating in national territory come from the United States. At twelve thousand checkpoints along the border, weapons are bought and sold without restrictions.
>
> ONCE NOTICIAS (CHANNEL 11, MEXICO CITY), JULY 19, 2007

52. In fact, J. L. Austin observes that the technical term "operative," "as it is used strictly by lawyers in referring to that part, i.e., those clauses, of an instrument which serves to effect the transaction (conveyance or what not) which is its main object, whereas the rest of the document merely 'recites' the circumstances in which the transaction is to be effected" comes closest to what he refers to as a performative (1962, 7).

53. Consider the Sunday, September 19, 2010, headline of Ciudad Juárez's *El Diario*, following the shooting of two of the newspaper's reporters: "¿Qué quieren de nosotros?" (What do you want from us?). The editorial, written by *El Diario*'s producers, continues defiantly, "This is not a surrender." Still, its authors query, "What information do you want us to disclose?" Consider that between 2006 and 2011, the United States Bureau of Alcohol, Tobacco, Firearms, and Explosives (ATF) ran a parallel set of "gunwalking" sting operations. The ATF Arizona Field Office enlisted licensed gun dealers to sell weapons illegally to Mexican nationals and straw buyers in the hopes of tracking the firearms to drug cartels. The most famous of these was "Fast and Furious," named after the Hollywood action film franchise.

WOMAN

1. While not naming Woman as an allegorical figuration, a plethora of psychoanalytic, feminist, queer, and postcolonial cultural criticism, at a remove from the specificity of the greater Mexican context, directly addresses symbolic Woman's status as a go-between, connector, bridge, and hinge (see, for instance, Lévi-Strauss 1969; Rubin 1975, 1994; Irigaray 1981; Lacan 1982; Deleuze and Guattari 1983, 1986; Sedgwick 1985; Anzaldúa 1987; Perlongher 1991).

2. I reference here an opposition between performance art and cabaret performance that the performance studies scholar Laura G. Gutiérrez beautifully circumvents in *Performing* Mexicanidad: Vendidas y Cabareteras *on the Transnational Stage* (2010).

3. Tlacuilas y Retrateras included Mayer, Ana Victoria Jiménez, Karen Cordero Reiman, Nicola Coleby, Patricia Torres, Elizabeth Valenzuela, Lorena Loaiza, and Ruth Albores (Mayer 2016, 18).

4. The audience's participation neither waxed nor waned: nine months after *Madre por un día*, a viewer phoned in to *Nuestro Mundo* with the question, "Did Ochoa give birth to a boy or a girl?" (Mayer 2004, 41). Of course, this question also betrays viewers' continued investments in gender binaries.

5. Obliquely, one could take an interpretative leap of faith, imagining Mayer and Bustamante's performance as enabling subsequent pop cultural interventions, such as Felipe and Rodríguez's February 14, 2001, nationally televised wedding. But this, of course, would overlook the important televisual contributions of other Mexican women, for example, those of the poet, playwright, and lesbian activist Nancy Cárdenas in the 1970s.

6. *Soy totalmente de hierro* received a great deal of press coverage, both positive and negative. Misinformed criticism leveled against the project assumed the model to be Wolffer, collapsing the "I" of the billboards into the "I" of their creator.

7. Tirado has confounded her critics, myself included, by alternating between two titles for this series: *Los nichos públicos/The Public Niches* and *Los nichos púbicos/The Pubic Niches*. When I asked Tirado about this mirroring effect, she replied, "Sometimes I call it the first title, sometimes the second, sometimes both, really it can't be one without the other" (2014).

8. Note that the trace of Tirado's day job—at the time of these pieces' creation she earned a living as a piercing and tattoo artist—informs both her photographs and her actions.

9. Viewers who doubt Bustamante's engagement with *mexicanidad*, need only turn to the artist's 2015 project *Soldadera (Female Soldier)*. "Soldadera" refers to the women who accompanied men on long marches and train rides during the Mexican Revolution. These "help-meets" cooked and cared for the soldiers, sometimes fighting alongside their male counterparts. Inter/national photography and popular music from the period documents the iconic figure of the "Adelita," as the "soldaderas" came to be called. In 2010, Bustamante began to investigate the role of Mexican women in the revolution. Bustamante's research led her to various archives in the United States, including the Benson Collection at the University of Texas at Austin. In Mexico, the artist interviewed Leandra Becerra Lumbreras, born the

same year that Queen Victoria celebrated her Golden Jubilee, 1887. Bustamante's retrospective *Nao Bustamante: Soldadera* includes documentation of her conversation with Becerra Lumbreras, at that time the oldest living person in the world. The show also includes footage of Bustamante's short enactment of an unrealized sequence of Eisenstein's *¡Que Viva México!* If Debroise staged via a "conversation piece" the circumstances of the filming of Eisenstein's project in *Un banquete en Tetlapayac*, noting the importance of women's documentation of Eisenstein's efforts for the reconstruction of the event, Bustamante attends to the soldadera's absent present in the Russian filmmaker's montage. Bustamante, like Astrid Hadad, also suggests that the spirit of her race speaks through her clothing (2012). A final significant component of *Nao Bustamante: Soldadera* includes lemon yellow Kevlar dresses that the artist created in collaboration with the costume designer Sybil Moseley. Fit for Hadad, the outfits, fashion-consciousness raising battle armor, once again draw attention to the parallel gestures of accessorization and historicization. In an action that carries the trace of Chris Burden's *Shoot*, itself created in response to Vietnam, another heavily multimediated war, Bustamante took pot shots at the garments. Bullets remain embedded in the bodice of one of the Edwardian dresses. The artist's single image documentation finally brings to mind Kahlo's iconic painting *My Dress Hangs There* (1933), metaphorically keying both Bustamante's and the *soldaderas*' border-crossing vulnerability and fortitude under fire.

BORDER

1. Founded in 1848, San Diego grew rapidly after 1880 in large measure due to the establishment and development of multiple military facilities in Southern California. Its especially pronounced growth during and after World War II had to do with the United States' focus on its Pacific theaters of war. In 1950, census reports attributed to Tijuana a population of roughly 60,000. By 2010, the city's population would clock in at 1,300,983.

2. My discussion here is enriched by the (2014) insights of Daniel Wasil, an artist and cofounder of Installation Gallery in San Diego.

3. According to Hilliard Harper of the *Los Angeles Times*, three sources of funding paid for the project: COMBO, a private arts funding agency ($4,600); Art Matters, based in New York City ($4,500); and the artists' personal funds resulting from the sale of their artwork to the La Jolla Museum of Contemporary Art ($2,500). The COMBO funds included "a National Endowment for the Arts grant matched two-to-one by money from the City of San Diego" (1988).

4. My discussion of the significance of the Bracero Program to Mexico's modern agenda and the intersection of that agenda with the United States' learns from Cohen (2011) and Schmidt Camacho (2008).

5. I reference the historian Michelle Alexander's *The New Jim Crow: Mass Incarceration in the Age of Color Blindness* (2012) to make an argument potentially connected to hers about racial continental divisions of labor.

6. According to the historian Kelly Lytle Hernández (2010, 6), the Border Patrol's

rise took shape within "a cross-border context of migration control," too, and evolved as "a very specific site of racial inequity" (9).

7. In the context of Arizona/Sonora, the historian Geraldo Cadava (2013) links PRONAF to the rise of the US Sunbelt.

8. For more on the connection between Puerto Rican and Mexico-US border industrialization, see Chomsky (2008, 115–116).

9. On a related note, the 1965 act included a provision barring LGBTQ-identified immigrants. The restriction remained in place until 1990.

10. For more on Northern Mexican border arts funding and the 1980s continued construction of Mexico's North as chaotic, denationalized, and culturally arid, see Zúñiga (1997) and Ochoa Tinoco (2009).

11. See libraries.ucsd.edu/speccoll/findingaids/mss0490.html. Many thanks to Curtis Marez for pointing me in the direction of this project.

12. According to Chavoya, Sisco claimed the middle image of handcuffed hands on the bus poster as "symbolic redress." She surreptitiously had snapped the image during an INS raid, hence, her assessment that "the poster places individuals removed in INS raids from city buses back on them" (Chavoya, in Chabram-Dernersesian 2006, 139).

13. My argument here has been buoyed by the conversations and correspondence that I have had with Avalos. Avalos details 1977 CCR actions organized against the KKK's patrolling of the San Diego–Tijuana border. According to the artist, the African American community actively supported CCR's efforts. In 1987, Avalos wrote the following for an exhibition at the Robert Else Gallery, which sponsored a solo exhibition of his work:

> In 1986, the situation of being both within and outside US society is exemplified by the undocumented worker. The social reality parallels that of the antebellum South. Black slaves were an integral part of plantation society, yet were kept out of social institutions through slavery laws. So, too, the Mexican laborer is an indispensable part of the economic vitality of the "sun belt" states, yet is kept out of all social institutions by US immigration law. (Avalos 2014b)

Finally, Avalos recalls that in 1987 Herman Baca referred to National City as a plantation in a written response to the passage of the Simpson-Mazzoli bill (Immigration Reform and Control Act of 1986).

14. For an overview of Lou's work, see Latorre (2012).

15. Ila Sheren (2011, 82) claims, "Avalos originally had planned to bring established Chicano artists together to do a show about the US-Mexico border, but he was deterred by the more commercial direction that mainstream Chicano art had taken by that point [1984]."

16. Active between 1988 and 1992, Las Comadres included Anna O'Cain, Carmela Castrejón, Maria Eraña, Lynn Susholtz, Emily Hicks, Cindy Zimmerman, Berta Jottar, Maria Kristina Dybbro-Aguirre, Kirsten Aaboe, Graciela Ovejero, Eloísa de León, Laura Esparza, Rocío Weiss, Frances Charteris, Yareli Arizmendi, Marguerite

Waller, Aida Mancillas, and Ruth Wallen, and was not itself without its own interpersonal tensions (Berelowitz 1998).

17. Gómez-Peña did not come up with the title of this essay, although he suffered the wrath of its reception. Steve Durland, one of the editors of *High Performance*, evidently named the piece (Gómez-Peña 2000).

18. Similarly, Fox (1999, 130) observes regarding Roger Rouse's ethnographic reading practices, "His [Gómez-Peña's] descriptions of 'border consciousness,' for example, appear repeatedly in an article by anthropologist Roger Rouse about a transborder migration circuit of undocumented workers between Aguililla, Mexico, and Redwood City, California, but at no point in the article does Rouse quote his informants regarding their lifestyle and consciousness."

19. The enactment sets Gómez-Peña apart from other figures like Roberto Bolaño, who also clearly inherited Paz's and Ramos's psychoanalytic and ethnographic inclinations. Bolaño's "infrarrealists," the protagonists of *Savage Detectives*, and the constituencies of the literal group to which the novelist belonged set out to debunk and discredit Paz's poetics.

20. Regarding intellectual unease with the working class and cultural slumming, Gómez-Peña notes of his own formation,

> Once in university, at the Facultad de Filosofía y Letras, I underwent a fanatical conversion to Marxism, but the ultra-nationalistic brand. I became intolerant of anything not Mexican or not working class. I only consumed national food, literature, music, philosophy, and political thought. I joined the already agonizing student movement and broke with my social class. (1991a, 24)

21. Gómez-Peña situates *The Broken Line/La línea quebrada* in the tradition of the 1960s Mexico City–based magazine *El Cuerno Emplumado/The Plumed Horn*, published by Margaret Randall and Sergio Mondragón. Gómez-Peña (1991b, 36) also notes that the magazine had a contemporaneous DF twin, *La Regla Rota (The Broken Rule)*, published by Rogelio Villarreal and Mongo.

22. The artist's debts to the poet Jerome Rothenberg and the artists Eleanor and David Antin, all UCSD faculty members, are apparent, too. "Border Brujo," a composite of various allegorical figurations, also signposts the poetic milieu of San Diego (home to such spoken-word phenomena as the Taco Shop Poets).

23. A neologism, La Pocha Nostra re-sites the word "pocha," a derogatory term for an individual of Mexican descent who does not speak Spanish or necessarily identify as Mexican, and the word "Nostra" from "La Cosa Nostra," the Italian mafia. The combined name suggests "a cartel of cultural traitors." La Pocha Nostra includes or has included Juan Ybarra, the collective EDEMA, Violeta Luna, Carmel Kooros, Nao Bustamante, Michelle Ceballos, Isis Rodríguez, and Sara Shelton-Mann, among others.

24. The chronology I offer emerges out of my research in the inSITE archives in the Special Collections and Archives at the University of California, San Diego Library from March to December 2010. It also reflects my biases as a witness. I attended two inSITE Exploration Weekends in 2001 and 2005.

25. The nickname stems from the artist's last name, the pronunciation of Ramírez's *R* in Spanish.

26. This metaphor is perpetuated in La Pocha Nostra's description of their work as that of "a virtual maquila, a conceptual assembly plant that produces brand-new metaphors, symbols, images, and words to articulate the complexities of our times" (La Pocha Nostra 2012). Note the collective's combined appropriation of narco-culture and the allegorical figuration of the Maquila here.

27. To clarify, "Nortec" refers to the activities of the Nortec collective, whereas "Nor-tec" refers to the underlying aesthetic associated with sampling in Tijuana circa 2000 (Madrid 2008, 5).

28. For more on Tijuana and tijuanense aesthetics, see Kun and Montezemolo (2012).

29. Artists, musicians, human rights advocates, and hacktivists conceived of Kein Mensch ist illegal following the murder of Aamir Ageeb by German Federal Police. Ageeb's death stood in for the treatment of all undocumented entrants at the German/Polish border. The festival included marches, talks, concerts, and workshops. Heralded as a turning point in the politics and aesthetics of documenta, documenta X represented the first time that the "museum of 100 days" had been curated by a woman—Catherine David.

30. For example, in *The Department of Marine Animal Identification of the City of New York (Chinatown Division)* (1992), Dion gathered specimens of marine life in New York City's Chinatown fish markets; identified, labeled, and preserved the specimens in glass jars filled with alcohol; and then displayed those jars in the gallery space of American Fine Arts, Co. Or, in *The Great Munich Bug Hunt* (1993), Dion, with a group of local German entomologists, installed a dead tree from the Black Forest in an art gallery. The team then extracted, identified, and preserved invertebrates living in the tree, presenting the process as a series of performances.

31. If there ever really was a question as to whether *Blind/Hide* was simply about the Tijuana River Estuary Basin, consider the following: in 2002, the birding unit became Mark Dion's Urban *Wildlife Observation Unit*, sited near the southwest entrance of New York City's Madison Square Park. The unit spawned the artist's *Field Guide to the Wildlife of Madison Square Park*, in which Dion again explores the smudged lines between natural and built environments (2002).

32. Deeply problematic from a disability studies perspective, this component of the action was envisioned by Téllez as contributing to the overall spectacle at hand.

33. It might come as a surprise to some readers to learn that Melanie Smith proposed a conceptually similar project for inSITE97, which was not approved. Smith hoped to hire a stuntman to jump the border on a dirt bike. Because of limited funds, she instead proposed and executed *The Tourists' Guide to San Diego and Tijuana*, which resembled *Blind/Hide* and inSITE's own information booths.

34. The selection I consider harbors affinities with work included in *Cine Mexperimental/Mexperimental Cinema: 60 Years of Avant-Garde Media Arts from Mexico* (González and Lerner 1998), although my compendium is border-specific and varied in its allegiance to the experimental. It also follows the logic of a film

program by the same name, *Undocumentaries*, sponsored by New York University's Center for Latin American and Caribbean Studies.

35. Read through the prism of Rosler and Sekula's shared interest in avant-garde movements like German New Objectivity, the disembodied hands of *Welcome to America's Finest* and *Tijuana Projection* are invested with additional significance.

36. Avalos included *Southern California* in *Border Realities*. More recently, the project has formed a part of one exhibit of the Getty's *Pacific Standard Time* initiative (2011).

37. Lerner should know, especially as hybrid fiction-documentary film relates to Mexico. He has produced such 16mm films as *Natives* (1991, 25 min.) with Scott Sterling, which follows participants in San Diego's anti-immigration movement; *Frontierland/Frontierlandia* (1995, 77 min.) with Rubén Ortiz-Torres, which features several artists, including Gómez-Peña; and *Magnavoz* (2006), which I referenced in "City."

38. If anyone doubts Rivera's designs on participating in the re/definition of Latinx art, consider his Facebook exchange with the art critic Philip Kennicott that the pair took to the pages of the *Washington Post* concerning the latter's review of the 2013 Smithsonian Museum of American Art exhibition *Our America: The Latino Presence in American Art*. Rivera challenged Kennicott's diagnosis: "a telling symptom of an insoluble problem: Latino art, today, is a meaningless category" (see Kennicott's "Art Review: 'Our America' at the Smithsonian," *Washington Post*, October 25, 2013). Their debate retreads the well-worn groove of the post-1980s culture wars.

39. *Señorita Extraviada* represented a locus of productive fantasy for *Maquilapolis*'s filmmakers, where to lend anecdotal credence to such a formulation, De La Torre and Funari confirmed that they had to scrap some of *Maquilapolis*'s footage because they had shot sequences so nearly identical to Portillo's that they risked accusations of visually replicating her project (Funari 2007). De la Torre and Funari imagined the films, deep in dialogue, as presenting two sides of globalization (De La Torre, 2007).

40. I modify Spivak's (1999, 287, 386) references to white men or white women saving brown women from brown men.

REFERENCES

Abaroa, Eduardo. 1999. "Bitácora artística: Aspectos y condiciones del arte joven contemporáneo de los noventa." Unpublished thesis for Universidad Nacional Autónoma de México, Escuela Nacional de Artes Plásticas.

———. 2012. Conversation with the author. Mexico City, July 25.

Abel, Elizabeth. 2010. *Signs of the Times: The Visual Politics of Jim Crow*. Berkeley: University of California Press.

Acevedo, Esther. 2000. "Entre la tradición alegórica y la narrativa factual." *Los pinceles de la historia: De la patria criolla a la nación mexicana 1750–1860*, edited by Rafael Tovar, et al., 114–131. Mexico City: Instituto Nacional de Bellas Artes.

Acha, Juan. 1979. *Arte y sociedad: Latinoamérica: El producto artístico y su estructura*. Mexico City: Fondo de Cultura Económica.

Adorno, Theodor. 1997 [1970]. *Aesthetic Theory*. Translated by Robert Hullot-Kentor. Minneapolis: University of Minnesota Press.

———. 1984. "The Essay as Form." Translated by Bob Hullot-Kentor and Frederic Will. *New German Critique*, no. 32, (Spring–Summer): 151–171.

Agamben, Giorgio. 1998. *Homo Sacer: Sovereign Power and Bare Life*. Translated by Daniel Heller Roazen. Stanford, CA: Stanford University Press.

———. 2005. *State of Exception*. Translated by Kevin Attell. Chicago: University of Chicago Press.

Ahmad, Aijaz. 1992. *In Theory: Classes, Nations, Literatures*. London: Verso.

Akerman, Chantal. 2002. *De l'autre côté/From the Other Side*. Brooklyn, NY: Icarus Films. DVD.

Alberro, Alexander, and Sabeth Buchmann, eds. 2006. *Art After Conceptual Art*. Cambridge, MA: MIT Press.

Alcalá, Rosa. 2010. *Undocumentaries*. Bristol, UK: Shearsman Books.

REFERENCES

Alexander, Michelle. 2012. *The New Jim Crow: Mass Incarceration in the Age of Colorblindness*. New York: The New Press.

Algara, Claudia. 2010. Conversation with the author. Tijuana, Mexico, October 26.

Almada, Natalia. 2001. *All Water Has a Perfect Memory*. New York: Women Make Movies. DVD.

———. 2005. *Al Otro Lado*. Brooklyn, NY: Altamura Films. DVD.

———. 2011. *El Velador: The Night Watchman*. Brooklyn, NY: Altamura Films. DVD.

Althusser, Louis. 1971. "Ideology and Ideological State Apparatus." In *Lenin and Philosophy and Other Essays*, 127–186. Translated from the French by Ben Brewster. New York: Monthly Review Press.

Alvarado Chaparro, Dulce María de. 2000a. Interview with the author. Mexico City: December 12.

———. 2000b. "Performance en México (historia y desarrollo)." Unpublished thesis. Microsoft Word file.

Alÿs, Francis. 2004. *Walking Distance from the Studio*. Wolfsburg, Germany: Hatje Cantz. Exhibition catalogue.

Alÿs, Francis, and Cuauhtémoc Medina, eds. 2005. *When Faith Moves Mountains/Cuando la fe mueve montañas*. Madrid: Turner. Exhibition catalogue.

Anderson, Benedict. 1991. *Imagined Communities: Reflections on the Origin and Spread of Nationalism*. 2nd ed. London: Verso.

Andreas, Peter. 2000. *Border Games: Policing the US-Mexico Divide*. Ithaca, NY: Cornell University Press.

Ankori, Gannit. 2001. "The Jewish Venus." In *Complex Identities: Jewish Consciousness and Modern Art*, edited by Matthew Baigell and Milly Heyd, 238–258. New Brunswick, NJ: Rutgers University Press.

Anzaldúa, Gloria. 1987. *Borderlands/La Frontera: The New Mestiza*. San Francisco: Aunt Lute Books.

Appadurai, Arjun. 1996. *Modernity at Large: Cultural Dimensions of Globalization*. Minneapolis: University of Minnesota Press.

Apter, Emily, and William Pietz, eds. 1993. *Fetishism as Cultural Discourse*. Ithaca, NY: Cornell University Press.

Arau, Sergio, and Yareli Arizmendi. 1997. *A Day Without a Mexican*. California: Arau-Arizmendi Productions. VHS.

Arce, Manuel Maples. 1921. "Actual No 1: Hoja de Vanguardia. Comprimido Estridentista." Museo Nacional de Arte, Mexico City.

Arias, Arturo, ed. 2001. *The Rigoberta Menchú Controversy*. Minneapolis: University of Minnesota Press.

Armstrong, Elizabeth, and Victor Zamudio-Taylor. 2000. *Ultra Baroque: Aspects of Post Latin American Art*. San Diego: San Diego Museum of Contemporary Art. Exhibition catalogue.

Arroyo, Chiara, ed. 2010. *Yoshua Okón*. Mexico City: Editorial Landucci.

Austin, J. L. 1962. *How to Do Things with Words*. Cambridge, MA: Harvard University Press.

Avalos, David. 2014a. Conversation with the author. La Jolla, CA, May 15.

———. 2014b. Correspondence with the author. June 3.

———. 2014c. Correspondence with the author. June 12.
———. 2014d. Correspondence with the author. June 23.
Babb, Sarah. 2001. *Managing Mexico: Economists from Nationalism to Neoliberalism*. Princeton, NJ: Princeton University Press.
Baddeley, Oriana. 1998. "Engendering New Worlds: Allegories of Rape and Reconciliation." In *The Visual Culture Reader*, edited by Nicholas Mirzoeff, 382–388. New York: Routledge.
Balderston, Daniel, and Donna J. Guy. 1997. *Sex and Sexuality in Latin America*. New York: New York University Press.
Barnett, Thomas P. M. 2004. *The Pentagon's New Map: War and Peace in the Twenty-first Century*. New York: The Berkley Publishing Group.
Barrera Herrera, Eduardo. 1995. "Apropiación y tutelaje de la frontera norte." *Puentelibre: Revista de Cultura* 4 (Spring): 13–17.
Barthes, Roland. 1981. *Camera Lucida: Reflections on Photography*. Translated by Richard Howard. New York: Hill and Wang.
Bartra, Roger. 1996 [1987]. *La jaula de la melancolía: Identidad y metamorfosis del mexicano*. Mexico City: Grijalbo.
Bataille, Georges. 1985. *Visions of Excess: Selected Writings, 1927–1939*. Translated by Allan Stoekl. Minneapolis: University of Minnesota Press.
Baum, Kelly. 2010. "Santiago Sierra: How to Do Things with Words." *Art Journal* 69, no. 4 (Winter): 6–13.
Beckman, Ericka. 2012. *Capital Fictions: The Literature of Latin America's Export Age*. Minneapolis: University of Minnesota Press.
Benjamin, Walter. 1968. *Illuminations*. Translated by H. Zohn. London: Cape.
———. 1978. *Reflections*. Translated by Edmund Jephcott. New York: Schocken Books.
———. 1996. *Selected Writings*, Vol. 1, 1913–1926. Edited by Marcus Bullock and Michael W. Jennings. Cambridge, MA: Harvard University Press.
———. 1998 [1928]. *The Origins of German Tragic Drama*. Translated by John Osborne. London: Verso.
———. 1999. *The Arcades Project*. Translated by Howard Eiland and Kevin McLaughlin. Cambridge, MA: Harvard University Press.
Berelowitz, Jo-Anne. 1997. "Conflict over 'Border Art': Whose Subject, Whose Border, Whose Show?" *Third Text* 40: 69–83.
———. 1998. "Las Comadres: A Feminist Collective Negotiates a New Paradigm for Women at the US/Mexico Border." *Genders* 28, accessed July 31, 2014. genders.org/g28/g28_lascomadres.html.
———. 2003. "Border Art since 1965." In Dear and Leclerc 2003, 143–182.
Bergson, Henri. 1914. *Laughter: An Essay on the Meaning of the Comic*. Translated by Cloudesley Brereton and Fred Rothwell. New York: Macmillan.
Berlant, Lauren. 2011. *Cruel Optimism*. Durham, NC: Duke University Press.
Beverley, John. 2004. *Testimonio: On the Politics of Truth*. Minneapolis: University of Minnesota Press.
———. 2011. *Latinamericanism after 9/11*. Durham, NC: Duke University Press.
Beverley, John, José Oviedo, and Michael Aronna, eds. 1995. *The Postmodernism Debate in Latin America*. Durham, NC: Duke University Press.

Beverley, John, and Marc Zimmerman. 1990. *Literature and Politics in the Central American Revolutions*. Austin: University of Texas Press.

Bey, Hakim. 1985. *T.A.Z.: The Temporary Autonomous Zone, Ontological Anarchy, Poetic Terrorism*. Brooklyn, NY: Autonomedia.

Bhabha, Homi K. 1994. *The Location of Culture*. London: Routledge.

Biemann, Ursula. 1999. *Performing the Border*. New York: Women Make Movies. VHS.

Bishop, Claire. 2004. "Antagonism and Relational Aesthetics." *October* 110 (Fall): 51–80.

———. 2006. "The Social Turn: Collaboration and Its Discontents." *Artforum International* 44, no. 6, 178–183.

———. 2009. *Double Agent*. London: Institute of Contemporary Arts.

———. 2012. *Artificial Hells: Participatory Art and the Politics of Spectatorship*. London: Verso.

Black, George. 1990. "Mexico's Past, as Edited for U.S. Display: A New Exhibit of Mexican History May Have as Much a Political as an Artistic Agenda." *Los Angeles Times*, October 9.

Bois, Yve-Alain, ed. 2009. *Gabriel Orozco*. Cambridge, MA: MIT Press.

Bolaño, Roberto. 1998. *Los detectives salvajes*. Barcelona: Editorial Anagrama.

———. 2004. *2666*. Barcelona: Editorial Anagrama.

Boltanski, Luc, and Eve Chiapello. 2005 [1999]. *The New Spirit of Capitalism*. Translated by Gregory Elliott. London: Verso.

Bolton, Richard, ed. 1992. *Culture Wars: Documents from the Recent Controversies in the Arts*. New York: New Press.

Bonfil Batalla, Guillermo. 1987. *México profundo: Una civilización negada*. Mexico City: Editorial Grijalbo.

Border Art Workshop/Taller de Arte Fronterizo (cited as BAW/TAF). 1988. *The Border Art Workshop (BAW/TAF) 1984–1989: A Documentation of 5 Years of Interdisciplinary Art Projects Dealing with US-Mexico Border Issues (a binational perspective) = Taller de Arte Fronterizo (BAW/TAF) 1984–1989: Documentación de 5 años de proyectos de arte interdisciplinario sobre asuntos de la frontera de Estados Unidos con México (una perspectiva binacional)*. San Diego, CA: Border Art Workshop/Taller de Arte Fronterizo.

Botey, Mariana. 2014a. Public lecture. Mexico City: SOMA, August 13.

———. 2014b. *Zonas de disturbio: Espectros del México indígena en la modernidad*. Mexico City: Siglo XXI Editores.

———. 2016. Conversation with the author. January 2.

Boullosa, Carmen, and Jesusa Rodríguez. 2000. "Los hijos de Freud (Pastorela inconsciente)." *Debate Feminista* 21: 301–318.

Bourriaud, Nicolas. 1998. *Relational Aesthetics*. Translated by Simon Pleasance and Fronza Woods. France: Les presses du réel.

———. 2009. *The Radicant*. Translated by James Gussen and Lili Porten. New York: Lukas and Sternberg.

Bowden, Charles. 1996. "While You Were Sleeping." *Harper's Magazine* 293, no. 1759 (December): 44–52.

———. 1998. *Juárez: The Laboratory of Our Future*. New York: Aperture.

Bowden, Charles, and Julian Cardona. 2008. *Exodus/Éxodo*. Austin: University of Texas Press.

Brady, Mary Pat. 2002. *Extinct Lands, Temporal Geographies: Chicana Literature and the Urgency of Space*. Durham, NC: Duke University Press.

———. 2008. "The Homoerotics of Immigration Control." *The Scholar and Feminist Online* 6, no. 3 (Summer): Part 2, accessed March 12, 2014. sfonline.barnard.edu/immigration/brady_01.htm.

Bronfen, Elisabeth. 1992. *Over Her Dead Body: Death, Femininity and the Aesthetic*. New York: Routledge.

Brown, Jonathan C. 1993. *Oil and Revolution in Mexico*. Berkeley: University of California Press.

Brown, Wendy. 1995. *States of Injury: Power and Freedom in Late Modernity*. Princeton, NJ: Princeton University Press.

Brünner, José Joaquín. 1998. *Globalización cultural y posmodernidad*. Santiago, Chile: Fondo de Cultura Económica.

Bryan-Wilson, Julia. 2012. "Dirty Commerce: Art Work and Sex Work since the 1970s." *differences: A Journal of Feminist Cultural Studies* 23, no. 2, 71–112.

Buchloh, Benjamin H. D. 1982. "Allegorical Procedures: Appropriation and Montage in Contemporary Art." *Art Forum* 21, no. 1 (September): 43–56.

———. 2000. *Neo-Avantgarde and Culture Industry: Essays on European and American Art from 1955 to 1975*. Cambridge, MA: MIT Press.

Buci-Glucksmann, Christine. 1994. *Baroque Reason: The Aesthetics of Modernity*. Translated by Patrick Camiller. London: SAGE Publications.

Buck-Morss, Susan. 1992. "Aesthetics and Anaesthetics: Walter Benjamin's Artwork Essay Reconsidered." *October* 62 (Autumn): 3–41.

Bulbo. 2010. *Tijuaneados anónimos: Una lágrima, una sonrisa*. Tijuana, MX: BulboTV.

Bürger, Peter. 1984. *Theory of the Avant-Garde*. Translated by Michael Shaw. Minneapolis: University of Minnesota Press.

Bustamante, Maris. 1998. "Árbol genealógico de las Formas PIAS." *Generación* 20 (October): 12–15.

———. 2001a. Interview with the author. Mexico City, March 27.

———. 2001b. Public presentation. Monterrey, Mexico, June 18.

———. 2008. "Conditions, Roads, and Genealogies of Mexican Conceptualisms, 1921–1993" in *Arte≠Vida: Actions by Artists of the Americas 1960-2000*, edited by Deborah Cullen. New York; El Museo del Barrio. 134–151.

———. 2009. "Grupo Polvo de Gallina Negra, 1983–1993." *Artes e Historia México*. Cultura.UNAM, March 3, accessed July 5, 2016. arts-history.mx/blog/index.php/component/k2/item/564-grupo-polvo-de-gallina-negra-1983–1993.

———. 2012. Interview with the author. Mexico City, July 26.

———. 2014. Conversation with the author. Mexico City, August 7.

———. N.d. "Los no-objetualismos en México 1963–1983: Veinte años de no-objetualismos en México." Unpublished manuscript, 1–23.

Butler, Judith. 1990. *Gender Trouble: Feminism and the Subversion of Identity*. New York: Routledge.

———. 1993. *Bodies That Matter: On the Discursive Limits of "Sex."* New York: Routledge.

———. 1997a. *Excitable Speech: A Politics of the Performative.* New York: Routledge.

———. 1997b. *The Psychic Life of Power: Theories in Subjection.* Stanford: Stanford University Press.

———. 2000. *Antigone's Claim: Kinship Between Life and Death.* New York: Columbia University Press.

Cadava, Geraldo L. 2013. *Standing on Common Ground: The Making of a Sunbelt Borderland.* Cambridge, MA: Harvard University Press.

Camnitzer, Luis. 2007. *Conceptualism in Latin American Art: Didactics of Liberation.* Austin: University of Texas Press.

Carroll, Amy Sara. 2010. "*Muerte sin fin*: Teresa Margolles's Gendered States of Exception." *The Drama Review (TDR)* 54, vol. 2 (T206), Summer: 103–125.

Castillo, Debra. 1998. *Easy Women: Sex and Gender in Modern Mexican Fiction.* Minneapolis: University of Minnesota Press.

Ceballos, Miguel Angel. 2003. "A través de cinco videoinstalaciones, Silvia Gruner propone huir a una atmósfera diferente." *El Universal*, September 20, accessed May 10, 2009. archivo.eluniversal.com.mx/cultura/30921.html.

Certeau, Michel de. 1984. *The Practice of Everyday Life.* Translated by Steven Rendall. Berkeley: University of California Press.

Chabram-Dernersesian, Angie, ed. 2006. *The Chicana/o Cultural Studies Reader.* New York and London: Routledge.

Chanan, Michael. 2007. *The Politics of Documentary.* London: British Film Institute.

Chavez MacGregor, Helena. 2015. Skype conversation with the author, August 4.

Chavoya, C. Ondine, and Rita Gonzalez, eds. 2011. *ASCO: Elite of the Obscure, A Retrospective, 1972–1987.* Germany: Hatje Cantz Verlag. Exhibition catalogue.

Chomsky, Aviva. 2008. *Linked Labor Histories: New England, Colombia, and the Making of a Global Working Class.* Durham, NC: Duke University Press.

Chomsky, Noam. 1994. *World Orders, Old and New.* New York: Columbia University Press.

Chow, Rey. 1991. *Woman and Chinese Modernity: The Politics of Reading between West and East.* Minneapolis: University of Minnesota Press.

Cockcroft, Eva. 1984. "The Story of Chicano Park." *Aztlán: A Journal of Chicano Studies* 15, no. 1 (Spring): 79–103.

Coffey, Mary K. 2010. "Banking on Folk Art: Banamex-Citigroup and Transnational Cultural Citizenship." *Bulletin of Latin American Research* 29, no. 3, 296–312.

———. 2012. *How a Revolutionary Art Became Official Culture: Murals, Museums, and the Mexican State.* Durham, NC: Duke University Press.

Cohen, Deborah. 2011. *Braceros: Migrant Citizens and Transnational Subjects in the Postwar United States and Mexico.* Chapel Hill: University of North Carolina Press.

Concheiro Bórquez, Elvira. 1996. *El gran acuerdo: Gobierno y empresarios en la modernización salinista.* Mexico City: Instituto de Investigaciones Económicas, Universidad Nacional Autónoma de México.

"Con los mensajes de Zedillo y Clinton, se inauguró inSITE97." 1997. *La Crónica*, September 28, 6.

Corrigan, Timothy. 2011. *The Essay Film: From Montaigne, After Marker*. Oxford: Oxford University Press.
Costantino, Roselyn. 1996. "Lo erótico, lo exótico y el taco: El reciclaje cultural en el arte y performance de Maris Bustamante." *Chasqui* 25, no. 2, 3–18.
Council of California Growers. 1959. *Why Braceros?* N.p.: Wilding-Butler Division of Wilding Inc. archive.org/details/WhyBrace1959.
Crimp, Douglas. 1993. *On the Museum's Ruins*. Cambridge, MA: MIT Press.
Cruz, Teddy. 2008. Interview with the author. San Diego, California, June 10.
———. N.d. "Political Equator." worldarchitects.com, accessed October 15, 2008, but site no longer exists. worldarchitects.com/index.php?seite=ca_profile_archi tekten_detail_us&system_ id=14396.
Cuevas, Minerva. 1999. Public presentation. Mexico City, July 20.
———. 2000. Interview with the author. Mexico City, December 11.
———. 2001. Interview with the author. Mexico City, May 23.
———. 2012. *Donald McRonald*. Mexico City: Alias Editorial.
Cypess, Sandra Messinger. 1991. *La Malinche in Mexican Literature: From History to Myth*. Austin: University of Texas Press.
Cypher, James M. 1993. "The Ideology of Economic Science in the Selling of NAFTA: The Political Economy of Elite Decision-Making." *Review of Radical Political Economics* 25, no. 4, 146–163.
———. 2001. "NAFTA's Lessons: From Economic Mythology to Current Realities." *Labor Studies Journal* 25, no. 5, 5–21.
Cypher, James M., and Raúl Delgado Wise. 2010. *Mexico's Economic Dilemma: The Developmental Failure of Neoliberalism*. Washington, DC: Rowman and Little.
David, Mariana, coordinator. 2011. *SEMEFO 1990–1999: De la morgue al museo/From the Morgue to the Museum*. Mexico City: Universidad Autónoma Metropolitana. Bilingual exhibition catalogue.
Davis, Diane E. 2014. "Competing Globalizations in Mexico City's Historic Centre." *Scapegoat Mexico DF/NAFTA* 6 (Winter/Spring): 155–165.
Davis, Mike, Jim Miller, and Kelly Mayhew. 2003. *Under the Perfect Sun: The San Diego Tourists Never See*. New York: The New Press.
Dear, Michael, and Gustavo Leclerc, eds. 2003. *Postborder City: Cultural Spaces of Bajalta California*. New York and London: Routledge.
Debord, Guy. 1994. *The Society of the Spectacle*. Translated by Donald Nicholson-Smith. New York: Zone Books.
Debroise, Olivier. 1987. "Un posmodernismo en México?" *México en el arte*, no. 16 (Spring): 56–68.
———. 1990. "Desde un México diferente." *La Jornada Semanal*, October 28, 25–32.
———. 2000. *Un banquete en Tetlapayac*. Mexico City: Incognito Films. DVD.
———. 2001a. "Dreaming on the Pyramid: Responses to Globalism in Mexican Visual Culture." *Discourse* 23, no. 2 (Spring): 44–60.
———. 2001b. "Mexican Art on Display." In *The Effects of the Nation: Mexican Art in an Age of Globalization*, edited by Carl Good and John V. Waldron, 20–36. Philadelphia, PA: Temple University Press.
———, ed. 2007. *La era de la discrepancia: Arte y cultura visual en México, 1968–1997/*

The Age of Discrepancies: Art and Visual Culture in Mexico, 1968–1997. Mexico City: Universidad Nacional Autónoma de México and Editorial Turner-México. Bilingual exhibition catalogue.

Deeley, Kate. 1994. "Location, Location, Location." *La Jolla Light*, September 22.

De La Torre, Sergio. 2006. "Maquilapolis: City of Factories." *POV-PBS*. October 10, accessed May 18, 2008. pbs.org/pov/pov2006/maquilapolis/behind_interview.html.

———. 2007. Interview with the author. San Diego, CA, February 25.

———. 2014. Correspondence with the author, August 30.

Deleuze, Gilles, and Félix Guattari. 1983. *Anti-Oedipus: Capitalism and Schizophrenia*. Translated by Robert Hurley, Mark Seem, and Helen R. Lane. Minneapolis: University of Minnesota Press.

———. 1986. *Kafka: Toward a Minor Literature*. Translated by Dana Polan. Minneapolis: University of Minnesota Press.

———. 1987. *A Thousand Plateaus: Capitalism and Schizophrenia*. Translated by Brian Massumi. Minneapolis: University of Minnesota Press.

———. 1994. *What Is Philosophy?* Translated by Hugh Tomlinson and Graham Burchell. New York: Columbia University Press.

De Man, Paul. 1979. *Allegories of Reading: Figural Language in Rousseau, Nietzsche, Rilke, and Proust*. New Haven, CT: Yale University Press.

Demos, T. J. 2013. *The Migrant Image: The Art and Politics of Documentary during Global Crisis*. Durham, NC: Duke University Press.

Denning, Michael. 1997. *The Cultural Front*. London: Verso.

Derrida, Jacques. 1984. "Signature, Event, Context." In *Margins of Philosophy*, translated by Alan Bass, 307–330. Chicago: University of Chicago Press.

———. 1995. *Archive Fever: A Freudian Impression*. Translated by Eric Prenowitz. Chicago: University of Chicago Press.

Diaz, Misael. 2014. "Marcos Ramírez ERRE on Oil, Soccer, and National Sovereignty." San Diego: KCET, accessed August 10, 2016. kcet.org/shows/artbound/marcos-ramirez-erre-on-oil-soccer-and-national-sovereignty.

Diego, Estrella de. 1998. "De la muerte, los demás y otras parábolas modernas." *Revista de Occidente*, no. 201, 47–60.

Dion, Mark. 1997. *Mark Dion*. London: Phaidon Press.

———, ed. 2002. *Field Guide to the Wildlife of Madison Square Park: Mark Dion's Urban Wildlife Observation Unit*. New York: A Project of the Public Art Fund.

———. 2011. Conversation with the author. Ann Arbor, MI, December 30.

Dolan, Jill. 2005. *Utopia in Performance: Finding Hope at the Theater*. Ann Arbor: University of Michigan Press.

Donovan, Jenny. 2006. Conversation with the author. San Diego, CA, October 10.

Dorfsman, Alex, and Yoshua Okón. 2005. *La Panadería, 1994–2002*. Mexico City: Editorial Turner de México.

Doyle, Jennifer. 2013. *Hold It Against Me: Difficulty and Emotion in Contemporary Art*. Durham, NC: Duke University Press.

Driver, Alice. 2013. "Representations of Feminicide in Ciudad Juárez in *Performing*

the Border: An Interview with Ursula Biemann." *Aztlán: A Journal of Chicano Studies* 38, no. 1 (Spring): 313–324.

Duggan, Lisa. 2003. *The Twilight of Equality? Neoliberalism, Cultural Politics, and the Attack on Democracy*. Boston: Beacon Press.

Duncan, Michael. 1995. "Straddling the Great Divide." *Art in America* 83, no. 4 (March): 51–53.

Dynamic Equilibrium: In Pursuit of Public Terrain. 2007. Edited by Sally Yard, Teddy Cruz, Olivier Debroise, and Steve Fagin. San Diego, CA: Installation Gallery.

Eckmann, Teresa. 2010. *Neo-Mexicanism: Mexican Figurative Painting and Patronage in the 1980s*. Albuquerque: University of New Mexico Press.

Eder, Rita. 1991. "El muralismo mexicano: Modernismo y modernidad." In *Modernidad y modernización en el arte mexicano, 1920–1960*. Mexico City: INBA/Museo Nacional de Arte, 67–81. Exhibition catalogue.

———, ed. 2014. *Desafío a la estabilidad: Procesos artísticos en México, 1952–1967/ Defying Stability: Artistic Processes in Mexico, 1952–1967*. Mexico City: Universidad Nacional Autónoma de México/Turner. Exhibition catalogue.

Ehrenberg, Felipe. 1994. "Review of InSITE." *La Reforma*, September 21.

———. 1997. "De instalaciones al aire y quimeras permanentes." *Artes de México* ("Serpiente Virreinal") 37: 8–9.

———. 2000. *El arte de vivir del arte: Manual para la autoadministración de artistas plástic@s*. Mexico City: CONACULTA/FONCA.

———. 2001. Interview with the author. Mexico City, March 30.

El Espectro Rojo 2.1. 2011. Exhibition publication for *Fetiches críticos: Residuos de la economía general*, curated by Mariana Botey, Helena Chávez MacGregor, and Cuauhtémoc Medina. Museo de la Ciudad de México, Mexico City: November 25, 2011–March 4, 2012.

Elhaik, Tarek. 2016. *The Incurable Image: Curating Post-Mexican Film and Media Arts*. Edinburgh: Edinburgh University Press.

Emmelhainz, Irmgard. 2015. "Some Thoughts on Art in Mexico from the 1990s and 2000s." *Seismopolite: Journal of Art and Politics* (April 30), accessed May 25, 2015. seismopolite.com/some-thoughts-on-art-in-mexico-from-the-1990s-and-2000s.

Emmelhainz, Irmgard, Jane Hutton, and Marcin Kedzior, eds. 2014. *Scapegoat: Mexico DF/NAFTA* 6 (Winter–Spring).

Escultura Social: A New Generation of Art from Mexico City. 2007. Curated by Julie Rodrigues Widholm. New Haven, CT: Yale University Press. Exhibition catalogue.

Espinosa, César, and Araceli Zúñiga. 2002. *La Perra Brava: Arte, crisis y políticas culturales*. Mexico City: Universidad Nacional Autónoma de México.

Evia, Gerardo. 2004. "La República de la Soja: Las alegorías de la globalización." First published in *La Insignia*, January 29, 2004, accessed August 12, 2016. agropecuaria.org/2004/01/la-republica-de-la-soja-las-alegorias-de-la-globalizacion/.

Expediente Bienal X: La historia documentada de un complot frustrado. 1977. Mexico City: Editorial Libro Acción Libre.

Fanon, Frantz. 1963. *The Wretched of the Earth*. Translated by Constance Farrington. New York: Grove Press.

"Felguérez dice que su generación no es de ruptura, sino de apertura universal." 2012. informador.com.mx. informador.com.mx/cultura/2012/362340/6/felguerez-dice-que-su-generacion-no-es-de-ruptura-sino-de-apertura-universal.htm. Last updated March 8, accessed February 1, 2014.

Ferguson, Roderick A. 2011. *The Reorder of Things: The University and Its Pedagogies of Minority Difference*. Minneapolis: University of Minnesota Press.

Ferguson, Russell. 2007. *Francis Alÿs: Politics of Rehearsal*. Los Angeles: Hammer Museum. Exhibition catalogue.

Fernández, Claudia, and Andrew Paxman. 2000. *El Tigre: Emilio Azcárraga y su imperio Televisa*. Mexico City: Grijalbo.

Fernández-Kelly, María Patricia. 1983. *For We Are Sold, I and My People: Women and Industry in Mexico's Frontier*. Albany: State University of New York Press.

Fisher, Jean. 2011. "Minerva Cuevas and the Art of Para-sitic Intervention." *Afterall: A Journal of Art, Context and Enquiry* 27 (Summer): 57–66.

Flaherty, George F. Forthcoming. "Consuming Desires: Beautification and Repatriation at Mexico's Northern Border." In *US/Mexico Border Spaces: Arts, Built Environments, and Landscapes*, edited by Katherine G. Morrissey, and John-Michael H. Warner, n.p. Tucson: University of Arizona Press.

Fletcher, Angus. 2006. "Allegory without Ideas." *boundary 2* 33, no. 1, 77–98.

———. 2012 [1964]. *Allegory: The Theory of a Symbolic Mode*. Princeton, NJ: Princeton University Press.

Foster, Hal, ed. 1983. *The Anti-Aesthetic: Essays on Postmodern Culture*. Port Townsend, WA: Bay Press.

———. 1996. *The Return of the Real: The Avant-Garde at the End of the Century*. Cambridge, MA: MIT Press.

Foucault, Michel. 2001. "Lives of Infamous Men." In *Power: Essential Works of Foucault, 1954–1984*, edited by James Faubion, 3:157–175. New York: Free Press.

———. 2008. *The Birth of Biopolitics: Lectures at the Collège de France 1978–1979*. Translated by Graham Burchell. New York: Picador.

Fox, Claire F. 1994. "The Portable Border: Site-Specificity, Art, and the US-Mexico Frontier." *Social Text* 41 (Winter): 61–82.

———. 1999. *The Fence and the River: Culture and Politics at the US-Mexico Border*. Minneapolis: University of Minnesota Press.

———. 2013. *Making Art Panamerican: Cultural Policy and the Cold War*. Minneapolis: University of Minnesota Press.

Franco, Jean. 1989. *Plotting Women: Gender and Representation in Mexico*. New York: Columbia University Press.

———. 1999. *Critical Passions: Selected Essays*. Edited by Mary Louise Pratt and Kathleen Newman. Durham, NC: Duke University Press.

Fregoso, Rosa Linda, and Cynthia Bejarano, eds. 2010. *Terrorizing Women: Feminicide in the Americas*. Durham, NC: Duke University Press.

Freire, Cristina, and Ana Longoni, organizers. 2009. *Conceitualismos do Sul/Sur*. São Paulo, Brazil: Annablume, 2009.

Frérot, Christine. 1990. *El mercado del arte en México, 1950–1976*. Mexico City: INBA.
Freud, Sigmund. 1962 [1930]. *Civilization and Its Discontents*. New York: W. W. Norton.
Fuguet, Alberto. 2009 [2001]. "Magical Neoliberalism." *Foreign Policy*. November 17, accessed August 1, 2016. foreignpolicy.com/2009/11/17/magical-neoliberalism/.
Fukuyama, Francis. 1992. *The End of History and the Last Man*. New York: The Free Press.
Funari, Vicky. 2007. Telephone interview with the author, March 20.
Funari, Vicky, and Sergio De La Torre. 2006. *Maquilapolis: City of Factories*. San Francisco, CA: California Newsreel. DVD.
Fusco, Coco. 1995. *English Is Broken Here: Notes on Cultural Fusion in the Americas*. New York: New Press.
———, ed. 2000. *Corpus Delecti: Performance Art of the Americas*. London: Routledge.
———. 2001. *The Bodies That Were Not Ours: And Other Writings*. London: Routledge.
Fusco, Coco, and Paula Heredia. 1993. *Couple in a Cage*. Chicago, IL: Video Data Bank. DVD.
Gabara, Esther. 2008. *Errant Modernism: The Ethos of Photography in Mexico and Brazil*. Durham, NC: Duke University Press.
Galindo, Carlos-Blas. 1994. "Grupo Semefo." *Arte en Colombia internacional* (October–December): 117.
Gallo, Rubén, ed. 2004a. *The Mexico City Reader*. Translated by Lorna Scott Fox and Rubén Gallo. Madison: University of Wisconsin Press.
———. 2004b. *New Tendencies in Mexican Art: The 1990s*. New York: Palgrave.
———. 2010. *Freud's Mexico: Into the Wilds of Psychoanalysis*. Cambridge, MA: MIT Press.
Gamboa Jr., Harry. 1998. *Urban Exile: Collected Writings of Harry Gamboa Jr*. Edited by Chon A. Noriega. Minneapolis: University of Minnesota Press.
Gámez, Rubén. 1965. *La fórmula secreta: Coca-Cola en las venas*. Mexico City. Film.
García Canclini, Néstor. 1990. *Culturas híbridas: Estrategias para entrar y salir de la modernidad*. Mexico City: Grijalbo.
———. 1991. *Hybrid Cultures: Strategies for Entering and Leaving Modernity*. Translated by Christopher L. Chiappari and Silvia L. López. Minneapolis: University of Minnesota Press.
———. 1995. *Consumidores y ciudadanos: Conflictos multiculturales de la globalización*. Mexico City: Grijalbo.
———. 2000. "Exploration Weekend." Roundtable presented at inSITE 2000–01, Centro Cultural Tijuana, Baja California, MX, February 24.
———. 2014. *Art beyond Itself: Anthropology for a Society without a Story Line*. Translated by David Frye. Durham, NC: Duke University Press.
Garciadiego Dantan, Javier, Begoña Hernández, María del Rayo González, Erika Reta, and Beatriz Zepeda. 1994. *El TLC día a día: Crónica de una negociación*. Mexico City: Grupo Editorial Miguel Ángel Porrúa.
García Manríquez, Hugo. *Anti-Humboldt: A Reading of the North American Free Trade Agreement*. Mexico City/Brooklyn, NY: Aldus Editorial/Litmus Books, 2015. Bilingual edition.

Gaspar de Alba, Alicia. 1998. *Chicano Art Inside/Outside the Master's House: Cultural Politics and the CARA Exhibition*. Austin: University of Texas Press.

Gaspar de Alba, Alicia, and Georgina Guzmán, eds. 2010. *Making a Killing: Femicide, Free Trade, and La Frontera*. Austin: University of Texas Press.

Gerken, Christina. 2013. *Model Immigrants and Undesirable Aliens: The Cost of Immigration Reform in the 1990s*. Minneapolis: University of Minnesota Press.

Gibson-Graham, J. K. 2006 [1996]. *The End of Capitalism (As We Knew It): A Feminist Critique of Political Economy*. Minneapolis: University of Minnesota Press.

Giunta, Andrea. 2007. *Avant-Garde, Internationalism, and Politics: Argentine Art in the Sixties*. Translated by Peter Kahn. Durham, NC: Duke University Press.

Global Conceptualism: Points of Origin, 1950s–1980s. 1999. Curated by Jane Farver, Luis Camnitzer, and Rachel Weiss. New York: Queens Museum of Art. Exhibition catalogue.

Godfrey, Mark, Klaus Biesenbach, and Kerryn Greenberg, eds. 2010. *Francis Alÿs: A Story of Deception*. London: Tate Gallery. Exhibition catalogue.

Goldberg, RoseLee. 2007. *Performa: New Visual Art Performance*. Edited by Jennifer Liese. New York: Performa. Exhibition catalogue.

Goldman, Shifra M. 1977. *Contemporary Mexican Painting in a Time of Change*. Austin: University of Texas Press.

———. 1994. *Dimensions of the Americas: Art and Social Change in Latin America and the United States*. Chicago: University of Chicago Press.

Gómez-Peña, Guillermo. 1984. "The Streets: Where Do They Reach?" *High Performance #28* 7, no. 4, 36–40, 92.

———. 1990a. *Border Brujo*. San Diego, CA: Cinewest Productions. VHS.

———. 1990b. *Son of a Border Crisis: Seven Video Poems*. Chicago, IL: Video Data Bank. DVD.

———. 1991a. "A Binational Performance Pilgrimage." *TDR* 35, no. 3. (Fall): 22–45.

———. 1991b. "Death on the Border: A Eulogy to Border Art." *High Performance #53* 14, no. 1 (Spring): 8–9.

———. 1991c. "From Art-mageddon to Gringo-stroika." *High Performance #55* 14, no. 3 (Fall): 20–27.

———. 1993a. "The Free Art Agreement/*El Tratado de Libre Cultura*." *High Performance #63* 16, no. 3 (Fall): 58–63.

———. 1993b. *Warrior for Gringostroika: Essays, Performance Texts, and Poetry*. Saint Paul, MN: Graywolf Press.

———. 1996. *The New World Border: Prophecies, Poems, and Loqueras for the End of the Century*. San Francisco: City Lights.

———. 2000. *Dangerous Border Crossers: The Artist Talks Back*. London: Routledge.

———. 2001. Interview with the author. Durham, NC, October 10.

———. 2002. *El mexterminator: Antropología inversa de un performancero postmexicano*. Mexico City: Editorial Océano.

González, Jennifer. 2008. *Subject to Display: Reframing Race in Contemporary Installation*. Cambridge, MA: MIT Press.

González, Jennifer, and Guillermo Gómez-Peña. 2009. "Pose and Poseur: The Racial Politics of Guillermo Gómez-Peña's Photo-Performances." In *Race and*

Classification: The Case of Mexican America, edited by Ilona Katzew and Susan Deans-Smith, 236–263. Stanford, CA: Stanford University Press.

González, Rita, and Jesse Lerner. 1998. *Cine Mexperimental/ Mexperimental Cinema: 60 Years of Avant-Garde Media Arts from Mexico*. Culver City, CA: Smart Art Press.

González Rodríguez, Sergio. 2012. *The Femicide Machine*. Translated by Michael Parker-Stainback. Cambridge, MA: Semiotext(e) Intervention Series.

Good, Carl, and John V. Waldron, eds. 2001. *The Effects of the Nation: Mexican Art in an Age of Globalization*. Philadelphia, PA: Temple University Press.

Gorostiza, José. 1996. *Poesía completa*. Mexico City: Fondo de Cultura Económica.

Goux, Jean-Joseph. 1990. *Symbolic Economies: After Marx and Freud*. Translated by Jennifer Curtiss Gage. Ithaca, NY: Cornell University Press.

Graeber, David. 2005. "Fetishism as Social Creativity, or, Fetishes Are Gods in the Process of Construction." *Anthropological Theory* 5, no. 4, 407–438.

———. 2012. *Debt: The First 5,000 Years*. Brooklyn, NY: Melville House Publishing.

Grandin, Greg. 2006. *Empire's Workshop: Latin America, the United States, and the Rise of the New Imperialism*. New York: Henry Holt.

Greenberg, Clement. 1961. *Art and Culture: Critical Essays*. New York: Beacon Press.

Greenblatt, Stephen J., ed. 1981. *Allegory and Representation*. Baltimore: Johns Hopkins University Press.

Griswold del Castillo, Richard, Teresa McKenna, and Yvonne Yarbro-Bejarano, eds. 1991. *Chicano Art: Resistance and Affirmation, 1965–1985*. Los Angeles: Wight Art Gallery, University of California, Los Angeles. Exhibition catalogue.

Gruner, Silvia. 1996. "Cubiertos." Unpublished artist statement.

———. 2000. *Circuito interior*. Mexico City: Museo de Arte Carrillo Gil. Exhibition catalogue.

———. 2009. *Un chant d'amour*. Mexico City: Editorial RM. Exhibition catalogue.

———. 2012. Studio visit with SOMA affiliates. Mexico City, July 25.

———. 2014. Conversation with the author. Mexico City, August 13.

Guevara Niebla, Gilberto, and Néstor García Canclini, eds. 1992. *La educación y la cultura ante el Tratado de Libre Comercio*. Mexico City: Nueva Imagen.

Guilbaut, Serge. 1983. *How New York Stole the Idea of Modern Art: Abstract Expressionism, Freedom, and the Cold War*. Translated by Arthur Goldhammer. Chicago: University of Chicago Press.

Gutiérrez, Laura G. 2010. *Performing Mexicanidad: Vendidas y Cabareteras on the Transnational Stage*. Austin: University of Texas Press.

Gutiérrez, Ramón. 1996. "The Erotic Zone: Sexual Transgression on the US-Mexican Border." In *Mapping Multiculturalism*, edited by Avery F. Gordon and Christopher Newfield, 253–262. Minneapolis: University of Minnesota Press.

Gutiérrez, Ramón A., and Elliott Young. 2010. "Transnationalizing Borderlands History." *Western Historical Quarterly* 41, no. 1 (Spring): 26–53.

Guzmán, Manuel. 1997. "Pa' la escuelita con mucho cuida'o y por la orillita [Going to school with caution and without making waves]: A Journey through the Contested Terrains of the Nation and Sexual Orientation." In *Puerto Rican Jam: Rethinking Colonialism and Nationalism*, edited by Frances Negrón-Muntaner and Ramón Grosfoguel, 209–228. Minneapolis: University of Minnesota Press.

Hadad, Astrid. 2001. Interview with the author. Mexico City, April 2.
———. 2012. *Por mi espíritu hablarán mis trajes*. Mexico City: Universidad Nacional Autónoma de México. Exhibition catalogue.
———. 2015. Correspondence with the author. February 4.
Hardt, Michael, and Kathi Weeks, eds. 2000. *The Jameson Reader*. Oxford: Blackwell Publishers.
Harper, Hilliard. 1988. "'Tourist Plantation' Reference Upsetting: Bus Poster Art Taxes Officials' Patience." *Los Angeles Times*, January 7, accessed September 19, 2015. articles.latimes.com/1988-01-07/local/me-33836_1_san-diego-tourist.
Harvey, David. 2005. *A Brief History of Neoliberalism*. Oxford: Oxford University Press.
Henaro, Sol. 2008–2009. "La deriva urbana y el ojo avizor de Melquíades Herrera." *Curare* 30/31, no. 2, 126–137.
———. 2014. *Melquíades Herrera*. Mexico City: Alias/Antítesis.
Herlinghaus, Hermann, and Monika Walter, eds. 1994. *Posmodernidad en la periferia: Enfoques latinoamericanos de la nueva teoría cultural*. Berlin: Langer Verlag.
Hernández, Kelly Lytle. *MIGRA! A History of the US Border Patrol*. Berkeley: University of California Press, 2010.
Hernández Romo, Marcela. 2004. *La cultura empresarial en México*. Mexico City: Grupo Editorial Miguel Ángel Porrúa.
Herner, Irene. 1986. *Diego Rivera: Paraíso perdido en Rockefeller Center*. Mexico City: Edicupes.
———. 1990. "La Toma De Nueva York." *Nexos* 156 (December): 5–13.
Herrera, Melquíades. 1999. *Divertimento, vacilón y suerte: Objetos encontrados (Colección Melquíades Herrera, 1979–1990)*. Mexico City: Museo de la Secretaría de Hacienda y Crédito Público. Exhibition catalogue.
———. 2000a. Interview with the author. Mexico City, December 12.
———. 2000b. Interview with the author. Mexico City, December 5.
Herrera-Prats, Carla, and Francisco Reyes Palma, eds. 2010. *Curare* 32/33 ("¿Conceptualismos en México?").
Herzog, Lawrence. 2006. *Return to the Center: Culture, Public Space, and City Building in a Global Era*. Austin: University of Texas Press.
Hicks, Emily. 2014. "Political Sorcery and a Magical Garden Behind El Lugar del Nopal: Border Art." *Occupy Thirdspace: Contemporary Transborder Art History Panel* (with Norma Iglesias Prieto and the author, organized by Sara Solaimani). La Jolla, CA: The University of California, San Diego, October 24.
Híjar, Alberto, et al. 2000. *Arte y utopía en América Latina*. Mexico City: Instituto Nacional de Bellas Artes.
Hirsch, Marianne. 1997. *Family Frames: Photography, Narrative, and Postmemory*. Cambridge, MA: Harvard University Press.
Hock, Louis. 1979. *Southern California: A Cinemural*. VHS.
———. 1986. *The Mexican Tapes: A Chronicle of Life Outside the Law*. Chicago: Video Data Bank. VHS.
———. 1997. *La mera frontera*. Chicago: Video Data Bank. VHS.
———. 2013. *American Tapes: Tales of Immigration*. Chicago: Video Data Bank. DVD.

———. 2014a. Conversation with the author. La Jolla, CA, May 15.
———. 2014b. Conversation with the author. San Diego, CA, October 27.
Hollander, Kurt. 1998. "inSITE." *Art in America* (May): 47–50.
Honig, Edwin. 1959. *Dark Conceit: The Making of Allegory*. Evanston, IL: Northwestern University Press.
Hughes, Holly, and David Román, eds. 1998. *O Solo Homo: The New Queer Performance*. New York: Grove Press.
Huntington, Samuel P. 1996. *The Clash of Civilizations and the Remaking of World Order*. New York: Simon & Schuster.
Iglesias Prieto, Norma. 2008. *Emergencias: Las artes visuales en Tijuana*. Tijuana: CONACULTA/CECUT.
inSITE94: A Binational Exhibition of Installation and Site-Specific Art. 1995. Edited by Sally Yard. San Diego, CA: Commercial Press. Exhibition catalogue.
inSITE97: Private Time in Public Space. 1998. Edited by Sally Yard. San Diego, CA: Installation Gallery. Exhibition catalogue.
inSITE2000–01: Fugitive Sites. 2002. Edited by Osvaldo Sánchez and Cecilia Garza. San Diego, CA/Tijuana, Mexico: Installation Gallery. Exhibition catalogue.
inSITE_05: Farsites/Sitios distantes. 2005. San Diego, CA: Installation Gallery. Exhibition catalogue.
inSITE_05: [Situational] Public/Público [situacional]. 2006. Edited by Osvaldo Sánchez and Donna Conwell. San Diego, CA/Tijuana, MX: Installation Gallery. Exhibition catalogue.
inSITE_05: A Dynamic Equilibrium. 2007. San Diego, CA: Installation Gallery. Exhibition catalogue.
Irigaray, Luce. 1981. "When the Goods Get Together." In *New French Feminisms*, edited by Elaine Marks and Isabelle de Courtivron, 107–111. New York: Schocken.
Irwin, Robert McKee. 2003. *Mexican Masculinities*. Minneapolis, MN: University of Minnesota Press.
Jackson, Shannon. 2011. *Social Works: Performing Art, Supporting Publics*. New York: Routledge.
Jameson, Fredric. 1979. *Fables of Aggression: Wyndham Lewis, the Modernist as Fascist*. Berkeley: University of California Press.
———. 1981. *The Political Unconscious: Narrative as a Socially Symbolic Act*. Ithaca, NY: Cornell University Press.
———. 1984. "Periodizing the 60s." *Social Text*, no. 9/10 (Spring–Summer): 178–209.
———. 1986. "Third-World Literature in the Era of Multinational Capitalism." *Social Text*, no. 15 (Autumn): 65–88.
———. 1987. "A Brief Response." *Social Text* 17, 26–28.
———. 1991. *Postmodernism, or, The Cultural Logic of Late Capitalism*. Durham, NC: Duke University Press.
———. 1992. *Signatures of the Visible*. New York: Routledge.
———. 1994. *The Seeds of Time*. New York: Columbia University Press.
———. 1995. *The Geopolitical Aesthetic: Cinema and Space in the World System*. Bloomington: Indiana University Press.

———. 1998. *The Cultural Turn: Selected Writings on the Postmodern, 1983–1998.* London: Verso.

———. 2002. *A Singular Modernity: Essay on the Ontology of the Present.* London: Verso.

Jauregui, Gabriela. 2011. "No-Grupo." *Frieze* 137 (March), accessed on April 24, 2011. frieze.com/issue/review/no-grupo/.

Johnson, Barbara. 1994. *The Wake of Deconstruction.* Oxford: Blackwell.

Jones, Amelia. 1998. *Body Art: Performing the Subject.* Minneapolis: University of Minnesota Press.

Jones, Amelia, and Adrian Heathfield, eds. 2012. *Perform, Repeat, Record: Live Art in History.* Chicago: Intellect.

Joseph, Betty. 2012. "Neoliberalism and Allegory." *Cultural Critique* 82 (Fall): 68–94.

Juhasz, Alexandra, and Jesse Lerner. 2006. *F Is for Phony: Fake Documentary and Truth's Undoing.* Minneapolis, MN: University of Michigan Press.

Kaplan, Caren, Norma Alarcón, and Minoo Moallem, eds. 1999. *Between Women and Nation: Nationalisms, Transnational Feminisms, and the State.* Durham, NC: Duke University Press.

Kaprow, Allan. 1956. *Assemblages, Environments, and Happenings.* New York: Harry N. Abrams.

Kaufmann, Thomas DaCosta. 2004. *Toward a Geography of Art.* Chicago: University of Chicago Press.

Kelley, Teresa M. 1997. *Reinventing Allegory.* Cambridge: Cambridge University Press.

Kester, Grant H., ed. 1998. *Art, Activism, and Oppositionality: Essays from Afterimage.* Durham, NC: Duke University Press.

———. 2004. *Conversation Pieces: Community + Communication in Modern Art.* Berkeley: University of California Press.

——— 2006. "Another Turn (response to Claire Bishop)." *Artforum International* 44, no. 9 (May): 22, 24.

———. 2009. "Lessons in Futility: Francis Alÿs and the Legacy of May '68." *Third Text* 23, no. 4 (July): 407–420.

———. 2011. *The One and the Many: Contemporary Collaborative Art in a Global Context.* Durham, NC: Duke University Press.

Khanna, Ranjana. 2003. *Dark Continents: Psychoanalysis and Colonialism.* Durham, NC: Duke University Press.

Kittelmann, Udo, and Klaus Görner, eds. 2004. *Teresa Margolles: Muerte sin fin.* Frankfurt: Museum für Moderne Kunst. Exhibition catalogue.

Klein, Naomi. 2007. *The Shock Doctrine: The Rise of Disaster Capitalism.* New York: Henry Holt.

———. 2010. *No Logo: 10th Anniversary Edition.* New York: Picador.

Krichman, Michael. 2000. Conversation with the author. Tijuana, MX, February 24.

Kubler, George. 1962. *The Shape of Time: Remarks on the History of Things.* New Haven, CT: Yale University Press.

Kuhnheim, Jill S. 1998. "The Economy of Performance: Gómez-Peña's *New World Border.*" *Modern Fiction Studies* 44, no. 1, 24–35.

Kun, Josh, and Fiamma Montezemolo, eds. 2012. *Tijuana Dreaming: Life and Art at the Global Border*. Durham, NC: Duke University Press.

Kwon, Miwon. 2002. *One Place after Another: Site-Specific Art and Locational Identity*. Cambridge, MA: MIT Press.

Lacan, Jacques. 1982. *Feminine Sexuality: Jacques Lacan and the école freudienne*. Translated by Jacqueline Rose. New York: W. W. Norton.

La Fountain-Stokes, Lawrence. 2009. *Queer Ricans: Cultures and Sexualities of the Diaspora*. Minneapolis: University of Minnesota Press.

La Frontera/The Border: Art About the Mexico/United States Border Experience. 1993. Curated by Patricio Chávez and Madeleine Grynsztejn. San Diego, CA: Centro Cultural de la Raza and Museum of Contemporary Art. Exhibition catalogue.

Lamas, Marta. 2011. *Feminism: Transmissions and Retransmissions*. Translated by John Pluecker. New York: Palgrave Macmillan.

La Pocha Nostra. 2012. "The Pocha Nostra Manifesto for 2012." San Francisco, July 20, accessed September 11, 2016. burl.co/1536A7B.

Latorre, Guisela. 2008. *Walls of Empowerment: Chicana/o Indigenist Murals of California*. Austin: University of Texas Press.

———. 2012. "Border Consciousness and Artivist Aesthetics: Richard Lou's Performance and Multimedia Artwork." *American Studies Journal* 57. Accessed May 5, 2016. DOI 10.18422/57-05.

Latour, Bruno. 1996. "On Interobjectivity." *Mind, Culture, and Activity* 3, no. 4, 228–245.

Lefebvre, Henri. 1984. *The Production of Space*. Translated by Donald Nicholson-Smith. Oxford: Blackwell.

———. 2004. *Rhythmanalysis*. Translated by Stuart Elden and Gerald Moore. London: Bloomsbury.

Leong, Nancy. 2013. "Racial Capitalism." *Harvard Law Review* 126, no. 8 (June): 2151–2226.

Lévi-Strauss, Claude. 1969. *The Elementary Structure of Kinship*. Boston: Beacon Press.

Lewis, Oscar. 1961. *The Children of Sánchez: Autobiography of a Mexican Family*. New York: Random House.

Limón, José E. 1992. *Mexican Ballads, Chicano Poems: History and Influence in Mexican-American Social Poetry*. Berkeley: University of California Press.

———. 1998. *American Encounters: Greater Mexico, the United States, and the Erotics of Culture*. Boston: Beacon Press.

Lippard, Lucy. 1998. *The Lure of the Local: Senses of Place in a Multicentered Society*. New York: The New Press.

Liquois, Dominique, comp. 1985. *De los grupos los individuos: Artistas plásticos de los grupos metropolitanos*. Mexico City: Museo de Arte Carrillo Gil. Exhibition catalogue.

Llanos, Fernando, and Martha Hellion, eds. 2007. *Felipe Ehrenberg: Manchuria Peripheral Vision*. Mexico City: Editorial RM/Diamantina. Bilingual exhibition catalogue.

Lloyd, David. 1999. *Ireland after History*. Notre Dame, IN: University of Notre Dame Press.

Lomnitz, Claudio. 1996. "Fissures in Contemporary Mexican Nationalism." *Public Culture* 9, no. 1, 55–68.

———. 2005. *Death and the Idea of Mexico*. Cambridge, MA: MIT Press.

———. 2012. "Time and Dependency in Latin America Today." *The South Atlantic Quarterly* 111, no. 2 (Spring): 347–357.

Lott, Eric. 1995. *Love and Theft: Blackface Minstrelsy and the American Working Class*. New York: Oxford University Press.

Louie, Miriam Ching Yoon. 2001. *Sweatshop Warriors: Immigrant Women Workers Take on the Global Factory*. Cambridge, MA: South End Press.

Lowe, Lisa. 2008. "The Gender of Sovereignty." *The Scholar and Feminist Online: The Barnard Center for Research on Women* 6, no. 3 (Summer), accessed on October 25, 2009.

Lowe, Lisa, and David Lloyd, eds. 1997. *The Politics of Culture in the Shadow of Capital*. Durham, NC: Duke University Press.

Lowrey, Annie. 2014. "NAFTA Still Bedevils Unions." *The New York Times*. Accessed March 29, 2014. economix.blogs.nytimes.com/2014/03/27/nafta-still-bedevils-unions/?_php=true&_type=blogs&_r=0.

Lukács, Georg. 1962. *The Meaning of Contemporary Realism*. Translated by John and Necke Mander. London: Merlin Press.

MacArthur, John R. 2001. *The Selling of "Free Trade": NAFTA, Washington, and the Subversion of American Democracy*. Berkeley: University of California Press.

MacLeod, Dag. 2004. *Downsizing the State: Privatization and the Limits of Neoliberal Reform in Mexico*. University Park: Pennsylvania State University Press.

Madrid, Alejandro L. 2008. *Nor-Tec Rifa! Electronic Dance Music from Tijuana to the World*. Oxford: Oxford University Press.

Marcos, Subcomandante. 2001. *Our Word Is Our Weapon: Selected Writings*. Edited by Juana Ponce de León. New York: Seven Stories Press.

Marcus, George, ed. 2000. *Para-Sites: A Casebook Against Cynical Reason*. Chicago: University of Chicago Press.

Marez, Curtis. 2004. *Drug Wars: The Political Economy of Narcotics*. Minneapolis: University of Minnesota Press.

———. 2016. *Farm Worker Futurism: Speculative Technologies of Resistance*. Minneapolis: University of Minnesota Press.

Margolles, Teresa. 2000. Interview with the author. Mexico City, September 11.

———. 2008. Artist Talk Videos. Presentation at Brooklyn Museum of Art, accessed October 22, 2008. Web. youtube.com/watch?v=HEO_iyYcFJ4.

Martínez, Rubén. 1991. "Free-Trade Art: The Frida Kahlo-ization of L.A." *LA Weekly* (November 1–7): 16–21.

Martínez-San Miguel, Yolanda. 2011. "Female Sexiles? Toward an Archeology of Displacement of Sexual Minorities in the Caribbean." *Signs: Journal of Women in Culture and Society* 36, no. 4, 813–836.

Marx, Karl. 1977. *Selected Writings*. Edited by David McLellan. Oxford: Oxford University Press.

———. 1992. *Capital*. Vol. 1, *A Critique of Political Economy*. Translated by Ben Fowkes. New York Penguin Classics.

Masiello, Francine. 2001. *The Art of Transition: Latin American Culture and Neoliberal Crisis*. Durham, NC: Duke University Press.

Mauss, Marcel. 1967. *The Gift: Forms and Functions of Exchange in Archaic Societies*. New York: W. W. Norton.

———. 1973. "Techniques of the Body." Translated by B. Brewster. *Economy and Society* 2, no. 1, 70–88.

Mayer, Mónica. 1996. "Con dinero y sin dinero II." *El Universal*, October 8, 4.

———. 2000. Interview with the author. Mexico City, June 17.

———. 2004. *Rosa chillante: Mujeres y performance en México*. Mexico City: CONACULTA/FONCA.

———. 2006. *Escandalario: Los artistas y la distribución del arte*. Mexico City: CONACULTA/INBA/FONCA, 2006.

———. 2016. *Si tiene dudas . . . pregunte: Una exposición retrocolectiva de Mónica Mayer/When in Doubt . . . Ask: A Retrocollective Exhibit of Mónica Mayer*. Mexico City: MUAC/UNAM. Bilingual exhibition catalogue.

Mbembe, Achille. 2003. "Necropolitics." Translated by Libby Meintjes. *Public Culture* 15, no. 1, 11–40.

McAlister, Melani. 2001. *Epic Encounters: Culture, Media, and US Interests in the Middle East since 1945*. Berkeley: University of California Press.

McCaughan, Edward J. 2012. *Art and Social Movements: Cultural Politics in Mexico and Aztlán*. Durham, NC: Duke University Press.

McClintock, Anne. 1995. *Imperial Leather: Race, Gender, and Sexuality in the Colonial Contest*. New York: Routledge.

McKenzie, Jon. 2001. *Perform or Else: From Discipline to Performance*. London: Routledge.

Meckler, Jeremy. 2012. "Natalia Almada's Borderlands: Life, Death, and Mexico's Drug War." *WALKER* magazine, September 20, accessed May 13, 2013. walkerartcenter.org/magazine/2012/natalia-almada-el-velador-film.

Medina, Cuauhtémoc. 1998. "La prohibición como incitación." In *Reliquias/Collares*, edited by Silvia Gruner, 39–57. Mexico City: Consejo Nacional para la Cultura y las Artes.

———. 2000a. Interview with the author. Mexico City, September 23.

———. 2000b. "Recent Political Forms: Radical Pursuits in Mexico/Formas políticas recientes: Búsquedas radicales en México—Santiago Sierra, Francis Alÿs, Minerva Cuevas." *TRANS>arts.cultures.media* 8 (New York): 146–163.

———. 2010. "Contemp(t)orary: Eleven Theses." *e-flux journal* no. 12, accessed August 15, 2016. e-flux.com/journal/contemptorary-eleven-theses/.

———. 2015a. Conversation with the author. Mexico City, July 22.

———. 2015b. Public lecture. Mexico City, SOMA, July 21.

———. 2015c. Public lecture. Mexico City, SOMA, July 22.

Melamed, Jodie. 2011. *Represent and Destroy: Rationalizing Violence in the New Racial Capitalism*. Minneapolis: University of Minnesota Press.

Mexico City: An Exhibition about the Exchange Rates of Bodies and Values. 2002. Curated by Klaus Biesenbach. Long Island City, NY/New York: P.S.1 Contemporary Art Center/Museum of Modern Art. Exhibition catalogue.

Mexico: Splendors of Thirty Centuries. 1990. New York: The Metropolitan Museum of Art and Little, Brown. Exhibition catalogue.

Meyer, Lorenzo. 1968. *México y los Estados Unidos en el conflicto petrolero (1917–1942)*. Mexico City: El Colegio de México.

Meyer, Richard. 2013. *What Was Contemporary Art?* Cambridge, MA: MIT Press.

Mignolo, Walter. 2000. *Local Histories/Global Designs: Coloniality, Subaltern Knowledges, and Border Thinking*. Princeton, NJ: Princeton University Press.

Miller, Toby, and George Yúdice. 2002. *Cultural Policy*. London: Sage Publications.

Minh-Ha, Trinh T. 1989. *Woman, Native, Other: Writing Postcoloniality and Feminism*. Bloomington: Indiana University Press.

Molina, Natalia. 2014. *How Race Is Made in America: Immigration, Citizenship, and the Historical Power of Racial Scripts*. Berkeley: University of California Press.

Molloy, Sylvia, and Robert McKee Irwin, eds. 1998. *Hispanisms and Homosexualities*. Durham, NC: Duke University Press.

Monsiváis, Carlos. 1970. *Días de guardar*. Mexico City: ERA.

———. 1981. *Escenas de pudor y liviandad*. Mexico City: Grijalbo.

———. 1991–1992. "La utopia indocumentada: La cultura mexicana de los noventas." Renato Rosaldo Lecture Series Monograph 9, 51–60. Tucson: University of Arizona Mexican American Studies and Research Center.

———. 1995. *Los rituales del caos*. Mexico City: Ediciones Era.

———. 2005. *"No sin nosotros": Los días del terremoto 1985–2005*. Mexico City: Ediciones Era.

Montero, Daniel. 2013. *El cubo de Rubik, arte mexicano en los años 90*. Mexico City: Fundación Jumex Arte Contemporáneo.

Monterroso, Augusto. 1969. *La oveja negra y demás fábulas*. Mexico City: CONACULTA/FONCA.

Morley, David, and Kuan-Hsing Chen, eds. 1996. *Stuart Hall: Critical Dialogues in Cultural Studies*. London: Routledge.

Mosquera, Gerardo. 1996. *Beyond the Fantastic: Contemporary Art Criticism from Latin America*. Cambridge, MA: MIT Press.

Muñoz, José Esteban. 1999. *Disidentifications: Queers of Color and the Performance of Politics*. Minneapolis: University of Minnesota Press.

———. 2006a. "Feeling Brown, Feeling Down: Latina Affect, the Performativity of Race, and the Depression Position." *Signs* 31, no. 3, 675–688.

———. 2006b. "The Vulnerability Artist: Nao Bustamante and the Sad Beauty of Reparation." *Women & Performance: A Journal of Feminist Theory* 16, no. 2 (July): 191–200.

———. 2009. *Cruising Utopia: The Then and There of Queer Futurity*. New York: New York University Press.

Muñoz Ríos, Patricia. 2013. "El TLCAN, 20 años de pesadilla económica, dicen ONG." *La Jornada*. December 31, accessed March 29, 2014. jornada.unam.mx/ultimas/2013/12/31/el-tlcan-20-anos-de-pesadilla-economica-dicen-ong-4472.html.

"NAFTA at 20: Ready to Take Off Again?" 2014. *The Economist*, accessed January 20, 2014. economist.com/news/briefing/21592631-two-decades-ago-north-american-free-trade-agreement-got-flying-start-then-it.

Nancy, Jean-Luc. 1991. *The Inoperative Community*. Translated by Peter Connor, Lisa Garbus, Michael Holland, and Simona Sawhney. Minneapolis: University of Minnesota Press.

¿Neomexicanismos? Ficciones identitarias en el México de los ochenta. 2011. Curated by Josefa Ortega. Mexico City: Museo de Arte Moderno. Exhibition catalogue.

Nevins, Joseph. 2002. *Operation Gatekeeper and Beyond: The War on "Illegals" and the Remaking of the US-Mexico Boundary*. New York: Routledge.

Newton, Esther. 1972. *Mother Camp: Female Impersonators in America*. Chicago: University of Chicago Press.

Ngai, Mae. 2004. *Impossible Subjects: Illegal Aliens and the Making of Modern America*. Princeton, NJ: Princeton University Press.

Ngai, Sianne. 2007. *Ugly Feelings*. Cambridge, MA: Harvard University Press.

Nichols, Bill. 1991. *Representing Reality: Issues and Concepts in Documentary*. Bloomington: Indiana University Press.

———. 1994. *Blurred Boundaries: Questions of Meaning in Contemporary Culture*. Bloomington: Indiana University Press.

Nixon, Rob. 2011. *Slow Violence and the Environmentalism of the Poor*. Cambridge, MA: Harvard University Press.

———. 2012. "Neoliberalism, Genre, and 'The Tragedy of the Commons.'" *PMLA* 127, no. 3, 593–599.

No-Grupo: Un zangoloteo al corsé artístico. 2011. Coordinated by Sol Henaro. Mexico City: Museo de Arte Moderno de México. Exhibition catalogue.

Noriega, Chon. 2000. *Shot in America: Television, the State, and the Rise of Chicano Cinema*. Minneapolis: University of Minnesota Press.

Ochoa Tinoco, Cuauhtémoc. 2009. "De la Bohemia a las instituciones: El sinuoso camino de las políticas culturales en la ciudad de Tijuana." *Andamios* 6, no. 11 (August): 323–352.

Okón, Yoshua. 2000. Interview with the author. Mexico City, June 10.

———. 2009. Conversation with the author. Mexico City, July 15.

———. 2011. Conversation with the author. Mexico City, August 5.

———. 2012. Skype conversation with the author, November 27.

Okón, Yoshua, Chiara Arroyo Cella, Andrew Berardini, and Guillermo J. Fadanelli. 2010. *Yoshua Okón*. Mexico City: Landucci. Exhibition catalogue.

Olalquiaga, Celeste. 1992. *Megalopolis: Contemporary Cultural Sensibilities*. Minneapolis: University of Minnesota Press.

———. 1998. *The Artificial Kingdom: A Treasury of the Kitsch Experience*. New York: Pantheon Books.

Oliviero, Katie E. 2011. "Sensational Nation and the Minutemen: Gendered Citizenship and Moral Vulnerabilities." *Signs* 36, no. 3 (Spring): 679–706.

Ollman, Leah. 2001. "Losing Ground: Public Art at the Border." *Art in America* 89, no. 5 (May): 68–71.

Orozco Quiyono, Lorena. 2000. Interview with the author. Mexico City, March 9.

Ortiz, Fernando. 1995. *Cuban Counterpoint: Tobacco and Sugar*. Translated by Harriet de Onís. Durham, NC: Duke University Press.

Ortiz Torres, Rubén. 2010. Skype conversation with the author, December 7.

Ortiz Torres, Rubén, and Tyler Stallings. 1998. *Desmothernismo: Rubén Ortiz Torres: A Survey of Work from 1990 to 1998.* Santa Monica, CA: Smart Art Press. Exhibition catalogue.

Otero, Gerardo, ed. 1996. *Neoliberalism Revisited: Economic Restructuring and Mexico's Political Future.* Boulder, CO: Westview Press.

Owens, Craig. 1992. *Beyond Recognition: Representation, Power, and Culture.* Edited by Scott Bryson, et al. Berkeley: University of California Press.

Paredes, Américo. 1958. *"With His Pistol in His Hand": A Border Ballad and Its Hero.* Austin: University of Texas Press.

Parker, Andrew, Mary Russo, Doris Sommer, and Patricia Yaeger, eds. 1992. *Nationalisms and Sexualities.* New York: Routledge.

Paz, Octavio. 1981 [1950]. *El laberinto de la soledad.* Mexico City: Fondo de Cultura Económica.

Pelligrini, Ann. 1996. *Performance Anxieties: Staging Psychoanalysis, Staging Race.* London: Routledge.

Pérez Melgosa, Adrián. 2012. *Cinema and Inter-American Relations: Tracking Transnational Affect.* New York: Routledge.

Perlongher, Néstor. 1991. "Los devenires minoritarios." *Revista de Crítica Cultural* 4: 13–18.

Phantom Sightings: Art after the Chicano Movement. 2008. Curated by Rita González, Howard Fox, and Chon Noriega. Berkeley/Los Angeles, CA: University of California Press/Los Angeles County Museum of Art. Exhibition catalogue.

Phillips, Lynne, ed. 1998. *The Third Wave of Modernization in Latin America: Cultural Perspectives on Neoliberalism.* Wilmington, DE: Jaguar Books on Latin America.

Piccato, Pablo. 2008. "All Murder Is Political: Homicide in the Public Sphere in Mexico." Public lecture, University of Michigan, Ann Arbor, MI, October.

Pimienta, Omar. 2014. Correspondence with the author, May 17.

Pincus, Robert. 1998. "The Objects of Her Affection." *San Diego Union-Tribune* (San Diego, CA), May 3.

Pinto mi Raya (Mónica Mayer and Víctor Lerma). 2000. Interview with the author. Mexico City, May 5.

———. 2011. Interview with the authors. Mexico City, August 5.

———. 2014. Conversation with the authors. Mexico City, August 13.

Poniatowska, Elena. 1988. *Nada, nadie: Las voces del temblor.* Mexico City: Ediciones Era.

Portillo, Lourdes. 1994. *The Devil Never Sleeps.* New York: Xochitl Productions/Women Make Movies. DVD.

———. 2001. *Lourdes Portillo: The Devil Never Sleeps and Other Films.* Edited by Rosa Linda Fregoso. Austin: University of Texas Press.

———. 2002. *Señorita Extraviada.* New York: Xochitl Productions/Women Make Movies. DVD.

Portillo, Lourdes, and Susana Muñoz. 1986. *Las Madres/The Mothers of the Plaza de Mayo.* New York: Xochitl Productions/Women Make Movies. VHS.

———. 1988. *La Ofrenda: The Days of the Dead.* San Francisco: Xochitl Productions. VHS.

Proyecto Cívico/Civic Project. 2008. Curated by Ruth Estévez and Lucia Sanromán. Tijuana: CONACULTA/Centro Cultural Tijuana. Bilingual exhibition catalogue.

Puar, Jasbir K. 2007. *Terrorist Assemblages: Homonationalism in Queer Times.* Durham, NC: Duke University Press.

Puga, Cristina. 2004. *Los empresarios organizados y el Tratado de Libre Comercio de América del Norte.* Mexico City: Universidad Nacional Autónoma de México/Grupo Editorial Miguel Ángel Porrúa.

Radway, Janice. 1991. *Reading the Romance: Women, Patriarchy, and Popular Literature.* Chapel Hill: University of North Carolina Press.

Raftery, Miriam. 1997. "Michael Krichman: Champion of the Arts." *Décor & Style Magazine,* May, 92.

Rama, Angel. 1996. *The Lettered City.* Translated by John Charles Chasteen. Durham, NC: Duke University Press.

Ramírez, Mari Carmen. 1999. "Contexturas: Lo global a partir de lo local." In *Horizontes del arte latinoamericano,* edited by José Jiménez and Fernando Castro Flórez, 69–81. Madrid: Editorial Tecnos.

Ramírez ERRE, Marcos. 2014. Correspondence with the author. June 23.

———. 2015. Correspondence with the author. September 2.

Ramos, Samuel. 1934. *El perfil del hombre y la cultura en México.* Mexico City: Colección Austral.

Rancière, Jacques. 2010. *Dissensus: On Politics and Aesthetics.* Translated by Steven Corcoran. London: Continuum.

Razo, Vicente. 1999. "Magia urbana y arte en un camino convergente: El uso del plástico." Unpublished undergraduate thesis for Universidad Nacional Autónoma de México, Escuela Nacional de Artes Plásticas.

———. 2000. Interview with the author. Mexico City, July 11.

———. 2002. *The Official Museo Salinas Guide.* Santa Monica, CA: Smart Art Press.

———. 2008. "Vicente Razo, *Public Address.*" *Artcat.* calendar.artcat.com/exhibits/7119, accessed May 11, 2010.

———. 2013. Correspondence with the author, January 25.

The Red Specter 1.1. 2010. Exhibition publication for *Critical Fetishes: Residues of General Economy,* curated by Mariana Botey, Helena Chávez MacGregor, and Cuauhtémoc Medina. Centro de Arte Dos de Mayo, Madrid, Spain: May 26–August 29.

Resisting Categories: Latin American and/or Latino? 2012. Organized by Hector Olea, Mari Carmen Ramírez, and Tomás Ybarra-Frausto. New Haven, CT: Yale University Press.

Richard, Nelly. 1993. *Masculino/feminino: Prácticas de la diferencia y cultura democrática.* Santiago de Chile: F. Zegers.

———. 2004. *Cultural Residues: Chile in Transition.* Translated by Alan West-Durán and Theodore Quester. Minneapolis: University of Minnesota Press.

Ritzer, George. 1993. *The McDonaldization of Society.* New York: Pine Forge Press/SAGE Publications.

Rivera, Alex. 1995. *Papapapá.* New York: SubCine. DVD.

———. 1997. *Why Cybraceros?* New York: SubCine. DVD.

———. 2002. *The Borders Trilogy*. New York: SubCine. DVD.
———. 2003. Conversation with the author. Durham, NC, November 17.
———. 2007. Conversation with the author. Ann Arbor, MI, April 13.
———. 2008. *Sleep Dealer*. New York: This Is That Productions. DVD.
———. 2012. Conversation with the author. Ann Arbor, MI, April 10.
Rivera Garza, Cristina. 2013. *Los muertos indóciles: Necroescrituras y desapropiación*. Mexico City: Ensayo Tusquets Editores.
Roach, Joseph. 1996. *Cities of the Dead: Circum-Atlantic Performance*. New York: Columbia University Press.
Robinson, Cedric J. 1983. *Black Marxism: The Making of the Black Radical Tradition*. London: Zed Press.
Rodríguez, Jesusa, and Liliana Felipe. 2001. *La boda/The Wedding*. Presented on Canal 40. Mexico City, February 14.
Rogin, Michael. 1988. *Ronald Reagan, the Movie, and Other Episodes in Political Demonology*. Berkeley: University of California Press.
Roscoe, Jane, and Craig Hight. 2001. *Faking It: Mock-documentary and the Subversion of Factuality*. Manchester: Manchester University Press.
Rubin, Gayle. 1975. "The Traffic in Women: Notes on the 'Political Economy' of Sex." In *Toward an Anthropology of Women*, edited by Rayna R. Reiter, 157–201. New York: Monthly Review Press.
———. 1994. "'Sexual Traffic': An Interview with Judith Butler." *Differences* 6, no. 2–3, 62–99.
Said, Edward. 1975. *Beginnings: Intention and Method*. New York: Columbia University Press.
———. 1978. *Orientalism*. New York: Vintage.
Salas, Alexis. 2016. "Making It Work: The Projects of Temístocles 44 Artists (Mexico City, 1991–2003)." PhD diss., Department of Art and Art History, University of Texas at Austin.
Saldívar, José David. 1991. *The Dialectics of Our America: Genealogy, Cultural Critique, and Literary History*. Durham, NC: Duke University Press.
———. 1997. *Border Matters: Remapping American Cultural Studies*. Berkeley: University of California Press.
Saldívar, Ramón. 1990. *Chicano Narrative: The Dialectics of Difference*. Madison: University of Wisconsin Press.
Salzinger, Leslie. 2003. *Genders in Production: Making Workers in Mexico's Global Factories*. Berkeley: University of California Press.
Sánchez, Osvaldo. 1997. "De orgias y aplatanamientos." *Reforma* (Mexico City), July 30.
———. 2001. "El cuerpo de la nación. El neomexicanismo: La pulsión homosexual y la desnacionalización." *Curare* 17 (January–June): 136–146.
Sandoval, Chela. 2000. *Methodology of the Oppressed*. Minneapolis: University of Minnesota Press.
Sanromán, Lucía. 2014a. Conversation with the author. Mexico City, August 16.
———. 2014b. *InSite: Cuatro ensayos de lo público, sobre otro escenario*. Cuernavaca,

MX: CONACULTRA/INBA/SAPSLT/Fundación and Colección JUMEX/CECUT. Exhibition pamphlet.

Santamarina, Guillermo. 2001. Interview with the author. Mexico City, April 4.

Santiago Sierra. 2006. Curated by Fabio Cavallucci and Carlos Jiménez. Trento, Italy: Silvana Editoriale. Exhibition catalogue.

Sarlo, Beatriz. 2000. *Siete ensayos sobre Walter Benjamin*. Mexico City: Fondo de Cultura Económica.

———. 2001. *Scenes from Postmodern Life*. Translated by Jon Beasley-Murray. Minneapolis: University of Minnesota Press.

Sassen, Saskia. 1991. *The Global City: New York, London, Tokyo*. Princeton, NJ: Princeton University Press.

Schechner, Richard. 1985. *Between Theatre and Anthropology*. Philadelphia: University of Pennsylvania Press.

———. 1994. *Environmental Theatre*. New York: Applause.

Schmidt Camacho, Alicia. 2008. *Migrant Imaginaries: Latino Cultural Politics in the US-Mexico Borderlands*. New York: NYU Press.

Schneider, Rebecca. 1997. *The Explicit Body in Performance*. New York: Routledge.

Schwartz, Alexandra. 2014. *Come as You Are: Art of the 1990s*. Berkeley: University of California Press. Exhibition catalogue.

Schwarz, Roberto. 1992. *Misplaced Ideas: Essays on Brazilian Culture*. Edited by John Gledson. London: Verso.

Scott, James C. 1998. *Seeing Like a State: How Certain Schemes to Improve the Human Condition Have Failed*. New Haven, CT: Yale University Press.

Sedgwick, Eve Kosofsky. 1985. *Between Men: English Literature and Male Homosocial Desire*. New York: Columbia University Press.

Sergie, Mohammed Aly. 2014. "NAFTA's Economic Impact." *Council on Foreign Relations*. Accessed March 29, 2014. cfr.org/trade/naftas-economic-impact/p15790.

Sharpe, Jenny. 1993. *Allegories of Empire: The Figure of Woman in the Colonial Text*. Minneapolis: University of Minnesota Press.

Sheren, Ila Nicole. 2011. "Portable Borders/Mythical Sites: Performance Art and Politics on the US Frontera, 1968-Present." PhD diss., Department of Architecture, Massachusetts Institute of Technology, Cambridge, MA.

———. 2015. *Portable Borders: Performance Art and Politics on the US Frontera since 1984*. Austin: University of Texas Press.

Shohat, Ella, and Robert Stam. 1994. *Unthinking Eurocentrism: Multiculturalism and the Media*. New York: Routledge.

Sholette, Gregory. 2011. *Dark Matter: Art and Politics in the Age of Enterprise Culture*. New York: Pluto Press.

Sierra Maya, Alberto, Víctor Manuel Enrique, and Augusto del Valle, eds. 2011. *Memorias del primer coloquio latinoamericano sobre arte no-objetual y arte urbano*. Medellín, Colombia: Museo de Arte Moderno de Medellín.

Sloterdijk, Peter. 2013. *In the World Interior of Capital: Towards a Philosophical Theory of Globalization*. Translated by Wieland Hoban. Cambridge, UK: Polity Press.

Slotkin, Richard. 1992. *Gunfighter Nation: The Myth of the Frontier in Twentieth-Century America*. New York: Harper Perennial.

Smith, Terry. 2009. *What Is Contemporary Art?* Chicago: University of Chicago Press.

Smithson, Robert. 1996. *Robert Smithson: The Collected Writings*. Edited by Jack Flam. Berkeley: University of California Press.

Sommer, Doris. 1991. *Foundational Fictions: The National Romances of Latin America*. Berkeley: University of California Press.

Sontag, Susan. 1966. *Against Interpretation and Other Essays*. New York: Farrar, Straus and Giroux.

Sophocles. 1982. *The Three Theban Plays: Antigone, Oedipus the King, Oedipus at Colonus*. Translated by Robert Fagles. New York: Penguin.

Soto, Sandra K. 2007. "Seeing Through Photographs of Borderlands (Dis)order." *Latino Studies* 5, no. 5, 418–438.

Spivak, Gayatri Chakravorty. 1988. "Can the Subaltern Speak?" In *Marxism and the Interpretation of Culture*, edited by Cary Nelson and Lawrence Grossberg, 271–313. Urbana: University of Illinois Press.

———. 1999. *A Critique of Postcolonial Reason: Toward a History of the Vanishing Present*. Cambridge, MA: Harvard University Press.

Stallabrass, Julian. 2004. *Art Incorporated: The Story of Contemporary Art*. Oxford: Oxford University Press.

Steele, Cynthia. 1992. *Politics, Gender, and the Mexican Novel, 1968–1988: Beyond the Pyramid*. Austin: University of Texas Press.

Steinberg, Samuel. 2016. *Photopoetics at Tlatelolco: Afterimages of Mexico, 1968*. Austin: University of Texas Press.

Steinmetz, Klaus. 1995. "Theory of the Ant." *Art Nexus*, no. 15 (February–April): 84–87.

Stewart, Susan. 1984. *On Longing: Narratives of the Miniature, the Gigantic, the Souvenir, the Collection*. Baltimore, MA: Johns Hopkins University Press.

Stoll, David. 2008. *Rigoberta Menchú and the Story of All Poor Guatemalans*. Boulder, CO: Westview Press.

Strange New World: Art and Design from Tijuana/Extraño nuevo mundo: Arte y diseño desde Tijuana. 2006. Curated by Rachel Teagle and Hugh M. Davies. San Diego, CA: The Museum of Contemporary Art. Bilingual exhibition catalogue.

Sultan, Terrie, ed. 2008. *Chantal Akerman: Moving through Time and Space*. Houston, TX/New York, NY: Blaffer Gallery and the Art Museum of the University of Houston. Distributed by D.A.P./Distributed Art Publishers. Exhibition catalogue.

Taussig, Michael. 1997. *The Magic of the State*. New York: Routledge.

———. 1999. *Defacement: Public Secrecy and the Labor of the Negative*. Stanford, CA: Stanford University Press.

Taylor, Diana. 1997. *Disappearing Acts: Spectacles of Gender and Nationalism in Argentina's "Dirty War."* Durham, NC: Duke University Press.

———. 2003. *The Archive and the Repertoire: Performing Cultural Memory in the Americas*. Durham, NC: Duke University Press.

Taylor, Diana, and Roselyn Costantino. 2003. *Holy Terrors: Latin American Women Perform*. Durham, NC: Duke University Press.
Tejada, Roberto. 2009. *National Camera: Photography and Mexico's Image Environment*. Minneapolis: University of Minnesota Press.
Terada, Rei. 2001. *Feeling in Theory: Emotion after the "Death of the Subject."* Cambridge, MA: Harvard University Press.
Teresa Margolles: What Else Could We Talk About? 2009. Edited by Cuauhtémoc Medina. Mexican Pavilion, 53rd International Art Exhibition, La Biennale di Venezia. Madrid: Editorial RM. Exhibition catalogue.
Teskey, Gordon. 1996. *Allegory and Violence*. Ithaca, NY: Cornell University Press.
Thompson, Nato, ed. 2012. *Living as Form: Socially Engaged Art from 1991–2011*. New York, NY/Cambridge, MA: Creative Times Books/MIT Press. Exhibition catalogue.
Tirado, Katia. 2000. Interview with the author. Mexico City, June 15.
———. 2013. Conversation with the author. Mexico City, July 17.
———. 2014. Conversation with the author. Mexico City, August 12.
Tovar y de Teresa, Rafael. 1994. *Modernización y política cultural: Una visión de la modernización de México*. Mexico City: Fondo de Cultura Económica.
Turner, Victor. 1974. *Dramas, Fields, and Metaphors: Symbolic Action in Human Society*. Ithaca, NY: Cornell University Press.
———. 1982. *From Ritual to Theatre: The Human Seriousness of Play*. New York: Performing Arts Journal Publications.
Uribe, Sara. 2012. *Antígona González*. Mexico City: Sur+.
Urrea, Luis Alberto. 2004. *The Devil's Highway: A True Story*. New York: Little, Brown.
Valis, Noël. 2002. *The Culture of Cursilería: Bad Taste, Kitsch, and Class in Modern Spain*. Durham, NC: Duke University Press.
Vanderwood, Paul J. 2010. *Satan's Playground: Mobsters and Movie Stars at America's Greatest Gaming Resort*. Durham, NC: Duke University Press.
Vasconcelos, José. 1948. *La raza cósmica*. Mexico City: Espasa Calpe.
Venturi, Robert, Denise Scott Brown, and Steven Izenour. 1977 [1972]. *Learning from Las Vegas: The Forgotten Symbolism of Architectural Form*. Cambridge, MA: MIT Press.
Villela, Pilar. 2001a. "Discursos y arte alternativo en México en los noventa; una aproximación crítica." Licenciatura thesis, Universidad Nacional Autónoma de México.
———. 2001b. Interview with the author. Mexico City, May 29.
Vinegar, Aron. 2008. *I Am a Monument: On Learning from Las Vegas*. Cambridge, MA: MIT Press.
Wallis, Brian. 1994. "Selling Nations: International Exhibitions and Cultural Diplomacy." In *Museum Culture: Histories, Discourses, Spectacles*, edited by Daniel J. Sherman and Irit Rogoff, 265–281. Minneapolis: University of Minnesota Press.
Ward, Douglas Turner. 1966. *Happy Ending and Day of Absence: Two Plays*. New York: Dramatists Play Service.
Warner, Marina. 1985. *Monuments and Maidens: The Allegory of the Female Form*. New York: Atheneum.

Warner, Michael. 1993. *Fear of a Queer Planet: Queer Politics and Social Theory*. Minneapolis: University of Minnesota Press.
Wasil, Daniel. 2014. Correspondence with the author, June 26.
Weheliye, Alexander G. 2014. *Habeas Viscus: Racializing Assemblages, Biopolitics, and Black Feminist Theories of the Human*. Durham, NC: Duke University Press.
Weiss, Rachel. 2011. *To and from Utopia in the New Cuban Art*. Minneapolis: University of Minnesota Press.
White, Hayden. 1987. *The Content of the Form: Narrative Discourse and Historical Representation*. Baltimore, MD: Johns Hopkins University Press.
Williams, Raymond. 1977. *Marxism and Literature*. Oxford: Oxford University Press.
Wodiczko, Krzysztof. 2000. "Exploration Weekend." Roundtable presented at inSITE 2000–01, Centro Cultural Tijuana, Baja California, MX, February 24.
———. 2015. "The Inner Public." *FIELD: A Journal of Socially-Engaged Art Criticism* 1 (Spring): 27–52.
Wolffer, Lorena. 1998. Correspondence with the author, October 7.
———. 2000. *Soy totalmente de hierro*. Mexico City. Exhibition catalogue.
———. 2001a. Interview with the author. Mexico City, April 4.
———. 2001b. Interview with the author. Mexico City, April 7.
———. 2001c. Interview with the author. Mexico City, June 4.
———. 2015a. Skype conversation with the author, April 22.
———. 2015b. Skype conversation with the author, April 29.
———. 2015c. Skype conversation with the author, May 12.
———. 2015d. Skype interview with the author, May 20.
Wright, Melissa W. 2006. *Disposable Women and Other Myths of Global Capitalism*. New York: Routledge.
Wynter, Sylvia. 1994. "'No Humans Involved': An Open Letter to My Colleagues." *Forum N.H.I.: Knowledge for the 21st Century* 1, no. 1 (Fall): 42–66.
Yúdice, George. 2003. *The Expediency of Culture: Uses of Culture in the Global Era*. Durham, NC: Duke University Press.
Yúdice, George, Jean Franco, and Juan Flores, eds. 1992. *On Edge: The Crisis of Contemporary Latin American Culture*. Minneapolis: University of Minnesota Press.
Zamudio Taylor, Victor. 2000. "Visitas a estudios de la Ciudad de México: Arte, violencia y agresión." *Atlántica: Revista de las Artes*, no. 25, 53–60.
Žižek, Slavoj. 2006. *The Parallax View*. Cambridge, MA: MIT Press.
Zúñiga, Felipe. 2010. Conversation with the author. Tijuana, MX, October 25.
Zúñiga, Víctor. 1997. "La política cultural hacia la frontera norte: Análisis de discursos contemporáneos (1987–1990)." *Estudios Sociológicos* 15, no. 43, 187–211.

INDEX

Note: Page numbers in *italics* refer to illustrations.

Abaroa, Eduardo, 60, 72, 84, 96
Abramovic, Marina, 248
Acha, Juan, 44
Adorno, Theodor, 279, 305
Agamben, Giorgio, 126, 135–136, 138, 174–175
Age of Discrepancies, The, 45, 119
Ahmad, Aijaz, 4–5, 35–36
Akerman, Chantal, 37, 303–305, *304*
Alarcón, Norma, 164
Alcalá, Rosa, 291
allegorical figuration: and Alÿs's work, 117; and BAW/TAF's interventions, 230; Border as, 38, 236; and Bustamante's work, 196; in colonial encounters, 35; and *End of the Line* performance, 229; and Gómez-Peña, 236, 237, 241, 244, 246, 253; and Gruner's work, 185; Laboratory as, 264; and Margolles's work, 138; Mexico City as, 32, 49, 83; and Orozco's work, 150, 152; and Paz's "The Pachuco," 240; and Tirado's work, 177
allegorical performative: about, 1, 4, 8–9; and Alÿs's *The Loop*, 117; and Bustamante's *America the Beautiful*, 197; and Cuevas's *Causa y efecto (Cause and Effect)*, 99; and ERRE's *Toy an Horse*, 266; gendered, 151; and Gómez-Peña, 244, 252; and Gruner, 193; and Hadad's *Copilli*, 316; and "Indigenous Question," 210; and Margolles's *Operativo I & II*, 143; and Mayer and Bustamante's *Madre por un día*, 152; and Orozco, 151–152; and Razo, 82; and Tijuana's cultural producers, 268; and Wolffer, 171; and Woman archive, 161, 202
Almada, Natalia, plate 22, 192, 305–310
Al Otro Lado (Almada), 306, 306–307
Álvarez Bravo, Manuel, 18
Alÿs, Francis, 108–120; background of, 109; *Barrenderos*, 105–106; *Cuentos patrióticos*, 111, *112*, 113, 145; *El colector (The Collector)*, 110; *Fairy Tales*, 110; and La Pocha Nostra, 248; *The Loop*, 116–117, 264; Medina's collaborations with, 110, 113–117; *Paradox of Praxis 1*, 110–111; *Placing Pillows*, 108–109; *The Politics of Rehearsal*, 115–116; *Rehearsal I*, 113–114; *Rehearsal II*,

375

INDEX

Alÿs, Francis (continued)
115–116; *The Seven Lives of Garbage*,
117; and Sierra's work, 121–122; *STC
Cleaning Service*, 105–106; *Turista*,
plate 3, 110, 125; *Viviendas por todos*...,
111; *When Faith Moves Mountains*,
plate 4, 114–115, 248
America the Beautiful (Bustamante, N.),
196–200, 197, 201
American Tapes (Hock), 288, 289
"America's Finest City," 205–206, 209
Amorales, Carlos, 93
Andreas, Peter, 132, 224
Anzaldúa, Gloria, 242
Appadurai, Arjun, 126
A propósito ... (Okón and Calderón),
85–86
Aranda, Guillermo "Yermo," 218
Arau, Sergio, 294–296, 295
Arcades Project (Benjamin), 4
Arizmendi, Yareli, 294–296, 295
Arkheia of the MUAC, 68
Artemio, 93
Artenstein, Isaac, 222, 230, 243
Artigas, Gustavo, 270, 272
Art Rebate/Arte reembolso (Sisco, Hock,
and Avalos), 233–234, 234
Asco, 37–38, 217, 241
Atentado al hijo pródigo (*Attack on the
Prodigal Son*), 55
Austin, J. L., 8–9
Autorretratos en la morgue (Margolles),
plate 5, 134, 135–138, 139
Avalos, David: *Art Rebate/Arte reem-
bolso*, 233–234, 234; *Border Realities*,
222; and cofounding of BAW/TAF,
222; and Gómez-Peña, 231, 234; and
Rivera's *Why Cybraceros?*, 294; San
Diego Bus Poster Project, 205, 221,
256; "A Wag Dogging a Tale," 232–
233; *Welcome to America's Finest*, 206-
207, 207; *Welcome to America's Finest
Tourist Plantation*, plate 13, 205–
206, 208, 213, 216, 221, 233, 256,
274, 310
Away from You (Gruner), 190–191
Azcárraga Milmo, Emilio "El Tigre," 21,
24

Bañando al bebé (*Bathing the Baby*)
[Margolles], 134–136, 137, 139
Barrenderos (Alÿs), 105–106
Barrera Herrera, Eduardo, 235
Barrio, Francisco, 169
Barrios, José Luis, 132
Barros Sierra, Javier, 45, 46
Bartra, Roger, 16, 36, 201, 249
Basbaum, Ricardo, 123
Baudelaire, Charles, 4
Becerril, Hilario, 59. *See also* Herrera,
Melquiades
Benjamin, Walter: *allegoria* emphasis
of, 4–5; on commodity form, 60;
on economy-culture connection,
30; Lukács's interpretations of, 54;
and Margolles's work, 144; *Origins
of German Tragic Drama*, 138; and
"sense of the 'originary,'" 161; and
Sommer, 15
Berelowitz, Jo-Anne, 215, 217, 220, 222,
224
Bergson, Henri, 88–89, 94
Berlant, Lauren, 3, 35
Berman, Sara-Jo, 222, 230, 241
Bermúdez, Antonio J., 211
Beuys, Joseph, 86, 244, 248
Beverley, John, 58
Biemann, Ursula, 297
Biennale de Paris (1977), 50–51, 55
Bishop, Claire, 34, 122, 124–125, 227
Blind/Hide (Dion), 273, 277–279, 278,
283, 313
Blurred Boundaries (Nichols), 296
Bocanegra (Okón), 91, 91–92, 93
Bolaño, Roberto, 145
Bolin, Richard, 213
Boliver, Rocío, 181–182
Boltanski, Luc, 32, 105
"Border Art Since 1965" (Berelowitz),
215
Border Art Workshop (Taller de Arte
Fronterizo), 221–234; *Border Art
Workshop (BAW/TAF) 1984–1989*,
226–227, 230; *Café Urgente* perfor-
mance, 223; *End of the Line* perfor-
mance, 227–230; founding of, 222;
and Gómez-Peña, 227, 243, 250,

376

251; laboratory analogy for, 222–223; and Las Comadres, 231; and *Light Up the Border* campaign, 225–226; membership in, 230–231; political aspirations of, 224–225; and political critiques, 223; and Superbarrio, 62; tactics of, 227; tension and differences in, 231–232; and "un-" prefix, 250
Border Brujo (Gómez-Peña), 243–245, 246
Border Field Park/Las Playas de Tijuana, 227–228, 272, 283, 292
Borderhack! 268, 269
Border Industrialization Program (BIP), 37, 212–213, 215
Border Projection (Parts I & II) [Wodiczko], 273–274, 275, 277
Border Realities (Avalos), 222
Borders Trilogy, The (Rivera), 292–294, 293
Botey, Mariana, 18, 73–74, 180, 184
Bourriaud, Nicolas, 34, 35, 69
Bowden, Charles, 169, 222, 305
Bracero Program, 209–212, 213–214
Bradley, Jessica, 262, 264
Brinco (Jump) [Werthein], 280–281
Broken Line/La línea quebrada (Gómez-Peña), 242
Bruguera, Tania, 81
Buchloh, Benjamin, 4, 8, 29
Buck-Morss, Susan, 93, 114, 269
bulbo, 282–283
Burden, Chris, 85, 259–260
Bustamante, Cruz, 196
Bustamante, Maris: and Alÿs's *Turista*, 125; *Caliente! Caliente! (Hot! Hot!)*, 57, 159; "Conditions, Roads, and Genealogies of Mexican Conceptualisms," 125; and Ex Teresa Arte Alternativo, 69, 70; *La patente del taco* (Taco Patent), 56, 56–57, 157, 158, 194; *Madre por un día (Mother for a Day)*, plate 7, 152, 157–161; *¡MADRES! (MOTHERS!)*, 155–156; and Margolles's work, 133–134; and Mayer, 156; and No-Grupo, 33, 52, 53; and PIAS Forms, 44, 238; and Polvo de Gallina Negra (PGN), 152, 156–157, 158, 160–161; and Sierra's remuneration series, 125
Bustamante, Nao, 193–202; *America the Beautiful*, 196–200, 197, 201; in drag, 198–199; and female form as allegory, 36; and food in intra-American relations, 194–195; *Indig/urrito*, 193–196, 229–230, 250; mediums of, 193
Butler, Judith, 136, 246

Café Urgente (BAW/TAF), 223
Calderón, Miguel: and *Critical Fetishes*, 73; and La Feria del Rebelde (Rebel's Fair), 87; and La Panadería, 84; *A propósito . . .*, 85–86
Caliente! Caliente! (Hot! Hot!) [Bustamante], 57, 159
Candiani, Tania, 184
CARA (Chicano Art: Resistance and Affirmation, 1965–1985), 30
Cárdenas, Cuauhtémoc, 12
Cárdenas, Raúl, 282
Cardona, Julian, 305
Castañeda, Tomás "Coyote," 218
Castellanos, Rosario, 151
Causa y efecto (Cause and Effect) [Cueva], 99–100
Centro Cultural de la Raza, 218, 223
Centro Cultural Tijuana (CECUT), plate 16, 219, 254, 258, 259, 267, 273, 275, 279, 282, 284, 287, 312
Century 21 (ERRE), 51, 258–259, 259, 316, 317
Chanan, Michael, 287
Chávez MacGregor, Helena, 73
Chavoya, C. Ondine, 206, 225, 233
Chocorrol (Chocolate Bread) [Okón], 87–89, 93
Chow, Rey, 153, 177
Clark, Lygia, 123
Cockcroft, Eva, 217, 218
Cohen, Arnaldo, 85
Collar de Antigua (Antigua Necklace) [Gruner], 182–183, 189, 317
Colosio, Luis Donaldo, 261
Come as You Are: Art of the 1990s (2014), 29

"Conditions, Roads, and Genealogies of Mexican Conceptualisms, 1921–1993" (Bustamante, M.), 44–45, 125
Congreso de Artistas Chicanos en Aztlán (CACA), 37, 218–219
Conozca México, visite Tepito (*Know Mexico, Visit Tepito*), 49–50
Consejo Nacional para la Cultura y las Artes (CONACULTA; National Council for Culture and the Arts): funding from, 24, 25; and inSITE, 263, 264; and Mexico City art of the mid- to late 1990s, 95; objectives of, 23; and PIAS Forms, 69–70
Copilli (Hadad), plate 24, 316
Corridos (Schleiner and Hernández), 280, *281*, 281
Costantino, Roselyn, 56
Couple in a Cage (Fusco and Heredia), 250
Crimp, Douglas, 70
Critical Fetishes exhibit, 73
Cruz, Teddy, 81, 316–317, 318–320
Cruzvillegas, Abraham, 96
Cuenca, Carmen, 262, 264, 269
Cuentos patrióticos (*Patriotic Tales*) [Alÿs], 111, *112*, 113, 145
Cuevas, Minerva, 95–108, *106*; *Causa y efecto* (*Cause and Effect*), 99–100; *Del Montte*, 101, *103*; *Dodgem*, 99; *Drunker*, 101–104, 107; and *Economía del Mercado* (*Market Economy*) show, 96–97; *égalité: Une Condition Naturelle*, 100, *102*; *El Ángel*, 96; logocentrism of, 95–101, 107, 128; *Mejor Vida Corp* of, 104–108, 145; *Melate*, 100; *Piensa global-Actúa local* (*Think Global-Act Local*), 97, *98*
Cuevas, José Luis, 19, 55–56
Curare, 58, 118–119
"Curso vivo de arte" (Living Art Course), 50
Cypher, James M., 13

David, Mariana, 93
Davis, Mike, 285–286, 291
Day Without a Mexican, A (Arau and Arizmendi), 294–296, *295*
Dead Letter Office (Sekula), 265

"Death on the Border: A Eulogy to Border Art" (Gómez-Peña), 232
Debroise, Olivier: and *Age of Discrepancies* exhibit, 45; on Chicanx art and culture, 241; and Gruner, 185; Hadad's influence on, 315; and inSITE, 264, 265; and Los Grupos, 48; on neomexicanismo, 26, 28; *Un banquete en Tetlapayac* (*A Banquet in Tetlapayac*), 119, 185, 315
De la Garza, Javier, 26, 27–28, 153
De La Torre, Sergio, plate 21, 274–275, 300–303, *301*
De l'autre côté (*From the Other Side*) [Akerman], 303–305, *304*
Del Conde, Teresa, 26
Deleuze, Gilles, 153, 172, 279
Delgado Wise, Raúl, 13
Del Montte (Cuevas), 101, *103*
Demos, T. J., 290
Dion, Mark: *Blind/Hide*, 273, 277–279, *278*, 283, 313; science-based art installations of, 277–278
Disappearing Acts (Taylor), 136–137
Divertimento, vacilón y suerte: Objetos encontrados (*Colección Melquiades Herrera, 1979–1990*) [Herrera], 64–67, *66*, 72
documenta: documenta X, 268; documenta 11, 287
Dodgem (Cuevas), 99
Dolan, Jill, 36
Dominguez, Ricardo, 274, 280, 289
Don't fuck with the past, you might get pregnant (Gruner), 36, 185–186, *186*, *187*, 189
Dos Ciudades/Two Cities, 232, 234, 256, 273
Drunker (Cuevas), 101–104, 107
Duchamp, Marcel, 1, 54, 81, 317
Duncan, Michael, 260

Eberhard, Jude, 222, 230
Economía del Mercado (*Market Economy*), 96–97
EDEMA, 182
égalité: Une Condition Naturelle (Cuevas), 100, *102*
Ehrenberg, Felipe: and Border Art Workshop (Taller de Arte Fronterizo), 223;

El arte de vivir del arte, 69, 72, 107; and Ex Teresa Arte Alternativo, 70; and inSITE, 261, 264; and Proceso Pentágono, 50
Eisenstein, Sergio, 119, 315
El Ángel (Cuevas), 96
El arte de vivir del arte (Ehrenberg), 69, 72, 107
El Colectivo, 48
El colector (*The Collector*) [Alÿs], 110
El cubo de Rubik, arte mexicano en los años 90 (Montero), 60
El Espectro Rojo (Botey, Chávez MacGregor, and Medina), 73
Elhaik, Tarek, 78
Elliott, Jim, 227
El Mago Melchor, 43–44, 62, 82, 84, 87, 145
El Museo de la Identidad Congelada (*The Museum of Congealed Identity*) [Gómez-Peña], 239
El nacimiento de Venus (*The Birth of Venus*) [Gruner], 182, 188, 189
El señor de los peines (Herrera), 61
El tendedero (*The Clothesline*) [Mayer], 156–157
El Velador (Almada), 306, 307–310, 308
Emmelhainz, Irmgard, 110
End of the Line (BAW/TAF), 227–230
En el aire (Margolles), 138
Enemigos I (De la Garza), 27–28, 153
Entierro (*Burial*) [Margolles], 135
Enwezor, Okwui, 287
ERRE. *See* Ramírez ERRE, Marcos
Escuela Nacional de Artes Plásticas (ENAP), 65
Esta coca-cola . . . (*This Coca-Cola*) [Herrera], 54
Estados de excepción (Wolffer), 174–175
Estévez, Ruth, 312
Estridentismo (literary and artistic movement), 44, 67, 238
Evia, Gerardo, 6–7, 107
Evidencias (Wolffer), 174
Exhivilización (Tirado), plate 12, 178–182, 179
Expediente Bienal X (*The Biennale X Case*), 51–52, 86
Ex Teresa Arte Alternativo (Ex Teresa Alternative Art) and Ex Teresa Arte Actual (Ex Teresa Contemporary Art), 64, 69–71, 73, 99, 125, 163, 178, 196, 197, 239, 240

Fairy Tales (Alÿs), 110
Felguérez, Manuel, 19
Femicide Machine, The (González Rodríguez), 169
Ferguson, Roderick, 214
Fetiches críticos exhibit, 73
Fetiches domésticos (*Domestic Fetishes*) [Gruner], 184
Fike, Edward L., 227
Fin (*End*) [Margolles], 145, 283
Finck, Carlos, 50
Finley, Karen, 170
First Salon of Experimentation at Mexico's National Institute of Fine Arts, 54
Fisher, Jean, 101
500 of Impotence or Possibility (Gruner), 192
Flaherty, George F., 211–212
Fletcher, Angus, 3, 86, 110, 319
Flores, Eduardo, 182
Fluxus International, 118, 224
Fondo Nacional para la Cultura y las Artes (FONCA; National Fund for Culture and Arts), 23–24, 69–70, 219, 262, 263, 264
Fornazzari, Alessandro, 6–7
Foster, Hal, 78, 287
Foucault, Michel, 3, 130, 172, 209, 260, 277
14 de febrero (Wolffer), 173
Fox, Claire, 17, 243, 286, 287
Franco, Jean, 14, 136, 151, 200
Fraser, Andrea, 69, 73, 119, 265–266
Frye, Northrop, 298
Fuguet, Alberto, 87
Fukuyama, Francis, 6, 251
Funari, Vicki, plate 21, 274–275
Fundación Cultural Televisa, A.C. (Televisa Cultural Foundation), 21, 24
Fundación de Investigaciones Sociales, 24
Fundación Jumex Arte Contemporáneo, 68
Fusco, Coco, 133, 248–252, 280

Galán, Julio, 26
Galería Arte Actual Mexicano (GAAM), 30
Galería Arte Mexicano (GAM), 30
Galería Kurimanzutto, 96–97, 102, 103, 106
Galería OMR, 30
Gallaccio, Anya, 192, 258
Gamboa, Harry, Jr., 37, 217
Gámez, Rubén, 55
Gamio, Manuel, 18
García Canclini, Néstor: and BAW/TAF, 222; and Dion's *Blind/Hide*, 273, 277; *Hybrid Cultures*, 159; and Tirado's self-portraits, 178; and Wodiczko's *Tijuana Projection*, 274, 276
García de Germanos, Pilar, 45
García Márquez, Gabriel, 51
Garro, Elena, 151
Garza Cervera, Renato, 117–118, *118*
Gaspar de Alba, Alicia, 216
Gathering, The (Okón), 92–93
Gender Trouble (Butler), 246
Gerken, Christina, 228
Gerzso, Gunther, 55
Gibson-Graham, J. K. (pseudonym, Katherine Gibson and Julie Graham), 35–36
Giunta, Andrea, 157
Godeau, Abigail Solomon, 298
Godfrey, Mark, 109
Goldberg, RoseLee, 116
Goldman, Shifra, 13, 20, 24, 50
Gómez-Peña, Guillermo, 235–254; and Avalos, 231, 234; background of, 238; and Border, 246, 251–252, 263–264; and Border Art Workshop (BAW/TAF), 222, 223, 224, 227, 243, 250, 251; *Border Brujo*, 243–245, 246; *Broken Line/La línea quebrada*, 242; Chicano-fascination of, 241–242; and Chicano Park, 217; and confrontations with audiences, 246; *Couple in a Cage*, 250; critiques of, 247; and culture of Tijuana–San Diego corridor, 219; "Death on the Border," 232; *El mex-terminator*, 237; *El Museo de la Identidad Congelada (The Museum of Congealed Identity)*, 239; "Ex-plendors," 253, 256; and Free Art Agreement, 253; and Fusco, 250; languaging of, 238, 245; and La Pocha Nostra, 247–248, 253; and Mexico City, 238, 241; and *NAFTAZTEC*, 252–253; "The Other History of Intercultural Performance," 250; and Paz's "The Pachuco," 240–241; *Performero ([Mere] Performer)*, 239, 240; and queerness, 245–246; *Son of Border Crisis*, 243–245; strategies of, 236, 237; and *Terreno Peligroso*, 196; *Two Undiscovered Amerindians Visit the West*, 248–252
Gonzalez, Rita, 279
González Rodríguez, Sergio, 129, 169
Gourbet, Lourdes, 179
Gramsci, Antonio, 182
Greenberg, Clement, 57
Greenblatt, Stephen, 200
Grobet, Lourdes, 50
Gronk, 37, 217
Gruner, Silvia, 182–193; *Away from You*, 190–191; background of, 183; *Collar de Antigua (Antigua Necklace)*, 182–183, 189, 317; *Don't fuck with the past, you might get pregnant*, 36, 185–186, *186*, 187, 189; *El nacimiento de Venus (The Birth of Venus)*, 182, 188, 189; and female form as allegory, 36; *Fetiches domésticos (Domestic Fetishes)*, 184; and fetishism, 182–189; *500 of Impotence or Possibility*, 192; *How to Look at Mexican Art*, 185–186; *In Situ*, 186–187, 188; *Inventario (Inventory)*, 183; Jewish identity of, 187–189; *Mi peso en jabón (My Weight in Soap)*, 188; *Narrow Slot (Hendija estrecha)*, 189–190, 270; *Natura-Cultura (Nature-Culture)*, 184; paradigm shift of, 190–191; and *Un banquete en Tetlapayac (A Banquet in Tetlapayac)*, 119, 185; *Un chant d'amour*, 190, 191, 192–193
Grupo Factor X, 274
Grupo Industrial Alfa, 20
Grupo Monterrey, 12–13, 21, 26
Guattari, Félix, 153, 172, 279
Guibault, Serge, 119

Gurrola, Juan José, 85
Gutiérrez, Laura, 196, 316
Guzmán, Daniel, 96

Hadad, Astrid, plate 24, 119, 315–317
Hall, Stuart, 152
Hammer, Armand, 20
Harte, Edward H., 227
Harvey, David, 11
Hedgecock, Roger, 225, 226
Hemi Encuentro, Lima, Peru, 199
Hemispheric Institute of Performance and Politics (Hemi), 199
Henaro, Sol, 65
Hernández, Alfonso, 49
Hernández, Ester, 98
Hernández, Ingrid, plate 23, 312–313
Hernández, José Antonio, 50
Hernández, Luis, 280, 281, 281
Herner, Irene, 18
Herrera, Melquiades: and alter ego, 59; conceptualism of, 60–61; *Divertimento, vacilón y suerte*, 64–67, 66, 72; and El Mago Melchor's body art, 43, 145; *El señor de los peines*, 61; *Esta coca-cola ... (This Coca-Cola)*, 54; interobjectivity of, 74; *La crisis existencial del sorprendente hombre araña*, 62, 63; and No-Grupo, 33, 52, 53, 54; and *Noticias del México surrealista*, 59–60; on performance, 61, 107; and Razo's thesis, 78; *Uno por 5, 3 por Diez (One for 5, 3 for Ten)*, 61
Herrón, Willie, III, 37, 217
Hertz, Betti-Sue, 88
Hicks, D. Emily, 223, 230, 242
Híjar, Alberto, 50, 51
Hirst, Damien, 132
Hock, Louis: *American Tapes*, 288, 289; *Art Rebate/Arte reembolso*, 233–234, 234; *The Mexican Tapes*, 288, 289, 290; and Rivera's *Why Cybraceros?* 294; San Diego Bus Poster Project, 205, 221, 256; *Southern California: Cinemural*, plate 19, 288, 288, 289; and undocumentary genre, 288; *Welcome to America's Finest*, 206–207, 207; *Welcome to America's Finest Tourist Plantation*, plate 13, 205–206, 208, 213, 216, 221, 233, 256, 274, 310
Holzer, Jenny, 168
How to Look at Mexican Art (Gruner), 185–186
Huntington, Samuel, 6
Hurley, Jim, 293
Hybrid Cultures (García Canclini), 159

If she is Mexico, who beat her up? (Wolffer), plate 8, 36, 164–166, 171
Iglesias Prieto, Norma, 279
Ilich, Fran, 268
Indigenismo, 16, 21, 44, 183, 239, 241
In God We Trust: Pirámides (Razo), 74–79, 75, 76
Indig/urrito (Bustamante, N.), 193–196, 229–230, 250
inSITE, 254–286; in 1994, 256–262; in 1997, 262–266; in 2000–2001, 266–279; in 2005, 279–284; and Alÿs's *The Loop*, 116; archives of, 256–257, 284–286; and Artigas's *The Rules of the Game*, 270, 271, 272; and Border as "installation," 260; and bulbo's *La tienda*, 282–283; and Burden's *A Tale of Two Cities*, 259–260; curators of, 262, 269; and Dion's *Blind/Hide*, 273, 277–279, 278, 283; and documenta, 268; and ERRE's *Century 21*, 258–259, 259; and ERRE's *Toy an Horse*, 266; and exposure for artists, 263–264; funding of, 255–256, 262–263, 264; and Fusco and Dominguez's *Turista Fronterizo*, 280; and Gallaccio's installation, 258; and Gruner's *Narrow Slot*, 189–190; *Inaugural Speech* of, 265–266; *InSite: Cuatro ensayos de lo público, sobre otro escenario (InSite: Four Rehearsals/Essays of the Public, in Another Scenario)*, 255; as "Maquila School," 95, 264; and Mexico City art of the mid- to late 1990s, 95; and NAFTA, 264, 284; and Nevarez and Rivera's *LowDrone*, 280; organizers of, 256, 257, 262, 265, 270; and *Proyecto Juárez*, 93; and Schleiner and Hernández's *Corridos*, 280, 281, 281; and Sekula's *Dead Letter Office*, 265;

inSITE (*continued*)
 and Téllez's *One Flew Over the Void*, plate 17, 283–284; and Torolab's *La región de los pantalones transfronterizos*, 282; and Werthein's *Brinco* (*Jump*), 280–281; and Wodiczko's *Tijuana Projection*, plate 16, 273–277, 275, 301–302
In Situ (Gruner), 186–187, 188
Installation Gallery, 206
Instituto Nacional de Antropología e Historia (INAH), 16–17, 24
Instituto Nacional de Bellas Artes (INBA), 16–17, 24, 70
Instituto Politécnico Nacional, 46
Inventario (*Inventory*) [Gruner], 183
Irigaray, Luce, 180

Jackson, Shannon, 84
Jacob, Mary Jane, 253
Jameson, Fredric: and the allegorical, 4–6, 7, 8, 15; and capitalism, 253; and Debroise, 28; on decolonization and neo-colonialism, 23; on detective stories, 164; and *Learning from Las Vegas*, 318; and postmodernism, 5, 8, 30, 318
Jodorowsky, Alejandro, 47
Johnson, Barbara, 150
Johnson, Rob, 3, 35
Jones, Amelia, 19, 196
Joseph, Betty, 28
Jottar, Berta, 230
Joven Escuela de Pintura Mexicana (Young School of Mexican Painting), 19
Juhasz, Alexandra, 291
Jumex Museum, 133, 315
Jurado, Concepción, 160

Kahlo, Frida, 13–14, *14*, 21, 27, 35, 160, 168, 185, 244, 315
Kalenberg, Ángel, 50, 51, 55
Kaplan, Caren, 164
Kaprow, Allan, 44, 111
Kaufmann, Thomas Dacosta, 115
Kein Mensch ist illegal (No One Is Illegal), 268–269
Kessler, Scott, 233

Kester, Grant, 22, 113, 114–115, 124–125, 195
Khanna, Ranjanna, 201
King, Martin Luther, Jr., 206–207, *207*, 208
Klein, Naomi, 98, 209
Krichman, Michael, 257, 262, 264, 269
Kruger, Barbara, 168
Kubler, George, 115
Kuhnheim, Jill, 247
Kuri, Gabriel, 96
Kuri, José, 96

Labyrinth of Solitude, The (Paz), 19, 158, 238–242
La crisis existencial del sorprendente hombre araña (*The Existential Crisis of the Amazing Spiderman*), 62, 63
Lacy, Suzanne, 156, 157
La era de la discrepancia (*The Age of Discrepancies*), 45, 119
La Feria del Rebelde (Rebel's Fair), 43, 82, 83, 84, 86–87
La fórmula secreta (*The Secret Formula*, 1965), 55
La Frontera, 231, 232, 233
La Jaula de la melancolía (*The Cage of Melancholy*) [Bartra], 36
La Malinche, 15, 35
La maquila-golondrina (Hernández), plate 23, 312
Lamas, Marta, 153
La Panadería (The Bakery): and border art's beginnings, 222; founding of, 83; and Hock's *Pirámide del Sol*, 288; and La Feria del Rebelde (Rebel's Fair), 43, 84, 86–87; and Margolles's work, 145; objectives of, 84–85, 95; and Okón, 94
La patente del taco (*Taco Patent*) [Bustamante], 56, 56–57, 157, 158, 194
La Pocha Nostra, plate 14, 247–248, 253
La promesa (Margolles), 145
La región de los pantalones transfronterizos (Torolab), 282
"La Ruptura" (Paz), 19–20
Las Comadres, 222, 231
La tienda (bulbo), 282–283
La toma del edificio Balmori (*The Taking*

of the Balmori) [Salón des Aztecas], 108
Latorre, Guisela, 216
Latour, Bruno, 74
Learning from Las Vegas (Venturi, Brown, and Izenour), 317–318
Lefebvre, Henri, 9
Lerma, Víctor, 67–69, *68*, 70
Lerner, Jesse, 291
Lewis, Oscar, 49
Lewis, Wyndham, 5
LeWitt, Sol, 69
Limón, José, 216, 239
Liquois, Dominique, 48, 49
Logan Heights (Barrio Logan), 217–218, 273
Lomnitz, Claudio, 25–26, 58, 183
Lonidier, Fred, 287
Loomba, Ania, 201
Loop, The (Alÿs), 116–117, 264
López Cuenca, Alberto, 120
Los Anthropolocos (Lou and Sánchez), 249
Los Contemporáneos (literary movement), 44, 73, 238
Los Grupos: about, 48–49; and BAW/TAF, 224; and *Expediente Bienal X*, 51–52; first and second waves of, 49; members of, 48; political issues addressed by, 48–49, 227; struggles of participants in, 67; works of, 49
"los grupos" (the groups), 12, 13, 22, 24, 28
Los montajes, 53
Los nichos púb(l)icos (Tirado), plate 10, plate 11, 36, 175–178, *176*, 180–182
Los penetrados (Sierra), 126–127
Los Toltecas en Aztlán, 218, 223
Lou, Richard, 222, 227, 249, 272
LowDrone (Nevarez and Rivera), 280
Lukács, Georg, 54
Luna, James, 248

Madre por un día (Mother for a Day) [Mayer and Bustamante], plate 7, 152, 157–161
¡*MADRES!* (*MOTHERS!*) [Bustamante and Mayer], 155–156
Madrid, Alejandro L., 266–267

Making It Safe (Lacy), 157
Man, Paul de, 4, 279
Manoftheyear I (Razo), 79–80
Manoftheyear II (Razo), plate 1, 79–80
maquiladoras (maquilas), 213, 214, 263–264, 274–275
Maquilapolis (De La Torre and Funari), plate 21, 274–275, 300–303, *301*
Marcos, Subcomandante, 81
Marez, Curtis, 309
Margolles, Teresa, 130–146; *Autorretratos en la morgue*, plate 5, 134, 135–138, *139*; background of, 132–133; *Bañando al bebé* (Bathing the Baby), 134–136, 137, 139; *En el aire*, 138; engendering in images of, 134; *Entierro* (Burial), 135; *Fin* (*End*), 145, 283; *La promesa*, 145; *Muerte sin fin*, 130, 140–145; and No-Grupo, 52; *Operativo I & II*, plate 6, 140–145; and SEMEFO, 131–134, 138, 145; *Vaporización* (Vaporization), 130–132, *131*, 138–140, 162, 198
Mariano, Nola, 247
Martín, Patricia, 88
Martínez, Rubén, 14, 25
Masiello, Francine, 6, 200
Masotta, Oscar, 58
"Maximum Effort, Minimum Result" (Medina), 114
Mayer, Mónica: and Bustamante, 156; *El tendedero* (The Clothesline), 156–157; and Ex Teresa Arte Alternativo, 70; "Feminist Art" thesis, 157; *Madre por un día* (Mother for a Day), plate 7, 152, 157–161; ¡*MADRES!* (*MOTHERS!*), 155–156; *Pinto mi Raya*, 67–69, *68*, 157; and Polvo de Gallina Negra, 152, 157, 160–161; *Rosa chillante* (memoir), 161; *Sin centenario ni bicentenario*, 157; *Si tiene dudas . . . pregunte*, 157
Mbembe, Achille, 126, 135–136
McClintock, Anne, 189, 201
McKenzie, Jon, 28
McOndo, 87
Medina, Cuauhtémoc: and *Age of Discrepancies* exhibit, 45; Alÿs's collaborations with, 110, 113–117; and Artigas's *The Rules of the Game*, 272;

Medina, Cuauhtémoc (*continued*) background of, 118; on contemp(t)orary art, 32; and *Critical Fetishes* exhibit, 73; and Cuevas's *Think Global–Act Local*, 97; and Debroise's *Un banquete en Tetlapayac*, 119; and La Pocha Nostra, 248; and Margolles's work, 133–134; "Maximum Effort, Minimum Result," 114; on neomexicanismo, 28–29; on Ponce de León's reception for Clinton, 185; and Razo's *20 Million Mexicans*, 82; and Segura and Cervera's *Cuauhtémoc Buddha*, 117–118, 118; Sierra's collaborations with, 120; and Sierra's remuneration series, 124; *STC Cleaning Service*, 105–106, 107

Mejor Vida Corp of Cueva, 104–108
Melate (Cueva), 100
Melquiades Herrera (Henaro), 65
Mesquita, Ivo, 264, 269
"Mexican Art on Display" (Debroise), 78
Mexican Delights (*Enemigos I*) [De la Garza], 28
Mexican School of Painting and Sculpture, 19, 24
Mexican Tapes, The (Hock), 288, 289, 290
"Mexico: A Work of Art," exhibit, 13–14, 14, 25
Mexico City: and Alÿs, 110, 117; artistic community of, 47–48, 119; "contemporary" art of, 32; and Cuevas, 104–105; and cultural citizenship, 201; and cultural nationalism, 16, 45; and earthquake of 1985, 62, 109; and economy of Mexico, 70; and El Ángel de la Independencia, 95–96; and El Palacio de Hierro's campaign, 161; as federal district, 34; and female artists, 157, 161; and Gómez-Peña, 238, 241; and Herrera's works, 65; informal economies of, 59; infrastructural transformation of, 47; and "Maquila School," 264; and Margolles's work, 130–131, 133, 135, 139, 141–142, 145; and Mayer, 157; migration to, 214, 307; and NAFTArt, 83, 191; and Olympics in Mexico (1968), 45–46; performance and neo/conceptual art in, 70; PIAS Forms in, 44, 54, 56, 270; place making and art making in, 71, 84, 314; and political critiques of DF artists, 34; and readymades, 49, 222; and responses to contemporary art, 32; and Rufino Tamayo Museum of Contemporary Art, 21, 105; and Sierra, 121, 126; and Superbarrio, 62; and World Conference on Women (1975), 156. *See also* La Panadería (The Bakery)

Mexico City: An Exhibition about the Exchange Rates of Bodies and Values, 130–131, 131
Mexico: Splendors: and cultural context of NAFTA, 25; and culture of the 1990s, 315; and de la Garza's *Enemigos I*, 27–28; and free trade, 30; Goldman on, 20; and Gómez-Peña's "Ex-plendors," 253, 256; and Kahlo's self-portrait, 35; and *Parallel Project*, 30; and Paz, 158; promotion of, 13–14, 25; and Tamayo's entry, 19
Mexico Today Symposium, 21
Meyer, Richard, 313
Mientras dormíamos (el caso Juárez) [Wolffer], 168–171, 170
Miller, Toby, 17
Minh-Ha, Trinh T., 185
Minutemen, 285–286
Mi peso en jabón (My Weight in Soap) [Gruner], 188
Mira, 48
Moallem, Minoo, 164
Modernity at Large (Appadurai), 126
Modernización y política cultural (Tovar y de Teresa), 69
Modotti, Tina, 18
Monsiváis, Carlos, 7, 25, 27–30, 58, 64, 72–73, 158–159, 244, 321
Montero, Daniel, 60, 83, 97, 168, 272
Montezemolo, Fiamma, 255, 300
Movie, The (Okón), 92
Muerte sin fin (Margolles), 130, 140–145
Muñoz, Armando, 268
Muñoz, José, 36, 193, 195, 196
Muñoz, Víctor, 50
Muros de réplica (Wolffer), 174, 174–175

Museo Carrillo Gil, 178
Museo de Arte Moderno (Museum of Modern Art), Mexico City, 55, 172
Museo de la Secretaría de Hacienda y Crédito Público, 64
Museo Jumex, 314
Museo Salinas (Razo), plate 2, 80–82, 117
Museo Soumaya, 314
Museo Universitario Arte Contemporáneo (MUAC), 45, 68, 80, 104, 118, 145, 157, 254, 284

NAFTA Spanish-English Dictionary (Razo), 83
NAFTAZTEC, 252–253
Nancy, Jean-Luc, 141
Narrow Slot (*Hendija estrecha*) [Gruner], 189–190, 270
National Endowment for the Arts (NEA), 22, 23, 37
National Institute of Fine Arts, 54
National Museum of Anthropology, Mexico City, 16–17
Natura-Cultura (*Nature-Culture*) [Gruner], 184
"neo-" prefix, 27–28, 31, 153, 202
Nevarez, Ángel, 280
Nevins, Joseph, 220, 228
Ngai, Mae, 214, 215
Nichols, Bill, 296, 297
Nitsch, Hermann, 133
No, Global Tour (Sierra), 127, 128
No-Grupo, 52–59; and commodity as allegory, 33; and Gómez-Peña, 251; and Herrera's corpus, 72; and inter-objectivity, 74; and Los Grupos, 48; members of, 53, 53; and "no-objetual" art, 72
No Logo (Klein), 98
Non-Aligned Movement (NAM), 253
"no-"/"non-" prefixes, 31, 33, 72–74, 82, 124, 127, 130, 162, 225, 313
Noriega, Chon, 216, 217
Nor-tec electronic music scene, 266–267, 268, 280
North American Free Trade Agreement (NAFTA): as allegory for globalization, 313; arts held up as shield against, 24; and Bustamante's *La patente del taco*, 56; changes effected by (NAFTA effect), 7–8; and Cueva's *Dodgem*, 99; and culture wars in US, 37; debates on, 29; and GDPs, 243; and Gómez-Peña's call for Free Art Agreement, 253; implementation of, 254–255; and inSITE, 264, 284; as inter-American allegory, 7; and neo-conceptualism/neomexicanismo opposition, 29; objectives of, 7; and Razo's *NAFTA Spanish-English Dictionary*, 83; reactions to, 7; and Salinas's reforms, 12; social and cultural context of, 22–23, 25; and US presidential election of 2016, 9, 320–321
"Notas del Camp en México" ("Notes on Mexican Camp") [Monsiváis], 27
"Notes on 'Camp'" (Sontag), 27
Noticias del México surrealista (*News from Surrealist Mexico*; Herrera), 59–60
Núñez, Alfredo, 33, 53

Obelisco roto portátil para mercados ambulantes (*Portable Broken Obelisk for Ambulatory Markets*) [Abaroa], 60, 72
Ochoa, Guillermo, 56, 155, 157–158, 159
Ochoa, Victor "Cozmos," 218, 222
October, 28, 29, 72
Okón, Yoshua, 83–95; *A propósito . . .*, 85–86; *Bocanegra*, 91, 91–92, 93; *Chocorrol* (*Chocolate Bread*), 87–89, 93; *Excusado* (with Sierra), 314; *The Gathering*, 92–93; and La Feria del Rebelde (Rebel's Fair), 86–87; and La Panadería, 84–85; *The Movie*, 92; *Oríllese a la orilla* (*Pull Over to the Curb*), 89–90, 93; *Poli* series, 90–91; *Risa enlatadas* (*Canned Laughter*), 93–95, 95, 116, 128, 145; and SOMA, 83–84; *A Walk in the Park*, 92
Oliviero, Katie, 286
Ollin, Nahui, 160
One Flew Over the Void (Téllez), plate 17, 283–284
"On Interobjectivity" (Latour), 74
Operation Bootstrap (Operación Manos a la Obra), 213

Operation Gatekeeper, 8, 37, 220, 260–261, 292, 304–205
Operation Gatekeeper and Beyond (Nevins), 228
Operativo I & II (Margolles), plate 6, fig. 0.1, 140–145
Ordaz, Díaz, 207
Origin of German Tragic Drama, The (Benjamin), 4
Oríllese a la orilla (Pull Over to the Curb) [Okón], 89–90, 93
Orozco, Gabriel, 29, 32, 34, 86, 96, 120
Orozco, José Clemente, 16, 30, 133, 149–150, 151–152
Orozco, Lorena, 36
Ortega, Damián, 96
Ortega, Rafael, plate 4, 41, 111, 112
Ortiz Monasterio, Patricia, 30
O Solo Homo (Hughes and Román, eds.), 246
Owens, Craig, 4, 8, 109, 127–128, 166

Paik, Nam June, 167
Pani, Mario, 212
Papapapá (Rivera), 291–292
Paradox of Praxis 1 (Sometimes Doing Something Leads to Nothing) [Alÿs], 110–111
Parallel Project, 30
Paredes, Américo, 7–8
Paz, Octavio: and Gómez-Peña's actions, 239, 240–241, 243; *Labyrinth of Solitude*, 19, 158; and "La Ruptura," 19–20; male identity portrayed by, 238–239, 240–241; and postrevolutionary rhetoric, 19
Pelligrini, Ann, 189
Performero ([Mere] Performer) [Gómez-Peña], 239, 240
Peyote y la Compañía, 48
PIAS Forms (las Formas PIAS): about, 44; bus benches as, 233; and Cuevas's *Mejor Vida Corp*, 104; and Estridentismo movement, 44, 238; female form as, 201; and Herrera, 72; and inSITE, 264; lack of recognition for, 67; and Los Grupos, 67; and Margolles, 138, 145; new PIAS Forms, 56, 69, 71, 87, 95; and No-Grupo, 54; and Okón, 87, 88; and Razo's pyramids, 82; and scope of NAFTArt, 191
Piensa global-Actúa local (Think Global-Act Local) [Cueva], 97, 98
Pinto mi Raya (Mayer and Lerma), 67–69, 68, 157
Placing Pillows (Alÿs), 108–109
Plan for the Betterment of Tepito (Tepito Arte Acá), 50
Plegaria espiritual macroeconómica (Razo), 76
Plotting Women: Gender and Representation in Mexico (Franco), 151
Poli series of Okón, 90–91
Politics of Rehearsal, The (Alÿs), 115–116
Polvo de Gallina Negra (PGN; Black Hen Powder), 36, 152, 155–162
Polyesis Genética, 241
Porter, Katherine, 18
Portillo, Lourdes, plate 20, 296–300, 299
Posada, José Guadalupe, 132
"post-" prefix, 25, 31, 153, 180, 202, 244
Postmodernism (Jameson), 5–6, 8, 23, 30, 35–36, 253, 318
"Postmodernism, or, The Cultural Logic of Late Capitalism" (Jameson), 5
Prejudice Project (ERRE), plate 18, 285–286
Presidencola (Presidential Cola) [Razo], 82
Prieto Stambaugh, Antonio, 180, 181
Proceso Pentágono, 48, 50–51
Programa Cultural de las Fronteras (PCF; Cultural Program of the Borders), 219
Programa Nacional Fronterizo (PRONAF; National Border Program), 211–212
Proposition 187, 8, 244, 247
Proyecto Juárez, 93
Proyecto Pentágono (Proceso Pentágono), 51
Puar, Jasbir, 23, 137, 321
Public Address (Razo), 73–74, 79
"Puertas de México" (Gateways to Mexico), 212
Puga, Cristina, 12

¡Que viva México! (Eisenstein), 119, 315
Quint, Mark, 256, 257

386

Ragasol, Tania, 280
Ramírez, Armando, 49
Ramírez, Mari Carmen, 1, 2
Ramírez ERRE, Marcos, 24, 282, 284; Century 21, 51, 258–259, 259, 260, 317; Prejudice Project, plate 18, 285–286, 291, 310; and shields from crude oil barrels, 316; Toy an Horse, plate 15, 266, 279
Ramírez Vázquez, Pedro, 97, 212, 219
Ramos, Samuel, 19, 238–239, 241
Rancière, Jacques, 3, 141, 303, 310
"Rasquachismo: A Chicano Sensibility" (Ybarra-Frausto) and rasquache, 29–30, 39, 229, 244–245, 267, 314
Razo, Vicente, 74–83; and El Mago Melchor's performance, 43; In God We Trust: Pirámides, 74–79, 75, 76; and La Feria del Rebelde (Rebel's Fair), 84, 86–87; Manoftheyear I, plate 1, 79–80; Manoftheyear II, 79–80; Museo Salinas, plate 2, 80–82, 117; on museums, 80; NAFTA Spanish-English Dictionary, 83; Plegaria espiritual macroeconómica, 76; Presidencola (Presidential Cola), 82; Public Address, 73–74, 79; Revolucionario institutional (Institutional Revolutionary), 82; Seguridad, 75–76; Strange Currencies: Art and Action in Mexico City, 1990–2000, 82; 20 Million Mexicans Can't be Wrong, , 82–83
Red Specter, The (Botey, Chávez MacGregor, and Medina), 73
Rehearsal I (Ensayo I) [Alÿs], 113–114
Rehearsal II (Alÿs), 115–116
Reimers, David, 214
reMex (term), 1–9, 10, 13, 21, 27, 30, 33, 312–322
"re-" prefix, 31, 149–150, 162, 202, 225, 313
Restrepo T., Juliana, 72
Return of the Prodigal Son, The (Cuevas), 55
Revolucionario institutional (Institutional Revolutionary) [Razo], 82
Richard, Nelly, 149
Ríos Montt, Efraín, 101
Risa enlatadas (Canned Laughter) [Okón], 93–95, 95, 116, 128, 145

Rivera, Alex, 280, 292–294
Rivera, Diego, 14, 16, 18, 21
Rivera, Jenni, 306–307
Rivera Garza, Cristina, 141, 169
Robarte el arte (Stealing Art; 1972), 85
Rodríguez, Jesusa and Liliana Felipe, 195
Rogin, Michael, 25
Román, David, 245–246
Rosa, María Laura, 157
Rosales, Luis Humberto, 268
Rosen Morrison, Manuel, 219
Rosler, Martha, 287
Rubio Burgos, Magdiel, 306, 307
Rufino Tamayo Museum of Contemporary Art, 21
Rules of the Game, The (Artigas), 270, 271, 272

Said, Edward, 25, 31, 322
Salas, Alexis, 96, 97
Salcedo, Doris, 133
Saldívar, José David, 216
Saldívar, Ramón, 216
Salón des Aztecas, 108
Sánchez, Chalino, 307
Sánchez, Osvaldo, 27, 269
Sánchez, Robert, 230, 249
San Diego, California, 205–208; and Committee on Chicano Rights (CCR), 221; and Dos Ciudades/Two Cities, 232, 234, 256, 273; and inSITE, 256, 257, 258, 261, 262; and Light Up the Border campaign, 225–226; and Logan Heights (Barrio Logan), 217–218; and RNC Convention, 207–208, 265; and San Diego Bus Poster Project of Sisco, Hock, and Avalos, 205, 221, 256; and Sekula's Dead Letter Office, 265. See also Welcome to America's Finest Tourist Plantation
Sanromán, Lucía, 255, 312
Santamarina, Guillermo, 70, 86
Sarlo, Beatriz, 319
Schechner, Richard, 199
Schleiner, Anne-Marie, 280, 281, 281
Schmelz, Itala, 43, 84, 145
Schmitt, Carl, 126
Schneider, Rebecca, 161, 166, 170

Schorr, Michael, 222, 230
Schwartz, Alexandra, 29
Schwarz, Roberto, 6, 57, 65, 98
Scott, James C., 16
Segura, Joaquín, 117–118, *118*
Segura, Juan, 183
Seguridad (Razo), 75–76
Sekula, Alan, 265–266, 287, 291, 292
Self-portrait with Monkeys (Kahlo), 13, *14*, 35
SEMEFO, 131–134, 138, 145
Señorita Extraviada (Portillo), plate 20, 296–300, *299*
Serrano, Andres, 132
Servicio Médico Forense (SEMEFO), 131–134
Seven Lives of Garbage, The (Alÿs), 117
Shape of Time, The (Kubler), 115
Sheren, Ila Nicole, 215, 220, 222, 252
Shohat, Ella, 195, 250
Sierra, Santiago, 120–130; and Alÿs's performances, 121–122; background of, 120–121; de-lineations of, 145; *Excusado* (with Okón), 314; *Los penetrados*, 126–127; and Medina, 106, 120; *No, Global Tour*, 127, *128*; and Okón's *Risa enlatadas* (Canned Laughter), 94; and *Proyecto Juárez* (*Sumisión*), 93, 128–130; remuneration series of, 122–126, *124*; street protests of, 121
Sifuentes, Roberto, 247
Signs of the Times (Abel), 221
Silva, Ernest, 256, 257
Simposio Internacional de Teoría de Arte Contemporáneo (SITAC), 117
Sin centenario ni bicentenario (Mayer), 157
Siqueiros, David Alfaro, 16, 77, 168, 208
Sisco, Elizabeth: *Art Rebate/Arte reembolso*, 233–234, *234*; and Rivera's *Why Cybraceros?* 294; San Diego Bus Poster Project, 205, 221, 256; *Welcome to America's Finest*, 206–207, *207*; *Welcome to America's Finest Tourist Plantation*, plate 13, 205–206, 208, 213, 216, 221, 233, 256, 274, 310
Si tiene dudas . . . pregunte (Mayer), 157
Small, Deborah, 206, 233

Smith, Melanie, 60
Smith, Terry, 313
Smithson, Robert, 31, 33, 48, 127–128, 215
SOMA, 83–84
Sommer, Doris, 15, 151
Son of Border Crisis (Gómez-Peña), 243–245
Sontag, Susan, 27, 28
Southern California: Cinemural (Hock), plate 19, *288*, 288, 289
Soy totalmente de hierro (Wolffer), plate 9, 166–168, *171*
Spiral City (Smith), 60
Spivak, Gayatri Chakravorty, 15, 140, 151, 172–173, 274, 277, 298
Stam, Robert, 195, 250
STC Cleaning Service (Alÿs and Medina), 105–106, *107*
Steinberg, Samuel, 113
Steinmetz, Klaus, 260
Stewart, Susan, 180
Strange Currencies: Art and Action in Mexico City, 1990–2000 (Razo), 82
Strange New World: Art and Design from Tijuana, 285
Suma, 48, 50, 51
Sumisión (Sierra), 128–130, *129*
Superbarrio, 62–63, 179, 194

Táboas, Sofía, 96, 192
Tale of Two Cities, A (Burden), 259–260
Taller de Arte Fronterizo (Border Art Workshop), 62, 221–234
Taller de Arte e Ideología (TAI)/Art and Ideology Workshop, 48, 50–51
Taller de Arte y Activismo Feminista, 156
Taller de Gráfica Popular, 48
Taller de Investigación Plástica, 48
Tamayo, Rufino, 19
Tamayo Museum, Mexico City, 105, 159
Taussig, Michael, 81
Taylor, Diana, 136–137, 247, 249
Teagle, Rachel, 267
Tejada, Roberto, 17, 287
Téllez, Javier, plate 17, 283–284
Tepito Arte Acá (Tepito Art Here), 48, 49–50, 208

Terreno Peligroso, 196
Teskey, Gordon, 35, 151
Tetraedro, 50
"Third-World Literature" (Jameson), 5, 23, 35
Thouard, Sylvie, 296
Tijuana, Mexico: aesthetic of, 267; and *Borderhack!* 269; and De La Torre and Funari's *Maquilapolis*, 301–303; and *Dos Ciudades/Two Cities*, 232, 234, 256, 273; and ERRE's *Century 21*, 258–259, *259*; GDP of, 243; and Gómez-Peña, 242; infrastructure of, 219; and inSITE, 254–286; and Muñoz's "La Mona," 268; and Nor-tec electronic music scene, 266–267, 268; and *Strange New World*, 285. *See also* Centro Cultural Tijuana (CECUT)
Tijuana Projection (Wodiczko), plate 16, 273–277, *275*, 301–302
Tijuana Sessions, Vol. 3 (2005), 268
Tijuaneados anónimos (Tijuaneados Anonymous), 282
Tirado, Katia, 175–182; *Exhivilización*, plate 12, 178–182, *179*; and female form as allegory, 36; influences, 181; *Los nichos púb(l)icos*, plate 10, plate 11, 36, 175–178, *176*, 180–182
Tiravanija, Rirkrit, 96
Tlacuilas y Retrateras, 157
Tlatelolco massacre, 33, 45–46, 48, 67, 111, 172
Toledo, Francisco, 19
Torolab, 282
Torrero, Mario, 218
Torres, Salvador "Queso," 218
Torres-García, Joaquín, 230
Toscano, Alberto, 292
Tovar y de Teresa, Rafael, 69
Toy an Horse (ERRE), plate 15, 266
Trauerspiel (Benjamin), 4, 54
Treasures of Mexico exhibit, 20
Tribe, Mark, 280
Turista (Alÿs), plate 3, 110, 125
Turista Fronterizo (Fusco and Domínguez), 280
Turner, Victor, 4, 31, 171
Twenty Centuries of Mexican Art exhibit, 18

20 Million Mexicans Can't be Wrong (Razo), 82–83
Two Undiscovered Amerindians Visit the West (Gómez-Peña and Fusco), 248–252

Ukele, Mierle Laderman, 106, 144
Un banquete en Tetlapayac (A Banquet in Tetlapayac) [Debroise], 119, 185, 315
Un chant d'amour (Gruner), 190, 191, 192–193
undocumentary: about, 286–311; 32, 39, 49, 52, 91, 173, 220, 227, 250, 266, 273–274, 279
undocumentation, 38–39, 99, 115, 139, 173–174, 189, 193, 220, 225–226, 230, 250, 278, 285–287, 290–291, 293, 296–297, 300, 305, 310, 313, 319, 321
Uno por 5, 3 por Diez (One for 5, 3 for Ten, 1992), 61
"un-" prefix, 31, 225, 249, 250, 290, 305, 313
Unthinking Eurocentrism (Shohat and Stam), 195, 250
Urrea, Luis Alberto, 305

Valdez, Patssi, 37, 217
Valencia, Rubén, 33, 52, 53
Vaporización (Vaporization) [Margolles], 130–132, *131*, 138–140, 162, 198
Vasconcelos, José, 15, 194, 315–316
Vásquez, Álvaro, 45
Venice Biennale, 124, 144–145, 230, 269
Villanueva, Ema, 182
Vinegar, Aron, 317–318
Vinicio González, Marco, 242
Viviendas por todos . . . (Housing for All . . .) [Alÿs], 111

"Wag Dogging a Tale, A" (Avalos), 232–233
Walk in the Park, A (Okón), 92
Wallis, Brian, 13–14
Warner, Marina, 177
Watson, Muriel, 225, 226
Weiss, Rocio, 230
Welcome to America's Finest installation, 206–208, *207*, 225

Welcome to America's Finest Tourist Plantation: about, plate 13, 205–206, 208, 213, 310; and inSITE's beginnings, 256; and PIAS Forms, 233; political/economic context of, 216, 221; and Wodiczko, 274

"Welcome to the New Berlin Wall" (inSITE), 260

Werthein, Judi, 280–281, 282

Weston, Edward, 18, 314

When Faith Moves Mountains (Cuando la fe mueve montañas) [Alÿs], plate 4, 114–115, 248

Why Cybraceros? (Rivera), 293–294

Williams, William Carlos, 68

Wilson, Fred, 183–184, 278

Wilson, Pete, 207, 208, 212, 226, 265

Witker, Alejandro, 51

Wodiczko, Krzysztof, 108, 273–277, 288, 317; *Border Projection* (Parts I & II), 273–274, 275, 277; and De La Torre and Funari's *Maquilapolis*, 301–302; *Tijuana Projection*, plate 16, 273–277, 275, 301–302

Wolffer, Lorena, 36, 163–175, 177, 181, 185, 188, 196, 197, 198, 200, 208, 248, 285, 297; body art of, 163–164, 173, 175; "El género es violencia" bumper sticker, 315; *Estados de excepción*, 174–175; *Evidencias*, 174; and female form as allegory, 36; *14 de febrero*, 173; *If she is Mexico, who beat her up?*, plate 8, 36, 164–166, 171; *Mientras dormíamos (el caso Juárez)*, 168–171, 170; *Muros de réplica*, 174, 174–175; and ritual, 175; *Soy totalmente de hierro*, plate 9, 166–168, 171; and *Terreno Peligroso*, 196

Woman, Native, Other (Minh-Ha), 185

"Woman in Difference" (Spivak), 140

"Women and Allegory" (Johnson), 150

Wynter, Sylvia, 3, 35, 241

Yard, Sally, 264, 269

Ybarra-Frausto, Tomás, 29–30, 244–245

Yeuani, 274

Yúdice, George, 17, 51, 263, 264, 274

Zapatistas, 8, 9, 26, 81, 113, 239, 286, 315

Zenhil, Nahum, 168

Zerpa, Carlos, 57

Zona MACO México Arte Contemporáneo, 84

Zortibrandt, Melchor. *See* El Mago Melchor

www.ingramcontent.com/pod-product-compliance
Lightning Source LLC
Chambersburg PA
CBHW021546200526
45163CB00016B/2480